Fiery Cinema

To Richard and Jane,
For the love of
architecture.

Warmest regards

My T. Bao

April 7, 2019

Weihong Bao is assistant professor of film and media and Chinese studies at the University of California–Berkeley.

Fiery Cinema

The Emergence of an Affective Medium
in China, 1915–1945

WEIHONG BAO

A Quadrant Book

University of Minnesota Press
Minneapolis • London

Quadrant, a joint initiative of the University of Minnesota Press and the Institute for Advanced Study at the University of Minnesota, provides support for interdisciplinary scholarship within a new, more collaborative model of research and publication.

http://quadrant.umn.edu.

QUADRANT

Sponsored by the Quadrant Global Cultures group (advisory board: Evelyn Davidheiser, Michael Goldman, Helga Leitner, and Margaret Werry) and by the Institute for Global Studies at the University of Minnesota.

Quadrant is generously funded by the Andrew W. Mellon Foundation.

Portions of chapter 1 were previously published as "From Pearl White to White Rose Woo: Tracing the Vernacular Body of *Nüxia* in Chinese Silent Cinema, 1927–1931," *Camera Obscura* 20, no. 3 (2005): 193–231. Portions of chapter 5 were previously published as "In Search of a 'Cinematic Esperanto': Exhibiting Wartime Chongqing Cinema in the Global Context," *Journal of Chinese Cinemas* 3, no. 2 (2009): 135–47.

Published by the University of Minnesota Press
111 Third Avenue South, Suite 290
Minneapolis, MN 55401-2520
http://www.upress.umn.edu

Library of Congress Cataloging-in-Publication Data

Bao, Weihong.
 Fiery cinema : the emergence of an affective medium in China, 1915–1945 / Weihong Bao.
"A Quadrant book."
 Includes bibliographical references and index.
 ISBN 978-0-8166-8133-4 (hc : alk. paper)
 ISBN 978-0-8166-8134-1 (pb : alk. paper)
Motion pictures—China—History—20th century. I. Title.
 PN1993.5.C4B334 2015
 791.430951—dc23

 2014019917

Printed in the United States of America on acid-free paper

The University of Minnesota is an equal-opportunity educator and employer.

21 20 19 18 17 16 15 10 9 8 7 6 5 4 3 2 1

To my parents, with love

Contents

Introduction

On January 27, 1940, at the Weiyi Theater in Chongqing, the wartime capital of Nationalist China, the public crowded into one of the best theaters in the city for the afternoon screening of *Mulan congjun* (*Mulan Joins the Army*, 1939). Directed by veteran filmmaker Bu Wancang, the film had already become a sensation in Shanghai, where it was made, as well as in Nanjing and Hong Kong. The adaptation of the widely circulated folktale of Mulan served as a star vehicle for Hong Kong actress Chen Yunshang, whose vivacious presence complemented the film's dramatic narrative, comic relief, and allegorical reference to the war to make its debut a success.[1] All of these were strong selling points to the Chongqing audience, whose anticipation had been stirred by newspaper publicity preceding the film screening.

Yet not everyone greeted the film warmly. In the middle of the first Chongqing screening, a young man climbed onto the stage and condemned the film emphatically. He pointed out that both the director, Bu Wancang, and the Shanghai-based studio, Xinhua, had collaborated with the Japanese, who by then had occupied the great cosmopolitan city (except for the areas of international settlement) and infringed upon the independence of its film industry. Following this agitated speech, another man planted among the audience called for action. Roused, the enraged audience stormed the projection room, snatched the first five reels of the film print, and set them on fire outside the theater. Shortly, five more reels arrived from the other first-run theater in town, Cathay; the audience snapped them up as well and threw them into the blaze.[2] The commotion attracted a large crowd, which conflagrated into a riotous mass. Police were called in to put an end to the incident.

The *Mulan Joins the Army* incident was quickly denounced as "brutality in broad daylight" and is still considered an instance of

"mob violence" against Shanghai commercial cinema in the wartime hinterland.[3] Closer scrutiny reveals, however, far more complex implications of burning the film.[4] More than a single episode of mob violence, the burning of the film could be seen as a provocative and self-conscious intermedia event. This incident involved a ploy by renowned dramatists Hong Shen and Ma Yanxiang and filmmaker He Feiguang. After learning about the film screening and failing to convince more than ten newspapers in Chongqing to publish their petition, they decided to stage a public protest at the movie theater.[5] At the screening of *Mulan Joins the Army,* the film and theater workers took control of the space by sending people to the electricity room, to the projection room, and to the gate. Just as Chen Yunshang was about to make her screen appearance at the end of a film sequence, the light was switched on, and an actor (Tian Chen) went onstage to denounce the film. With another actor planted among the audience calling for action, two more actors led the audience to the projection room to seize the film print.[6] Simultaneously calculated and eruptive, the event achieved success not only through a carefully orchestrated collaboration among dramatists and filmmakers but also by the spontaneous response from a combustible audience. The affective impacts of the event went, however, beyond a modernist gesture. Once the masses took to the street, the scripted protest developed into a potentially unmanageable conflict.

The incident thus raises more questions than its condemnation could answer. It cultivated an active spectatorship to such an extent that the myth of realism at the heart of cinema's institutionalization encountered its demystification at its own expense through its material death/destruction. Should we consider this cinema's worst nightmare or its ideal realization? What, then, is cinema? Is it the image on the screen, its material technological support—the screen, the projector, the celluloid print, its built environment—or the social space articulated? Or is it what eventually affects the spectators—the crowd that completes and destabilizes cinema's realization through transformations of their perceptions and actions? What is the role of theater in this case? Is it a competing medium, a social space, or a particular mode of performance? In other words, what constitutes the medium of cinema? What role does other media play? And what has affect got to do with it?

Several key points can be made about the *Mulan Joins the Army* incident. First, it almost too perfectly performed an ideological critique of the cinematic apparatus at the height of its institutionalization in China. The lead protestors unchained the spectators—prisoners of Plato's cave—by turning their heads away from the shadows on the screen toward the electric fire flickering at their backs in the projection booth. By revealing the mechanism, or *dispositif*, of the classical viewing situation of cinema—with its artificial darkness, invisible operation, and disciplined audience behavior corresponding to a film aesthetic of absorption—the event disrupted the film's fictional construction of reality and reflected upon the role of cinema in its public space of exhibition, confronting cinema with its mass spectators and its own material "thingness" and finality. If the cinematic apparatus very much enforces what Heidegger calls *enframing*, the reduction of the world to a separate realm of representation, the incident of burning the film effectively unframed the world picture by an act of deframing.

Important to note, this act of unframing the apparatus was realized by casting a new dynamic between two media: film and theater. This intermediality ran a peculiar logic by staging old as new. If theater was the older medium, it turned out to be "wiser" as an agent of reflection. The scripted event transformed a film screening into an avant-garde theatrical performance that effectively illuminated the social space of the spectators. Yet what was staged was not a simple media competition that reified medium borders, executed in an act of "medium violence," but something that changed conceptions and practices of cinema and theater, through which a new connection between them was forged. The triumph, first of all, was not of theater per se but of a particular kind indebted to the Chinese avant-garde theater of the late 1920s and mid-1930s, for which planting people in the audience and carrying the performance to the street were trademarks. This was vividly captured in dramatist Xiong Foxi's slogan "Jump out of the picture frame, shake hands with the audience, open the roof top, break the walls, and blend in with nature."[7] In this sense, the rebellion of theater was against a modern proscenium theater that shared much with the cinematic apparatus in its institutionalization of a disciplined space and a fictional construction of reality. More intriguing, what was staged was the triumph not merely

of avant-garde theater itself but of a new conception of cinema, that of agitation, a cinema prone to inducing audience action that necessitated dissembling an earlier arrangement of the medium by cultivating its deep connection with another media. If apparatus theory has been long challenged by its gender blindness and transhistorical claim, this incident actually illuminated its historicity as a specific, albeit privileged, modus operandi for cinema as well as theater. A new cinema was introduced not by the absolute newness of a medium but by a new kind of operation, initiating a new dynamic with the "old" positioned as such.

Intermediality thus operates as a rhetoric, or a politics that illuminates the changing operation of a medium through a triad process of unframing, deframing, and reframing, mobilizing the dynamic between the old and the new in a sense of liberating from, annihilating, and redrawing medium boundaries. That intermediality was intimately linked with the geopolitics of cinema in wartime China, which was itself the placeholder for the competition between particular kinds and practices of cinema—in this context, a commercially oriented cinema versus a politically oriented one, or entertainment versus propaganda. Yet as I show, even that distinction is murky, and to further complicate the direct lineage between avant-garde theater and cinema, the incident drew also from the commercial convention of *film event* popular in 1920s China, a publicity stunt that inserted a live performance into a film screening. The most famous such event was at the first screening of *Liangxin fuhuo* (*Resurrected Conscience*, 1926), made by the director of *Mulan Joins the Army*. At the tragic climax the lead actress, Yang Naimei, appeared onstage and performed the theme song live. In wartime Chongqing, film event had resurged in movie theaters, with live political speech, performance, and charity events embellishing film screenings at the height of mass mobilization. Although Bu Wancang's *Mulan Joins the Army* received a treatment entirely different from the film event for *Resurrected Conscience,* the burning of the film was an act of condemnation that unwittingly created more sensation and further piqued the curiosity of the Chongqing public. As it turned out, after the Nationalist government's intervention the film continued to be screened even after the incident and with substantial success.

Intermediality is not at all immune to such messy politics that

seek to make geographical, generic, and media distinctions. To investigate this historical operation, I need to reframe *dispositif* itself—attributed to Baudry for its first use in relation to cinema and translated as "apparatus" in Anglophone film discourses—so as to engage a much broader social landscape and consider changing conceptions and practices of cinema embedded in a heterogeneous network of social and political discourses, media technology and operation, and aesthetics. Joining recent interest in the renewed understanding of the *dispositif* in relation to media theory and media history, this book makes its unique contribution by inquiring into how social politics intersect with media politics, especially with the politics of medium specificity and intermediality. Like a criminologist who follows a modus operandi to uncover the hidden and repressed identity of a criminal agent, I examine what the *dispositifs* of shifting social and media practices can tell us about the different political agents, institutions, and media involved. Yet as a media scholar I am less interested in pinning down the hidden identity than in questioning it as a trope of false unity. That inquiry will start by questioning the notion of *medium* itself and decoupling it from its easy conflation with material media technology.

Finally, such an unframing and deframing of cinema was realized by an act of enflaming, a literal burning of the frame by an instrumental and spontaneous resort to fire that precipitated the criminality of the media event and the affective density of the occasion. This encounter between fire and cinema was, I argue, a provocative instance of intermediality that redrew the medium's boundary. Fire itself is an unstable medium, straddling a material, an image, and a technology with tremendous affective power. Animating, metamorphosing, and corroding, it moves across space and time as an agent of simultaneous assimilation and perpetual differentiation. The competition between cinema and fire hence suggests a more fundamental reconception of the medium. This is a notion of the medium as a *mediating environment* that not only redraws individual medium boundaries in an empirical sense but, in an attempt to transcend such boundaries, exploits the continuity between space, affect, and matter while reconnecting body, collectivity, and technology. I will call such a medium an *affective medium*, drawing on the centrality of affect to such a formation but also on the mutual transformation of

affect and medium by bringing them together. The enveloping force of such a medium converts spectators into the crowd, an amorphous, ever-shifting, and socially menacing force for which fire has been a common trope. The dream of the fiery and affective medium, carrying cinema's desire to overcome its historical self by self-induced medium violence—from generic and aesthetic crossing of the representation frame to endured obsession with images of fire and similar entities to physical destructions of film screens, prints, and sites of exhibition—has always been with us in international film history. Yet such radical deframing by fire to forge an affective medium has also been cinema's worst nightmare, associated with its material finality (nitrate film stock), technological instability (fire in the projection room), and the precariousness of public screenings.[8] Worse still is its symbolic and political association with inflaming, a particular tradition within cinema and mass media condemned for its mental manipulation and appeal to the senses, the name of which is *propaganda*. The *Mulan Joins the Army* incident was just such an instance of political agitation, meant to usher propaganda cinema and theater into Chongqing to compete with Shanghai commercial cinema in a heterogeneous film culture. How to understand the radical promise, unfinished dream, and troublesome legacy of the affective medium is key to my inquiry. Situating propaganda cinema at the beginning and the end of this book, I want to highlight it as central, rather than anomalous, to our understanding of modern media history and mass culture.

This book traces the permutations of the affective medium in modern China as a way to rethink cinema as a material, aesthetic, and social medium deeply connected to the artificial production of affect central for the consolidation of media institutions and the formation of mass publics. I argue that affect, rather than something intrinsic to a private individual, was evoked and engineered as a sharable social experience through media technologies and their aesthetic interplay; in return, media institutions and the social agents involved became solidified. My inquiry traces the rise of mass-media culture in China from its flourishing in the 1910s to its increasing politicization in the 1930s, culminating in China's participation in World War II. By investigating mass media's engagement with colonization, urban consumption, and mechanized warfare, I trace the shift from

commercial to political modernist and propagandist film and media culture. Placing my narrative end point at wartime propaganda, my project creates a critical genealogy of spectatorial affect to examine the affinity and tension between commercially and politically oriented mass culture and their particular promises and stakes.

By focusing on the changing *dispositif* of the affective medium—a distinct notion and practice of medium as mediating environment—I approach cinema's intimate dynamic with other media as conversations with historical political discourses, institutions, and material practices in shaping public perception and experience. As an animating, metamorphosing, and manifold affective medium, fire serves as a linchpin in this book. It manifested as the imponderable ether insinuated within late-Qing political philosophy, as the heroic action emblazing the screen in the 1920s martial arts subgenre of fiery films (*huoshao pian*), and as electromagnetic waves harnessing the dreams of wireless cinema. It stirred up storms and torrents, confronting and shaping the political crowds of 1930s left-wing cinema. It demolished the urban landscape as incendiary bombs dropped from the air, stimulated a resistance cinema imbued with fire imagery, and embodied a utopian notion of propaganda media ensemble—a "vibrating art in the air." It even morphed into its unlikely sibling, glass, a material product of fire and a unique industrial medium that shaped a new mediating environment that destabilized optical and spatial distinctions and sensual and critical boundaries. Interweaving film and media practices with political philosophy, literary and aesthetic modernism, popular scientific discourses, spiritualist practices, and propaganda theory, I investigate the historical operations and unique materiality of the affective medium, combining inquiries into the hardware of technology and the software of aesthetic construction and political articulations.

The Affective Medium

I coined the term *affective medium* to describe a distinct conception of medium as a *mediating environment,* in contrast to the currently dominant understanding of medium as a vehicle of information transmission according to an epistolary communication model—predicated on divisions between the sender, the receiver, and the

message. The affective medium connotes a new conception of medium, space, and spectatorial body as well as the entwinement of media in a dynamic ecology. The affective medium also heightens affect as a shared social space in commercial and political mass publics. In this sense, the affective medium is larger than a singular media technology as we conventionally understand it. I illustrate that modern China provides a compelling case through which the ideals and problematics of affective medium were repeatedly pursued, debated, and experimented with. It gives us a way to rethink film history and film theory not simply by debunking cinema's singularity and inviting studies on its intrinsic intermediality; rather, by resituating cinema within broader questions of perception, social space, and politics, it cautions us against privileging a particular medium because of its technological-material-ontological advantage, which itself is a discursive product and embeds a logic of rupture that entails cinema's own obsolescence.

The notion of the affective medium entails a negotiation with current understandings of affect and medium, two central concepts across a number of disciplines for which a critical reflection of both terms is necessary. Before we approach affect, the term *medium* needs to be rethought. It is helpful to clarify the distinction between *medium* and *media,* which have been often used interchangeably. Although contemporary use of *media* usually refers to mass media, a phenomenon that has been ascending since the late nineteenth century, *medium* has a much longer history, with various strands of connotations. My following discussion thus insists on using the singular form *medium* in order to refer to historical and critical conceptions that are broader than modern mass media but shape our understanding of mass media as such.

In a broad stroke, I suggest that three conceptual models have persisted in current understandings of the medium: (1) a linear model of the medium as a directional transmission of a message, (2) an intermediary model that conceives medium as the interface and intervening entity facilitating the two-way exchange between the subject and the objective world, and (3) a spherical model that understands the medium as an immediate environment or field that encompasses a variety of media and constitutes a shared space of experience. These three models are not empirical categories but

rather different conceptions of the medium aligned with particular historical practices, ideologies, and social institutions that recast the relationships between subject and object, space and body, and perception and action.

The linear model, increasingly dominating our understandings of media as communications, is predicated upon the divisions between the sender, the receiver, the message, and the channel. I call this an epistolary model, as it evokes the trope of the letter as an ideal for interpersonal exchange across distance, hence the desire for secure transmission aiming at a private destination. Such an ideal, as Bernhard Siegert's provocative study of the postal epoch illustrates, transformed into the anxiety of interference with the rise of the postal service as a mass-delivery system around the 1840s and was exacerbated by the invention of telecommunication technologies such as the telegraph and the telephone.[9] Postwar information theory, inspired by cybernetics, furthers this model by conceiving communication as a process of information transmission and noise control.[10] The epistolary model has also shaped a particular strand of media archeology along the basic parameter of information theory. Friederich Kittler, for example, traces the rise of modern media technologies and historical optical media in terms of a genealogy of data recording, storage, transmission, and noise cancellation. As the human subject recedes and information takes the foreground, this trajectory anticipates the computer and electronic communication in the posthuman condition.[11] Yet the linear model is haunted by its structural breakdown. As Siegert points out, relay, as the underlying principle of the postal epoch, contains an intrinsic paradox of interference as the condition of transmission. Based on the linguistic model of communication, the epistolary conception of medium has been obsessed with the gap between the sender and the receiver of the message, the interference and the interception at the channel, hence the perpetual interplay between signal and noise, ranging from a function-oriented pursuit of efficient communication against interference to treating noise as a positive generator of information.[12]

Whereas the epistolary model already implies its compromise by the structural paradox of transmission as interference, the intermediary model of the medium has foregrounded the interface between two distinct entities as the site for exchange. This conception

can be traced to Aristotle's notion of *medium diaphane* (translucent middle): a medium of refraction such as air, crystals, and water creating an optical distortion in the process of perception.[13] Between 1600 and 1800, as Stefan Hoffmann illustrates, the "refractive media" were extended to both artificial optical instruments and the natural "imponderables"—ether and other mysterious fluids and forces in their all-pervasive, permeable form. In the long nineteenth century, the human body emerged as a new medium when practices and theories of mediumism—mesmerism, somnambulism, and spiritualism—aimed at transforming the human body into a vehicle for communicating with external or supernatural forces, often in light of mass media, as in the case of spiritual telegraphy, photography, and other media inventions.[14] The rise of mass media since the nineteenth century has entailed, however, a more substantial discontinuity in the connotations of *medium* versus *media*. As Wendy Hui Kyong Chun points out, in English the Latin meaning of *medium* as "middle, center, midst, intermediate course, intermediary" changed in the fifteenth century to "intervening substance."[15] *Media,* in contrast, was associated with the emergence of mass media and became a plural–singular noun in the late nineteenth and twentieth centuries. Notably, the connotation of *media* as "intervening" was replaced by its portrayal as "transparent."[16] This change anticipated the tension between media and mediation, which has preoccupied social theorists, media scholars, and cultural historians. Two trajectories of mediation have prevailed in the discussions—a unidimensional social mediation treating media as passive reflections of socioeconomic superstructure and a revisionist emphasis on culture as a dynamic site of mediation, with the emphasis on representation over reflection.[17] Yet the assumption of separating two qualitatively different entities as implied in the mediation model, as John Guillory observes, poses a challenge to revisionist Marxist scholars such as Raymond Williams to consider mediation as a vehicle to bridge social divisions.[18] Although Guillory himself has proposed distanciation to further the mediation model in order to consider media as means of *possible* but not *actual* communication, the desire to bridge the mediation gap has persisted.[19]

The spherical model, which posits medium as an encompassing environment, registers the impulse to cross over the separation that

conditions medium as a mediating entity. This model subsumes a few distinct constellations, ranging from understanding medium as immanence to medium as a system, an ecology, a social practice, or an immersive environment. Unlike the intermediary model, which posits the division and distance between two qualitatively different entities (the subject and the object, the image and the spectator), the spherical model dissolves such a division. In effect, any single medium is not understood in isolation but entails a larger media context, an ecological environment. One could trace the notion of medium as environment to historical conceptions of ether and other "natural imponderables" figured as the enveloping and pervasive force. The spherical medium is also foregrounded in visual studies' surging interest in immersion as a persistent perceptual mode covering diverse media environment from panorama to virtual reality.[20] In line with similar interest in medium as environment, recent architecture and museum studies have emphasized built space as a dynamic, haptic environment interacting with the spectator as moving bodies.[21] In film studies, visual studies, and new media studies, increasing emphasis on touch, haptic vision, and embodied perception continues to challenge the intermediary model.[22] This challenge is largely realized by foregrounding the centrality of the body in sensorial perception that critiques the hegemony of vision relying on the division between image and spectatorial space. The spherical model recurs in media theories ranging from Niklas Luhmann's system theory to Marshall McLuhan's media ecology to W. J. T. Mitchell's discussion on the shifting boundaries of the medium entailing the context of a medium's social practice and institution.[23] Although the spherical model subsumes a variety of distinct constellations and intellectual lineages, I consider them together in their similar challenge to the mediation model by problematizing the subject/object division and foregrounding environment as the all-encompassing and mediating force to foster a more creative dynamic.

These three models—linear, intermediary, and spherical—are not mutually exclusive. The linear model already entails mediation with the structural paradox of transmission and interception. Conversely, the environmentally conceived medium could serve to transmit a highly directed message if interpellated by external social agents. The intermediary and spherical models of medium

also implicate each other. The intermediary separates two distinct entities but brings them into a relationship, gesturing toward a connection, and leaves open potential crossovers; conversely, medium as immanent environment entails both a homogenizing and a self-differentiating process, simultaneously assimilating and dissimilating, enveloping and mediating. W. J. T. Mitchell provides an ingenious metaphor of the potential convertibility between these two models by conceiving media as an elastic middle that could expand to include their outer boundaries.[24] Ether, the ancient medium that recurred in crucial moments of medium conception, embodies this elasticity. Invisible, amorphous, intermediating, and yet all permeating and pervasive, ether stands for the connectivity that constitutes the continuum of body, space, and matter. Fire, like ether and with much kinship to the latter's ancient meaning, contains similar instability in its ontological status, oscillating between an image, a moving entity, and an enveloping force.

Of particular interest for this book are how the linear model becomes complicated by the mediation and environmental models and the tension and affinity between these two that makes it possible for us to conceive the history and politics of the affective medium. This is where affect enters the picture. I argue that in modern mass-mediated society, affect registers this tension and affinity as the tendency and potentiality to cross the intermediary boundary, which yet remains mediated and mediating. Neither purely interior nor physiological, affect is the virtual milieu, the mirroring third space of the media intermediary that yet envelops the media product and the perceiving subject in a continuous space. That space is never homogeneous but an experiential sphere through which the interchange and tension are acted out and transformed. Eventually, this horizon is a social milieu beyond the individual personal. It relates to both the body (as the surrogate milieu of affect) and the emotions but resists the latter's codification and interiorization. Affect is thus a medium. The affective medium is not any singular empirical medium but suggests affect as a platform/interface of experience produced by media technology and media aesthetic in interaction with the perceptual subjects.

My conception of the affective medium is indebted to Henri Bergson, who has radicalized our understanding of the world in a

quasi-material continuum of aggregated images, challenging our distinction between image and matter and self and object.[25] For Bergson the image is the intermediary entity between representation and matter, and our body and the object (another body) constitute the two ends of the continuum of images, which he calls *body-image* and *object-image*. While pure perception remains exterior as an attribute of the object, our body remains a center of indetermination with a potential to spring into action. The only way to make the image relevant to our body and enable the transformation from virtual to real action is by covering the interval between object/perception and body/action with affection, a quality or state that measures the distance between body and object, the gradual diminishing of which is experienced as sensation. Affection thus makes perception impure but also makes exterior image relevant to us. While it is impossible to summarize Bergson here and unpack the complexity of his thoughts, which have already inspired myriad interpretations and appropriations, what I find particularly useful is to consider perception not immediately our own but external, and the only way to reclaim it is through affection, conceived as a spatial terrain allowing the extensity of the body to reach the object and prepare for action. Affect for Bergson is thus not an abstract quality but a process, which acknowledges the distance between self and object, but serving as a bridge. What makes this bridging possible is the erasure of qualitative difference between image and body, the extensity of which makes the world a continuum of perpetual vibrations. This is, to me, a conception of the world as an affective medium, a continuum of matter, image, and space through which affect operates as a necessary intermediary as well as one that crosses over it. It also modifies perception from pure, external, and objective to subjective.

I evoke Bergson here not to return affect to certain transhistorical and transcultural notions and thus render it transcendental, a point of suspicion that has entailed Ruth Leys's poignant criticism, but to situate it in modern China and uncover its surprising connections with modern mass-media aesthetics and politics.[26] Bergson was an important figure in modern China, whose major works were translated into Chinese in the 1910s and 1920s and whose thoughts were popularized via a vernacular process of transnational mediations, mistranslations, and active appropriations through the 1940s. The

key notions—perception, affection, and action—took on quite historically and politically specific meanings in modern China, which I illustrate throughout this book. Specifically, I examine several *dispositifs* of the affective medium that link these three key categories in myriad constellations to particular historical moments in the 1920s, 1930s, and 1940s, redefining cinema by linking heterogeneous cultural discourses, media practices, and technological innovations.

By rethinking affect and medium as overlapping categories and thus creating a compound, I point out that the spectator as a category needs to be rethought. While the three models converge at the end of the spectator, the tension and affinity between the models suggest the categorical instability and problematic of the spectator, which has too often been considered the locus of affect. The major difference between the conception of medium as intermediary and as environment should not be that of distance or closeness, or of rational thinking versus emotional/affective engagement, but rather whether medium functions as an external, third category that enables reflection or as something from which the human subject cannot be separated. Bergson himself has linked affect with sensation, the experience of the decreasing distance between body and object experienced physically. Yet I would like to pursue affect as a category broader than sensation, not least because for Bergson sensation suggests zero distance between body and object (his primary example is pain), whereas affection designates the interval between them, as well as between perception and action. More important, I want to emphasize affection as an act, a process through which a field of uncertainty modifies perception with a potential to action, serving as a fertile ground for public experience and political action. This corresponds to the Chinese term for affection *ganyingli* (the power to affect), an ideal for cinema frequently evoked in political modernist film discourses as well as discussions of propaganda. Further, affect, while distinct from emotion, maintains an open relationship with the latter, open to but also resisting emotion's assimilation and qualification. Affect in this sense maintains an ideological ambivalence rather than a radical alterity. Further complicating the distinction between affect and emotion is the materialist tendency in modern China to consider emotion a transmittable matter or, even, the hovering, quasi-material yet imponderable environment, which was

sometimes literally confused with ether, as in late-Qing intellectual thought, as illustrated in chapter 2.

A key component of the controversial "affective turn," affect has become a subject attracting considerable attention and criticism in recent discussions across humanities, social sciences, and cognitive and neural sciences. Although still ill defined, affect is identified by its affinity with the body, its proximity with physiological experience and sensation, its distance from contemplative cognition, and its power to overwhelm human perception and experience. Often distinguished as qualitatively different from emotion, the latter identified by its psychological dimension, scholars of affect emphasize its nonsubjective, prepersonal, nonqualified experience as an intensity-resisting narrative and semantic containment, "not ownable or recognizable and . . . thus resistant to critique."[27] The sometimes mystifying and "anti-intellectual" gesture of conceptions of affect, though motivated by particular political agenda, has entailed criticism from scholars such as Ruth Leys, who has recently critiqued the "turn to affect"—especially, the mutual reinforcement between particular philosophical strands and interpretations of neuroscience—as politically suspect anti-intentionalism that makes meaning or ideological critique irrelevant.

My take on affect carries a dialogue with the recent affective turn, benefiting from particular strands of thought but also qualifying its promises and pitfalls with a historically and culturally situated perspective. I would argue that the previous characterization of affect, which itself registers a critical desire to demarcate certain positivity of affect through a rhetoric of negation, is not at all that of a free-floating quality of an objective entity—affect, after all, is "nonqualified"—but a symptom of a post-Cartesian critical insistence on the radical alterity of body to mind, a resistance to representation, signification, and objectification that has characterized the epistemological rupture of modernity and the logic of capitalism. Affect is, then, a product of modernity, and it is not immune to meaningful construction and modern regimes of power. As William Mazzarella forcefully argues, modern social theory and social psychology demonstrate how affect has remained central rather than radically other to theories of modernity and sociality. For Mazzarella recent celebration of affect in social and cultural analysis rekindles

the fantasy of "immediation," an illusion of premediated existence as a political practice that "in the name of immediacy and transparency, occludes the potentialities and contingencies embedded in the mediations that comprise and enable social life."[28] By proposing modernity as "structurally affective," Mazzarella points out how affect remains complicit or instrumental in modern governmentality and institutional practice: "Any social project that is not imposed through force alone must be affective in order to be effective."[29] In critiquing the romantic fascination with affect as immediacy, he seeks to rethink mediation and affective immediacy not in antithetical terms but as mutually constitutive. Positing mediation as "incomplete, unstable, and provisional," Mazzarella observes how the illusion of immediation is "at once the outcome of mediation and the means of its occlusion."[30]

If affect has been central to modernity, it has been closely entwined with modern media institutions. Their mutual dependence is key to the consolidation and authentication of mass media as platforms of the public sphere and engines of social experience. In other words, media technologies and aesthetics are also modern technologies of affect. I coin the notion *affective medium* precisely to capture the interdependence between affective immediacy, mediation, and mass media. The dynamic of this set of relationships has a tendency, however, of displacing mediation and mass media with the immediacy of affect, in the sense that affect becomes the supramedium that enfolds and displaces individual media and mediation in a virtual space of experience. Running counter to this fallacy, my study restores affective media as a manufactured environment enfolding the individual subject, a virtual space (itself highly mediated) mediating between the prepersonal and the social. As I show in this book, the clichéd terms for affective immediacy in modern China—*resonance, transparency,* and *agitation* (the last laying bare the instrumentalization of affect, especially through media technology)—are by no means self-explanatory notions of experience but *dispositifs* of the affective medium that entail discursive construction, institutional battles, technological operations and procedures, and aesthetic experiments.

Yet it is important to keep the tension between affect and its modern management, or the disruptive and productive power of affect. In this regard, I carry a more direct conversation with a few disciplines

closest to film studies—art history, visual studies, new media stud-
ies, and media archeology—as well as pioneering scholarship on
modern China. This is not to reaffirm the authenticity of affect but to
better illustrate how affective immediacy has fascinated both estab-
lished orders and radical cultural discourses and practices and how
mass media become again entwined in such battle. The few sibling
disciplines of film studies frequently intersect in their conception
of affect as embodied experience, problematizing the distinctions
between internal perception and the external world, sensuous expe-
rience and conscious thought, and subject and object. In changing
"scopic regimes," in the "technique of the observer," in "cinema and
the invention of modern life," in the shift from "gaze theory" to "body
genres," and in the "virtuality of new media," affect remains key to
the constructions of the modern subject while problematizing it as
a stable category.[31] My only complaint is that more often than not
the body effectively displaces the modern subject without being ques-
tioned for its own historical constructions and, hence, often ends up
authenticating affect. In scholarship on modern China, Haiyan Lee
and Eugenia Lean have examined emotion and mass-media sensation
at great length and depth, teasing out their historical constructions
and political implications by compelling examples from either dis-
cursive constructions of love (Lee) or the mass-mediated production
of public passion (Lean).[32] As I draw insights from these studies, my
focus on affective medium allows me to historicize the ambivalent
implication for affect in modern China while linking it more directly
to media institutions and making it relevant to media studies, espe-
cially by rethinking how affect has played a part in shifting medium
boundaries, medium constituents, and questions of spectatorship. By
decoupling body from affect and dissociating the former as the sole
and naturalized vehicle and manifestation of affect, I can more effec-
tively explore the social space of experience and its implications for
the modern public produced by mass media.

Vernacular Modernism, Political Modernism, and Propaganda

By tracing the public fate of affect in modern China through the
media fascination with fire and other ethereal mediums, this book

seeks to outline a different genealogy of Chinese cinema. Up to the mid-1980s, official accounts from the People's Republic of China aligned the history of modern Chinese cinema closely with that of the nation, subsuming the politically oriented left-wing Chinese cinema (1932–37) and its postwar legacy under the grand narrative of communist revolution and national salvation pitted against the "frivolous" entertainment films produced from the 1920s to the 1940s.[33] Such a highly dichotomous and reductive history has been challenged in the past two decades, paralleling the country's increasing marketization and transition from socialism to postsocialism. A new generation of film scholarship has rediscovered the entertainment cinema as rich and viable articulations of a commercial public sphere centered in cosmopolitan Shanghai before the eruption of the Second Sino–Japanese War (1937–45).[34] This revisionist scholarship has excavated 1920s genre films and recontextualized left-wing cinema in a vibrant commercial horizon with due attention to questions of gender, technology, and film culture. While this has provided invaluable insights and broadened the scope of modern Chinese film studies, the particular politicality that marked left-wing cinema, already reductively conceived and assimilated in official grand narrative, remains unexplored and further marginalized. In effect, the rhetorical opposition between commercially and politically oriented cinema in prewar Shanghai as established in official historiography is further entrenched. The problematic opposition between these cinemas before the Sino–Japanese War translates into a geopolitical division in the writing of wartime Chinese film history that dichotomizes cosmopolitan coastal cities (the nexus of Shanghai–Hong Kong) and the nationalistic hinterland (northwest and southwest China under the Nationalist regime centered in the wartime capital Chongqing). As a result, an important chapter of Chinese cinema remains largely neglected: the wartime resistance cinema centered in Chongqing and its entwinement with the legacy of both the political modernist and the vernacular modernist cinemas.

The Sino–Japanese War figured as an interruption of a vibrant commercial film culture and a change of orientation. It is hard to steer attention away from the question of propaganda, which has preoccupied concerns about various political regimes and film studios, despite the wartime geopolitical divisions between Nationalist,

Communist, and Japanese colonial regimes. In fact, the highly politicized and propagandistic wartime mass culture poses a methodological challenge larger than its geopolitical divisions and the inaccessibility of archival materials. This might explain why pioneering works on wartime Hong Kong and Shanghai cinema have focused on the continued flourishing of commercial film culture in which stardom and entertainment cinema played an ambiguous role in changing political regimes. How to deal with the tremendous complexity of propaganda and its relationship with commercial mass culture remains a troubling question in our conceptions of cinema, media, and public sphere.

For these unanswered questions, it is necessary to return to the scope and premises of vernacular modernism, a key concept in film theory with tremendous purchase in the study of transnational cinema and mass culture yet whose promises, potentials, and limits are better understood when placed in dialogue with issues of political modernism and propaganda. Vernacular modernism, as Miriam Hansen proposes, originates from an interest in considering the role of cinema in capitalist industrial modernity, and hence, Hansen juxtaposes two seemingly incompatible terms—*vernacular* and *modernism*—to provoke a radical rethinking of modernism from its narrow confinement to Western aesthetic high modernism to the broadest demarcation of aesthetic product that reflects, articulates, and negotiates the experience of modernity.[35] Hansen characterizes vernacular modernism by two distinct operations of reflexivity that complement modernist formal reflexivity and a Marxist realist reflection: one tackles cinema's reflexive relationship with industrial modernity due to its mimetic technology, aesthetic organization, and link to a Fordist mode of production; the other draws on a linguistic notion of reflexivity that, by pointing to Hollywood cinema's global impact and subjection to local translation and appropriations, circles back to reaffirm (Hollywood) cinema's reflexive capacity in relation to modernity. The terms *vernacular* and *modernism* thus tap into two different interests and orientations, especially in the case of world cinema. While the notion of modernism is an argument for the cinematic medium, covering all national cinemas or particular historical practices (in this case, *vernacular* is a qualifier, closest in its meaning to "everyday, promiscuity, plebian"), the notion

of vernacular concerns translocal cultural circulation and the en-counter between global and local forces.[36] The aporia of this critical model shows precisely on the second level of reflexivity, when the translatability of Hollywood cinema—predicated on its first level of reflexive relationship with modernity—and its subjection to transla-tion worldwide become inseparable and conflated in the production of a global vernacular. Affect plays a crucial role in reconciling this paradox of a universal particular by authenticating technology's re-flexivity through the individual sensory reflex of the spectators—an innervation yoking technology and the body with the spectators' mimetic engagement—and by providing a collective, sharable "sen-sory reflexive horizon" that serves as an alternative public sphere.

Hansen's reevaluation of (classical Hollywood) cinema as re-flexive articulations of capitalist modernity fostering a commercial public sphere makes a powerful endorsement of commercial cinema in other regions, as she herself sets out to do so in her discussion of Shanghai cinema and Japanese cinema in the interwar period; the emphasis on the vernacular not as a single idiom but as a process of global–local contact and transregional circulation allows scholars of international cinema to envision film practices and film culture be-yond the framework of national cinema. Yet it is important to note the implicit automaticity of Hansen's discussion on the two levels of reflexivity, both in terms of her assumptions of technology's re-flexivity complementary to the audience's sensorium and in terms of the notion of global circulation as a neutral, self-regulatory process predicated upon the free market. On the first level, Hansen's notion of cinematic reflexivity is deeply indebted to (high) modernist dis-course of medium specificity, especially the modernist investment in the alterity of technological perception advanced by writers such as Jean Epstein, Dziga Vertov, Béla Balázs, and Siegfried Kracauer. Her privileging of sensory reflex draws on the "neurological" conception of modernity contemplated by social theorists such as Georg Sim-mel, Kracauer, and Walter Benjamin, who characterize the modern urban and industrial environment as saturated with sensorial over-load, with both Kracauer and Benjamin regarding cinema as com-pensating for the impoverishment of experience by organizing thera-peutic countershocks.[37] On the second level, the questions remain of how to address the heterogeneity of the local cultural scene and the

politics involved, especially the political agency of such appropria-
tions, and whether the sensory reflexive is immune to such politics.
These questions eventually circle back to address the first level of re-
flexivity on a global scale: how were affect and technology theorized
and practiced differently in local contexts, in ways that addressed
specific political agenda beyond an automatic reflexivity?

Here comes the question of political modernism, which has yet to
be rearticulated in light of vernacular modernism and the situation
in modern China. The term *political modernism* designates a vein in
post-1968 film theory and film practice that weds semiotic and ideo-
logical analysis with aesthetic and political radicalism in reaction
against mainstream, commercial, narrative cinema.[38] I find the term
relevant not so much for its historical reference but for its subsequent
critical treatment. David Rodowick has effectively analyzed politi-
cal modernism as a discursive field—at the height of countercinema
and the converging strands of poststructuralism, literary semiology,
psychoanalysis, and Marxism—predicated on a set of rhetorical,
binary oppositions such as modernism and realism, materialism
and idealism, as well as a network of themes.[39] Silvia Harvey points
out political modernism as a selective appropriation of political and
aesthetic practice of the leftist avant-garde from the 1920s and 1930s,
especially that of Brecht. As Harvey illustrates, although post-1968
political modernism focused on "politics of form" and narrowly in-
terpreted Brecht's radical experiment in terms of a stylistic rejection
of realism in favor of modernism, Brecht's work, which intersected
with interests of Russian futurists in the 1920s, should be understood
more broadly as an epistemological and social project concerning
"aesthetic form, social reality, and social change."[40] Instead of posing
realism as the stylistic antithesis of modernism, Harvey interprets
realism for Brecht and Russian futurists as a perception of reality
from the point of view of social change, unmasking the dominant
perception as connected to particular regimes of power.[41]

It is in light of these critical treatments of political modernism—
as a historically specific discursive field concerning the construction
of knowledge, world, and power encompassing film practice and film
theory (and in effect ushering countercinema and film studies as
legitimate film practice and academic discipline) and as an *incom-
plete project* that invites a revisit to the European and Soviet leftist

avant-garde—that I would like to reclaim it as a necessary comple-
ment to vernacular modernism.[42] I would like to propose political
modernism as an interventional and critical epistemology, impart-
ing alternative social perceptions to dominant perceptions with a
mind to social change. As product of the modern industrial society
and mass media, political modernism bears a reflexive relationship
with them but also tries to reflect upon such relationship through al-
ternative engagement with media technology and the materiality of
the form, through sensitivities of the changing mediality of technol-
ogy and body (Brecht, for instance, was interested in new modes and
methods of representations involving new media such as radio), leav-
ing the space for spectators in terms of both conscious contemplation
and sensorial engagement.[43] Instead of mere text-oriented aesthetic
exercise, political modernism is a heterogeneous ensemble involv-
ing both media practice and media theory, interweaving discursive,
institutional, and industrial practices rather than staying outside
them. Unlike vernacular modernism's emphasis on the agency of
media and the automatic, unconscious reflexivity of spectatorial
engagement, political modernism registered an anxiety and crisis
of the modern subject in its negotiation with the power of media to
master and manage reality just as reality became increasingly hard
to pin down; whereas vernacular modernism focused on commercial
cinema, political modernism tried to maintain a distance from it yet
continued to operate in relation to it in symbiotic proximity.

This distance is, of course, precisely the ideology of political
modernism that sets itself against commercial cinema in terms of
a binary opposition. If we do not wish to repeat the ideological im-
passe of political modernism, to which Rodowick alerts us, a revised
notion of political modernism would benefit tremendously from the
critical field opened up by vernacular modernism, by rethinking
political modernism not as the exclusive terrain of aesthetic high
modernism but as part of the cultural articulations and negotiations
of the process and experience of modernization across the division
between high and low, serious and fun, by understanding its embed-
dedness in mass media, and by considering sensorial engagement as
a substantial form of social perception.[44] Nevertheless, by insisting
on political modernism as a distinct strand rather than dissolving
it in the sum of cultural articulations, we can highlight rather than

neutralize particular political agencies and projects as well as their critical promises and limits.

Seen in the global context and from the perspective of the peripheral, both international and domestic, political modernism takes distinct forms in various historical and geopolitical situations but bears a unique reflexive relationship with the shifting centers of power. In the case of modern China, cinematic political modernism in the 1920s and 1930s was always embedded in commercial film industry—there were no independent or avant-garde alternatives to commercial cinema. The Chinese case of political modernism did build a strong connection with a broad range of Western high modernism beyond the leftist avant-garde: fin-de-siècle modernism such as aestheticism, symbolism, and art nouveau introduced under the umbrella term of *neoromanticism*; Soviet montage; architectural modernism; and a whole range of European cinematic modernism from pure cinema to poetic realism to constructivism and expressionism. Concurrently, it invited a deliberate appropriation of popular genres and tastes from both China and the West—martial arts films, action thrillers, melodramas, and musicals, as well as motifs from folklore and popular literature.

Political modernism in interwar China thus suggests a powerful case of reflexive modernism reframing global high and low cultural forces in colonial modernity: it bears a reflexive relationship with Western high modernism and popular genres in the form of a mimetic mediation that registers and negotiates with the colonial hierarchy of knowledge and power. This doubling is not at all immune to what Rey Chow calls a "mimetic desire," an attempt to imitate the powerful other in order to gain equality with and recognition from that other.[15] Yet it is also a strategic doubling, an uncanny double of the dominant Other that upsets the prior relationship through its own distorting mirrors. More important, different agents of political modernism in China sifted through various global forces (American, western European, Soviet, Japanese) to pick up particular strands (Americanism, the global leftist movement, proletarianism, anarchism, Marxism) for their own distinct articulations by forging shifting aesthetic and political alliances with these various strands, crossing both national borders and divisions within those forces. In the 1920s, cinematic new heroism—a particular instance

of political modernism in China—endorsed martial arts films with a desire to emulate American action thrillers, carrying a fascination with American bodies, values, and imagery, yet this Americanism was seasoned with an interest in symbolist aesthetic and vitalist philosophy as well as political orientations toward anarchism and Marxism, filtered through a nationalistic critique of colonialism and racism just as Shanghai audiences viscerally experienced Hollywood's racist depictions on the screen. Left-wing cinema of the 1930s provides another instance of political modernism, in which filmmakers and critics pitted Soviet and European cinema, especially their experimental aesthetic, against Hollywood cinema.

As a reflexive practice from the periphery, political modernism helps flesh out the heterogeneity within local and global forces and the more complex transnational traffic in commodities, knowledge, and sentiments. In the case of modern China, I conceive the reflexivity of political modernism in light of vernacular modernism in the following terms: its intrinsic reflexive relationship with industrial modernity and commercial cinema in its conditions of production; its mimetic and mediational reflexivity vis-à-vis global high modernism and popular culture in the form of distorted copying; its operational, not simply formal, reflexivity of its own media technology and materiality in relation to other media; and finally, a simultaneous reliance on and reflection of sensorial reflexivity in terms of spectatorship. The politics of political modernism, aiming at radical social effects, is tied to these aspects of reflexivity, complementary to notions of reflexivity developed in aesthetic high modernism and vernacular modernism. I hasten to add that these categories—vernacular, political, and aesthetic high modernism—are theoretical models for relevant historical practices rather than their natural distinctions, and hence, vernacular modernism and political modernism can refer to the same historical phenomenon with different interpretative emphases. If vernacular modernism elucidates the process of cultural formation, political modernism highlights the particular agency and desire of specific social groups and interests.

To emphasize the way political modernism complements vernacular modernism regarding global politics is to draw attention to the politics of media in the production of mass affect. By "politics of media," I mean the strategic and rhetorical positioning of cinema

vis-à-vis media old and new. Tracing the changing notions of cinema at different historical junctures, this book engages a broad range of film and media discourses produced and circulated during the first half of the twentieth century in China that were constantly in dialogue with then-contemporary theory and practice abroad. The reflections shown in these discourses upon mass affect reveal a significant difference from vernacular modernism. In the case of left-wing cinema in China, filmmakers consciously illustrated how affect was not simply "induced" from spectators by film but rather "produced" by media technology and intermedial aesthetics in order to generate alternative social perceptions, forge new modes of collectivity, and reside in proximity to commercial modes of affect production and consumption. These political stakes of affect consciously and deliberately conjured by political modernism make it a necessary complement to vernacular modernism.

If political modernism complements vernacular modernism with its distinct reflexive approach to affect, propaganda further complicates their distinctions on a different political horizon. During the Sino–Japanese War, in the Nationalist regime centered in the wartime capital Chongqing and remaining southwest and northwest China, political modernism found an unlikely ally when left-wing filmmakers and critics sought sponsorship from the state for self-preservation and political ambitions. Although their interventional and critical epistemology was compromised by their conflict-ridden alliance with the dominant regime of power, their incorporation of media technology provides a way to understand renewed notions and practices of cinema as an affective medium.

Whereas propaganda has been associated with affective exploitation and ideological instrumentation, often allocated to certain "bad" genres or "bad" phases of film and cultural history, it remains a significant chapter in the history of film and media and, for my interest, a peculiar instance of the affective medium whose connection with vernacular and political modernism calls for investigation.[46] Wartime propaganda cinema in China, as I illustrate in chapter 6, had close links with both vernacular and political modernist cinema in terms of film textual constructions of affective spectatorship, combining sensory resonance with ideological transparency and often involving a skillful deployment of intermediality

for directed reflexivity. A more substantial transformation involves the conception and practice of cinema in relation to media, affect, and public sphere. Propaganda cinema, both in theory and practice, was embedded in a media network, creating a pervasive, nonneutral environment for mass mobilization. Cinema was seen as a "technological system," an infrastructure interweaving a media ensemble, a network of instant, simultaneous dissemination and transmission that conjoined film and other media—posters, photography, painting, street performance—in innovative forms of distribution and exhibition. Wartime Chongqing propaganda presents a unique case of the affective medium by exploring the continuity from individual emotions to affect as a mediasphere. Its potential for public sphere, as I illustrate in chapter 5, resides in the coexistence of and interpenetration between commercial and political propaganda, and it is within their fissures and often multiple and conflicting agendas that possibilities for alternative public sphere remain open.

Dispositifs of the Affective Medium

Although recent scholarship on media history has favored an archeological approach, drawing on Foucault's *Archaeology of Knowledge* for methodological rationales for examining the discontinuity of a media history with multiple origins, dead ends, and an "astonishing otherness of the past," I have found genealogy a more challenging and rewarding approach to exploring Chinese film and media history.[47] The distancing from genealogy in media history, as I see it, has to do with a conflation between genealogy and teleology, in conception and practice, and hence, archeology has provided a way to explore media history as a series of discontinuities rather than a naturalized teleology.[48] In the case of film history, as Thomas Elsaesser points out, such teleology entails systematic exclusions of "deviant" inventions and practices from the privileged institution of cinema as an entertainment industry and exhibition venue.[49] Yet for Foucault genealogy and archaeology are quite closely related, and genealogy is meant as a remedy for the archeological method's inability to account for the causes of historical transitions as anything beyond a series of discontinuous discursive and epistemic formations. The challenge and reward of a genealogical method is precisely not to

affirm a teleology or the victory of historical subject or reason but to find fissures, displacements, and loose ends that makes the dominance of certain historical modes contingent. For me, emphasizing the affinity between genealogy and archaeology helps us approach notions such as cinema or affective medium as false or camouflaged continuities and invites us to explore the process and tension involved in certain dominant modes of operation and what remains unaddressed and goes underground. It also forces us to acknowledge our own critical positions, in contrast to certain media archaeological tendencies, whose search for alternative origins of media or audiovisual modes often has an eye toward contemporary media formations and manifestations without fully accounting for their commitment to that connection.[50]

In this book the recurrent trope of fire as played out in a variety of Chinese film and media products is an instance of such false unity of the affective medium. The affective medium is not a singular medium in an empirical sense; it is not limited to any particular set of media technology, material support, operational procedure, or aesthetic codes. Instead, it poses itself as a supramedium—a mediating environment yoking technological, natural, and human forces, constituted by (yet at the same time covering up) the interdependence between affect, mediation, and media institutions—that was configured differently at different moments in modern China. Fire gives shape and tangibility to what seems an amorphous, imponderable, yet overpowering and all-encompassing medium; it also registers its plasticity, animation, vitality, its destructive and creative force, and its affinity with varied experiences of modernity, media technology, and aesthetics. In that sense, fire is not a singular medium. At different historical moments, it has been associated in turn with technical mediums such as sound and wireless technology, ethereal mediums such as crowd and natural forces, and material mediums such as glass. A genealogical approach to the affective medium allows me to explore the historical connections and differences between vernacular modernism, political modernism, and propaganda by inquiring into how the mutual dependence between affect and media institutions intensified in the first half of the twentieth century in constituting mass publics, how commercially and politically oriented cinemas converged and diverged in their strategies for the

intermedial operation of affect, and how this shared interest in the affective medium provides a crucial clue to understanding the major transformations of wartime mass culture and propaganda cinema in the hinterland.

To trace such a critical genealogy, I have found "*dispositif* analysis" a useful tool to engage the complex entwinement between technological and cultural history. As mentioned at the beginning of the introduction, the term *dispositif*, previously translated as "apparatus," emerged in the 1970s in close connection with Jean-Louis Baudry's apparatus theory, although the term's broader associations and more complex implications have only recently attracted the attention of scholars in the humanities and social sciences.[51] Beyond Baudry, Foucault's exposition of *dispositif* is key to its renewal beyond the connotation of "apparatus," of "device," "tool," or "mechanism." Foucault conceives *dispositif* as a heterogeneous ensemble consisting of discursive and nondiscursive elements, which forms a system of relations as a strategic response to an urgent situation—sometimes as programming of an institution, sometimes as masking or reinterpreting of an unspoken practice.[52] As an alternative to discursive analysis but inclusive of it, Foucault's approach to *dispositif* helps us understand the entwinement of heterogeneous elements in specific historical formation in relation to power and knowledge, but it also helps us explore the vastly rich terrain between discursive and nondiscursive, the symbolic and the material, said and unsaid, and visible and invisible.[53] Hence, as Frank Kessler points out, *dispositif* should be seen not only for its regulatory, totalizing, and anonymous operation but also for its openness, internal contradictions, potential forking, deviations, and breakdowns.[54] In the social sciences *dispositif* analysis has emerged as an alternative to discourse analysis, combining the linguistic and nonlinguistic, symbolic and material.[55] For my own analysis it is useful to keep *dispositif*'s everyday usage to encompass both the "mechanical side" of the term and its connotation as a specific "disposition," in terms of mechanical and institutional "arrangement" and mental and psychological "tendencies."

The methodological openness of *dispositif* analysis and its advantage in binding discursive and nondiscursive elements helps us resituate film history in media history, in terms of both rethinking cinema or any given medium as historically specific and varied

configurations and debunking any reductive understanding of medium as media technology. This is very much the case for modern China when we think about the multiple and shifting identities of cinema in relation to other media. In its initial introduction to China, cinema was conceived as shadow play (*yingxi*) and shadow picture play (*yingxihua*), among its many names, forging a connection with existing but also changing forms of picture and play. In the 1920s, early television was seen as a new development of cinema (just like sound, color, and stereoscopic film); a hybrid between radio and cinema; and an improvement on telephones, with visual access (see chapter 2). More important, medium should not be seen merely as the synonym of media technologies but as encompassing its material, symbolic, and operational dimensions. This can be seen in the example of the 1930s' left-wing filmmakers, who configured natural forces such as wind, torrent, and fire as comparable to cinema with a political desire to forge an affective medium; meanwhile, their interest in critical disclosure prompted them to problematize the intrinsic connection between certain material medium such as glass and its critical power by defining cinematic transparency as a matter of aesthetic organization. In the 1940s at the height of wartime propaganda, filmmakers and propagandists repositioned cinema, along with other mass-mediating forms, as a wireless medium not in terms of material technology but in terms of strategies of distribution and exhibition. By analyzing the changing *dispositifs* of cinema, we gain a better understanding of Chinese film history by situating it in a much broader context of mass media, problematizing a technologically determined teleology.

My approach therefore carries a dialogue with the emerging scholarship on media history and theory that examines historically specific configurations of perception in relation to technology, aesthetics, and spectatorship. Yet it remains a question how to introduce politics in the inquiry of histories of perception tied not simply to mechanisms, operations, or capitalist economy at large but to more situated politics in specific cultural and historical contexts. Recent archaeologies of media history still tend to focus on the "technical" side of *dispositif,* with inquiries into devices and mechanisms in relation to perception, which, despite affording us insight to the technics and process of power, remains one layer removed from their

entwinement with discursive and institutional battles, power strug-
gles, and economic, political, and material forces in specific cultural
history. I caution against repeating Baudry's search for the perfect
alignment between technology, text, and spectatorship, however
historically varied, because it would close off the more open-ended
and complex traffic between the ensemble of viewing situations and
the broader social and political context. What we see as historical
dispositifs are by no means coherent systems but rather a masking
of internal contradictions in a "social field shaped by in-between
experiences, schemes of signification, meaning in an ever-emergent
context of folding spaces, practices, and signification," hence, as John
Pløger points out, "the inevitable contingency and opacity of a *dis-
positif.*"[56] At the same time, it is useful to return to Baudry, to think
about how politics and ideology matter in specific viewing situations
that comprise technology, film aesthetics, and spectatorship. In this
sense, how to identify a *dispositif,* what counts as one, and the naming
of one as such are not simply matters of history but historiographical
questions inseparable from our own critical positions in relation to
contemporary societies and concerns.[57] Hence, *dispositif* remains a
heuristic tool, rather than an identifiable fact, for us to articulate the
particular complexities of historical moments.

Drawing from recurrent themes in discursive and nondiscursive
constructions in cultural discourses, emerging media technology,
and film aesthetics, I have designated three *dispositifs* of cinema as
the affective medium to explore the rich complexity and interplay
at respective historical transitions. These are not only historical
configurations but, more important, heuristic tools for capturing
distinct regimes of perception and sociality in relation to the spec-
tatorial subject. This book is thus organized around these modes
into three sections, each focusing on a particular period: *resonance,*
the first half of the interwar period (1915–31); *transparency,* the left-
wing cultural turn (1929–37); and *agitation,* the Sino–Japanese War
(1937–45). By dividing the book into these three constellations, I
have chosen to unsettle some standard demarcations in periodiza-
tion and regional divisions to plural forces at play across a particular
period and region.[58] In part 1, I locate the rise of martial arts films
(1927–31) on an international, intermediated horizon of reception
and production. For this purpose I push the time frame backward to

1915, when the serialized action thriller began to be widely circulated in Shanghai and other port cities. Part 2 starts from 1929 instead of 1932. Thus, I place left-wing cinema in the larger context of the left-leaning cultural turn that had been already under way in literature and theater movements since 1929. Meanwhile, I examine the left-wing interest in aesthetic affect that intersected with the discourses around and the practice of martial arts films. Part 3 focuses on wartime Chongqing but highlights the interactions across the three regions of Chongqing, Hong Kong, and Shanghai, as well as the international network of film exhibition. Throughout these three parts, the phenomenal profusion of fire and other ethereal and material mediums on and off screen illuminates a more complex trajectory of Chinese cinema across internal divisions, in which media configurations of affect remained central to producing distinct modes of spectatorship, subjects of knowledge, and public spheres.

These three *dispositifs* are heuristic categories that capture certain prominent though not the single most dominant configurations of cultural experience and perceptions in terms of material technology, film and media aesthetics, spectatorial arrangement, and political subjectivity. They are by no means precise but help capture a certain historical sensibility at a particular moment that congealed various interests across different media and social groups and served as concentric and overlapping centers for a discursive, cultural, and technological network. These three modes I outline are not exclusive of each other, either. There were historical overlaps, coexistences, and recuperations with substantial transformations.

There are, of course, other concurrent and competing regimes of perception, and what I outline is only a particular trajectory that makes us rethink existing assumptions about Chinese cinema in its early stage. Despite the rich film history recovered by recent scholarship on the contested terrain of China, what constitutes cinema as a medium in relation to other media needs investigation; more important, how politics played into such media identities, conceptions, and operations is yet to be historicized and theorized.

The three *dispositifs* I trace are close in function to what Errki Huhtamo calls "topos," clichéd elements in culture that function as "discursive engines" and molds of experience.[59] What I examine operates, however, in both the discursive and the nondiscursive and

encompasses cultural and political discourses as well as technological, aesthetic, and institutional operations. Whereas Huhtamo examines the cyclical nature of the recurrent topos in history and across cultures, seeking a delicate balance between universalism and historical specificity, my scope is more grounded in modern China, looking at the recurrence of the *dispositifs* synchronically across various cultural discourses and practices and approaching these topos from a genealogical perspective. I perform a double take on each *dispositif,* approaching each in two chapters so as to cover the material technological, social discursive, aesthetic, and institutional forces at play.

Resonance, which I examine in part 1, is a tangible topos of the 1920s concerning the aesthetic and technological attunement of the spectator's body in cultivating a sensorial field of social experience as an affective medium. Tracing resonance (*gongming*) as a new coinage drawn from physics and psychology, I associate it with the rise of martial arts films as a cross-section of technologies of body and perception involving cultural discourses on vitalism and neoromanticism, new media technologies such as television and other wireless technologies, and new modes of knowledge such as hypnotism, psychology, and physiology. By examining these fields as overlapping and parallel developments underlying the *dispositif* of resonance, I tease out its varied connotations and operations as a mode of affective spectatorship built upon a confrontational dynamic between screen action and audience response, an atmospheric mood created in the process of artistic appreciation, an involuntary response induced through the techniques of suggestion practiced by psychology and hypnotism, a procedural attunement entailed in wireless reception coordinating the machine, the wave, and the body, and last, a nonneutral ethical sphere as mediating environment perpetuated by the vibrations of ether and contingent upon its ephemeral materiality. As resonance concerns both technologies of body and the shaping of an affective field, it raises questions of the ambiguous political promise concerning spectatorial passivity and activity as well as the potential for a sensorial public sphere.

Chapter 1 takes as its point of departure the sweeping success of fiery films (*huoshao pian*), a subgenre of the martial arts film in Shanghai from 1927 to 1931 that I situate in the transnational circulation of Hollywood action serials, the rise of popular theater, and a

vitalist, anti-colonial, modernist discourse of neoheroism. I analyze how an action-based film aesthetic foregrounded the actor's body in relation to technology and promoted a more confrontational actor–audience dynamic competing against the realism of live stage interaction in popular drama. This new aesthetic was stimulated by the intermediated encounter between Chinese martial arts films and Hollywood serialized thrillers through the popular stage, which provided exhibition spaces for both serialized film thrillers and its own dramatized renditions. Meanwhile, the resonant spectatorship embraced a composite modernist discourse of new heroism, one of the earliest conscious attempts to theorize spectatorial affect for its distinct social and aesthetic agendas, encompassing symbolist aesthetics, social activism, and the nationalist reenergization of Chinese cinema. Bergson's theory on affect, widely translated and circulated in China in the 1920s, gained a distinct meaning through its participation in the discourse of new heroism.

Chapter 2 places resonance in relation to emergent media technologies—wireless technology and newly invented media as well as popular scientific imaginations of the diverse future of cinema—to consider a renewed notion of the medium connecting the spectator's body and a field of social experience incarnating the affective medium. This resonance was predicated on the spectator as a medium capable of responding with sympathetic vibration and on the possibilities of televisuality, in which hypnotism and distant communication technologies intersected. Resonant spectatorship was also enmeshed in a broader discourse network, where psychology, physiology, and vitalist philosophy cross-fertilized one another as competing technologies of perception. These diverse social practices and cultural discourses endowed fire and action with rich connotations while complicating their immediacy and radical alterity. My inquiry eventually leads to a re-visioning of martial arts film not from a genre-specific perspective but through an understanding of the historical formation of intermedial spectatorship.

Transparency, the center of discussion in part 2, is the clichéd topos for perception pertaining to 1930s Shanghai at the intersection of the rise of left-wing cinema, film sound, modernist glass architecture, and a commodity culture of display. Transparency functioned as a discursive trope in cultural debates, as a perceived property of a

new material medium (glass), as an effect of aesthetic organization, and as a new promise of media technology. As I illustrate, left-wing filmmakers exercised a reflexive and political modernism by negotiating transparency's various dimensions, exploring the convergence between critical and affective spectatorship in their effort to engage the mass audience through sensorial affect as well as politicized perception at the juncture between silent and sound cinema.

Chapter 3 examines how left-wing spoken drama and films invoked fire, torrents, and other natural forces to politicize spectatorial affect through visual and sensory confrontations. Starting with Tian Han's spoken drama *Dances of Fire* (1929) and its cinematic adaptation, I explore the shift of Tian's aesthetic symbolism to political symbolism, which retained much continuity with fiery films yet opened up an alternative to resonant spectatorship. I then revisit the dichotomy between left-wing and "soft" film critics and filmmaking by evoking the question of medium specificity at the center of their debate. Seen in this context, Cai Chusheng's film practice offers a rich example of engaging politicized perception through an active exercise of intermedial aesthetic while reflecting upon cinema's relationship with other media. Montage, as a new film theory and practice, provided a novel means to animate the force of images and to mediate affective immediacy

In chapter 4 transparency gains material significance as I illustrate its historical association with glass as a new building material and perceptual medium. I consider the dynamic interaction between Chinese architectural discourses and cinematic reflections in the mid-1930s evolving around a "culture of glass" closely affiliated with international modernist architecture and a commodity culture of display. Left-wing cinema interacted with other perceptual media in pursuit of a critical spectatorship that would reflect upon the sensorial intoxication produced by commodity culture. Architectural and cinematic discourses, produced in their particular semicolonial settings, competed with each other, claiming transparency that could transform perception, dwelling, and sociality. Upon the advent of sound cinema, Chinese left-wing filmmakers sought a "vertical montage" of sound and image meant to create a politicized, critical spectatorship to rival the radicality of modernist glass culture while

appealing to the local masses in hope of creating a third space between the global hegemony of Hollywood and Soviet cinema.

Part 3 concludes my critical inquiry with wartime propaganda cinema, which was as deeply embedded in early conceptions of the affective medium as it was suggestive of a significant transformation. While *agitation* is a key trope for highly instrumentalized affective spectatorship, its operation is intimately entwined with propaganda, which in wartime Chongqing was not a denigrated term but a cultural imperative preoccupying filmmakers, critics, and propagandists. More than a discursive trope, propaganda was implemented by distinct conceptions and practices of film and other media. Through the infrastructure of simultaneous dissemination and mobile exhibition, cinema was reconceived as a "vibrating art in the air," a media ensemble embodying a unique operation of the affective medium with an all-pervasive mediating environment.

Chapter 5 follows the migration of the Chinese film industry from Shanghai to Chongqing during the Sino–Japanese War, examining how the impact of the war on film production, exhibition, and film theory initiated a radical rethinking of Chinese film practice. Prompted by urgent demands of the war to consolidate both local and global audiences, filmmakers sought to bridge film aesthetics and audience responses in the search for the "cinematic Esperanto," an aspiration toward a world cinema and an international film language across the Babel of sound cinema. This search for a new cinema was embedded in the rise of propaganda and the aggressive expansion of a communication network, leading to a reorientation of the cinematic medium as an infrastructure of media ensemble enabling simultaneous dissemination and mobile exhibition.

Chapter 6 complicates the unique claim of propaganda as a utopian media infrastructure by examining the distinct aesthetic participation and reflection of cinema in the atmospheric war. I return to individual films and focus on the phenomenon of "agitational cinema," films that capture the menace of the war with shared interest in perception and action, to show the transregional traffic in film production and aesthetics across the geopolitical division between Chongqing, Hong Kong, and Shanghai. Agitation, I argue, is not simply a mode of highly directed spectatorship serving propaganda

but also an intense stage of affect that registers the crisis of perception and action in an overwhelming world of the war. Sampling film productions in these three regions, I highlight how agitational cinema shared an interest in and negotiation with practices of affective spectatorship in earlier film history in China. I first reconstruct Sun Yu's highly popular but no longer extant film *Baptism by Fire* (1941), made in wartime Chongqing, by drawing on various sources, including documentary footage and visual and textual fragments. This film negotiates with the traumatic and liberatory experience of the war, amalgamating the media intertexts of fire and spectatorial operations discussed in the previous chapters. I then examine a film about wartime Shanghai made in the Hong Kong branch of a Chongqing film studio, *Paradise on Orphan Island* (1939), as well as the first Chinese feature-length animation, *Princess of the Iron Fan* (1941), produced in Shanghai. In the process I map out the transregional aesthetic of agitation indebted to left-wing and commercial cinema, whose interest in spectatorship and aesthetic affect was central to the constitution of modern Chinese cinema and media culture.

Part I

Resonance

1 Fiery Action

Toward an Aesthetics of New Heroism

Between 1927 and 1931, the rise of fiery films (*huoshao pian*) made a phenomenal impression on the Chinese cultural scene as a major subgenre of the burgeoning martial arts film.[1] The sweeping success of *The Burning of the Red Lotus Temple* (*Huoshao hongliansi,* 1928), by Mingxing Studio, was followed not only by its seventeen sequels (between 1928 and 1931) but also by more than forty other fiery films, all with titles beginning with *burning.* Examples include *The Burning of the Green Dragon Temple* (*Huohao qinglongsi,* Ren Yutian, 1929); *The Burning of the Nine-Dragons Mountain* (*Huoshao jiulongshan,* Zhu Shouju, 1929); *The Burning of the Pingyang City* (*Huoshao pinyangcheng,* Yang Xiaozhong, 1929), with seven sequels; *The Burning of the Sword-Blade Village* (*Huoshao jianfengzhai,* Ren Xipan and Fei Boqing, 1929); and *The Burning of the Seven-Stars Mansion* (*Huoshao qixinglou,* Yu Boyan, 1930), with six sequels.[2] These films, modeled after *The Burning of the Red Lotus Temple,* all assume a similar narrative pattern: a group of heroes and heroines meet at a site of evil—a temple, a village, a mansion, a town, or a nunnery—where feverish bodies struggle and compete in swordsmanship, magical sorcery, or other forms of battle. The success of fiery films, according to surviving documents and images, was due to the physicality of the action, the excess of special effects, and the marvelous trick setting (*jiguan bujin*), culminating in the fire scene, where the most thrilling action takes place. Much of the attraction of these films seems to have come from the burning scenes, characteristically placed at the end.

None of the fiery films are extant today. Without substantial evidence from the film texts, we are challenged to discern what constituted their affective density. This problem of "lost cinema" has plagued the study of international silent cinema, perhaps more so in contexts outside North America and Europe, where a much smaller

number of films have survived, due to the ravages of war, technological conditions, and archival politics.

Instead of lamenting the loss of these films, I would like to consider its productive possibilities when we are forced to turn our attention elsewhere. A more innovative research methodology is needed to approach these "lost films," one in which they are a void around which a much broader social landscape comes into view and circumscribes the meaning of such loss. Just as the history of affect itself remains continually under construction, I consider the formation of martial arts films as an "intermediated" process. More specifically, I ask what conditioned the mutual reinforcement between fire and action to articulate a distinct notion of the cinematic medium as well as spectatorship defined not by the "look" but by the affective impact of cinema. This articulation was possible not because of intrinsic generic development but because of multifarious threads of China's social and cultural condition. Market competition between popular drama and cinema intensified the pursuit of hyperrealism on stage and screen, and the global hegemony of Hollywood genre films, especially action thrillers since the mid-1910s, had inspired a new wave of action-centered genre films in China just as the national film industry was on the rise. This emphasis on cinematic action tapped into an anxiety about "national character": Chinese were often presented as weaklings, an image reinforced in racist depictions on Hollywood screens. Furthermore, high modernism in Chinese literary and artistic discourses made its way to film production and film criticism, particularly through neoromanticism—a May Fourth term for fin-de-siècle modernism and its cinematic variation, new heroism. These diverse social practices and cultural discourses foregrounded fire and action and endowed them with rich connotations, contributing to the maximum spectatorial affect they evoked while complicating the immediacy and radical alterity of affect.

The discourse of new heroism challenges our understanding of the first generation of martial arts film, previously conceived as a predominantly popular phenomenon harnessing anarchic energy and an anachronistic mixture of the old and the new and posing a substantial threat to the enlightenment discourse, entailing government censorship and intellectual contempt. While this is a valid point, it is important to note that martial arts films entered a cultural

field invested with conflicting and consensual interests, and elitist modernist artists and writers had taken an active part in shaping this cultural phenomenon. Mediated by a circle of filmmakers, critics, editors, and writers, intellectuals quite readily appropriated this phenomenon, not simply as extrinsic circles making derogative comments but as part of the film production and film discourses forming an important strand of the film culture.

This discourse was one of the earliest conscious attempts to theorize action and spectatorial affect in terms of resonance for various social and aesthetic agendas, encompassing symbolist aesthetics, social activism, and nationalist re-energization of the Chinese people and Chinese cinema. The new heroism discourse of martial arts films provides a rich case of reflexive modernism from the global and domestic periphery, intersecting in a significant way with the Japanese literary critic Kuriyagawa Hakuson (1880–1923), an influential figure in modern China whose writings on fin-de-siècle Western modernism played an important role in the transnational circulation and mediation of literary and aesthetic modernism. By juxtaposing new heroist discussion of spectatorial resonance with Kuriyagawa's writing on artistic appreciation—a creative interpretation of Bergson, Freud, and symbolism—we gain a renewed understanding of Bergson's notion of affect mediated in the global context.

At the center of these plural investments in fiery action is Huaju Film Studio, whose martial arts film productions, as well as publicity discourse, provide an illustrative case for my inquiry. Situating the Huaju productions in dialogue with other martial arts films in the same period, I investigate the tension and symbiosis between two major components of spectatorial affect—namely, sensation and sentimentality. I focus on the figure of the female knight-errant (*nüxia*), whose mobilization of both qualities would persist in subsequent decades in Chinese cinema, particularly in wartime. In the end, the celebration of fiery action in the 1920s raises the question of affect in relation to collective spectatorship and its political implications.

Between Stage and Screen: An Intermediated Encounter

Even though fiery films seemed a unique phenomenon in 1920s China, this was not the first time fire had appeared in popular media.

At the peak of new drama and reformed Beijing opera from the early 1900s to 1910s, live fire, together with other catastrophic attractions, was frequently staged. The popular use of these hyperrealistic spectacles coincided with the fall of the last imperial dynasty in Chinese history and the founding of the republic. Popular drama's minimized distance and sensorial immersion created feverish mass anticipation of a modern nation, fostered by a hyperbolic rhetoric of revolution. The new drama waned between 1912 and 1913, immediately after the establishment of the Republic, but revived starting around 1914 and rechanneled politically affective spectacles for an increasingly solidified commercial audience.

The continued strength of popular theater complicates standard narratives of cinema's "evolution" from live stage performance. Instead of being replaced by cinema, what happened onstage in China interacted intensely with the screen, especially *Chinese* theater with imported *American* films during this period. Whereas by 1909 the American stage's sensational melodramas had been largely replaced by their filmic counterparts, especially serial queen films, the Chinese popular stage—new drama, reformed Beijing opera, civilized play—much akin to sensational melodrama, remained vital well into the early 1920s, until it gradually gave way to a growing domestic film industry around 1924. The heyday of the modern Chinese popular stage paralleled the rise of American films in the Chinese market, when the decline of French film dominance in the wake of World War I gave way to the simultaneous increase in American film exports.

Between 1913 and 1926, American film exports to China increased approximately fifteenfold, from 190,000 to 3,000,000 feet. By 1926 an average of 75 percent of the films shown in China were from the United States. Among those imported to China, the most popular were the "low" genres such as slapstick comedy, westerns, adventure serials, and detective films. According to C. J. North, chief of the Motion Picture Section of the U.S. Department of Commerce, "Pictures of a particularly lurid nature which would never receive first-run showings in the United States" were distribution favorites in the early years and were received with enthusiasm by Chinese audiences. These low genres, especially Wild West pictures, "immediately achieved startling popularity among Chinese theatergoers

and at once stamped American life in their minds as an almost con-
tinuous medley of hard drinking and riding, interspersed with gun
play and violent deaths for all but the favored few." Following the
success of Wild West pictures, there came adventure serials, which
according to North generated "even greater excitement of the Chi-
nese audience."[3]

Among the serial adventures, the serial queen films were most
successful in the Chinese film market. As sensational melodrama
these films feature a robust and fearless heroine plunged into end-
less adventures and perils. The earliest serial queen adventures, in-
cluding Pearl White films, came to China around 1916, a time that
coincided with the rise of American power in Asia. In 1917 the twenty
episodes of *The Iron Claw* (1916) (Figure 1.1), starring White, were
shown, as was another Pearl White serial, *The Clutching Hand* (or *The
Exploits of Elaine*, 1914).[4] Other films starring White included *Pearl
of the Army* (1916) (Figure 1.2), shown in 1921; *The Perils of Pauline*
(1914), shown in China in 1916; *The Black Secret* (1919), released in
1920 as *The Great Secret of Germany*; and a few other films yet to be
identified.[5] These films were tremendously popular.

Other female stars in this genre were also popular in Shanghai
movie theaters. Stars such as Clara Kimball Young, Mabel Normand,
Marguerite Courtot, and Eileen Percy sustained the presence of the
serial queen in local theaters in China. Yet while the "fearless, peer-
less" Pearl White enjoyed unsurpassable popularity in China, only
one other name approached her rank. When Ruth Roland's *Ruth of
the Rockies* (1920) (or *Baoshi qi'an* [*Marvelous Case of the Diamond*])
was shown in Shanghai in 1921, Roland was referred to as one of the
"peerless pair" (*shuangjue*) on-screen competing for the favor of
Chinese audiences. Screenings in China of Roland's *The Girl Detec-
tive, The Adventures of Ruth*, and *The Red Circle* were all documented.[6]

The rhetoric of stardom surrounding these female daredevils is
similar. In an advertisement for *Ruth of the Rockies*, Roland is praised
for her stunts, similar to those of White: "Riding on a raging stal-
lion climbing the cliff as if walking on flat land, her talents are un-
surpassable."[7] This verbal depiction was matched with a pictorial
rendition in an illustrated synopsis of the film in *Yingxi zazhi* (*The
Motion Picture Review*) (Figure 1.3). Renewing the iconography of
female heroism with the visual portrayal of a sexualized Western

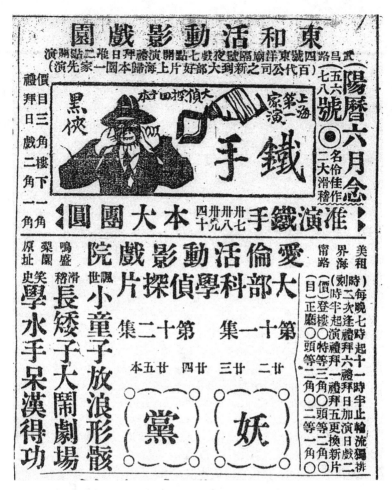

Figure 1.1. Newspaper ad for the American serial queen thriller *The Iron Claw* (*Tieshou,* 1916). *Shenbao,* June 6, 1917.

woman conquering the craggy cliff while maintaining full control of an unbridled horse—a metonym of her own physical prowess and carnality—advertisements and illustrations like this one created a new fantastic body whose physicality contrasted with the asexual body of *nüxia,* the female knight-errant recurrent in Chinese folkloric imagination.

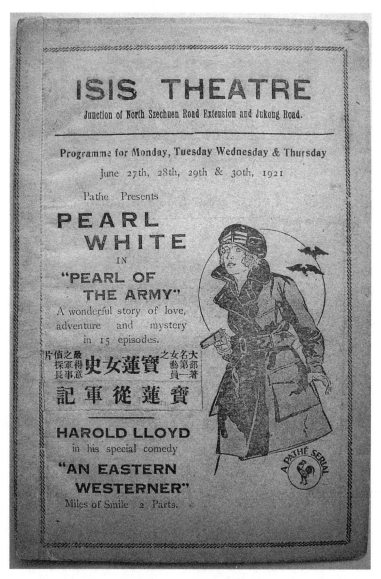

Figure 1.2. Film program for *Pearl of the Army* (1916) at Shanghai's Isis Theater, 1921. Private collection.

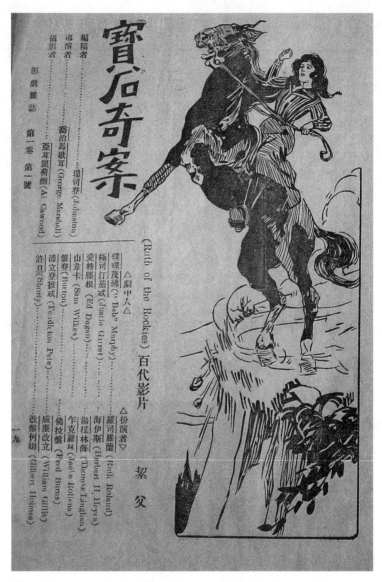

寶石奇案

（Ruth of the Rockies）百代影片

△劇中人△

璞瑾茂絲（"Baby" Murphy）

極司汀茄武（Justin Garret）

愛特朦根（Ed Dugan）

山韋卡（Sam Wilkes）

盤登（Burton）

潘立登披武（Tenditton Pete）

許日（Shorty）

△扮演者▽

羅司羅蘭（Ruth Roland）

海伊斯（Herbert H. Heyes）

湯樫林海（Thomas Lingham）

乍克羅林（Jack Hollins）

佛拉盤（Fred Burns）

威慶改立（William Gillis）

改黎何姍（Gilbert Holmes）

絜父

編稿者……項司登（Johnston）

導演者……喬治馬歇耳（George Marshall）

攝影者……亞耳凱荷德（Al Cawrood）

影戲雜誌 第一卷 第一號

一九

Figure 1.3. Illustrated image of Ruth Roland in *Ruth of the Rockies* (1920). *Yingxi zazhi* 1 (1922): 15.

Although Chinese film journals did not emerge until 1921 (coinciding with the rise of the domestic film industry), the newspapers of the period reveal the impact of serial queen films on the local cultural scene, including live entertainment theatrical genres. Browsing through newspapers from 1911 to 1923 in Shanghai, one might be surprised by the relatively few cinema (Chinese and foreign) advertisements and reviews, although they did steadily increase over this period. American films dominated the Chinese market in the 1910s and 1920s, but they certainly did not take over the local entertainment world. An entertainment page from the July 9, 1917, edition of *Shenbao,* for instance, shows advertisements for Beijing opera and civilized play sharing more than three-quarters of the page, whereas film programs occupy the relatively humble corners.

A closer look at the new drama and the reformed Beijing opera shows an increasing interaction between adventure film serials and these dramatic forms. Film and theater shared not only the same space and mode of exhibition but also similar narratives. On the new drama stage, two episodes of a serialized play were shown each night, often along with two episodes of a detective serial film. The films were sometimes shown in separate venues, at Chinese- and foreign-owned movie theaters, but without exception two episodes (two reels for each episode) were shown each time.[8] In addition, many of the serialized stage plays were themselves detective adventures, including *Shijie diyi da zhentan Fu'er mosi* (*The World's Greatest Detective Holmes,* 1917) and *Jiushi wo* (*It's Me,* 1916), a serialized play based on a French detective novel, *The Sinner in the Flames.* Insofar as both plays and films were exhibited in serial form, both media conjoined variety and causal progression in their organizations of narrative and "attractions." The two media converged most intimately in the practice of linked plays (*lianhuan ju*). Modeled after Japanese chain drama, these plays, often detective and adventure stories, combined modern popular drama and film into a single entity by integrating filmed sequences into stage performances for exterior scenes and scenes of magical martial arts.[9] The linked plays effectively serialized each episode into an alternation between stage and screen and spoke most eloquently to the interpenetration of the two media.

That the stage interaction with the screen was mainly limited to foreign serial adventure films during this period also had to do

with the instability of the emerging domestic film industry. It is well known that Chinese cinema had been entwined with the stage ever since its inception, not only in their overlapping exhibition space but also in early productions that relied heavily on existing stage practices. The alleged first Chinese film, a static recording of the Beijing opera sequence *Ding junshan,* was made in 1905 by the Beijing Fengtai Photograph Studio, which continued to record short Beijing opera sequences until the studio was destroyed by fire in 1909. The first China-based film company, the Asian Film Company, established in Shanghai and Hong Kong in 1909 by the U.S. merchant Benjamin Brodsky (a Russian Jewish immigrant from Odessa), also depended on cooperation with local drama actors and crews to produce a dozen short features (from three hundred feet to two reels).[10] This dependence on the new drama continued even after Brodsky left for the United States in 1913. Two American cameramen bought the company and contracted the filmmaking to Xinmin, a small business company made up of members from a previous new drama troupe, Minmingshe, including Zheng Zhengqiu and Zhang Shichuan. The company, after operating for merely one year and producing fourteen one- and two-reel short features, closed, however, at the outbreak of World War I.[11] The company's disbanding is often attributed to the lack of film stock, which had been obtained mainly from Germany.[12] Yet two additional factors were in play. As veteran actor and director Zheng Junli astutely points out, the foreign monopoly in Shanghai's movie theater network denied these films access to the same theaters that were showing foreign films, and scant financial backing prevented the company from making a quantity of films that could rival the output of new drama at its heyday.[13] Between 1914 and 1921, domestic films, although sporadically made, faded from the entertainment scene.[14]

This interaction between American cinematic serial adventures and Chinese new drama, as well as reformed Beijing opera, missing in existing accounts of early Chinese cinema, significantly challenges the predominant understanding of an "internal" one-way traffic from Chinese stage to screen. As the standard narrative has it, new drama, or civilized play, waned after the end of the Republican Revolution in 1911 and was partly revived only when Zheng Zhengqiu reoriented the genre to produce family melodrama in 1913. In the meantime,

Chinese cinema ascended in recognition and borrowed heavily from new drama practice, whose popularity was already in decline by the mid-1910s.[15] Contrary to this understanding, new drama flourished well into the early 1920s and did not reduce its practice repertoire to family melodrama after 1913. Rather, it continued to stage sensational realism while interacting with American serial adventures in mode of exhibition, narrative structure, and thematic and generic features. Chinese cinema faded, however, during World War I and remained marginal until 1921, as testified by major newspaper entertainment pages.[16] This cross-media interaction places new drama at the center of a deferred encounter between American serial adventure and Chinese cinema. More important, this mediated encounter questions the reductive historiographical model that conceives of Chinese cinema as a foreign medium "sinicized" through an "indigenous" culture. Although new drama indeed remained a vibrant *local* cultural practice, it was hybrid in form, shared much with Western sensational melodrama, and interacted constantly with serial adventure films.

This triangulated and not exactly simultaneous interaction among American serial adventure, new drama, and Chinese cinema precipitated an intense competition of plural modes of realism.[17] No wonder that of the three earliest feature-length Chinese films, all produced in 1921, two closely resemble adventure serials, and both make multiple claims of realism.[18] *Yan ruisheng*, a crime-fiction film based on a sensational murder in Shanghai, was first adapted with great success to the new drama stage. Its filmic version makes hyperbolic claims of indexical and iconic realism: the film uses the murderer Yan's own car; the heroine (a prostitute who is the murder victim) is played by an actual prostitute; Yan is played by his friend and colleague, who bears a great physical resemblance to Yan; and the film is shot on location in Shanghai's various scenic attractions, where the original murder trap took place.[19] *Hongfen kulou* (*Red Beauty-Skeleton*) resorts to sensational realism that is even closer to the serial adventure in its plot organization, location shooting, and interior design of mechanized traps to create terror, thrills, and suspense. The film, supposedly based on a French detective novel, is obviously influenced by Louis Feuillade's *Les vampires* (1915), with its references to underground crime groups and female criminals.[20] *Red Beauty-Skeleton*'s director and screenplay writer, Guan Haifeng,

underscores again the juncture between new drama and serial adventure films. A veteran actor on the new drama and reformed Beijing opera stages, Guan gained his reputation by successfully adapting the American detective adventure *The Phantom Bandit* (Chinese distribution name *Heiyidao*) into a new drama play.[21]

To some extent, the transformation in Chinese popular entertainment from stage to screen has a parallel in the transition from American turn-of-the-century stage sensational melodrama to cinematic melodrama. According to Ben Singer, cinema was believed by some film and drama critics of the 1910s, as well as film historian Nicholas Vardac, to be superior to live theater in its rendition of diegetic realism in terms of depth of space, speed, inclusion of real-world exteriors, quick scene changes, crosscutting, and multiple vantage points within scenes. Hence, cinema was viewed as being more capable of producing "realistic, rapid fire sensations."[22] Yet as Singer points out, such a conception of realism is built more on an absorptive/illusionistic principle than on an apperceptive principle. It underestimates the realism of live interactions between the audience and the stage when the artificiality of devices, overt theatricality, heightened media awareness, and the presentational style of performance are fully acknowledged and appreciated by spectators.[23]

If in the Chinese context sensational stage realism garnered higher praise than cinematic realism, it was for both aesthetic and political reasons. Aesthetically, cinema seemed a rather pale rendition of the spectacular realism so flaunted on the Shanghai popular stage, with its use of footlights, raucous color and sound effects, and real material objects placed in the representational space. The very thin line between the stage and the live audience was constantly traversed by the audience's loud calls, the actors' gestural and vocal addresses to the audience, and the material "overflowing" of water, fire, and props thrown into the audience. Politically, this live interaction was encouraged because of its shared public sensation of radical social change carried by the utopian promise of the Republican Revolution. Moreover, many popular stage productions capitalized on recent events and stories. Although revolutionary energy dwindled after the establishment of the new republic, sensational stage realism continued to thrive on a growing commercial audience, sustaining

the vital public sphere fostered by new drama's affective aesthetics and communicative power.

The transition from stage to screen might have owed less to the latter's triumphant realism than to economic motives of both the audience and the producer. As Singer argues in the American case, by 1909 the cost of going to the movies and of making them was significantly lower than the risks and expenses involved in stage productions, which included building and operating complex stage sets; maintaining the actors, technicians, and staff members; and paying the middleman between theaters and traveling troupes. Movies, in comparison, cost less to make and reproduce and could be rented within a wider network without middlemen cutting into the profit for producers, distributors, and theater owners.[24]

Film production, exhibition, and reception enjoyed similar advantages in China in the 1910s, albeit to a much lesser degree. By 1917 a new drama play cost ten to sixty cents per ticket depending on the seating, twice as much as a movie ticket (ten to thirty cents) on the higher end but the same on the lower end, instead of the fivefold price difference in the United States.[25] Moreover, films were shown twice each night, usually running from 7:00 to 11:30 p.m., in addition to midweek and weekend matinee shows (Wednesday, Saturday, and Sunday starting at 1:30 or 2:30 p.m.), whereas theater performances could be given only once at night and once in the daytime.[26] Furthermore, each theater needed to maintain its own basic actors, musicians, technicians, and managers in addition to paying stage stars from other theaters, although this maintenance cut down the much higher cost of inviting the whole troupe from the star actor's home theater. New drama and reformed Beijing opera were therefore able to compete with cinema for an entire decade, until the 1920s. Nevertheless, in the long run, with lower production and exhibition costs and higher running frequency and economic returns, film gradually gained ground. The economic advantage of cinema was further sustained by the steady increase of movie theaters and the constant supply of serial adventures and short comedies. These films' emphasis on physical thrill and narrative suspense bridged the linguistic divisions among both international audiences and domestically diverse dialect groups.[27] By 1924–25 new drama had lost its stage to the

modern spoken drama and was relegated to marginal entertainment centers.[28] At the same time, the increased popularity of film, the relatively stable growth of the domestic economy during World War I, and the 1922 stock market crash made funds available for an emerging domestic film industry.

Extraordinary and Technological: The Virtual Body and the Locus of the Real

By the time of the rise of the martial arts film in 1927, the dynamic between the two media institutions was much altered, as was the whole landscape of Chinese film exhibition and production. The two modern, popular dramatic forms (new drama and reformed Beijing opera) had receded into marginal entertainment quarters in Shanghai. The domestic film industry, which emerged around 1922, mushroomed to over one hundred film studios by 1926 and solidified at thirty-two studios in 1927. Domestic exhibition space grew to approximately 150 movie theaters, which provided second-run opportunities for Chinese films. The tide of Chinese film genres had shifted from family melodrama to social problem plays to romance to costume drama. These shifts provided a growing film audience with a constant supply of novel narratives, styles, and (female) film stars.

At the same time, cinema did have to aspire to the widely popular hyperrealism of the theater to win audiences. In other words, the emphasis on the sensational real on the stage and its power to communicate created the audience and the media environment in which subsequent Chinese film practices would have to compete. The anchoring of the real in cinema had to be found elsewhere.

In 1928 a film was adapted from the highly popular new drama play *Jiushi wo* (*It's Me*), based on the Western detective novel *The Sinner in the Flames* (*Huoli zuiren*).[29] The publicity for the film recounts the popularity of the 1916 drama version but introduces the superior adaptation of the "shadow play":

> The stage did not allow as many grand sets to be constructed, nor could the intrigues and subtleties in the plot be acted out fully. Finally these can all be realized in the shadow play. For

example, the mechanized water prison [*jiguan shuilao*] is not only stunning and dangerous but also particularly real. In the fire scene, the black smoke bellows to the sky, and the flames dance like tens of thousands of snakes. Anybody who sees these fire scenes will be stunned and thrilled. Even the fire scenes in foreign films are only this good.[30]

The 1916 version was a typical sensational-realist play, filling the stage with thunder and storm, a fire burning down a three-story Western-style mansion, and a real fire engine. Boasting "colorful and rare stage sets," the play also featured a live horse, an actual car, and a real cannon.[31] The serialized play, composed of sixteen episodes, was famous particularly for its ingenious use of mechanized sets (*jiguan bujin*) on a mobile stage, which not only inspired many serialized plays to follow but also made the play itself a constant on the new drama stage.[32]

Compared with its new drama version, the realistic claim of the film could have seemed rather lackluster. Despite its publicity about even grander sets and more realistic effects, the cinematic presentation of reality must have looked much tamer without the splashing of water into the audience and the accidental eruption of fire or a horse running offstage. In contrast with the live stage, the technological production of the cinematic real paradoxically distanced the material world and the audience. An alternative anchor of the real was located, however, in the human body through its ability to "give a name and a face to the spectacle, to humanize the machinery of production."[33] Not surprisingly, within the same publicity the film is acclaimed for its exciting fighting sequences that look both authentic and skillful.[34]

This reorientation of acting toward the actor's body distinguished the martial arts genre. In his review "On Actions in Film," which discusses a 1927 film production of *Bai furong* (*The White Lotus*), starring Wu Suxin, Cheng Yan ranks action films as the most demanding compared with other genres, including romance, sentimental drama, and detective fiction.[35] According to Cheng, film genres such as romance and melodrama do not require "true competence" (*shili*), because through persistent practice an actor can learn to laugh, cry, and express sadness. These emotions can also be faked: "We used to

think that crying is rather hard to perform, but now we know that honey is often used as a substitute for tears." *Shili* cannot be achieved by practice, however. A fight or a fall cannot be faked, because one tinge of fakeness can spoil the effect of the real and thus the exciting quality of film. The idea that the camera can fool the audience with substitute tears but not with false physical action denies the authenticity of biological bodily functions, which are thought to be easily reproduced and reenacted. The aura of the real is instead attested by a singular extraordinariness of the body, articulated in "true competence" and at the same time paradoxically realized by its demonstration of particular "skills" that conflate the notions of techniques, skills, and technology.

In the preface to the first issue of *Yingxi zazhi*, the editor, Gu Kenfu, considers film to be composed of literature, science, and technology. By "technology," Gu does not mean film equipment, which he refers to as "science"; rather, he defines technology in terms of acting, or technologies of the body. He gives some examples in other types of performance such as singing, martial arts, gesture and movement in Beijing opera, and oral delivery and transmission of emotions in new drama. For film actors, technology means something unusually demanding: "We have seen many films imported to China from America and Europe, where they have to show their genuine technology in swimming, horseback riding, boat rowing, operating an airplane, driving a car." Gu marvels at how the actors seem to master these presumably difficult tasks with ease, although his peculiar use of the term *jishu* (technology) should not be reduced to mere "technique," or "skill," which often corresponds to a different Chinese phrase, *jiqiao*.[36] Gu's conflation of technology with technique is illustrated by examples of action adventures in which the actor's body in motion is at once technological and human/organic, often in synchrony with the machines displayed on-screen.

The rise of a strong physical culture in China since the 1910s also contributed to Gu's conception of bodily skills in relation to technology. Andrew Morris has documented in great historical detail how the rise of *tiyu* (physical education) in China tied the cultivation of the physical body and bodily skills to a nationalist and modernization agenda.[37] While late-Qing military drills gave way to a more democratic popularization of physical training in education and

entertainment, borrowed largely from Western and Japanese models, martial arts also underwent transformation, shaking off feudal and superstitious trappings. Pushed to urban centers from rural poverty, martial artists collaborated with business entrepreneurs and broad-minded intellectuals to reshape martial arts into a modern institution.

The foremost organization pioneering this effort was the Jingwu Athletic Association (Jingwu tiyuhui), now a popular legend in the history of Chinese martial arts. Founded in Shanghai in 1910 and changed to its current name in 1916, the association established its own training school and publications, funded by its commercial enterprises, with political endorsement by prominent Republican leaders, and marked as visibly modern. With its carefully designed uniform, insignia, and building architecture, Jingwu endeavored to be a modern institution of physical improvement and teamed with other educational institutions to legitimize its culture.[38] Jingwu endeavored to "update" its physical training by encompassing both traditional martial arts techniques and Western competitive and lei-surely sports such as basketball, soccer, tennis, roller-skating, hiking, hunting, billiards, and cycling.[39] Equally notable was the association's effort to provide training in not only physical skills but also other "technologies," including painting, music (Chinese string and West-ern orchestra instruments), chess, drama, and photography. More important, the association used modern media technologies, particu-larly photography, film, and the gramophone, for publicity and to disseminate its training in other regions and abroad—most success-fully in Southeast Asia, which also provided the largest market for martial arts films during the rise of the genre. Jingwu members took copious photographs to commemorate and document events, for self-endorsement and glamorization, and as pedagogical tools. Each fight scene was carefully posed, with stylized choreography (especially for group fights) and carefully designed clothing, sometimes glamorized to the extent of exoticizing and sexualizing the male body.[40]

Photography joins forces with a scientific approach to martial arts, dissecting fluid human movement into exact moments and poses. A picture framed in Jingwu's publication *Tantui* (*The Tan-Style Leg Movement*) shows an almost cinematographic dissection of the Tan-style leg movement from beginning to end, corresponding with a diagram of abstract dots suggesting the movement of the body

across time, strongly recalling Étienne-Jules Marey and Eadweard Muybridge's chronophotographs. The association even engaged in moviemaking. A 5,000-foot documentary was made in 1919 in preparation for the visit of the five leading members of the association to Southeast Asia.[41] The group rented movie theaters in Singapore, Malaysia, and Java, combining live demonstrations with screenings of the Jingwu film.[42] Although the film is yet to be located, a list of its contents made by its cinematographer and one of the five leading members, Chen Gongzhe, shows that it consisted of five reels and surveyed the association's individual departments, showcased its martial arts performances, and documented various training classes—music, drama, oratorical skills, and filmmaking.[43] Notably, the third reel concluded with a section dismissing the superstitious tales of martial artists' superhuman skills, including flying over roofs and walking up walls.

As martial arts training updated itself as a regimented, mass-mediated technology of the physical and performance culture, actors' training was being conceived in a new light. In "The Technology of Acting," Hong Shen, a prominent dramatist recently returned from the United States, proposes the following three steps for acting preparation: (1) study the physiology of emotion; (2) study character behavior, namely, situationally determined rather than character-centered behavior; and (3) study the norm of acting. Hong mentions over twenty Western books on acting that he consulted, mostly French, and stresses the dialectics between the acting norm and specificity.[44]

For Hong it is no longer character/personality but *habit* that matters for acting. Emotion matters most on-screen as a kind of exteriority contingent on a number of variables, including personality, power relationships, and coded cultural behavior, the sum total of which Hong characterizes as habit—a routinized, predictable physiological response of a person to a certain situation, often reductively interpreted as emotional expression. Hong points out the tricky mismatch between interior emotion and exterior expression— the same expression might be attributed to diametrically opposite emotions—and questions the indexicality of physiological expressions for "inner emotion." Hong thus makes it possible to manipulate acting as a mechanical skill devoid of emotion so as to subject emotion to training. Ironically, this mechanically produced behavior

would be interpreted as the most effective, powerful, communicative, and widely understood screen index for emotion.

Seen in the broader context of the technologized body and performance culture, the extraordinariness of the actor's body as the locus of the real is not so much a "cover-up" of technology's artificiality and inhumanity as a negotiation between the mechanical and the organic; the "true competence" of the human vis-à-vis mechanical technology does not so much naturalize a prosthetic body as offer an equally demanding and coexisting technology. Precisely this struggle between the two technologies makes action films more exciting and, hence, more real than tears or sentiment. The body itself is, then, not sufficient as the locus of the real but has to be mobilized into full action. Similarly, the teary faces of the first generation of actresses on the silver screen that touched many hearts with "true feelings" were not sufficient to move audiences and needed to be replaced by bodies in motion. This emphasis on action derived not only from within the machinery of production but also from the broader social context.

Modernist Action: Toward an Aesthetics of New Heroism

The rise of martial arts films has so far been regarded as a popular commercial phenomenon mobilizing a modern folk culture in continuation of popular traditions. The canonical *History of the Development of Chinese Cinema* describes martial arts films as popular articulations of alternative justice and representations of struggle amid drastic social change, emerging when the nationalist war of the Northern Expedition that ended years of factionist warlordism gave way to Chiang Kai-shek's massacre of the communists in April 1927.[45] More recent scholarship has emphasized the internal logic of the film industry and its role in a wider context of commercial culture.[46] For film historians Li Suyuan and Hu Jubin, the end of the Northern Expedition brought about stable economic growth and improved transregional communication that further boosted the domestic film industry. Like the successful genre of the costume drama, popular between 1925 and 1927, martial arts films thrived on the growing market of martial arts narratives in the burgeoning print culture and the ongoing tradition of storytelling. For Li and Hu the "superstitious" masses entrenched in the popular cult of folk

heroes, spirits, and ghosts were susceptible to belief in the magical effects of martial arts films, which were, ironically, the product of maturing techniques and technologies in the Chinese film industry.

Criticizing this account, Zhang Zhen instead asserts that the alloy of "magic and science" was a popular intervention of the teleological logic of modernization. For Zhang the vast reservoir of folkloric imaginations, remobilized in a modern print culture and cinematic technology, created a mosaic space of "overlaid temporality."[47] The "anachronistic" confusion of the old and the new in modern folk culture and the anarchic energy in the technologically produced fantastic bodies posed a threat to the nationalization and modernization agenda upheld by cultural forces from the Right and the Left. For this reason, as Zhang recounts, martial arts films were eventually excised from the Chinese film industry by liberal critics and the Nationalist government (despite their initial enthusiasm) and were rejuvenated only in Hong Kong after the Shaw Brothers Studio's predecessor, Tianyi Studio, migrated from Shanghai in 1937.[48]

Despite their different stances, Zhang agrees with both Cheng's canonical history and Li and Hu in conceiving martial arts films as popular commercial products antithetical to elitist and nationalist endorsements of unidirectional modernization. This conception underestimates, however, the internal connection between these polar forces that was to persist in the later years of Chinese film history. In this sense, the intellectuals' early enthusiasm for martial arts films deserves particular attention. Amid the plural discourses of modernization, nationalization, anarchism, and Marxism catalyzed by the Northern Expedition, martial arts films were actually celebrated by various elite modernists, among whom the advocates of new heroism were most enthusiastic. Clustering around Lu Mengshu, the editor in chief of the highbrow film journal *Yinxing* (*Silver Star*), various literary scholars, art historians, writers, and screenplay writers recognized in martial arts films a refreshing aesthetic that they identified as new heroism (*xin yinxiong zhuyi*). Vaguely defined and often used together with neoromanticism (*xin langman zhuyi*) and new idealism (*xin lixiang zhuyi*), new heroism was a composite modernist discourse interwoven with a class-conscious social critique and a nationalist emphasis on Chinese cinema. Sharing intimate connection with film journalism and film production, the new

heroist discourse demands closer scrutiny to understand the reception and production of martial arts films.

As a modernist aesthetics, new heroism identified itself with neoromanticism, a May Fourth ur-term for modernism that covered all major turn-of-the-century literary movements, although closest to aestheticism, symbolism, and decadent literature. Introduced in the early 1920s as a milestone in Western literary history, which was presented as a dialectic progression from the Renaissance to classicism, romanticism, and naturalism, neoromanticism was considered the ideal combination of scientific objectivism and subjective power, overcoming the limitations of previous aesthetics, especially those of romanticism and naturalism.[49] While the reception of neoromanticism in China was quite varied and subject to various interests and interpretations, the new heroist critics saw neoromanticism as best embodied in film, the newest form of art, advocating a radical cinema while elevating Chinese cinema to the status of the latest addition to a naturalized and universalized Western aesthetic teleology.[50]

This neoromanticist cinema, endowed with the observational power and innovative visual language of the medium, enabled the viewer's "acute subjective power" to intuit "the hidden mysterious aspects at the innermost of the inner life beyond the exterior" and unearthed an aesthetic of the ugly as the most desirable beauty. This definition, closest to symbolism in its emphasis on scientific observation, subjective power, and mysticism, also imparts heightened ethical connotations. The screenplay writer Chen Zhiqing contrasts it with the representation of "artificial, passive, and languid beauty" or the excessive aestheticization in costume drama as "benign" beauty. As Chen observes:

> Why don't we nakedly expose all the ugly and painful
> matters of life in films so that the audience will be
> shocked heart and soul and experience a cathartic release?
> The representation of such ugly and painful matters is
> mobile, forceful, and active, or we can say it is beauty closer
> to evil; it is genuine beauty. What we need in the new heroist
> cinema is precisely such a mobile, robust, active spirit and
> the articulation of all that is ugly and painful: it is beauty that
> approximates evil.[51]

By championing the ugliness associated with the motion, force, and action of cinema, Chen taps into two significant social impulses. First, his emphasis on the "ugly and painful matters in life" is simultaneously a symbolist revelation of "the hidden beauty beyond the exterior" and a new heroist activist exposure in line with the ascendant proletarian literature. This literature addressed the inhuman condition of metropolitan life and recognized that scientific progress and material improvement were only exasperating the exploitation of the proletariat.[52] Second, upholding the ugly as the vehicle of force and mobility is part of a nationalist self-critique focusing on a flawed "national character" believed to be embodied in the past and future of Chinese cinema.[53]

The notion of national character at stake here was derived from the late eighteenth- to early nineteenth-century German romanticist discourse of *Volksgeist* (especially circulated by Johann Gottfried von Herder) and popularized and inflected in nineteenth-century missionary writings on the Chinese character, most infamously in Arthur Smith's *Chinese Characteristics* (1889). Translated at the turn of the twentieth century in China, these writings were used by late-Qing reformists and later by May Fourth intellectuals to diagnose the alleged weaknesses in the Chinese people. The national character discourse paradoxically internalized a racial hierarchy in its own enlightenment agenda.[54] In the discussions of new heroist film, this national character complex centered on the lack of "life-force"—Henri Bergson's *élan vital*—observed in the images of frailty in traditionalist Chinese costume drama.[55]

The call for life-force drew on the symbolic capital of Western philosophy, specifically a Japanese-mediated understanding of Bergsonian vitalism, which I discuss in detail in the next section.[56] The lack of life-force produces what Chen Zhiqing sees as gender inadequacies in men and women. He deplores the Confucian designation of the fragile scholar as an inferior standard of male beauty compared with the European–American triumph of physical strength (*li*). As for Chinese women, Chen considers them mere "shadows" whose efforts to preserve feminine fragility, tenderness, and propriety are eclipsed by foreign women with their fully developed and fleshy bodies and lively and charming spirits. Worse still, Chinese men and women are considered introverted in spirit, which "does not radiate from inside to the outside, but contracts from outside to

inside," and hence is deemed unsuitable for the "extroverted spirit of cinema." Chen concludes that the predominant representation of "Oriental culture" in Chinese cinema would only be ridiculed by foreigners. Instead, the national character should be changed so as to produce successful Chinese films.

A qualitative difference between Western and Chinese cinema is likewise described by Lu Mengshu, who attributes to Western films "vigorous motion and passionate love" while calling Chinese films "gray," with static and regressive qualities.[57] Again and again, the new heroism discourse reiterated the East/West binary of national character, valorizing the West and critiquing the East. The East (China) was conceived as mysterious and spiritual, whereas the West was "naked, fleshly, macho, competitive and bloody." Boiled down to one point, the Chinese "character" was static (*jing*), whereas Westerners were dynamic (*dong*).[58] The dynamic was unambiguously identified with the American national character as it was supposed to have manifested in music (jazz), dance (the Charleston), and drama (the musical). The American character of mobility became a worldwide zeitgeist through the dissemination of American action films that emphasized bodily movement over facial expressions and preferred speed, agility, and intense action.[59]

These binary oppositions of national character, which had been previously articulated in the traditionalist discourse in an inverse hierarchy, came to justify a new cinema with a distinct look and energy at a time when the widely popular costume drama was waning. The new nationalist sentiment was emphatically Occidentalist in the sense that it upheld the supposedly Western national character as the universal cultural and aesthetic ideal as it was derived from American serial queen and male action films. Chen's embrace of the "extroverted" nature of cinema characterized by "robust bodies, lively actions, and emotional expression" constituted a generic definition of the cinematic medium: identified with the dynamic body in American male and female action films, cinema was considered to be *expressive* in nature.[60] Because the Chinese national character was diagnosed in terms of gender inadequacy (on the part of both men and women), the new heroist embrace of the action adventure and serial queen genre implicitly linked gender with genre—and cinema with character—with the aim of revitalizing the national character.

The urge to remold the Chinese national character and Chinese

cinema was, however, contemporary with derogatory Western cine-matic representations of Chinese people in films that were fre-quently screened in Shanghai and other urban theaters—ironically, in the very American action films the new heroists advocated. In se-rial queen thrillers, male-hero action adventures, slapstick comedies, and sentimental melodramas, there was no lack of racist depictions of Chinese people, which inevitably provoked local indignation. The reaction against such films was most famously documented in dramatist and screenplay writer Hong Shen's protest in front of the theater showing Harold Lloyd's *Welcome Danger* (*Bu pa si*) in 1930 and in the banning of Josef von Sternberg's *Shanghai Express* in 1932. Audiences also complained about the derisive portrayal of the Chi-nese in D. W. Griffith's *Broken Blossoms* when it was shown in the Empire Theater in Shanghai in 1925.[61]

Criticizing Western films that "fabricated nonexistent ugliness" in representations of Chinese characters, these reactions neverthe-less differed in their responses to two kinds of portrayals of ugli-ness.[62] In an article comparing the racist treatment of the Chinese in *Broken Blossoms* and *The Thief of Bagdad* (Raoul Walsh, 1924), Wu Qingmin writes that the racial profiles of the Chinese characters in the two films are different.[63] He considers the depiction of the effemi-nate Chinese man in *Broken Blossoms* to be "particularly embarrass-ing," although the story "meant well to our nation."[64] In *The Thief of Bagdad* although the Mongolian Khan (Kamiyama Sojin) and the female palace slave (Anna May Wong) are depicted as evil and con-niving, Wu argues that they are nevertheless presented as strong and capable.[65] Therefore, "even though the foreign audience might detest them, they will be feared and taken seriously."[66]

These reactions amplify the psychic conflict between the inter-nalized racial hierarchy in the discourse of national character and the anxiety about foreign "misrepresentation" acutely experienced in the global circulation of Hollywood cinema.[67] Yet the action ad-venture, in the eyes of the local beholder, opens up a subaltern space of articulation precisely through the genre's peculiar portrayal of ra-cial ugliness. This ugly image of the virulent but powerful Chinese Other bears an uncanny resemblance to the American icon of force-ful mobility, of which Anna May Wong's shining dagger provides a brief glimpse. This unexpected proximity urges us to reevaluate

the cultural politics underlying new heroism in China after the mid-1920s. Apparently, new heroists internalized a self-image of China as effeminate weakling after viewing Hollywood action and serial queen thrillers that provided them with the ideal symbolist and Occidentalist model of robust, dynamic ugliness. Yet to dismiss new heroists simply as passive, unreflective consumers victimized by the discourse of "Chinese characters" and enchanted by the hegemony of Americanism is to miss an important underside of the phenomenon. That is, what they embraced as the ugly sublime was actually an inverted image of the subordinate Chinese themselves, projected by the same American film genres. Behind the vigorous "white" figure of the Thief of Bagdad stood the evil yet no less powerful Khan and Chinese slave woman, the abject by-products that Western dominance had failed to exorcise. In a gesture of Occidentalism, the new heroists unwittingly reappropriated the power of abjection assigned to the subordinate in Hollywood action and serial queen thrillers.

The enthusiasm for martial arts films therefore derived partly from the desire to present a more positive image of the Chinese national character in the global circulation of Chinese cinema. Counteracting the "ugly" national image of frailty and passivity, martial arts films portrayed a different kind of ugliness endowed with the protoprimitivist life-force of the lower class, which at once competed with and emulated robust Western characters. The aesthetics and ethics of action were endowed with neoromanticist scientific objectivism and symbolist sensibility, along with the new heroist social activism and nationalism that endorsed an alternative beauty and national image.

The Audience's Resonance: Kuriyagawa and Bergson in Martial Arts Films

The new heroist celebration of martial arts films endorsed a distinct cinema distinguished not only by its aesthetic "look" but also, more important, by its affective impact on the audience. The robustness, mobility, and speed of new heroist cinema graced the screen with a positive image of a modernist national character that was also to be transferred across the screen through violent force, molding the spectators into modernist national citizens. To portray the affective power of the new heroist cinema, Chen Zhiqing first of all

differentiates it from the "film for the eyes," which is satisfied with letting the audience "have a good time" (English in the original). In contrast, the new heroist cinema should deliver its force to the audience by "everlasting stimulation." The tragic but heroic and chivalric stories can "violently assault the audience's heart and strike sparks in their corporeal life [*rou de shengming*], and stimulate their resonance. What's more, they will have an impact on their actual life."[68] Second, the film's effectiveness should not rely on a didactic form or the intertitles. It should "show" not "tell" and in this respect differs greatly from the May Fourth problem plays (*wenti ju*) striving for didactic enlightenment of the masses.[69]

The point that this distinct notion of cinema was defined by its power to stimulate resonance in the audience was framed in a larger context, centered on the notion of resonance as a neologism for spectatorship. An elaboration of the notion appears in *Huaju Special Issue,* a publication of Huaju Film Studio specializing in martial arts films. An article in the 1927 issue, "Guanzhong de gongming" ("The Audience's Resonance"), argues that cinema should contain "a fiery (burning) quality" (*ranshaoxing*) so that it does not just entertain the audience but "creates vibrations at the bottom of their heart."[70] Mixing the metaphors of fire and water (*bodong,* "vibrations," literally "movement of waves"), the author circumscribes the key concept *gongming* (resonance):

> Everybody possesses the faculty of judgment and appreciation. When we watch singing and dancing, as long as our eyes are not blind and our ears are not deaf, we inadvertently hum gently and dance happily. Even if these effects might not be detected from the outside, in our hearts we are still singing and dancing. Such a suggestion [*anshi*] that stirs up new vibrations [*bodong*] is the inner resonance [*gongming*].[71]

Interestingly, the notion of *gongming* was at the time a rather recent lexical import to China, borrowed from the Japanese neologism *kyōmei*—the translation of the English word *resonance.*[72] As the translation of a special term from Western modern physics and acoustics, *gongming* ("resonance" or "sympathetic vibration") describes the physical phenomenon of two objects sharing the same

frequency being able to vibrate simultaneously or to initiate vibrations in each other.[73] Also necessary for resonance is the medium of air, or ether, for the delivery of the wave. The figurative connotation of *gongming*—namely, "the movements or utterances as sympathetic responses to sound or gestures" or "a particular emotion aroused in oneself in response to a similar emotion demonstrated in someone else," a notion widely used in modern Chinese and taken for granted in everyday vocabulary—was derived from this newly imported scientific term.[74]

Coupled with the notion of resonance is another foreign term in this context, *anshi* (suggestion).[75] An imported term from psychology, *anshi* is defined in the Republican-period modern Chinese dictionary *Cihai* as a psychological effect produced when an external object or phenomenon creates a certain will in the human subject and, without the person's conscious knowledge, elicits a bodily reaction. The application of a psychological term here is one of the many instances of the popularization of psychology and spiritualist practice in early Republican China. Hypnotism as an alternative science and popular attraction was gaining ground, as I detail in the next chapter, and various schools of psychology introduced into China in the 1910s were widely circulated during the late 1920s and early 1930s.[76] Although existing scholarship has focused on the impact of Freudian psychoanalysis in China, especially in literary creations, the scope of psychology introduced to China grew much broader.[77] Various schools of experimental psychology, applied psychology, social psychology, and popular psychology were constantly being introduced and discussed through translations, secondary writings, and journal articles. These included the American and Soviet schools of behaviorism, Gestalt psychology, cognitive science and learning psychology, crowd psychology, industrial psychology, hypnotism and telepathy as a combined product of spiritualism, popular medicine, and technology.[78]

The variety of psychological literature disseminated at the time provided multifarious and conflicting interpretive frameworks that account for the *Huaju* author's "misuse" rather than "use" of this knowledge, especially the conflation of physics and psychology and of interior and exterior experience. At the same time, this "misuse" provides insight into the powerful experience of spectatorship. The

author's "abuse" of the term *anshi* is rather obvious. In the previous quotation, *anshi* is taken as the equivalent of *gongming*. The author refers to the psychological effects as both causing and equivalent to the audience's reaction, comparable to the phenomenon of shared and spontaneous movements described in modern physics. Later in the same article, however, *anshi* is used to mean something like matter that is being transmitted across space through a certain medium: "[Cinema] must secretly contain a medium [*meijiewu*] of stimuli that will transport *suggestions* [*anshi*] to the audience and stir up waves in their inner heart, so that the audience will respond immediately with *resonance* [*gongming*]."[79] At the close of the article, the author summarizes the "fiery" quality of the film:

> Cinema must contain an *igneous* quality, which enables the audience to go beyond exterior beauty to its inner content. When excitement arouses an inner image at the depth of the senses, the theme of the film can reach the audience and create waves deep in their hearts. This way *suggestion* [*anshi*] has finally achieved its ultimate purpose.[80] (emphasis added)

Here, *anshi* describes a psychological effect that carries a purpose or a calculated psychological effect. This effect builds on an understanding of the human body that is both psychosomatic (*anshi*) and physically objective (*gongming*). The understanding of the human subject as inadvertent, automatic, and predictable in responding to certain stimuli destabilizes the very integrity and autonomy of the subject, and at the same time, the observation of the inner image and psychological effects on the inner experience pays due respect to the subjective dimension of experience, quite in line with the neoromanticist/symbolist pursuit of the mysterious image at the end of senses, as illumination and externalization of the invisible. Such understandings of the spectators had interesting implications for filmmakers.

Another source illuminates the conceptual intertext for the article in *Huaju*. A comparison of this article with Kuriyagawa Hakuson's *Kumon no shōchō* (*The Symbol of Angst*), widely popular between 1921 and 1927 in China, demonstrates striking similarities.[81] More specifically, the three passages I have quoted in this section

intersect significantly with Kuriyagawa's discussion on readership in his book's second part, entitled "On Artistic Appreciation."[82] It is therefore helpful to examine how Kuriyagawa defines modern readership, or more broadly, audience response.

Although relatively obscure in contemporary Japanese scholarship, Kuriyagawa Hakuson (1880–1923) remains an influential figure in modern China, particularly for the May Fourth writers. He was better known in China probably through the writer and critic Lu Xun, who translated two of his works, *Symbol of Angst* and *Zoge no to o dete* (*Out of the Ivory Tower*), in the mid-1920s. Born in Osaka and educated in English literature at Tokyo Imperial University, Kuriyagawa taught as a professor at Kyoto Imperial University from 1917 until his death in the 1923 Great Kanto earthquake.[83] He was a prolific writer and a frequent public lecturer whose works were collected posthumously in six volumes in 1929. His works were translated in China and widely read, including *Kindai bungaku jukko* (*Ten Lectures on Modern Literature*, 1910, published in 1912), *Symbol of Angst* (1921), *Out of the Ivory Tower* (1920), *Kindai no ren-aikan* (*Modern Views on Love*, 1922), and various articles published in literary journals in the late 1910s and early 1920s.[84] In fact, the earliest introduction of neoromanticism was probably by way of Kuriyagawa. One chapter from his *Ten Lectures*—the ninth lecture, on neoromanticism—was first translated into Chinese and published in 1920 for *Dongfang zazhi* (*Eastern Miscellany*). Some of the significant articles on neoromanticism, including a long essay by the influential dramatist Tian Han written in 1920, also quote Kuriyagawa.[85] Considering that Tian Han and Zheng Boqi—another important literary figure—were two of the Chinese overseas students in Japan who attended Kuriyagawa's lectures in person, his direct and indirect influence in China was considerable.[86] His writings on Western literature served also as popular sources for Chinese readers who had less access to this literature.

In *Symbol of Angst* Kuriyagawa proposes a theory of creativity that combines Bergsonian vitalism and Freudian psychoanalysis. Dissatisfied with Freud's account of creativity as limited to artistic sublimation of repressed sexual desire, Kuriyagawa replaces libido with Bergsonian *élan vital*, defining creativity as mobilized by the conflict between external social constraints and the uninhibited,

freedom-seeking life-force.[87] Kuriyagawa follows, however, the Freudian interpretation of the dream as a process similar to that of literary creation. He conceives of Freud's account of the dream as a process of "symbolization"—distortion and condensation of latent dream thought into manifest dream content made of signs and symbols. Literary creation for Kuriyagawa involves a similar "symbolism," though beyond latent sexual content. Instead, symbolism converts complex spirit, idea, thought, and emotion into a simple yet concrete exterior form, or literary or artistic "manifest content."[88] To summarize it from the perspective of Bergsonian vitalism, literary and artistic creation express the painful conflict between life-force and external social constraints, as the title *Symbol of Angst* highlights. This notion of symbolism provides a general definition of literature beyond the specific contours of the fin-de-siècle symbolist movement.

The second part of the book, "On Artistic Appreciation," concentrates on reader and audience response. Although mainly concerned with literature (including dramatic texts by Shakespeare, Ibsen, and so on), Kuriyagawa's interest in the psychic and experiential conditioning of literary impact upon readers makes his observations relevant to broader discussions of artistic media and audience response. Significantly, Kuriyagawa introduces a new dimension into his notion of the symbol. Shifting his vantage point from that of the author to that of the reader and audience, Kuriyagawa redefines the symbol as the medium of transmission: "The symbol is suggestion [*anshi*], stimulation; or simply the medium that transmits to the audience what lies at the bottom of the author's inner life."[89]

To understand this rather enigmatic observation of symbol, or literature, as the stimulating medium that carries psychological/ experiential suggestion, we need Kuriyagawa's earlier explication of the very specific fin-de-siècle symbolism itself, which he claims to exceed in his general definition of literature as the "symbol of angst." In *Ten Lectures on Modern Literature,* written a decade earlier than *Symbol of Angst* but translated into Chinese at about the same time (1921–22) and even more popular, Kuriyagawa introduces symbolism in his last lecture, framed in fin-de-siècle decadence and dilettantism.[90] Drawing on Western social theories, especially Max Nordau's pathology of modern life in his book *Entartung (Degeneration)*,

Kuriyagawa summarizes the drastic changes in modern life as the cause of nerve fatigue, entailing neurasthenia and psychopathy, the epidemic of the fin-de-siècle. Yet Kuriyagawa criticizes Nordau's negative attitude based on materialistic and scientific observations and instead upholds the modern being as endowed with sensitive nerves, prone to suggestion.[91] For Kuriyagawa this gives rise to a new type of literary symbol, practiced in fin-de-siècle French symbolism. Instead of resorting to sensual and concrete material to suggest the abstract and infinite (morality, religion, philosophy, life)—the previous literary use of symbols—symbolist works operate directly on the sensitive nerves of modern human beings to create only a mood or an atmosphere, which Kuriyagawa names "mood symbolism."[92] Because of the hypersensitivity of modern people's nerves and senses, the effect of the stimulation becomes particularly complex and can no longer be organized into certain "emotions," as was possible for earlier literary movements, as for instance in romantic literature. Rather, this effect can be portrayed only as a certain mood—that is, the atmosphere at the very fleeting moment when the human senses/nerves react to the external stimuli.[93]

In this context, Kuriyagawa defines symbolism as a process of mood production and reproduction: "After certain organic functions, the stimuli create a rhythm in the poet's heart or vibrations in the poet's nerves, resulting in a particular mood. When this mood is transmitted to the audience, it evokes their resonance. This is symbolist art."[94] If the symbol captures the mood created in the poet, it also functions to re-create a similar mood in the reader by producing certain stimuli that lead to the mood and suggest its connection to the mysterious, invisible, and infinite, paradoxically evoked in the language of scientific materialism. In this sense, the symbol functions as the medium between the poet and the reader, by way of stimulation and suggestion. Moreover, the exterior form and content of the symbol are no longer differentiated; language is no longer representational and functions like music. Just as musical melody stimulates the nerves directly and creates a mood in its own fluctuations, touching the human heart without resorting to any external explanation or other psychological mechanism, symbolist poetry makes its meaning subservient to its language and creates a mood by its prosody, converting "the melody of the mood" to "the melody

of the symbol," relying on the musicality of the language to create the vibration of the nerves.[95]

Kuriyagawa's particular understanding of French symbolism in *Ten Lectures* puts in perspective his observation in *Symbol of Angst* that the symbol functions as stimulus, suggestion, and medium. His discussion of mood strikes a resemblance to the notion of *Stimmung* (with connotations of "resonance," "mood," "attunement," and "atmosphere") in German aesthetic and literary tradition from eighteenth-century aesthetics to fin-de-siècle art theory.[96] At the same time, his definition of symbolism from a psychoneurological rather than a purely formalistic framework lends itself to wider discussions of readership. A decade later, in his own theory of creativity and reader response with more concentrated Freudian and Bergsonian influence, Kuriyagawa defines the symbol more generally as the equivalent of literature, whose suggestive content points to the conflict between the liberating life-force and social–moral constraints. For Kuriyagawa artistic appreciation is possible because of this sharable content of human life made of conflict, alternatively defined as the realm of *Erlebnis* (experience), and is realized precisely by the mechanism of *resonance* through the medium of the symbol:[97]

> So-called artistic appreciation is based on the communicability of the shared *experience* between the author and the reader. That is, there exists a communicable *experience* between the author and the reader in their unconscious, preconscious, and conscious. An author only needs the strong *stimulating* force of the *medium* of the symbol to communicate the *suggestion* to the reader, and the latter will immediately respond in *resonance*, and spread a similar *fire of life* in their chest.[98] (emphases added)

Interweaving a Bergsonian notion of experience with a Freudian understanding of consciousness and depicting the mechanism of resonance modeled on his understanding of French symbolism inflected by German aesthetic theory and European social psychology, Kuriyagawa's observation of artistic appreciation remains ambivalent about locating the reader's and spectator's experience in their psychological interior or physiological exterior. Hence, he defines

Erlebnis as "the totality of what a person has felt deeply, thought, seen, heard, or done, that is, the sum up of what the person has experienced, internally and externally."[99]

This ambivalence is even more pronounced in its Chinese transposition, interestingly appearing in the same article in *Huaju*. The article, as discussed at the beginning of this section, states that cinema, without exception to any aesthetic works, "must secretly contain a medium of stimuli that will transport suggestion [*anshi*] to the audience and stir up vibrations in their inner heart, so that the audience will respond immediately with resonance [*gongming*]." This observation demonstrates a striking resemblance to Kuriyagawa's definition of symbol, especially when compared to Lu Xun's rendition, the most popular edition among the three translations of *Symbol of Angst*, reprinted five times by 1927.[100] That the psychological operation of suggestion is perceived as a matter to be transmitted to the audience's interior, where then to cause physiological resonance, situates the audience experience between the interior and the exterior, the physiological and the psychological.

The next passage in *Huaju*, which I quote again here, reflects yet another connection with Kuriyagawa:

> Cinema must contain an igneous quality, which enables the audience to go beyond exterior beauty to its inner content. When excitement arouses the inner image at the depths of the senses, the theme of the film can reach the audience and create vibrations deep in their heart. This way suggestion [*anshi*] has finally achieved its ultimate purpose.[101]

This passage is again grafted from Kuriyagawa's second part of *Symbol of Angst*, specifically his discussion of the psychological stages of artistic appreciation.[102] If we remap them in Kuriyagawa's framework and examine the rearrangement and revision the *Huaju* author takes the liberty of doing, we find an interesting perception of film spectatorship.

Kuriyagawa divides artistic appreciation into four stages as the symbol (literary/artistic works) reaches, respectively, the realms of the intellect, the senses, the imagination, and mood or experience. The first stage, the realm of the intellect, is limited to the basic meaning of language and narrative and satisfies the reader's intellectual

curiosity; this is accomplished by historical and scientific descriptions, adventure and detective novels, and low genres of film. The second stage touches the human senses, including vision and hearing, evoked for example by the sound and color of poetry and, in the case of the decadent poets, smell and taste. The third stage reaches the imagination, or the "inner image at the bottom of the senses" evoked by the imagination. For Kuriyagawa these three stages are exterior responses to the symbol. Only when the symbol reaches the unconscious of the reader, or when "the suggestive power of the stimuli touches the content of life," does the symbol arrive at the fourth and final stage. At this stage the symbol is able to evoke the reader's resonance and shared experience, and the appreciation of art and literature is fully realized: "The author's unconscious has finally reached the reader, and evoked the resonance on the strings of their heart. Hence the suggestion finally reaches its purpose."[103]

Although these four stages are delineated as following a teleological order with a sense of hierarchy, Kuriyagawa adds that they are emphasized differently in different literary genres and styles. Essays, fiction, and landscape poetry emphasize the first three stages. Lyrical poetry, especially symbolist poetry, glides over the first and third stages and usually emphasizes the second stage of sensual experience to directly reach the fourth stage, the realm of the mood, and evokes the subjective "vibration" (English in the original). There is also a hierarchy among the readers or spectators. The audience members with "low" tastes remain at the first stage, whereas other readers or spectators mostly reach only the second and the third stage.

The *Huaju* article follows Kuriyagawa's delineation of the process of artistic appreciation, yet with significant revisions. In stating how cinema could enable the audience to reach from exterior beauty to inner image, the author portrays the audience's experience as similarly passing from the realm of the senses to the imagination and eventually resonance, or "vibrations deep in their heart." The *Huaju* article differs, however, from Kuriyagawa's on several accounts. First, even though Kuriyagawa treats "low" film genres and their audience with "vulgar" tastes as confined to the first stage, the *Huaju* writer treats films in general as sharing equal status with literature and art. Hence, Kuriyagawa's observation, originally limited to literature, art, and drama, is now extended to cinema. Second, the author and his/

her cinematic equivalent, the director, disappears in the *Huaju* article's discussion. What matters seems no longer to be how symbols or artistic works enable the audience to retrieve the unconscious of the author. Instead, the communication is now between the film and the audience, or the screen as a medium of stimuli that can carry a certain suggestion. At the same time, what lies behind the suggestion is more implicit and ambivalent. Further, although it is the theme that defines the result of the third stage, the audience's resonance is the ultimate goal for cinema. Third, by resorting to the metaphor of fire, the author perceives the film-reception process as one that resembles burning: from the exterior to the interior, from sensation to image or, rather, images on another level arising from this process. The cinematic "fire" thus conceives of both film and film reception as self-effacing processes that condition perception. The succession of the images erases the distinct images per se and converts the film-viewing experience into a distinct temporality, that of duration. At the same time, the viewing process is portrayed as moving from image-sensation to (inner) image-(inner) vibration, establishing a continuity between image and body, sensation and perception.

This account of film reception is rather akin to Bergson's understanding of perception and affect. For Bergson perception should not be understood as the separation between mind and body, bracketed out of space and time. While the body is considered the center of action, the brain continues the bodily perception of possible action in relation to other bodies, with stimuli from the environment. The perception of the body in relation to other bodies is what Bergson defines as affection, or sensation, whereas the perception of the present moment in relation to other moments is what constitutes duration, or memory.[104] Furthermore, duration is not infinitely divisible as empty homogeneous time but contains multiple rhythms to "measure the degree of tension or relaxation of different kinds of consciousness."[105]

Bergson's revisionist understanding of perception—as located between affection and memory, as the extensity between subject and object, as a continuous process between body (another image), image, and matter (aggregations of images)—provides an apt model of spectatorship that corresponds with Kuriyagawa and the *Huaju* author's explication of audience resonance. Let us consider the following passage from Bergson:

The progress by which the virtual image realizes itself is noth-
ing else than the series of stages by which this image gradually
obtains from the body useful actions or useful attitudes. The
stimulation of the so-called sensory centers is the last of these
stages: it is the prelude to a motor reaction, the beginning of
an action in space. In other words, the virtual image evolves
toward the virtual sensation and the virtual sensation toward
real movement: this movement, in realizing itself, realizes
both the sensation of which it might have been the natural
continuation and the image which has tried to embody itself
in the sensation.[106]

What Bergson describes is the process through which memory
image realizes itself through the mobilization of sensation and the
actual movement of the body. In his understanding, the virtual al-
ways needs the life and energy of sensation to realize itself. Although
he describes an introspective process about the realization of recol-
lection through sensation and bodily movement, this applies to the
film reception process because for Bergson the body and the external
image are but a continuum of aggregated images connected by the
extensive power of sensation. This perceptual scenario corresponds
to Kuriyagawa and the *Huaju* author in understanding image as an
interactive medium that is complete only when it realizes itself in
sensation and actual movement. In other words, the "virtual" image
of cinema becomes realized only when it carries "virtual sensation"
across the screen to be transformed into actual image and actual sen-
sation within the spectator's body. The inner image that arises in the
depth of the audience's heart is the corresponding memory image
and is nevertheless actual rather than virtual, as it is vitalized by
the spectator's motor movement. At the end point of this reception
process is the inner resonation, or what Kuriyagawa calls "mood"
or experience, which remains ambiguously positioned between the
physiological exterior and the psychological interior, as discussed
earlier, and cannot be reduced to or organized as emotion, because
of the interaction between complex stimuli and the hypersensitivity
of the modern human being.

To juxtapose Bergson with Kuriyagawa and the *Huaju* author is
not as contrived as it might seem, as Bergson's works were translated

at great length from the 1910s to the mid-1920s in China and Japan. Bergson was first introduced to China in 1913 by Qian Zhixiu in an article published in *Eastern Miscellany*.[107] Bergson's *Creative Evolution* was translated in 1919, *An Introduction to Metaphysics* in 1921, *Matter and Memory* in 1922, *Mind and Energy* in 1924, and *Time and Free Will* in 1926. These books, together with numerous secondary writings on Bergson, were almost all published by the most prestigious publisher in China, the Commercial Press.[108] In February 1921 the future prominent Chinese philosopher and political figure Zhang Junmai (aka Carsun Chang) (1886–1969) visited Bergson with Zhang's friend Lin Zaiping. The conversation during this visit, published in the journal *Gaizao* in August 1921, spurred an ascending interest in Bergson, and a special issue of the journal *Guotuo* was devoted to him.[109] With a visible impact on leading intellectuals such as Liang Qichao, Zhang Taiyan, Liang Shumin, Li Dazhao, and Chen Duxiu, Bergson's spiritual presence in China culminated in the great intellectual debate on "science versus metaphysics" in 1923, instigated by Zhang Junmai.[110] Meanwhile, Kuriyagawa himself incorporated Bergson's ideas avidly into his writings. Both Bergson and Kuriyagawa were important figures behind the neoromanticist and new heroist discourse. Although often emphasizing a nationalistically inflected notion of *élan vital* and a modernist sensibility of "intuition," these discursive deployments of Bergson's work—borrowing also its symbolic capital—shared his vested interest in reconceiving human body in relation to perception through the mediation of the cinematic image and medium. More specifically, however, the new heroists imbricated their interests with social and political concerns, articulating a nationalist anxiety of citizenship in a semicolonial condition and in the unequal exchange of global image circulation.

Hero in the Fire

Just as the *Huaju* author anticipated the "igneous" quality of film, fire appeared frequently in new heroist discussions of cinema and its affective power. This was perhaps not coincidental, as the analogy had already appeared in Kuriyagawa's discussion of *élan vital* and audience reception. The Chinese writers who advocated new

heroism similarly excoriated the "lack of life-force" among the Chinese people as the "lack of fire." As Chen Zhiqing writes, foreigners slight and humiliate the Chinese not so much because of the difference in skin color but because "in all their life, their fire of life never erupts forcefully."[111] In Chen's critical account of Chinese cinema, the filmmaker lacks the dynamic *élan vital*, or the eruption of fire to create artistic films, while the masses similarly lack the vigorous life-force to receive such films, to provide themselves as artistic material. The only solution is to ask the filmmakers to create forceful works that will "ignite the flickering sparks of the masses."[112] Resorting to his favorite metaphor of nakedness, Chen writes:

> Take off my coat, shed my underclothes. Am I naked enough? But the blazing fire is still inside the skin, beneath the bone, in the depths of my heart! Since I have taken off my clothes, why don't I peel off my skin and my bones, and let the burning fire radiate its light so that it shines through the universe and heats up the crowd? This precious fire is the true life of the artist. Only when the fire is released in this way can an artist produce his artwork. Rarely do we see any spark of fire in Chinese films.[113]

Fire, the life-force, and artistic impulse are equated in a call for a powerful Chinese cinema. Similarly, Du Shihuan asks filmmakers to use the surgical force of a doctor so as to create a "reformed new life" of the nation and "rekindle the fire of life."[114] In the same spirit, Lu Mengshu's edited volume on new heroist cinema is entitled *Xinghuo* (*The Spark of Fire*). The cover, designed by China's animation pioneer Wan Laiming, whose work I discuss in chapter 6, features an art nouveau–style muse at the core of a red spark of fire (Figure 1.4). In the new heroist discourse, fire circulates as a symbolically charged currency by its association with the life-force, art, affect, collectivity, and the force of iconoclasm. In the martial arts films advocated by the new heroists, fire is homologous to action, which equally embodies life-force and the affective power to "violently assault the audience's heart and strike sparks in their corporeal life."[115]

It is perhaps not surprising that the *Huaju* article that echoes the elitist new heroist discourse appears in the publication of a film

Figure 1.4. Book cover design by Wan Laiming for *Xinghuo* (*The Spark of Fire*) (Shanghai: Liangyou, 1927), featuring an art nouveau–style muse at the core of a red spark of fire.

studio that specialized in the "low" genre of martial arts films. Huaju was a relatively small studio, founded by the brothers Zhang Qingpu and Zhang Huimin from the wealthy Zhang family of Cantonese origin. The studio produced mainly martial arts, adventure, and detective films and was particularly keen on parading its actors in Western attire while they wrestled with, competed against, and mastered modern technology (Figure 1.5). Despite its interest in "ultra-low" genres, Huaju maintained close ties to various elitist writers and critics, including screenplay writer Gu Jianchen, one of the earliest spoken-drama playwrights and the founder of the high-modernist group the Shanghai Drama Society (Shanghai xiju xieshe). *Huaju Special Issue* also published modernist poetry, essays advocating the May Fourth enlightenment project, discussions of screenwriting techniques, and philosophical arguments about cinema's affective impact and artistic status. Moreover, many of its messages resonate in exact wording and rhetoric with the new heroist discourse. The journal not only set a mission for martial arts films to serve the age of revolution and save China from its "subcolonial" condition but also made explicit reference to Byron, Ibsen, Wilde, and other romanticist and neoromanticist idols in its appeal for the life-force in a new kind of cinema.[116] One essay writer even wants to "smash the silver screen" so as to end exhibitions of "tepid" films.[117] These writings indicate that martial arts films were subject to heterogeneous interests and reveals the new heroist short circuit between the high and the low.

Huaju also seems to have had a proclivity toward fire. The first issue of the film journal starts with a dedication poem about fire that alludes to the Prometheus myth and claims as their studio's mission to spread the fire of life, creation, and wisdom. Huaju made a two-reel documentary entitled *Shanghai jiuhuo hui* (*Shanghai Fire Brigade*) in 1926.[118] In 1928, shortly after the singular success of *The Burning of the Red Lotus Temple,* Huaju made *Huoli yingxiong* (*Hero in the Fire*), released in October. In that film a young man from the countryside, Jin Guoxiong (Zhang Huimin), saves a young woman, Yingying, swept away by the Qiantang River tide (*Qiantang chao*) on a family outing to see the spectacular tide. In return, her father, a wealthy mine owner, grants Jin's wish to join his fire brigade. Gradually, Jin perfects his skills and wins a silver medal in a firefighting

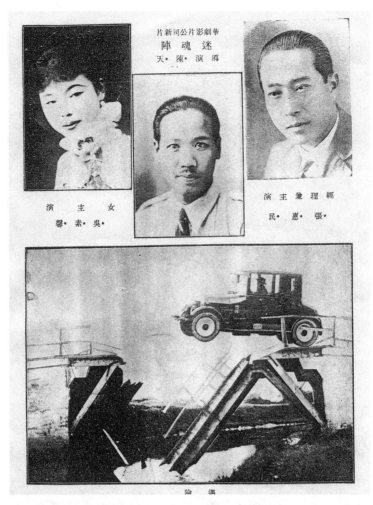

Figure 1.5. Huaju Film Studio publicity for *Mihunzhen* (*Trap for the Soul*, 1927). *Dianying yuebao* 1 (April 1928).

competition as well as the heart of the other daughter, Juanjuan (Wu Suxin). At the same time, the rich father is lured into a trap set up by his former business partner, whom he betrayed. To save the father, the daughter Juanjuan follows him by car, and both end up in a secret chamber. The young firefighter hero arrives, and an adventure-ridden fight in a sea of fire takes place. The story ends with Jin saving Juanjuan, carrying her out of the fire and jumping from the seventh

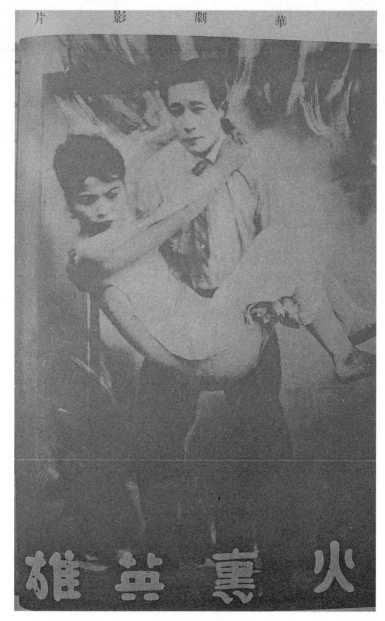

Figure 1.6. Publicity still for *Huoli yingxiong* (*Hero in the Fire,* 1928). *Dianying yuebao* 8 (December 1928).

floor, while the rich man is engulfed in fire as he fights with his foe; both will die from their greed for the gold mine (Figure 1.6).[119]

Although the film is no longer extant, synopses, film ads, and comments highlight its excess of attractions, including the natural spectacle of the Qiantang River tide, car chases, professional fire-fighting, male cross-dressing, and climbing and jumping from an extreme height, all of which makes the climax of the characters' fighting within the fire the culmination of multiple attractions. This qualifies *Hero in the Fire* as a quintessential fiery film. The synesthetic force of fire epitomizes the multiple effects of technological wonder, physical thrill, and psychosomatic immediacy upon the audience and carries these effects to a higher level. The aggressive albeit communal force of fire, its destructive yet transformative power, and its infectious quality and hegemonic violence make it a most acute weapon of pathos, with phenomenological roundedness and symbolic contradictions.[120] The fiery films propel and thrive on the affect of cinema.

This fire does not simply cater, however, to the popular taste for excess and multiple attractions. *Hero in the Fire* is also highly symbolic. The male protagonist's name, Jin Guoxiong, means "golden national hero." His profession as a firefighter is a rather modern icon of heroism. Firefighting was one of the major attractions in late nineteenth-century Shanghai, featured frequently in the lithographic pictorial journal *Dianshizhai huabao*. With modern technology such as the fire engine and high-pressure water, together with the firefighters' physical skills of conquering extreme heights and danger, firefighting created real-life thrillers in the modern everyday urban space. The superhuman body of the firefighter, with the sound of the siren and the speed of the fire engine, summoned a considerable degree of authority. The emergency situation and the physical sensation it entailed congealed the power to assemble the public, albeit only temporarily. Although firefighting seems to be the counterpart of the new heroist endorsement of fire as a symbol of the life-force and affect of cinema, the physical thrill of firefighting does not come so much from the eventual fire quenching as from the close, sensorial engagement with fire. The iconic power of the firefighter resides in its similarity to fire itself, embodying the energy of the life-force and the mobile, violent, conquering force. As I show later in the book, the firefighter, the fire engine, and the hero rescuing the

female protagonist in the sea of raging flames recurred in films and other media productions as the sensational thrill of fire was adapted by different forces beyond new heroism.

Sensation and Sentimentality: The Dual Operations of Affect

Although the new heroist film advocates did not specify cinematic techniques to create such optimal audience responses, the *Huaju* article provides two examples of the stated spectatorial experience. One is the author's own speculation about a ruthless rich old man who saw the separation between a mother and a son in a film and shed tears inadvertently: "This is because a sad whirlpool is created in the abyss of his unconscious, and what drips down his face is a teardrop of such an emotion."[121]

In the second example, the author recounts an incident in Shanghai in 1926 when the film *Volga Boatman* (Cecil B. DeMille, 1926) played for three days in the Olympic Theater, until the police called it off. During the three days of exhibition, the audience filled the theater with enthusiasm. The movie screening was accompanied by a Russian orchestra. When the film showed the victory of the revolutionaries, the audience, already excited by the heightened emotional effect of the music, shouted with joy and applauded, creating tremendous commotion. Some threw copper coins to the stage; the ones who knew the songs sang along loudly. The author explains, "This is all because the hot blood of revolution in the film splashed directly at our hearts and caused them to burn with it together."[122]

These two examples, resulting respectively in shed tears from the whirlpool (wave) of sadness and the burning of the collective heart, prescribe a difference in the spectatorial effects produced by the two different films. The first example, referring to the film *The Orphan Rescues Grandfather* (1923), one of the earliest successful domestic melodramas by Mingxing Film Studio, focuses on the effect on individual interiority through a mode of identification. Resembling the protagonist in the film, who is also an old man (the grandfather), rich, stingy, and callous, the old male spectator reacted in a way that demonstrated a rather solitary, private film-viewing experience. In the second example, however, the optimal effect is not so much

identification but stimulation. The author emphasizes the speed, force, and immediacy of the sensorial impact of the film on the audience and the political potential of the collective spectatorial experience. The different audience reaction corresponds to not only a different film aesthetics but also a different mode of exhibition. The live music accompaniment and the mass vocalization and celebration of a revolutionary spirit evoke the collective experience of the here and now in the high tide of the Northern Expedition and places the film in a different context from that implied in the film text. This explains the audience's celebration of the revolution despite DeMille's own film narrative, which makes the tsarist aristocrats sympathetic characters.[123]

The two viewing examples cited in the *Huaju* article provide two distinct emotional models, one of sentimentality and one of sensation. The former is associated with the effects of interiority and identification, and the latter, with physiological response, collectivity, and a certain conflation between interiority and exteriority, experience and perception. The examples are from two different genres, sentimental melodrama and action films—more specifically, family melodrama, which was prevalent between 1922 and 1925, and martial arts films, emerging in 1927.

Nevertheless, many of these action-oriented fiery films, or, more broadly, martial arts films, paradoxically feature rather sentimental scenes. Despite the celebration of bodily manipulation of clashes with novel technology, physical stunts, and martial fights/fistfights, these films show no hesitation in staging tears, longing, and suffering of the soul. The sentimental scenes are usually associated with sensational fighting and adventure through romantic love. Separation from one's love (romantic lovers or family members) by evil forces often results in some fierce fighting and adventures. At the same time, the films pause at deliberate moments for private feelings. In describing the making of *Bai furong* (*The White Lotus*, 1927), one of the earliest martial arts films produced by Huaju Studio, the screenplay writer and the male lead, Zhang Huimin, recounts that director Chen Tian and Zhang's brother, Zhang Qingpu, modeled the film after a Cantonese opera but changed the mourning scene and the opera title: *Yediao Baifurong* (*Nightly Mourning for the White Lotus*). In the original play the male protagonist is making a nightly

sacrifice to mourn the death of his lover, the White Lotus, when her apparition emerges from the lotus flower. The film changed the original title to *The White Lotus* and deemphasized "the superstitious" appearance of the apparition. Instead, the male protagonist laments her death at the riverside, and in his imagination the White Lotus appears from a lotus flower pond and gradually ascends into the air. In the end, White Lotus turns out to have been not drowned but saved by a fisherman and reunites with the male protagonist. In this film sentimentality performs a significant role in constructing interiority. The film is also designed as "half sentimental, half martial arts."[124] Writer Cheng Yan applauds that the film unites the merits of two film genres, romance and martial arts.[125]

The sentimental binding takes an extreme turn in *Xuezhong guchu* (*The Orphan of the Storm*, Zhang Huimin, 1929), a hybrid remake of D. W. Griffith's *Way Down East* combined with an action adventure, which has luckily survived. The survived film print, subtitled in English, alludes to another Griffith film, *Orphans of the Storm*, by its English translation of the title and the characters (actress Wu Suxin's sister, Wu Susu, plays the more masculine and righteous daughter of the rich family who comes to Wu's rescue several times). The female lead (Wu Suxin) suffers from repeated misfortune in the story. Married to a dullard and suffering from the physical abuse of her mother-in-law, she escapes the arranged marriage and faints on the railway track. Through a Griffith-style last-minute race between the train and an automobile (driven by Zhang), she is rescued by the hero, Zhang Huimin, and offered a job in Zhang's household to help with housecleaning and maintenance. She is again abused by the eldest daughter of the family and distrusted by the father, and she loses the family's trust through several unfortunate coincidences. Her physical and mental suffering reaches the utmost when she leaves the family and roams aimlessly in the field. Enduring a heavy rain (probably created by scratching the film print or by using a mask in front of the camera lens) and struggling through the vast field of snow and ice, she eventually faints. This scene, one of the several attempts in Chinese film history to reproduce the famous floating-ice scene in *Way Down East*, consists of two sequences that together last approximately seven minutes. In several long shots and long takes documenting the heroine's enfeebled body enduring the abuses of

nature, the film is melodramatic and sentimental to its most elemental detail. The sequence ends with the heroine's second rescue by the male protagonist. The plot, however, makes a sharp turn at this point.

The remainder of the film, which lasts over twenty minutes, one-third of the film's length, becomes an action thriller, a more typical Huaju film genre that shares much with the martial arts films despite its modern setting. "One hour later," as the intertitle remarks, the romantic couple is discovered by the villainous relative of the idiot husband's family. Lusting after Wu Suxin, the relative, followed by a group of hooligans, tries to abduct Wu Suxin and launches a prolonged and intensive fistfight with Zhang Huimin. Zhang jumps into the water from a cliff and showcases his swimming skills, which he repeats in a number of survived Huaju films such as *Ye mingzhu* (*Lustrous Pearls,* Chen Tian, 1927) and *Duo guobao* (*Fighting for the National Treasure,* Zhang Huichong, 1929). Wu is abducted and taken to the gang's secret den. It is a prototypical mechanized setting, including a deceptive entrance (a large Chinese lantern as camouflage for an automated entrance), a passage to the underworld, a secret chamber for indoor fighting, and hidden devices for imprisonment. Wu Suxin refuses to give in and is locked up in a cell. To terrorize Wu, the gang opens a box and sets free a lizard in her cell. The Grand Guignol style of female imperilment is carried to its maximum when the lizard climbs up Wu's body and the camera cuts to a close-up of her panic-stricken face. In the end, Zhang Huimin finds the secret dungeon, fights feverishly with the gang, saves Wu Suxin, and puts the villain into the cell as the lizard climbs up his body.

The excessive suffering that Wu endures marks *Xuezhong guchu* as a sentimental melodrama. Publicity for the film further evokes the genre association with melodrama by claiming that Wu Suxin's expression and gestures closely resemble those of Lillian Gish (Wu was nicknamed the "Oriental Lillian Gish" in the Chinese film world once the film was released).[126] The genre is "marred," however, by a jarring combination with a martial arts film. I cite this more extreme example from Huaju to show the routinely "incongruous" co-existence of the emphases on sentimentality and sensational action that could seem a forced union of two distinct genres. The most sentimental film, *Yuli hun* (*The Soul of Jade Pear,* Zhang Shichuan, 1924), for example, includes a sensational revolutionary aspect, as the male

protagonist dies on the battlefield after he leaves his lover because of unfulfilled love. So does *The Orphan Rescues the Grandfather,* another signature family melodrama cited often in film history, which involves a thriller subplot about the abduction and rescue of the grandfather. Hou Yao's *A String of Pearls* also includes a detective thriller subplot with a blackmailer. A similar pairing between sentimentality and sensation appears in Griffith's own films. In addition to the sensational appeal of the floating ice sequence in *Way Down East,* both *Orphans of the Storm* and *The Birth of a Nation* are set amid extreme social turmoil, and the unrest of the crowd and the battle are more akin to "blood melodrama" than to sentimental melodrama, such as early teen melodramatic films.[127]

The coalescence of two genres in these films thus does not merely present a "variety" that would attract a wider audience. The dual operation of affect in these films simultaneously brings out the double aspects of melodrama. These aspects can be mapped onto the two historical periods in American cinema, from the 1890s–1910s stage and screen sensational melodrama to the post-1910s sentimental melodrama, in which sensation is narratively integrated, if not "tamed," domesticated, or co-opted by sentimentality. Yet such historical division of the duality of melodrama into two generic subcategories misses the point of a more fundamental rethinking of melodrama as a modern "structure of feeling." The Chinese martial arts films, family melodrama, and love films highlight the coexistence of sensation and sentimentality, equally operative in classical melodramatic films in the West. The duality of sensation and sentimentality is better understood in terms of what Linda Williams calls the "dialectic of pathos and action," a crucial mode of aesthetic operation that characterizes melodrama not as a genre but as a mode, a quintessentially modern and more prominently American mainstream cultural form that structures moral feelings for the society in general.[128] For Williams, the symbiosis of pathos and action becomes an operational mode to recover an archaic truth or primal innocence, often worked out through the tension between the irreversibility of time (pathos) and heroic attempts at its reversal (action). Even though the Griffith films are much more cohesive in alloying sensation and sentimentality, in the Chinese films, which sometimes yoke these two aspects in a jarring way—each aspect usually distinguished by distinct genre

conventions that define the look, costume, acting style, and setting of the film—there is still a tendency to merge the two. In the Chinese context, however, pathos and action contain culture-specific connotations; more important, they are the very result of heterogeneous discursive construction and cinematic technique and technology.

A closer examination reveals that the ostensible polarity between sentimentality and sensation in these films is actually a much closer affinity in a rather tight narrative. In terms of the narrative structure, these films contain an *ernü yingxiong* (heroic romance) pattern consistent with the late eighteenth- and nineteenth-century vernacular novel. Haiyan Lee outlines this pattern in her cogent reading of modern Chinese literary and cultural history from the late-Qing to the mid-Republican period. In Lee's genealogy of the *ernü yingxiong* tradition, with a prehistory on the discourses of sentiment in premodern China, she narrates that the previous incompatibility between heroism and passion, explored respectively in the separate vernacular fictional genres of chivalric fiction and scholar–beauty romance, came to a significant juncture in the late eighteenth to mid-nineteenth centuries. The two genres were joined as the *ernü yingxiong* novels. *Ernü* touches on the ambiguity of love and filial piety, while *yingxiong* refers to heroism, or chivalry. The urge to combine these two genres, in Lee's analysis, originated from the desire to eradicate the contingency of romance and heroism, each of which, when indulged separately, jeopardized the ritual stability of the family to "the accidental, the uncertain, and the capricious."[129] Lee detects that the *ernü yingxiong* genre, in the "sentimentalization of the heroes and the heroicization of sentimental lovers," enabled a highly functional structure to subjugate the "horizontal" uncertainty of heroism and love to the "vertical" stability of filiality. Realigning romance with filial piety and valorizing the latter as heroic preempted romance and heroism in familial ethics. At the same time, public virtue and private sentiment reinforced each other, with the former appearing not as an external force but rather as the subject's active embrace of inner feelings.

This outline of the *ernü yingxiong* does not celebrate the continuity of "tradition" but emphasizes the appearance of a modern regime of biopower. For Lee the rise of the *ernü yingxiong* structure of feeling is precisely not an enduring tradition but a modern regime of

power, reflected and enabled by fictional discourses starting in late eighteenth-century China—hence the very Foucauldian process of productive power that manufactures modern subjectivity. In analyzing Wen Kang's 1870 novel *Ernü yingxiong zhuan* (*A Tale of Heroic Lovers*), which exemplifies the *ernü yingxiong* tradition and narrative pattern, Lee concludes, "The novel spins a riveting tale of romance and heroism, only to have the hero and heroine submit voluntarily to a properly ordered life of career and family."[130]

For Lee this operational structure of *ernü yingxiong* remained unchanged throughout the next several decades, with the only variation in definitions of "virtue," "sentiment," and "heroism." In the Huaju films, though, the binding force of virtue, associated with family, is rarely realized. In *Hero in the Fire,* the wealthy father who grants the male hero the fire brigade job turns out to be a selfish and greedy exploiter and is rightly devoured in the fire, not even worth rescue by his own daughter. The tale of love and heroism with a moral against capitalist greed is realized in a literal and symbolic patricide. This narrative arrangement is rather different from Lee's insightful outline of the *ernü yingxiong* mechanism. In *Touying moxing* (*Stealing the Shadow and Imitating the Form,* Zhang Huimin, 1929), the mother allies herself with her evil nephew and arranges her daughter's marriage against the daughter's will. Similarly, in *Xuezhong guchu,* the father carries the entrenched class prejudice and contributes to the heroine's misery.

Yet importantly, the interpenetration of romance and heroism does produce a "sentimental" subject capable of action. Sentiment first of all gives a name to anonymous and anarchic energy (characteristic of the masses). Second, it authenticates this energy with "genuine, internal feeling" so that it can be channeled into other social aspects, such as "national feeling." What complicates this argument is, however, the ambiguous location of "feeling" between interiority and exteriority. In the sentimental scenes interiority is privileged, yet its *realization* depends heavily on a process of externalization enabled by cinematic technology. Hence, in *The White Lotus,* even though the sentimental lamenting subdues the "superstitious" apparition to the male protagonist's interior imagination, this interiority remains partly exteriorized by juxtaposing the subject and the "imaginative" image in the air. Instead of typical Hollywood-style

invisible editing that "zooms in" to interiority through a close-up of the face to offer privileged access to character psychology, this juxtaposition underlines the very process of the construction of interiority while making sentiment closer to the notion of *stimmung* (a mood, an atmosphere, literally "bubble"). A similar production of interiority appears in *Hongxia* (*The Red Heroine,* Wen Yimin, 1929). When the male protagonist misses the Red Heroine, who is separated from him, his reflections about their past appear in the upper-right corner of the screen, juxtaposed with his own image on the left side as the subject of recollection. Such visual construction is a far cry from the "dream bubble" in late-imperial Chinese wood-block prints and nineteenth-century popular lithographical prints. The "pictorial" lineage of these images helps denaturalize the production of interiority through narrative sentimentalism and photographic realism.

The fabrication of interiority is further exposed by its conflation with the technological apparatus of film. In *Xuezhong guchu,* after Wu Suxin suffers enough misfortune from the family, the intertitle reads, "In the stillness of the night, the miserable affairs of her past unravel in her mind reel by reel like cinema pictures." It is peculiar that the word *mu* in the original Chinese intertitle is translated in the original English subtitle as "reel" instead of "scene," as we often interpret it now. This self-reflective moment not only turns the human mind into a projection room but also refers to the not-too-distant exhibition convention for serial adventures, whose narrative episodes were unraveled reel by reel rather than scene by scene. Whether the analogy alludes to film projection or reception, the production of interiority is directly associated with film technology and its creation of memory, perception, and reflection.

The dual operation of sensation and sentimentality in these martial arts films thus creates an interesting variation to the dialectic of pathos and action in American melodrama. If in American melodrama pathos and action both expose and reconcile the perpetual tension between exisiting social order and its potential transgression, in Chinese martial arts films the alliance between sensation and sentimentality showcases a complex cultural and technological processing of affect key to modern subjecthood. This *dispositif* of affect, more specifically *resonance,* involves a dialogue with not only narrative conventions such as *ernü yingxiong* but also heterogeneous

and transnational discourses on the modern, neuroaesthetic sub-
ject. As I show in the section on the audience's resonance, both
Kuriyagawa and the *Huaju* author emphasize audience experience
as lodged between psychological interiority and physiological ex-
teriority. Kuriyagawa's ambivalence is entwined with his interest in
fin-de-siècle symbolism, German aestheticism, European social psy-
chology, Freud, and Bergson, whereas the *Huaju* author's inflection
of Kuriyagawa registers the influx of a wide range of psychological
studies in the period and Shanghai's film exhibition practice. Such
ambivalent location of the human psyche does not exempt it, how-
ever, from any political incorporation. My discussion of new heroism
illustrates that not only martial arts as a genre but also its emphasis
on action and affect is neither autonomous nor intrinsically subver-
sive. The affect argued for by new heroist film advocates is traversed
by modernist aesthetic interests, industrial genre and media differ-
entiation, and nationalist building of a competent and competitive
subject. This subject is defined by an audience who has overcome its
national apathy and is capable of producing adequate affective re-
sponses to artistic stimuli. Cinema, or new heroist cinema, is advo-
cated because of its ability to penetrate the apathetic exterior surface
and create a strong affective reaction, hence cultivating a new audi-
ence as well as a new national subject, an "emotional being."

It is important to recognize that the coexistence of sentimentality
and sensation does not always guarantee the implantation of virtue
but creates "a dialectical interaction between moral significance and
an excess aimed precisely at noncognitive effects, thrills, and sensa-
tions."[131] What needs to be examined further is, however, whether
sensation itself is subject to moral signification. The new heroist dis-
course was invested, with heightened nationalist and modernist in-
terests, in the empowerment of the body. If fire could function as "a
vertiginous image of order destroyed and discourse rendered mean-
ingless," it could also create an iconoclastic moment when discursive
forces found new anchorage precisely in the images and forces of de-
struction.[132] As discussed in future chapters, fire returned in later
historical watersheds that capitalized sensations for significations.

2 A Culture of Resonance
Hypnotism, Wireless Cinema, and the Invention of Intermedial Spectatorship

It was New Year's Eve 1927. Lu Mengshu, the editor in chief of the major film journal *Yingxing*, had just finished editing an anthology of film criticism, *Film, Literature, and Art*. He concluded the book with an optimistic observation:

> The electric fire [*dianhuo*] above is beaming. The charcoal in the hearth is blazing, filling the whole room with radiant light and warmth. The plaster statue of the Muse also greets me with a gentle smile. Sounds of firecrackers remind me that this is the morning of the seventeenth New Year of the Republic of China. I cannot help throwing away my pen and praying silently that cinema becomes literature and art, literature and art turn into cinema!

Greatly anticipating the growing affinity between film, literature, and art, Lu was writing at the moment when film criticism started to consciously carve out its own space for the new muse, just as the national film industry was solidifying. Recognizing cinema as the seventh or eighth art, film enthusiasts embraced its unique power derived from its technological and material bases, its industrial mode of production, its mass form of consumption and democratic promise, and its ability to harness both reality and fantasy to transcend space and time. Meanwhile, they sought increasing affinity between cinema and other arts, both as legitimating devices for the newcomer and for the exciting transformative power infused into existing media.

Yet the affinity between cinema and other media went beyond the conventions of literature and art. As Lu drew from his immediate

environment auspicious signs for a new beginning, sound, light, and electricity bore particular significance and promise at the beginning of 1928: news of sound cinema had just trickled through Chinese printed media, and electromagnetic waves provided a new equivalent to sound, light, and color via a number of exciting inventions, including radio, television, and color and sound film. Either in practice or in news circulated in China, these evoked immense creative energy and imagination for increasing ties between cinema and other media. "Electric fire," a contemporary term for electric light as well as for thunder and electric sparks, provided an apt metaphor conjoining the primitive force of fire with new technologies, conveying synesthetic energy as well as the knowledge and technological control to properly channel this force.

In this context, resonance gains new significance. As discussed in chapter 1, resonance as a mode of spectatorial affect was actively theorized in 1920s China in the transnational traffic in action thrillers, literary modernism, and political philosophy. This chapter looks more closely at how spectatorial resonance was engineered at the intersection of media technology and other technologies of the body: psychology, biology, physics, and spiritualist movements. Methodologically, I am interested in how intermediality—the synchronic interplay between cinema and other media—pertains to not only formal and textual aesthetics but also spectatorship. Coining the term *intermedial spectatorship*, I consider how intermediality contributes to historically specific notions and practices of spectatorship by mobilizing formal and social intertextuality across media while incorporating the materiality of technology; how cinema overlaps with and parallels other media as technologies of the body and perception; and how the technological and formal binding of the human sensorium places spectatorial affect within a broader social network. A historical inquiry will inform us of how cinema was already considered in other terms and experienced by other means, with the concomitant proliferation of other media and social practices. Conversely, film aesthetics and practices intersected with the ways other media were conceived and practiced, providing the "cultural interface" with these media.[1]

Starting with hypnotism as a key site of such intersection, I examine how practitioners in 1920s China actively engaged photography

and cinema to strengthen believability while authenticating the optical media. Meanwhile, the fascinating notion of telepathy and news of the medium of television embedded cinema in the novel imagination of distance communication. Along with popular scientific imaginations of diverse futures of cinema—panoramic theater and stereoscopic television theater—this inspired new conceptions of the relationship between medium, space, and the spectatorial body, hence a renewed film–audience relationship. While a continuum between space and medium was perceived as plausible given the recognition of ether and wireless technology, the spectator's body was converted to a corresponding medium capable of "sympathetic vibrations." The resonant spectator was also enmeshed in a broader culture of productive receptivity, where circulated knowledge of wireless technology and amateur radio reception provided new possibilities of simultaneous interaction and modes of control. The ambivalent promise of this spectatorial resonance is further explored in this chapter.

Under China's semicolonial condition, resonance emerged as a new mode of intermedial spectatorship as well as a cultural *dispositif*, framing the ways wireless technologies interacted with cinematic imaginations and political philosophy in the production of a modern spirituality. Probing the technoscientism of Chinese intellectuals, writers, and popular cinema in their cultural translations of ether, energy, and wireless technology, I suggest the notion of an affective medium as mediating environment that invites considerations of ethics and politics while revising the conceptions of virtuality and screen media.

"Empirical Evidence" (*Shizheng*): Hypnotism and Photography

The Chinese reception of Bergson, as discussed in chapter 1, was never unmediated. Chinese intellectuals quickly found affinity between the spiritual impulse of Bergsonian philosophy and Confucian thinking, Buddhism, Daoism, Songming Neo-Confucianism, and twentieth-century Neo-Confucianism (which Zhang Junmai played a significant role in fostering). Despite complaints about "distortions" of Bergsonian philosophy by a handful of Western-trained

Chinese scholars, the trend was to interpret Bergson as the primary opponent of scientific progress, propelled by Liang Qichao and Zhang Junmai after their 1918 visit to Europe. Witnessing the catastrophic aftermath of World War I, Liang and Zhang found Bergson and *Lebensphilosophie* an apt critique of scientific rational thinking and mechanical materialism. Zhang stayed on in Europe for two more years to study philosophy at Berlin University and subsequently sought mentorship from Rudolf Eucken, another influential figure of *Lebensphilosophie*.[2] Searching for the role of Chinese culture in the modern world, Chinese intellectuals actively sought connections between Bergson and Chinese philosophical and religious thought in order to negotiate with a full-scale Westernization. Yet the artificial breakdown between science and metaphysics served more the purpose of polemics among high intellectuals. In reality the spread of various schools of psychology, popular psychology, physics, and popular scientific understanding of media technology greatly complicated the issue and provided a unique discourse network in which to trace the ramifications and cultural implications of resonance.

The particular understanding of film spectatorship as a mode of resonance, reflected in the *Huaju* article evoking the conceptual and metaphoric vocabulary of Kuriyagawa Hakuson and Bergson, would have remained rather rarefied and esoteric in a narrow cultural landscape. In reality the conflation between physics and psychology in "The Audience's Resonance," discussed in chapter 1, took place particularly through the practice of hypnotism.

Hypnotism was introduced to China in the late nineteenth century via Japanese mediation.[3] During the height of the spiritualist movement in the West, mesmerism and hypnotism migrated to Japan in the 1870s; their popularity soared in the early twentieth century with the founding of the Imperial Society of Hypnotism in Tokyo in 1902.[4] Seven years later, a group of Chinese overseas students, Yu Pingke, Liu Yuchi, Zheng Hemian, Tang Xinyu, and Ju Zhongzhou, founded the China Mentalism Club (Zhongguo xinling jülebu) in Yokohama, with a shared interest in mentalism–psychical research (*xinlingxue*) and hypnotism (*cuimianshu*). The club relocated to Tokyo in 1911 and changed its name to Dongjing liuri Zhongguo xinling yanjiu hui (The Chinese Hypnotism School).[5] The school published *Xinling zazhi* (*The Journal of Psychic Research*), the first

Chinese-language journal on spiritualism, and offered classes, medical treatment, and even instruction by mail, thus gaining overseas popularity.

In 1918 a branch of the Chinese Hypnotism School was established in Shanghai, and its Tokyo headquarters relocated there in 1921. The school, renamed the Chinese Institute of Mentalism (Zhongguo xinling yanjiuhui), launched its own publisher, the Book Bureau of Mentalism (Xinling kexue shuju), in 1923, coinciding with the great debate on "Science and Metaphysics."[6] By 1929 Yu Pingke, the president of the institute, stated that it had over forty thousand members.[7] By 1931 one of the institute's journals, *Xinling yundong* (*The Spiritualist Movement*), had increased its circulation from ten thousand to one hundred thousand since its first issue in 1921.[8] Meanwhile, a cluster of hypnotist and spiritualist clubs, societies, and institutes mushroomed in Beijing, Shanghai, Hangzhou, Suzhou, Tianjin, Nantong, and Hankou. These spiritualist societies published more translations, practice manuals, and mailed instructions, resulting in over three thousand publications by 1931, based on the statistics from the Chinese Institute of Mentalism.[9]

In addition to publications of books, journals, correspondence courses, and lectures by these societies, hypnotism entered the public arena through performances and demonstrations in schools, parks, street festivals, and entertainment centers, including theaters and movie theaters.[10] Stage demonstrations of hypnotism elided the boundary between performance and manifestation, with comedic performance of hypnotism often appearing in variety programs. Sharing the same space as cinema, the cultivation of a new authority of knowledge—a science and practice of the mind transcending the boundary of the body—contributed to the believability of cinematic magic in martial arts films and other supernatural tales enabled by film technology.

Although the Chinese practice of hypnotism entered the public arena as a counterdiscourse of science at the height of the May Fourth debate on "Science and Metaphysics," often evoking the vocabulary, rhetoric, and stance of the metaphysics camp, hypnotists frequently deployed science in the service of psychical research. Resembling the English Society for Psychic Research established in 1882, whose presidents included intellectual luminaries such as William James

(1894–95) and Henri Bergson (1913), the Chinese Institute of Mentalism made numerous experiments to provide "empirical evidence" for parapsychological phenomena. Hypnotism was introduced as a modern science of the mind (*jingshen kexue*) imported from the West just like the other domains of science. Its liminal status between magic and science, quackery and serious research was vividly rehearsed, however, by repeated attempts at experimentation—a scientism as a counter-discourse of science. Aided by small devices such as the planchette (*bailingshe*) and the electric mirror (*dianjing*), hypnotists and amateurs tested the possibilities of self-transformation by following step-by-step instructions to disarm the guard of the consciousness.[11] Aiming at transcending physical and mental limits to achieve extrasensory perception, hypnotism became an incredible science and technology to transform the body into a compliant medium of suggestion.

The hypnotic technology of the body as medium was often paired with other media, particularly optical technology. A popular publication by Yu Pingke, *Qianliyan* (*Telepathy/Tele-vision*), readily demonstrates such kinship.[12] The title page itself is worth pondering (Figure 2.1). Against a black rectangular background, the book title is written vertically in calligraphy in a silver-white color, with the following caption below the title:

These three characters, "*qian li yan*" [thousand-miles eyes], were first written with ink brush on a piece of transparent paper by Mr. Kenzaki Kousaku from Japan. He then placed the paper on top of a box containing a photographic dry plate. With an electric lamp held on his hand for 30 seconds, Mr. Kenzaki Kousaku applied his psychic power [*lingli*] to make traces of his writing penetrate the box and appear on the dry plate.

This page, which constitutes the physical inside of the book cover, ingeniously aligns psychic power with optic technology. What resembles a photographic negative (or a rubbing, a traditional method of tracing calligraphy carved on a stele) is presented as the product of spiritual force, which, significantly, collaborates with optical technology.[13] Photography and psychic power are shown to enhance, complete, and provide witness for each other. Moreover, electric light becomes the equivalent of psychic power when they join forces

to penetrate the surface obstacle and act on the chemical base of the dry plate. Despite the fact that photography is utilized here for spiritualist purposes—to provide visual evidence for the penetrating power of clairvoyance or telekinesis, the ability to transport objects across distance—a peculiar inversion takes place in this trading of metaphors. While with telepathy it is usually the subject who sees through a closed box the hidden object or signs, here it is the photosensitive dry plate that seems to have seen through the box and further made the contents visible to others; or to make photography the metaphor of telekinesis, the dry plate seems to have acquired the power to extract the writing from outside, just as the psychic power could drive it inside from without. In this metaphoric transaction telepathy and photography become interchangeable, as do vision and motion, the optical and the tactile.

Telepathy, as Yu defines it, is "a unique psychic operation that reaches what one cannot perceive with their naked eyes."[14] In other words, telepathy—as a technology of perception—is about not so much the distance of the object as whether "one can perceive the object in terms different from ordinary ways of perception" and how this can be achieved through practice and experiment.[15] Yu lists clairvoyance (x-ray vision), thought transmission, precognition, dream vision, telekinesis, and tele-vision within this domain, embellished with anecdotal reports taken mostly from Western and Japanese publications.[16] Meanwhile, the Chinese term *qianliyan* (thousand-miles eyes), deployed similarly as an overarching term for the diverse phenomena of extrasensory psychic action, emphasizes tele-vision, or psychic perception, more specifically as vision at a distance (*xinling yuanganli*)—with its allusion to the Daoist god who can see across thousands of miles. Because of Yu's particular use of *qianliyan* as a double evocation of the general psychic phenomenon of extrasensory perception (beyond the five senses) and the specific phenomenon of remote viewing, I have chosen two terms, *telepathy* and *tele-vision,* to correspond to the general and the specific use, respectively. Notably, this double evocation reveals the tension and liaison between vision and other senses, which I explore later.

Publications by hypnotist societies commonly accumulated "empirical evidence" (*shizheng*) through members' successful experiments, reported from an impressive range of geographical locations,

千里眼三字，係日本監崎孝作氏先用毛筆，寫上透明紙上，用來放於裝有映相乾片之匣子上面，一手執着電手燈，以三十秒鐘之久，運用靈力將字跡透映到匣內乾片上頭所顯現的。

Figure 2.1. Title page for *Qianliyan* (*Telepathy/Tele-vision*). Yu Pingke, *Qianliyan* (Shanghai: Chinese Institute of Mentalism, 1929).

including Shanghai, Beijing, Hankou, Jiangsu, Zhejiang, Anhui, Guangdong, and the Chinese diasporic community in Bangkok, the Philippines, Burma, and the United States. In addition to textual testimonies, photography was deployed often to further harden the material evidence. Reports were accompanied by photographic portraits of the members, and more lavish photographs were printed by the societies for instructional and evidentiary ends. In a self-help booklet, *Shiri chenggong cuimian mishu* (*Secret Manual for Successful Hypnotism in Ten Days*), a man under hypnotism is shown in a number of photographs to experience unusual perceptions: carefully posed, he is shown to be tasting black tea as red wine, trying in vain to lift a fan as if it weighed over one hundred pounds, eating his wool hat as a steamed bun, picking up a nugget of coal as gold, and writing a confession without any inhibition. With the change of perception, his body also alters its state: he looks stiff as a piece of wood; he shows no expression of pain with a needle piercing his chin (Figure 2.2); he wields a sword with grace, as if acquiring the technique from god; and he struggles against an invisible rope that seems to have tied him up (Figure 2.3). In these visual testimonies, telepathy, as the general psychic phenomenon of extrasensory perception, is manifested through the malleability of the human body—as a medium of suggestion providing physical evidence of its transformation in an altered state of perception and experience. These images, looking both documentary and theatrical, strike one as skillful acting.

In a parallel context, acting itself underwent a transformation as new knowledge of the body—biology, psychology, and physiology—circulated in China while new styles of acting were introduced to cinema and modern spoken drama, both in competition with popular performance and the more privileged Beijing opera. As Hong Shen, a prominent playwright and screenplay writer, explains, even though acting for film and modern drama looks naturalistic and spontaneous, it is not necessarily easier than operatic performances, which takes years of rigorous training. Borrowing explicitly from evolutionary biology, behavioral psychology, and physiology in his exegesis, Hong states that both drama and film acting entail an acute understanding and control of the body's responses to external stimuli in a specific dramatic situation or film scene.[17] Capturing the specific response of an individual in a given situation involves

針 刺 痛 無

(圖 一 十 二 第)

Figure 2.2. Photograph showing a man under hypnotism giving no sign of pain with a needle piercing his chin. Yu Pingke, *Shiri chenggong cuimian mishu* (Shanghai: Shanghai Chinese Institute of Mentalism, 1929).

not sheer imitation of external behavior but rigorous training of one's mind and body—the nerves and glands, in Hong's words—to produce the desirable response: "The art of acting is to assume the existence of a certain stimulus and imitate one's reaction."[18] Hong describes the advantage of film acting over stage performance as follows: because of the discontinuity in film acting (multiple takes,

脱不扎挣绑捆索無

（圖一十第）

Figure 2.3. Photograph showing a man under hypnotism who struggles against an invisible rope that seems to have tied him up. Yu Pingke, *Shiri chenggong cuimian mishu* (Shanghai: Shanghai Chinese Institute of Mentalism, 1929).

editing), one can take advantage of external stimuli irrelevant to the scene or the story to produce the optimal physiological response. Yet the highest standard for both drama and film acting, as well as the most cost efficient, as Hong understands it, is the ability to rely

not on external stimuli (which could be costly and hard to control) but on one's power of imagination. The best actor has the power to imagine a dramatic situation and turn that hypothetical situation into real stimuli, thereby summoning the corresponding responses. This power of imagination is such that it becomes extrasensorial:

> His senses to respond to the stimuli are exceptionally acute. His eyes can see images that do not exist at that moment and place; his tongue can taste flavors differently; his ears can hear otherwise; his nose can detect nonexistent smells; his skin can sense physical conditions (heat or cold) that are not present; his hands can also touch what does not exist here and now. Even though the situation and objects in the play are not real, all that he experiences is real. Even though all the stimuli are hypothetical, the stimuli he physically experiences are real. His imagination is so powerful that it materializes the stimuli; his behaviors and gestures are consequently true responses/reactions to the stimuli.[19]

Hong calls this capacity "sympathy" (*tongqing*), the ability to "put one's body in another's situation/place" (*shesheng chudi*) so that "one can forsake one's subjectivity and transform into anything in the world to experience in their place. These things in the world, which he was indifferent to previously, should also substantially affect him."[20] To cultivate sympathy, Hong suggests an actor learn about human life and recognize the powerful stimuli through observation. This is best done directly but could also be achieved indirectly by reading literature, science, and philosophy as well as by appreciating artworks and watching stage and screen performances, suggesting a direct link between spectatorship and acting.

This notion of sympathy sets itself apart from sympathy seen through the tradition of moral philosophy, which exerted considerable influence in modern Chinese literary discourse and debates on national character.[21] A rich discussion descending from Adam Smith, as a few scholars have demonstrated, emphasizes sympathy as a conscious construction of self and society by simultaneously annihilating and marking the unbridgeable social distance.[22] The individual, perceived as the "impartial spectator," maintains a delicate

balance between self-control and approximation to the other that renders the immediate, physical experience suspect.[23]

Sympathy for Hong Shen is, however, a kind of positive and productive receptivity, a mode of perception and relationality that connects one to the world to achieve a physical transformation from one state of the body to another, from imagination to experience. In the case of film and drama, sympathy is an acquired mode of spectatorship, through direct and indirect observation, that leads to acting or action. "Acting," as Hong concludes, "is to faithfully and precisely manifest, onstage or in front of the camera, one's physical reaction to certain stimuli in life, according to the actor's will."[24] The physical part of the reaction demands equal training. Hong suggests a series of simple breathing exercises to relax the body so that it provides the optimal reactions to stimuli.

This ability to transform one's physical state under influence, be it external or internal stimuli, brings us back to the practice of hypnotism, with implications for spectatorship that converge with Hong Shen's thought. Suggestion is exercised on the hypnotic subject to achieve an imaginative state experienced physically. Just as Hong defines acting as "not playing oneself but playing one's opposite character," the power of hypnotic suggestion is its ability to transform a subject into a different state, a different character, or more precisely, a character in a specific "dramatic" situation. Hong Shen and Yu Pingke thus suggest spectatorship as a kind of sympathetic acting, constructed through physical and mental training to sharpen one's imagination and capacity to experience. Applicable to both acting and hypnotism, resonance can be seen as not simply a genre-specific mode of spectatorship related to martial arts film but a more general cultural transformation in regimes of perception with implications for acting and experiencing. The power dynamic for such a mode of perception remains ambivalent, however. In one of Yu's most popular manuals, *Dianjing cuimian fa* (*Hypnotism by Electronic Mirror*), he lays out the basic parameters to achieve hypnosis by way of suggestion, "the psychic power by which the hypnotist communicates with his/her subject."[25] A hierarchical relationship between the hypnotist and the subject ensures the authority of the hypnotist, reaffirming gender imbalance and social order in cultivating an unconditional trust and obedience. On the one hand, Yu suggests using verbal

commands to "affect, persuade, criticize, discipline, command, menace so that people can obey, remember, change, and execute."[26] On the other hand, the hypnotic manuals are self-help books for the reader as both hypnotist and hypnotic medium, learning to exercise the power of control and that of positive receptivity, and in the case of self-hypnotism, which often requires an observer as an on-site aid, the distinction between hypnotist and subject proves futile.

Tele-vision, Photoplay Fiction, and Cinematic Point of View

If a general conception of telepathy as extrasensory perception was often demonstrated through physical transformation of the body, recalling modern stage and screen acting, the narrow definition of telepathy, tele-vision as distant viewing, was manifested through a new visual logic. A series of photographic images included in the book *Qianliyan* document an experiment conducted by the Chinese Institute of Mentalism. Three photographs are arranged vertically, forming a photomontage (Figure 2.4). At the center is a man framed from waist up, opening the window and looking out. Above him is a photograph of Shanghai's Longhua Pagoda. Below him is another photograph showing a film crew shooting a movie on location. The caption reads, "Our hypnotized subject, Ru Kun, looked far out of the window and felt as if he were climbing up the Longhua Pagoda [Longhuata]. Looking around on the top of the pagoda, he saw a film crew making a movie in the Bansong Garden [Bansongyuan], which was later confirmed." In a more detailed account later in the book, the author explains that Ru Kun, despite never having been to the Longhua Temple, was able to see the pagoda in front. When the hypnotist (Yu Pingke) suggested he climb up the pagoda, he saw the railway station, the arsenal, and the Huangpu River. He then saw the Bansong Garden crowded with people. A film crew was shooting a movie there, and he was able to give details of the film's plot. Since the institute was only twenty minutes by car from the garden, Yu went over and confirmed these details, including the film's plot, exactly as Ru Kun described.[27] The Bansong Garden was located in east Shanghai near the Huangpu River, whereas the Longhua Pagoda was in the southwest suburbs. It remains baffling why, though the institute was geographically much closer to the Bansong Garden, the hypnotist subject needed to make

the detour to Longhua Pagoda to gain a tele-sight whose clarity of detail superseded any actual vision from a given height.

What makes this document of hypnotism less peculiar is the way the photographs are arranged in relation to the text. The mini-narrative composed of text and photographic images is reminiscent of the popular genre *yingxi xiaoshuo* (photoplay fiction), an inter-medial product of film stills and textual narrative often circulated in film journals and newspapers as publicity for newly produced or imported films, simultaneously consumed as entertainment in its own right.[28] Writers such as Yu Tianfen experimented with creative photoplays by staging and photographing scenes for their own writ-ings.[29] The popularity of photoplay fiction, as dramatist and screen-play writer Hu Chunbing (1906–60) observes, exemplifies the "cine-matization of literature" (*wenxue yingxihua*), which he saw happening in the 1920s around the world.[30] World literature, Hu notes, be it new symbolism, neoromanticism, or naturalism, all share a tendency to emphasize *anshi* (suggestion): a gesture or a brief utterance would suffice for writers to dispense with verbose descriptions in portray-ing personalities. As Hu sees it, the demand of the epoch—to convey the richest thoughts and feelings in the most economical manner—naturally makes theater and cinema the best models for fiction. Yet unlike theater, fiction shares more kinship with film because they are not bound by fixed time and space. Plus, Hu adds, cinema and fiction are both silent and demand one's vision and imagination only.[31]

This ability to compose a narrative out of plural frames of time and space, best manifested by photoplay fiction, strengthens the photomontage testimony of tele-vision in *Qianliyan*. The detour of the Longhua Pagoda establishes a believability based not so much on hypnotist faith as on the new perceptual habit shaped by the cine-matic dissection of space and time. The three photographs could be seen as a sequence of point-of-view (POV) shots: the first picture of Ru Kun suggests the subject of vision; the second shot of the pagoda matches his point of view while offering itself as a new vantage point; and consequently, the third picture completes the second point of view from the pagoda. The vision shown in the photographic im-ages could not have been Ru Kun's own with his naked eyes; liter-ally, it is the look of the camera. This psychic tele-vision, if distinct from the vision of the naked eyes, is precisely how the POV shot is

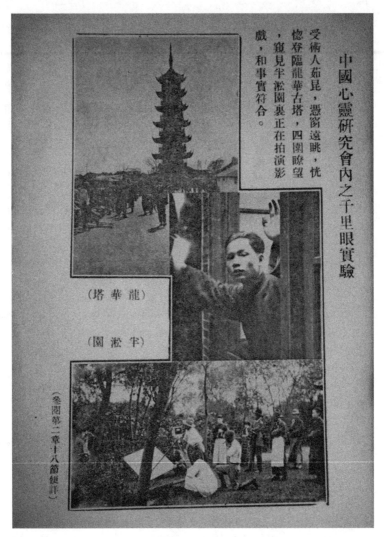

中國心靈研究會內之千里眼實驗

受術人茹昆，憑窗遠眺，恍
惚登臨龍華古塔，四圍瞭望
，窺見半淞園裏正在拍演影
戲，和事實符合。

（塔華龍）

（園淞半）

（參閱第二章十八節便詳）

Figure 2.4. Photomontage as evidence of the subject (Ru Kun) experiencing telepathy under hypnotism. Yu Pingke, *Qianliyan* (Shanghai: Chinese Institute of Mentalism, 1929).

understood. Alexander R. Galloway distinguishes the subjective shot (the camera showing the actual vision of a character) from the more general POV shot by stressing that the latter is an abstract, surrogate vision that never matches "the physiological or subjective

sense" of the character seeing.[32] "If it did," he elaborates, "it would not be stationary but would flit and jostle around; it would be interrupted by blinking eyelids, blurring, spots, tears, and so on."[33] The discrepancy between the look of the character and that of the camera is inherent in the structural disjunction in the cinematic look. In the case of the POV shot, as Peter Wollen astutely points out, the three looks—those of the character, the camera, and the viewer—are not perfectly identified with but superimposed on each other, hence the viewer's reliance on what Merleau-Ponty calls the "temporal gestalt" to decipher the meaning of the shots.[34] In other words, cinematic editing allocates the sequential relationship between shots, which determines the content of individual shots.[35] Further, the edited sequence facilitates a leap of perception and "creates a new reality which is not merely the sum of its parts."[36]

The photomontage tale of Ru Kun's psychic tele-vision is conditioned on a temporal processing rather akin to the structure of perception of the POV shot, through which the disjunction between the three looks of the photomontage is papered over. Incidentally, "tele-sight," as the German mystic philosopher Carl du Prel defines it, is not "seeing in the physiological sense" but "brain intuitions" translated into "images existing in space" and projected outward.[37] To believe in the psychical tale of tele-vision, the readers of such publications position themselves as film viewers. Through a temporal gestalt, the exterior images in space (dissected in the manner of POV shots) are translated back into brain intuitions: the mental cinema of the tele-vision matches that of the cinematic viewer.

The conventional conflation of the subjective shot with the POV shot relies, however, on the overlap of the three looks of the cinema. More important, this identification of the viewer's look with those of the character and the camera transports the viewers elsewhere: "Through the technique of the POV shot, viewers are mentally lifted out of their seats and put in the place of a character up on the screen, seeing the action as if through that character's eyes."[38] This effect, close to that of telekinesis, or tele-vision accompanied by the experience of a physical dislocation, helps us understand the thrill of intermedial spectatorship that informs the photomontage of hypnotic tele-vision: if cinematic editing creates an artificial unity of space and time and evokes the mental perception of tele-vision, the viewer's

physical (not just visual) identification with the character manages to transport the viewer to distant and distinct spatial planes. This mode of spectatorship is not purely cinematic but intermedial: the reader of the photographic image and text, who is simultaneously a film spectator, experiences the photomontage informed by conventions of reading, viewing, and film watching. This informed perspective re-creates the spatial and temporal logic of the photomontage, mimicking a cinematic effect that is outside the movie theater.

To be sure, these three shots, framed respectively in medium, extreme-long, and long range, do not conform to the perfect grammar of continuity editing but are more elliptical and open-ended. The eye-line matching is slightly "off," with Ru Kun's eyes looking a bit toward the right while the pagoda is placed above him to his left. Straying from the usual grammar of the POV shot, the sequence does not end with a reaction shot (which completes the meaning decoding) but with the image of a second point of view. With an open-ended sequence rather than a closed circle of meaning, the relay of the POV shot further emphasizes the coexistence of the triple frames of cinematic look while they overlap and are superimposed on one another. Meaning gives way to seeing, and the viewer is enraptured in the abyss of perception, as propelled by the *mise-en-abîme* structure, which tellingly winds up showing a scene of film shooting. The cinematic nature of hypnotic tele-vision is thus captured in a nutshell by a picture about film shooting that itself allegorizes the perpetuation of vision: within the picture the film crew watches the director and the cameraman, who look, partly through the glass eye of the camera, at a female character dressed in traditional costume wiping her eyes with a long sleeve. Positioned at the edge of the frame, with her face hidden beneath the sleeve and her figure slightly faded in the light that seeps through the edge, she looks like a receding ghost, tantalizing as the fascination and limit of vision (Figure 2.5).

Technology of Resonance: Wireless Cinema and the Synchronous Subject

That the psychical phenomenon of tele-vision relied on photography and cinematic perception to vindicate itself underscores the interdependence between the material and the immaterial, the visible and

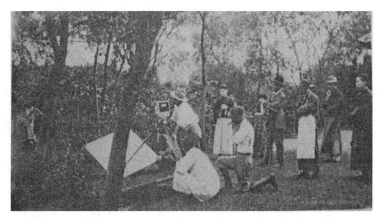

Figure 2.5. Enlargement of the bottom image of the photomontage showing a film crew shooting a movie at Banson Garden. Yu Pingke, *Qianliyan* (Shanghai: Chinese Institute of Mentalism, 1929).

the invisible, and more important, the parallel and overlapping development between media technology and other technologies of the body, such as hypnotism and stage acting. By 1929 another media technology entered the scene, providing a new link to psychic tele-vision while changing perceptions of cinema in relation to other media.

This was *dianshi* (television), a scientific invention in the making that Yu learned about as "wireless cinema" (*wuxian dianying*). He describes how this cinema, by transmitting a live stage play to the distant audience, "will create the experience of telepathy for every common person."[39] Differentiating telepathy from television—one subjective and spiritual, the other objective and material—but acknowledging that their effects are similar, Yu makes a further analogy between the psychic and material television:

The television I discussed above can be seen as a kind of
materialized psychic tele-vision [*xinling wuzhihua de qianliyan*].
Material effects like television must have seemed impossible
to people in the past. Yet even this ostensibly fantastic tale
[*qitan*] is now being realized. What about real tele-vision?
Will it be achieved by free will? This should not be difficult.
I believe the time will come.[40]

The incredibility of scientific invention and the power of spiritualism are evoked to authenticate each other. Earlier in the book, Yu cites the examples of submarines and airplanes, which sounded as impossible as telepathy yet were made into reality. In an essay about hypnotic distant healing (*gedi zhiliao*), another prominent figure in psychical research, Ju Zhongzhou, similarly invokes scientific inventions, particularly transportation and distant communication technologies—steamboat, car, telegraph, airplane—to pair the incredulity expressed about technology and spiritualism, both of which challenge fixed spatial and physical boundaries.[41]

In the context of Britain and Germany, Stefan Andriopoulos has shown through compelling research the interdependence between occultism and technological inventions from the late nineteenth century to the 1920s. Scientists were prominent in the spiritualist movement, whereas the spiritualists drew on technological inventions to authenticate and legitimate their vision. Psychical researchers not only envisioned and metaphorized inventions as material counterparts of psychic action but even participated actively in the development of new technologies for the spiritualist cause; furthermore, they provided theories of image transmission, projection, and perception crucial to the invention and cultural reception of television. The cross-fertilization and two-way exchange between spiritualism and science challenge our conventional dichotomy between the fields, and more important, as Andriopoulos puts it cogently, they underscore the reciprocal production of culture and technology against a media teleology dominated by technological determinism. If there is a similar connection in the Chinese case—less in terms of technological invention than in terms of cultural reception that intersects scientific and occultist circuits of knowledge—what remains important for my discussion, and this is probably not unique to China, is how cultural imaginations and receptions of new media inventions connect them with existing media and undercut assumptions and claims of the singularity of any medium. This is of particular historical significance in late 1920s China, when cinema underwent institutionalization and the discourse of medium specificity was on the rise but was by no means the dominant or only conception of the medium. Equally important is an understanding of how discussions of cinematic affect, particularly resonance as a mode of

affective spectatorship, are embedded in a network of technologies of affect and perception, including hypnotism, wireless devices, photomontage, and print disseminations of global popular scientific imagery. This convergence points to the collaboration across ostensibly incompatible fields in the invention of not only the technological medium but also the human body as the ultimate, malleable medium of perceptions.

Coincidentally, in a 1929 article, television is described as *qianliyan* in the major film journal *Dianying yuebao*. In "Dianyingjie de jizhong xin faming" ("Several New Inventions in the Film World"), television is introduced as "the truly groundbreaking invention in the world of science and cinema."[42] By 1929 Chinese translations of the term *television* were plural: television was called *qianliyan* (television), *chuanxing* (wirelessly transmitted image), *guangbo dianying* (radio movie), *guangbo xiju* (radio drama), *wuxian dianying* (wireless cinema or, more literally, "wireless electric shadow" or "radio shadow"), and *dianshi* (electric vision), the contemporary common term for television.[43] These names not only conjoin old myth and scientific invention by introducing television as a realization of the Chinese mythology of the godly eye that penetrates thousands of miles but also present this new media technology as an extension and mixture of existing ones, particularly radio and film.[44] In other words, the new technology creates a shared platform across a variety of media, hence the prospect of mixing and recombining them for new perceptual possibilities. Radio, or electromagnetic waves, seems to have emerged as a new equivalent to light, image, sound, and motion, as the common medium of translation. A more widely understood convertibility and liaison among media are thus projected, particularly in elucidations of scientific principles and future inventions.

The *Dianying yuebao* article on recent inventions clearly highlights this convertibility and malleability of media (telephone, telegraph, radio, television, sound and color film). More important, the technology of television provides a new ontology of photography and cinema. The author, Shen Xiaose, explains that the photograph is nothing but black-and-white dots of light arranged to *resemble* the image of objects. Film simply projects such photographs made of light dots at the speed of sixteen frames per second. In the case

of television, Shen explains, each of these photographic pictures (at sixteen frames per second) is scanned by a light dot sixty times, thus reproducing the image by sixty lines of light.

Judging from the included photographs and pictorial illustrations, Shen's new ontology of film and photography is based upon the electromechanical model of television dominant until the end of the 1920s. Combining mechanical, optical, and electronic technology, the electromechanical television had been actively experimented with since the late nineteenth century, having originated with the discovery of the photosensitivity of the chemical element selenium in 1873 and the invention of an image-scanning disk by German inventor Paul Gottlieb Nipkow in 1884. The system solidified in the late 1920s, culminating in John Logie Baird's public demonstration of his television apparatus in Britain in 1926, followed by the Bell Telephone Labs' demonstration in the United States on April 7, 1927 (consisting mainly of a wired transmission of the then secretary of commerce Herbert Hoover's speech from Washington, D.C., to New York City) and the U.S. demonstration of the GE Mechanical System in January 1928.[45] News of these well-publicized experiments and demonstrations spread through Chinese print, across a wide range of journals and newspapers catering to both military and technological professionals and to more general readers of popular science and of film and entertainment, as well as in Christian evangelical publications and students' and children's journals.[46]

Beyond circulated news wireless image transmission technology, such as telephotography, appeared in China. On October 14, 1926, Édouard Belin (in Chinese, Bai Lan)—the French engineer who invented the first telephoto transmission apparatus, the Belinograph—gave a slide show and lecture on telegraphed images at the Beijing Sino–French University upon the invitation of Li Shuhua, the interim president of the university. The lecture was attended by over eight hundred prominent Chinese and foreign bureaucrats, diplomats, businessmen, and educators. Before Li Shuhua, Belin had been first invited by Zhang Zuolin, the powerful warlord from Manchuria, who experimented with the electric transmission of Chinese writings at Fengtian. After his Beijing lecture, Belin visited Manchuria and conducted experiments there, followed by a public demonstration of the Belinograph at the physics laboratory

at Beijing University on October 30.[47] Several thousand people were reported to have attended, including such luminaries as the director of the Beijing Telephone Bureau, Jiang Bing; the French ambassador, Damien de Martel; and the "young marshal" Zhang Xueliang (Peter H. L. Chang), son of Zhang Zuolin. The Manchurian military, sending several top-ranked officials, expressed serious interest in applying the telephoto technology and escorted Belin to Tianjin and then back to Manchuria. Belin also gave a public demonstration in Shanghai in 1927.[48]

Based partly on news on television in the magazine *Science and Invention,* the *Dianying yuebao* article gives a lucid explanation of the electromechanical television as a system of transmitting of distant still and moving images, enabled by the convertibility between light and electricity. With a strong beam of light filtered through a spiral of square holes on a rotating disk (the Nipkow disk), the image is scanned and turned into sixty lines of light. These lines, with various degrees of intensity corresponding to the shades of the image, reach the photoelectric cell, whose electric resistance alters according to the volume of light, thus generating varying intensities of electric current. The current is then broadcast like radio waves or through wired devices such as the telegraph. On the receiving end, aided by a neon light tube that amplifies the wireless electric current, the current is converted back to light, and through another spinning disk with holes, the lines of filtered light are reassembled into the original image (Figures 2.6 and 2.7).[49]

The key to this process of image transmission, enabled by the mutual translatability between light, electricity, and sound, is synchronization. As Shen explains, the two spinning disks must contain the same number of pinholes and rotate with identical speed, propelled by the motors controlled by the wireless electric current generated by a tuning fork kept in a thermostatically controlled box. The receiving end uses the same electric current and ensures the same speed.[50] In reality the technical problem of synchronization persisted as a major challenge, yet an ingenious solution was proposed—to posit the spectator as the tuning fork of synchronization.

The economic rationale for depending on the spectator to maintain the synchronization is clearly spelled out in the U.S. report on the GE television demonstration in *Popular Mechanics:*

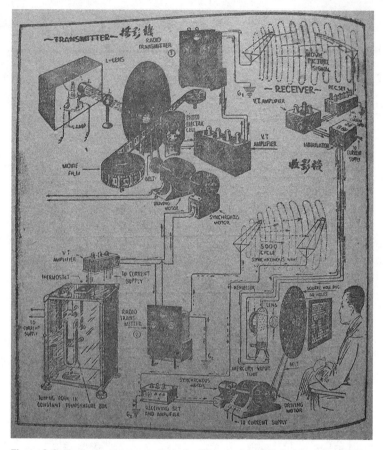

Figure 2.6. Illustration demonstrating scientific principles of television broadcasting and reception. Shen Xiaose, "Dianyingjie de jizhong xin faming," *Dianying yuebao* 9 (1929): 1–7.

The one great problem that has perplexed television experimenters for years—how to synchronize the transmitter and the receiver—was solved by simply ignoring it. Instead of all the elaborate, and very expensive, equipment necessary to keep the whirling disk of pinholes that paints the image on the receiver screen in absolute step with the corresponding mechanism that transmits the original image, the television

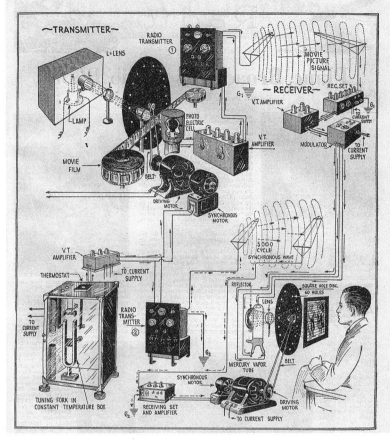

Figure 2.7. Illustration from *Science and Invention* 16, no. 7 (November 1928), on which Figure 2.6 is based.

receiver for home use has a simple rheostat control on the end of an extension cord that permits the spectator to do the synchronization himself.[51]

Making an analogy to film projection, when the moving film strip occasionally falls out of step with the shutter gate, the author adds that the spectator, like the movie theater projectionist, needs only

to adjust the speed of the motor for the television receiver. The task is not as easy as it sounds, however, since even a slight asynchronization of the receiving motor with the transmission motor causes the picture to go out of focus or to drift away from the screen. To repeatedly correct and maintain the motor speed requires skill, sustained concentration, and sharp perception. "It is as simple," the GE television inventor E. F. W. Alexanderson explains, "as learning to drive an automobile."[52]

An elaborate article in the November 1928 issue of *Science and Invention* explains the technical details of this synchronization for homemade television receivers: to ensure the proper motor speed of the receiving disk, one needs to use a tuning fork in coordination with a stroboscope as a reference frame.[53] The fork, chosen at the right pitch, is to be held several inches from the eyes and twisted at such an angle as to create a very small aperture and a line of sight—a vibrating diagonal line between the upper and lower fork legs—through which to examine the line pattern on the stroboscope. If the lines on the stroboscope appear stable, then the speed is correct. This check has to be done repeatedly while one regulates the rheostats to adjust the motor speed.

This synchronization process is illustrated on the cover page of the same issue, which shows a man seated in front of a Nipkow disk attached to a small screen with a cone-shaped visor, providing almost a tunnel vision (Figure 2.8). His eyes are not directed at the screen, however, but turned down at a tuning fork in his left hand and a button on the image-receiving platform, which his right index finger presses. Holding the tuning fork close to his forehead, he "listens" intently while pushing the synchronizing button. Caught in technological trance with utmost attention focused on the complex coordination of vision, sound, body, mind, and the machine, he turns himself into a synchronous device, a vibrating acoustic fork, a medium of resonance.

This construction of a resonant subject made its way to China as both a new cultural imaginary and knowledge acquisition. Via circulated news, imagery, and theoretical and applied science that encouraged an amateur following, *gongming*, or synchronic vibration, as showcased in amateur television reception, tapped into a new cultural

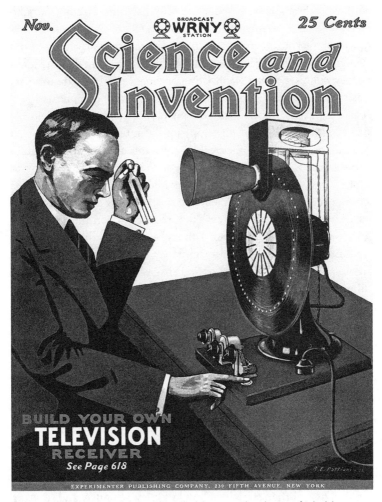

Figure 2.8. The technical demand in television reception. Image of television reception showing the use of a tuning fork in coordination with a stroboscope as a reference frame. *Science and Invention* 16, no. 7 (November 1928), cover.

sensibility of technologically produced *receptivity* (Figure 2.9). This new receptivity was not only culturally imagined but also experimented with. Popular science magazines as well as magazines for students, women, and children explicated principles of radio reception

with self-help manuals for people to purchase and assemble a radio receiver set and antennas (Figure 2.10).[54] Due to the material conditions in China, where maintaining a constant supply of electricity and standardized voltage remained an issue and a preassembled and high-quality radio set (usually consisting of three to eight vacuum tubes) was expensive, radio consumption entailed a more complicated process of assessing and stabilizing the energy supply, adjusting the rheostat, assembling the set, and setting up the antenna. Reception itself was thus not immediate but involved constant adjustment to maintain a subsystem of energy flow, detection and capture, and conversion to create the eventual resonance. Compared with the more expensive amplifier receiver that used vacuum tubes, the more affordable option, the crystal receiver, required even more concentration and fine-tuning to detect the rather faint sound. Although a distinct radio amateur culture and identity did not solidify until the mid-1930s, the technological alignment of radio with its reception ensemble allowed for active cultural consumption of wireless technology.

The synesthetic construction of a resonant spectator makes a vivid appearance in Huaju Studio's 1929 silent film *The Orphan of the Storm,* discussed in chapter 1. A curious scene early in the film shows the wealthy family that comes to Wu Suxin's rescue. The male protagonist's sister, played by Wu Susu, looks at her watch and turns on the radio, attached to a large horn speaker (Figure 2.11). A Chinese man in blackface appears in the speaker. Wearing a white shirt and bow tie, he bows to the audience and starts to sing (Figure 2.12). The image is followed by a jazz band framed by the speaker, visibly set against the modern home decor with patterned wallpaper and fine furniture (Figure 2.13). The camera provides a reaction shot of Wu and her mother, showing them talking vivaciously and reacting pleasurably to the scene as if they are listening as well as watching the performance with their heads turned toward the radio (Figure 2.14). When the camera cuts back to the speaker-framed image, the blackfaced man reads another announcement and performs a dance number. Crosscutting between the minstrel jazz performance framed by the loudspeaker and the audience reaction, the film embodies the resonant spectator most fully when the camera cuts to the reaction of the male servant, who carries a feather duster and dances

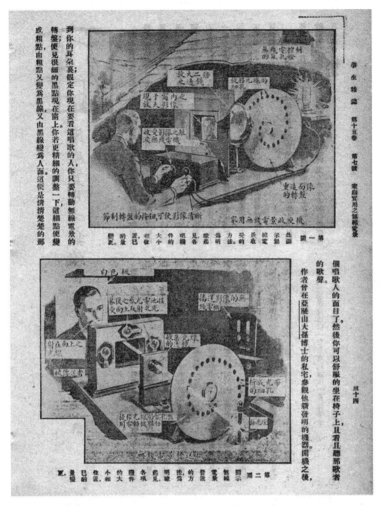

Figure 2.9. Illustration of television reception circulated in Chinese journal. *Xuesheng zazhi* 15, no. 7 (1928).

in imitation (Figure 2.15). He enjoys the performance wholeheartedly and responds with a rhythmic bodily movement, in "tune" with the broadcast.

While the liveness of the broadcast is enhanced by the minstrel performer's announcements that punctuate the show, this scene,

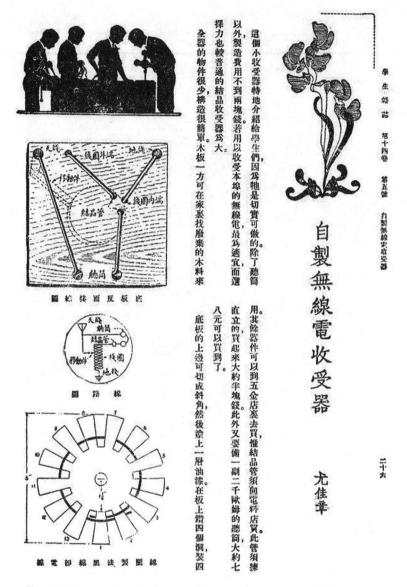

自製無線電收受器 尤佳章

這個小收受器特地介紹給學生們，因為牠是切實可做的，除了聽筒以外製造費用不到兩塊錢若用以收受本埠的無線電最為適宜而選擇力也較普通的結晶收受器為大。全器的物件很少構造很簡單木板一方可在家裏找廢乐的木料來

用。其餘器件可以到五金店裏去買，惟結晶管須向電料店買。此管須揀直立的買起來大約半塊錢此外又要備一副二千歐姆的聽筒大約七八元可以買到了。

底板的上邊可切成斜角然後塗上一層油漆在板上鑽四個洞裝四

Figure 2.10. Illustration of self-made radio receiver. *Xuesheng zazhi* 14, no. 5 (1927).

Figure 2.11. Wu Susu turns on the radio attached to a large horn speaker. Film still. *Orphan of the Storm* (1929).

Figure 2.12. A Chinese man in blackface appears in a speaker for the radio. Film still. *Orphan of the Storm* (1929).

Figure 2.13. A Jazz band framed by the speaker, set against the modern home decor. Film still. *Orphan of the Storm* (1929).

Figure 2.14. Wu and her mother reacting pleasurably to the broadcast, as if watching the performance. Film still. *Orphan of the Storm* (1929).

Figure 2.15. The servant responds to the radio broadcasting with his full body by dancing with the feather duster. Film still. *Orphan of the Storm* (1929).

featuring a radio—a novel technology for live entertainment in domestic consumption—is mediated by the visualization that alludes to more than one technological novelty in relation to cinema. The minstrel show by a Chinese man in blackface hints at the most celebrated early sound films, *The Jazz Singer* (Alan Crosland, 1927) and *The Singing Fool* (Lloyd Bacon, 1928), allegedly the first feature-length films with synchronized dialogue sequences, heralding the transition from silent to sound cinema.[55] Yet contemplating sound, in terms of both live radio broadcasting and sound cinema, while reorienting silent cinema's visual expressivity in relation to it, the film simultaneously projects the fantasy of television: by conjoining silent cinema with radio broadcasting, endowing silent images with radio's capacity for simultaneous and instant transmission and reception, cinema becomes live, acoustic, and connected to a distant performance while visualizing it. In this brief moment cinema becomes *qianliyan*, the thousand-miles eye that is both the material and the hypnotic television. This distant viewing, by way of cinematic suggestion, is also experienced through other senses,

which are made interchangeable. Sound, vision, and wireless vibrations, as epitomized by the vibrations of the musical instruments, create a synesthetic experience of cinematic viewing. While Wu and her mother express their enjoyment of the program through vivacious conversations and hand clapping, Wu's servant imitates the jazz singer with his chicken-feather duster, a moment reminiscent of *The Romance of the Western Chamber* (1927) when the little monk, excited about the fight, imitates the battle with his physical body. In this moment resonance is a synesthetic experience, a conversion of the spectatorial body into a medium of synchronic and sympathetic vibration.

In this utopian moment of cinematic television, the racial subtext is hard to miss. Al Jolson's blackface covering his own Jewish origin in *The Jazz Singer* is mirrored in the Chinese actor's blackface camouflaging his yellowness by synchronizing with the jazz age.[56] The latter anticipates the great presence of African American jazz bands in Shanghai clubs and dance halls in the 1930s.[57] The racialized musical body is displaced by the class hierarchy when the servant provides the perfect model of a resonant spectator. In this context, the politics of race and class doubles that of media, when cinema becomes the mimetic body that both absorbs and heightens the otherness of other media through a simultaneous assimilation and displacement. Although cinema aspires to be the ultimate medium through its ability to represent other media, in this gesture of convergence and divergence it turns into something else.

We could take this scene as a prime example of technological display, when the film deviates from narrative unfolding to a moment of cinematic attraction, indulging in the pleasure of technological wonder. Yet what is on display? Is it the radio, sound cinema, or television? Which medium is the newer one? Which is the older? If television is as new as sound cinema, it is also significantly older, its technological origin concomitant with and even older than the invention of film. This is a moment of intermedial spectatorship, when one medium reflects upon and invites comparisons to other media while they simultaneously frame one another. The temporal dimension of media reception demonstrates time control—Wu Susu looks at her watch and turns on the radio, illustrating how resonant

spectatorship is conditioned by the new imperative of time in the consumption of acoustic entertainment.

The difference in temporality between electrical media and cinema recalls what Bruce Clarke summarizes as the distinction between communication technology and media technology. For Clarke communication orchestrates *real time* (synchronous and sequential temporality), whereas media technology operates on *virtual time,* involving processes such as "inscription, storage, and retrieval." These processes, according to Clarke, could "suspend or manipulate the time of communication."[58] Clarke follows Lev Manovich's distinction between "representational technologies" (film, audio, video, and digital-storage formats) and "real-time communication technologies" (everything starting with *tele-,* such as telegraph, telephone, telex, television, telepresence). This distinction, as Clarke asserts, is complicated by contemporary digital media that both transmit and store information.

The question is, as Paul Young sharply asks, what was the impact on notions and experiences of spectatorship if cinema posited itself as both representational and communicational technology, especially when the discourse of telecommunication shaped and affected how cinema was conceived and experienced?[59] Although Young focuses on the affinity between the telegraph and cinema in America, the issue of temporality clearly recurred in the discourse on distant communication technologies in the Chinese context. In introducing telephotography versus television, for example, Belin divides the "telegraph that transmits images" into three types: *dianchuan zhaoxiang* (telephotography), which transmits a still photograph; *dianchuan wumian* (telecommunication), electric transmission of images and sounds of a live person or object (simultaneity); and *dianchuan dianying* (telefilm), which combines the principles of the first two and transmits still photographs of a film from the point of departure to arrive as live images at the destination.[60] For telephotography, as Belin emphasizes, time does not matter, whereas for telecommunication time matters a great deal—the image disappears as the transmission ends. Notably, the third type, electrically transmitted film, is not conceived as entirely live but combines issue of prior storage, simultaneous transmission, and reanimation of still into moving images.

If Belin's description of various distant transmissions of images

already questions the distinction between communication and media technology in terms of real versus virtual time, the prospect of wireless cinema further complicates the assumptions of temporality that cut across the two categories. Wireless cinema, as both live show and broadcasted film, encompasses real-time communication as well as virtual and representational time in the storage, transmission, and reanimation of still images. The virtual time of reanimation is simultaneously a retrieval and a telepresence, collaborating with the real time of transmission. Just like the radio "broadcasting" of a Chinese copy of *Jazz Singer*, it reactivates the film but simultaneously makes that show "live."

Trading Wire for Space: The Wireless Movie Theater

The introduction of wireless technology as both material apparatus and circulated knowledge starting in the nineteenth century in China generated new conceptions of human sensory perception in relation to technology. As early as 1904, electromagnetic waves, or "wireless/radio electric waves" (*wuxiandianbo*), had already entered public discussion in China via the article "Wireless Electronic Communication" in the journal *The Continental*. [61] By introducing ether (*yisa*), a ubiquitous entity permeating the spaces between human bodies, objects, and the planets, the author provides a new conception of sound, light, heat, and electricity as phenomena resulting from different vibration frequencies of the ether perceived by the human sense organs—eyes, ears, and skin. These physical phenomena are thus conceived as techno–human interfaces rather than objective entities. While ether is considered indispensable for vibration and hence transmission of information, the wireless, or "electric air waves" (*dianqibo*), is but one of the variations of its vibrations. Also at this point, mechanical and human senses are made interchangeable. Making an analogy between human ears and eyes and detectors of sound and light waves, the 1904 article describes electric waves as a kind of light imperceptible by the naked eye, and hence, the differences between sound, light, heat, and electric waves are the result of ether vibrating at different frequencies perceived by different "sense detectors of vibrations" (*ganshou jianboqi*), including both machines and the human organs. [62]

As sensory perception was reconceived in relation to wireless technology, a new spatial imagination of the world in communication emerged. An epistolary conception has obviously persisted by dividing the producer and the detector of wireless waves into the sender (*songxinji*) and the receiver (*shouxinqi*) and calling wireless communication "wireless electronic letters" (*wuxian dianxin*). This model, while emphasizing the technology of reception, is complicated, however, by its reliance on the ontological model of the ether as the medium of vibration. The distance between sender and receiver is annihilated by technological progress, and increasingly their distinction becomes meaningless. The fascination with wireless technology for transcending spatial distance, in contrast to other modes of communication and transportation—trains, steamboats, and telegraphs—lies in its material "nothingness" and instantaneity, which the author, under the pen name Tinggong (Man of Thunder), compares to an echo, or a shadow following its image.[63] The author differentiates "wireless" (*wuxiandian*) from "telegraph" (*dianbao*) by associating the latter with "wire," hence introducing "wireless" as a giant leap toward distant communication unbound by "material" technology. This is followed by a utopian image in which the wireless "so permeates the earth that citizens from different nations and races seem to be face to face, hand in hand, crowding in one room in conversation with each other."[64] From wire to wireless, the line transforms into a circle in the production of a communicative sphere as the author conjectures how, with wireless stations constructed in major international cities from Egypt to India to Japan to Hawaii, the electric wave will manage to circle the earth in an instant.

This new spatial imagination via wireless communication did not, of course, emerge in a political and economic vacuum. The technological and economic development of wireless capability, with its various applications (telegraphy and radio, for example), was entangled with conflicts in colonial power expansion, economic interests, and issues of labor, all of which ran into resistance from heightening national consciousness. While embracing the development of wireless technology, Chinese scientists alerted the government to assert Chinese participation so as to avoid economic monopoly, as had happened in the Marconi case in the United States a decade before. Wireless technology was also strongly associated with business

interests—its instantaneity crucial to profit and loss in international and domestic trade and investment. Already there was tension between its military uses and commercial applications, based on two models of communication: the former focusing on the secret transmission of information, reinforcing an epistolary model of the unobstructed and secured line from A to B, and the latter capitalizing on accessibility and educational and entertainment value, creating a public sphere for shared information and sensual enjoyment. When the military tried to limit wireless technology for fear that it might become handy for revolutionaries to transmit secret information, Ni Shangda, a prominent physicist and experimenter, insisted that wireless technology allows no room for secrecy. Appealing to the government to allow civilian construction of broadcast stations, Ni explained, "Even conversation in a secret chamber can be eavesdropped on; how could it be possible with radio, since a voice produced from one site could be received everywhere?"[65]

The conception of wireless communication as a "room" without bounds continued to incite the popular scientific imagination, including at the movies. In the article "Movie Theaters of Tomorrow," author Li Fan envisions a radical transformation of theaters that will transcend the structural limits of the rectangular screen: a triangular-shaped building will allow the film to be shown in panorama on a curved screen that occupies an entire side of the building; the theater will project the film in stereoscope, created by two synchronized projectors installed at the back on each side of the triangle, to achieve the three-dimensional perceptual effect; in addition, sound and color will accompany the projected moving image (Figure 2.16).[66] Li Fan points out the primary limitation of movie theaters at the time: they are so small and narrow that the audience has to concentrate all of their energy on the rectangular screen to notice the movement of human figures, as if watching specimens of animals and plants under a microscope. While most of these observations and the article's illustrations are grafted directly from another *Science and Invention* article, "The Movie Theater of the Future," the Chinese author begins conjecturing on his or her own from this point on.[67] The current limit of the movie theater, Li Fan argues, affects not only spectatorship but also acting, since the movements and gestures of the actors have to fit unnaturally within the field of

vision designed for the screen. Thus, future movie screens should stretch out to a curve so that the audience does not have to confine their vision to the screen and can instead appreciate the panorama of the scene. How lively it would be, the author conjectures, if the shadowy human figures on the flat screen materialized and suddenly left the screen to walk toward the audience. Within such a theater, as the audience enjoyed the marvels of music, dialogue, and vivid three-dimensional figures and landscapes with natural colors, the author concludes, they would "certainly forget themselves as spectators and become part of the film."[68] The emphasis on the scope (panorama) and the three-dimensionality of perception (stereoscope) expresses the desire to transcend the frame of the screen and achieve a total cinema. Aided by sound and color, this total theater animates the shadowy screen image while turning the cinematic medium into a total environment and a lively art.

This total space is, however, highly mediated. In another newly imagined space—stereoscopic television theater—television joins forces with cinema through levels of mediation. In an article describing "radio movie theater" (*guangbo dianyingyuan*), the author states that the division between film and theater is now annihilated.[69] Citing the watershed event of the first televised broadcast of the one-act play *The Queen's Messenger* on September 11, 1928, by General Electric, the author concludes that anybody with an adequate sound-and-image receiver could hear and see the play wherever they were. While the text devotes considerable space to explaining the technical details of the production involving three electromechanical cameras, two illustrations accompanying the text, obviously taken from *Science and Invention,* depict scenes from both sides of the screen, cultivating an image of a technologically enabled and mediated reception.[70] At the front, two vertical rows of loudspeakers frame a pair of stereoscopic images while each audience member sits behind a pair of stereoscopic lenses (Figure 2.17). A "voice and television director" sits at the far-right corner beside the screen, adjusting rows of image and sound receivers. The second picture illustrates the reverse side of the screen, where a stereo television projector in front of a rotating disk projects stereographic images onto the screen (Figure 2.18). A set of radio receivers attached to an antenna is placed beside a set of television receivers and amplifiers, corresponding to the set of

Figure 2.16. Illustration of a future movie theater. *Dianying yuebao* 9 (1929).

receivers in front, with a number of technicians sitting at the far-left corner beside the screen. This complicated loop of wireless image and sound receivers, paralleling the spatial divisions—the screen divides the technological space of reception into two halves, and the railed stage and the raised platform in front of the audience for stereoscopic viewing devices further demarcate the viewing spaces from that of representation—testifies to the highly intermediated nature of public reception that makes possible the dream of a total cinema and a contiguous space. To complete the dream, the spectator, situated within and in front of layers of technological mediation as well as connection, needs to perform a series of skillful visual and acoustic adjustments to "tune in" as the resonant subject. While he stays in tune, he is connected with an outside world that breaks down the walls of the movie theater.

The complexity and constant adjustment involved in this process of synchronization, popularized in amateur science activities and popular science journals that made their way to China, posits a

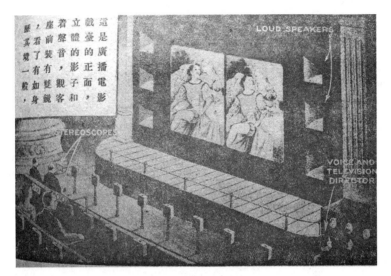

Figure 2.17. Illustration of stereoscopic television theater, front side of the screen. *Dianying yuebao* 9 (1929).

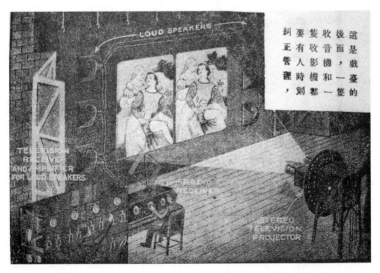

Figure 2.18. Illustration of stereoscopic television theater, reverse side of the screen. *Dianying yuebao* 9 (1929).

new dimension of image reception: the incorporation of technology. If film production, including acting itself, heavily involves technology, as recognized by Gu Kenfu in the first issue of the Chinese film journal *Yingxi zazhi,* as discussed in chapter 1, the newly invented television projects a technologization of the body as an integral part of reception. The image is not just out there but is to be composed, with attention, proper coordination, and knowledge.

That television requires the body for reception also suggests continuity between the body and the image, as well as their mutual dependence. It is tempting to consider the image not as the final product conjured at the end of wireless reception but, within a Bergsonian framework, as the continuum between body, image, and perception. For Bergson image functions as the intermediary between the material world and representation. Whereas he conceives of the body as the aggregate of images, representation becomes an impoverished version of the image, or what he calls "pure perception." Hence, intuition, in contrast to pure perception, places image back into the flux:

> If you abolish my consciousness ... matter resolves itself into numberless vibrations, all linked together in uninterrupted continuity, all bound up with each other, and traveling in every direction like shivers. In short, try first to connect together the discontinuous objects of daily experience; then, resolve the motionless continuity of these qualities into vibrations, which are moving in place; finally, attach yourself to these movements, by freeing yourself from the divisible space that underlies them in order to consider only their mobility—this undivided act that your consciousness grasps in the movement that you yourself execute.[71]

It remains to be considered how the cultural imaginary of wireless technology and the related mode of receptivity could have mediated Bergson's exegesis of the intuitive process.[72] Yet the resonant subject did tap into a new cultural sensibility of instant communication, synchronic but plural temporality, and ever-expanding public spaces and shrinking physical distances. This sensibility provides a new perspective for understanding the popular fascination with fiery films. Fire, as an affective medium through its perpetual movement,

annihilation of distance, and homogenization of space, registered the intersection of wireless communication, televisuality, and hypnotism. Televisuality itself had ceded the primacy of vision to a sensorial vibration, turning the spectator into a resonant medium. We come back full circle to "The Audience's Resonance" and understand now why cinema should contain "a fiery [burning] quality" so as to "create waves at the bottom of their [the spectators'] heart" and stir up "new vibrations." Resonance, as a new qualifier for a distinct notion of the cinematic medium and spectatorship, ironically points to cinema's dream of its others. Perhaps it is not too far fetched to say that the fad of fiery films captured the dream of "wireless cinema."

Trance Medium, Ether, and Affective Medium

An alternative conception of medium can now be drawn from the popular scientific imagination of cinema, positing the resonant spectator in the public space of the "wireless movie theater" connected to the world afar. Instead of a secure "wire" to transmit exclusive information from the sender to the receiver—an epistolary model based on the prototype of the wired telegraph—the wireless imagination of the future of cinema envisions a continuous, expansive, mobile space of vibration, a medium as environment. Meanwhile, the technological incorporation of the resonant spectator reinvents/converts the human body into a medium of vibration connected to spatially, temporally, and ontologically distant spheres.

This conception of medium as environment, yoking the human body with media technology and occultist practice, is better understood when we consider the historical concept of the "trance medium." Erhard Schüttpelz has pointed out how contemporary media theories remain deeply indebted to ideas of the medium that can be traced to both a metaphysical tradition from antiquity and theories and practices of media in the nineteenth century.[73] For Schüttpelz the notion of medium associated with technical and mass media and the condition of trance is a modern development that evolved most intensively between the late eighteenth and late nineteenth century (1784–1890), when practices of and debates about the legitimacy of mediumism—mesmerism, somnambulism, and spiritualism—precipitated mutual promulgation between the spiritualist trance

medium and mass media. This is the case of spiritual telegraphs, spiritualist photography, and direct contributions to technological inventions such as radio in the spiritualist search for imponderable and telecommunicative forces. This connection has been largely disavowed in later history (from the 1890s to the 1940s), yet trance mediums, associating occultist/scientific/medical induction of a trance condition with media technology, resurfaced in permutated forms—in the psychoanalytic notion of the unconscious, in para-psychology's seeking empirical proof for a medium's "extrasensory" capacities, in avant-garde artistic practices drawing eclectically on mediumistic practice, and most important, in the notion of "sug-gestibility" persisting as a key concept in mass psychology, sociol-ogy, and social anthropology, fields concerned with the psychosocial effects of crowds and mass media.

In rethinking historical ideas and practices that continue to evolve around the medium as both an intermediary for perception and a pervasive, imponderable force for sociality, Schüttpelz's genealogy of trance medium, situated at the intersection of body, technology, and the suprahuman (divine, magic, cult), raises crucial questions concerning the agency of the medium and its political implication. Portraying mediumism as a "boundary object" that remains both stable and indeterminable under various claims, Schüttpelz singles out what holds together the different sides of debates across skeptics, believers, researchers, and mediums—the shared belief in the pas-sivity of mediums. "Authentic mediumism," Schüttpelz summarizes, relied on the will-less passivity of the subject and the deepening gulf between action and passivity, often assigned to different agents and roles, such as the powerful hypnotizer versus the will-less medium. The gaps between passivity and action seem to have shrunk in the later period after the 1890s, when increasing dissatisfaction with the passive medium led to an emphasis on the interplay between ac-tivity and passivity, drawing attention to the medium's self-control and self-activation, as well as the role of imagination. Yet modern media theory, as a number of studies demonstrate, continues to evoke trance medium (nineteenth-century mediumism) to discuss media effects that register the conflict and anxiety about technology and magic, with their simultaneously empowering and disempow-ering effects. Jaap Ginneken has studied how social psychologists

coined "crowd" as a mythological category in bourgeois society to harness fears about the masses as mediums prone to contagious suggestions.[74] Stefan Andriopoulos illustrates how the emergence of cinema triggered comparisons of its powerful effect with the suggestive power of hypnotism.[75] Jeffrey Sconce delineates an enduring history of public fascination and anxiety over new media since the mid-nineteenth century—telegraphy, wireless communication, radio, television, and contemporary digital media and related phenomena (computer, cyberspace, and virtual reality)—and how the autonomy of technology created unsettling concerns about the sovereignty of human subjects.[76] As Schüttpelz astutely observes, the archaization of trance mediums since the 1890s, propelled by colonial encounters that dichotomized new media and trance mediums into Western invention and primitive religions, made the emergence of each new medium a return of the archaic and "the repressed," reconnecting media technology with trance mediums. The passivity of the subject hovered as a specter in assessments of the effects of any new media, with unsettling implications of the split agency between human being and technology as an autonomous force.

This "legacy" of mass psychology, especially the notion of suggestibility as "a universal cultural interpretive mode of media effects," renders resonant spectatorship in 1920s China politically suspect.[77] One might critique the implied passivity of the spectator and their subjection to technology and a capitalist system of productive labor, yet that passivity, seen in the context discussed in chapter 1, is invested simultaneously with political activism and enthusiasm for scientific knowledge and media developments. In the Chinese context resonant spectatorship was couched in a broad discourse network involving the practice of hypnotism, the development of wireless technology, and the global circulation of the popular scientific imagination of the future of cinema in relation to other media. This broad network of technological and formal binding of media and the human body underscores the interplay between passivity and activity, as in the case of self-hypnotism; the role of imagination in inducing hypnotism and dramatic acting; and the active role of the spectators, acquiring scientific knowledge and skill to engage in resonance as an acquired competence. Importantly, this active resonance, as illustrated in chapter 1, was also invested with political

energy, as in the case of new heroism harnessing anarchic, Marxist, modernist impulses. Through a new heroist celebration of screen action to generate a resonant spectatorship, resonance is interpreted as active seeing as well as a conduit to political action and agency.

However, emphasizing the interplay between passivity and activity does not take away the ambivalent political implications of resonant spectatorship. The activity of the spectators/mediums, be it part of the hypnotic method, technological competence, cooperation in wireless reception, or political engagement with nationalist, modernist, and anarchic impulses, does not eliminate the possibility of spectatorial activity being an element of the "grand design," or co-optation into a larger regime of productive power. This ambiguity persisted in later Chinese film and media history, which I explore in chapters 3 and 4, leading to the development of propaganda cinema in chapters 5 and 6. Meanwhile, the anxiety of passivity in relation to media technology itself reveals discomfort with the radical dissolution of agency and subjectivity and with the historical connection of media technology, the occult, and the human body, which was disavowed in the process of modernization. Hence, we should not discount the historical specificity of the excitement and enthusiasm for such active/passive engagement with media, as in the case of resonant spectatorship.

This anxiety about the magical sovereignty of technology and its power over mass spectators was already being acted out in China in the 1920s. As Zhang Zhen illustrates, the Nationalist government censorship of martial arts films concerned both the film representation of magic and superstition and occult spectatorial practices like burning incense in front of the screen.[78] Describing the martial arts audience as "spellbound" and "mesmerized," Zhang nevertheless qualifies their "kinesthetic energy" as "a near anarchic experience that is predicated on mobility, sensation, intensity of enjoyment, and identification rather than passivity, stability, and conformism."[79] The contradiction between activity and passivity in spectatorial experience provides a useful perspective from which to understand the Nationalist government's growing hostility toward martial arts films. The censorship effort could be seen as part of the unidirectional modernizing project campaigning against any "backward" association with the past; more important, though, it registers the

political regime's anxiety about the alternative and subversive power associated with certain spectatorial *active passivity,* whose power and agency is attributed to cinema, the modern mass medium.

As Zhang Zhen rightly points out, it was not martial arts films per se but "the emergence of a sociophysiological sensorium inside and outside the auditorium space" that posed the greatest potential threat.[80] The antagonism against martial arts films was not, then, simply resistance against a specific film genre with subversive social content but, more important, sensitivity about a different conception of the cinematic medium that reoriented the relationship of media technology and aesthetics, the environment, and the spectatorial body toward an encompassing environment that came dangerously close to the social trappings of trance medium.

Ether in Late-Qing Political Philosophy

This conception of a medium as an all-pervasive environment and a space of continuous vibration is not possible without the prevalence of ether as a key concept in the transnational circulation of knowledge. A hypothetical medium since antiquity, a mysterious world-filling substance, ether was central to physics in the nineteenth century, arising with the wave theory of light and the discovery of the electromagnetic field addressing such phenomena as radioactivity and the Hertzian waves of wireless telegraphy. As a necessary medium to propagate light and electromagnetic waves, as Linda Henderson points out, ether was attributed with a paradoxical quality as both elastic solid and rarified, able to pass through matter. Invisible, imponderable, impalpable but conceived as space filling and as the source of matter, ether from the late nineteenth to the early twentieth century was "the ultimate sign of continuity and signified a realm of continuous cohesion and diffusion, materialization and dematerialization, coursed through by forces and vibrating waves."[81] In occultist writings ether was also considered the bridge to the invisible world, often called "the fourth dimension."[82] Einstein's 1905 theory of relativity presumably dissolved the scientific myth of ether, but Henderson argues that the theory was not popularized until 1919, and ether continued to exert a strong hold in scientific community and popular literature well into the 1920s and beyond.[83] This was

also the case in China. Although Einstein's theory was introduced between 1917 and 1921, despite less resistance due to a weaker foundation of classical physics in China, the concept of ether persisted in both scientific discourse and the popular imagination, and vanguard Chinese physicists strove to reconcile the theory of relativity with the notion of ether.[84] As discussed earlier, ether figured prominently in the introduction of wireless technology and popularized knowledge of the electromagnetic field from the late nineteenth century to the 1910s; even in the discussion of television in the late 1920s, ether was still posited as a necessary medium for the transmission of electronic waves.

Introduced to China in the 1860s, through Christian missionary efforts to translate and popularize Western science in collaboration with Chinese intellectuals, ether also entered Chinese political thought and was famously evoked by political reformists such as Tan Sitong and Kang Youwei. Importantly, ether (*yitai*) was posited not as a neutral medium but as one endowed with heightened ethical dimensions as a potential social and moral force. For Tan, who synthesized Western science with Christianity, neo-Confucian thought, and Buddhist philosophy, ether is a material but also a philosophical foundation for social cohesion, with its capacity to transmit thoughts across distances and create interconnectedness in a shared milieu.[85] As David Wright points out, Tan draws from the Chinese notion of *qi* (cosmic fluid) as a source of matter, communication, and transmission and the notion of *ren* (benevolence) as a universe-filling entity linking human beings and other parts of the world.[86] Influenced by Western science, especially the wave theory of light, the theory of electricity, chemistry, and biology, Tan conceives ether as both infinite and infinitesimal. As the source of matter, it forms the material base and cohesive force for atoms and the anatomical components of the body; as a medium for social cohesion, it connects individuals with family, nation, and the world; as the conduit for the propagation of waves, it makes sensory perception (vision, hearing, taste, smell, touch) possible.[87] As Wright analyzes, Tan does not differentiate the nature of ether from its manifestation, and hence, ether is associated simultaneously with light, electricity, spirit, the Christian notion of compassion, the Buddhist notion of mercy, universal love, and benevolence.[88] One of the key concepts Tan develops is the notion

of *tong* (mutuality or perfect intercommunication), a property by means of which benevolence is transmitted across distance without obstruction, like a ripple across the lake, as a manifestation of the ether. Wright interprets Tan's understanding of ether as an ethical instead of neutral medium:

> The source and receiver were both in a relationship of communication; it was not a matter of an active source and a passive receiver. The ether was both the receptacle of the process, and an active participant in it, and could therefore be said to be positively good rather than (like an electric wire transmitting a telegram) indifferent to the ethical quality of the messages it carried. Just as two waves on the water surface can pass through one another without hindrance, the non-obstruction or complete interconnectedness of all things was ensured as their mutual *ren* or benevolent attraction was transmitted by the all-pervading ether.[89]

In this passage Wright insightfully captures Tan's notion of ether as enabling a mode of communication alternative to the wired telegraph. Ether is not an "indifferent" conduit but a positive molding force, participating in and affecting the ethical content of the message in the process of enabling its transmission. The ether medium is thus immanent and mediating, all pervasive and intermediary in the meaning-production process. Instead of a unidirectional communication, ether enables a mutuality, like two ripples allowing each other to pass. The difference between these two models is not, then, that of two spatial conceptions or modes of communication. Rather, in conceiving of ether as a prototypical medium as an environment, an ethical dimension of communication is asserted. As Wright observes, Tan considers this total interconnectedness as equality; identified as mutuality, it is in the end *ren,* or benevolence.

By identifying ether as a medium as environment but simultaneously negotiating the ethical process of communication, Tan's notion of ether suggests a revision of what Schüttpelz calls "trance medium." Instead of operating via the passivity of spectators, the late-Qing intellectual theorizes the ether medium in terms of the mutuality of communication so that it does not reify the divide between a subject

and an object but envelops them in a continuum of space and matter, rendering the question of agency irrelevant. This ether medium not only has an ethical dimension but also is an engine of affect. The affective nature of ether communications is more vividly conceived by Kang Youwei, Tan's fellow political reformist who led the 1898 Hundred Days' Reform. In his book *Datongshu* (*Book of Great Unity*), Kang contemplates how we could feel others' sufferings. Giving the example of Bismarck burning the city of Sedan in France, Kang wonders why, having no prior feeling of grief at the age of ten when the event took place, he felt deeply distressed when later seeing a magic lantern show that depicted the burning houses and scattered corpses:

> What is the reason behind this? Is it what the Europeans call *yitai*? Is it what was called in ancient times the "heart that cannot bear the sufferings [of others]"? Is it the case that everyone has this "compassionate heart"?[90]

In Kang's reasoning, compassion and ether constitute each other in the experience of sympathy. Sympathy is not simply an internal affective capacity or experience generated by the biological and ontological locus of the heart but is also a manifestation of this overwhelming, all-pervasive medium. In this context, the ether medium as an engine of affect is associated with a visual medium, a magic lantern show. In contrast to Kang's prior indifference to the event, the show seems to have activated the ether medium, allowing Kang to share others' sufferings from a geographically and temporally distant sphere. It is yet to be determined when and where Kang saw the magic lantern show, but such performances in the late nineteenth century already involved multiple images with a sophisticated narrative, using visual tricks such as the dissolve and superimposition to create a sense of movement and animation.[91] Kang would have experienced the show as not a single projected picture but a synesthetic sonic and visual experience with a live narrator. Similarly informed by Western science in reconceiving Chinese philosophy and society, Kang has, however, a specific ethical interpretation of energy. Describing the world as the product of *qi*, which creates heat through friction that is then converted to lightning, Kang conceives of this energy as the elemental matter making up the sun, the earth, and material things. For

Kang this power to regenerate or, more precisely, to convert energy in the creation of things finds its ethical equivalent in human beings as *ren*, the ultimate fulfillment of the potentiality of its power, and *yi* (righteousness), the restricted and controlled use of energy.[92]

Tan and Kang's reimagination of ethics and sympathy in terms of an ether medium and energy is key to an alternative understanding of medium as trance medium, which I would call *affective medium*. In contrast to the notion of trance medium, which separates spectators from a higher order of all-pervasive, imponderable beings whose power remains mythically ominous, affective medium opens up the affinity of medium, affect, and ethics and roots their continuity in a sociocultural landscape. The affective dimension of medium evokes culturally coded emotive experiences but defies their borders—in Tan's case compassion, mercy, and love are equated with light and electromagnetic waves as manifestations of vibrations of the ether. Kang's understanding of energy is rather akin to classical thermodynamics, which, as Bruce Clarke illustrates, arose in the mid-nineteenth century with a broad concept of energy as encompassing both natural processes and cultural activities. In contrast to the older concept of mechanical force, which understands the tendency of a body to move from one place to another, energy depicts the power of an object arising from its motion or the tension between things, a "multifarious *power to do work*, a universally conserved and multiply convertible activity or potentiality."[93] As Clarke argues, the rise of energy as a new scientific term connects its scientific authority to historical associations of energy in a broader cultural field. In literature and philosophy, *energy* was used to refer to emotional, textual, and physical intensity as well as intellectual and bodily vigor. It also referred to power in reserve or exercised efficiently, with religious connotations between the physical and the divine.[94] Kang's notion of *ren* and *yi* runs close to these rich connotations of energy in its inspiration from thermodynamics and its cultural ramifications, yet with a distinct ethical claim akin to Neo-Confucianism. Importantly, Kang's "energetic" understanding of the ether medium as an engine of both affect and ethics evokes a continuum among physical, intellectual, and emotional intensity with strong ethical connotations, which I consider the key to affective medium.

Tan and Kang's appropriation of *ether* and *energy* as scientific

terms for active cultural interpretations provides powerful examples of "technoscientism." Bruce Clarke coined the term based on two ideas: scientism, a derogatory term about the inappropriate use of science in other domains that shows the close connection between science and its technological and cultural ramifications, and technoscience, Bruno Latour's conception of the cross-fertilization of science and culture, the interfolding of science, technology, and society as a whole. For Clarke technoscientism refers to the structure and processes of allegory operating throughout the modern and postmodern cultural fields to provide form, rhetorical structure, and ideological force to scientific and technological discursive circulation. For late-Qing Chinese intellectuals such as Tan and Kang, the ether medium and thermodynamic energy provides timely rhetorical tropes and alternative authority for their cultural translation, appropriation, and reconfiguration into a complex thesis of political philosophy.

The creative interpretation of Western science, especially evoking the notion of energy in the construction of an affective medium, returned with a different spin in the 1920s. Bergson and neoromanticism were on the rise on the Chinese literary and cultural scene, and "energy" converged with Bergson's notion of *élan vital* in a seminal poem by Guo Moruo, a prominent poet and passionate advocate of neoromanticism. In his 1920 poem "Tiangou" ("The Heavenly Hound"), Guo depicts the heavenly hound—a Chinese folkloric creature embodying evil as a source of chaos and misfortune, which was believed to have caused lunar and solar eclipses—as a modern self exploding with energy.[95] Having swallowed the sun, the moon, and all the planets, the heavenly hound radiates with the light of the planets, x-rays, and the energy of the whole universe. Burning like fire, screaming like the ocean, and running like electricity, the heavenly hound uses this power to run on its own nerves, spine, and brain and tears itself apart as it experiences the explosion of energy. Significantly, Guo uses the English word *energy* in the printed text of his Chinese poem. Energy is identified with biological vital force, light, electricity, and electromagnetic waves. In the article "Literature of Life" written the same year, Guo reflects upon Bergson's notion of *élan vital* by interpreting life as the essence of literature. Having recently read Bergson's *Creative Evolution* and pointing out Bergson's

connection with Goethe, Guo again repeatedly punctuates his text with the word *energy* and considers creation as the radiation of energy, which produces "sound, light, heat, and electricity" as well as "emotions, impulses, thoughts, and consciousness": "The more sufficient the Energy is, the healthier the spirit will be, the more vital, more authentic, the better and more aesthetic literature would be."[96] Guo thus identifies "literature of life" as an affective medium whose aesthetic form is justified by its conveyance of vital energy, interpreted as an ethical notion of "truthfulness." More important, energy, a key term in Guo's early literary works, often associated with fire, blood, and other eruptive fluid, provides a conception of affective medium that brings us back to Bergson's notion of affect.[97]

Guo's allegory of the modern self as a heavenly hound embracing the universe for energy absorption, conversion, and transmission to effect a radical self-transformation captures the excitement of closing the distance between object and self, which for Bergson concerns the experience of sensation and affection. Conceiving of self and object in a spatial continuum between image and body, which he calls the *object-image* and the *body-image,* Bergson describes perception as a process of the body-image subtracting features from relevant object-images. While a distance between the body-image and the object-image counts only as "virtual action," perception continues to compel the body-image to move closer to object-images in order to spring into real action. As he puts it, "The more distance decreases between this object and our body . . . the more does virtual action tend to pass into *real* action."[98] The closer the distance, the more the body-image will acknowledge the exterior object-image in itself, through sensation. For Bergson the internalization of this sensation within the body, as localized perception, is affection.[99]

The Affective Medium: Rethinking Immersive and Virtual Media

This collapsing of the distance between object and self, experienced as affection, constitutes a significant dimension of the affective medium, the annihilation of the gap between the spectator and the realm of representation. Bergson's discussion of the move from virtual to actual, experienced through sensation and affection, invites

us to reconsider Anne Friedberg's differentiation between virtual and immersive media.[100] Friedberg, drawing from Oliver Grau, conceives of the *immersive* and the *frame* "spaces of illusion" as two distinct visual systems. While the immersive space—associated with panorama, cineorama, stereoscope, sensorama, and 3-D IMAX—sustains a visual system of a total, dynamic space with multiple and unfixed perspectives, the frame system—including cinema, television, and the computer screen—operates on the separation between the image and spectatorial space: "The screen began to rely on an observer on the 'outside,' not the 'inside.'"[101] For Friedberg the frame functions as a threshold between the immobile spectator and the mobile images while separating the *material* space of spectators and the virtual *immaterial* space seen within its boundaries. Dissociating the virtual from "immersive realities" for Friedberg allows exploration of still and moving "virtual" images, as in paintings, photographs, camera obscuras, magic lanterns, films, and television—her substantial intervention into the technologically determined dominant association of virtuality with digital media.

The notion of affective medium problematizes this separation between two visual systems and their respective strategies and traditions of representation, between the *immersive* and the *frame* spaces. While affective medium is not limited to any singular medium or media technology, just as Friedberg defines the virtual as an "ontological, not a media-specific property," affective medium questions the *physical* separation of the spectatorial and representational spaces as the ultimate demarcation of a visual system (the frame) constituted by a variety of media, including cinema. This separation, understood by Friedberg as an aesthetic system compensating for the immobility of the spectator with the mobility of the mediated images, minimizes the role of the spectator, renders the physical separation unbridgeable, and reasserts the ontological gulf between self and object, or between body-image and object-image.

While this gulf is questioned by Bergson's philosophy of affect, it is equally challenged by actual media practice. To use cinema as an example, certain genre films, such as action thrillers, musicals, horror films, melodramas, and pornography—what Linda Williams terms "body genres," albeit in a frame system of visuality—bridge

the physical separation of the two spaces by generating spectatorial affect in a material and physical manner. Yet to limit this challenge to a film-generic tradition is to screen off larger cultural discourses and social practices—namely, a wide-ranging emphasis on the promise of the mass media for connecting representational and spectatorial space based on political, epistemological, and perceptual interests. In this sense, the Chinese "culture of resonance" in the 1920s provides a substantial case to demonstrate how the frame system could simultaneously evoke a sense of separation and an effect to overcome that distance, but that experience was not merely the product of a particular visual system. The convergence of politics, technologies of the body, media technologies, and aesthetics in China's semicolonial condition in the 1920s created a fertile ground for cinema to be conceived and practiced as an affective medium that challenged the boundary between the virtual and the material. Meanwhile, its interaction with other media, especially distant communication media (television, radio, and other wireless technologies), changed the way cinema was conceived and experienced. A broadly shared desire to transcend the spatial limit between the space of representation and spectatorial/auditorial space found satisfaction in martial arts films, which participated in both the frame and immersive culture.

I would like to return, however, to Friedberg's definition of the virtual in order to address the phenomenal prevalence and appeal of fiery films in 1920s China. Other than its spatial construct, Friedberg defines the virtual as "any representation or appearance (whether optically, technologically, or artisanally produced) that appears 'functionally or effectively *but not formally*' of the same materiality as what it represents."[102] She describes virtual images as having "a materiality and a reality but of a different kind, a second-order materiality, liminally immaterial."[103] To flip Friedberg's notion of liminal immateriality, liminal *materiality* is precisely what interests me in considering the perceptual appeal of fiery films and the affective medium akin to the ether medium. In Henderson's observation the epistemological currency of ether inspired modernist artists to reconceptualize space and matter and their relationship. Embodying matter as simultaneously "dematerializing and materializing," the conception of ether and matter comes rather close to what Friedberg

describes as the second-order materiality of the virtual.[104] That liminal materiality also prepares the conceptual ground to bridge the spatial and ontological gap of self and object, through vibration.

Cinematic fire becomes a fitting emblem of virtuality: first, it is an optically and technologically mediated representation that appears "'functionally or effectively *but not formally*' of the same materiality as what it represents"; second, it embodies the second-order materiality, a liminal materiality. Given the broader history of the culture of resonance I have described, it is tempting to consider fiery films as a cultural practice of technoscientism, an allegory reconfiguring the confluence of media technology, technologies of the body and perception, and political tensions. This heterogeneous sensibility provides a lens to consider how in martial arts films fire and action reinforce each other by evoking a field of energy with far-reaching implications for conceptions of cinema, the body, and spectatorship. Although cinema was conceived in multiple ways in relation to other media and its plural futures, these relationships boil down to cinematic affect—its relationship to the audience by evoking a heightened field of energy. This field was produced by the popular practice of psychical research, the spread of pragmatic psychology and physiology, the renewal of knowledge via the introduction of Western physics, and the plural discourses of modernist vitalism—particularly, neoromanticism, with its trappings of nationalist postcolonial critique, symbolist aesthetics, anarchist impulses, and Marxist social critique. This heterogeneous and continuous field of energy, often represented by the metaphorical and metonymic figure of fire, enabled a transformed understanding of the (human) body as a malleable medium of perception that could be tuned to a "sympathetic vibration" with cinema (predicated upon presence of the ether as a continuous, neutral but substantial and material medium). Cinematic technology and the body became "sympathetic medium" to each other in an operation of resonance. The notion of resonance as a mode of spectatorship struck numerous chords and introduced a reconception of the relationship between body, matter, and space that radicalized the cinematic experience.

In such a context, we can revisit the affective density of Chinese fiery films in the 1920s, albeit through its ashes. Two publicity images for *Hero in the Fire,* discussed in chapter 1, provide a peek into

the energy field it evokes and the desire to transcend the cinematic frame. While the first publicity image, a color drawing of a seven-story house on fire (Figure 2.19), shows the devouring flames bursting out of the window frames, the second image, a still photograph tinted entirely in red, shows the hero holding the heroine in his arms, rushing out of the room engulfed in fire (see Figure 1.6). Here, passion, energy, rage, and action converge in the overwhelming fire that threatens to transgress the photographic and our imagined cinematic frame. We meet at the edge of this frame, across time and distance. Out of the film house on fire, what fiery films bring us is the dream of an affective medium.

By examining the technological and social-discursive practice of resonance as a new mode of spectatorship in 1920s China, this chapter considers intermedial spectatorship a plausible approach to address the synchronic interplay between cinema and other media. Cinematic spectatorship overlapped with other technologies of the body (hypnotism, photography, television, and other wireless technologies) as well as imaginary media inventions and spaces of exhibition in shaping specific modes of perception and subjectivity. The material and formal binding of these technologies—as exemplified by the point-of-view construction of "empirical evidence" for hypnotic telepathy reminiscent of photoplay fiction, as well as the meticulous coordination of the spectator's body with technologies of synchronous reception—highlights the intermediated nature of media spectatorship and points to the social implications of the body as a reinventable medium. Resonant spectatorship, corresponding to spatial imaginations of the wireless movie theater, annihilates the distance between the sender and the receiver but, more important, provides an alternative to such an epistolary model of the medium. Instead, a medium is conceived as an environment, an expansive category that problematizes the boundary between the sender and the receiver, the realm of representation and that of reception.[105] I argue that this alternative model sets itself apart from the epistolary model (with its emphasis on information transmission) by emphasizing the medium as "affective." Perceiving the medium as fundamentally a medium of affect elides the boundary between producer and receiver; meanwhile, this medium of affect centralizes spectatorship to define its operation and boundary and to foreground

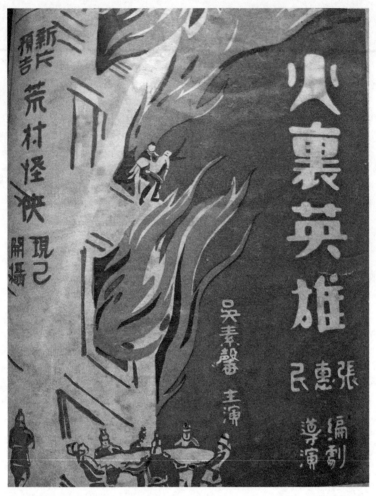

Figure 2.19. This color drawing of a seven-story house on fire for the film *Hero in the Fire* shows the devouring flames bursting out of the window frames.

questions of ethics and politics. The social implications of such a desire to transcend the cinematic frame, as a model of the public sphere and spectatorial subjectivity, are immense and full of ambivalence. Yet resonance, a technologically mediated psychosomatic response presupposing an affective medium, does not imply the pure passivity of the spectators and the singularity of temporality. While we need

to question the anxiety of human agency and the radical forsaking of human subjectivity and its political operations, what resonance entails in this context is precisely the intermediated nature of affect that complicates any autonomous notions of human body and mind in the operation of a productive receptivity. Moreover, fascination with the instantaneity and simultaneity of wireless technology fostered a cultural imagination that invited and reinvented the distant past in close encounters with the present. Lastly, this historical inquiry into intermedial spectatorship provides a new way to understand spectatorship beyond a sociological or an ontological model. This method allows us to focus on early Chinese cinema by transcending the genre- and medium-specific approach so as to translate the historiographical problem of "lost cinema" into a productive cinema by other means.

Part II Transparency

3 Dances of Fire
Mediating Affective Immediacy

"September 18," "January 28"—machine guns, airplanes, bombs, cannons . . . a cacophony of strident sound bombarded the nerves with intense shocks—reactions—changes—seeking a way out—transformation of thoughts—social transformations—the film world has also transformed.

–Cheng Bugao, "*Kuangliu*" ("*Torrent*"), *Xiandai dianying* 1, no. 1 (March 1933): 22

Writing in the spring of 1933, in the aftermath of two recent incidents—the Japanese takeover of Manchuria on September 18, 1931, and the bombing of Shanghai on January 28, 1932—veteran film director Cheng Bugao captured the sensorial shocks of the war as the dramatic backdrop for the making of his film *Kuangliu (Torrent, 1933)*.[1] The film was a collaboration with left-wing playwright and film critic Xia Yan and Zheng Boqi, who translated Pudovkin's *Kino-rezhisser i kino-material (Film Director and Film Material)* into Chinese and appended the film script as an illustration of their putting montage theory into practice. The strident noise of the mechanized war delivered sound as a new affective medium, serving as the overwhelming environment in which the Shanghai film world underwent transformation.

James E. Pickard, an engineer working for Western Electric to install the first sound film systems in Shanghai and Tokyo movie theaters, documented with his own camera the bombing of Shanghai urban architecture, including department stores and movie theaters.[2] In his photograph of the bombing of the Odeon, one of the earliest movie theaters with an installed sound system, a man, identified as Eddie O'Connor from MGM by Pickard's handwriting on the

photograph, stands pensively in profile in front of the theater (Figure 3.1). Behind him looms the ruined building with shattered glass doors, through which one can see a back wall torn open, creating a "screen" through which the real world from behind is now seen in broad daylight against the darkness of the theater space. On the right side, a wrinkled movie poster advertises a foreign film with "sound, dialogue, singing and dancing," its Chinese translated title, *Huan-meng chuxing* (*Upon Awakening from a Merry Dream*), uncannily appropriate.[3] In Pickard's earlier photographs, he had documented men carrying boxes of sound equipment into the Grand Theater, which he identified as the second movie theater installed with a Western Electric sound system (Figure 3.2). Another early sound theater was the Capitol Theater (Guanglu daxiyuan), next to the capitol building, where his office was located.[4] On the same top floor of the capitol building, an international film empire with multinational distributors overlooked the city: General Film Exchange (a distributor on behalf of United Artists), Twentieth-Century Fox, Paramount Films of China, European Film Distributors, Independent Film Exchange of China, Film Board of Trade, and others. Western Electric had chosen an ideal spot to share, teaming up with the distributors to install sound-projection systems in Shanghai.[5] For Pickard, who had been traveling between Shanghai and Tokyo as well as other major Chinese cities and had made numerous friends in both countries, the Japanese bombing of Shanghai movie theaters must have been particularly poignant.

The transformation of Shanghai film culture hence coincided with two kinds of sonic invasions (the bombing of the city and the onrush of foreign sound cinema), positing the film industry against the dramatic backdrop of the impact of war, renewed film technology, and a sense of national crisis under the economic, cultural, and military surge of foreign capital, goods, and artillery. These changing experiences of reality were realized through new sensorial mediations with powerful affect and a poignant transparency. In the film world, just as cinema was transformed during the uneasy and difficult incorporation of sound, with substantial impact on film production and film exhibition, active deliberations on cinematic technology and the specificity of the medium constituted a significant strand of film discourse and film theory. Meanwhile, new film aesthetics,

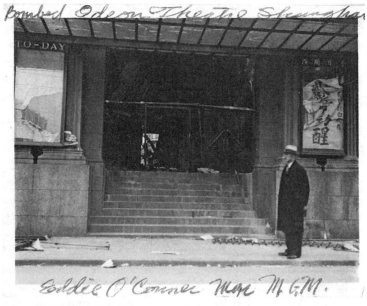

Bombed Odeon Theatre Shanghai

Eddie O'Conner Mgr. M.G.M.

Figure 3.1. Bombed Odeon Theater. Photograph by James E. Pickard. Courtesy of James E. Pickard Jr.

Figure 3.2. Chinese laborers carrying sound equipment to the Grand Theater. Photograph by James E. Pickard. Courtesy of James E. Pickard Jr.

spurred by the inrush of a wide range of international cinema, the emergence of sound, and the introduction of montage as a major film theory and practice, changed the look and feel of Shanghai cinema.

In this context, we can revisit left-wing cinema (*zuoyi dianying*), a term much at stake in recent writings of Chinese film history. As a number of scholars point out, left-wing cinema, referring to leftist film criticism and film production from 1932 to 1937, was largely constructed retrospectively and canonized in official Chinese film historiographies in the 1950s and 1960s and reappeared after the Cultural Revolution, coming back into use in the 1980s.[6] These film historiographies have emphasized the left-wing association with the Communist Party, embracing film culture as part of the myth of Republican Communist liberation.[7] Precisely for the same reason, new revisionist writings have challenged the political allegiance of these films, attempting to rename the film culture and recontextualize it in relation to a broader, heterogeneous film world embedded in commercially oriented film studios and inheriting popular film conventions such as melodrama and folkloric narratives.[8] The opposing camp, long condemned as reactionary "soft-cinema" advocates, is gaining long-overdue attention and more positive treatment, especially for its theoretical contribution to film form and aesthetics.[9] The political edge of the left-wing film movement, realized in radical film theory and film practice, is further marginalized, however, by both official accounts and revisionist writings that continue to reify the dichotomy between the leftist and rightist camps along the split between form and content, aesthetics and politics, and cosmopolitanism and nationalism. Such narratives in effect reconfirm the official historiography of left-wing cinema's political dogmatism and simplicity; meanwhile, new scholarship recontextualizing left-wing cinema in the urban consumer culture in relation to popular film conventions further dissolves the political edge of the film movement.

Having benefited tremendously from the scholarship and insight of these revisionist writings—and I think the effort is well spent in debunking the myth of left-wing cinema by pinpointing its historical problems and contradictions—I would like to turn my attention to exactly what constitutes the *politicality* of the film movement that remains irreducible to either party politics or commercial strategies. To me the edge of left-wing cinema, as constructed and problematic

as the term is, resides in its enduring interest in mobilizing mass affect and perception as the condition of a new political subjectivity, and this is realized by cultivating a new medium sensibility via media politics and aesthetics. Such a position is informed by a wide range of international cinema and film theory filtered through Shanghai film market and print culture, enriched by selective transformations of popular film and cultural conventions. The parallel transformation of media technologies (sound cinema, radio, and television, for instance) prompted a reflection of cinema in relation to older and newer media, as (silent) cinema quickly aged from a new medium to one facing the threat of obsolescence. I would argue that it is the pairing of these two politics—the engineering of affective spectatorship to cultivate a class-conscious political subjectivity and the negotiation of a medium-conscious aesthetic—that constitutes the unique politicality of left-wing cinema that has escaped critical attention.

Notably, the politics of affect and medium converge in the formulation of a new medium beyond and in relation to empirical media: this is the reinvention of the crowd—an earlier trope of aleatory public and mass spectators as witnessed in late-Qing illustrated magazines—into a medium of affect and a collective political subject by positioning the crowd in confrontation and analogy with the natural medium of cosmic energy and forces (fire, torrent, storm, wind) and hence politicizing each other. This conversion involves a renewed interest in media technology and aesthetics by repositioning medium old and new, especially at a moment when sound as a new addition and challenge to film technology was engaged and negotiated. Importantly, such a negotiation does not just operate on the technological and medium-aesthetic level but registers and reflects upon the economic and cultural struggle against colonial power and global capital manifested through competition and renewal of media technology (exhibition venues, foreign capital, linguistic imperialism). In this sense, the politics of affect and medium builds on the contiguity and tension between medium in various senses: natural (fire, water, wind), cultural (crowd), material (glass), and technological and sensual (sound, vision). The main thrust of this politics is the forging of a medium that is simultaneously affective and critical. The left-wing film politics is thus a media politics of affect through which film aesthetics and film technology are deployed

to emulate and compete against the authenticity and power of the cosmic and human mediums: nature and crowd. I thus treat affect in relation to medium in these terms.

To tease out this politics, I need to reconsider the two camps—the left-wing and the aesthetic modernist—as two necessary variants and antitheses of the new film culture movement. I revisit Chinese film scholar Li Shaobai's attempt to rename this film phenomenon "the new film culture movement" (*xinxing dianying wenhua yundong*) but explore what constitutes the "newness" of the movement in relation to politics and media aesthetics. The new film movement is, I suggest, a new cinema not only for its cultural and political "newness" but for a medium-conscious politics of newness that reflects upon the relationship with older media (including silent cinema). The two camps converged in discussions of film form and aesthetics, largely revolving around spectatorial affect in relation to the specificity of the cinematic medium, which underwent major challenges with the arrival of sound. The left-wing film movement itself was the vanguard in the aesthetic experiment with sound while consciously politicizing and reflecting on the medium. The political as well as perceptual radicality of left-wing films (for example, their understanding of montage and their sound/image experiments) is far from being fully explored.

By looking closely at this film movement's interaction with Soviet and European film theory and film productions, I inquire the two political camps' convergence and divergence in the question of medium specificity, a term that has been celebrated by recent rediscovery of "soft cinema" and taken for granted. Instead of thinking of filmmakers as passively obeying the doctrine of the critics, I would like to treat these films as sites of complex negotiation, not simply negotiating between leftist political doctrines and demands of the commercial industry but engaging the legacies of earlier film traditions as well as international film theory and film aesthetic. It is this level of politics, rather than explicit party doctrines and alliance, that gives us a better look at the stakes of affect, media technology, and instances of media.

In the following, I first examine the paradoxical attitude of left-wing filmmakers and dramatists toward media productions of affective immediacy. Tracing the stage and screen metamorphosis of the playscript *Huo zhi tiaowu* (*Dances of Fire*), written by left-wing

dramatist and screenplay writer Tian Han, I situate the work in a cluster of left-wing films simultaneously invested in and distrustful of affect. Through their stage and screen productions, left-wing film-makers and dramatists performed social criticism of visual and affective consumption, which entailed the artist's self-critique. In contrast, they showed persistent interest in the emergence of the crowd as a political subject. This subject was configured in visual tropes of natural forces, such as the fire and the torrent, whose symbolic and subliminal power relied precisely on their affective immediacy. Such affective immediacy was, as I demonstrate, a product of distinct film aesthetics, particularly through Chinese filmmakers' and film critics' engagement with montage film theory and practice.

I then pause to consider the "newness" of the new film culture movement by examining the convergence between left-wing and non-left-wing film critics on questions of cinematic medium specificity and how it dramatically reshapes perception. The theoretical discussions between the two film camps in close conversation with European and Soviet film theory are counterbalanced by filmmakers' experiments with politicized perception with popular appeal. I approach Cai Chusheng's film practice as active reflections upon the semiotic, material–technological, and social dimensions of the medium as well as cinema's relationships with cognate media such as photography and newspapers. Particularly, I examine Cai's negotiation with commodity culture through a politics of intermediality. By exploring left-wing filmmakers' dual political interest in embracing critical perception and affective immediacy, I illustrate that left-wing cinema remains irreducible either to a party-affiliated media instrument or to a politically disguised popular cinema subsumed under a commodity culture. The radicality of left-wing cinema resides not only in the filmmakers' political agenda but also in their film aesthetics and experiments. Moreover, their innovations aspire toward an alternative vision and mode of perception that traverses the commodity cultural surface while maintaining affective impact.

Dances of Fire: Burning the Artist's Balcony

In 1929, at the height of the rage for fiery films, one of China's most prominent dramatists, Tian Han, wrote a spoken-drama script

entitled *Dances of Fire*.[10] Set in the shantytown of the city, the play opens with a fight between a rent collector and a poverty-stricken worker that knocks a light off the wall and sets the straw hut on fire. The second scene shifts to a wealthy family's living room, where the family members, spotting the fire that has now spread to the whole shantytown across the river, place a sofa on the balcony to enjoy the scene, which is "more interesting than watching a play."[11] The son, a symbolist/decadent poet, pays tribute to the fire by composing a poem on the pagan emperor Nero's burning of Rome, accompanied by guitar music composed by his sister. To further enjoy the scene, he calls the family members onstage to form three dancing couples. The bourgeoisie, seeking entertainment and "nerve stimulation" from the spectacle and sensation of fire, soon get their retribution. The destructive force of fire knows no boundary: a telephone, connecting both sides of the river, reports that the fire has extended to the factory owned by the family patriarch. The father, enraged by the dancing couples enjoying themselves as he receives the bad news, shouts, "Do you know on what substance you are dancing?"

The third scene returns to the other side of the river. The family's factory property turns out to be well protected by fire insurance, while the poor workers have suffered from death, injury, and loss of homes. The characters from the second scene pay an exotic visit to the factory site, where the poet son compares the burned factory to the ruins of Rome and laments the imagined death of a lilylike female worker in the rubble. Temporarily inhabiting the same space, the wealthy family and the workers are acutely aware of their social gap. The workers comment that the poet/son speaks an unintelligible foreign language and the rich people all look like lunatics. In the end, a fight breaks out between the workers and the rent collector, and a call to arms spreads among all the workers.

Significantly, the suggestion to place the sofa is made by the daughter and her female friend. Their indulgence in the scene and indifference to the tragic damage caused by the fire are associated with the gendered stereotype of female consumption. The female friend is more upset about having ruined her silk stockings than about having lost a boyfriend. This stereotypical attitude is integral with the emergence of the entertainment audience, composed significantly of a growing number of women. Their indulgence foreshadows the

mid-1930s Shanghai film debate about hard versus soft films, condensed in the film metaphor "ice cream for the eyes."

Ironically, the scene itself registers Tian Han's exposure to, if not avid consumption of, popular films. The stage reproduces the scene of an E. S. Porter film, *Nero and the Burning of Rome* (1908) (Figure 3.3): the poet replaces Nero watching the fire, and his family and friends resemble Nero's decadent guests, accompanied by music.[12] Although the record of the Porter film's exhibition in China is yet to be found, a much later film, *Nero,* produced by the Fox Studio and shot in Italy in 1922 (directed by J. Gordon Edwards), was shown in China between 1925 and 1927 and was featured on a 1925 cover of one of the earliest film journals, *Yingxi chunqiu.*[13] The son's symbolist imagination of the archaic is matched by its secular and contemporary counterpart in the daughter's seating arrangement, which both reproduces the Hollywood imagery onstage and resembles the seating in the theater. This stage scene in effect obliquely registers the Chinese reception of foreign "fire films," which had been popular since the earliest film exhibition in China in the late 1890s.[14] At the same time, the stage reproduction provides a critical distance from the mass attraction of fire films and challenges the radical claims of a resonant spectatorship embraced by new heroist advocates.

The backdrop of the fire, the fox-trot rhythm of the phonograph music, and the sirens of the passing fire engines heighten the decadence of the upper class, oblivious of the others' suffering. This scene translates into an explicit political allegory of affect and perception. Within the diegesis the signs of emergency such as the siren and the devouring fire are rendered interchangeable with the hypnotic rhythm in the family's consumptive spectatorship and physical reaction, on the family balcony that easily converts to a theater balcony. In effect, this excess of sensory stimuli, evoking the protospectators' visceral and kinetic responses, vividly literalizes the affect of a fiery film and the operation of the audience *resonance,* as described in the *Huaju Special Issue* article mentioned in chapter 1. As dramatized by Tian Han, however, this spectatorial resonance, triggered by the profusion of sensory stimuli, does not lead to any critical perception or political vision. Rather, the contrast between the shantytown workers' suffering in the fire and the family's enjoyment of the scene creates an antithesis between visual pleasure and critical perception.

Figure 3.3. *Nero and the Burning of Rome* (E. S. Porter, 1908). Film still. Reproduced from Charles Musser, *Before the Nickelodeon: Edwin S. Porter and the Edison Manufacturing Company* (Berkeley: University of California Press, 1991).

This central scene of the play performs a complex engagement of the question of affect. By examining visual and sensory consumption, *Dances of Fire* reflects upon existing practices of spectatorship. It thus distances itself from previous media configurations of fire in lithographic pictorials, popular drama, and fiery films. In his rather heavy-handed class commentary, Tian Han points out the limit of affective immediacy, which despite its power to constitute the popular media public, exhausts itself in the activity of consumption. His radical reformation of audience spectatorship in *Dances of Fire* is, however, more ambiguous than it seems. The title *Dances of Fire* highlights the ambiguity of the central characters. Whether it is the fire or the dancers who occupy center stage is equivocal. Just as ambivalent is the play's reference to popular as well as avant-garde intertexts. The title evokes Loie Fuller's *Fire Dance* (1906), whose experiment with glass, mirrors, and an elaborate lighting system associates fire with the creative potential of the modern stage as well as the female body in motion.[15] Tian Han might not have heard about Fuller's stage production or film version, but he surely had seen the 1926

modern dance in Shanghai performed by Irma Duncan—adopted daughter of Isadora Duncan and disciple of Fuller. Reincarnating Fuller's fire spirit in a red dress and in the modernist movement of her body, Duncan suggested to Tian Han the spirit of the modern age, about which Tian avidly wrote.[16] This dance then both operates as an acidic attack on bourgeois decadence and propels a pleasurable aesthetic experience. The rhythmic music functions as the binding force fusing the sensory cues of conflicting connotations into a synesthetic horizon of pleasure. Between theatrical production of and metatheatrical reference to affective immediacy, Tian Han enables his critique of media production of affect by precisely engaging it.

Notably, the play translates the paradoxical production of affect and apathy among its bourgeois consumers into a spatial construction of spectatorship that is increasingly standardized. The viewers' enjoyment of sensorial thrills depends on their separation from the action. In the play the river is featured as prominently as the balcony. Emblematic of the social gap mapped in the urban geography that divides the upper class and the shantytown, the river figures also as the division between the spectator and the realm of exhibition. On the other side, the workers' suffering in the fire evaporates easily into a spectacular backdrop for entertainment. Although Tian Han evokes the corrosive power of fire to annihilate geographical as well as social partitions, he suggests that the protective social system keeps the social gap intact; similarly, the all-inclusive force of the artwork desired by Tian Han remains remote from the masses. In his preface Tian Han recalls that the play turned out to be a failure when it was performed in Nanjing and Shanghai at a time when spoken drama still enjoyed very limited audiences.[17] The play was also written at a significant moment in Tian Han's career when he started to reflect upon his indulgence in symbolist and expressionist drama that failed to embrace the masses.

In 1933 Tian Han, by then writing screenplays for the rising tide of Chinese left-wing films, made the play into a film titled *Lieyan* (*Raging Flames*). The story is much altered from the original play's. The scene of the worker's family is changed into a love story between young peasant A Gui and his cousin A Zhen. A Zhen leaves her lover and becomes the mistress of a rich man. A Gui, with his robust body, becomes a firefighter. One day, A Zhen's villa is on fire. A Gui,

climbing to the window as a firefighter, saves A Zhen's life, though he refuses her love.

The play's second scene, showing the wealthy family, is changed to a historical moment: on the night of January 28, 1932, when the Japanese airplanes dropped incendiary bombs on Zhabei (the Chinese residential and factory zone) in Shanghai, thousands of refugees ran in despair into the fire; people in the foreign concessions, however, watched the burning spectacle across the Suzhou River. Although the film ends with the male protagonist leading people to extinguish the fire, the topos by which the river divides the safe zone and the site of suffering remains intact.

Fire and the Crowd

The ambivalence of fire, between an agreeable image and an invasive entity, captures well the intellectual conception of the duality of the crowd. In Marston Anderson's account, the early 1930s saw rising interest among Chinese realist writers in formulating a new political subject to compensate for the intellectuals' lack of vitality and activism. This resulted in an enthusiasm for the crowd as a new, if "anonymous and undifferentiated," protagonist.[18] To capture the paradoxical character of abstract yet "overwhelming physical immediacy," writers evoked metaphors of nature as figures of the crowd protagonist. These included "fire, water ('tide,' 'tempest,' 'torrent'), animal and insect packs ('frenzied tigers,' 'swarms'), and the wind."[19] Anderson argues that the rise of this new protagonist was accompanied by a change in literary representation of the crowd from the 1920s to the 1930s. In the 1920s the (intellectual) protagonist maintained a safe distance and remained detached, disaffected with, and alienated from the crowd despite his pleasure in being on site to endorse the mass strikes and parades. The protagonist of 1930s fiction was, in contrast, radically undifferentiated from the crowd, and readers were not provided with a single perspective but merged with the crowd.

Anderson's differentiation between 1920s and 1930s literary representation of the crowd is similar to what Walter Benjamin distinguishes as the *flâneur* and the *badaud* (gawker), fin-de-siècle literary figures of modern urban experience. While the *flâneur*'s leisurely appreciation of the crowd sustains his individuality as a subject of

knowledge, the gawker is intoxicated and impersonalized, losing himself in the urban spectacle.[20] Taking his cue from Benjamin, Tom Gunning theorizes the *flâneur* and the gawker as archetypes of two distinct modes of urban spectatorship, or rather, film spectatorship as it was first "rehearsed in the urban environment."[21] Rereading Edgar Allan Poe's "The Man of the Crowd," Gunning characterizes the *flâneur* as an observer of the urban surface from a single vantage point, whereas the gawker savors "visual delight in a constantly changing spectacle irrelevant to the knowing gaze."[22] Aligning this distinction with what Dana Brand terms the two modes of urban spectatorship, "detached observation" and "desperate search for sensation," Gunning treats the two models as consecutive rather than concurrent, corresponding to a historical transition of urban modernity. The *flâneur* figures an early nineteenth-century mode of viewing, a leisurely observation, on the one hand, afforded by the unhurried pace of the urban environment and, on the other, encouraged by Parisian fashion for physiognomic and physiologic study of urban types. The gawker is synchronic with the accelerated pace of the later nineteenth century, which provided kaleidoscopic visual delights—technologically assisted and commercially packaged—as part of the new entertainment industry, culminating in cinema at the end of the century.[23]

Gunning's historical model of urban spectatorship, seen in light of Anderson's insight into 1920s and 1930s Chinese realist fiction, suggests a unique link between modern perceptual modes and political subjectivity in China. Similar to the prototypical *flâneur* in Poe's story, whose detached observation is made possible by a large plate-glass window at a London coffeehouse, the intellectual protagonist in Chinese realist fiction secures his privileged perspective from his "grandstand view" in a second-story restaurant, as exemplified by the poet Fan Bowen in Mao Dun's 1930 novel *Midnight*. Anderson remarks that this privileged position of the intellectual individual in relation to the crowd still appears in early 1930s realist fiction, although such individuals are the target of political satire rather than sympathy. In *Midnight* Fan's nonparticipation is criticized by others as "Nero fiddling while Rome burned."[24] This striking similarity to Tian Han's poet in *Dances of Fire* testifies to the pervasiveness of the Nero motif in this period across the media of literature, drama, and later, cinema. More important, the politicization of modern urban

spectatorship is mediated by the role of American cinema. In this case, the circulation of Hollywood films provided Chinese intellectuals with efficacious imagery that had popular currency—a political and aesthetic perceptual idiom that could be repeatedly cited in the making of a political vernacular.

Dances of Fire, similar to *Midnight,* seems to be poised between the *flâneur* and the gawker positions of the intellectual. It self-reflectively marks a transitional stage when the individual artistic vantage point is critiqued, while merging with the masses is not yet possible. The figure of the decadent poet is indeed a self-mockery of Tian Han's own past, especially during the early and mid-1920s. Trained in Japan and an early advocate of neoromanticism, he showed a fascination with Western symbolism and aestheticism in his earlier plays, most notably *Gutan de shengyin* (*Sound of the Ancient Pool*), *Hushang de beiju* (*Tragedy on the Lake*), and *Nangui* (*Homebound South*). Most of these plays, labeled poetry drama, lyrical drama, or tragedy, capitalize on a mysterious mood, outlandish imagery, and sentimental characters.[25] *Homebound South* was publicized as "filled with poetry, saturated with tears." Tian Han also adapted Oscar Wilde's *Salomé* so that the play was "filled with beautiful sensuous descriptions and the symphony of the eccentric and dazzling music of poetry."[26] In light of his earlier plays, *Dances of Fire* and another new play, *Yizhi* (*Unanimous*), therefore can be read as Tian Han's self-denunciation and appeal to the masses. Both were praised for having rid themselves of sentimental disillusionment, disappointment, and anguish. Interestingly, *Dances of Fire* casts the same actors as major characters on both banks of the river (the daughter and little brother of the wealthy family and the worker's wife and son are played by the same two people) to "show that the characters hold opposite vantage points because of their different situation."[27] This makes a conscious comment on visuality and social perception, attributing individual vantage points to differences in social outlook. The two male protagonists are played, however, by two different actors. The poet, played by Wan Laitian, renowned for his sentimental roles in Tian Han's earlier plays, remains distinct and not interchangeable with the worker. This arrangement, reminiscent of Tian Han's earlier casting choices, makes possible his self-reflective critique while setting the poet distinctly apart from other characters.

Torrent: The Limit of the Mobilized Virtual Gaze

Beginning in 1933, the first wave of left-wing films seemed taken over by nature: films such as *Zhongguo hai de nuchao* (*Angry Tide of the Chinese Sea,* Yue Feng), *Kuangliu* (*Torrent,* Cheng Bugao), *Yanchao* (*Salt Tide,* Xu Shenfu), *Raging Flames* (Hu Rui), and *Feng* (*Wind,* Wu Cun) greeted the audience with an unusual rage. When asked about the significance of wind in his eponymous film, director Wu Cun reflected, "Since it's hard to address it directly given the current situation, I could only choose more metaphoric means. I think wind is the most powerful force in the universe. It can destroy everything, so I use wind to symbolize revolution."[28] The affective immediacy that Tian Han paradoxically embraced and critiqued returned with a vengeance by aligning with a new political subject: the crowd. As a pure medium of affect envisioned in tropes of natural forces, the crowd gained the power and authenticity of a cosmic medium larger than life. Yet it had to be mediated with another medium, that of film. With the major film studios such as Mingxing recruiting literary talents to strengthen film production, the prevalence of crowds in realist fiction and drama spilled over the screen, albeit with a new medium consciousness. One of these films, *Torrent,* was claimed as the first left-wing film. Based on an actual 1931 flood in Wuhan along the mid–Yangtse River, *Torrent* depicts the conflicts between the peasants and the local landlord (Fu Boren), who had devoured the fund for flood prevention (Figure 3.4). The director, Cheng Bugao, had travelled to Wuhan in 1931 during the great flood and made a publicity documentary for Mingxing to help fund-raising for the flood victims, and he used some of the documentary footage for *Torrent.* The film was known not only for its success but, more important, as a model for a new type of film writing—screenplay as an essential component of film production. Perhaps for this reason, despite the loss of the film, the complete film script by Xia Yan is worth a closer look.

Left-wing cinema is recognized by the primacy of screenwriting, which is associated with literary writers inheriting the May Fourth tradition.[29] While the designation of "May Fourth literature and drama" is problematic, it is important to note that the screenplay writing from this era is deliberately differentiated from literary writings.[30] As Mingxing Studio's screenwriter Hong Shen points out,

Figure 3.4. *Torrent* (Cheng Bugao, 1933). Film still. Courtesy of China Film Archive.

screenwriting is an essential part of film production and the first step for "cinematization."[31] A successful script needs to be informed by knowledge of directing, cinematography, and editing, instead of a simple transplantation of literature and drama. In the preface to the book containing the translation of Pudovkin's *Film Director and Film Material* and the screenplay for *Torrent*, Hong Shen cites *Torrent* as an approximation of Mingxing's new standard. One of the most poignant scenes in the script reveals some interesting parallels and medium-conscious negotiation with the problematic of crowd, self, and perception as explored in 1930s realist fiction, as well as Tian Han's *Dances of Fire* and *Raging Flames*—the moment when the landlord's family watches the flood through binoculars from a balcony in the Japanese concession:

(*Fade-in*) People are channeling the water on the streets. Sandbags, flooded urban streets, refugees. On the balcony of the Fu family, Heqing, Boren, and his concubine are

watching. Heqing gives his binoculars to Boren, and points at it:

(*Intertitle*) "If this were not the Japanese concession, we would have to move again."

Boren looks through the binoculars. Long shot framed in the contour of the binoculars: ocean water, refugees.

(*Pan*) A small boat rows over to the refugees and delivers the buns. Boren exclaims. His concubine takes the binoculars. Seen through the binoculars, the refugees fight for the buns; the helper flees.

(*Close-up*) Among the refugees, a father, mother, and a three- to five-year-old child, skeletal, almost to the extent of deformation.

(*Intertitle*) "Look, somebody is coming to deliver food!"

The father walks closer, and the mother takes a tiny bun from her bag and sneaks it to the child. The father sees it and immediately grabs the bun, stuffing it into his mouth. The child cries. The mother covers her face.

(*Fade-in*) The concubine returns the binoculars to Boren, laughs. Boren says to Heqing:

(*Intertitle*) "Climbing the tower to observe the water, what a fortune for the eyes!"

Heqing nods his head and points in the distance. Drawing a circle with his hand, he says:

(*Intertitle*) "Looking from afar is not real. It's best to rent a motorboat to take a look!"

Boren gladly agrees. The concubine walks to the desk and takes a toothpick.

(*Close-up*) Candy and cakes abound on the desk.

(*Fade-out*)[32]

In this scene the binoculars stand in as a self-conscious camera, first framing the flooded landscape in an establishing long shot, then panning to reveal frightening scenes of hungry refugees fighting over steamed buns, and lastly motivating a closer shot of a minidrama in the refugee family. This sequence quite economically conducts a continuity editing that Pudovkin illustrates frequently through Griffith's films, and the binoculars adopt Pudovkin's example of *cachette*,

one of the basic film techniques for spectatorial attention and identification with the camera's point of view. Xia Yan also mimics the use of binoculars through versatile mobile framing and focal changes. Yet the binoculars stage a critique of such spectatorial identification and the pleasure of such, in addition to a gendered division of labor in the distinct visual modes involved. The male characters (Heqing and Boren) maintain control of the vision through a total perspective, whereas the concubine focuses on the drama framed by a closer look. The leftover food on the table is analogous and contiguous to the visual consumption that the Fu family seeks in the tragic scene. This critique of sensual pleasure, as suggested by the shot of the leftover food, is realized, however, by the association of female spectatorship with the illegitimacy and feudal stigma of the nameless concubine—a polygamy practice that had already been outlawed by the Nationalist government.

Boren's reference to "climbing the tower to observe the water" (*denglou guanshui*) obviously alludes to the tradition of literati climbing the famous Yellow Crane Tower (Huanghe lou) to appreciate the water scenery in the Yangtze river–lake area in Wuhan, a social event involving poetry composition, recitation, and hard drinking that can be traced back to the seventh century. The Yellow Crane Tower is featured earlier in the film, in scene 7, a landscape sequence that highlights the local attractions of Wuhan. "Fortune for the eyes" (*yanfu*) plays with a pun of its homophone (with slight tonal difference) "fortune of (possessing) a beauty" (*yanfu*). This pun is evoked in the following scene when the Fu family and Heqing take a ride in the motorboat to get a closer look at the flood. While Heqing navigates the boat using his binoculars, a closer shot reveals a refugee family who sells the wife to save the father. The man waves at the boat, and Boren gazes at the woman in a moment of stupor. The concubine sees through Boren's absorption in the scene and walks over to block his vision. Boren laughs in embarrassment.

Although the Fu family's motorboat adventure on the flooded river allows a closer look, the naked eye's contact with the scene is accomplished and mediated by the motorboat and the binoculars as mobile perceptual vehicles, enabling what Anne Friedberg terms a "mobilized 'virtual' gaze."[33] For Friedberg this gaze characterizes modern visual consumption (rooted in the lasting tradition of

walking and traveling), aided by visual vehicles such as the Ferris wheel, the moving walkway, and the ascending elevator of the Eiffel Tower. The virtual gaze in turn refers to "*received* perception mediated by representation," including photography and cinema.[34] In *Torrent* Heqing is presented as particularly experienced in navigating a perceptual machine to realize a mobilized virtual gaze—conjoining his eyes, the binoculars, the captain, and the boat. If the boat mobilizes the gaze, then the binoculars mediate the representation of the scene through optical technology. Just as Friedberg discusses modern visuality as a continuum between the mobile and the virtual, captured in the mobilized virtual gaze, Heqing's sightseeing activity vividly captures the continuous mobilized virtual visuality. The film challenges Friedberg's formulation considerably, however, and raises questions of its political implication. While Friedberg associates the mobilized virtual gaze with female spectatorship and consumption as a liberating antithesis to the male voyeuristic gaze dominating earlier theorizations of film spectatorship, the mobilized virtual gaze in *Torrent* is conjoined with a scopophilic interest gendered as *both* male and female. The scene changes from the previous consumption of food (*shi*) to that of "color-sexuality" (*se*), wherein the male *and* female spectators enjoy the sensual and sexual connotations of the scene. While the sensual pleasures form a continuum between taste, motion, and vision, moving beyond the strictly scopophilic, the political implication of the mobilized virtual gaze is rendered suspect.

Anderson's comments on the individual protagonist in 1920s realist fiction resonate here: "They watch the crowd as pornographers, half fascinated, half repulsed; though provided with a frisson, they keep their emotional distance."[35] The film indeed resonates with Ding Ling's novel *Shui* (*Water*, 1931), which mobilizes the metaphorical contiguity between water and crowd. *Water* was acclaimed as heralding a new fictional realism focused on the collective subject to overcome the May Fourth intellectual's individual protagonist.[36] The first wave of left-wing films parallels the changing representation of the crowd from the 1920s to early 1930s realist novels by ridiculing characters such as the Fu family (resembling their intellectual counterparts in the 1920s fiction) while erasing the distinction between the crowd and the destructive power of natural forces. *Torrent* ends with the river bursting the dam and devouring the Fu family while keeping

the country folk afloat and reunited. This change is refigured, however, through a consciousness of film technology and technique while carrying a self-critique along the line of class division.

Director Cheng Bugao later recounted how he drew from his experience and the actual footage he made from the 1931 documentary of the Wuhan flood.[37] Cheng spent a month in Wuhan to shoot the film and alternated his trips to the flooded villages and the protected urban center where he lived. While describing the sharp contrast of urban leisure and sufferings in the countryside, he documented his use of a small motorboat to travel to the flood zone, not unlike the Fu family taking advantage of the same mobilized vehicle to get a closer peek of the scene. He also described, by way of montage, how the film crew successfully integrated documentary footage with film set, creating a seamless contiguity between the real and the fake. The binoculars stand in, then, for film editing that conjoins two spaces and times, creating a cushioned visual experience for the urban moviegoers, resembling the Fu family's fascination with and anxiety in encountering the raw power of the flood and of the masses. Applauded for its creative uses of camera movement and editing, *Torrent*'s experiment with film aesthetics corresponds to a self-conscious reflection upon perception, technological mediation, and class.

In both *Dances of Fire* and *Torrent,* the figure of the balcony as a privileged vantage point occurs prominently as the object of critique. For Tian Han the balcony is simultaneously a consumerist configuration of the spectator (a theater balcony) and an artist's ivory tower (this tower is literally burned in the 1937 film *Yeban gesheng* [*Midnight Singing*], cowritten by Tian Han). This artist's balcony supports the symbolist imagination yet is quickly ridiculed. In *Torrent,* similar to *Raging Flame,* also made in 1933, the balcony is configured in terms of both class and coloniality. It is located in the semicolonial urban space, within the foreign (Japanese) concession. The nationalistic and class critique of the privileged perception reframes an artist's self-critique as a response to the demand of the time: to merge with the masses. This merging is paralleled, however, by creative efforts to forge a medium of affect, by binding three notions of the medium: the crowd, natural forces, and film technology and techniques. I now turn to the cultural discourses regarding the question of the medium that help us resituate left-wing cinema and beyond.

The New Film Culture Movement and the
Question of Medium Specificity

While recent scholarship on left-wing cinema has adopted the alternative term "the new film culture movement," exactly what constitutes the "newness" of this movement is worth investigating. The effort to neutralize the political edge of left-wing cinema in this new naming attempt is not without irony. Chinese film historian Li Shaobai, one of the three authors of the canonical official historiography *Zhongguo dianying fazhanshi* (*History of the Development of Chinese Film*), which anointed the use of "left-wing cinema," has proposed renaming it *xinxing dianying wenhua yundong* (the new film culture movement) in order to reconnect its historical reference and association with the Chinese Film Culture Association and address the movement's open-ended and heterogeneous nature.[38] This renaming is echoed in English-language scholarship on Chinese cinema. Yet the English translation of *xinxing dianying wenhua yundong* as "the new film culture movement" dissolves the historical political specificity of *xinxing* to the perpetual "newness" of capitalist modernity. Li Shaobai himself explains that this act of renaming "does not change the nature of the movement being led by proletarian culture and thought."[39] Regardless of whether this explanation is given as an act of self-censorship or implies any internal contradiction, *xinxing dianying wenhua yundong* evokes *xinxing's* historically specific connotation of "newly arising" or "emergent," which in China in the early 1930s referred to Soviet and global proletarian art after the Russian Revolution.[40] The immediate predecessors of the "emergent film culture movement" are the "emergent drama movement" (*xinxing xiju yundong*) and the "emergent art movement" (*xinxing meishu yundong*), both directly associated with global proletarian art and literary movement.[41] More specifically, *xinxing* is a translingual borrowing of the Japanese term *shinkô*. In an article published in *Shalun* (*Siren*) in 1930, Ye Chen, pen name for the Japan-trained dramatist and later left-wing film director Shen Xiling, uses the term *xinxing dianying yundong* and identifies it explicitly with proletarian film (*puluo dianying*).[42] The same issue of *Shalun* also claims to provide the comprehensive forum for "emergent" drama, literature, art, music, and film. Similar to the Japanese Prokino film movement,

Shen suggests a "small-gauge film movement" (*xiaoxin dianying yun-dong*) to promote 16 mm films, pointing out their advantage in film-making and exhibition, the latter gaining mobility similar to that of the mobile theater (*yidong juchang*).

This connection of the new film culture movement with global proletarian literary and art movement, as well as its close affinity with Japan, suggests a new possibility to reassess the Chinese left-wing film movement in comparative perspective.[43] This exchange was facilitated by the human traffic across national borders—the core members of both left-wing and non-left-wing film advocates, such as film critics and screenwriters Xia Yan and Zheng Boqi, filmmakers Shen Xiling and Xu Xingzhi, and soft-film theorist and screenwriter Liu Na'ou, were trained in Japan—as well as circulation of knowledge through a global network of print culture. In Lu Xun's translation of excerpts from Iwasaki Akira's *Film and Capitalism,* he identifies his source as the Japanese art journal *Shinkô geijutsu* (translated in the article as *Xinxing yishu*), to which he had obvious access.[44] Lu Xun, of course, famously befriended the Japanese book merchant Uchiyama Kanzo (1885–1959), who stayed in China from 1917 to 1947 and owned the bookstore Uchiyama shoten, a main venue for proletarian liter-ary and art publications. Liu Na'ou, the soft-film advocate, owned the bookstore Shuimo shudian, which sold leftist books and journals published in China, Japan, Russia, and beyond. In the 1930s around one hundred registered foreign bookstores were in Shanghai. Major Chinese presses such as the Commercial Press had imported for-eign books since 1914. Access to foreign books and journals through bookstores, university libraries, local educational centers, Christian missionary organizations, and individual subscriptions in a variety of languages, most prominently English, Japanese, Russian, French, and German, constituted everyday intellectual life in Shanghai, Bei-jing, Tianjin, and other major port cities.[45]

Such a global network of knowledge exchange brings out, how-ever, a second dimension of the newness of this movement that com-plicates its connection with the proletarian movement. The discur-sive battle between the two camps was entangled with the publishing industry, film production, and other social institutions in a much more complex picture and, hence, merits a closer examination.

Despite the labeling of leftist and nonleftist or proletarian and

aesthetic modernism, it is too often forgotten that the historical figures assigned to each camp had multiple professional and political identities and even worked together in the media industry. Two prominent examples were Zheng Boqi and Liu Na'ou. Zheng Boqi, a core member of the Left-Wing Writers' Association and Left-Wing Dramatists' Association, worked in a commercial publishing house and film studio while producing left-wing film criticism and screenplays. Zheng was a veteran writer and intellectual. An early participant in the Republican revolution (1910–11), he studied in Japan from 1917 to 1926 and launched his literary career a decade earlier as a core member of the left-leaning Creation Society (1921) and as founder of the Literary Association (1921) and later participated in the proletarian literary and art movement (1927). Between 1932 and 1935, Zheng was a screenplay writer for Mingxing Film Studio and an editor for the commercial press Liangyou Publishing Company. While a mutual dependence between Mingxing and the left-wing screenplay writers and directors revitalized the studio and provided a commercial venue for the writers to reach a broader audience, the publishing house of Liangyou offered a platform for both leftist and new sensationalist writings that with a cosmopolitan, urban sophistication, competed against mandarin duck-and-butterfly fiction. Even within the film journal edited by Zheng Boqi, *Dianying huabao,* published under Liangyou, the tension between "soft" images and "hard" verbal explications existed. Chinese literary scholar Ge Fei points out the "multiple cultural identities and orientations" of left-wing writers in Shanghai in the 1930s, especially after 1932, when left-wing culture permeated the industry and necessitated a mutual transformation.[46] In the case of Zheng, the different pen names he assumed in multiple professional capacities, as Ge Fei argues, registered the tension among the left-wing cultural intellectuals' multiple social roles, associated with distinct writing styles and political orientations.

It is often disavowed that, among the soft-film advocates, the new sensationalist writer Liu Na'ou himself had his "left turn" in the 1920s. He opened a bookstore in 1928, Diyixian (Front Line), and published the journal *Xinyishu* in 1929, both of which were banned by the Nationalist government for disseminating works with a strong Marxist tendency. His second bookstore, Shuimo shudian, established in 1929, was essentially a publishing house without a shop

front that published a wide range of books, including European and Japanese aesthetic modernist works, works by left-wing writers, and a book series on Marxist literary and art theory. The series includes, most notably, Vladimir Friche's *The Sociology of Art* (1926), which in 1930 Liu himself translated into Chinese from the Japanese translation.[47] Despite his alleged departure from his leftist tendency in the late 1920s, Liu continued to provide critiques on capitalism with a strong Marxist framework. In his essay "Ecranesque," beyond his interest in the medium specificity of film, he readily identifies cinema as "the 'registered commodity'" of "capitalist sentimentalism" and a "hypnotic drug" that provides urbanites a social, escapist "spiritual food" through which the sellers of such commodities reap tremendous profit.[48]

The "competing moderns" could be seen, then, not so much as a competition between opposing camps but as internal tensions within each camp. Shi Shumei has pointed out that Liu's embrace of seemingly contradictory texts and theories—the political vanguard from a Marxist standpoint and avant-garde aesthetic radicalism with a high-aesthetic and decadent thrust—were enabled by the Chinese modernists' interest in the equally new and vanguard character of both modernist practices. These elements, Shi argues, could be "wedded harmoniously" and afforded a possibility for "Chinese modernists to be anticapitalist (not necessarily nationalist)" and formally innovative.[49] Although these elements might not wed so harmoniously and may not be limited to the new sensationalist writers such as Liu Na'ou, I am interested in the convergence between both camps, in a radical cinema that registered modernist film theory and film aesthetics from a variety of contexts (western European, Soviet, American, and Japanese) while maintaining a critical political stance. I propose to treat soft-cinema advocates and left-wing film movement as two variants of the broader new film culture movement, yet specific enough so as not to neutralize and dissolve them into a commercial cultural horizon.

A third dimension of the newness of the new film culture movement was a medium consciousness shared by intellectuals from both camps about what constituted the cinematic medium and how to cope with its newness undergoing challenge. It is therefore constructive to consider how the two sides converged and diverged on

questions of the cinematic medium concerning film technology, aesthetics, and spectatorship and how their discussions informed and interacted with film productions at the time.

As a founding myth crucial to cinema's institutionalization, the international discourse of medium specificity has had a lasting impact on film studies as a discipline, until it was recently challenged by the rise of digital media. Although film scholars have started to question the material–technological "essence" of cinematic medium, which from a historical hindsight has proved to undergo perpetual mutation, new reflections on the question of mediality provide more insight into the crux of the debate between left-wing and non-left-wing film critics. Marie-Laure Ryan summarizes three major categorizations of medium: semiotic, material–technological, and cultural. Whereas the semiotic approach divides media in terms of sensory channels and codes, the material–technological classification encompasses the raw material supports and the elaborate technology. The third dimension, the cultural use of media, does not necessarily correspond to the semiotic and technological definitions and instead understands media in terms of social impact.[50] Seen in this light, the debate between the two film camps is not so much one between content and form as a divergent understanding of what constitutes the cinematic medium. But as I show, even on this point the line between the two camps is not clearly drawn.

Among the critics across the Left and the Right, Liu Na'ou probably most forcefully argues the specificity of the cinematic medium, which has been applauded by revisionist scholarship for turning the attention away from politics back to film itself. Yet for Liu, writing at the emergence of sound cinema and witnessing the full-scale transformation of film, the definition remains open-ended. Posing a question about film art, he conjectures, "Who says the theory of film art will stay unchanged, when the time is ripe for color film, stereoscopic film, and television [*diansong yingxi*], and when other technologically bound dimensions of film come to fruition and are widely exhibited?"[51] Still, he tries to provide a tentative definition: "Film art takes as its aim to express the form and content of every aspect of human life and appeal to the human emotions, whereas this purpose is fulfilled only by a camera and a recorder/radio."[52]

Liu's interest in the art of cinema continues and departs from

the discourse of medium specificity that arose in China in the mid-1920s, when discussions of film as art entered the Chinese film discourse just as cinema emerged as a new media institution. In a dual move not so different from 1920s film discourses in Europe and in the United States, cinema was considered as both aspiring to established arts and distinctive in itself. While embedded in the global discourse of cinema as the seventh art—or in the Chinese case, often the eighth art, as it was called via Japanese mediation—the discussions generated conflicting and contradictory definitions of cinema.[53] The question of the cinematic medium was never treated as merely a question of cinematic technology and aesthetic techniques; more often, it concerned spectatorial affect and the industrial, moral, and political function of film.

In the 1930s, increasing attention was paid to the question of film technology and filmmaking techniques. If cinema had been born twice—first as an extension of existing media and then as an assertion of its own independence—as André Gaudreault and Philippe Marion argue in their genealogy of media, 1930s film discourse in Shanghai did mark the shift from an interest in film's symbiosis with other media to a conscious self-differentiation. In a collective review of Fei Mu's film *Chengshi zhiye* (*The Night of the City*, 1933), the left-wing critics called for an end to cinema's prolonged dependence on drama: "Film should contain its own artistic specificity. It is not drama in disguise, nor should it be the extension of drama.... Now that cinema has reached its maturity, it should try to develop its own specificity instead of subsuming itself to drama."[54] Although "drama" in this context remained a vague category, encompassing both theater and dramatic narrative, film's distinctive features were seen as departing from the hyperdramatic narrative to portray "fragments of life through powerful contrast," through montage.[55]

This attention to the medium specificity of film as determined by its technological and aesthetic singularity was exercised in the demand for specialized knowledge for film criticism and film studies. In this regard, the two camps had similar inclinations. Despite the reified narrative of the divide between left-wing and soft-film critics on content versus form, left-wing critics, such as Zheng Boqi, repeatedly called for informed criticism, asking critics to conduct research

on the production and aesthetics of film. Explicitly encouraging interaction between film practitioners and critics to research film art, Zheng asked for collaboration from producers and exhibitors to provide critics and scholars opportunities for previews and extra time for film viewing.[56] He critiqued a simplistic thematic reading and, in his own example, followed the most recent innovations in film technology and aesthetics while remaining sensitive to the films' social significance and the impact of the market. For Zheng film criticism should not be merely destructive but should find ways to be constructive, and hence, mere ideological critique would not suffice.[57] Zheng was not alone. His focus on "constructive" film criticism echoed a collective call by left-wing film critics and filmmakers to shift to constructive critiques engaging with film editing, technology, and performance.[58]

For Liu Na'ou the material–technological base of cinema predetermines its unique art. Posing cinema as the product of the "interracial marriage" between science and art, he understands its modes of expression as inherently mechanical. Emphasizing motion as the key element of the "cinematic Esperanto," Liu cites, from psychologist and classical film theorist Hugo Münsterberg, the distinct advantages of film over other arts: the use of location shots, quick changes of scenery, the reorganization of time and space through cut-backs and parallel cutting, the manipulation of speed, and various effects created by close-ups, double exposures, and so on. Liu lists camera angle, movement, and editing as modes of "mechanical description" but also includes new developments such as "close-ups" in time (slow motion) and "close-ups" and "fades in and out" in sound (amplification).[59] Such "mechanisms" of description should be the basis of film art and give filmmakers a distinct privilege over practitioners of other arts. In "Ecranesque" Liu calls the specific nature of cinema *yingxide* (characteristic of shadow play), or *cinégraphique,* a term borrowed from early French film theory as well as Soviet montage theory, which I discuss in detail in chapter 4. In an emphatic negative definition, he stipulates *yingxide* as "nonliterary," "nondramatic," and "nonpainterly."[60] Describing the medium specificity of film as the art of motion, the play of light and shadow, the effect of camera work, and the interplay between image and sound, Liu observes how cinema educates the human senses:

From its very beginning, film cultivates the "divine percep-
tion": it educates our eyes, enhances our technology of "see-
ing," and teaches us to comprehend the symbolic meaning
of the screen/scene in an instant. Its role is to create illusion
and attract the audience's thoughts and consciousness to the
narrative track moving fast on the thin membrane [*bomo*] [of
the celluloid]. Hence people call film "daydream," which is
the unique effect of the camera's distinctive quality.[61]

The particular impact of film on human perception is a direct result
of the technology of the moving camera, which contains the extra
power of observation:

The camera has an additional eye besides the eye of the
photographer. This eye can observe an entity objectively
from every perspective and capture on its retinal membrane
[*yanmo*] every subtle shadow and movement of the object.
The camera can perceive "meanings beyond words" and pre-
sent any state and process that escapes human vision. Accord-
ingly, the camera is not merely the illustrator of the original
story or screenplay, but is the creator of its own.... But this
unique quality of the camera will not sustain its own creative
life without its collaboration with the miraculous *Montage*.[62]
(italics added for English in the original)

Liu's explication of the power of perception beyond human vision
was part of an enduring trend in international film theory that Mal-
colm Turvey calls the "revelationist" tradition. Examining classical
film theorists such as Jean Epstein, Dziga Vertov, Béla Balázs, and
Siegfried Kracauer, Turvey points out their shared distrust of human
vision, a skepticism in favor of mechanical perception. Turvey traces
their shared investment in this revelationist tradition to the develop-
ment of modern science, the "cult of the machine," romanticism, and
Bergsonian philosophy, resulting in an almost "religious" belief in
cinema's magical power to reveal the extra dimension of reality that
transcends human vision.[63] This revelationist tradition played a key
role in the discourse on medium specificity; meanwhile, the faith in

cinema's perceptual power was based on both the machine and the particular aesthetics derived from it.

Yet despite Liu's emphasis on film's medium specificity in terms of its technological base and related techniques, the other term he uses, *écranesque,* provides a much broader definition. Although now obscure, *écranesque* appeared in 1920s French film discourse, often used as a synonym of *cinematographique* to describe the quality of film.[64] It is worth noting that instead of "Cinégraphique" Liu chose "Ecranesque" as the title of his essay. As an overarching term, it allows Liu to discuss materially determined film aesthetics as well as questions of spectatorship and politics. Acknowledging film as the product of capitalist exploitation of visual pleasure, Liu nevertheless recognizes the value of this "hypnotic drug" while asking, "Without film's hypnotic sentimentalism, its irrationality, fashion, intellectual tastes, romance, and fantasy, wouldn't this favorite object of modern men become a desert?"[65] In the enigmatic ending of the essay, he differentiates spectatorial modes in terms of the audience's social profile: bachelors watch films in contemplative connoisseurship; romantic couples enjoy the film; and the group audience watches in a state of distraction.

Liu's notion of *écranesque* thus engages what Marie-Laure Ryan summarizes as the three dimensions of media—the semiotic, material–technological, and cultural—despite his emphasis on the first two. Indeed, the debate between the two film criticism camps often revolved around these three understandings of media. Whereas the left-wing critics were known for emphasizing political, social, and economic analysis, the non-left-wing critics were often cited as favoring the material–technological in their exegesis.[66] Such a divide is, of course, necessarily reductive. Just as left-wing film critics expounded extensively on questions of montage and cinema's material bases, some of them even experimenting with sound technology and sound aesthetics, the soft-film critics were highly aware and critical of cinema's social function, although with a different purpose. In this sense, when examining their debates with critical and historical hindsight, one should not fetishize the soft-film critics' emphasis on medium specificity by taking the term for granted. That specificity, as Liu Na'ou acknowledges, cannot be fixed, just as film technology and its material bases keep evolving and challenge us to

understand cinema anew. Meanwhile, the deliberately reductive understanding of medium as its material–technological dimension is clearly an equally political gesture, which offers insight into left-wing film critics' reluctance to separate the political and social aspects of media from the semiotic and material. It is by investigating left-wing cinema's edge in terms of the three "newnesses" of the new film culture movement—its radical political stance, its imbrication with opposing camps in social institutions and shared interests in formal and political innovations, and its reflection on media ontology, aesthetics, and politics—that I return to the actual film productions.

Cai Chusheng's Politics of Medium Specificity and Intermediality

The tripartite concerns about the nature of the cinematic medium were shared by filmmakers, whose film practice carried on an intimate conversation with the debates and discussions. From this period Cai Chusheng's films are particularly worth revisiting, for they showcase a continuing interest in engaging the three dimensions of medium in conversation with opposing film critics. They also help us understand the distinct "newness" of left-wing cinema.

In the first issue of *Modern Screen,* a film journal established by Liu Na'ou that provided a forum for left-wing and non-left-wing film critics and filmmakers, novice director Cai Chusheng published the lyrical prose piece "Zhaoguang" ("Light of the Dawn").[67] In it a first-person narrator awakens from a "horrific nightmare" with the disheveled hair of an artist. He dashes to the end of the hallway and welcomes the "first beam of dawn light in 1933." With the residue of the fog of 1932 receding, he notices that the morning light has entered through one of the small glass panes of a slightly opened window, and the light, "as if being cut squarely, is projected straight onto the ground." For a while the narrator stays in the hallway to watch the struggle between the cold but refreshing morning air and the interior heat mingled with dust. He tries to intervene in the battle with his own breath, but his effort proves futile. The morning air eventually wins and blows open the entire window. The narrator, shivering but stimulated by the cold, steps forward and opens another window. Then the symphony of the metropolis floods in:

The remote roaring of the first trolleybus from the factory; its
approaching noise, and then the honk of its electric horn . . .
the monotonous shouting of the tricycle drivers . . . the yelling
of rickshaw boys . . . the clanking of small carts being pushed
forward . . . the shrieking of the factory steam whistle . . . the
next-door shuffling of mahjong after all night long's play . . .
the snoring of those who are still in bed. . . . In this split
second under marvelous observation, these sounds criss-
cross and weave a city symphony. . . .

Out the window, the pinnacles of the city's grand archi-
tecture penetrate the clouds like aligned pyramids; their
golden edges shine brightly in the morning light. . . . In the
factories along the river, tens of thousands of workers bur-
dened by life are rushing to work. . . . The forest of giant
chimneys sends up black smoke that devours the sky. . . . The
walls are pasted with disorderly *haowai* newspapers [extra
papers for breaking news] whose characters sting the eye. . . .
These observations, albeit collected in a brief moment, are
enough to alert us that the year of 1933 heralds the arrival of
a prodigious epoch!

Morning Light! Bright Light of the Dawn! After I com-
prehend this grandiose revelation, my heart is humbled and
trembling! Please forgive me! Let me forget all my past and
start my future![68]

In this highly allegorical New Year's resolution, Cai Chusheng
puts forward his own position in the field of Chinese cinema. Stand-
ing at the window at the joint between upstairs and downstairs, he
cannot interfere with the great struggle of inside and outside, the old
and the new, but he can at least assist the great cause once its arrival is
proclaimed by opening another window. While the "divine" light of
the day is blocked and tailored to fit the glass of the window and then
projected onto the ground—an allusion to the light beam behind the
projection box in an enclosed and regulated space—the great force
of the morning wind lets in a whole world from without and, first and
foremost, the symphony of the city. The first beam of light in the year
1933 heralds the grand entrance of sound and a whole perceptual and
social space previously excluded. Cai's modernist conception of the

urban noise as a city symphony is mediated by films such as Walter Ruttmann's *Berlin: Die Sinfonie der Grosstadt* (*Berlin: Symphony of a Great City* (1927), Dziga Vertov's *Chelovek s kino apparatom* (*Man with a Movie Camera*) (1929), Joe May's *Asphalt* (1929), King Vidor's *The Crowd* (1928), and Paul Fejös's *Lonesome* (1928)—city symphony films and city films shown in Shanghai in the early 1930s. More important, not only does sound bring into the movie theater the hustle and bustle of a modern industrial city, but these urban noises also animate the images and make them fuller, with greater depth and social dimensions. At the center of this revitalized scene is the hitherto absent crowd of industrial laborers, swarming onto the screen with energy and the force of social critique. The entrance of sound is conditioned simultaneously by the opening of the window; this new perceptual dimension of cinema promises more immediate access to reality without the mediation of the glass.

Cai Chusheng's text makes a grand statement of his own transformation in the age of sound and social activism. Cai's film career began with an interesting connection with the Huaju Studio. A native of Canton, Cai (1906–68) worked as a shop apprentice in Shantou, Guangdong. He joined the clerks' union in 1925 and started participating in social activities, including part-time drama performance, writing, and painting. He was cast by Huaju director Chen Tian as a minor character in the comedy *Daiyun* (*The Simpleton's Luck*, 1927), which features a Charlie Chaplin impersonation.[69] The film was made as a side product in collaboration with local drama and film enthusiasts during the Huaju crew's travel to the Shantou area to shoot *The White Lotus*. Cai went to Shanghai the same year and apprenticed with Huaju, Tianyi, and several minor film studios. He worked as a screenplay writer, actor, and assistant director before joining the Mingxing Studio in 1929.[70] There, he acted as assistant director for veteran film director and screenplay writer Zheng Zhengqiu on six films.[71] In 1931 Cai was recruited by the Second Lianhua Studio and started directing his own films.

In his prose in *Modern Screen*, Cai refers to 1932 as a year heavy with fog, a nightmare from which he awakens. That year was indeed pivotal in Cai's career and brought several ups and downs. He made his first three films, *Nanguo zhichun* (*Spring in the South*, 1932),

Fenhongse de meng (*Pink Dream*, 1932), and *Gongfu guonan* (*Together for National Salvation*, 1932), and gained increasing recognition. Yet his film *Pink Dream* was severely criticized by left-wing film critics. In a series of articles published in the column "Meiri dianying" ("Daily Films") in *Chenbao* (*Morning Daily*), a major forum for left-wing film critics, *Pink Dream* received sharp comments for its "imported modern"—that is, its copying of Hollywood decor, luxury, and decadence—while remaining remote from social reality.[72] Critics were also dissatisfied with Cai's dichotomous positioning of the decadent modern girl and the virtuous wife. The male protagonist's reunion with the obedient and tolerant wife was considered a return to feudalism. In "When Do We Wake Up from the Dream?" film critic Lu Si asks the director to sober up from his "pink dream" that indulges in love triangles as leisure entertainment for the gentry class.[73] These repeated wake-up calls contributed to the social pressure that forced Cai to declare his departure from 1932's "heavy fog" and "horrific nightmare" in the 1933 essay.[74]

These criticisms were, of course, highly polemical. With a group imperative to urge filmmakers to engage social reality and portray the lower classes, the critics were impatient with any alliance with bourgeois ideology, especially the decorative "look" of cinema. To be fair to Cai Chusheng, *Pink Dream* is more complex in its treatment of women than the critics claimed. The wife might be "feudalistic," but she is also well educated and self-supporting. After her husband's departure, she leaves for the countryside to work as a teacher and then returns to provide him with financial support by writing a novel based on her experience, yet publishing it under her husband's name. The reconciliation twists the feudalistic ideal with a reversal of the traditional gender roles, although the film compromises the wife's independence with her unconditional love and sacrifice. The film establishes several well-executed visual motifs that return in Cai's later films: visual rhyming, the dance hall as a prominent spatial trope, and the use of photographs as a self-reflective device. These were recognized by one of the reviewers, Xi Naifang (a pen name for Zheng Boqi), who applauded the film for its economic and creative film aesthetics.[75] These merits were considered minor, however, compared with the ideological problems of the film.

The Left-Wing Sugarcoat

Cai's "Light of the Dawn" was a timely response—not only to pub-
licize his resolution but also to promote his new film. The text was
published in March 1933, the same month his film *Duhui de zaochen*
(*Dawn over the Metropolis*) was released. The sound-and-image
stream that breaks through the glass window in Cai's prose closely
resembles the opening sequence of that film: the arrival of a trolley-
bus is followed by a street scene of people hurrying to work, and
then, a steam whistle placed at the center of the screen dissolves
into a large crowd of workers swarming into the factory. The next
two shots show the rhythmic movements of the machine and then
human laborers pulling a cart of wood. Opening with familiar motifs
of the city symphony films—crowds, traffic, and the machine—but
set in the specific locale of Shanghai, with a comment on industrial
labor, the film has a melodramatic plot, with two brothers brought
up in two different families, one rich, one poor, distinguished by dia-
metrically opposed personalities and social outlooks. This arrange-
ment, similar to Tian Han's doubling of characters in *Dances of Fire*
for socially opposed roles, was to be repeated in Zheng Zhengqiu's
Zimei hua (*The Sisters,* 1934) a year later, a familiar narrative privileg-
ing class over blood relationship.

Dawn over the Metropolis received rave reviews, not only for Cai's
determination to "write about the life of the lower class" but also for
the montage method he deployed. As Ke Ling and Yi Wen write:

> Each shot is aesthetically composed. The *Camerawork* that
> connects each shot and each scene is superbly clear. The
> *Rhythm* of the whole film is like a flowing symphony without
> any encumbrance.... The director has deployed the full ca-
> pacity of montage.[76] (italics added for English in the original)

Three different types of montage can be distinguished in the film:
the first for visual rhyming, the second for structural contrast, the
third for optical effects, as in the kaleidoscopic shots at the ballroom
party. In the last case, Cai experiments with prismatic shots of the
scene, which may have been inspired by the Busby Berkeley musicals
highly popular in Shanghai. He follows the aerial shot of the table

with six-way kaleidoscopic images of fragmented human faces. The kaleidoscope motif and the ballroom scenario recur in Cai's wartime films with a most interesting variation. The political implications of these kaleidoscopic shots remain ambiguous. The highly surgical interventions of human perception distort the human faces to the point of absurdity and carry much political satire about the upper class, consistent with other uses of montage in the film. They also become "attraction shots," however, that cater to the audience in a different way.

The question of attraction recurs with a conscious reflection on cinema in two striking sequences. The rich man's son, Yuan Cong-mei, feeling bored at his father's office, starts playing with a flip book. As the pages turn rapidly, an animated "film" appears on-screen showing a woman punishing her male pursuer with her umbrella. Tired of the flip book, he opens a movie magazine with two full-size photographs of Hollywood stars, one male and one female. Staring at them for a while, Yuan smiles, takes the chocolate from his mouth, and applies it to each of their lips. He then closes the magazine to let the two stars perform an actual kiss, with chocolate sticking the two faces together. The next shot shows Yuan moving the page with the woman's photo up and down so that the woman's chocolate-smeared mouth smudges the man's face.

These two consecutive sequences, self-reflective about the making and reception of cinema, provide two distinct understandings of cinematic affect. The flip book sequence offers a scientific interpretation, showing the moving images as the result of still pictures successively displayed at regular intervals, creating an automatic sensation of motion. The magazine sequence posits, however, the socialized spectator as the anchor of affect. The flat images are animated not through scientific regulation of time but by sensorial attraction built on cultural conventions and the viewer's social experience. This affective power derives from heterosexual eroticism initiated through the codified gesture of a kiss and the connotation of chocolate as the candy of love. The power of such attraction also draws on the ideology of realism inscribed in the continuum of photographic image, stardom, and cinematic paratexts, such as movie magazines nestled in a commodified film culture. At the same time, the sequence suggests an analogy between cinema and sensorial gratification, not so

remote from the alleged soft-cinema motto that film is "ice cream for the eyes."[77] Through a sarcastic comment on Yuan's decadence, this self-reflective and physiologically reflexive moment delivers an understanding of spectatorial affect as both automatic and socially conditioned, integral to the culture of consumption. Just as the still images of the film stars are animated through the material link of their mutual attraction, the audience (Yuan) defers the sensorial gratification of chocolate in favor of cinema and, hence, equates the two sensual attractions.

Playing for eighteen consecutive days, the film broke Chinese box-office records and was positively received by the critics. It seems, though, that what critics had previously targeted as Cai's indulgence in the "pink dream" had not fully disappeared: the dance hall scenes, the love triangle, and the "imported modern" decor are still present, although reorganized through a consistent system of contrast along class lines. One year later, Cai Chusheng made *Yuguangqu* (*Song of the Fisherman*), a hit that broke a new box-office record, running for eighty-four consecutive days. Cai affirms his concern about the audience for his films: "The most important precondition for a good film is that it can interest its audience. . . . Hence to facilitate the audience's acceptance of a director, one has to sugarcoat the correct idea so that the audience interest can build to accept it."[78] He also admits that the workers and peasants were unfortunately not able to see films and that the movie audience remained predominantly petty urbanites. Cai's attention to the audience and his pragmatic understanding of their social demography bring his left-wing film practice much closer to soft-film critics' understanding of cinema. Yet if he "sugarcoats" the screen with chocolate, or elements of the "imported modern," he brings his petty bourgeois audience a little too close to home through the double consciousness of "attraction." By positing his audience simultaneously in and outside the position of Yuan, his antagonist in *Dawn over the Metropolis,* he engages cinematic affect as both gratifying experience and object of satire.

The New Woman: Cinema's Medium Violence

Although photography and flip books are treated as prototypes of cinema in these films, in his celebrated *The New Woman* (1934), Cai

approaches photography and other media in deliberate contrast to cinema to foreground the latter's political function. The film portrays the downfall of a young and attractive woman, Wei Ming, from an aspiring music teacher and writer to forced prostitution and suicide as the double victim of patriarchal society and mass-media sensation. In this film photography and newspapers are staged as two media competing against cinema, contributing to and exploiting the surface culture of display. Photography figures prominently as a key material object circulating in the four diegetic spaces: the public space in the publishing house and the press bureau; the private interior of Wei Ming (played by the silent screen diva Ruan Lingyu); the comprador's household; and the transitional and ambiguous spaces between public and private—the train and the hotel that Wei's daughter from an earlier marriage occupies.

In the first three spaces, Wei's studio photograph—female star Ruan Lingyu's publicity photo—circulates in the public and private domains as a consistent symbol of the commodification of female glamour, perpetuating a culture of surface display and erotic consumption. This image is however undercut by another photograph being examined on the train by her innocent child. As the child demands to know about her mother, her aunt reluctantly takes out a wedding photograph, at which point the still image dissolves into a reel of film about Wei's hidden past.[79] In a cartoonish and sketchy recapitulation, the film within the film narrates an educated Ruan's pursuit of free love against the will of her feudal family, ending with a failed marriage, an innocent child, and her departure for Shanghai. This minifilm is executed strikingly without intertitles, relying on highly codified spatial cues and objects: an ancestor's tablet (patriotic authority), scissors and ropes (suicidal instruments to maintain female chastity), a wedding ring and gown (Westernization), the urban tenement attic (for petite bourgeoisie), and the traditional household. Effectively executed by this elliptical and schematic film narration, the flashback ends by returning to the child, who now gains a depth of knowledge beneath the photograph's surface. Notably, film, often treated as the ontological extension of the photographic medium, is now presented as its antithesis. Through the moving image, performance, and editing, an understanding of the photographic image is eventually obtained beyond the surface depiction. Emblematically,

the sequence ends with the child violently defacing her father's image and tearing it apart from her mother's image (Figure 3.5). In an act of medium violence, the child throws away the bad object and selectively retains the good partial object in collaboration with cinema.

This contrast between photography and cinema recalls Pudovkin's comparison between the photographic and the cinematographic, asserting the latter as a radical reconception of reality through reorganization of space and time, which I discuss in more detail in Chapter 4. The technique specific to cinema would be montage.[80] By contrasting photography with cinema in a way similar to Pudovkin's, in aligning their respective medium specificities with their epistemological power, Cai emphatically differentiates film from journalism, which is shown providing a "fake depth" to the photographic surface image by perpetuating a scandalous culture of display and voyeurism at the expense of people's lives. The moment when the newspaper reporter Qi Weide "reports" feverishly at Wei Ming's deathbed is particularly poignant; as Kristine Harris incisively puts it, it "does put the print media on trial."[81] The condemnation of the newspaper, like that of photography (though more selective), is carried out physically in an act of violence. Toward the end of the film, as the dawn arrives, the newspaper, titled *Shimin yebao* (*Urbanite's Evening News*), is thrown out of the car as "yesterday's news" (*jiuwen*) and stepped over by marching female workers. Whereas the news is devalued by time, the cinema asserts itself with lasting impact (Figure 3.6).

If the cinematic medium is deliberately pitted against other cognate media, such as photography and newspapers, sound as a novel medium is introduced as highly politicized. In this film, sound is sparingly given only to the machine and the collective female voice. In an elaborate sequence intercutting between Wei Ming at the nightclub and her friend A Ying, a female worker and teacher, the film contrasts the nightclub singer with the singing female workers. The moment the singer at the dance hall opens her mouth, the film cuts to A Ying and the night class for union workers at the silk textile factory, denying the audience the pleasure of the "decadent" song "Taohuajiang" ("Peach Blossom River").[82] Instead, the film cuts to the classroom and the collective singing of the female workers. A wipe appears from the bottom of the screen, moves upward, and stops two-thirds of the way, leaving the moving image of the singing workers juxtaposed with

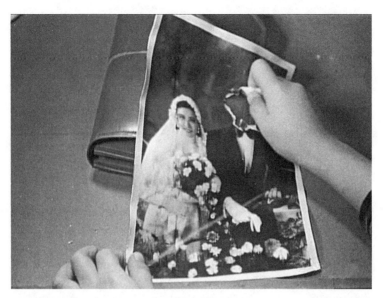

Figure 3.5. Medium violence. The child violently defaces her father's image in the wedding photograph. Film still. *The New Woman* (1934).

the cityscape on a diagonally split screen. Whereas the woman's singing in the previous scene is confined within the dance hall/nightclub, the female workers' singing voices permeate the city, creating an assertive soundscape reframing the colonial landscape. The singers are positioned at the top-left corner, above the city, which occupies the center and right bottom of the screen. As the images unfold on both sides of the diagonal line, two sets of montage simultaneously operate: the two parallel film sequences are each edited constructively. Meanwhile, they create a dialogue across the division. In the cityscape sequence the camera pans with a high-angle shot of the angel of peace overlooking the bund, with the rest of the panorama constructively achieved through elliptical montage editing: the camera pans to reveal imposing neoclassical and art deco buildings, trolleys, foreign ocean liners and battleships, and a bronze lion, all juxtaposed with the female workers singing. In a brief but powerful constructive montage, the bronze lion at the Hongkong and Shanghai Bank Building is intercut with the battleship and then reappears, juxtaposed on the split screen with a close-up of A Ying's face leading the collective

Figure 3.6. Yesterday's news. Newspaper stepped over by marching female workers. Film still. *The New Woman* (1934).

singing (Figure 3.7). The lion first appears in a long shot intercut with an ocean liner, and in the second shot, the lion fully occupies the lower part of the split screen, this time intercut with a battleship with its cannon occupying the focal center. Through this double montage between A Ying's singing and the lion/battleship intercut, the lion, a symbol of colonial military prowess and economic exploitation, its roaring mouth at the focal center, dramatically changes its meaning. The visual and acoustic simulation of "roaring" evokes the phenomenal success of the stage play *Roar, China,* based on Sergei Tretyakov's 1929 play staged globally in the Soviet Union, the United States, Japan, and various cities of China, including Shanghai in 1933. By then, the central stage setting of the foreign battleship and the acoustic metaphor of roaring had gained iconic status, circulating across a variety of media, politicizing the voice.[83] Through this double montage—being associated with both the battleship (foreign power) and female singing (colonial subjectivity)—the lion gains an anticolonial subjectivity, animated by the female voice. The sequence ends with the steam whistle at the factory at the center of the screen

superimposed onto factory cranes, onto chimney stacks with black smoke, and then onto the crowd. The whistle, accompanied by the steam, magnifies the sound of the machine with a sound-and-image montage that resonates with what Cai writes in "Zhaoguang" and the opening scene of *Dawn over the City*. The human voice is sublimated by the machine, giving privilege to the sound as a technological product. The whistle also resembles the microphone, as if giving voice to the singing women from the first place. The voice and the whistle are superimposed to create a metaphoric resonance, identifying the female singers with the factory crowd.

In contrast to this politicized, collective voice, which returns at the end of the film to the same sound-and-image montage, this time with the factory crowd, Wei Ming remains silent but distinctly articulate. On her deathbed, upon reading in the tabloids about her suicide, she protests in large written characters, "I want revenge; I want to live," her last words, delivered in "silent speech." As Kristine Harris astutely puts it, the film favors "the silent visual gesture of cinematic and theatrical 'showing' as more reliably authentic than the journalistic 'telling' of gossip and public opinion."[84] Yet in 1934, the last year before the total conversion to sound in the Chinese film industry, it was also possible to read her last words, "I want to live," as an aesthetic reflection of the silent film medium, threatened but seeking an emphatic resurrection. Her expression is made particularly powerful by the use of animated, enlarged characters advancing aggressively outward to the screen, toward the audience (Figure 3.8). Although her silent exclamation is soon taken over by the sound of the collective, a strange continuum between sound and silence arises in the aesthetic production of affect. As the film repeats the imagery from an earlier sequence, with the monumental factory machinery, chimney stacks, and an iconic steam whistle superimposed on the crowds, sound is brought out as a synesthetic medium, conjoining the energy of the steam and the crowd and the factory in a sound-and-image montage (Figure 3.9). Just as Wei Ming's silent voice is articulated through the superimposition upon her convulsive body of enlarged characters in motion, the full force of sound is achieved only when it is brought out as synesthetic energy in an emphatic montage aesthetic. This aesthetic, while reflecting upon silence and sound as two media, delineates a clear political message.

Figure 3.7. Crosscutting between the split-screen montage of A Ying's singing juxtaposed with the lion, the battle ship, and back to the lion. Film stills. *The New Woman* (1934).

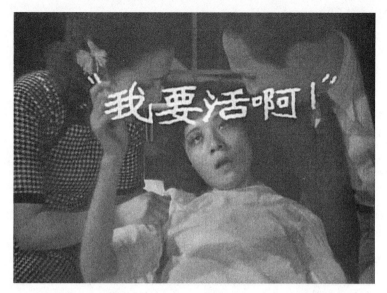

Figure 3.8. Silent cry. Wei Ming's cry, "I want to live," appears as animated, enlarged characters advancing aggressively toward the audience. Film still. *The New Woman* (1934).

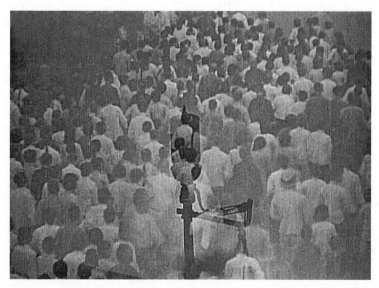

Figure 3.9. A factory steam whistle superimposed on the crowds. Film still. *The New Woman* (1934).

Cai Chusheng's politics of medium specificity and intermediality complicate the media genealogy proposed by André Gaudreault and Philippe Marion, who describe cinema's two births—from the emergence of a medium to its constitution—as a shift from a *spontaneous* to a *negotiated* intermediality. For Gaudreault and Marion, in the first birth cinema interacted with other media, as an extension and a subordination, spontaneously. In the second birth cinema recognized its own singularity, and its interplay with other media became a negotiated one as filmmakers' self-reflexive recognition of the medium's specificity coincided with its social and economic institutionalization. While Cai's films provide glimpses of such changing intermediality, allegorizing cinema as both an extension of and self-differentiation from other media, his treatment of the relationship between sound, image, and silence challenges the implied teleology in the genealogy of media. Sound and silent images are not seen as media antitheses but as operating on a continuum whose medium specificities remain relevant and flexible rather than absolute. Cai's complex film aesthetics engaging sound-and-image montage, animation, and changing scales of images also demonstrate how the aesthetic and political uses of media transcend a technological determinism. In the next chapter I more fully explore this dynamic between silence and sound.

4 Transparent Shanghai
Cinema, Architecture, and a
Left-Wing Culture of Glass

In 1933 Chinese artist and essayist Feng Zikai (1888–1975) wrote a brief essay entitled "Glass Architecture," published in the modernist literary journal *Xiandai* (*Les contemporains*).[1] Having recently read some of German architectural visionary Paul Scheerbart's writings on the subject via Japanese translation, Feng contemplates the impact on human life of this architectural revolution.[2] For Feng, as much as for Scheerbart, architecture provides the immediate and essential living environment from which culture arises. To create a new culture, then, one needs to foster an altered architectural environment. Glass became the prime component because its transparent walls and ceilings eradicate the sense of enclosure, isolation, and bourgeois pretensions. Referring to existing Western and Chinese architectural models such as draped cages and sheds, Feng anticipates a brave new world in which, without blocked vision and isolation from the natural environment and human neighborhoods, people could reconnect cosmic concerns with earthly preoccupations. Feng's utopian longing for a new world transformed by glass architecture situates him firmly within the Western high-modernist tradition, which Walter Benjamin similarly extols as a "culture of glass." In his essay "Experience and Poverty," written in the same year as Feng's piece, Benjamin reflects on how experience had become impoverished by the catastrophe of war, technology, and the capitalist economy, yet that moment also witnessed the birth of a new, positive barbarism built on the rubble of experience. Benjamin identifies this barbarism with the culture of glass and aligns himself with a new generation of modernist artists and intellectuals—the painter Paul Klee, the novelist Paul Scheerbart, the architects Le Corbusier and Adolf Loos, and the Bauhaus.[3] For Benjamin the virtue of

this new culture resides in architectural and artistic innovations in which transparency and nakedness triumph over bourgeois opacity, through the use of steel (Bauhaus) and glass (Le Corbusier and Loos) in architecture and, in painting, mathematical or machinic models that emphasize the skeletal structures of objects.

The parallel between Feng and Benjamin strikes a particular chord: the affinity between cinema and architecture. In the same essay Feng introduces cinema and architecture as the two dominant forms in modern art.[4] For him, compared with colossal and functional buildings, symphonic music appears trivial and incapable of satisfying modern men's materialist desires, whereas painting, already destroyed by cubist and futurist art, has dissolved into film. Benjamin focuses on the unique mode of perception characterizing both architecture and cinema: "Architecture has always represented the prototype of a work of art the reception of which is consummated by the collectivity in a state of distraction."[5] The connection between film and architecture is brought out even more forcefully by Sergei Eisenstein. In his article "Montage and Architecture," Eisenstein compares montage to architecture, identifying what cinematic montage achieves through time as being realized through space in architecture with a mobile spectator.[6] He even designed a film project between 1926 and 1930 entitled *The Glass House*. Setting his story in a modernist glass building inspired by Mies van der Rohe's design, he sought the perfect architectural analogy to montage, "a symphony of glass."[7]

In the Chinese context this affinity between cinema and architecture was vividly experienced at the rise of sound. The two sonic invasions, that of war and international sound cinema, provided an opportune moment for a new generation of modernist architects to design innovative movie theaters equipped with improved sound technologies. The immediate aftermath of the 1932 Japanese bombing of Shanghai destroyed major film studios and movie theaters, while the transition to sound demanded renewal of theater venues better suited for sound projection and insulation. As architects experimented with the building material of glass and innovative design to orchestrate reconstructions of vision and other senses, Chinese filmmakers were equally interested in new possibilities of perceptual transparency as they embraced montage film theory and practice to

radicalize perception after sound introduced a new dimension to film and film aesthetics. Montage, as I show in this chapter, enabled the filmmakers to construct their own film architecture by reorganizing Shanghai urban landscape to emulate modernist architecture design.

Glass transparency was, however, already in question. That the transparency of glass paradoxically housed a deceptive reality was a recurring motif in the left-wing film critics' debate with the bourgeois modernists. In the same year of 1933, Xia Yan published several essays under the pen name Luo Fu, one of which was entitled "Boliwu zhong toushizhe" ("Those Who Throw Stones in a Glass House").[8] Quoting the English idiom "People who live in glass houses shouldn't throw stones," Xia lists soft-film advocate Huang Jiamo's misrepresentation of the new generation of Chinese filmmakers, which in fact misses the target and ends up breaking his own glass house, portrayed as a space of illusion, isolation, fragility, and worse still, blocked vision. In another essay, "Baizhang le de 'shengyiyan'" ("The 'Business Eye' Afflicted with a Cataract"), Xia reverses Huang Jiamo's request for those from the opposing camp to enter the eye clinic and argues that it is the soft-film advocates who should be sent to the hospital—because the "business eye" they offer to the left-wing filmmakers is in fact afflicted with cataracts and thus limited in vision.[9]

Indeed, transparency seems to have been the notion at stake in this debate, though the term suggested rather different connotations to the opposing camps. While left-wing critics such as Xia considered transparency a violent act of exposure, soft-film critics such as Huang Jiamo and Liu Na'ou hinted at something more enigmatic and enchanting. In Huang Jiamo's provocative 1933 essay "Hard Film versus Soft Film," he considers the nature of cinema as "soft and transparent." Referring to the material base of film—the celluloid, with its flexibility and transparency—Huang interprets cinematic transparency in terms of a gentle, noninterventional access to the texture and vibrancy of reality.[10] Spectatorial pleasure and agency derive from cinema's pure reflection of reality without any compromise or distortion. In contrast, Xia's use of the glass house metaphor points out the seemingly transparent medium as always mediating. To illustrate this mediation, one has to resort to an aesthetic of exposure. Liu Na'ou calls such films *baolupian* (films of exposure), an

aspiring Marxist critique handicapped by censorship and immature filmmaking techniques.[11] Transparency for soft-film critics was, instead, not so much an exposure of reality as a reflection of life as it is, a commitment to the surface of reality, with its rich texture and full dimensions.

Soft-film critics' commitment to the surface of reality was derived from a dynamic mediasphere in which an expanded culture of glass generated mixed and conflicting promises quite beyond the modernist intent of glass houses. The fragile and cloistered glass house that left-wing film critic Xia aimed to break was not confined to a bourgeois movie theater but fostered by a much more expansive and vibrant modern consumer culture of display, celebrating the surface attractions of a commodified society. In this new culture of enchantment, glass enhanced the glamour of the commodity yet simultaneously functioned as a social barrier. As a modern everyday urban medium, it reflected and refracted, providing the consumer with an iridescent and disorienting space of phantasmagoria.

This chapter looks at the historically specific significance of transparency in 1930s Shanghai at the intersection of cinema and architecture at the rise of sound. Left-wing filmmakers' desire for critical transparency was embedded in and complicated by both modernist glass architecture and a material culture of glass. Glass had created a new mediating environment with promises of transparency by conflating the optical, spatial, critical, and sensual. Meanwhile, the increasing dominance of sound technology in international and domestic cinema forced the filmmakers to reflect upon the changing mediality of cinema and seek new strategies of political articulations. In this chapter I illustrate transparency's historical association with glass as a new building material and a perceptual medium and consider the dynamic interaction between Chinese architectural discourses and cinematic reflections in the mid-1930s evolving around a culture of glass closely affiliated with international modernist architecture and a commodity culture of display. Left-wing cinema interacted with other perceptual media, compelling audiences to reflect upon the sensorial intoxication produced by commodity culture. Architectural and cinematic discourses, produced in their particular semicolonial settings, competed with each other, claiming transparency that could transform perception, dwellings,

and sociality. Reclaiming transparency not as the exclusive material attribute of glass but that of aesthetic organization, left-wing film-makers theorized and practiced a unique notion of sound cinema as an alternative to the hegemony of Hollywood talkies, in effect questioning the intrinsic connection between perceptual transparency and material technology, including film sound.

Shanghai Glass Houses

Feng Zikai's discussion of glass architecture was situated firmly within the West, yet by the mid-1930s Shanghai had erected its own "glass houses" and become a main stage displaying a diverse range of Western-style as well as hybrid vernacular architecture. Western-style architecture had existed in China since the sixteenth century in Macau, Guangzhou, and Beijing as commercial buildings and exotic construction in the Imperial Gardens, although it was relatively isolated until the 1840s, when Western architecture was erected in the major port cities through three major venues: Christian missionary activities, foreign trade, and local dwellings.[12] Correspondingly, three types of architecture—Christian churches; colonial-style business, administration, and university buildings; and *shikumen*, vernacular residential buildings incorporating Western architectural elements—populated the Chinese port cities and hinterland from the mid-nineteenth to the turn of the twentieth century in various forms of compromise and integration with local building styles, materials, modes of construction, and everyday usage. Starting in 1900, a new wave of modern Western-style architecture—neoclassical buildings and eclectic modern styles—dominated major urban centers, until the early 1930s, when more functional modernist architecture entered the scene.[13] For Feng and many other Chinese, these buildings evoked mixed feelings. The neoclassical style, which adorned many banks and government buildings in major port cities such as Shanghai, Tianjin, Wu Han, and Chongqing, embodied the imposing and oppressive grandeur of modern capital, institutional authority, and colonial forces. Among these buildings, the Hongkong and Shanghai Bank Building (1923) featured in the film *The New Woman* was considered the most elaborate and perfected example. With its grand design of horizontal and vertical tripartite division,

three-story Corinthian columns, three-arched gate, and imposing dome, the building boasted ornate sculptural detail and luxurious interior design, adorned by two bronze lions imported from England at the entrance.[14] Standing prominently at the bund as the largest bank building in Asia, the building was frequently documented in film and photography, gaining iconic association with Shanghai as a semicolonial city.

Modernist architecture, in terms of both building design and critical discourses, entered the Chinese urban scene in 1927 and flourished for over a decade. Although modernist architecture remains an umbrella category covering a diverse range of practices, in its Chinese reception, often termed "modern architecture" (*xiandai jianzhu*) or "international style" (*wanguo shi*), architects and critics embraced it for its economical use of materials, industrial mode of production, and utopian social project (and hence its closeness to notions of functionalism and *Neue Sachlichkeit* [new objectivity] in Weimar Germany in the 1920s). In contrast to neoclassical buildings and the eclectic modern styles that continued to be built in the 1930s, the self-identified modernist architecture was radically streamlined, stripped of ornate details, and prone to use novel materials—steel, glass, and reinforced concrete.[15] Instead of emphasizing height and vertical energy, like many art deco skyscrapers, the functionalist buildings often highlighted their horizontal expanse and the interplay between visually and materially marked horizontal bars and vertical walls.[16] Glass was prominently featured in residential buildings, hotels, banks, schools, government buildings, and hospitals. The Wu Wentong Residence (1937), designed by the famous Hungarian architect Laszlo Hudec, consisted of three floors of large sunrooms with panoramic glass windows and a glass rooftop. Even Liang Sichen's design for the Beijing Jenli company, with characteristics of Chinese decorative details, was predominantly a functional building featuring large windows throughout and display windows on the first floor.

Applied in the spirit of rationality, hygiene, and enlightenment while privileging vision and electronic illumination, glass was used to mix rational design with democratic promise. The new bank and government buildings, instead of fostering credibility and authority through neoclassical grandeur and luxury, now relied on simplicity

of design and the use of concrete, steel, and glass to advertise transparency and efficiency as a new rational ideology.[17] Architect Yang Zhaohui, in an article on bank buildings, critiques the predominant neoclassical style for bank and government buildings. Instead of fitting particular architectural styles to different types of buildings, Yang argues, one should consider the spirit of the time and how pragmatic concerns best match the symbolic functions of different buildings. For banks, instead of the secrecy and mystery of the business in earlier times, the most important elements to symbolize would be solidity, security, and honesty.[18] This democratic claim presented a new dynamic between publicity and privacy. Many of the buildings featured massive windows of extended height and width on the ground floor, the main site of public activity, to enable two-way visual traffic; the upper floors, in both apartment and office buildings, used smaller windows to maintain some privacy and a more one-way visual access while still allowing glass to be the staple for transparency, rationality, cleanliness, and modern sensibility.

With its democratic claim and changing dynamics of privacy and publicity, modernist architecture carried a substantial ambition to reorganize human perceptual experience. This was staged vividly in the Hongqiao (Hung Jao) Sanatorium (1934), designed by Germany-trained Shanghai architect Xi Fuquan. The building featured not only large glass windows and doors for each floor but also a mathematically calculated line of vision: the spacious balconies, all facing south, allowing tuberculosis patients to receive maximum sunlight, were built in a receding line from bottom to top floors, with a partial shade made of reinforced concrete on each floor so that the patients could enjoy the sunlight while effectively evading any peeping from the people living one floor above.[19] The sanatorium is featured in the major architectural journal *Zhongguo jianzhu* (*Chinese Architect*), with more than twenty pictures of floor plans, three-dimensional perspective sketches, and actual photographs of the exteriors and interiors of the building, as well as a special "sunlight perspective drawing" (*yangguang toushitou*) detailing this design of directed vision (Figure 4.1). With its deliberate attention to architecturally framed vision, illustrated by this and several other perspective drawings as well as a photograph that highlights the exterior profile of receding floors and blocked vision from the top looking down, the

Hongqiao Sanatorium provides a perfect inversion of Bruno Taut's 1921 unrealized project for a movie theater for ill people in bed (Figure 4.2).[20] Taut, who believed film had a healthy influence on patients by intensifying their spiritual life, designed a movie theater with reclining seats in which the film is projected from the floor of the auditorium to the ceiling.[21] Treating cinema as a therapeutic institution to strengthen people's bodies through mental and intellectual stimulation, Taut designed the theater in the shape of an amphitheater to seat the sick spectators in a supine position. Both music and image sources are hidden (the projector at the bottom of the theater and the music/orchestra in the space below the seats); the image functions like a magical light next to a ventilation window. Assigning film the healing function of sunlight (at the sanatorium), Taut's design is thus in line with the hygienic discourse in German architecture in the 1920s and 1930s, which places a heavy emphasis on building in access to sun and air.[22] Whereas the images are shared in Taut's design with a carefully calculated line of vision and sound so that audiences can experience them without awareness of their actual source location, Xi's Hongqiao Sanatorium inverts the line of vision so that any potential voyeur sees only the concrete while every patient lying in bed or on a reclining chair enjoys the same sunlight. Xi's design realizes, then, a regular movie theater without darkness.[23]

By optimizing visual access to the "projected" sunlight and minimizing any prying vision, Xi's design positions the patients like a movie theater audience, performing a counterpoint to Taut's design with similar faith in light, hygiene, health, and modernist architecture. The yoking of sunlight, air, and vision as elements of health is seen in many of the photographs of the buildings, in which the glass windows are left open, letting in streams of light and air, in addition to the balconies' optimal exposure. A note about the restaurant situated on the third floor specifies how the design provides "sufficient light and air" with a pleasant gold-colored wall; plus, one could enjoy the beautiful scenery while taking a walk on the balcony to help digestion. To fend off dust, the interior walls in the patients' rooms are designed to form semicircular curves rather than straight corners. Mediated by photography and the format and publicity of architectural journals, the Hongqiao Sanatorium presentation exercises what Sigfried Giedion describes as "the fusion of landscape, point of

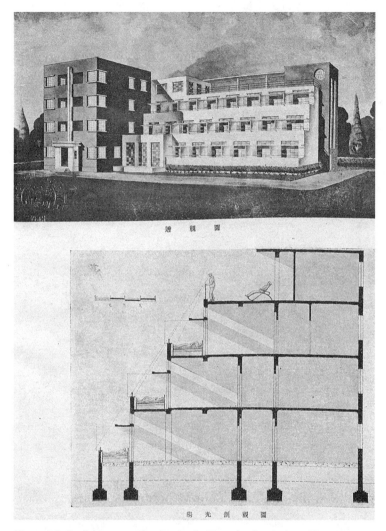

透 視 圖

防 光 剖 視 圖

Figure 4.1. Sunlight perspective drawing for Hongqiao Sanatorium. *Zhongguo jianzhu* 2, no 5 (May 1934): 9.

view floating above the ground, and solid architectural frame," with an emphasis on visual stimulation, psychological pleasure, and hygiene.[24] Equating architectural view with photographic vision, the design shows a photo of an idyllic view of the countryside from the south-facing balcony. The building also minimizes noise by using

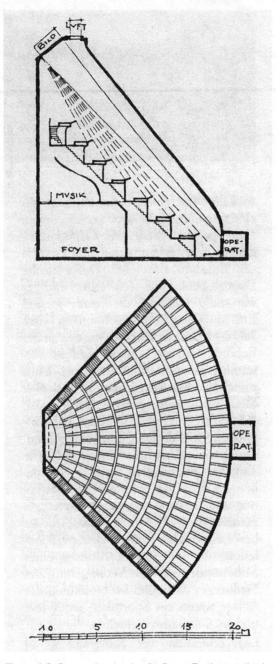

Figure 4.2. Perspective drawing for Bruno Taut's unrealized project for a movie theater for the ill people in bed. Peter Boeger, *Architektur der Lichtspieltheater in Berlin: Bauten und Projekte 1919–1930* (Berlin: W. Arenhövel, 1993), 21.

rubber floors, only the fourth building in Shanghai to do so, after the Shanghai Metropol Theater, the Paramount Dance Hall, and a prison hospital. Meanwhile, sound is restricted to an entertainment room with a radio, a piano, and newspapers. The healing power of light is mixed with a paradoxical yoking of publicity and privacy, turning architecture into a counterpoint of cinema.[25]

The year 1933 marked the rise of architectural journals, modernist buildings, and a new generation of movie theaters. Just as functionalist architecture in China heightened the coordination between vision and spatial construction—the rhythmic interplay between lines, building materials, and design components—architects designed a new generation of movie theaters, often featured in the same architectural journals advocating modernist designs. The Grand Theater (Da guangming daxiyuan, literally "Great Brightness Theater," 1933), designed by Hungarian architect Laszlo Hudec, is set apart from the neoclassical and eclectic modern styles by its geometrically orchestrated vertical and horizontal lines. The montage and rhythmic interplay of lines is also echoed in the theater's graphic design (Figure 4.3). Written in capital letters in English on a massive, semitransparent light tower, the letters of "Grand Theater" spread across the horizontal lines of the tower, playfully recalling musical notes on the staff. Large sheets of glass are used widely. Light is highlighted, as well, by the literal translation of the theater's Chinese name, "Great Brightness Theater."

The Metropol Movie Theater (Shanghai daxiyuan) was also built in 1933 (Figure 4.4). Designed by the Chinese architects Zhao Shen, Chen Zhi, and Tong Jun, who formed the company Allied Architects (Huagai jianzhu shiwusuo), the theater took thirteen months to build (starting in 1932) and cost 270,000 Chinese yuan, of which over 65,000 yuan was spent on infrastructure for electricity, water, heat, and air-conditioning.[26] While the description of the theater in *Chinese Architect* acknowledges the movie theater's liberal use of glass to "enhance its majesty" (*yizeng zhuangli*), the building also features a vertical neon sign of the theater's name in Chinese and English paralleled by eight vertical glass cubic columns filled with light that extend four floors, from the second floor to the top of the building. The glass columns, enshrining the theater entrance in contrast to the black marble beneath the neon lights, send forth a flood

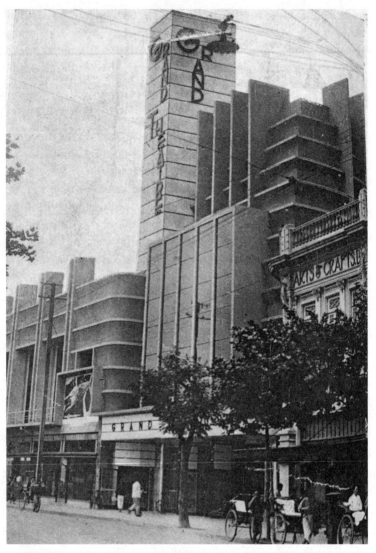

Figure 4.3. Grand Theater, 1933. *Shanghai daguan,* ed. Zhou Shixun (Shanghai: Wenhua meishu, 1933).

of light against the darkness of the night (Figure 4.5). The caption for the theater photograph reads, "Glistening with luster and vitality, it lifts the dispirited souls and awakens the dejected masses."[27]

The same issue of *Chinese Architect* features the Lyric Theater

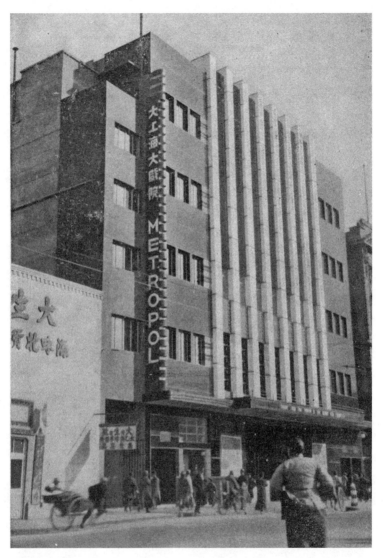

Figure 4.4. Shanghai Metropol Theater in the daytime. *Zhongguo jianzhu* 2, no. 3 (1933): 11.

(Jincheng daxiyuan), again designed by Allied Architects. While the building's semicircular curve softens the edges of the building, the light design echoes that of the Metropol with its vertical neon sign rhyming with the center part of the building, which is made of large

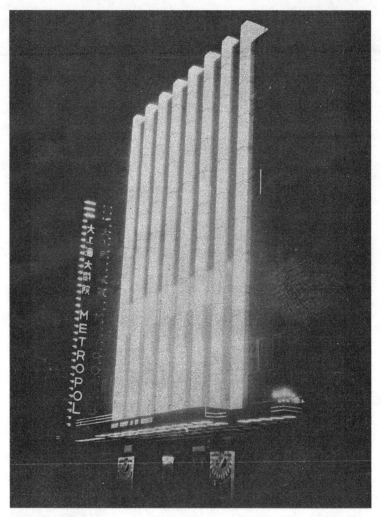

Figure 4.5. Shanghai Metropol Theater at night. *Zhongguo jianzhu* 2, no. 3 (1933): 13.

sheets of glass three floors high divided by vertical light columns (Figure 4.6). In a photograph a new Chinese film, *Sports Queen* (Sun Yu, 1934), is prominently publicized, with star Li Lili's face framed in a black arch. Just as the glass framed by the curves of the building creates the main attraction (light), Li's face forms the hollow center of the film advertisement, a transparent display window inviting a peek

into the dark theater. The film, promoting the New Life Movement, with its glamorization of hygiene and health and glorification of discipline as modern regimes of the senses, provides an apt endorsement of a building sharing a similar faith in the modernization project.

Architectural transparency was not limited to modernist buildings. At the same time modernist glass architecture was being erected in Shanghai, a parallel process of deornamentalizing buildings, opening their exteriors, and using glass was taking place within the most prominent type of vernacular architecture, *shikumen*. As is well documented, *shikumen* first appeared in Shanghai between 1853 and 1864, during the Small Swords Uprising and the Taiping Rebellion, in the form of constructed terraced houses quickly erected by British real estate speculators in the British residential area in response to the wealthy Chinese gentry fleeing the war to seek refuge under European rule. As a hybrid product incorporating Western-style architecture and residential architecture in the lower-Yangtze region, the *shikumen* buildings constituted the first real estate market in China. Mass produced in uniform style with commercial investment and management, these buildings were constructed by Chinese workers and craftsmen, largely adopting Chinese vernacular architectural style, building materials, and construction methods.[28]

Shikumen underwent several major transformations from the 1850s to the 1930s in building materials, residential demography, and respective spatial design. In 1870 wood was replaced with brick, wood, and cement in order to abide by new building regulations to prevent fire hazards in the international settlement. Early edifices, between the 1870s and the 1900s, hosted well-to-do families from the lower-Yangtze region. The houses adopted the enclosed and symmetrical structure of the courtyard house, with tall walls about five yards high separating the residents from the outside and all windows and doors facing inward to the courtyard (Figure 4.7). Since 1912, however, a new migration wave comprising lower-class immigrants had changed the profile of these houses. They were further compartmentalized and built with cheaper materials, less ornamentation, and glass windows facing the street, sometimes with an added story. Handmade tiles were replaced by machine-produced flat tiles, and new materials, such as reinforced concrete, were used. The exterior wall of the *shikumen* unit was lowered below the second-floor window.

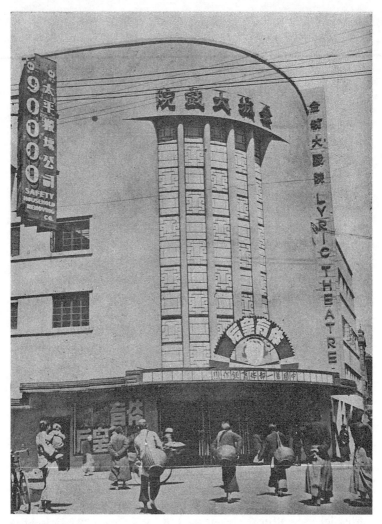

Figure 4.6. Shanghai Lyric Theater. *Zhongguo jianzhu* 2, no. 3 (1933): 21.

A second floor was added in the inner unit, with a balcony and an attic. After 1920 a small number of three-story *shikumen* buildings were also constructed (Figure 4.8). While the square footage for each unit substantially decreased (to only one-fourth of the original size), the scale of the terraced apartment house greatly expanded, from twenty-seven to thirty units before the 1910s to over one hundred to

two hundred and even as many as six hundred units after 1912. With increased access to the outside world and intensified communication within the buildings, a perceptual transparency, often created out of necessity more than modernist glamour and hype, characterized these everyday dwellings. Through vision, sound, smell, and touch, the residents constantly brushed shoulders within the narrow space of the housing complex, a shared public interior.

In the mid-1920s the construction of *shikumen* buildings gradually came to an end. New-style terraced houses (*xinshi lilong*) were erected in Shanghai, with widened alleys, reinforced concrete, and better access to light and air, as well as running water, electricity, and sanitary facilities. Some even came with gas and heating facilities. The residents in such buildings were, of course, largely middle class: doctors, writers, government bureaucrats, and petty merchants.[29] The lower and lower-middle class—factory workers, teachers, clerks, shop assistants, and aspiring literary youths and artists—continued to live in the *shikumen* buildings, the favorite setting for Shanghai left-wing films in the 1930s. Films such as *Shennü* (*The Goddess*), *Xin nüxing* (*The New Women*), *Xinjiu Shanghai* (*Shanghai Old and New*), *Malu tianshi* (*Street Angel*), *Shizi jietou* (*Crossroad*), *Taoli jie* (*The Plunder of Peach and Plum*), *Tianming* (*Daybreak*), and *Ye Meigui* (*The Wild Rose*) stage the most vivid demography and social life of the residents, ranging from alienation and everyday strife to temporary solidarity. Modern Shanghai architecture, lit up by electricity and transformed into "light architecture" at night, often serves as the glamorous yet intangible phantasmagoria in these films, seen through the windows of *shikumen* buildings as an unreachable dream and estranged cityscape, with a great sense of irony.

Invention of a Modern Medium: A Material and Social History of Glass

The modernist association of glass with transparency is complicated, however, by a much broader "culture of glass" emerging in China. To tap into the rich and often conflicting connotations of glass and transparency in modern China, a material and social history of glass as a new perceptual medium is in order. Although China had a long history of producing nontransparent glass for jewelry and other

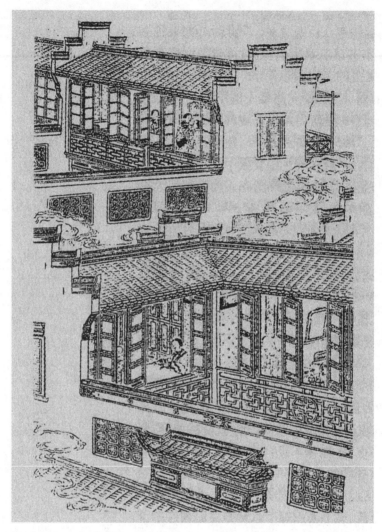

Figure 4.7. Old-style *shikumen* in Shanghai in the 1870s. Yang Bingde, *Zhong-guo jindai Zhongxi jianzhu wenhua jiaorongshi* (Wuhan: Hubei jiaoyu chubanshe, 2003), 234.

imperial or household leisure items, plate glass was not introduced to China until the eighteenth century and remained an exotic com-modity even at the turn of the twentieth century. High-quality plate glass remained largely a foreign import well into the 1930s, as attested

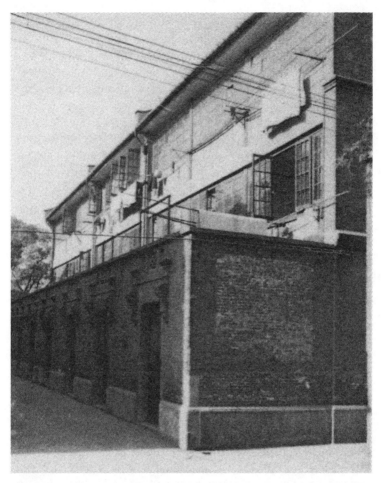

Figure 4.8. New-style *shikumen* in Shanghai in the 1920s. Yang Bingde, *Zhongguo jindai Zhongxi jianzhu wenhua jiaorongshi* (Wuhan: Hubei jiaoyu chubanshe, 2003), 241.

by documentation in architectural journals. As early as 1842, following the Taiping Rebellion and the Treaty of Nanjing, glass windows were luxury items for rich households to display their wealth and status in Beijing (1845), Manchuria (1880), Shanghai (1870s), Jiangsu (1880s), and Canton (Figure 4.9).[30] Wang Tao, in his book *Yingruan zazhi* (1875), describes the ubiquitous use of colored glass in foreign settlements, in mansions as well as teahouses and wineshops, earning

these areas the nickname "glass world" (*liuli shijie*).[31] Pictorial depictions of glass windows in urban household and entertainment centers (brothels, opium houses, teahouses) appear frequently in illustrated journals from the mid-1880s, such as *Dianshizhai huabao*.[32]

Between 1872 and 1900, scientific exposition and fantasies about the making and use of glass were printed in the earliest modern newspapers and journals, especially in Chinese-language Christian missionary journals and later Chinese journals actively promoting modern science. The various uses and possibilities of glass, as a medium of transparency and reflection that was durable (acid proof, bulletproof), flexible (bendable and shapeable), and ideal for creativity (such as sculpture), rendered glass a novel material for construction (windows, walls, and floors), decor (interior decor), scientific and industrial instruments (test tubes and lightbulbs), optical devices (lenses), everyday utensils (cups, vases, lamp shades, paperweights, ashtrays, etc.), and textiles (glass fibers for knitting).[33] A medium of metamorphosis, glass seemed to promise infinite possibilities as the interactions among science, industrial technology, and commerce progressed.

Although glass factories appeared in China at the turn of the twentieth century, the domestic glass industry did not flourish until around 1912, competing against the dominant Japanese glass factories that had been in China since the 1890s.[34] World War I destroyed the glass industry in Belgium—the major source of glass imports for China—and provided an opportunity for Chinese glass factories to spread in coastal cities (Shanghai, Tianjin), Manchuria (Harbin), and the depths of the hinterland (Hunan, Guizhou, Sichuan), while an impressive concentration of glass factories were found in Boshan, Shandong province. A 1932 survey documents the widespread glass industry in China, with Boshan and Tianjin as the centers of production and Changsha boasting the largest number of factories (around three hundred) before World War I. By 1932 Shanghai had forty to fifty glass factories.[35] Most of the domestic glass factories specialized, however, in making glass utensils, particularly glassware. These items tended to be sold in the regions where they were produced because of the difficulty of packaging and transportation.[36]

Despite the start of domestic industrial production of plate glass in 1903 in Hubei, Shandong, and Jiangsu, these factories lasted for

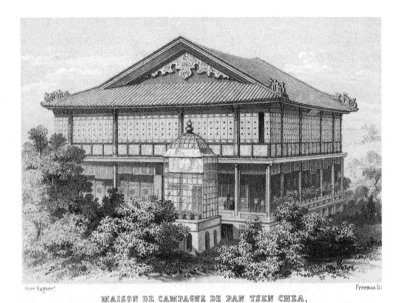

MAISON DE CAMPAGNE DE PAN TSEN CHEA,
près Canton.

Figure 4.9. Lithographic print of a daguerreotype made by Jules Itier documenting a Cantonese merchant's garden with possible glass window. Jules Itier, *Journal d'un voyage en Chine en 1843, 1844, 1845, 1846* (Paris: Dauvin et Fontaine, 1848–53). Courtesy of Getty Research Institute Special Collections.

less than a decade due to poor financial support and business management.[37] China continued to rely on imports from Germany, Austria, and predominantly, Belgium for optical and high-quality plate glass well into the 1930s.[38] Within China the Japanese still owned the majority of the factories, especially in Tianjin, Shanghai, Hankou, Dalian, and An Dong. An exception was the Yaohua Glass Factory, established in 1921 in Qinhuangdao as a joint venture with Belgium.[39] Well funded and equipped with the most advanced technology, Yaohua was considered the largest factory in East Asia by 1932. With one thousand workers, it boasted of producing high-quality, machine-made large sheets of glass, at a rate of seven hundred boxes (each containing one hundred square feet) per day, which sold as far away as Shanghai, Tianjin, and Hong Kong.[40] In Shanghai the largest Chinese-owned glass factory was called Guangming (The Brightness)—similar to the lavish movie theater Da guangming

daxiyuan, which as mentioned, translates literally as the Great Brightness Theater. As I have shown, glass and cinema were associated not only because of their shared affinity with light (brilliance), vision (*guangming* can mean "vision"), optical quality of radiance, luster, and sensorial effect of bedazzlement but also because of the large application of glass in a new generation of movie theaters of modernist design.

The novelty and foreign nature of glass displaced, of course, China's long history of producing glass for decorative objects.[41] Instead, glass was reintroduced for its transparency, not opacity, and as a modern industrial, mass-producible material, not a semiprecious material for craftsmanship. The 1932 article "The Epoch of Glass" sums up the importance and primacy of the material for the modern era.[42] The author portrays history as progressing from the age of stone to those of bronze, iron, and now, glass. Associating glass with hygiene (food utensils), health (absorbing ultraviolet rays as medication), science (various optical lenses), dwelling (building materials), and mobile vision (car windows), the author conceives of glass as the ultimate material for modern times, malleable and transformable: it could be used to make any everyday object, but with enhanced quality. Simultaneously artistic and practical, glass was used to replace paint for home decor, metal for a variety of uses, and concrete for walls. This power of miraculous metamorphosis seemed to come from the ways various kinds of glass were produced: the simple material of silica and sodium carbonate changed into glass under intense heat and pressure; with the addition of specific chemicals, glass obtained a spectrum of dazzling color; bulletproof glass could be produced through a complex process of layering and pressuring. The malleability of glass was inseparable from scientific experiments and industrial technology.

The material immateriality of glass also instituted the paradox of ultimate visual access and physical separation, underscoring the uneven distribution of wealth in a class-based society and the structure of desire for a commodity culture of display. The author of "The Epoch of Glass," after an impressively detailed and accurate description of the manufacturing process for bulletproof glass, suggests its use for domestic environments (doors and windows), display windows, and car windows to ensure security. While the durability

of the bulletproof glass further solidifies the spatial boundary, the author, anticipating glass architecture in the future, also envisions the use of mirrored glass for walls to enable one-way viewing for future home use. In this sense, the potential of glass as a building material does not so much transform dwellings the way Benjamin envisions—as a revolutionary destruction of bourgeois opacity and the cocooning of a secured individual self—as render visual pleasure and vision a privileged one-way access.

While popular scientific magazines and mass journals (for women, students, and children) continued to exploit the fascination and fantasy of glass well into the 1930s, a 1929 short story published in the famous mandarin duck-and-butterfly popular literary journal *Zi luolan,* entitled "Boli jianyu" ("Glass Prison"), depicted the irony of scientific progress and material civilization embodied by glass as a building material and a visual and spatial medium.[43] In the story a scientist, out of humanistic benevolence, builds a glass prison as a gift to criminals, to provide material comfort and evoke repentance. The prison, made entirely of transparent glass walls and windows, enables two-way visual traffic from inside and outside yet is solid enough to prevent any breakouts. By providing visual access to the outside world, it is designed to maintain the psychological health of the criminals while inspiring them to repent the deeds that caused their physical isolation. One day, a man unwittingly commits an error and is wrongly accused by his enemy of disrupting public security. Sentenced to three years in prison, he readily accepts the charge, learning that he will be put in the newest glass prison. For a month he enjoys his glass paradise, which, facing the street, allows him close visual encounters with the hustle and bustle of the outside word. Then, a few incidents occur that increase his anxiety. A fight breaks out on the street one day, which greatly excites him yet disallows his participation, aggravating his experience of physical confinement and disability. On another day, he witnesses how his own son attempts to visit him in prison and is rejected and brutally humiliated by the guards. The ultimate torture arrives when he sees his enemy walking with his wife on the street. His enemy, aware of his presence, deliberately stops in front of his cell and engages in physical intimacy with his wife, who seems utterly indifferent to her husband's presence. The criminal now finds it hard to accept the benevolence of the scientist

but only curses him for his cruel torture in creating the glass prison. "Such is the backdrop for modern living standards, scientific progress, and material civilization," the author concludes.[44]

"Glass Prison" joins the global imagination of glass associated with surveillance, isolation, and the nightmare of ultimate vision. Yevgeny Zamyatin's futuristic science fiction novel *We* contrasts the glass dome that holds everyone under surveillance to a green wall dividing them from animals. Eisenstein's *Glass House* project conceives of a glass tower where people live in utter isolation despite their close physical and visual proximity. Even worse, the residents cannot see their neighbors until somebody breaks the glass barrier. Glass not only divides, separates, and subjects one to visual scrutiny but, more disturbingly, becomes a paradoxical perceptual medium that provides both ultimate access and isolation, visual transparency and obfuscation.

These paradoxical connotations of glass disrupting a consistent visual and spatial order were sustained by a glass culture in Shanghai that was much more permutated than modernist architecture and that cut across the department store, art photography, modernist literature, and film. This expansive and vibrant culture of glass evolved around a modern consumer culture of display. The increasing availability of large-size plate glass in China contributed to the flourishing of new public spaces. Between 1917 and 1936, four huge department stores were established in Shanghai. Deploying large sheets of glass in the construction of what Anne Friedberg calls "the proscenium of intoxication," the display window, these new public spaces were registered in cinematic representations with tantalizing promise (Figure 4.10).[45]

Like the department store and the movie palace, the dance hall was another prominent site that provided a phantasmagoric environment through the play of optical and acoustic illusions. Dance halls in the 1920s and early 1930s, such as the Majestic (Dahua) and the Paramount (Bailemen), featured glass floors, footlights, and extravagant lighting systems (Figures 4.11 and 4.12). In addition, there were the "glass cup" (*bolibei*) ladies, who served tea in glass cups and solicited intimate conversations.[46]

This commodity culture of glass, with its ambiguous promises and optical play of transparency, illusion, and reflection, stimulated art photography and modernist literature. New sensationalist writer

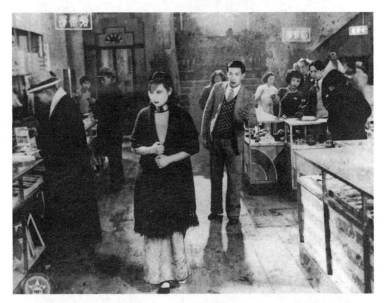

Figure 4.10. Department store registered in cinematic imaginations. The actress Hu Die walks through glass counters that serve to frame cosmetics and the saleswomen. *Zhifen shichang* (*Cosmetics Market*, Zhang Shichuan, 1933).

Mu Shiying, whose writings incorporated cinematic techniques of montage, rapid cutting, and visual rhyming, used the revolving glass door as a structuring medium in his short story "Five Characters at the Night Club." The clear glass serves as the threshold between the secular and fantasy worlds, through which Mu introduces his characters in a surrealist light. Dan Duyu, an innovative filmmaker, painter, and photographer, produced an impressive number of photographs experimenting with the optical play of glass transparency, translucency, reflection, and refraction (Figure 4.13).[47] Glass, fabric, and bamboo screens are transformed into media of transparency, interacting with the opaque female body stripped naked, as if the two can compete with or convert each other in their capacities as reflections, shadows, and transparent pure medium.

This expanded horizon of glass culture radically renewed vision and visuality, communication, and the perceptual experience of modernity. In this sense, the widespread application of glass can be considered the invention of a modern medium. Glass, as another

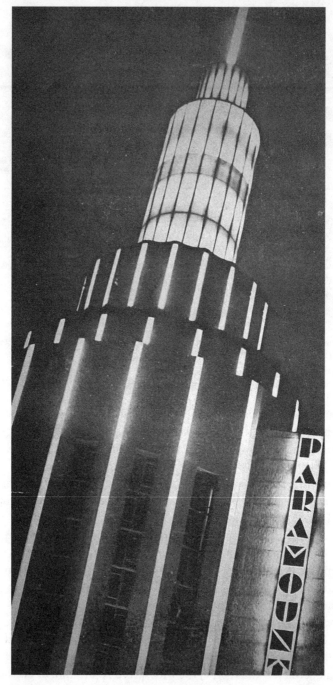

Figure 4.11. Paramount Dance Hall. *Zhongguo jianzhu* 2, no. 1 (1934).

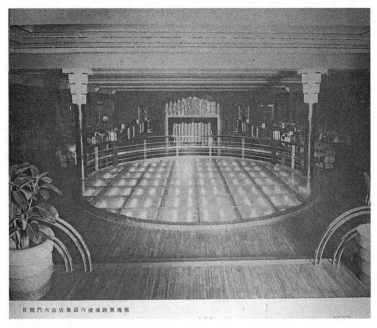

百樂門大飯店舞廳內玻璃跳舞地板

Figure 4.12. Glass floor at Paramount Dance Hall. *Zhongguo jianzhu* 2, no. 1 (1934).

liminal material or the material of "dematerialization," served as the intermediary between the interior and exterior, surface and depth, visual and spatial, sensual and critical.[48] The representational function of glass was well illustrated when one of the four major Shanghai department stores, Sun Sun, erected in 1925, constructed a glass-enclosed radio station on its sixth floor as the store's major attraction. New sound technology was displayed and *represented* by the medium of glass, qualifying it as a modern perceptual medium.

This material and social history of glass highlights transparency as an ambiguous and conflicted category. In these examples, transparency, as a feature of the material culture of glass, is associated with translucency, optical illusion, reflection, refraction, and penetrating vision. A prominent optical trope for the commodity culture of display enabled by glass as an indispensable architectural device, transparency constitutes the visual and spatial affiliate of phantasmagoria, producing optical illusions and impressions of spatial

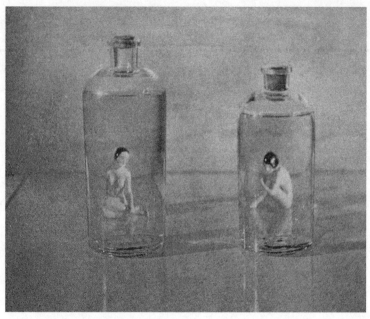

Figure 4.13. Dan Duyu photograph. Optical play of glass transparency with the opaque female body. Dan Duyu, *Meide jiejing* (Shanghai: Shanghai meishe, 1930). Courtesy of Judy Dan Woo.

transgression by technical manipulations. As an aesthetic and moral ideal associated with the rational ideology of modernist architecture, unobstructed visual penetration triumphs over bourgeois notions of ornament and a secluded mode of living. These contradictory notions of transparency are further complicated by translucency, evoking the liminal space between transparency and opacity and between fantasy and reality.

The Sound Picture: *Scenes of City Life* and an Alternative to the Talkie

Produced in this context, the Chinese left-wing film *Dushi fengguang* (*Scenes of City Life*) performs an ingenious experiment in sound and images, participating in and differentiating itself from this glass culture while providing a novel mode of cinematic transparency that

reflects upon the commodity culture of display in Shanghai in a humorous and incisive manner.

Scenes of City Life was hailed as the first musical comedy in China (Figure 4.14). This genre needs some clarification. Distinctly different from American musicals, *Scenes of City Life* does not contain spectacular song-and-dance sequences, backstage romance, or metadiegetic devices such as confusion between reality and stage spectacles. Instead, the film seems to have drawn inspiration from Chaplin's *City Lights* (shown in Shanghai in 1931 and 1932) and other film sources. If anything, the film is more akin to *cine-opérette*, a French variation of the film musical that draws on the tradition of the *opéretta*, a genre of light opera that developed in Europe starting in the mid-nineteenth century, gaining great popularity for its wit, frivolity, satire, and erotic appeal.[49] Left-wing critic Zheng Boqi (under his pen name Xi Naifang) describes *cine-opérette* as a new musical genre derived from such a tradition yet distinct, adding characteristics of a revue while taking full advantage of sound for a new form of cinema "most suited to the masses with powerful affect."[50] Identifying fine examples of *cine-opérette* in films such as René Clair's 1930 *Sous les toits de Paris* and 1931 *Le million* (both shown in Shanghai in 1932 and tremendously popular) and Fyodor Otsep's *Mirages de Paris* (shown in Shanghai in 1934), Zheng notes in particular their creative use of sound, especially the *contre-puncto-methode* (contrapuntal method).[51] Comparing these films with American musicals, Zheng argues that such European musical comedies are more cohesive and less susceptible to the jarring combination of dramatic scenes and song-and-dance spectacles, such as those in Lloyd Bacon's *Wonder Bar*, which had become an object of the soft-film versus hard-film film debate. In introducing *Mirages de Paris,* Zheng applauds Otsep for the film's more radical experimental practice and lack of bourgeois sentimentality: "For those who have grown tired of American films, this is a refreshing drink."[52]

Zheng's dissociation of these films from American musicals and preference for alternative terms such as *cine-opérette, revue,* and *musical comedy* delineates a larger cultural impulse of left-wing film critics, who strove to distance themselves from the global hegemony of Hollywood commercialism and turned to western Europe as a third

Figure 4.14. Publicity image for *Scenes of City Life* showing the film advertised as a "new-style musical comedy" (*xinxing yueju*).

space opened up between the United States and Soviet Russia. Although critics lauded Chaplin and more politically oriented American films such as *All Quiet on the Western Front* (Lewis Milestone, 1930), *I Am a Fugitive from a Chain Gang* (Mervyn LeRoy, 1932), and *Broken Lullaby* (Ernst Lubitsch, 1932), they remained critical of these films' tendency toward sentimentalism and happy endings, including Chaplin's films.[53] Zheng comments on the dominance of American films in the Chinese film market, which had shaped audience tastes and viewing behavior.[54] As a result, Zheng observes, European films, especially British, German, and French films, more selectively imported with higher quality, were met with less enthusiasm. European sound films were often shown with dialogue in the original language and English subtitles, posing an additional challenge to Chinese audiences. In reality, Chinese films, including celebrated left-wing films, incorporate elements from Hollywood cinema in narrative, mise-en-scène, and characterization. But *Scenes of City Life* demonstrates features beyond the American musical. Further, its experimentation with sound reflects the growing interest in the aesthetic, economic, and political potential of sound cinema.

Film journals began to discuss sound cinema as early as the mid-1920s, culminating in a special issue of *Dianying yuebao* (*Film Monthly*) devoted to sound cinema in December 1928, which coincided with the demonstration of a sound film by Dr. C. H. Robertson at the Sichuan Road branch of the YMCA in Shanghai in November 1928.[55] Although these discussions showed much curiosity and apprehension concerning the mechanism and promise of sound technology, the 1930s discussion on sound, better informed by the increasing exhibition of foreign sound films, showed a more direct engagement with sound aesthetics in film and their political potential. In 1930 the journal *Yishu yuekan* (*Art Monthly*) published a group discussion entitled "The Future of Sound Cinema," in which the editor, Shen Duanxian (another pen name for Xia Yan), poses the following questions:

> Is the explosive prosperity of the "talkie" a temporary phenomenon? Is there a possibility that the *Talkie* will permanently and *Internationally* replace the *Movie* and even stage drama? Will the *All singing, All dancing, and All talking* films

in vogue today stay popular forever? Otherwise, what other forms will replace the current practices?[56] (italics added for English original)

The discussions cover a broad range of topics: the relationship between talkies and stage plays (whether the former would eliminate the latter), the compromising of silent film aesthetics in sound films, the limit of talkies' potential for more creative sound aesthetics, and the question of language and dialect entailed in the international circulation of talkies. Contributors question the claim of linguistic universality of English and German while encouraging the use of dialect, other national languages, and Esperanto. Most of the writers share reservations about synchronized sound films, which often seem to disrupt perfected silent film aesthetics and sacrifice the ontological singularity of cinema by borrowing from other genres (theater, music, and dance). Yet they remain positive about the potential of this innovation, admittedly constrained in its early stage of technological imperfection.

Perhaps the most significant recognition of the potential of sound cinema is the distinction made between the "talkie" and the "sound picture" (*yinhua,* English in the original), replacing the debate between the "talkie" and the "movie" (silent film), which seemed quickly outdated. Shen Duanxian (Xia Yan) defines the sound picture as a film devoid of dialogue, deploying sound effects and orchestral accompaniment while maintaining intertitles.[57] Proclaiming the 1930s "the age of the Sound Picture," Shen foresees the movie being surpassed by the sound picture instead of the talkie, which he deems a temporary phenomenon. Similarly, Feng Naichao sees the sound picture as compensating for the limitations of silent cinema but overcoming the problem of the talkie's shrinking global market, anticipating that "the future of sound cinema is the extension of the Sound Picture."[58] The sound picture is often contrasted with the musical, which is seen either as the exception to the generally dissatisfactory status of the talkie or, more often, as representing the loss of film's medium specificity. The musical is seen as a cover-up of the defects of talkies or, worse still, as merely parading American capitalist consumption. Needless to say, American musicals were abundant in the Chinese film market in the early to mid-1930s. Films such as

Show Boat (Harry Pollard, 1929), *42nd Street* (Lloyd Bacon, 1933), *Wonder Bar* (Lloyd Bacon, 1934), *Fashions of 1934* (William Dieterle, 1934), and *Flying Down to Rio* (Thornton Freeland, 1933) were widely popular.[59]

The writers' optimism about the sound picture draws from their experience with Chaplin's *City Lights* (1931) and European musicals shown in Shanghai, including French films by Clair and Otsep and German Ufa musicals such as *Das Lied der Sonne* (*Song of the Sun*, Max Neufeld, 1933), *Bomben auf Monte Carlo* (*Monte Carlo Madness*, Hanns Schwarz, 1932), and *Der Kongress tanzt* (*Congress Dances*, Erik Charell, 1931), films that suggest a range of film-sound aesthetics broader than that of American musicals and talkies.[60] This interest in the sound picture or, rather, a close relative of the silent picture with sound effects, contrasts with discussions in the 1928 *Film Monthly* special issue, which celebrates the primacy of the reproduced human voice on-screen and the integration of image and sound. Contributors recall their first encounter with the sound picture, the Edison Kinetophone shown in Shanghai in 1914. In comparison with the 1926 sound film demonstrations, they denounce these early films as inauthentic "sound cinema." In Zhou Jianyun's words, what they saw in 1914 with various sound effects was only "film with sound" (*youyin dianying*) instead of "film with voice" (*yousheng dianying*), as witnessed in Robertson's demonstration. Even though the *Film Monthly* special issue includes Hong Shen's translation of the famous manifesto on sound by Eisenstein, Pudovkin, and Alexandrov, "A Statement," this translation omits the Soviet filmmakers' most significant claim on the contrapuntal use of sound.[61] Hong, the Harvard-trained dramatist who wrote the screenplay for the first Chinese sound film (sound on disk), *Genü hongmudan* (*Songstress Red Peony*, Zhang Shichuan, 1931), does not attend to the Soviet filmmakers' emphasis on the asynchronic use of sound against the image as an extension of their montage principle. Instead, he omits the two prominent paragraphs on their contrapuntal method and paraphrases them in the diametrically opposite direction: "Only when sound and image are in harmony are seeing and listening homologous."[62]

This was, however, no longer the case in the 1930s. Zheng Boqi, the Japan-trained drama activist and film critic who translated Pudovkin's *Kino-rezhisser i kino-material* (*Film Director and Film*

Material), was particularly interested in the contrapuntal method and other sound experiments. He was exhilarated to find the notion of *montage du ton* (montage of sound) in the credits for *Sous les toits de Paris* and identified its use in the Ufa musicals.[63] The sound picture, as several Chinese writers argued, promised the enrichment of silent film aesthetics rather than its annihilation. For them the sound picture was more intrinsic to cinema than the American talkies—musicals based on a theatrical model. Similarly, Liu Na'ou, in his well-known essay "Ecranesque," considers the resistance of sound cinema "anachronistic" (English in the original), yet he refers to the mechanical alignment of sound and movement of the American "all talkie" (English in the original) as nothing but a "typewriter" reducing the possibility of "artistic sublation" to "mere physics."[64] For Liu the power of sound does not necessarily lie in the "synchronization" (English in the original) of sound and image but in how these elements collaborate to create the most powerful expression. Evoking the Hegelian term *aufheben* (*yangqi* in Chinese), Liu positions silent and sound cinema in a dialectical relationship in history, positing sound cinema as a transformation conditioned by a simultaneous cancellation and preservation of silent cinema, maintaining the tension between the medium's past and present as the path of its advancement.

Indeed, questions of medium specificity and the future of cinema were central concerns for more theoretically informed film critics across the Left and non-Left divide, as discussed in chapter 3. Liu's interest in the interplay between sound and image beyond synchronization delineates a deliberate distancing from the new connection between sound cinema and theater, a position shared by Zheng, who articulates it more forcefully in relation to montage. As Zheng points out, the contrapuntal method enables sound cinema to depart from theater and recuperate film techniques perfected in the silent era, particularly as an extension of montage.[65] In another essay on sound cinema, he describes international sound cinema in three phases. In the first phase sound effects, especially noise and other striking sounds, dominated while dialogue remained minimal and quite removed from human voices. The second phase privileged harmony between music and dance, which eclipsed the defect of sound technology in re-creating human voices—this was the decisive era when

sound cinema took hold in China. In the third phase spoken drama dominated the scene when film-sound technology minimized the difference between the human voice and machine sound. Interestingly, in this third phase film critics such as Zheng Boqi and Liu Na'ou distanced themselves from such naturalized sound and the immediacy of perception. Instead, their interest in the interplay between sound and image as an alternative to synchronicity seemed to return to early sound film with its various hybrid forms (especially, partial-sound films with minimal or no dialogue but rich musical and sound effects or singing sequences), not only for aesthetic expression but also to call attention to the medium—to extend the medium specificity of silent cinema by paradoxically staging the otherness of sound as an added medium. The modernist interest in denaturalized, nonsynchronized sound across hard- and soft-film advocates such as Zheng and Liu is not unique to China. The notions of sound picture and talkie strike a resonance with the distinction made between *film sonore* (postsynchronized sound) and *film parlant* (synchronized sound) in France in its early sound era. While *film sonore* gradually gave way to *film parlant* as a transitional and hybrid genre, it was revived by Soviet and European avant-garde filmmakers including Eisenstein, Clair, and Abel Gance as a more "cinematic" genre in contrast to *film parlant*'s "theatrical" tendency.[66] The Chinese filmmakers' interest in sound picture was quite in line with this transnational modernist move, which in the name of cinema's purity, advanced the experimental use of sound through a paradoxical alliance with silent cinema.

The film studio Diantong was in the vanguard with sound experiments in film aesthetics and technology. Diantong (Denton) was originally a sound equipment company established in 1933 by three electrical engineers educated in the United States—Ma Dejian, Situ Yimin, and Gong Yuke—who invented one of the earliest sound-on-film recording systems in China, the Sanyou-style recording system (*Sanyoushi luyingji*). Before Sanyou several sound-on-film processes had been invented in China since 1931, including S-tone by Shi Shipan; Zhu Qingxian's Qingxiantone, used in *Chunfeng yangliu* (*Willow in Spring*, Wang Fuqing 1932); and Yan Heming's Hemingtone, used in *Chunchao* (*The Tides of Spring*, Zheng Yingshi, 1933).[67] Yet the Sanyou-style recording system had a broader impact on film

production, in films such as *Yuguangqu* (*Song of the Fishermen,* Cai Chusheng, 1934), *Dalu* (*The Big Road,* Sun Yu, 1934), *Xin nüxing* (*The New Woman*), *Langtaosha* (*Sand Washing the Waves,* Wu Yonggang, 1936), and *Dao ziran qu* (*Back to Nature,* Sun Yu, 1936), as well as all four films made by Diantong, *Taoli jie* (*The Plunder of Peach and Plum,* Ying Yunwei, 1934), *Fengyun ernü* (*Children of Troubled Times,* Xu Xingzhi, 1935), *Ziyou shen* (*Goddess of Freedom,* Situ Huimin, 1935), and *Scenes of City Life.* In 1934 Diantong changed into a film studio. Lasting less than two years, Diantong made only sound films, and its first film, *Plunder of Peach and Plum,* already showed a strong interest in the expressive application of sound.

Although Diantong was forced to shut down for economic and political reasons, the studio attracted an impressive array of artists, including animation pioneers the Wan Brothers; artists and drama activists such as Wu Yinxian, Xu Xingzhi, and Ying Yunwei; left-wing film critics and playwrights Shen Duanxian and Situ Huimin; and actors Chen Bo'er, Wang Ying, and Tang Na. Compared with Mingxing and Lianhua, Diantong was more identifiably left-wing, with relatively younger artists who were active particularly in spoken drama. Not surprisingly, *Scenes of City Life* featured a strong left-wing cast. The male lead was played by Tang Na, one of the foremost left-wing film critics engaged in the soft-film versus hard-film debate. Gu Menghe, who played the antagonist, was a former member of the Nanguo Society led by Tian Han. He was considered one of their most talented actors and played the male lead in a number of renowned plays. Zhou Boxun was an active member of the Shanghai Artistic Drama Society (Shanghai yishu jushe), which became a center for leftist drama productions after 1930. The photographer Wu Yinxian painted stage sets for the Shanghai Artistic Drama Society. And lastly, Lan Ping, a celebrated stage actress most famous for playing Nora in Ibsen's *The Doll House,* later left for Yan'an's Marxist and Lenin Institute in 1937 and married the Communist Party leader Mao Zedong. Changing her name to Jiang Qing, she went on to become the most notorious persecutor and advocate in the film and drama world during the Cultural Revolution. Although Lan Ping played only a minor role in *Scenes of City Life,* she was the major reason the film was kept from public screening for several decades. Yuan Muzhi, Wu Yinxian, and Chen Bo'er all went to Yan'an in 1938.

Dissecting Urban Space: Film Architecture, *Photographique*, and *Cinégraphique*

Diantong's political orientation, framed in its unique connection with sound technology and critical discussions deriving from the international exhibition context in Shanghai, puts in perspective the experimental practice of sound and image in *Scenes of City Life*. In many senses, the film functions as a sound picture. While human dialogue is minimal, machines creating various sound effects further distance sound technology from human voices, and voice itself is appropriated simultaneously for expressive purposes away from human language. The film's innovative use of sound demonstrates an interest in mobilizing film sound as a means of expression beyond the verbal; further, these sound experiments interacting with images provide a distinct mode of transparency, which I name the left-wing "culture of glass."

Scenes of City Life draws attention to sound as a newly added dimension of the cinematic medium and has a heightened self-reflective quality. The film opens at a small-town railway station with a road sign pointing to Shanghai. A family of four in country outfits links arms as they depart for Shanghai. While nondiegetic music—organ music combined with Chinese percussion instruments such as gongs and drums—is synchronized with the family's rhythmic body movements and sets the comical tone for the film, diegetic sound is introduced as an element of confusion. After the first panning shot of the family and the rest area, the camera cuts to the interior of the railway station with the manager sleeping at his desk. A ringing sound awakens him. He picks up the phone, and after hearing no sound, he reverses the speaker and receiver positions but again fails to hear anything. He then reaches toward an alarm clock and turns it off. In this brief and comically delayed bit of synchronization, diegetic sound arrives from elsewhere, looking for a plausible image source.

Waiting for the train to Shanghai, the four family members (parents, daughter, and nephew) are solicited by the one-eyed vendor to look into the "Western mirror" (*xiyangjing*), a peep show that had been popular in China since at least the eighteenth century. The Western mirror is advertised in a poster hanging above them: a perspectival still photo of the iconic Shanghai daytime street scene

dominated by Western-style architecture. The picture is then replaced by a full-screen neon-lit night scene. Suddenly, as if propelled by the soundtrack shifting from the vendor's monotonous singing to a symphony, the picture starts to move. In an unstable, jerky manner reminiscent of the trolleybuses moving through the urban intestines of Shanghai in the 1920s and 1930s, the camera tracks in, taking the audience on a phantom ride through the city in a reel of moving pictures.

A fast-paced montage of highly diverse images of the Shanghai cityscape heightens the attraction while making a bleak political commentary about the semicolonial condition of the city. The intoxicating neon hieroglyph of the consumer paradise of Shanghai at night is contrasted with a sober daylight delineation of the city, juxtaposing bronze lions and foreign churches with cheerless Chinese faces. Propelled by the rhythm of montage and versatile camera movements—aerial shots, panning, and tracking that culminate in a maddening New Year's Eve party scene—the journey ends back at a still picture of the neon-lit street that appeared at the beginning of the ride, occupying the full screen. Mimicking the change of a slide, a new image appears with cartoon sketches of four figures in modern attire, which in a second transforms into another reel of moving pictures, unfolding the major narrative of the story.

This sequence, while outlining the semicolonial topography of Shanghai, also provides a condensed history and typology of Western-style architecture in the city: Catholic, Protestant, and Russian Orthodox churches from the nineteenth century, neoclassical buildings in the 1910s and 1920s (the Hongkong and Shanghai Bank Building and the customs office building), modernist movie theaters (the Grand Theater and the Metropol) and dance halls in the 1920s and 1930s. Although the sequence samples a few modernist structures, it draws from a much broader urban landscape to compose its own film architecture: modernist theaters intercut with various opera theaters (Tianchan dawutai and Gongwutai); public transitional spaces such as the park, the bridge, and streets; human figures and figurines such as sculptures, crowds, and pedestrians; and neon-lit signs advertising the tastes of and cures for urban sensual pleasures—brothels and medicine for sexually transmitted disease, monosodium glutamate, toothpaste, olive oil, and the curries

of Indian restaurants. The camera movement emulates the vertical energy of the buildings and their pursuit of height and grandeur but also radicalizes the buildings and other spatial topos by its own devices: extreme low angles, diagonal framing, and the interplay between horizontal and vertical movement, crisscrossing in opposite directions. Out of the eclectic architectural "material" in Shanghai, a cinematic building is constructed with a distinct spatial design and modernist claim, under certain unifying principles of correspondence, conflict, and contrast. While this montage sequence emulates modernist architecture through its celebration of rhythm, straight lines, and grids, the somber tone in presenting the Hongkong and Shanghai Bank creates a moment of intellectual montage by superimposing coins dropping from the air upon low-angle shots of the building and the two imposing stone lions. A dialectical image is thus formulated in a distinctly political way.

A glass architecture is erected by cinema's own means of transparency, that of montage, superimposition, and the violent yoking of distinct images in creating a political analogy. The two kinds of abstractness, evoking modernist rationality in formal design as well as a political abstraction of images, nevertheless have tremendous affective power. The impact of this sequence despite its abstract nature can be better appreciated by revisiting Feng Zikai's analysis of the propagandistic power of architecture, its relationship with abstract form, and the role of affect.

In his *Lectures on Western Architecture,* Feng begins by pointing out that all forms of art have functioned as propaganda for their respective societies and historical moments, yet he singles out architecture as the most powerful for three reasons: (1) its colossal size and public visibility create a deep impression and affective pressure on the people; (2) architecture is the art closest to human life and society, and hence, its public reception is associated immediately with its social use; (3) as the site of public space, architecture has the "power of affinity" (*qinheli*) to consolidate the public affect. For example, people who watch the same majestic buildings share a similar sense of awe, and places such as dance halls, hotels, and cafés are carefully designed to overcome individual emotion so as to promote business. In Feng's opinion, "Architecture draws its power of affinity from pure (and meaningless) shapes and colors, which did not appeal

to the intellect but to one's affect."[68] Painting and sculpture compose beauty out of figural imagery, and hence, their artistic mode of expression is descriptive, appealing partly to intellect and partly to emotion. In contrast, architecture is composed of pure shapes and colors, so its mode of expression is symbolic. Architecture asserts its power of affect through suggestion by specific shapes, colors, and proportions. Among the three characteristics of architecture most amenable to propaganda, as Feng points out, this last, its "power as symbol" (to affect people), is the most important.

The montage sequence in *Scenes of City Life* evokes affective power in a way similar to Feng's conception of architecture. Even though the sequence is built from figural images, these are transformed into abstract shapes and forms through a radical cinematography (camera movement, angle, and height) and editing principle. This level of abstraction, precipitated by the frantic cutting and music, creates an immediate sensation of rhythm, speed, and motion. Yet the individual imageries evoke rich associations of Shanghai's urban scenery and history with acute observation on colonial modernity, summoning affective response on a different, perhaps more concrete, level. The tension between the intellectual and the affective—or two kinds of affect, one on the general, abstract level, experienced as sensorial and physiological, and the other, emotional reactions and associations determined by situation, context, and experience—further intensifies the affect by engaging its plurality and internal conflict, rendering it a vehicle for politicized perception.

The central role of montage in producing affective power is theorized by Liu Na'ou in a consideration of medium-specific aesthetics. In an elaborate account of the art of cinema, Liu differentiates between *photographique* and *cinégraphique* (French in the original).[69] Cinema, which he calls *yingxi* (shadow play), should be considered not as passively photographed reality but as *created* by film-specific methods, especially montage. If the camera films the object only with a fixed angle and a method without any particular planning, as Liu conjectures, the audience sees nothing but a "dead object" (*side duixiang*); the movement of the object will remain "aimless," without vitality. For Liu the only value of such shots is *photographique* (*zhaoxiangde*). With advanced planning, however, if one films the object with other discrete objects in separate scenes, as part of a unity made up of many

isolated and distinct visual images, the object then acquires *ciné-graphique* (*yingxide*), vitality and value. Through montage one can transfer objects onto the screen by a *cinégraphique* rather than a *photo graphique* process. To give a simple example of the *photographique* and the *cinégraphique*, Liu refers to the actress Ruan Lingyu, considered the most "erotic" among the female stars (English in the original). If the cinematographer shot only her face, chest, waist, legs, and feet and listed them as a visual inventory, the audience would be given "raw meat" instead of a "cooked dish." This would impose an ordeal for an experienced audience because they would be shown *photo-graphique* source material instead of *cinégraphique* images.

Liu's discussion of the *cinégraphique* draws on French avant-garde film discourse in the 1920s, an intense era of debate on cinema's medium specificity and diverse possibilities, especially the notion of *cinégraphie* (film writing).[70] Later in the same essay, Liu devotes two full sections to *le film pur* (pure cinema) and its practitioners, covering a wide range of avant-garde film practice by European and American filmmakers such as Viking Eggeling, Hans Richter, Walter Ruttmann, Fernand Léger, Man Ray, René Clair, Robert Florey, and Henri Chomette. Liu was fascinated by their interest in claiming film's aesthetic independence from other arts by foregrounding medium-specific techniques, especially the play between light and shadow, the analogy to visual symphony, the annihilation of plot and performance, and the reliance on abstract, mathematical shapes and forms to create new symbols. In an earlier essay on French and Russian film theory, Liu identifies an even broader range of avant-garde film practices, citing French film journals such as *Cinéa-ciné pour tous* as his sources and demonstrating his enthusiasm and quick grasp of these practices and competing notions of cinema.[71] In his later essay, however, he critiques, by way of Paul Ramain, pure cinema's isolation of human life and disengagement from the social dimension of film.

Despite Liu's clear identification with European modernist film theory, he draws explicitly on Soviet film theory, particularly that of Pudovkin, by quoting from Pudovkin's discussion on montage and citing his films as examples. His translation of "montage" as *zhijie* coincides with the same term in the Chinese translation of Pudovkin's *Film Director and Film Material* by left-wing film critics Xia Yan and

Zheng Boqi, published in *Chenbao* in serialized form in the same year Liu was writing, 1932.[72] In his interpretation of Pudovkin's film theory and practice, Liu celebrates montage as the "genitor of reality":

> Isn't it a miracle that the director constructs *Montage* scenes shot from different moments and places to "create" a new cinematic time and space, which becomes "filmed reality"? People often add the word "photograph" before the word "film" to say "photographed film," but film is not simply photographed. According to Pudovkin, the word "photograph" should disappear from the kingdom of film, because film is actually constructed by *Montage*. The "mechanical" camera should not rule the soul, yet once the camera unites with *Montage,* it acquires a miraculous power to transform the essence of an object and renders the object anew, endowing it with unprecedented significance.[73] (italics added for English in the original)

A closer look at Liu's sections on montage and *photographique* and *cinégraphique* in his essay reveals that he has followed closely and even translated at times sentence by sentence, without full acknowledgment, Pudovkin's introduction to the German edition of *On Film Technique,* published in 1928 and translated into English in 1929.[74] Clearly, Liu had access to this introduction, which is missing from the Chinese translation by Zheng Boqi and Xia Yan. Liu was fluent in Japanese and English and could have read the Japanese translation from German of *On Film Technique,* which includes this introduction, published in 1930, or he could have read the English translation of the same introduction in 1929.[75] Nevertheless, it is worth noting the minor changes he makes in his paraphrase of Pudovkin's work. In the discussion of *photographique* versus *cinégraphique,* Liu replaces Pudovkin's use of "cinematographic" with *cinégraphique* and "photographic" with *photographique,* registering the European, especially French avant-garde, film discourse in the 1920s, when *cinégraphique* was a central term.

The "film architecture," or its architectonic organization of space and time, is, then, *cinégraphique* rather than *photographique,* or it draws on the tension between the two to capture the social environment. Liu himself provides an analogy between cinema and architecture

in "Ecranesque": "Just as architecture serves as the purest embodi-
ment of the rationality of mechanized civilization, that which could
portray the *social* environment of mechanized civilization in a unique
manner is cinema."[76] The social is articulated precisely by this tension
between the image and the cinematic aesthetic principle. This film
architecture is distinctly politically modernist because it draws on a
broad range of international and Chinese avant-garde film theory and
practice and because of its political message, which goes beyond a pure
embodiment of the rationality of modernity and incisively captures
its social environment. Its power of affect is interpreted as vitality. For
Liu, as he interprets Pudovkin, montage is "the most vital essence" in
the birth of cinema, an animating, dynamizing force. Perhaps it is not
surprising that he discusses a sequence in which dynamite is used in
Pudovkin's *Konets Sankt-Peterburga* (*The End of St. Petersburg*) as an
example of the affective power of montage.

This dynamic film structure is experienced even in the process
of filmmaking. The published shooting diary for *Scenes of City Life*,
compiled by the script supervisor, Bai Ke, describes the shooting
of this sequence as coupled with excitement, speed, and energy
through the filmmakers' intimate engagement with urban architec-
ture and the cityscape:

August 6 (Tuesday Sunny)

We spent a whole day taking location shots. Starting from 1:00
p.m., the film crew, assuming an air of literati with "elegant
taste," took a car ride and arrived at the bund to shoot the
Broadway building, the Garden Bridge, and the bronze statue
of the Goddess of Peace. We went back to take a brief rest; at
4:00 p.m., we started out again to the Grand Theater to shoot
the scene of the departing audience. Coincidentally, Tang Na
and Lan Ping stepped out of the movie theater, accompanied
by Shi Chao and Miss Ye Luxi.[77] Soon afterward we went to
Route J. Frelupt to shoot images of the International Radio
Broadcasting Station (Chinese Government Radio Admin-
istration), the St. Ignatius Cathedral of Shanghai (Xujiahui
Cathedral), the Shanghai Observatory, and Jessfield Park
(Zhaofeng Park). It was only 5:30 p.m. when we finished

shooting. Muzhi treated (Wu) Yinxian, Bai Ke, and the re-
porters to a movie at the Grand Theater, *Paris in Spring*.[78]

At 9:00 p.m., we started out for the third time, taking a
total of 25 shots of "Neonlight" (English in the original) com-
mercials. By the time we got back, it was already midnight.
As our car passed Haining Road, we stopped at a café. . . .

It was already 1:00 a.m. when we got back to the studio.
Miss Shu Xiuwen and her boyfriend, Pan Jienong, had already
waited at Diantong for a long time. They were paying a special
visit to Muzhi. Immediately they went out again.[79]

Mimicking the rapid-cutting montage sequence framed in the peep
show machine, the film crew's fast tempo and vast reach of the city
delineates the frenzy and excitement in their grasp of the "cityscape"
(the literal translation of the film's title, *Dushi fengguang*). While
different buildings and social institutions collide—churches, movie
theaters, and high-rise apartment buildings—the crew's extended
working hours coincide with the scene of urban consumption, with
the day starting after noon and continuing far past midnight, fol-
lowing the rhythm of the city. Surveying the monumental sites and
public spaces, they enjoy urban entertainment, going in and out of
the movie theater and chatting away at a café. The scenes they shot,
shown most intensively in the montage sequence framed by the
peep show, capture not only the eclectic architectural types and
urban spaces but also the tempo of urban life that enables the radi-
cal collapse of different social spaces. The Grand Theater features as
an architectural monument, a social environment, and the place of
entertainment for the filmmakers. Like the peep show's frame, it oc-
cupies the actual social space in the urban landscape but also affords
the filmmakers a phantom ride to which their own work contributes.

The film took three months to make (from June to September)
and was screened one month later, in October 1935, at the Lyric Thea-
ter, an exhibition venue with which Diantong teamed. The Lyric The-
ater was a modernist building using large amounts of glass, designed
by the Chinese architectural group Allied Architects. Whereas the
Grand Theater, a place the film crew frequented, was reserved for for-
eign first-run films, the Lyric Theater provided the exhibition space
for all of Diantong's films, as well as other Chinese films made during

this time. Moving in and out of modernist glass houses, the film crew constructed their own urban analysis.

A Left-Wing Culture of Glass: Parallel Montage versus Montage of Sound and Image

The aforementioned fast-paced montage sequence, evoking the tradition of city symphonies, with interest in the crowds and ambiguous celebration and darkness of the city, outlines the semicolonial topography of Shanghai in a cogent and expressive manner reminiscent of the film *Shanhkayskiy dokument* (*Shanghai Document*, Yakov Bliokh, 1928), a documentary by Soviet and German filmmakers shot in Shanghai between 1926 and March 1927 and released in the Soviet Union. The film disassembles the phantasmagoric city in the most poignant, if unsubtle, manner. The film is organized rhetorically through a systematic parallel montage contrasting the life of Western "wanderers" (also the name of one of the motorboats featured) and the local Chinese. While white Westerners are shown enjoying their social prestige in leisure activities such as horse racing, swimming, dancing, and sailing, the Chinese are seen as hard laborers—coolies at the port, rickshaw boys, and factory workers—overworking in poor environments with little labor protection. The film's modernist interest in visual composition (mostly in the scenes showing Westerners) and its ethnographic fascination with Chinese everyday life at times lessen this highly politicized contrast. The film devotes a considerable amount of time to folk art and handcraftsmanship, food, street shows and theatrical performances (acrobats, monkey plays, puppet shows, Beijing opera), and mythologized images of fortune-telling and religious piety. Nevertheless, this basic contrast remains consistent throughout the film in both its overall organizational structure and its particular construction of scenes—foreigners stirring lemonade and Chinese people waiting in line to drink from the bamboo container; a whirling phonograph and the spinning wheels of the human-pulled cart. The Chinese and the Westerners are shown mostly in separate spaces, and whenever they appear together, the principle of contrast applies: the white factory boss gives orders to Chinese laborers, and Western children enjoy a ride with Chinese pushing the cart.

The use of a politically framed parallel montage as a structural principle for portraying social contrast can be seen in a number of left-wing films, such as Cai Chusheng's *Dawn over the Metropolis* and *Twenty-four Hours in Shanghai* (Shen Xiling, 1934). This is perhaps not surprising considering the increasing impact of Soviet film, film theory, and the utopian social imagination they instilled—a certain Sovietism since the early 1930s appropriated by various modernist camps. The hiatus between the private showing of Eisenstein's *Battleship Potemkin,* organized by the Nanguo Society led by Tian Han in 1927, and the absence of Soviet films until 1932—when the Guomindang established foreign relations with the Soviet Union—prepared an even more enthusiastic public reception for Soviet films. Pang Laikwan has documented the box-office and critical success of Soviet films such as Pudovkin's *Potomok Chingis-Khana* (*Storm over Asia,* 1928) and *Mat* (*Mother,* 1926) and early 1930s films such as *Putyovka v zhzn* (*The Road to Life,* 1931), *Zlatye gory* (*Golden Mountains,* 1931), *Chapaev* (*Chapayev,* 1934), and *My iz Kronshtadta* (*We Are from Kronstadt,* 1936).[80] In her brief analysis of the Soviet elements in left-wing Chinese cinema, Pang attributes their influence to Soviet films of the 1930s rather than the 1920s and to Pudovkin's montage as association rather than Eisenstein's montage as conflict. In cases where Chinese films deploy conflict as a structural principle, Pang identifies it more as "melodramatic" than as "montage":

> This notion of conflict as definitely more "melodramatic" than "montage" refers more to the content than to the form. That is to say, Chinese films in the 1930s were highly aware of using conflicts, which correspond, however, more to the emotional confrontations within the story than to Soviet montage designed for intellectual enlightenment. It is therefore hardly convincing that the conflictual confrontation observed in the plots of left-wing films was a Marxist dialectic; rather it was a practice rooted in a traditional aesthetics that valued the balancing of oppositional forces into harmony.[81]

A look at Chinese film journalistic discourses and film practices suggests, however, a more nuanced reception of montage theory, as well as the structural affinity between conflict as a formal principle and

as a narrative device for affective impact upon spectators. Although it was Pudovkin's works that were translated and circulated in the 1930s, they were similar to Eisenstein's in defining montage as a radical reorganization of time and space.[82] Even Liu Na'ou, labeled the most important soft-cinema critic, introduced Pudovkin's notion of montage as a means to manipulate time and space—despite his camp's supposed distaste for Soviet films. Liu was also enthusiastic about Vertov's kino-eye (camera eye) and discussed his films *Man with a Movie Camera* and *Entuziazm* (*Enthusiasm*, 1931). *Enthusiasm* appeared in the third issue of *Modern Screen* as a vanguard film.[83] The Soviet film influence clearly went beyond the narrative films from the 1930s. Nor was the enthusiasm for Soviet modernist films limited to left-wing film critics.

Not only did the understanding of montage go beyond the "associational," but the conflict principle was applied in left-wing films as a major device to reorganize time and space in a mode of political expression that would maximize affective impact. In *Dawn over the Metropolis*, this conflict principle is limited to several scenes: the rich man dying in his sick bed is crosscut with the son fooling around in the dance hall, and within the same scene, the workers' hard labor contrasts with the son being waited upon while yawning.[84] The conflict principle is most consistently carried out in *Twenty-four Hours in Shanghai*, structured around events that happen to two families in the course of twenty-four hours. Starting at four o'clock in the afternoon and ending at the same hour the next day, the film goes back and forth between the debauched family life of the factory manager and the misery suffered by an injured worker and his family. Although the emergency of the worker's injury instills a linear narrative drive, the film's crosscutting is distinct from Griffith's last-minute rescue formula, which counts on the final meeting of the accelerated parallel plotlines for narrative resolution. Instead, the plot divides the film evenly into two-hour segments that unravel the life of the two families. The two lines of narrative meet in the middle of the film at the manager's house, but not at the end. Instead of being rescued at the last moment, the injured worker dies finally of neglect and lack of medication. Contrary to Pang Laikuan's assessment, such a montage of conflict simultaneously produces "intellectual enlightenment" and "emotional confrontations." For one thing, the practice

of montage itself is never devoid of affect and hence does not contradict the emotional intensity within the film, and for another, this structural conflict is clearly indebted to Soviet film theory, as well as Marxist political theory, rather than to "a traditional aesthetics that valued the balance of oppositional forces into harmony."[85]

Scenes of City Life rehearses a similar method of politically framed parallel montage, dissecting Shanghai's semicolonial spatiality in the fast-cutting documentary sequence. The rest of the film operates, however, on a different structural principle. The major narrative after the Western mirror sequence shifts from the provincial railway station to metropolitan Shanghai. The family members are assigned new roles in the city. The parents and the daughter remain in one family while the nephew becomes a "literary youth" in Shanghai, pursuing the daughter. As the story evolves around two men's rivalry for the affection of the daughter, the film surveys the social spaces of Shanghai commodity culture, which pervades and constitutes individual private life and human perception. The social spaces in the film are not so much contrasted as deconstructed from within by a persistent undercutting of surface impressions.

Remarkably, this disassembling of the obfuscating surface is not realized by crosscutting between social spaces but executed through innovative interactions of sound and image. Sound as a novel addition to the cinematic medium enhances its metadiegetic capacity together with other intermedial devices the film deploys (peep show machine, cartoon, animation, and still photography). While the film is committed to providing an acute, transparent vision of Shanghai, it also aspires to turn around and reflect upon the shadow of its own "silver light"—a critique of the commodity culture that will not be complete until it executes a self-reflexive critique of its own making.

The tongue-in-cheek inquiry into Shanghai surface culture starts right at the inception of the major narrative with the male protagonist (the nephew in the beginning montage sequence). With the montage sequence replaced by a cartoon image of the four family members, now with new identities and urban attire, the camera tracks in on the young male figure at the center. The next shot cuts to a whistling young man, Li Menghua (Tang Na), in a Western suit, polishing his leather shoe. As the whistling continues, the camera tracks slightly along with him as he moves around his humble apartment adorned with movie stills,

books, and a glass-framed diploma. The next shot cuts to a close-up of the shoe in the man's hand. As the shiny shoe top is turned over, the bottom is shown to the audience with a hole through which the man's index finger sticks out.[86] Mimicking the rhythm of the whistle and the shoe polishing, the finger occupies the center of the screen, facing the audience and making a tickling, affective gesture. As the whistling continues, the camera pans down the young man's Western shirt and pants and pauses at his left foot, with his big toe sticking out of the sock. The foot slightly taps the floor in the same rhythm and lifts up to meet the shoe with the worn-out bottom, and the camera recedes to show Li getting dressed to leave the apartment.

Li counts his money and accidentally drops a coin. As the coin hits the ground with a ding, the ears within the *shikumen* are activated. Two women, apparently landladies of the house whose ears are tuned to this particular sound, show up at Li's and echo the ding with a knock on the door. Li opens the door and replies with a dead-pan, ready-made answer, "Rent, and deposit, I will pay them tomorrow." To hide the coin, he spits out his chewing gum, steps on it, and covertly sticks the coin to the bottom of his shoe. Li victoriously walks out, but as he goes downstairs, his coin betrays him with a noise at every step. As he walks along the street and passes a newly paved sidewalk, he leaves his shoe print with a coin at the center, which attracts the curious gaze of street children.

In these two sequences sound is inserted as an irreducible presence that interacts with the image to create a perforation of surface. The whistling and the wandering camera produce an interplay of sound and image that allows the audience to observe the apartment and the young man's attire as an index of his social status and identity. As the polished shoe turned upside down reveals its perforated bottom, the young man's jovial whistling changes to a light satire of the modern man's effort to cover up his poverty beneath and inside. The tickling gesture that scratches the screen surface and winks at the audience is appealing to shared knowledge of the situation as well as an idiom in Shanghai dialect, *cuebang*, or "the sole is worn out," which denotes the exposure of a lie, trick, or disguised identity. The sound of the coin echoes in the porous space within the alley house, the vernacular "glass architecture" whose perceptual transparency is dictated by a social hierarchy and the tyranny of money.

As money is foregrounded through an exaggerated sound effect—his stepping downstairs is produced by drumming—it resurfaces at the center of the shoe print that coincidentally covers up the shoe hole. The visibility of the money that points to Li's lack makes a blatant sound and imprint that pierce the surface culture.

In the next scene the economics of the surface culture is investigated through an equally innovative interplay between sound and image. We first see the back of a fashionable woman standing on the sidewalk of a busy street, with traffic noise and human voices around. Two women turn and look at her briefly. Then, Li walks past from behind and stops beside her (Figure 4.15). He lowers his head, as if apologetic for being late for a date, leans forward to look at her face, appreciates her clothes back and front, and puts his arm intimately around her shoulder. The woman asks, "How about it?" "Pretty good," Li answers and takes off her coat, at which point his "date" is revealed as an armless mannequin with a nude upper body (Figure 4.16). Li walks toward the left as the camera tracks with him to the counter of a store, where he inquires as to the price of the coat. The cashier's answer reveals that she is the source of the voice that we have mistaken for the mannequin-woman's.

This scene is conducted in one take that begins with a static long shot changing to a tracking shot, and a tremendous amount of information is condensed in this contrapuntal play of sound and image, aided by the mediation of the liminal materiality of glass. What we take as a street scene is indeed the montage effect of sound and image from a variety of sources across the display window. The mannequin and Li are inside the store behind the window, while the two women and street traffic are outside. The street itself is filled with objects and activities: stores across the street, pedestrians passing in different directions on both sides of the street, rushing rickshaws, laboring tricyclers, cars, a traffic policeman in the far background, and a bus approaching in the middle ground to let the passengers descend. The human and vehicle traffic crisscrosses in different directions and at different speeds to create the effect of a particularly bustling street that distracts and confuses the audience's perception. Even more misleading is the subdivision in the foreground between the two women farther back and Li with the mannequin closer to the front. Pedestrians walk through the space between them, including

Figure 4.15. Mannequin lover behind the display window. *Scenes of City Life* (1935).

Figure 4.16. Mannequin revealed. *Scenes of City Life* (1935).

a newspaper vendor who approaches the women, walks back toward Li and the mannequin, waves her newspaper in their direction, and then moves to the right, where a third woman stands slightly to the front-right side of the mannequin. In her diligent solicitation of the crowd in every possible direction, the newspaper girl creates the illusion of a shared space across the glass division. Sound contributes further to the illusion by bringing the street noise into the store. Meanwhile, the cashier's voice from within provides another source of confusion that in effect animates the mannequin.

This sequence executes two kinds of "vertical montage," a notion I borrow from Eisenstein, though with very different connotations. Eisenstein used "vertical montage" to discuss a sound/image correspondence in his making of *Alexander Nevsky* at the later stage of his career when his discussions of montage geared toward totality, synesthesia, and synchronization.[87] What we see in this scene suggests, however, a strong sense of contrast in arrangement of space, sound, and image. In contrast to the horizontal montage between the shots, we witness, first, a vertical montage of sound and image that produces dialectical meaning through asynchronicity and, second, a visual montage within a single shot that processes information on different planes in the visual depth of the field, from foreground, middle ground, and background. These two means of vertical montage capture the disorientation of senses and perceptions in the modern metropolis, mediated by the display window. Sound and image are seen as sources of confusion creating optical and acoustic illusions that inspire a sexual fantasy. The montages of sound and image participate in the creation of this fantasy yet also enable its denaturalization. While the camera tracks left to the cashier at the counter and includes another visual field of knowledge that retroactively supplies synchronicity, the revealed asynchronicity of the previous scene enables a reflection upon the constructedness of the sexualized commercial fantasy, culminating in Li's undressing of the female body. Allegorized in this dramatic gesture of disrobing, the critique of the surface culture is realized by a pornographic mode of knowledge and its simultaneous frustration. At the center of the surface culture is the unsettling status of the female body, which defies this male mode of knowledge by its lack of differentiation from the mannequin, the fashion model, and the commodity.

Even though the view is from behind the display window, the deployment of asynchronicity and the conflation of plural planes of the visual field on the same surface create a fantasy that places the audience outside the store, on the side of the consumers and spectators of the display—embodied by the two women on the street gazing at the dressed mannequin. The audience is thus positioned at the symmetrical vantage counterpoint from street onlookers outside. With such positioning, *Scenes of City Life* provides a timely reflection on cinematic transparency: the film screen is turned into a glass surface that functions similarly to the display window, contributing to the sexual fantasy that lures people from both sides. However, a new film aesthetic involving a radical interplay between image and sound, asynchronicity, effectively traverses the surface confusion of a purely visual aesthetic and provides a new mode of transparency. This is enabled precisely by an attention to intermediality, by pointing to and playing with the differences and collaboration between images and sounds.

Transparency, as argued by Gyorgy Kepes, implies both an optical quality, the capacity to "interpenetrate without optical destruction of each other," and a spatial order, "a simultaneous perception of different spatial locations. Space not only recedes but fluctuates in a continuous activity."[88] Colin Rowe and Robert Slutzky describe transparency as both a material condition of permeability to light and air and an intellectual imperative with moral overtones. Because of this conflation between the spatial and optical and the material and critical, the notion of transparency is endowed with ambiguity instead of a self-evident clarity. The aesthetic execution here, associated with a distinct notion of transparency, invites dialogue between what Rowe and Slutzky call "literal" and "phenomenal transparency." In their attempt to clarify notions of transparency promoted by modernist architecture, Rowe and Slutzky conceive of literal transparency as the inherent quality of a material substance (glass), whereas phenomenal transparency is an "inherent quality of organization," an aesthetic product they attribute to the legacy of cubism.[89] In cubism phenomenal transparency is seen as a spatial ambiguity achieved by the contraction of foreground, middle ground, and background, a simultaneous assertion of spatial extension and the painted surface.[90] In modernist architecture phenomenal transparency refers

to the contradiction between shallow and deep spaces, real and implied spaces, which creates rifts in observers' spatial perception, encouraging fluctuations in interpretations. Critiquing the Bauhaus's reliance on material in producing a simplified and unambiguous spatial order, Rowe and Slutzky place Le Corbusier's architectural design in the 1920s in the "postcubist order" as exemplifying a spatial stratification "by means of which space becomes constructed, substantial, and articulate," which they regard as the essence of phenomenal transparency.[91] By emphasizing phenomenal over literal transparency, Rowe and Slutzky render the promise of new building material—glass, steel, reinforced concrete—peripheral, if not entirely irrelevant. Yet we witness in this film scene precisely the mutual dependence between literal and phenomenal transparency, an aesthetic organization of sound and image that collaborates with the materiality of glass in creating a rift in our spatial perception. It is from such collaboration that a left-wing culture of glass arises.

Medium of Reflection

After Li makes his purchase—a sweater less expensive than the fur-collared coat worn by the mannequin—he walks to bring it to meet his actual date, Zhang Xiaoyun (Zhang Xinzhu), but encounters another man leaving the woman's home. The lady's maid will not open the door for him until Li knocks on the gift box, the sound effect announcing the arrival of the gift in an exaggerated loud drumming. The lady comes down from her boudoir and on her way stops at a door to look through the keyhole. Inside the house her parents are arguing about the lack of money. This brief glance at the family's financial crisis evokes image and sound in a style of citation. An enlarged keyhole frames the scene, and the parents' sentences rhyme, mimicked by the heavy drumming.

The citational mode recurs in the film and functions as another structural device that encourages self-reflexivity. When Li and Zhang go to the movie theater, they are shown a Mickey Mouse cartoon that recollects their meeting at Zhang's household, identified by three different points of view. The cartoon, drawn by the famous Wan Brothers, whose work is discussed in chapter 6, first shows Mickey walking happily with a gift box and meeting a wolf at a house

entrance. As the wolf raps Mickey on the head with his walking stick, the camera shows three reactions from the audience. Li's rival, who happens to be in the same theater, recognizes the scene and smirks. Zhang looks amused, and Li in turn looks angry. The next scene shows Mickey giving his girlfriend a scarf. The girl puts on the scarf, and the two dance and kiss. The camera shows Li looking happier and the girl turning sullen. In the third scene of the cartoon, a big-bellied pig watches their kiss and snorts angrily. The camera turns again to Li and Zhang, this time in a two-shot showing them looking around and then smiling at each other with slight embarrassment.

The minicartoon recapitulates the previous scene and evokes the spectators' recollection and reflection by staging cinema as a reflective medium and moviegoing as an act of affective reflection. In contrast, glass, framed inside the commodity culture, seems to cultivate a different mode of reflection. After the movie Zhang encounters her other beau, who offers her a ride, and leaves with him. As Li is left alone in anger, he sees a Ford car behind a glass window framed in an advertising couplet: "Buzuo qiche, busuan piaoliang" ("No car, no charm"). The next shot shifts inside the display window as he looks in, with the name of a bank behind him. The camera then shifts back to Li's point of view. As Li tries to look closer through the glass, he sees nothing but the glass reflection of the bank title: "Chuxu yinhang" ("Savings Bank"). Li turns around, and what he sees is not the bank itself but publicity made by a cartoon divided into three sections. The first panel shows a man looking pensively at his accounting book; the second shows him depositing money at the bank counter; and the third shows a happy couple driving away in a car. An arrow goes from the couple in the car to two savings jars while four Chinese characters appear above the car: "chuxu cheng-guo" ("the fruits of saving"). As the camera tracks in on the two jars, a car appears inside one of them and rotates with radiance. Li smiles and comes back home with a savings jar. He puts his change in the jar, shakes it, and listens to the sound while an image of Zhang appears inside.

In this scene Li is sandwiched between two entities of the capitalist economy: the display culture of consumption and the circulation in the guise of accumulation that promises a positive return. Whereas the display window associates the fantasy of a modern girl

with the car, the savings bank projects a "pragmatic means" to obtain the fantasy. Framed between these two entities that reinforce each other, individual reflection is short-circuited by an optical effect of glass reflection. Time is deposited as virtual money that sustains the promise by the savings bank. With his watch at the pawnshop and himself losing track of time, Li's only extravagance is time travel through the sketch, which eventually leads him back to the promise of the display window: the car and the woman. While the window and the bank run full circle through mutual citation, perception is seen in this scene as hijacked by the vicious cycle of the optical effect of the culture of display.

Glass and cinema are not always contrasted, however, as competing media of perception in the films produced in this period. Cai Chusheng's *The New Woman,* for example, presents the car window as a metamedium whose transparent and reflective quality is directly associated with film. In a notable scene, as Wei Ming rides in the car with the comprador Mr. Wang, street scenes pass by, seen through the window. In a moment the window dissolves into a projection screen showing a minifilm with intertitles, a flashback in the form of silent cinema. While the minifilm is framed in the car window occupying the center of the screen, Wei remains visible as the spectator in the darkness watching her own reflections of the past, her facial expressions lit up by the projection light. Here, glass and cinema converge as homologous media of transparency and reflection. In another scene the glass surface of the watch is made transparent, transformed into a movie screen showing a montage contrast between the consumptive labor at the dance hall and productive laborers at a textile factory. The indulgence of the dancers and the fatigue of the workers are both dictated by the clock.

The most poignant scene takes place, however, when Wei agrees to prostitute herself for one night in order to save her daughter from a medical emergency. As Wei looks in the mirror, with the landlady helping her with her hairdo and makeup, the camera cuts to another room, where her sister walks back and forth with great anguish. We see the sister watching through her room window and across another window of the room where Wei is being made over; the sister turns around toward us and then back to watch the scene. The camera closes in on Wei and her landlady and cuts to a close-up of the sister's

face, filled with tears, pity, and sorrow. The camera then cuts to a medium-long shot of the sister from the back, showing her watching the scene intensely and collapsing in the room. When the camera cuts back to Wei, she is completely made over, adorned with new hairdo, earrings, and dress, but with tears on her face. This poignant scene of spectatorship renders glass not only a medium of perception and reflection but also one of transformation. While the sisters' gazes never meet, the audience becomes the nodal point for the exchange, where three ways of watching and self-reflection—of Wei, the sister, and the audience—converge in the act of seeing through transparent and reflective surfaces. In the car window scene as well as this scene, the glass/screen is rendered as both a spatial and a temporal medium, in front of which we witness Wei's transformation from a petite bourgeoisie to a prostitute, but also from the character of Wei Ming to Ruan Lingyu, the glamorous film star. As we watch Ruan's forced smile in front of the mirror across the glass window, the camera and the glass become complicit in the moment of magical transformation and violent coercion.

Medium Old as New: Unframing the Western Mirror

Scenes of City Life ends with the utter despair of the four main characters: Li goes completely broke and becomes homeless after being driven out of the *shikumen* house; the parents' pawnshop is failing; and the daughter is abandoned by her husband fleeing from bankruptcy. The father and daughter chase the escapees in vain to the train station. As the railway bell rings, the camera cuts back to the small town with the county train station manager ringing another bell while the four characters are dumbfounded by their virtual tour of Shanghai. A whistle startles the four family members, and two trains arrive one after another. The camera pans to show each of their stupefied faces and cuts to a close-up of a blinking single eye that occupies the full screen. The family hurries onto one train and then gets off to board another. Caught in between two trains, the family circles around an electricity pole as both trains take off and accelerate in opposite directions. Meanwhile, the Western mirror man's song continues in the background. An animated black circle closes in and ends the film with a question mark that occupies the full screen.

Framing the major narrative within the Western mirror, the film makes a conscious choice in adapting an old medium as a meta-diegetic device to reflect on the role of cinema in molding physiological and critical perception, reflecting upon how sensorial perception interweaves with social perception and how possibilities of critical perception could be sought out. Although their date of inception remains to be determined, peep shows became popular in eighteenth-century China in the lower-Yangtze area in cities such as Yangzhou. As documented by A Ying, who was incidentally one of the members of the left-wing film group, the peep show machines in this period were small, intended either for royal entertainment with Western-style painting in rich colors or for popular entertainment with woodcut prints with added color.[92] Peep shows were also called "West Lake scenes" (*xihujing*), mainly because many of the pictures featured the scenery of West Lake. The genre was popularly known as the Western mirror to emphasize its foreign and exotic nature and to evoke audience curiosity. The peep shows featured pornographic images, landscapes, vernacular stories, aristocratic life, famous paintings, images of the West, and world geography. Peep shows were also called "Western landscape" (*xiyangjing*), which highlighted the connection with landscape, exoticism, and travel. According to A Ying, between the late eighteenth and the mid-nineteenth century, peep shows started to be performed in public squares, accompanied by singing and musical instruments. These pictures were much larger than the privately used ones, the size of a full-size calendar poster.[93] Joseph McDermott documents the use of peep shows by the mid-nineteenth century in places such as Canton, Suzhou, Hankou, and Sichuan. Those in southern cities were small sized, whereas the ones in the central provinces such as Hankou and Suzhou were large and equipped with ten or fifteen large viewing lenses (Figure 4.17).[94]

The Western mirror featured in *Scenes of City Life* closely resembles what A Ying and McDermott describe as the apparatus shown in a public square, with a calendar poster–size image and four viewing lenses. Presented as a public medium for simultaneous private enjoyment, the peep show served as a prototype for cinema, shaping perception in everyday consumption. As the peep show framed the cinematic moving image, the viewer's body, figured by an enraptured single eye in several extreme close-ups, alternately opening

Figure 4.17. Peep show as public and private viewing. *Exotic Commodities: Modern Objects and Everyday Life in China* (New York: Columbia University Press, 2006).

and closing, was shown to fully correspond with the movement of the image in discontinuous seconds (Figure 4.18). The bodily coordination governed by the visual apparatus is given a darkly humorous reference, however, in the one-eyed vendor whose profession suggests an abuse of the faculty of vision, even as the degeneration of the eye allows for its prosthetic extension by the peep show lens (Figure 4.19). The contiguity between the lens and the eye is further highlighted with another touch of humor when the mother, not being able to see the pictures clearly (due to farsightedness or the lack of the right mode of viewing), uses a handkerchief to clean the peep show lens.

In a McLuhanesque gesture, media technology is shown as simultaneously enabling prosthetic extension and conditioning disability, with cinema contiguous with its primitive precedent. The old and new media thus enter a dialectical relationship. Instead of cinema being the absolute new media technology, its very nature is allegorized by the old medium—the peep show machine. At the

Figure 4.18. Close-up of the single eye. *Scenes of City Life* (1935).

same time, cinema provides another frame that engages us to witness the operation of the peep show machine. As much as the peep show machine transforms cinema into moving pictures contained in a primitive box, the camera converts the peep show machine into both a diegetic object and a metadiegetic, self-reflexive device. In this perpetual mutual framing and imbrication, the absolute break between the old and the new is dissolved. Their coexistence and contemporaneity are most eloquently demonstrated in the city symphony sequence contained within the peep show machine, when the old medium provides the critical frame of and is identified with the most radical montage film aesthetic.[95]

This recalls but also complicates what Jay Bolter and Richard Grusin term the double logic of remediation, the twin operation of immediacy and hypermediacy. In their formulation the new medium is often flaunted as the transparent medium in a gesture of self-erasure. Yet this brings into consciousness its differentiation from other (often older) media, creating a sense of hypermediacy;

Figure 4.19. Western mirror and the one-eyed man (played by director Yuan Muzhi). *Scenes of City Life* (1935).

meanwhile, by juxtaposing old and new media in their mutual refashioning, a new level of fullness and immediacy is achieved. I want to quickly clarify the different connotations of "immediacy" in these two formulations and their implications, which are not addressed by Bolter and Grusin. In the first case immediacy is identified with a conscious perceptual transparency when the new medium is privileged as the ultimate frame of perception. In the second case immediacy is identified with an experiential immanence, a kind of sensorial overload and disorientation as the effect of a hyperreality. These two connotations of immediacy, one consciously perceptual, the other sensorial, posit perception and affect in a continuum. Meanwhile, the distinction between old and new media is further solidified. In *Scenes of City Life*, it remains undetermined what serves as the ultimate transparent medium and frame of perception. Nor is the distinction between old and new media absolute. While cinema renders itself invisible to demonstrate the operation of the older medium, the peep show contains cinema in its viewing box and provides the

radical critical frame for us to reflect upon cinema's impact on spectatorial affect and perception of reality. In this mutual framing, the "old" is not necessarily older but contemporaneous with the "new."

If there is a transparency aspired to in this film, it is not associated with a specific medium, just as cinematic transparency is already problematized in the earlier sequence with the display window. Instead, the film deploys a distinct aesthetic that I would call "intermedial display," an aesthetic strategy to reflect upon the interaction between media on display, approaching each other as sites of mutual exhibition, hence enabling critical reflections upon media institutions and their constitution of sensorial and social perception. In *Scenes of City Life,* cinema is in intensive interplay with a variety of media— the peep show machine, photography, drawings, and animation—as well as sound, a distinct new dimension that opens up film's aesthetic and political expressivity. Cinema is, then, no longer a singular, fixed medium. And it is precisely decomposing that myth, mobilizing an intermedial display, that makes a critical transparency possible.

The appearance of the Western mirror entertainer allows a reflection upon the role of the film director. The one-eyed peep show man was played by the director, Yuan Muzhi, who wrote the story of *Scenes of City Life* a year before as a literary piece (Figure 4.20).[96] Trained as a theater actor and director, Yuan was active in the Chinese spoken drama world. He joined one of the earliest drama societies, the Xinyou Student Society (Xinyou xue she), in 1927 and founded the influential spoken drama journal *Xi* (*Drama*) in 1933. The journal was a major forum for advocating modernist theater and devoted much attention to marionette theater and constructivist theater and featured the stage design of the celebrated adaptation of Tretyakov's *Nuhou ba, Zhongguo* (*Roar, China*) by the Shanghai Drama Society (Shanghai xiju xieshe). A talented playwright, Yuan also published two collections of single-act plays. In 1934 he joined Diantong and played the male lead in *The Plunder of Peach and Plum* and *Sons and Daughters of the Storm.* As the "Chinese Lon Chaney," Yuan was famous for his wide-ranging acting roles and his versatile makeup skills and wrote two books, on acting and character makeup, respectively. His most celebrated acting showcase was in *Shengsi tongxing* (*Unchanged Heart in Life and Death,* Ying Yunwei, 1936), in which he played the two leading men with distinct appearances

Figure 4.20. Yuan Muzhi's publicity photo for *Scenes of City Life*. *Denton Gazette* 10 (1935): cover.

and voices. One of them, a revolutionary whose face was maimed in a prison fire, prefigured the Song Danping character in Ma-Xu Weibang's 1937 horror film *Midnight Singing*.

Yuan's chameleon look enables him to insert himself as an anonymous presence in *Scenes of City Life*, although his disguise as a Western mirror entertainer reflects upon his social function as a film director. The one-eyed man, often a reference to the cameraman as well as the director, with their excessive and monocular vision, is engaged with a touch of irony and ambivalence. As the man presents his view of Shanghai to the country folk, he functions as a disillusioning force, yet he seems to have confused rather than guided the spectators. His self-induced sinister look incriminates him as a participant in an entertainment industry that exploits spectatorial curiosity in the name of enlightenment. Furthermore, as a magician and a ventriloquist (the public square peep show was usually accompanied by singing and narration), the peep show man could be a source of "false" sound or knowledge, enacting another phantasmagoria or simply embodying the operation of ideology. The ending of the film is unavoidably allegorical: the family spectators, after watching the peep show preview of Shanghai, are so stupefied that they get caught between two trains going in opposite directions. Between the train and the Western mirror, virtual and actual travel, the city and the country, the traditional and the modern, and entertainment and enlightenment, the spectators and the director are positioned in the same dilemma.

In this chapter I have examined Shanghai left-wing cinema's persistent interest in mass-mediated perception and its role in molding a radical subject by innovations in film theory and film aesthetics. This helps us reframe left-wing cinema within larger issues of colonial urban modernity and complicates left-wing cinema's relationship with popular cinema and high-modernist literary and artistic practices. More specifically, I have resituated left-wing cinema in conversation with these parallel practices, particularly in their articulations of competing notions of transparency. As an integral part of the material commodity phantasmagoria, as literary surrealist liminality, as photographic pictorialism, or as cinematic politicized vision, these notions of transparency function as modes of knowledge and experience in coping with the drastic transformation of the social

landscape and of perception itself. Moreover, they participate in and change the profile of an international culture of glass advocated by European architects and avant-garde filmmakers. Meanwhile, this cinematic transparency recasts the dynamics among Soviet, American, and European cinema in their international circulation with the emergence of sound. Drawing on a wide range of international cinema and film theory, film critics across the divide between the left-wing and the soft-film camps converge in their reflections upon medium specificity and cinema's affective impact. Incorporating both the material culture of glass and the novel technology of sound, a new aesthetic of transparency derives from a conscious interplay between media. Positioning cinema in relation to historical "old" and "new" media helps us revisit left-wing cinema without reiterating the dichotomy between aesthetics and politics.

Part III Agitation

5 "A Vibrating Art in the Air"
The Infinite Cinema and the Media Ensemble of Propaganda

In 1941 a curious essay entitled "The Infinite Cinema" appeared in *Dianying jishibao* (*The Movie Chronicle*), which was based in Chongqing, China's Nationalist capital during the Second Sino–Japanese War.[1] In the article the author, Li Lishui, portrays the history of art along a spiral logic of dialectical development. When it comes to cinema, however, Li puts this trajectory on hold.

Li conceives cinema as an infinite medium transcending the limit of every earlier medium as well as any later art. This is because cinema contains a special "energy" (*neng*) that radiates in time and space and can then be "broadcasted" so as to exceed any boundary. Using biochemical analogies of osmosis (*shentou zuoyong*) and diffusion (*misan zuoyong*), Li describes how cinema can break its rigid boundaries and expand and leap to the infinite. Hence, "The cinematic body—in terms of its realm of activity—is immense and exists in the universe, embedded in the infinite *ether*."[2] Its movement can be either regular or random like Brownian motion, but one thing is certain: "Cinema is an art that starts from the earth but moves to the whole universe . . . a vibrating art in the air."[3]

What does it mean to conceive cinema in terms of energy, radiation, and broadcasting? What is the relationship between cinema and other media, on the one hand, and communication technologies, on the other? How did *ether* enter the Chinese cultural imagination during World War II, and what role did it play in reenvisioning film and mass media?

In this chapter and the next, I shift my focus from Shanghai to Chongqing, where cinema was radically reconceived against the cultural backdrop of mass migration and dislocation, military defense, political mobilization, and global communication. Li Lishui's

seemingly idiosyncratic, hyperbolic ontology of cinema was informed by sea changes in the political and cultural horizon in China. If Shanghai was the center of film production and film exhibition up to 1937, the eruption of the Second Sino–Japanese War split China into at least five geopolitical zones and film centers: Japanese-annexed Manchuria boasted the largest film studio in Asia; film culture continued to flourish in semicolonial Shanghai and British-colonized Hong Kong under increasing Japanese surveillance and supervision; in northwest China the Communist-headed "liberation zone" actively fostered a new film and performance culture; and the Nationalist government, on the retreat to central and southwest China from Japanese aggression, relocated its capital from Nanjing to Chongqing, a remote treaty port (opened in 1891) upstream along the Yangtze River. Amid the westward migration of the country's military, financial, industrial, commercial, and cultural forces, Chongqing quickly emerged as a new geopolitical center, attracting international attention accompanied by the increased presence of foreign presses, embassies, military and intelligence agencies, religious and philanthropic organizations, and businesspeople.

While wartime film cultures in Manchuria, Shanghai, and Hong Kong have gained increasing critical attention, the story of Chongqing is little told, due in large part to the methodological challenge presented by its distinct constellation of film industry and film culture. Unlike the commercial film industry in prewar Shanghai, film production in wartime Chongqing was semi–state run, receiving government sponsorship and subject to in-house censorship while maintaining its own commercial venues and partial funding from other sources. Meanwhile, film exhibition, operating in both commercial and noncommercial venues, flourished under the convergence of various networks that reflected the changing dynamic between the local, national, and international. In the commercial venues transregional traffic perpetuated a continuous flow of films from Shanghai and Hong Kong, including prewar productions; and a large number of foreign films from the United States, the Soviet Union, Britain, and India swept the city, bringing various genre films in black and white and glorious Technicolor. A more radical change took place *beyond* the commercial theaters when mobile projection teams brought films to the vast hinterland, reaching the

rural area as well as the military, factories, schools, administrative centers, and other public spaces. In the international arena *outside* China, Chongqing-based film studios developed film exhibition networks in South and Southeast Asia, North America, and Europe. In addition, audiovisual education provided a new context for film production and film exhibition. The Jinling University's Audiovisual Education Department set an early example of a comprehensive education in film engineering and film production and, more broadly, of "electronic" (audiovisual) education. Running their own film and media journal, an active program of film exhibition, and an exchange with American educational film institutions, the program made a unique contribution to the film cultural scene in the hinterland and effected a conscious reflection of film in relation to media history.

These substantial changes in production and exhibition were not unique to the realm of cinema. A more profound transformation of mass culture took place with the eruption of the war and carried over into the Nationalist hinterland. This was a shift from relatively stable sites of production and reception to a more mobile and flexible model, from predominantly urban, commercial, and bourgeois settings to more mixed settings, combining state-based enterprises with commercial and makeshift venues to mobilize established and alternative public spaces, targeting both urban *and* rural audiences and fostering a collective identity of a national community.

In this broad change mass media expanded with heightened mobility, moving beyond existing institutional confines and conventional spaces of exhibition. Poetry was recited in mass rallies and public gatherings; plays were performed on the street; photography, cartoons, and writings were put up on the wall; and reportage literature delivered stories from factories, the battlefield, and the countryside.[4] Transgressing galleries, theaters, and private living rooms, literature and art became mass-mediated weapons. Paralleling the military war, a media war was wielded as an equally mobile and total tool of mobilization and synchronization.

These general changes in mass media intensified cinema's interactions with other media, conceived together as a new media network in the service of the war. To understand this media network, we need a serious engagement with the theory and practice of propaganda, a loaded, highly stigmatized term that has made wartime

Chongqing film and media culture suspect, contributing to its neglect and want of a critical methodology. For me this is a missed opportunity to consider propaganda as an essential chapter in the study of film and mass media. In other words, propaganda should not be considered a historical anomaly, a particular genre or type of film and media practice, but rather could be approached to consider renewed notions of cinema through its intensified interaction with other media, its role in national and international politics, and the stakes of affect. Despite and through the instrumental use of mass media, propaganda carried forth utopian dreams and radicalized earlier practices of cinema and media. In this sense, this chapter and the next serve as the culminating point of this book, dealing with the highly politicized production of affect through intermediality on a new level. The earlier *dispositifs* of perception—resonance and transparency—will return with charged and altered significance.

This chapter places Chongqing and hinterland cinema in dialogue with wartime propaganda theory and practice, with a special interest in considering how a synchronous, mobile, affective medium was forged out of an ensemble of media aiming at massive and simultaneous dissemination for political mobilization. Li Lishui's notion of a cosmic cinema, "a vibrating art in the air," captures the propaganda fantasy of cinema, whose mobility and vitality know no bounds. The theory of a vibratory cinema reflects both a technoscientism—deploying metaphors from biology, chemistry, and physics and capitalizing on the expansive power of wireless technology—and new practices to disseminate film and other media in the production of a simultaneous space-time. This megamedium suggests a new operation of affect, overwhelming and encompassing the masses in the media network serving the purpose of wartime mobilization. Wireless technology serves as an actual and figural technology to conceive this media ensemble and a newly imagined interconnectedness.

In the following section, I introduce the historical background of Chongqing cinema, paying particular attention to the ramifications of the change from the Shanghai-based commercial enterprise to semi-state-sponsored cinema. Situating this change in the diverse film distribution and exhibition culture in Chongqing, I examine film debates and film criticism in journalistic discourse on

the construction of a new Chinese cinema and reflect on the multiple possibilities opened up by resistance cinema. I will show how the issues raised in these debates about the potential of state cinema and "rural cinema" interacted with actual film productions.

At the center of this intense interaction between film criticism and film practice was the filmmakers' and film critics' pursuit of a new film vernacular in the effort to reach diverse audiences with distinct dialects, aesthetic tastes, and viewing habits. This search for a more encompassing cinema demonstrated the filmmakers' heightened awareness of Chongqing cinema's multiple exhibition contexts (both domestic and international) as well as the diverse film culture flourishing in the wartime capital. In conscious competition with the hegemony of Hollywood cinema as a universal language, the filmmakers sought alternatives such as rural cinema and a "cinematic Esperanto." These discussions paralleled the development of a hypermediatized mass culture intermingling cinema in a network of communication technologies and a public exhibition culture used for the mobilization for war.

The second half of the chapter takes a closer look at this communication network by shifting from film language to alternative understandings of the cinematic medium situated in the parallel development of propaganda theory and the mediasphere in wartime Chongqing. Propaganda theorists' reconception of mass media converged with the ambitions of the state and competing parties to produce an encompassing environment of media, which was carried out by an expansive exhibition culture (film, painting, photography) through which the wireless served as the master metaphor of the power and saturation of propaganda. As cinema was reconceived as a vibrating art in the air and its body was defined by its "realm of activity," the ether medium, capitulating to the draw of wireless technology in the 1920s, returned to evoke propaganda as an affective medium with a different political agenda.

A Singular Time

In September 1936 *Zhongguo de yiri* (*One Day in China*) was published in Shanghai, an unusual compilation of 490 short pieces on what happened on May 21, 1936. Modeled after Maxim Gorky's proposal for a

book entitled *One Day in the World* that would collect writings from around the globe, a plan not yet carried out, left-wing writers Mao Dun and Wang Tongzhao, journalist Zou Taofen, and educator Tao Xingzhi posted repeated announcements in a variety of national and local Chinese newspapers beginning in April 1936 to solicit writings from all over China that would report what people observed on May 21. This assignment generated more than three thousand pieces by authors from various vocations in the metropolises as well as remote corners of the country, representing a variety of literary genres such as essay, diary, poetry, novella, drama, and reportage as well as visual arts such as photography, cartoon, and woodcut.[5] The rich complexity of the contents aside, what is most striking is the book's journalistic invention of a national event out of a random date, the way it homogenized a point in time and initiated a national experience of the intensity of now. Mass media, in this context remediated and totalized via the print medium, was assembled to synchronize an experience of time made ever more pressing by the increasing Japanese aggression toward China from 1931 onward.[6]

A miniature panorama featured in the front and back endpaper of the volume captures how mass media served as a synchronizing engine to reconfigure time and space for a new political experience. This is a woodcut print by artist Tang Yingwei entitled *Guonei dashiji* (*A Chronicle of Major Events in China*).[7] Executed in the form of a serial picture, the woodcut depicts scenes of natural disaster, war, and iconic mass movements in twentieth-century China. While geological and built borders (mountains, rivers, the Great Wall) subdivide the scenes, the movement of the people in all directions (soldiers, protesters, refugees) bleeds the boundaries, overwhelming the picture with physical energy and urgency, forging a highly politicized landscape of national crisis and mass movement. Despite the temporal and spatial differences of the depicted events and scenes, a strong sense of totality and simultaneity is conveyed. In effect, Tang's woodcut panorama spatializes "one day in China" as a continuous presence, a condensation and culmination of historical events that collapse the natural, national, and political landscape.

One Day in China, with its "total mobilization of mental power" (*naoli zong dongyuan*), soon proved to be useful training.[8] On July 7, 1937, less than a year after its publication, the attack at the Marco

Polo Bridge in a suburb of Beijing launched Japan's full-scale inva-
sion of China.[9] This incident, which was not made known to most
Chinese until two days later and whose implications were unclear
until the Nationalist government decided to fight back in early Au-
gust, was recognized in historical hindsight as the watershed event
that began China's eight-year War of Resistance (Kangzhan). As in
the making of One Day in China, the mass media played a significant
role in this retrospective identification of the Marco Polo Bridge
incident as a historic event. On August 7, 1937, the spoken drama
Baowei Lugouqiao (Defending the Marco Polo Bridge) was performed
in a movie theater in the Chinese zone of Shanghai. It boasted a di-
rectorial team of eighteen renowned film and theater directors and
more than one hundred actors, most of them film and spoken drama
stars.[10] The staging of Defending the Marco Polo Bridge, together with
a variety of other plays, reports, and novellas, marked another ex-
traordinary invention of the "event" as a new temporal reference to
synchronize and unify the nation.

The national identification of the Marco Polo Bridge incident—
heavily mediated by the operation of mass media, including poetry
recitations, spoken drama performances, newspaper reportage, jour-
nalistic articles, and newsreel films—conveyed the national War of
Resistance as organized around a singular time, with an intensely
experienced present as a radical departure from the past.[11] As Shang-
hai fell three months later, that departure took a spatial turn with
the nation's westward migration of financial, industrial, commercial,
educational, and human forces to the vast hinterland. As if turning
the leaves of One Day in China, the westward migration moved from
the center to the periphery of the country. In a manner that the Guo-
mindang (GMD) leader Chiang Kai-shek called "trading space for
time," this mass migration became a military strategy to mobilize
for a total war by moving civilians along with the military and the
government so as to embrace an elongated present of a nation at war
in a receding space.[12]

While synchronization was the key to maintaining a national
imagination, mass media played an important role in the technologi-
cal operations of simultaneity. Between August and September
1937, thirteen performance troupes were organized by the Shang-
hai Theater Circle National Salvation Association (Shanghai xijujie

jiuwang xiehui), eleven of which traveled across the country to a great number of cities, towns, and villages. Along with these performance troupes, writers, musicians, artists, photographers, and filmmakers set their feet on the battlefront and the inland. Eventually, they arrived in Wuhan and Chongqing, where the national centers of resistance culture had been established.[13] Their efforts to synchronize relatively isolated small towns and villages with a national time of emergency reoriented local life in order to prepare for and contribute to a total war.[14] They stirred the imagination of the migrant masses such that they experienced the initial defeat as the inception of the national war. The losses on the east coast and in northern China were seen as the mobilization of space by the people's own movement.

While the whole nation was on the move, two film studios, the Central Film Studio (Zhongyang dianying sheyingchang, "Zhongdian" for short) and the China Motion Picture Corporation (Zhongguo dianying zhipianchang, "Zhongzhi" for short), relocated to Chongqing. Zhongdian originated in 1927 as a military filming group under the Political Affairs Section of the GMD and was established in 1934 in Nanjing. Mainly devoted to newsreel documentation, they recorded the major political and social events in China, culminating in the filming of the 1933 National Games.[15] Between 1933 and 1936, they made a few docudramas and feature films and provided training for military film projection.[16] At the outbreak of war, Zhongdian sent film crews to several battlefields, and their newsreel special report *Lugouqiao shijian* (*The Marco Polo Bridge Incident*) was shown nationwide and was received with great enthusiasm. While shooting in Shanghai after the battle of August 13, they started to accept filmmakers and workers from the Shanghai film circle, including the screenplay writers Xu Sulin and Pan Jienong and the director Cheng Bugao. In February 1938, Zhongdian relocated to Chongqing. In the first three months there, the studio made *Dong zhanchang* (*Battlefield in the East*), *Huoyue de xixian* (*The Active Western Front*), and a special report on the victory in Tai'erzhuang, Shanxi province. With the help of a GMD general, Fan Shaozeng, Zhongdian rented his private indoor tennis court and reconstructed it as a film studio. They began recruiting more feature-film workers, as well as directors Sun Yu and Shen Xiling and actors Bai Yang, Zhao Dan, Wei Heling, and Shi Chao.

Zhongzhi did not move to Chongqing until October 1938. Having originated in the Hankou branch of the GMD military filming group in 1935 (the Film Department of the Political Training Office), it was devoted to shooting newsreels and documentaries and holding traveling exhibitions within the military. In the fall of 1937, with the war in Shanghai, Chiang Kai-shek realized the political importance of mobilization by mass media and provided funds to expand the original film department into the China Motion Picture Corporation. With the major government departments and cultural forces having moved to Wuhan, Zhongzhi recruited a large number of film workers originally based in Shanghai. Its staff grew from eighteen people to more than 120. The newly organized Zhongzhi became a branch (the Second Branch of the Sixth Section) of the Third Bureau of the Political Department, under the direction of the Military Affairs Commission, a wartime propaganda bureau of the united front between the Chinese Communist Party and the GMD. During the year the organization was based in Wuhan (1937–38), they made three features, five documentaries, eight cartoons, and seven newsreels. In addition, they sought domestic as well as international distribution of their films.[17]

The two film studios, with their direct affiliation with the state and their previous experience with newsreel and documentary filmmaking and traveling exhibitions, significantly changed the nature of the films that were produced. At the same time, the film crews, including the actors, directors, and screenplay writers, came from the previously Shanghai-based film industry and the spoken drama stage. How did these diverse forces converge in the perception and production of resistance films?

Creating a united front of the film world first of all entailed reworking the time of Chinese film history. Heralding the "birth of a new cinema," former Shanghai drama and film critic Tang Na, who played the male lead in *Scenes of City Life,* conducted a telegraphic genealogy of Chinese cinema in his editor's note to the first issue of the film journal *Kangzhan dianying* (*Resistance Cinema*).[18] In it Tang identifies three transitional moments in Chinese film history: the January 28 incident of 1932, in which the Japanese bombing of Shanghai made anti-imperialism and antifeudalism the common cause; the 1934 soft-film versus hard-film debate, which divided the film world

into opposing camps; and the 1936 call for "national defense films," which initiated the united front of the film world.[19] Tang spatializes this temporal trajectory into a geopolitical alignment: the new resistance films being made in the hinterland are the direct descendants of the left-wing, hard, national defense films, whereas the "others" are resurging in occupied Manchuria and Gudao (the "Orphan Island" of Shanghai), with martial arts and god-spirit films regaining popularity (most notably in the reexhibition of the long-banned *Burning of the Red Lotus Temple*) and soft-film advocates receiving funding from the Japanese.[20] This genealogy of a nationalist, leftist Chinese cinema locates the January 28 event as a beginning point of temporal identification that anticipates the continuity of Chinese cinema overcoming its troublesome others, unifying a perpetual present.

Wartime Chongqing

The leftist filmmakers and film critics, now a visible force at the two studios, had a rare opportunity to perpetuate a simultaneously radical and pragmatic film culture in the service of the war. Yet Chongqing was an urban center distinct from Shanghai at an unusual historical juncture. A unique geopolitical dynamic between the local, national, and international fostered a qualitatively different mass public.

The city of Chongqing did not become a municipality until 1929, but the area had enjoyed a long history since the establishment of the Ba State in the eleventh century BCE. Nestled in the mountainous area in southwest China and connected by the upper Yangtze River waterways, the area evolved with relative independence due to its geographic inaccessibility but emerged as a trade center in the late nineteenth century facilitated by development in water transport. The European colonial expansion forced Chongqing to open as a treaty port in 1891, spurring significant industrialization and commercialization.[21] In the 1920s and the 1930s, the city further developed in commerce, banking, manufacture, and modern infrastructures for transportation and telecommunication, albeit at a pace and scale inferior to those in the coastal cities. In 1935 the Nationalist government realized the strategic importance of Chongqing by enhancing military control of the region and accelerating transregional

road constructions, yet before the war broke out, Chongqing was still conceived as a backwater dominated by local warlords and gangs.[22]

The exile of the Nationalist government to Wuhan and then to Chongqing shifted not only the political center but also the economic, cultural, and demographic axes in China.[23] From November 1937 to December 1938, the relocation of the Nationalist government to Chongqing was accompanied by the large-scale migration of governmental administrations, troops, industrial plants, major banks, newspapers and publishers, universities, and the entertainment industry.[24] Between July 1937 and June 1938, an estimated 419,000 people migrated to Chongqing from the mid- and lower-Yangtze regions. From 1937 to 1945, the city's population tripled from 473,904 to 1,255,071.[25] One-third of the country's factories (around two hundred) and universities (thirty-five) relocated to Chongqing and its suburbs.[26] The seven major publishers in China, including the Commercial Press, Zhonghua, Zhengzhong, Shijie, Kaiming, Dadong, and Wentong, all reestablished their headquarters in Chongqing.

The Western/foreign presence migrated, too. Foreign embassies and consulates mushroomed in Chongqing, and major newspapers opened their bureaus in the wartime capital. These included news agencies from Russia, France, Britain, Germany, and America and reporters from the *Times* (London), the *New York Times, Life, Time,* and *Paris Daily.* The Korean government in exile, established after 1919 in Shanghai against the Japanese colonization, also transferred its headquarters to Chongqing, receiving financial and emotional support from the government and the public.

The unusual concentration of national and international power, capital and cultural enterprises marked Chongqing as a distinctive urban hub. It would be difficult to apply the Shanghai model to the case of Chongqing, as the latter's abrupt explosion in population and urban infrastructure was built on a wartime hypothesis full of contradictions. The official acronym for the epoch, *kangjian,* standing for *kangzhan jianguo* (battle for resistance and building the nation), suggests the double missions of the Nationalist regime: to lead the embattled home front against the Japanese invasion and to intensify a continuing process of modernization that should not vary between days of peace and war. The tension between the emergency state of

war and the normality of everyday life created a mixed sentiment of living in this city when the wartime capital, not meant to last, provided an anchor for temporary stability. This double sense of dwelling, orchestrated by air-raid sirens and lantern alerts, alternated the routine of work and leisure with the race for dugouts. The city housed highly centralized political, military, and cultural institutions at the peak of the country's nationalization while providing refuge for provincial as well as coastal migrants, profiteers and adventurers, philanthropists and patriotic students, and intellectuals on the Left and the Right, all blending in a cacophony of dialects, traffic, sirens, and fires. This multitude of diverse social groups complicated notions of the local, the national, and the global.

How could new films made in Chongqing serve as aesthetic and political responses to the impact of the war on the human sensorium and the social/geographical landscape? How was a national imaginary possible across the geopolitically divided nation and the globe, as already registered in the international film scenario in Chongqing? How could Chongqing cinema distinguish itself among the vast supply of Chinese and foreign films from past and present? How could the new cinema capture and sustain its audience while realizing its mission of wartime mobilization?

A State Cinema: Film as Infrastructure

The national defense cinema, situated in a genealogy that aligned the new cinema with the singular time of the War of Resistance, took to state sponsorship to carry out its agenda. A collective discussion "on the establishment of the national defense cinema" took place in early 1938, involving former left-wing filmmakers, GMD educational film advocates, and spoken drama directors such as Shi Dongshan, Fei Mu, Yao Sufeng, and Yuan Muzhi.[27] The twelve speakers focused on the nature and functions of the national defense cinema that set it apart from commercial cinema. Because of the emphasis on national resistance and mass mobilization, as Shi Dongshan observed, these films would not be exhibited in the occupied big cities, nor would they generate profits in other cities. This low-profit yet high-cost cinema—in demands of financial, human, and material resources—could thus be sponsored only by the government. This

marked a significant departure from commercial cinema: the state-run cinema was not profit driven and oriented itself toward "educating" rather than entertaining the masses, as Communist screenplay writer Yang Hansheng explained.

In a separate article Luo Jingyu divided world cinema culture into two camps with distinct genealogies: the commercial, entertainment-oriented cinema epitomized by American cinema and the education-oriented, "spiritual food" cinema exemplified by Soviet and German cinema.[28] Luo traced a brief history of American cinema from the earliest film exhibitions during the 1890s to the film boom from 1903 to 1908 to the maturation of the studio system in the production of a "mass commodity" (*qunzhong shangpin*) that "gradually invaded the 'market' of churches and bars" with its technological innovations, "precise and scientific standard," and alliance with the Wall Street economy. Despite American cinema's great contribution to world cinema, Luo observed, it did not carry any value for "national policy cinema" because it operated under "the natural law of commodity exchange."[29] In contrast, German and Soviet films had refreshed world cinema since 1926 with their creative imagination and innovative techniques. Luo lauded the influence of the unique quality of Soviet cinema between 1926 and 1929 and cited the works of Eisenstein and Pudovkin as the perfection of film principles established by American filmmakers such as Porter, Griffith, and DeMille. At the same time, he praised these films' devotion to educating their citizens in order to contribute to the social, political, and scientific improvement of the nation.[30]

The distinction between commercial and education-oriented cinema was not new in China, nor was this the first time state-sponsored films were discussed and practiced. Education-oriented films can be traced to the Moving Picture Department (Huodong yingxibu) of the Commercial Press in 1918 and the investment in educational films started by several social organizations in the 1920s, culminating in the establishment of the National Educational Cinematographic Society of China (Zhongguo jiaoyu dianying xiehui) in 1932 as part of the international educational film movement.[31] State-sponsored film production, by contrast, dates back to 1924, when one of the earliest film pioneers, Li Mingwei, started making documentaries in association with Sun Yatsen and the Nationalist Party. The

state collaboration with various film studios aside, the Nationalist Party itself established a film section under the Central Propaganda Committee (Zhongyang xuanchuan weiyuanhui dianyinggu) in 1929. The two studios that relocated to Chongqing, Zhongdian and Zhongzhi, were also film branches for the GMD military. Despite their separate origins, educational cinema and state cinema were often conflated categories, with the former broadly defined as the vehicle of state policy, mass literacy, and state modernization projects.[32] To some extent, the wartime call for state cinema continued a trajectory of educational and state film development from earlier decades, and many of the wartime discussants were participants in such institutions. We need to attend, however, to educational and state cinema not as naturalized categories or preexisting entities but as sites of constant tensions and discursive struggle. In wartime Chongqing this struggle was particularly intense given the diverse interest groups: educational film advocates, state propaganda bureaucrats from the GMD, and migrant film workers from Shanghai's commercial film industry, including both left-wing and non-left-wing filmmakers. Rather than the sheer imperative to extend the party organ to cinema, the interest in state cinema was mixed with utopian impulses for a new national cinema in competition with Hollywood, in terms of alternative models of the industry (production and exhibition) as well as film language and aesthetics.

In considering film industry, a new conception of cinema as *infrastructure* emerged. For Luo Jingyu, the vice president of Zhongzhi, cinema should be treated as a state-owned enterprise similar to the railway, the telegraph, grain, and the water supply.[33] Placing cinema in the same category as transportation, communication, and energy dispersal, Luo understood cinema as the "spiritual food" to be transmitted across space but also as the technical structure that made the movement across space possible, thus effectively constructing a space of the nation by linking the city and the country in the hinterland. Conceiving cinema as a comprehensive and widespread infrastructure, he turned the question of state cinema into a proposal for full-scale film education, production, exhibition, and distribution with a technological revolution that would have rich implications for a national cinema. Citing Lenin's support for Soviet cinema, Luo asked for governmental sponsorship of the following: (1) establishing

a film academy to provide systematic education to specialized film workers, including directors, scriptwriters, cinematographers, sound engineers; (2) developing a nationwide film exhibition network and, in case "monetary" usage is not annihilated, making film exhibition a significant component of the state enterprise, generating monetary returns to cover the cost of filmmaking and obtaining due profit for the nation; and (3) aiming at self-sufficiency in film facilities and material supplies by manufacturing film stock, cameras, projectors, spare parts, and so on.

In conceiving cinema as infrastructure, Luo amplified the role of a particular apparatus that he welcomed as "the great revolution of film technology": 16 mm film. Luo observed that although its invention was not new, its perfection and the competition it created for 35 mm film were contemporary phenomena worth particular attention in China. Much less flammable and with one-quarter of the weight of 35 mm film, 16 mm was a durable film stock with a low cost. In addition, existing sound films and even color films could be reproduced by reducing their size to 16 mm. Citing examples from Germany and the United States, Luo pointed out that there were already over four hundred 16 mm movie theaters in Germany and that 16 mm theaters had also been established in American schools and civil organizations despite the resistance by commercial theaters. Luo called for the Chinese film industry to seize this great opportunity to "welcome the baptism of the revolution in film technology."[34]

This interest in 16 mm films was not unprecedented, but Luo's conception was qualitatively different. As early as 1931, left-wing filmmakers had discussed the potential of 16 mm films, as an example of "small-gauge films," a term borrowed from the Japanese proletarian film movement referring to a range of non–35 mm film stocks and cameras (16 mm and 9.5 mm).[35] Sixteen-millimeter film was a pragmatic choice during the educational film movement in the 1930s because of its feasibility in local production and its flexibility in screening domestic and imported films in nontheatrical settings. Whereas previous advocates of 16 mm films had applauded its affordability, mobility, and documentary capacity, Luo considered the invention of 16 mm films not as a single technology but as the introduction of a revolutionary "technological system" (*jishu tixi*).[36] He argued that the international dominance of 35 mm films put Chinese

film industry at an advantage to embrace 16 mm films.[37] The heavy investment in 35 mm films in the United States (including technological, financial, and management elements of the studio system and movie theaters) rendered 16 mm film a potential threat to the large capital investment in the previous technology. In contrast, China's number of 35 mm theaters—294 nationwide in 1937 before the war and 79 in the ten unoccupied provinces after the outbreak of war—was significantly smaller than those in the United States (22,624) and the Soviet Union (number not available), so small that it posed little resistance to the new ones to be established. This would in turn bring two advantages: China would be able to solve some of the technical difficulties that the restricted use of 16 mm in other countries could not solve and, hence, facilitate new inventions, but more important, the switch could resist the monopoly of foreign films in several ways. The invasion of derogatory foreign films would be screened out because the 16 mm movie theaters would present a "natural refusal" of those films; the previously foreign-controlled movie theaters would no longer be compatible with 16 mm films; and the foreign film companies would be forced to either reduce print all of their original 35 mm films or establish a gigantic network of 16 mm exhibitions throughout China, which Luo deemed impossible.[38] This way, 16 mm film would mobilize a systematic transformation of film production and film exhibition to mitigate the monopoly of foreign films and foreign capital in China.

Luo's proposal for a 16 mm technological system might have exaggerated its effect against foreign monopoly—after all, a movie theater can accommodate both 16 mm and 35 mm films without major transformations—and drawn more from the experience of China's transition to sound, when the expense of sound equipment provided an opportune moment for Chinese expansion of film production and exhibition. Yet Luo's vision subtly set him apart from state bureaucrats such as Zheng Yongzhi, Luo's colleague and the head of Zhongzhi. Zheng, a former graduate of the Huangpu Military Academy and a propagandist for GMD in the 1920s, wrote one of the earliest books on state cinema in China.[39] Promoting film as a tool of the state, Zheng drew on state cinema in Italy, the Soviet Union, Germany, Britain, and Japan as alternative models to commercial cinema and called for resistance against foreign dominance in the film mar-

kets. Although Zheng similarly called for state sponsorship and establishment of film schools, Luo's proposal was less policy oriented than Zheng's, which considered film a direct tool for statecraft and argued for film censorship.[40] Through a subtle move, Luo substituted the term "national policy film" (*dianying guoce*) for "cinema's national policy" (*dianying de guoce*), rendering the agency to film rather than to the state. This agency, or autonomy of film, hinged on a technological system built on 16 mm film as a core technology that would ramify into a whole industry—shooting and printing equipment, projection systems, optical lenses, film architecture—not only for film but also for the state economy. Luo anticipated an autonomy for this state cinema, free from foreign monopoly and the influence of Hollywood. Yet the "technological system" and the ripple effect of commercial development that Luo pictured—potential for stage cosmetics, theater architecture and its internal decoration stimulating industrial manufacturing, film facilities' potential for wider uses such as camera production attracting commercial investment—looked quite like his description of the ingenious industrial and commercial production of American cinema. Through a state monopoly the American model was transformed into state capitalism, and cinema could become a vital component in the revitalization of the national economy.

In thinking of cinema as infrastructure built on 16 mm film as a "technological system," Luo's plan hit the heart of infrastructure as a key ideology of modern development. Emerging in the 1850s and gaining a strong hold in urban politics from World War II until the 1960s, infrastructure was seen as technical systems that integrated cities, regions, and nations into a cohesive geographical or political unity, a social ideal deeply embedded in the developmental logic of Western industrial modernity.[41] In a different context, Brian Larkin discusses how the ideal of infrastructure operated equally powerfully in Nigeria under British colonization and, more important, how film and media networks were conceived as infrastructure, making media technology a vehicle of British colonial rule.[42] For Larkin the autonomous power of media technology—its different logic, attractions, and failures—often led to social consequences beyond the sponsor's design. What I would like to highlight in wartime Chongqing is how such conceptions of cinema as infrastructure were mediated by different social agents and how the agency of

media technology was introduced precisely to negotiate the control over film and its social power. In this sense, Luo's defense against criticism concerning his technology-heavy proposal revealed infra structure as a technical process that was simultaneously social and political.[43] As Luo explained, his enthusiasm for 16 mm film was supported by his understanding of international film history in two genealogies espousing commerce versus education. In other words, the "technological system" he proposed was a political system materializing a particular stance on cinema, mass education, and statecraft. By swiftly transforming the question of "national policy film" (*kuokusaku eiga*) to one concerning "the national policy *of* film," Luo substituted a single category of film aligned with the state with a new definition of cinema, capitalizing on the state's endorsement as the opportune moment of a structural self-transformation of cinema. Conversely, this alliance with the state transformed cinema into a social–technical structure of governance.

The film workers' collective investment in a state-sponsored, education-oriented cinema had ambiguous implications. Their shared enthusiasm for governmental support mixed their self-preservation impulses with a utopian anticipation of furthering the left-wing film cause. State sponsorship of film production and the prospect of establishing a systematic distribution and exhibition network would free leftist film from the confines of commercial cinema, yet this marriage with the state itself jeopardized that autonomy. As it turned out, making resistance films involved constant battles with state interests. State interference in the management of the film studios, heavy censorship, and budget shortages plagued the production of resistance films, just as much as state financial, material, and human resources provided needed support.[44]

Rethinking the Cinematic Vernacular: National, Local, Global

Despite Luo Jingyu's detailed plans for a state cinema as infrastructure, resistance films were faced with a concern more pressing than the utopian vision of a "technological system": the challenge of reaching a new audience through its *symbolic* system. The desire to achieve domestic mobilization in the vast hinterland placed new demands on

the quality of this cinema and generated tremendous conflict among the film workers regarding their perception of the masses, the nature of film, and film aesthetics, demanding that they radically rethink Chinese film history in terms of film language.

Cinema for the (Hinterland) Masses: A Rural Cinema?

Yang Cunren articulated his concern with film language by proposing a "rural cinema" (*nongcun dianying*), which quickly became a focal point of debate. For Yang resistance cinema was equivalent to rural cinema because "the urban residents in inland cities [were] not necessarily better educated than the farmers and farmer-turned-soldiers."[45] Reducing the diverse audience groups to "farmers," Yang's rather derogatory assumption nevertheless prompted a reevaluation of Chinese film practice. As Yang saw it, ever since its inception, Chinese cinema had been focused on producing "urban films." Modeled after European and American genres, these films were aimed at urban dwellers who had developed an understanding of established film conventions. Rural folks would find it a challenge, however, to understand the grammar of continuity editing without knowing what happened between the cuts. The same audience had also found some of the recently made resistance films too alien and exotic to relate to. To make "rural films," Yang suggested that filmmakers choose topics and settings familiar to country people and preferably craft stories about them. For the sake of narrative clarity, they should also provide plot summaries, modeling after the silent-era live narration accompanying film exhibitions in Guangzhou and Hong Kong. Instead of an on-site lecturer, Yang proposed that a "plot reporter" (*juqing baogaoyuan*) be included within the film. This reporter would be a skilled storyteller whose narrative rendering would be accompanied by the music in the film rather than interfering with it. Other advocates of rural cinema suggested using silent film and avoiding editing techniques such as dissolves, fade-ins, and fade-outs.[46] In wartime Chongqing rural cinema seemed to be in full swing, and by 1941 the film studio Zhongzhi had planned to make 40 percent of its annual productions cater to the rural population.[47]

Yang Cunren's proposal for a rural cinema provoked a larger concern regarding the massification (*dazhonghua*) of resistance cinema

and generated divergent responses. Massification (*dazhonghua*), or vernacularization (*tongsuhua*), as playwright Song Zhidi explained, entailed in this particular historical circumstance a regression of film practice by choice: "We have to force our production technology to go back for ten years" and to "combine the twentieth-century technology with the nineteenth-century mass appreciation standard."[48] While some interpreted this as a change of audience taste, documentary director Pan Jienong turned it into a question of national style.[49] Pan cited director Ying Yunwei's division of Shanghai cinema into a Mingxing style and a Lianhua style—referring to the two most prominent film studios in 1920s and 1930s Shanghai. Pan agreed with Ying that the Lianhua style, modeled after the more economical Euro-American techniques, did "best in imitating the taste and expression of industrial society" but would prove inaccessible to the wider audience in the War of Resistance. Ying found that the excessive superimposition he used in *Babai zhuangshi* (*Eight Hundred Heroes*, 1938) and the montage sequence from train to boat to truck in Shi Dongshan's *Baowei women de tudi* (*Defending Our Land*, 1938) could not be comprehended by the audience when the films were shown in Inner Mongolia, despite the praise for these techniques in Chongqing, Wuhan, Guangzhou, and Hong Kong.[50] Instead, Ying argued that the Mingxing style, with narrative clarity akin to the indigenous Chinese popular novel, would be more suitable to mass demand. Following Ying, Pan cited a parallel contrast between the May Fourth new novel and popular vernacular novels, such as Zhang Hengshui's *zhanghui*-structure novels. The latter, whose interconnected chapters with narrative suspense were presented clearly by means of well-stated introductions and closure, were much more accessible to popular readers than were the new novels, which experimented frequently with narration. Although popular writer Zhang Hengshui's works might not exclude innovative descriptions or modern vernacular language and the films of Zhang Shichuan (the famous Mingxing Studio director and producer) might not do away with close-ups or superimpositions, they applied these techniques within the limits of what the Chinese audience found intelligible.

Xiang Jinjiang severely critiqued the assumption inherent in Yang Cunren's call for rural cinema and Pan Jienong's preference for the Chinese film style.[51] For Xiang the claim that country folks could

not understand Western-style films remained a highly prejudiced myth. Xiang noted that in the past Chinese films did not reach the countryside not because they were unintelligible but because of the commercial nature of cinema, whose distribution network had excluded the countryside. The popularity of the film *Xiao tianshi* (*The Little Angel,* Wu Yonggang, 1934) when shown in the countryside of Zhenjiang, Jiangsu province, supported his thesis. Xiang believed that with more film exhibition in rural regions, the audience would get used to fade-ins, fade-outs, superimposition, and other film techniques; after all, cinema and drama were the most popular art forms because of their ability to circumvent the barrier of written language. As to the argument that rural spectators were incapable of making sense of continuity editing signifying travel, Xiang felt that "such a dismissive attitude about Euro-American film styles and techniques might reject the basic elements of cinema."[52]

By emphasizing the internationally shared styles in film techniques, acting, and costumes, Xiang cautioned against a narrow, nationalistic rejection of Western elements, which he called "neonational essentialism" (*xin guocui zhuyi*). At the same time, he disagreed with those who thought that a foreign import such as cinema could not develop a national style. Anything in the hands of Chinese creation would differ from its original foreign art form. For instance, an early Chinese film such as *The Burning of the Red Lotus Temple* could not have been created in other countries. Xiang also added that the films reflecting a new China in the War of Resistance would become an equally unique Chinese product in the realm of world cinema.

Xiang's affirmation of the Chinese adoption and translation of Western film styles created a counterpoint to the easy rejection of film experiments with the call for massification.[53] At the same time, his cautions against a dangerous "regression" of cinematic techniques in the name of nationalism betrayed the internationalization of certain nationally drawn film conventions as the universal standards on which he insisted. For example, Xiang's worry that filming the "passage scenes" of travel would produce "loose structure, tedious narration, and repetitive description, and result in a product totally deprived of any artistic value" was based on the economical film grammar of Hollywood cinema and did not consider alternative film practices that took the demands of a neophyte audience into

account. By equating such film grammar with the essence of the cinematic medium, he evoked the ghost of medium specificity, to which I will soon return.

These discussions and debates regarding the massification of Chinese cinema participated in the larger debate of "national form" (*minzu xingshi*) during the war, most heated between 1939 and 1942 in China. Originating in the Communist foothold Yan'an and spurring wide discussions in Hong Kong and hinterland China, the question of "national form" responded to the need of wartime mobilization and national construction to create shared forms of cultural identification.[54] In this debate questions of "local form" (*difang xingshi*) and "folk form" (*minjian xingshi*) emerged as key issues as the result of the mass migration and departure of writers, artists, and performers from the coastal cities to the inland, spurring the rise of new cultural centers and the changing dynamic between the city and the country. Local and folk forms provided authentic content to the empty national form yet also created tensions with the latter, which constantly demanded to transcend disparate locality to create a national, homogeneous whole. In an insightful study Chinese scholar Wang Hui discussed how the wartime debate of local form, folk form, and national form for the first time threatened the legacy of the May Fourth vernacular movement and undermined assumptions of tradition versus modern, old and new, country and the city.[55] While the May Fourth literature was espoused by commercial print culture based in colonial urban centers, the wartime change in the dynamic among the local, national, and global was thought through questions of language and form. In a similar fashion, these debates in the film world were effected by the physical relocation of the film industry inland, where new audiences beyond commercial urban centers and the prospect of a state cinema posed serious challenges to established film aesthetics and film language. These challenges concerned the universality of Hollywood continuity editing and vernacular film conventions established in previous urban centers such as Shanghai (Mingxing or Lianhua style). Yet the tension between local, distinctly Chinese, and potential international film style and film language persisted.

Notably, wartime resistance films participated in the film debates via film practice in the filmmakers' efforts to respond to theoretical

concerns and in the tension created by practical and other concerns.[56] *Eight Hundred Heroes* (1938) provides an early example of Yang Cunren's suggested plot reporter within the film. A silent full-length feature on the heroic resistance of the GMD army in the Shanghai battle against the Japanese, the film starts with a performance sequence before the camera cuts to the battlefront. During the performance, titled "Eight Hundred Heroes," the camera pans right to reveal the female drummer/singer, who narrates the story and then recedes to present the audience. Cutting back and forth between shots from behind the performer and shots from behind the audience, the opening sequence situates the film audience within the performance space, soliciting a self-reflexive identification with an active viewing while the performed narration helps the audience comprehend the story. The story itself is divided into two parts by an extended montage sequence. Director Ying Yunwei later self-criticized this as being in the Lianhua style and inaccessible to the countryside audience, but it does serve an important function. This sequence summarizes the story up to that point, realizing the transition from the battlefront resistance by the eight hundred heroes (the first half of the film) to the girl scout Yang Huimin (Chen Bo'er) sending the national flag to the soldiers (the second half of the film). The montage sequence itself shows the spreading of the news and the citywide support for the soldiers, repeating the same story through a variety of media, superimposing transitions from revolving printers to Chinese and English newspapers to newspaper vendors on the street, as well as telephones, telegraphs, and radios.[57]

Shi Dongshan's *Defending Our Land* (1938), *Hao zhangfu* (*The Good Husband*, 1939), and *Shengli jinxing qu* (*Marches of Victory*, 1940) are all set in the countryside. Shi radically changed his film style to create a more intelligible language for the wider masses in the war, discontinuing his excessive deployment of decor and sentimentality from the 1920s and his flamboyant montage rhythm from the 1930s.[58] Instead, he emphasizes a "simple and forceful plot, not too complex inner activity," "complete and detailed narration of the plot, a slowed tempo of acting."[59] In *The Good Husband*, another silent film, Shi frequently uses medium, long, and tracking shots while avoiding closeups.[60] As drama critic Ge Yihong points out, these scenes incurred blame from "critics" for their lack of concision, yet "what is criticized

is precisely what the director labors to achieve."[61] While one could lament Shi Dongshan's "regression" from more modernist looks and techniques, this is the conscious product of a new style developed for resistance films and based on the assumption of a modified audience.

In Search of a Cinematic Esperanto

Filmmakers striving to make "rural cinema" often faced conflicting interests and technological challenges that compromised their goals. In order to cover the costs, some films designed for the country audience were shown also in the cities. In anticipation of this market, as Shi Dongshan explains, filmmakers had to "quicken the tempo of acting a bit, and make narration more succinct."[62] A second problem arose regarding the films made for export.[63] While some people had proposed making films specifically for an international audience, they hesitated at the problems of differentiating between the domestic and international audiences and deciding whether the films should aim at earning "foreign sympathy" or "foreign exchange."[64]

The shared desire to address simultaneously multiple audiences and exhibition contexts raised the pressing issue of film language. This problem is articulated most explicitly by modernist poet Xu Chi, whose two-part article "The Limit of Cinema" registers a split between a utopian impulse toward a universal film language and a practical challenge posed by the traveling sound cinema, which encountered a new, diverse audience speaking distinct dialects.[65] In the first part of the article, Xu follows Gotthold Ephraim Lessing in portraying an evolutionary chain of new artistic forms, each transcending the limitations of its predecessor.[66] Placing cinema at the end of this chain, Xu expresses his enthusiasm for a "limitless" cinema that would explode the confines of the most synthetic art form (drama) by reaching the widest audience through mechanical reproduction and overcoming the boundaries of theatrical space through cinematic techniques such as close-ups and mobile framing. For Xu this "electric mechanical" art naturally calls for internationalism, as "concrete images do not require translation, and the narrative developments cannot depend on dialogue" but rather on movement. Such an art form is "in its essence socialist and democratic" because it "cannot be owned by a few free men, the aristocrats, or a

certain class."[67] The question for Xu is, then, whether a nondemo-
cratic country can still produce film or whether films not made for
the "democratic ideal" still count as cinema. He challenges himself
with the enigmatic phenomenon: many Hollywood films are con-
sidered obstacles to the democratic ideal, but they are still shown
in front of tens of thousands of people.[68] Xu's explanation is sim-
ple: these productions have not entered the "national territory of
cinema," because they lack the democratic essence of cinema. Xu's
problem with Hollywood cinema, or the popularity of those films
despite their being "obstacles of progress," betrays the irony of his
notion of "the national territory of cinema" (*dianying de guojing*)—an
international realm of democratic films that still takes on a nation-
alist ideology in its own ideological exclusiveness. Underlying this
irony is the dilemma that still faces us today: should cinema be an
emphatic category whose positive character is necessitated by its
medium and style—in Xu's words, the "democratic," "socialist," and
"international" nature determined by its mechanical reproduction
and its image and movement? Or should cinema be defined by its
message and ideology—in Xu's rather ambiguous assertions, its
ability to "propel the world forward"? Xu's discussion reevokes the
question of medium specificity that haunted the 1930s film debate
in Shanghai. The desire to encompass the material–technological,
semiotic, and social dimensions of the medium lies at the core of
Xu's concern. For Xu and many other filmmakers and film critics
from the late 1920s onward, the social function of cinema continued
to create tension with the material–technological and the semiotic
aspects, often narrowly understood as the staples of cinematic me-
dium specificity. Xu's nationalist analogy to medium specificity also
reminds us that the boundary of medium, as in the case of Lessing's
division between temporal and spatial art, has often served as a foil
to other borders, be it nation, class, or gender.[69]

 In the second part of "The Limit of Cinema," entitled "On the
Question of Language in Cinema," Xu shifts to a more practical
problem: the use of spoken language in sound film.[70] He cites the
great examples of Dante's, Pushkin's, and May Fourth intellectual
Hu Shi's promotion of vernacular language. But Hu's incomplete
vernacularization project, as Xu points out, faced a serious chal-
lenge when sound films were exhibited in the hinterland provinces

to audiences speaking a wide variety of dialects. Xu does not, however, encourage a return to silent cinema. He cites the example of the silent film *The Good Husband* as "losing one limb" of cinema, which was compensated for only by the local film lecturer when it was screened in northwest China. Instead, Xu splits the solution of language between the use of dialect and the invention of a common mass language incorporating the elements of a variety of local oral input. Xu considers the possibility of incorporating different dialects in films for local exhibition but acknowledges the high cost of such a practice. As an alternative, he proposes the use of a common mass language, at times aided by a local lecturer. The best solution for Xu is, of course, the use of Esperanto, the thought that ends his enthusiastic essay.[71]

Xu's desire to incorporate Esperanto into Chongqing cinema is not so surprising, given the Chinese intellectuals' interest in internationalizing and modernizing the Chinese language since the late 1910s. Discussions of Esperanto, Romanization and Latinization of Chinese, and experiments in language reform were entwined with social movements such as anarchism, the mass-literacy movement, the May Fourth enlightenment, and the proletarian cultural movement.[72] A modernist poet active in Shanghai in the 1930s, Xu Chi combined his interest in Esperanto with a bent toward imagism and symbolism in his poetic revolution. An avid translator of European and American modernist poetry, Xu introduced and translated Vachel Lindsay's works in *Xiandai (Les contemporains)*.[73] Lindsay, coincidentally, wrote the alleged first theoretical work on cinema, *The Art of the Moving Picture,* in which he made the famous comparison of cinema with hieroglyphics.[74] Inspired by written scripts in Egypt, China, and Japan, Lindsay foretold that the motion picture would become a self-evident universal "picture alphabet" that might "develop into something more all-pervading, yet more highly wrought, than any written speech."[75] Of course, he was not alone in his enthusiasm for cinematic hieroglyphics. A widely circulated discourse of cinema as a new universal language captured the enthusiasm of filmmakers and film critics across Europe and America— the American filmmaker D. W. Griffith, the French director Abel Gance, and the Soviet filmmaker and critic Sergei Eisenstein, to name a few—for cinema's democratic promise, universal appeal, and

potential to radicalize conscious thought by encouraging "thinking in pictures."[76]

Yet if the imagists were inspired by Chinese characters and Lindsay was impressed by ideograms and hieroglyphics because their visuality potentially lent them to universal communication, the Chinese-language movement, especially the script reform and alphabetization of Chinese language, had tried persistently to eliminate Chinese characters as obstacles of literacy, science, and culture in favor of an alphabetic writing system. Esperanto was an extreme case of such reform. Xu Chi's discussions convey a central conflict between a desire for an internationally shared film language and a need to address the diversity within both domestic and international audiences—regarding dialect language, cinematic techniques, and narrative strategies. The dual tensions underscoring his inquiries— between medium and message, written and spoken language/local dialect and Mandarin—hit the crux of the issue of modern Chinese language reform. As Wang Hui points out, despite its claim to restore oral language in literary writing, the vernacular movement was not a phonocentric movement privileging orality over literacy, local dialect over a national language, but rather an antiaristocratic, class-oriented movement aimed at creating a rationalized, scientized, modern *written* language. The script reform and alphabetization of Chinese were in line with the vernacular movement more as a reform on writing than one on adapting oral language. Hence, the question of dialect had always remained more peripheral than central to the vernacular movement. Only until the Second Sino–Japanese War did dialect, along with the question of local form, come to the foreground in intellectual debates, when mass migration changed the dynamic between city and country and displaced writers and print culture with performance-centered genres—street plays, the recitation of poetry, storytelling, and local opera.[77] While the question of dialect and local form for the first time challenged the legacy of the May Fourth vernacular movement, Wang points out that the internal contradiction between local form/orality and national form and the universalist tendency in the discussion of national form determined that the question of dialect and local form could only be subsumed under rather than contradict the national form and the establishment of a common language (*putonghua*).[78]

Seen in a global landscape, the obvious difference between Xu Chi and Chinese-language reformers' interest in Esperanto and the imagists and "picture-thinking" enthusiasts—the preference for an alphabetic writing system versus one for a visual script—becomes less crucial than their shared interest in transcending the linguistic medium in search of a universal medium of communication, through either an international medium more immanent to spoken language or a visual script. The internal tension between Xu's interest in dialect and the eventual goal of Esperanto betrays the desire that the local dialect will always remain subsumed under rather than override the question of national language, form, and a potential international language.

Meanwhile, in the American context, as Miriam Hansen points out, the universal-language discourse coincided with the shift from a "primitive" to a classical mode of narration between 1909 and 1916, which gave rise to the notion of spectatorship. By developing a standard grammar of camera framing, movement, and directionality—key components of the continuity editing style—classical Hollywood cinema created a self-contained narration that made the spectator the nodal point of coherence and emotional identification. As Hansen argues, the universal-language discourse unwittingly served as the ideology for the classical mode of spectatorship. Facilitated by the separation of film space and theater space, the classical codes were designed to transform an empirical moviegoer into the spectator as a structural construct, the collective into a singular viewer, and diverse class backgrounds into a middle-class outlook and experience.[79] Ultimately, the spectator was evoked as "a singular, unified but potentially *universal* category, the *commodity form of reception.*"[80]

In wartime Chongqing there was a similar impulse among filmmakers and film critics to forge the broadest political community transcending ethnic, regional, and national boundaries, hence the uncanny resemblance between commercial and propaganda films' efforts to create the universal spectator and reception. Xu Chi's proposal of a cinematic Esperanto, seen in the context of contemporary film debates in the wartime hinterland, however, was a sharp critique of the classical mode of narration as well as spectatorship. That narrative mode's global accessibility was called into question under three circumstances concerning the language of cinema. First, the

challenge of local reception as conceived by the film critics denaturalized the ostensibly "transparent" and universal codes of Hollywood cinema and its Chinese counterpart. Second, the international conversion to sound cinema, paralleling the rise of national cinemas, increasingly problematized any claim to universal language. Third, the wide range of dialects thriving in the wartime capital Chongqing further compromised the institution of Mandarin as a common national language in sound cinema. On top of this, the extreme experience of the war demanded a cinematic treatment and emotional response different from Hollywood narrative evocations of codified sentiments and sympathy.

In this sense, Xu's discussion of cinematic Esperanto almost reverses the process of the classical mode of spectatorship. The audience is not reduced to a private individual but recuperated as localized, social beings identified with a collective. While that social dimension is rechanneled into a nationalist ideology, this proposal for a new international film language and spectatorship not simply is a textual construct but consciously registers the experience of film exhibition and reception in wartime Chongqing. By attempting to bridge the gap between local and global audiences with a cinematic Esperanto, Xu paradoxically brackets the national in the service of nationalist war mobilization. Here, nationalism speaks the rhetoric of transnationalism, not as a strategic conflation but as an alternative to the one-way traffic of the "dominant particular."[81] Locality, the embattled site for both nationalist and transnational construction, puts them in perpetual dialogue.

"A Vibrating Art in the Air": The Infinite Cinema

A response to Xu Chi's essay on film delivers a more ambitious vision of cinema, free from concern with cinematic language and the tension between form and content. This is Li Lishui's two-part essay "The Infinite Cinema." Li expands Xu's discussion into an emphatic assertion of cinema as the ultimate megamedium, with a powerful affective impact.[82] For Li the limit of one art does not mean its death but is the border from which a new art springs and transforms the existing art. The history of art thus builds on a spiral logic of dialectical development. When it comes to cinema, however, art transcends

both spatial and temporal limits, Lessing's two axes for art. For Li the two axes of time and space intersect to demarcate art, but they become infinite parallel lines in the case of cinema.

Conceiving of cinema as an infinite medium, Li assigns cinema's ability to transcend the limit of any medium to its radiating "energy." This energy allows cinema to break its medium boundaries that guide and limit its growth, as in the biological process of osmosis, and thus to expand and leap to the infinite, as in the chemical process of diffusion.[83] A cosmic vision of the cinema comes forth: cinema, defined in terms of its realm of activity, possesses an immense body that cannot be contained in any movie theater; moving either regularly or randomly in the manner of Brownian motion, its infinity is embedded in the limitless ether that seeks its existence in the universe.[84]

Mixing a variety of scientific analogies from biology, mathematics, physics, and chemistry, Li's technoscientism ties cinema's deterritorializing vitality and mobility to an analogy to ether, intimately associated with wireless technology: "Wherever ether exists, cinema's life is attached. Without any obstruction, cinema will appear in front of people at any time and space."[85] With the existence of radio facsimile, as the author claims, cinema is already "a vibrating art in the air" (kongzhong de bodong yishu).[86] In the second part of his essay, Li continues to describe the infinity of cinema by linking it with the possibilities promised by wireless technology. Critiquing any attempt to limit the growth of art and to freeze and rigidify cinema into a static medium, Li describes how cinema can exist at a certain time and space, but it can also develop beyond that. Cinema can be shown at different spaces at the same time, enjoying the privilege of simultaneity and infinity, hence becoming "a mobile art leaping in the air."[87]

Importantly, the infinite cinema eventually binds cinema to affect. Li addresses Xu Chi's concern about the limit of cinema posed by linguistic differences, pointing out that language is not the only form of expression. Instead of proposing an alternative means of expression, however, he goes directly to affect itself: "Because human beings share the same love and hatred, anger, and sadness, this provides the major basis for cinema's infinite reach."[88] By way of affect and pushing the limits of cinema, cinema will form not only the "national vernacular

language" (*quanguoxing de dazhong yuyan*) but also a "global vernacular language" (*quanshijiexing de dazhong yuyan*).[89]

Li in his "limitless" cinema makes a categorical departure from Xu by reconceiving cinema in entirely different terms. To a large extent, Xu is still preoccupied with earlier notions of cinematic medium specificity, caught between the lingering dreams of silent cinema as the seventh art as well as a pictorial universal language and the challenge posed by sound cinema and local reception. Li refuses, however, to consider cinema a static, fixed medium. By positing cinema as infinite, he goes beyond Xu and other Chinese filmmakers, who primarily identify cinema as an audiovisual text and seek its translatability across regional and national differences. Instead, Li conceives cinema as a technology of *instant transmission* and *simultaneous dissemination* as well as a *medium of affect*. His notion of cinema as a global vernacular is not dependent on language, verbal or filmic, but on cinema's ability to convey human emotion simultaneously and across distance. In other words, the dual dimensions of cinema—as a medium of affect and one of simultaneous transmission and dissemination—depend on each other, forming a distinct notion of cinema and of the medium as environment. Here, affect is not simply codified human emotion but symbiotic and synonymous with technologies of transmission and dissemination, a quasi-material force circulating and expanding to reach and transform its object of resonance. In this radical reconception of affect and medium, Li identifies cinema with wireless technology and the ether medium in his techno-utopia as a "vibrating art in the air" with "radiating energy." His utopian vision recalls the dream of wireless cinema and the affective medium in the 1920s, yet with a distinctly different context and content. The 1920s culture of resonance was built less on reality than on circulated news of wireless technologies, including early television, coupled with spiritualist movements, anarchism, and vitalist philosophy and potential subversive political energy and ambivalent social promise. In contrast, Li's discussion of cinema as an infinite medium registers the substantial transformation of film exhibition in the wartime hinterland, which repositions cinema's relationship with other media. Moreover, as I show later, Li's ever-expanding, vibratory cinema is intimately embedded in the notions and practices of propaganda.

Broadcasting Cinema: Audiovisual Education and Innovating Exhibition

Li's conception of cinema as an infinite, vibratory medium makes more sense if we consider wartime innovations in film and media exhibition, which throw a new light on the repositioning of cinema in relation to wireless technology. A journal promoting audiovisual education, *Dianying yu boyin* (*Film and Broadcasting*, from 1942 to 1948), provided a ready forum for such connections. Sponsored by the Audiovisual Education Department of the Christian missionary university Jinling, which was relocated to Chengdu, *Film and Broadcasting* was the first journal conjoining film, wireless technology, and film exhibition practices in the context of audiovisual education (*yingyin jiaoyu*) or "electronic education" (*dianhua jiaoyu*).

Acknowledging the significance of wireless technology in its journal title, *Film and Broadcasting* introduced wireless technology as a crucial link to cinema, both as its technological extension and potential competitor. In the poem "Wuxiandian zishu" ("Autobiography of Wireless Technology"), the author identifies the birth date and inventors (Maxwell, Hertz, and Marconi) of wireless technology but devotes more space to the speed, spread, and power of wireless technology as a plural and global media. Identifying its use for telegraphy, telephones, and radio, the poem sets the center stage for television and conducts a vivid anatomy of its structure and mechanism, ending with an enthusiastic plea to those working in the film industry: "My film friends, please do not shudder. You will not lose your business, since I will not compete with you but perfect your profession—you make million-dollar masterpieces, and I will broadcast them to the world at any instant."[90] In another detailed account of television published by the journal, however, television is presented as cinema's competitor. The author, M. G. Scroggie, points out the fundamental difference between film and television: unlike film, television is not a storage medium but one for simultaneous transmission, and hence, it belongs to the same family as telephone and radio.[91] The challenge is then posed to film: in an age of wireless technology and simultaneous transmission, how will cinema live up to the same standard as wireless media, which promise unsurpassable speed and coverage?

Despite that the promise of television as broadcast cinema existed more as foreign news than as a domestic reality, film exhibition during the wartime was already aspiring to be a broadcast media. This was achieved through mobile projection in conjunction with other media.[92] Mobile projection gained substantial momentum during the Second Sino–Japanese War, which for precedents had traveling exhibitions before the age of the picture palace and military and educational film exhibitions starting in the 1920s. In the wartime hinterland, a number of institutions organized 35 mm and 16 mm travelling exhibitions: GMD's Political Department under the Military Committee had the largest mobile projection team, the Chief Film Projection Team (Dianying fangying zongdui); and the three Chongqing-based film studios, Zhongzhi, Zhongdian, and Chinese Education Film Studio, each had their own mobile projection teams. In addition, local and international religious, educational, and political institutions, such as the YMCA, Jinling University's Audiovisual Education Department, the Education Ministry's local audiovisual education offices and "mass education centers" (*minzhong jiaoyuguan*), and the late addition in 1944 of the United Nations Picture News Office (Lianheguo yingwen xuanchuanchu), all provided active screenings in various settings beyond movie theaters. The foreign relations and intelligence offices such as the Sino–Soviet Cultural Association (Zhongsu wenhua xiehui), the Sino–American Cultural Association (Zhongmei wenhua xiehui), and the U.S. Office of War Information (OWI) also provided their own screenings. Although a total statistics of these screenings are hard to obtain given the diverse agencies involved, statistics from various surveys suggest the reach and appeal of mobile projection in the hinterland. GMD's Chief Film Projection Team had 104 projectionists and ten projection groups covering ten battle districts in China. Between 1939 and 1941, the team held 493 screenings attracting 27 million attendees.[93] In 1942 the Education Department showed 123 screenings in Chongqing and its suburbs, with 391,550 attendees. The National Audiovisual Education Travelling Team had fifty-two troupes covering nineteen provinces.[94] In 1944 Jinling University's Audiovisual Education Department showed films 828 times attracting 900,000 attendees in Chongqing and Chengdu.[95] Many of these projections took place in open air, attracting unprecedented numbers of people

beyond the capacity of any movie theater. Jinling University's weekly outdoor screening attracted between five and ten thousand people per night.[96]

These travelling and outdoor film screenings, often combined with slideshows, live performance, music-record playing, and radio broadcasting, amalgamated the apparatus of cinema with a media ensemble and heightened the awareness of film exhibition in its immediate media environment. Sun Mingjing, the founding editor of *Film and Broadcasting,* and his colleagues at Jinling University designed projection screens made of local material (silk and bamboo) and invented a mobile poster cart—a four-wheel wood cart mounted with posters on both sides to appear at public gatherings such as open-air film screenings—to further enhance the effect of film exhibition on information dissemination and mass mobilization.[97] Devices combining multiple image technologies, involving magnification, photography, and projection, such as microscope projectors and microfilm, were introduced into classroom teaching and research.[98] Notably, microfilm was called "film book" (*yingpian tushu*), conceived as the alloy of film and textbook—the ideal of visual education.

Positioning cinema as integral to a larger media culture, Jinling University held two exhibitions on audiovisual education in 1943 and 1945. Inspired by the 1939–40 New York World's Fair, which Sun Mingjing attended, the two exhibitions became conscious constructions of media technology and media history, turning the exhibition into an event to enlighten and entertain a diverse range of audience. The 1943 audiovisual exhibition, as part of the celebration of the university's fifty-fifth anniversary, which attracted 300,000 people in two days, comprised seven sections, including a radio broadcasting station, exhibition spaces featuring amateur wireless technologies, live film and slideshows, and printed material on audiovisual education. As the audience entered the exhibition hall, they were greeted by an automatic bell. A connecting hall hung posters in midair printed with cartoon figures from Disney and enlarged statements about media technology and "autobiographies" of film and wireless technology. Vacuum tubes dangled in the air, forming two crystal curtains along the staircases leading to the radio station, introduced by a sign reading, "The vacuum tube is the soul connecting film and radio." The chief exhibit was "film engineering" (*dianying gongcheng*),

consisting of nineteen sections showcasing film with a history in-
volving numerous media technologies and components. Featur-
ing shadow play as precinema and 16 mm film as a promising film
technology, the exhibition demonstrated facilities related to pho-
tography, film, animation, sound recording, and broadcasting and
featured devices such as self-designed microscope projectors and
microfilm readers. All exhibition items were accompanied by illus-
trations and live demonstrations, among which television was named
as the "future of cinema."[99] In this exhibition the print medium, in
both image and text, was considered an important component in the
audiovisual media ensemble. The 1943 exhibition included a room
displaying audiovisual material from Jinling University and inter-
national visual education institutions; the practice was repeated in
the 1945 exhibition, a small-scale show for experts and policy mak-
ers to envision postwar reconstruction of the film industry.[100] In a
detailed report about the exhibition, *Film and Broadcasting* in effect
turned each section into an individual exhibition room, converting
the printed page into an extension of the exhibition.[101]

Through these media exhibitions and mobile film projections, a
deterritorialization of cinema took place. The thirty-eight statements
of media technology hung in the 1943 audiovisual exhibition pro-
vided a broad definition of communication: from knot making and
stone carving to speech, writing, and printing; from painting to pho-
tography; from the postal service to wireless technology, television,
and film. Film occurred as the end point of the list of communication
tools, yet it was already defined broadly as part of communication
technology, being praised for its ability to stretch, shrink, expand,
condense, and reproduce space and time. In the end, the media en-
semble prevailed over any singular medium. As the statements con-
cluded, "The more media technologies one deploys, the more effec-
tive and the stronger the impression on the receivers."[102]

These exhibitions gave increased attention to display, raising
public awareness of the social role of media. Media performance
(*yongyiqi biaoyan*) and exhibition were listed as legitimate catego-
ries of communication. The techniques of display turned media
technologies into attraction and material constitutions of social
spaces. By vertically arranging printed media and vacuum tubes as
architectural devices to attract, shock, and overwhelm the audience,

media's original functions were substantially altered. In effect, the exhibition on audiovisual education heightened the visibility, audibility, and tactility of media, making the show both the media of propaganda and the propaganda of media.

Xuanchuan/Propaganda: Affect versus Information

Li Lishui's vibratory cinema found footing in the innovation in film and media exhibition in the wartime hinterland, yet its political implication became murkier in light of the theory and practice of propaganda. The standard Chinese term for propaganda, *xuanchuan*, was used long before its modern associations. The term, a compound made of two verbs, *xuan* (to announce from an authority) and *chuan* (to transmit, disseminate), appeared as early as the third century in the historiography *Sanguozhi* (*Records of the Three Kingdoms*) to denote dissemination of military skills. The premodern use of *xuanchuan*, as Chinese scholar Cao Futian points out, mainly referred to dissemination of ideas and information from the ruling classes.[103] With the modern invention of media and communication technologies, *xuanchuan* appeared frequently in Chinese printed media at the turn of the twentieth century, changing from its exclusive association with state affairs to broader usage after the late 1910s. The term became associated with religious propagation and dissemination of knowledge, information, and thought for educational and commercial purposes as well as for political and military causes. The 1920s witnessed the rise of political propaganda in China associated with the revolutionary discourse and the legitimation of the new Nationalist government. With the establishment of the Nationalist Central Ministry of Propaganda in 1924, propaganda as a modern political institution was solidified.

In its many faces, propaganda figured in China as a neutral term in association with commercial publicity, provided a polemic understanding of literature and art in the late 1920s with the rise of proletarian literature, and was embraced by the science and education film movement in the early to mid-1930s as broadly defined education.[104] Within the realm of cinema, propaganda was recognized alternately as a distinct category (along with entertainment, culture, and advertisement films) and a renewed understanding of cinema

as an audiovisual instrument to educate the senses. Despite its positive conception, however, propaganda did not escape the tension between aesthetics and politics. A debate in 1928 between the Creation Society member Li Chuli and veteran writer Lu Xun at the rise of proletarian literature evolved around Upton Sinclair's famous quote, "All art is propaganda. It is universally and inescapably propaganda; sometimes unconsciously, but often deliberately, propaganda."[105] While Li Chuli affirmed Sinclair's observation in order to introduce his own class analysis of literature, Lu Xun emphasized the value of content and form in order to differentiate art and literature from propaganda.[106] Lu Xun extended his negative assessment of propaganda to film in the early 1930s by translating "Film as the Instrument of Publicity and Agitation," an early chapter draft from Iwasaki Akira's *Film and Capitalism*.[107] Yet for filmmaker and political bureaucrat Pan Jienong, it was precisely the artistic element of propaganda film that set it apart from advertisement and educational film.[108] Still more writers and critics used Sinclair's quote to effect a critical reflection on the social function of art and literature.[109] The looming war put these debates on hold and spurred more enthusiastic evaluations of propaganda following the rise of the national defense film and literature movement after 1935. By 1937 the notion of propaganda met much less critical opposition.

During the War of Resistance, the tension between art and politics was more effectively erased. Art critic Zhu Yingpeng, who set out to provide a much broader definition of propaganda, echoed Sinclair in observing that propaganda was not a specific genre but the nature of all literature and art: as long as one desired to communicate a thought or emotion so as to create shared ideas and experience, one created propaganda, regardless of social agents, intentions, and artistic means.[110] Propaganda was thus less a moral controversy than a matter of pragmatics and techniques. Yet these pragmatic concerns, articulated by policy makers as well as artists and filmmakers, often involved repurposing a particular artistic medium into a medium of mass communication, partly to legitimize and further institutionalize a medium in the midst of national crisis. Two major trends emerged, one focusing on propaganda as a vehicle of sensory stimuli, the other, on propaganda as an instrument of information control, as I illustrate through Zhu Yingpeng and Zhang Zhizhong, respectively.

Interested in propaganda's effect on the senses, art critic Zhu Yingpeng singles out painting as a tool advantageous over other media because of its perceptual impact, reproducibility, and public access. To fully realize the power of painting, though, one needs to break its physical institutional boundaries—to take artworks cloistered indoors and put them on display at the crossroads. Art, as Zhu observes, must change from "a subtle smile to a maddening roar" and reach everyone's eyes and heart.[111]

To achieve propaganda's perceptual and affective impact, Zhu focuses on the means and sites of display, emphasizing tactics of scale and saturation. As Zhu observes, indoor display, such as the numerous exhibitions of anti-Japanese war-themed cartoons, woodcuts, and photography, is appropriate only for urban intellectuals, students, and youths. For the common folks in the countryside, art exhibitions should be taken to the squares and streets; the paintings, made by local artists from local materials on local topics, should be grand in size; and if using small reproductions, one must ensure a large quantity. Zhu gives the example of how the ancient temples or monasteries all sought grandeur in their architecture and sculpture and often used murals because at these sites of public gathering the majesty of the architecture and the grand size of the murals would shock the people's eyes and ears, move their hearts, and transform their thoughts. Echoing Feng Zikai's discussion of architecture as propaganda, Zhu evokes art theory of empathy similarly to consider the affective impact of art and its potential as propaganda.

As to artistic form, Zhu asks artists to apply crude lines, basic colors, and intuitive shapes so as to appeal to the rural masses. Stating how such simple and unadorned form gives the most natural revelation of human innocence and purity, Zhu's observation inherits a critique of modernity that lies at the heart of modernist primitivism. He argues that modern art has shifted from the most refined and ornate to the plain and simple in order to appeal to people living in modern society under extreme stress in the overdeveloped material civilization. Hence, in the realm of pure art, primitive art and children's art has always occupied an important position.[112] Evoking modernist primitivism to privilege the senses, he puts it to good use in the service of the wartime propaganda.

Zhu's interest in art as propaganda reflects its ambiguous lineage

in Republican China. Zhu was an art critic, journalist, and bureau-crat. The founder of an important art society in Shanghai, Chenguang meishushe, and coauthor of an influential art criticism volume, *Yishu sanjiayan*, he taught at various art schools and served as editor and writer for a number of major newspapers, including *Shenbao, Shibao, Shishi xinbao,* and *Damei wuanbao.*[113] Notably, he also served on the Nationalist government's Party Monitoring Committee in Shanghai and was an advocate for nationalist literature (*minzu zhuyi wenxue*) in the early 1930s.[114] Nationalist literature was largely denounced by leftists and other groups of writers for its fascist tendency to glam-orize the war, its national essentialist/racist ideology, and its back-ing by the Nationalist government. With the rise of national defense literature and resistance literature, however, the line between pro-tofascist national essentialism and anti-Japanese nationalist senti-ment became blurred.[115] In *Kangzhan yu meishu* Zhu quotes from his much-criticized writing published in the nationalist literary forum *Qianfeng (Vanguard)* in 1930 and reclaims its ground for appropriat-ing art as propaganda for the War of Resistance.

Seen in this context, Zhu's resort to vitality and affect as vehicles of biopower gains new significance. In his end section on the "art and the training of one's spirit," he cites Cai Yuanpei's discussion of the role of emotion in aesthetic education in the 1920s and singles out two important features of art in relation to affect to be put to great service in times of war: its generality and its transcendence, which render the artists cultivators of *élan vital*. Recasting Bergson's discussion of creative evolution, Zhu redefines artistic creation as the conflict between the constraints of the environment and the creative life-force. Since creative evolution applies to the individual and the collective, Zhu reasons that the life-force is indispensable for the survival of the nation. The artist, being the best embodiment of those able to overcome such conflicts in order to release the life-force, should naturally serve as trainers for the nation to do the same. Calling for the fire of life and a combination of new heroism and the philosophy of the superhuman, Zhu ends with the names resounding in 1920s China—Nietzsche, Bergson, Rudolf Eucken, Kuriyagawa Hakuson—to endorse Chiang Kai-shek's call for war by following the Confucian doctrine of self-sacrifice, *shashen chengren* (to die for a noble cause).

Zhu Yingping's conception of propaganda falls in a realist paradigm, drawing on the authenticity and authority of affect and vitality as the basis of biopower. In contrast to propaganda as techniques of affect, another notion of propaganda is articulated by Zhang Zhizhong, the communist propagandist who renders the question of realism and truth value completely irrelevant.[116] Instead of painting and cinema, Zhang examines news (*xinwen*). He points out three features that sustain its power as propaganda. First, news is repetitive. Because of its routine nature, certain concepts can be applied repeatedly to stimulate readers and "strengthen its degree of suggestion."[117] With its power of suggestion and stimulation through repetition, readers take the news as proven fact. Second, news is authoritative. Because news carries a great degree of authority, once it is published, it is taken as fact. Despite its distortion of facts and later corrections of or disavowals from the subjects and news organizations, the impact of the news still exists. Third, news is good at exposure and agitation. By exposing the enemy's privacy and ugliness and inciting one's allies with a negative feeling, one overcomes the opponent and establishes one's own opinion.

Propaganda, as seen from the practice of news reporting, operates precisely on the distortion of truth, as Zhang states unambiguously. In his words propaganda is "the propagation or exaggeration of the news, opinions, and reports beneficial to one's own country and meanwhile exposing the enemy country's negative aspects so as to incite the leading class of the enemy country to fight each other."[118] As the executor of national policy, propaganda "is the bravest, always standing at the international front line, manufacturing exaggerated, distorted reports so as to damage the spirits and disturb the united front of the enemy country.[119] Zhang hence gives a striking definition of the news: news is not *reflecting* social reality but *manufacturing* reality.

Information enters the propaganda discourse as a significant element that recasts the dynamic between truth and fabrication. Zhu Yingpeng holds onto the truth value of propaganda. In dismissing the common perception of propaganda as deception relying on hyperbolic rhetoric and the fabrication of facts, he differentiates between propaganda and information (*qingbao*) and sees only the latter as a tool for political appropriation through the distortions of facts.[120]

Zhang, in contrast, renders the realism value of news irrelevant and sees news/propaganda as a purely pragmatic functionalist weapon. He also alters the meaning of *exposure,* which for him means a highly charged revelation of negative aspects of the enemy, not so different from a well-targeted distortion of facts, the precise opposite of the critical transparency that Shanghai left-wing filmmakers pursued.

Zhang's argument that news is a highly selective, subjective, and pragmatic fabrication of reality brings information to the foreground in the propaganda war. In contrast to news as reflections of reality, a common belief Zhang considers "conservative," information is simultaneously disinformation, and it serves the goal of propaganda: not necessarily to well inform but to misinform or counterinform. If the truth value of information is already at stake or suspended, more important is the actual operation of a communication network to provide surplus information and create a saturated media environment.

The different emphasis of propaganda on affect versus information, as represented by Zhu Yingpeng and Zhang Zhizhong, convey two paradigms of and approaches to propaganda: one appealing directly to sense perception and emotions, the other to intellect. The affective paradigm considers propaganda as built on certain truth claims with realistic value and an appeal to the affect by its genuine nature, whereas the information paradigm targets rational thought and renders any truth claim irrelevant. These two separate approaches converge, however, in the end to cultivate desired emotional attitudes either by way of sensory immediacy or via the detour of information cognition. Both affirm propaganda as a necessary product of modern rational society, one as its potential cure (by reviving primitivism and vitalism), the other as its default operation (as Zhang illustrates in how news is generated). Importantly, the authenticity of the affect as the end result—either as experience of the sublime via sensory stimuli or as negative feelings via information—does not prevent the artificial fabrication by their means. On the contrary, they constitute each other, hence the shared nature of these two paradigms in treating affect as a targeted, produced result. The intensity of the artificial means ironically guarantees the authenticity and moral authority of such affect.

Perhaps this is the more troubling implication of Li Lishui's utopian vision of cinema as a vibrating art in the air, an affective medium

that is attached to an expansive propaganda network as an ever-extending, moving, infinite medium, like the biochemical process of osmosis and diffusion. This megamedium materializes and transforms affect as a broadcastable entity but also tries to shape it into codified emotions, beliefs, and attitudes to the advantage of the war. The two paradigms of propaganda theory delineate the troublesome symbiosis between art and propaganda, the latter being its enabling condition for its radical transformation but also its necessary constraint and instrumentalization.

Battle of the Nerves: Wireless Propaganda and a Media Ecology

It would be easy to subsume propaganda theory in wartime Chongqing, as evidenced in the affective and information paradigms, under the category of *psychological warfare*, an alternative term to *propaganda* coined after World War I that gained popularity only at the onset of World War II.[121] Combining research on psychological experiment, mass survey, practices of political persuasion, and development in communication technologies, psychological warfare marked a new stage of modern warfare by waging a mass-mediated war as an extension of but also a substitute to military warfare.[122] Both the affective and information approaches to propaganda would fit the parameters of psychological warfare, as they aimed at manufacturing functional, exploitable emotional attitudes through strategies of fabrication, multiplication, and dissemination. Both approaches justified means by their ends and emphasized the former, which prioritized the realization of propaganda through mass media. As communication networks and mass culture came to the foreground, however, the actual operation of this media ecology revealed more complex political implications.

The more common Chinese term for psychological war was *shenjin zhan*, literally, "war of nerves."[123] A prominent example of *shenjin zhan* was the radio war, which the Nationalist government actively waged. Peng Leshan, head of the radio section for the government's Chinese Information Committee (CIC) under the Ministry of Propaganda, calls the radio war a "battle at the fourth front," a new battlefront extending from the land, the sea, and the air to the boundless ether.[124]

Peng describes the following distinct quality of the new war: unlike modern warfare bound by time and space, this war has no intermissions and allows no neutral territory. Through radio language gains new power. Once the sound wave changes to electromagnetic waves, it can fly over mountains and oceans, traverse national boundaries, and escape censorship and capture by secret police. It can reach the illiterate, educated, common people, soldiers, officers, and merchants, regardless of their level of education and experience. Combining the affective force of voice and the speed of communication technology, radio waves are the most powerful weapon of war. This new weapon, with a shooting range beyond the cannon, a speed faster than an airplane's, and dissemination beyond the control of censorship, can penetrate the most solid bomb shelter and cross the most guarded blockade. Peng specifies the power of the radio war as *shenjing zhan*, yet in his hyperbole of the unique and pervasive power of radio, one senses a subtle change of the connotations of "nerves."

In fact, wartime communication was already being compared to nerves in the popular perception. In the Chinese–English bilingual photo magazine *Dadi huabao* (*Tati*), a full-page portrayal of the Chinese warfront features Chinese soldiers using a wireless telegraph, wired telephones, pigeons, bicycles, telescopes, and flag signaling for distant communication (Figure 5.1). The English title for the group of photographs is plainly "Battlefield Communications," but the Chinese title is more sensationally "Zhendi shang de shenjing" ("Nerves on the Battlefield").[125] Although the wireless is highlighted as "the most important of all means of communication," says the caption for the photograph of an operator and decoder for wireless telegraph, the main caption under the illustration title calls for a more inclusive view: "Whether it be wireless telegraph and telephone, wired telephone, or military carrier pigeon, one should treat them indiscriminately and adopt whatever suits the actual situation. All these information tools are like the *nerves* connecting the main center. They are the most important instruments in the war."[126]

If wireless technology fulfilled the ideal of propaganda and served in the war of information, it also provided the concept for the reappropriation of all tools, transportation and communication included, into a communication network extending out and reconnecting back at the center. This ensemble of communication is

Figure 5.1. "Nerves on the Battlefield." *Dadi huabao* (*Tati*) 5 (April 1939): 34–35.

embodied in the large photograph that occupies almost two-thirds of the two-page spread. Three male soldiers in the foreground—one standing at the center stretching his arms in a perpendicular angle to flag signal, another on the left holding a pair of binoculars to his eyes, the third on the right squatting on the grass, taking notes with his notepad and pen—form an ensemble of communication that simultaneously separates and conjoins the perceptual and communication functions of each human body. To ensure the continuous operation of this ensemble, two soldiers stay behind them as if participating in a relay race. This enlarged, unframed image thematizes the whole page and stands out as an iconic image of wartime communication, suggesting a creative interpretation of wireless communication that constitute the nerves of the war.

Wireless communication, though a privileged technology during the war, hence became a more encompassing figure metaphorically and metonymically connected to the ensemble of communication. Communication, transportation, and media technologies conjoined and transformed their technologically bound functions and operations. Just as a pigeon could substitute for the wireless telegraph, a bicyclist might race against the telephone. An intense remediation

was taking place in the context of wartime communication, a vast propaganda network, and a vibrant exhibition culture.

A case in point was photography. With the outbreak of the Pacific War, China took center stage, resulting in the migration of major news agencies to Chongqing and increased supplies of photography and film-screening equipment, photography prints, negatives, heliotypes, and photo-processing material. In 1942 twelve news-photography publishers and agencies were established in Chongqing, including the publishers of *Lianhe huabao* (*United Pictorial*), *Tianjia huabao, Xingdao huabao,* and *Xinshijie huabao,* as well as the Sino–British–American United News Agency (Lianheguo yingwen xuanchuanchu). As international news media provided photo-offsets to the Chinese media and allowed them to reproduce the images in the most efficient manner, an active photography exhibition culture quickly took off. Numerous photography exhibitions were held in Chongqing and the hinterland by China, the Soviet Union, the United States, and Britain, featuring both art photography and images of the war and the wartime culture of the Allied forces. Chinese war photography was also exhibited abroad. CIC selected over three hundred photographs and held exhibitions in countries such as the Soviet Union, the United States, Britain, and the Netherlands.[127] Beyond the exhibition halls, photography was disseminated in a much broader terrain. The major photo magazine *United Pictorial,* with over one hundred distributors in the hinterland and subscriptions reaching fifty thousand, dropped their photography pages from each issue into the Japanese-occupied cities in China from U.S. planes. From 1943 *United Pictorial* published a biweekly journal, *Zhongmei tuhua bibao* (*Sino–American Illustrated Wall Newspaper*), featuring free large-size photographic images devoted to a specific theme to be displayed by factories, schools, and other educational units in public spaces.

A new alloy between wireless technology and photography, radio-photography, emerged in Chongqing. The Sino–American radio-photography service started on December 15, 1942, transmitting Roosevelt's writing accompanied by a photograph. At the time, it took about eight minutes to receive an eight-by-ten-inch photograph. The images, whose quality was described as "resembling raindrops," were accompanied by captions and textual explanations.

United Pictorial published over one hundred radiophotographs

between 1943 and 1945. These images, despite their high cost and poor quality due to technological constraints, were prized for their news value and often reserved for international news featured in the front section.[128] Radiophotography was also conducted between Kunming and Chongqing and was opened to the public in 1943.[129] Through wireless technology, an aura of authenticity and instantaneity enhanced the value of photography, by now a mundane medium due to its everyday use and the saturation of printed media.[130] Through these innovative means of exhibition and distribution, photography was no longer a singular medium but adapted to different formats for private reading, for public display, as weapons dropped from air, and as a "live" medium vibrating through wireless waves.

Wartime Chongqing showcased the increasing symbiosis between a media network and propaganda. Propaganda depended on media to operate and exercise its power on the masses, and the media relied on propaganda to extend their life, expand their reach, and advance their authority. In this process wireless technology was conceived broadly as a master metaphor for a process of intense remediation. The new institution of propaganda interwove various media and communication technologies—cinema, photography, radio, telegraphy, newspapers—in a vastly expanding communication network. Simultaneously, it created innovative means of reproduction, dissemination, and exhibition in order to circulate a wide range of verbal, visual, and acoustic propaganda in the form of printed texts; illustrations and paintings; musical, dance, and dramatic performances; and mass parades. In effect, the "war of nerves" was supplanted by the "nerves of war," an ensemble of communication that connected to and substituted for the human brain. The success of the former would depend on the perpetual feedback loop between the two, forming a perfect circuit.

The Political Symbiosis of Propaganda: A Potential Public Sphere?

Reality is, however, always a bit messier than the perfect design of propaganda. To understand the political culture of the media-saturated propaganda in Chongqing, it is useful to revisit Jacques Ellul's differentiation between political and sociological propaganda.

For Ellul political propaganda, usually deployed by a pressure group—the state, a party, or an administration—is highly centralized and directed with precise but limited goals, calculated methods, and a well-defined political objective.[131] In contrast, sociological propaganda aims at "the penetration of an ideology by means of its sociological context." [132] It is vast, more diffused and integrated, and gentler and exerts a subtler but more pervasive force. Instead of a top-down dissemination of an official ideology, sociological propaganda operates when existing economic, political, and sociological factors prepare the ground for the penetration of ideology. Sociological propaganda works on the fundamental structural integration of an ideology into one's way of life, linking economic behavior to social beliefs. Ellul uses (American) commercial society as the prime example of sociological propaganda, in contrast to Hitler's or Stalin's highly directed political propaganda. Importantly, Ellul sees a dialectical relationship between these two types of propaganda. He points out the intimate connection between the two types in his analysis of American society's conformist tendency shaped by the commercial ideology of the "American way of life" promoted globally by popular media such as Hollywood films. In other words, sociological propaganda shapes a conformist society and prepares the ideal ground for highly organized and directed propaganda at moments of crisis, when a more directed, political propaganda is needed to effectively convey a clear message.

To a large extent, the commercial culture embedded in everyday life in prewar Shanghai prepared the ground for shaping masses and developing the media networks. The affinity between commercial and political propaganda is highlighted in the double meaning of *xuanchuan* as both "commercial publicity" and "highly directed propaganda." Within the realm of cinema, during interwar Shanghai, questions of publicity versus propaganda, the commercial and political use of the media, converged and were frequently conflated. Just as Pan Jienong tried to distinguish propaganda cinema from advertisement cinema and education while bringing out their convergence in meaning and function, the same term, *xuanchuan*, was being used to describe fully integrated film publicity. Business strategies such as free or discounted tickets, gifts, integration of movie studios and movie theaters, a broad film culture cultivated by film magazines

and fandom, and aggressive advertisements targeting various sensory channels and social spaces—newspapers; posters in teahouses, hotels, and restaurants and the display windows in stores; and large murals and neon-lit signs at movie theaters—all were efficient methods of xuanchuan.[133]

In wartime Chongqing these dual notions of xuanchuan continued to operate for cinema, but Ellul's dialectic of political and sociological propaganda was complicated by not only their coexistence but also the fissures and disjunctures within political propaganda, carried out by multiple political agents in various forms with different political interests and orientations. Although the Nationalist government held considerable power over the funding, content, and distribution of the mass media, there was by no means a unified system of operation. Multiple agencies—the central government, the Nationalist–Communist United Front, the Chinese Communist Party, leftist intellectuals, various commercial venues serving major business and financial companies, Sino–foreign joint ventures, the information and intelligence offices of the Allied forces, and international business and political forces—operated simultaneously in a collaborative and contentious symbiosis. Due to the wartime material conditions, these agencies actively shared information resources, media equipment, distribution venues, and human power, but their varying political and economic interests made these shared venues centers of contention.

Between 1937 and 1945, a total of 127 newspapers were registered in Chongqing.[134] These newspapers, with different political orientations, had great visibility and provided forums for multiple social voices—sometimes with the same newspaper printing different political views under separate columns or shifting its views with changes in editorship and financial and political backing. Foreign news agencies crowded into Chongqing, increasing their presence especially after the outbreak of the Pacific War, culminating with thirty news agencies, including the Associated Press, the United Press International, Reuters, ITAR-TASS, and Havas, and reporters from major newspapers, magazines, and photo magazines, including *Time*, *Life*, and *Fortune*. Foreign information and intelligence agencies, most prominently from the British, American, French, and Soviet administrations, were actively weaving a network enhancing their

respective national influence and profile in China about their war aid and participation. Among them the China branch of the OWI—the American Information Service (AIS) (Meiguo xinwenchu)—also had a visible presence.[135] Established in Chongqing in 1942, AIS had its own sections producing photography, radio, and photo magazines. AIS also issued *United Pictorial,* which ran for eight years, from 1942 to 1949.

These international news and information agencies collaborated with the CIC, which itself actively pursued international propaganda to gain support for the government and China's War of Resistance. The CIC held weekly press conferences to inform the international news media, organized film screenings in China and abroad, published its own journal in English, French, and Esperanto with more than 290 issues, and distributed more than 11,000 photographs and 700,000 pamphlets.[136] In addition, CIC provided radio service for the foreign news reporters, allowing them to use China's International Radio Broadcasting to send news abroad and collect overseas information much faster than via telegraphy. However, these shared venues and information strengthened the international propaganda network but also functioned as means of censorship and sources of contention. Criticism of CIC censorship was intense; many reporters interested in China beyond the official news wrote extensively about the tension between the two parties, governmental corruption, urban poverty, and other social issues.[137]

These tensions within the shared media network break the fantasy of a seamless total sphere of propaganda. As different political voices and aspects of reality seep through the fissures and disjunctures among various media institutions and agents, we are forced to rethink the question of the public sphere in relation to propaganda. Since Jürgen Habermas's influential study on public sphere as a historical formation for public life and civic interactions emerging in the eighteenth century, recent approaches to public sphere have tried to address the exclusive nature of his model—the particular class and gender profile of its subjects reserved for bourgeois, male, literate liberals and the positioning of public sphere as an autonomous sphere separate from the market and other interests—as well as its critical incapacity to address mass-mediated society with new modes of social interactions. Focusing on the culture of production

and consumption in advanced capitalism, Oskar Negt and Alexander Kluge have suggested a model of public sphere characterized by its inclusiveness and dialectical nature.[138] As Miriam Hansen points out, Negt and Kluge's alternative model emphasizes two levels of inclusion and dialectical imbrications. First is the coexistence of the alienating experience in capitalist production/reproduction, the structural exclusion of articulation of such an experience, and the resistant response of the exclusion as such. Second, instead of an autonomous, neutral, and separate sphere, public sphere operates as an inclusion of various spaces and social contexts, often in conflict with each other.[139] In contrast to a homogeneous, singular entity, public sphere should be seen as an aggregation of different types of public life, not in isolation from each other but "in mutual imbrications, in specific overlaps, parasitic cohabitations and structural contradictions."[140] It is this mixed and aleatory nature of public sphere that lends it to the emergence and inclusion of different social voices, making visible the function of the public sphere as not simply certain institutions and activities but "a social horizon of experience."[141]

Negt and Kluge's theorization of public sphere as a mediated and syncretistic space enabling the social horizon of experience, albeit focused on an advanced-capitalist mode of production and consumption, lends a useful lens to us for reconsidering the political dynamic of the propaganda sphere in wartime Chongqing. If Negt and Kluge's notion of public sphere remains "emphatically utopian," predicated upon the possibilities and potentials of public sphere as a volatile process and the fissures between "uneven institutions of public life,"[142] then it is by recognizing alternative public sphere as alternative conceptions rather than absolute negations (counterpublics), as utopian possibilities, that we reconfirm the dialectical nature of the public sphere so as not to exclude the historical formation of propaganda sphere as an anomaly but to include it as an essential chapter in modern mass-mediated society.

If anything, wartime Chongqing propaganda was equally unstable, full of accidental collisions, unlikely cohabitations, and unpredictable development that led to possibilities and potentials beyond the institutional design of propaganda. In a way similar to the capitalist public sphere, the propaganda sphere in Chongqing

was not homogeneous but rather syncretistic, containing an array of national, international, and regional organizations with varied and often conflicting interests and political orientations. Living in symbiosis, they relied on each other to share media infrastructures, resources, audiences, concrete social experience and contexts, and recognizable aesthetic forms, languages, and emotions. Despite their exclusive agendas, they appealed to the broadest possible public to gain their legitimacy.

More important, in light of Ellul's theorization of propaganda, public sphere in advanced capitalism and the propaganda sphere in a hegemonic or totalitarian state should not be seen as mutually exclusive. The benefit of combining the insights from Negt and Kluge and Ellul is to further the dialectical nature of their cultural analysis in bringing out each of their nondialectical residues.[143] Just as Negt and Kluge's analysis of the mixed nature of the public sphere makes Ellul's integrated propaganda not as seamless, Ellul makes it impossible to separate political and integrated propaganda into two irrelevant categories contained in two separate societies. Wartime Chongqing provides a rich case where both types of propaganda coexisted and transformed each other, with the highly directed political propaganda bleeding into integrated propaganda, diffused into different agencies beyond a singular center while integrated, commercial culture sought a parasitic living with political propaganda. Within such coexistence and the fissures of different institutions and agents, propaganda turned into a perverted space for the social horizon of experience. Exactly how that experience was articulated is explored in the next chapter.

6 Baptism by Fire
Atmospheric War, Agitation, and a Tale of Three Cities

In late August 1940, the third summer after the Guomindang (GMD) government relocated from the coastal city of Nanjing to the hinterland city of Chongqing farther up the Yangtze River, Chongqing was still the world's most-bombed city (the London blitz started in September of the same year) (Figure 6.1). American writer Graham Peck visited the wartime capital and later recounted his jarring experiences. He joined a farewell party with a number of Americans at the Chongqing Club, where people watched home movies made by the guest of honor:

> After the customary false starts and homely joke, the screen flickered into enough clarity to show a group of people in white clothes, fumbling with a picnic among trees by a brook.... Two girls on the screen had begun a parody minuet by the brook when, without warning, the scene changed to what seemed another grove of curiously black, mis-shapen trees, wavering on a mound beside a wider brook. A row of shrubs sprang out of the ground and with puffing motions soon grew into trees. This new brook was the huge Yangtse, the trees were explosions, and the mound was Chungking [Chongqing].[1]

Peck recounted what happened several days later when he himself witnessed the bombing in the city: "From the South Bank, the raids were a super-spectacle with yellow blasts and scarlet flames in lurid techni-color, but they were even harder to recognize as a danger ... when watched from some shaded porch or terrace full of other foreigners busy with their cameras and cool drinks."[2]

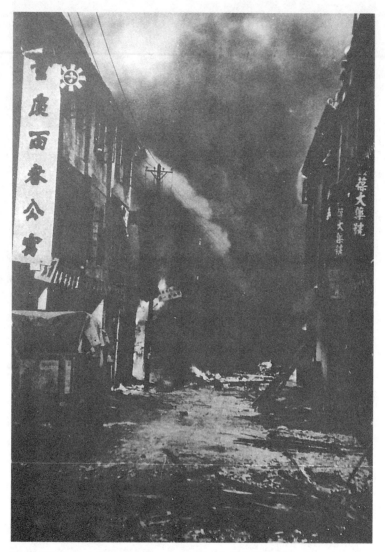

Figure 6.1. Image of Chongqing under the May 3, 1939, bombing. *Dadi huabao* 7 (July 1939): 14.

The air bombing was one of the most commonly shared experiences of war in Chongqing. Between February 1938 and August 1943, the city of Chongqing underwent frequent bombing. From spring to autumn, in the seasons unprotected by the winter fog, Japanese

airplanes cruised overhead, dropping incendiary bombs that set thousands of houses on fire. Over a period of five and a half years, approximately 17,000 houses were destroyed and 12,000 people were killed by air bombing. With over 9,900 flyovers, the planes dropped more than 20,000 bombs.[3] These terror bombings—the Japanese strategy targeted not military bases but residential areas, business districts, schools, and hospitals—were meant for destroying the morale of the enemy and incubating a prolonged climate of fear. The attacks varied from large-scale, concentrated surprise attacks creating massive casualties to more sporadic, less life-threatening flyovers, and the Chinese side became increasingly prepared for alerting and sending people to the bomb shelters carved out of the hard rocks holding the mountainous city. In these years the air bombing was an everyday reality ranging from the tragic to the banal, and civilians learned to orchestrate their lives in between seeking dugouts.[4] These atrocities were captured in wartime documentaries and feature films as well as stage plays, fiction, photography, and painting, with fire as the prominent motif on the wartime horizon of experience.

The terror bombings constitute a prime example of *atmoterrorism,* as Peter Sloterdijk calls it, a staple of modern warfare that targets the enemy's life-sustaining environment rather than their physical bodies alone.[5] Such an atmospheric war creates a blurred boundary, challenging the possibility and ethics of visual perception. At the south bank of the city where Peck was standing, Japanese airplanes had left pockets of neutral zones due to the presence of foreign presses and embassies, affording the visual pleasure of the home movies that Peck witnessed. Peck's account illuminates a hypermediated wartime capital in a crisis of perception, exacerbated by the technology of the war, cinematic mediation, and a racially and class-differentiated spectatorship. His self-criticism raises poignant questions regarding the cinematic use and abuse of reality, particularly the conflation between reality and illusion, and the potential risk of its consumption for visual pleasure at a politically critical moment. His depiction strikes an uncanny resemblance to prominent scenes in left-wing theatrical and filmic productions such as *Dances of Fire, Raging Flames,* and *Torrent,* which critique visual and sensorial pleasure as a class-bound leisure at the expense of those caught in the catastrophe. The questions that haunted the left-wing

filmmakers return in acute poignancy: How was critical transparency possible or necessary in the midst of the war? Was cinema's technologically enabled and ontologically privileged access to reality sufficient to register the extreme experience of war in China, with its complex social dynamics?

This crisis of perception was further aggravated by the proliferation of propaganda in a media ensemble. The saturated media sphere, with radio waves permeating the ether, photographs dropped from the air, and movie screens popping up in the remote countryside, might have interwoven to create what Walter Lippmann calls a pseudoenvironment, yet articulated from different agents with conflicting interests, it only rendered highly charged notions such as truth and knowledge, information and fact more ambivalent, contradictory, and suspect.[6] As reality remained hard to penetrate, how to mold mass perception for the advantage of particular interest groups occupied the concern of many while the traumatic experience of war and mass dislocation prevailed. In this context, the role of propaganda was not only to inform and emotionally move but also to expose and perpetuate the right perception, so as to "agitate" the spectators to turn into subjects of action.

This chapter takes a second look at wartime propaganda's production of an affective medium by closing in to the film and media productions and inquiring how they capture the experience of the war while articulating a distinct aspect of affect to shape it for social perception and politicized action. As I show in chapter 5, affect was substantially reworked in Chongqing propaganda, instrumentalized as either codified emotional attitudes or quasi-material environment contiguous with the ensemble of wireless technology and innovative exhibition and dissemination. A third dimension of affect concerns the tentative suggestion with which I end chapter 5. I am interested in how propaganda sphere could function as a potential public sphere if we moved the focus of propaganda from institutions and activities to the social horizon of experience. By inquiring public sphere in terms of not physical but virtual sites of exchange, we can see media products as activating such a sphere and hosting conflicting social voices and contexts. This change of perspective requires me to engage more fully the question of aesthetics, which played an important role in negotiating public experience and the stakes of perception in the atmospheric war.

I focus on agitation, a mode of affective spectatorship in the service of propaganda that registers the very conflicting experience of the war and the crisis of perception concerning the subject in relation to the overwhelming environment. Agitation not only was the goal of propaganda but also involved complex negotiation of the earlier history of Chinese cinema. To examine the aesthetic and political components of agitation, I focus on its two crucial aspects: action and perception. Action, the key component of agitation, interwove legacies of martial arts films and action thrillers of the 1920s and 1930s with modernist notions of artistic action, which transformed the action thrillers into a politicized apotheosis in the propaganda films. As we move from the shock of urban modernity to the terror of modern warfare, generic features of action thrillers wed with left-wing film tradition's critiques of commercial modernity, which ends up treating the war as its inversion and antidote by conflating art and war and enacting action as the art of war. As these films were made often by left-wing filmmakers from Shanghai who participated in commercial filmmaking in prewar Shanghai, these connections became more tangible and personal, as I illustrate in specific histories of filmmakers, artists, and thinkers.

My inquiry of agitation takes me beyond the geographical confines of Chongqing and the hinterland so as to problematize the distinction between entertainment and propaganda that serves to entrench the geopolitics of Chinese film history. Tracing the development of the history of affect and action in a larger context, I turn to film productions made in the three geopolitical zones in wartime China—Chongqing, Hong Kong, and Shanghai—to examine the transregional traffic not only in human movement but aesthetic experiments. These films illustrate an intimate dialogue across the geopolitical divide and with prewar Shanghai cinema. I conduct three case studies of films made in these three cities, each of which engage in spectatorial affect in specific ways that reflect upon the history of Chinese cinema. In this sense, this chapter serves as a tentative conclusion in which Hong Kong, Shanghai, and Chongqing converge and collide, anticipating an uncertain future.

I start by reconstructing Sun Yu's no longer extant *Baptism by Fire* (1941), drawing on various paratexts, including synopses, reviews, film advertisements, and historical reflections, but more important,

I situate the film in the broader scope of documentary film and photography in order to examine their shared aesthetic operation of affect aimed at motivating spectatorial action. To illustrate the historical specificity of agitation as a mode of spectatorship, I reflect on earlier film practices in China to examine how wartime Chongqing cinema remained deeply embedded in prewar practice but also signified a departure. That departure was conceptualized by Gao Changhong's theory of artistic action, which envisioned propaganda in terms of spectatorial agitation. I then analyze two Hong Kong and Shanghai film productions in order to tease out the rich intertexts of these films in rethinking the history of spectatorial affect, weaving an alternative history that reconnects film action to political action in genres ranging from martial arts films to left-wing cinema and wartime features, documentaries, and animation films.

Perception, the other component critical in the transition from affect to action, involved evoking earlier modes and creating new constellations in order to construct a politicized spectatorship. More important, the construction of perception relied on the interplay between various media. I draw on a variety of media to reconstruct the lost film *Baptism by Fire* and trace the aesthetic resonance across media. In *Paradise on Orphan Island,* the relation between affect, perception, and action is highlighted by the effective editing between music, vision, and action, while the production of transparency is executed through a deliberate resort to cinematic disability that in effect brings out a dynamic intermediality between different senses, objects, and means of expression. I end with *Princess Iron Fan,* which with the material constraints and possibilities of cel animation, allegorizes the challenge of perception and action in the atmospheric war. The plasticity of the cinematic medium, embodied by the metamorphosis of the characters and the productive formlessness of animation, continues to challenge our assumptions of stable media identities and spectatorial positionings, as the distinction between enemy and us becomes increasingly difficult to pin down.

Baptism by Fire

In May 1941 Sun Yu's *Huo de xili* (*Baptism by Fire*) was first screened in the major movie theaters in Chongqing, including Weiyi, Cathay,

and Kangjiantang. The film was popular: newspaper records show that it ran for seventeen consecutive days, four times a day, holding its own against the theaters' busy schedule of Hollywood, Soviet, British, Shanghai, and Hong Kong films as well as live modern stage plays. On its ninth day of exhibition, a newspaper ad for the Weiyi theater stated that the thirty-five consecutive screenings of *Baptism by Fire* had "beaten the records set by any Chinese or foreign film shown in public within the past three months" in Chongqing.[7] The theater proudly added that even in the case of blackouts, it could show the film, using power from its own electric generator.

One of the major attractions of the film, as an audience member recalled, was the grandiose scene of the city on fire:

> The scenes in the film are so grand, especially when they show the whole of Chongqing on fire. It is absolutely soul-stirring and heart-wrenching. All these shots were taken under great danger. In other words, the backgrounds of all the scenes in the film are the crystallized blood and tears of our Chongqing brothers. . . . All of these images, in the eyes of our fellow citizens who have experienced the exact situations, are even more resonating![8]

In the publicity for the Hong Kong exhibition of the film, a newspaper ad highlighted the character for fire by using large, bold type with exclamation points: "Fire! Fire! Fire!" (Figure 6.2).[9]

Indeed, one of the salient features of resistance films made in Chongqing is the profusion of fire images. Films such as *Defending Our Hometown* (He Feiguang, 1939), *Marches of Victory* (Shi Dongshan, 1940), and a variety of cartoons, songbooks, documentaries, and unrealized screenplays feature fire extensively. The clichéd association of fire with propaganda—illustrated by the connotations of words such as *shandongxing* (agitating) in Chinese and *inflammatory* and *fiery* in English—increases our conditioned aversion to these films. At the same time, fire constitutes one of the earliest attractions of cinema, in both the Chinese and Western contexts. What has sustained the perpetually attractive and repulsive character of fire? On what historical experiences and expectations does the "propagandistic" fire in resistance films build? What modes of address do

Figure 6.2. Hong Kong newspaper advertisement for *Baptism by Fire. Dagongbao*, July 2, 1941.

these films construct to produce the ultimate affective impact of fire? And what is at stake in the euphoria of an affective horizon of fire?

Among the resistance feature films made between 1938 and 1941, *Baptism by Fire* was a bit of an anomaly. During this time, fourteen feature films were made by the film studios Zhongdian and Zhongzhi, in addition to about 125 newsreels, documentaries, cartoons, and songbooks.[10] Most of these feature films were set in either an anonymous countryside (*Defending Our Land, Defending Our Hometown, The Good Husband, Sons and Daughters of China, Youth China*) or the hinterland (*Marches of Victory, The Light of East Asia*), but Sun Yu set his story solely and explicitly in the city of Chongqing. Sun Yu made the film in between shooting a much more ambitious film, *Changkong wanli* (*Iron Birds Fly High,* 1941). A tale about the Chinese air force, it was shot in Yunnan and took three years to finish. *Baptism by Fire* was completed in four months, and it became an instant hit in Chongqing.[11]

According to the synopsis, the film depicts a female spy, Fang Yin (Zhang Ruifang), sent from the Nanjing puppet government to Chongqing to destroy munitions factories in the hinterland. Disguised as a worker named He Ying at one such factory, she successfully collects data but falls in love with a fellow worker, Lao Wei (Wei Heling) (Figure 6.3). Soon, the enemy's airplanes arrive to demolish the factory. Although they miss the target, they kill many civilians and destroy their living quarters. Witnessing the great atrocities she has caused, Fang confesses the truth to Lao Wei, provoking his immediate rage and contempt. Deeply remorseful, Fang reports the location of espionage headquarters to the national army, which surrounds the building and sets it on fire. The enemies within are trapped. In the end, Fang, already severely wounded, is carried out of the fire by Lao Wei, who brings her peace as she dies.

Although *Baptism by Fire* unfortunately does not survive, synopses, spectators' impressions, and publicity materials all attest to the prevalence of images of fire in the film.[12] Fire occurs at three significant moments. First, at the munitions factory, the fire in the furnace provides the heat and melting force for hammering steel into weapons. This reflects Sun Yu's enthusiasm for industrial images: "Thousands of gears coordinate with each other at high speed; thousands of arms form one muscular arm; thousands of hearts merge into the

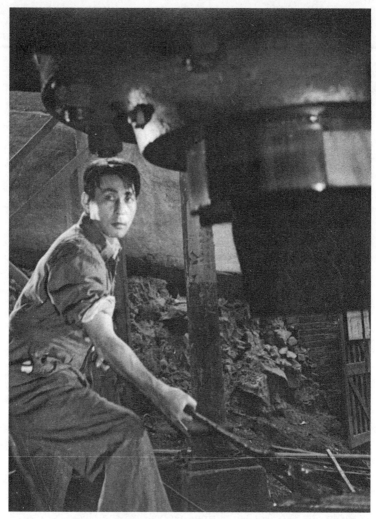

Figure 6.3. *Baptism by Fire* (1941). Film still. Courtesy of China Film Archive.

heart of a giant."[13] The symbolism and physicality of this scene of industrialism in the wartime capital is indeed reminiscent of Soviet avant-garde documentaries, especially Dziga Vertov's *Enthusiasm*. Fire in this context highlights the creative force and sublime image of modern industrial technology and the formation of a new collective *physis*. Second, caused by the incendiary bombs dropped by Japanese

airplanes, fire devours half of the city in the most horrific scenes in the film. In these scenes fire is a destructive force, and they are the film's most sensational attraction. Finally, the rage of the people is consummated in ruthless fire that annihilates the enemy in their headquarters. Here, fire is both metaphoric and metonymic of emotion as well as the force of the crowd. Ending with He Ying's salvation, the burning fire highlights what Sun Yu describes as the theme of the film: "Ninety-nine torches can light the one that is not ignited."[14]

Sun Yu's own notes record that he wanted the film to "portray a background, a spirit, a raging fire." That background was the devastating air raids that haunted Chongqing.[15] Between 1939 and 1941, Chongqing was bombed 268 times in Japanese air raids. During the May 3 and May 4 raids alone, 4,400 civilians were killed (many burned to death), and 200,000 were made homeless (Figure 6.1). On August 19, 1940, two months before the filming of *Baptism by Fire*, Chongqing was bombed four times in twenty-four hours, and two thousand houses were consumed by fire.[16] These air raids, using primarily incendiary bombs as part of a "war of nerves" military strategy, constantly set the city on fire and put the people on edge.[17] In Sun Yu's words, these only "stimulated even more furious fire from us."[18] With the population including local and migrant residents from all demographic strata, these air-raid fires created a broad horizon of shared atrocity, sympathy, and wrath. To catalyze this affect for a united front of defense and to transfer such an experience to other places beyond the immediate site of Chongqing, Sun Yu resorted to a mode of address that built on both the intensity of such traumatic experiences and the reservoir of available media practices across the division between Shanghai and Chongqing, present and past.

According to Sun Yu, the scene of Chongqing devoured by fire was executed by putting together a long sequence of documentary shots.[19] The film used some stock footage of the most atrocious bombings in August 1940, but as the stage manager, Tong Yu, recalls, during their shooting season there was still constant bombing by Japanese airplanes. Some of the most joyful scenes in the film, including Lao Wei and A Ying's expression of love at the Southern Hot Spring (Nanwenquan) waterfall in Chongqing, were shot with Japanese airplanes hovering above.[20] The film's reliance on the unfailing power of the documentary as an emerging cinematic Esperanto was

thus based on a naive yet provocative assumption: at this unusual time in history, the best film with maximum spectatorial affect was one that could bring the spectators closest to the scene, with the shock of reality.

Unlike *Baptism by Fire*, a good number of documentaries on wartime Chongqing have luckily survived. The Japanese air raid appears as a recurrent subject. A comparison with Japanese newsreels made of the same bombings reveals different visual logics at play. In the Japanese documentaries the privilege of the aerial perspective is constructed through a narrative journey of the flight.[21] The airplanes are shown first on the ground as the pilots board them, the physical and machinic bodies merging into one. As the airplane ascends, it is shown from the interior and exterior soaring in the air. A profile shot of the pilot and the airplane window frames the spectatorial vantage point of subsequent shots, identifying the camera eye with the eye of the pilot and the screen with the airplane window. The celebration of the aerial perspective culminates in the dropping of the bombs, aligning the precision and power of mechanized mobile vision with the effectiveness of destruction. In these films the bombed place remains an abstract landscape. Just as such films typically start with an animated map of China and identify Chongqing as a hollow dot, the eventual dropping of bombs from the air shows the city only as a topographical approximation of the map. One documentary even shows the pilot comparing the map in his hand with the aerial perspective showing the Yangtze River.[22]

Whereas the Japanese documentaries flaunt "air conquest," the Chinese documentaries demonstrate the perspective from the earth and the destruction of the bombings absent from the aerial perspective.[23] A narrative of destruction and reconstruction recurs in these documentaries. Extreme long shots, often taken from mountaintops in the South Bank, establish sources of destruction as bombs explode on the land and in the Yangtze River, creating towering columns of water and smoke. Closer shots bring the camera to the scene of destruction, showing houses engulfed in fire completely lit up at night, with the flames seeping through the windows and leaving the buildings as skeletons. Daytime shots reveal the extent of the demolition in an aesthetic of the ruins composed of slanted electric poles, rubble, injured human bodies and remains, and relics of the building.[24]

In these films the panning shot becomes the master visual idiom. While the camera pans horizontally and vertically to provide a total vision, its movement continues to unfold the off-screen reality as larger, beyond the scope of the documentary. These panning shots are intercut with closer shots of the devouring fire and smoke that threaten to exceed the frame of the screen and annihilate the spectatorial distance. The dialectic operation of panoramic unfolding and haptic sensation immerse the audience in the scene of destruction.

Counteracting the force of destruction is the defiant effort at reconstruction. The documentaries often feature spectacular firefighting, sometimes with collective manual production of high-pressure water streams to combat the flames. In a changed acoustic and visual tone, the remains of the buildings are shown stubbornly standing. Another round of panning shots performs a unique time travel between ruined and reconstructed buildings, moving from sites of destruction to newly erected modernist buildings, new shop fronts, and display windows.[25]

The scene of construction is monumentalized in a documentary made by Zhongzhi about the August 19 and 20 bombing, in which workers orchestrate their collective bodies with geometrically ordered scaffolds, rows of roof tiles, and building sections.[26] An industrial image of construction includes the film studio itself by showcasing a film in production (*Baiyun guxiang*) and the film-development process. In a tribute to Vertov's *Man with the Movie Camera*, the film workers are shown examining film strips, developing film prints in a gigantic processer, mounting the reels, and placing labels on the reel cases. Instead of relishing the making of a single film, the film-development process shows the mass reproduction of the prints, ready to be sent out to a new exhibition network. The industrial scene of construction is most lavishly portrayed in *Minzu wansui* (*Long Live the People*, Zheng Junli, 1941), a lyrical documentary that contains an extensive sequence of the industries using mass production: textile, steel, and munitions. The organized laborers, situated in enormous plants working in synchrony with the machines, create a subliminal imagery that echoes Sun Yu's cinematic vision of an industrial giant emerging from the alloy of machines, human arms, and hearts.[27]

These scenes of destruction and construction in the wartime

documentaries echo visual motifs and compositions in documen-
tary photography published in newspapers and photo magazines.
In a series of photographs published in the Shanghai-based photo
magazine *Liangyou,* which features the May 3 and 4, 1939, air raids
in Chongqing, images of the city engulfed in fire and images of the
ruins with similar aesthetics create a cross-medial resonance. While
the gigantic remains of the building dwarf the scale of human emo-
tion, the photographs capture images of God to articulate a divine
accusation. A photograph shows the statue of Balthazar destroyed
in the courtyard of the Mission d'etranger de Paris in Chongqing
(Figure 6.4). Against the remains of the church, the statue is framed
prominently in the foreground, surrounded by a French priest and a
number of Chinese. The statue's body is hunched as if overwhelmed
by the weight of sadness. As the group look down at the statue, cre-
ating a focal center, a man on the right looks pensively toward the
camera, creating a point of contact with the spectator in a poignant
moment. A dynamic interplay between absorption and theatrical-
ity heightens the affective power of the image, with strong religious
overtones. Not surprisingly, this series of pictures is entitled "Xue yu
huo de xili" ("Baptized by Blood and Fire").[28]

Coupled with this page of " baptism by fire" are two full pages of
photographic images entitled "Jingshen zong dongyuan" ("National
Spiritual Mobilization") (Figure 6.5). Featuring Chiang Kai-shek at
the top, in front of the prominent radio sign XGOA, the page show-
cases mass rallies at various locations, featuring eminent politicians
framed by a row of microphones. The second page features, interest-
ingly, a "fire parade" as part of the mobilization event. A giant "fur-
nace of fire" emits fierce flames at the center of the gathering, and an-
other photograph shows the spectacular stream of fire on the street at
night and is captioned, "How the torch parade looked from above."[29]

In these images fire is deployed as a mobilization device, as a me-
dium of affect: as fire shrouds the city in a shared experience of atrocity,
it is re-created to harness the contiguity between energy and affect in
the simultaneous evocation and configuration of the crowd. Crowds
and fire merge and become interchangeable. If the conspicuous pres-
ence of radio microphones in the previous photographs emphasizes
the highly mediated mass mobilization, the fire parade utilizes fire as
a comparable medium, as capable of distant communication as the

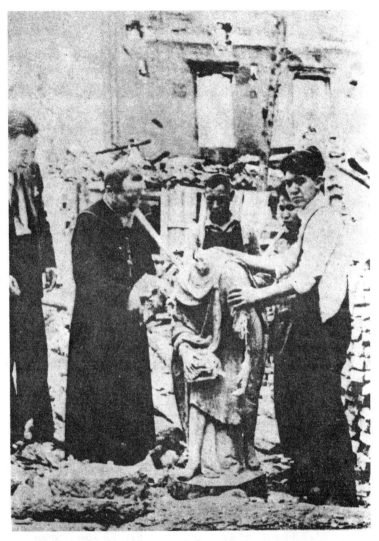

Figure 6.4. A photograph shows the statue of Balthazar destroyed in the courtyard of the Mission d'etranger de Paris in Chongqing. *Liangyou* 143 (June 1939).

radio waves, while gesturing against the threatening force from the sky. Through images of the microphone and fire, photography captures the absent soundscape and the heat of the flames, spreading the affective impact by its own means of mediation.

Figure 6.5. Fire parade as part of the "national spiritual mobilization." *Liangyou* 143 (June 1939).

A History of Fire

Sun Yu's heavy reliance on fire, although framed in a highly patriotic and symbolic context, built on a much longer history of fire configured in modern Chinese mass media concerning the human subject in relation to perception and action, has been traced throughout this book. One of the early depictions of fire appeared in the popular lithographic prints affiliated with the Shanghai newspaper *Shenbao*, the *Dianshizhai Pictorial* (1884–98). A recurrent subject in this illustrated journal, fire was often shown erupting in the bustling urban streets and drawing a large crowd. These urban fires catalyzed the formation of aleatory spectating publics and centrifugal gazes grounded in the heterotopic social spaces of fin-de-siècle Shanghai. Similar to the popular effect of the fires themselves, these pictures, enhanced by the meticulous detail of lithography and the ease of its circulation in the booming print culture, attracted diverse gazes as well as social groups, soliciting a new reading public with sensational news effects and a novel visuality.

In the next two decades, fire figured in new media such as short foreign fire films and modern popular drama, the latter frequently

staging live fires. The attraction of fire made its most phenomenal return in the rise of fiery films as a major subgenre of burgeoning martial arts films between 1927 and 1931.[30] As discussed in chapters 1 and 2, the sweepingly successful fiery films orchestrated the genre conventions of martial arts films for mutual reinforcement between fire and action. Imbricated with multifarious social practices and cultural discourses, cinematic fire and action asserted the actor's body vis-à-vis technology, executed a competing realism against live stage interaction, and embodied a new heroist aesthetics to re-mold Chinese cinema as well as the national character. Further, if action induced audience–actor innervation through the evocation of the audience's reflexive response, fire traversed the audience–screen division through a radicalization of space and time. This new experience of space-time, foregrounded by the notion of a *resonant spectator*, was enabled by other technologies of the body—wireless technology, hypnotism, new styles of acting—as well as by popular scientific imaginations of the diverse futures of cinema. Cinematic fire in these films produced a haptic and environmental visuality beyond two-dimensional space and defied a total vantage point. Meanwhile, the self-effacing fire on the screen highlighted cinematic image making as a process of perpetual erasure. This annihilation of the infinitesimal standard division of frame and time provided a Bergsonian notion of duration that encouraged audience participation, inducing and projecting their plural memories onto the screen. Together, fire and action challenged the contemplative and auto-nomic subject and spectator.

The synesthetic force of fire—the promise of a radical specta-torship achieved through physical thrill and psychosomatic im-mediacy for the audience—was challenged by left-wing dramatists and filmmakers. In Tian Han's play *Dances of Fire,* a rather heavy-handed class commentary, the impact of fire was mediated by the river. The river, emblematic of the social gap mapped in urban geog-raphy, also functioned as the division between the spectator and the realm of exhibition. This division was endowed with historical significance in the 1933 film adaptation of the play. The film, *Raging Flames,* repeated the motif of the male heroic rescue of the heroine, as in *Hero in the Fire,* discussed in chapter 1, but the river was shifted to that between the foreign concession and the Chinese zone on the

night of the Japanese bombing of Shanghai in 1932. Nevertheless, the river division indicated that the social and spectatorial gap remained intact.

While these media configurations of fire portrayed, embraced, or critiqued the spectating public through various "sensorial reflexive horizons," these fiery horizons were historicized not only by different media practices but also by different political agendas.[31] As fire in *Dianshizhai Pictorial* and martial arts films catered to the popular audience with an ambivalence that evoked the traumatic and utopian effects of modernity, it was no less political than more didactic productions. Yet Tian Han's spoken drama showed a paradoxical embrace of the "attraction" of fire by remolding it into a more explicit political allegory. His leftist anxiety about media impact on the masses translated into a self-reflexive moment of the spectating scene that remained poignantly divided between the spectators and the media product.

The divergence between popular positivism and leftist skepticism toward media attractions was undermined, however, by a formal convergence among the martial arts fiery film *Hero in the Fire,* the modern spoken drama *Dances of Fire,* and the left-wing film *Raging Flames.* More specifically, they converged in the mise-en-scène of fire: the attraction of firefighting, the hero rescuing the heroine from a fire, and the river's partitioning of spectators from the image world.[32] The fact that Yihua Studio started with Tian Han's cooperation with two previous martial arts film stars, Zha Ruilong and Peng Fei, further highlights left-wing film's affinity with the popular genre it most explicitly rejected.[33]

I have traced the configurations of fire along an extended zigzag across the mass media in modern China, among high and low genres, and traversing pictorial, theatrical, and cinematic media. This rather prolonged excursion has allowed me to delve into the intricate imbrications among media and genres in different planes. Although official film historiography praises revolutionary left-wing films and dismisses martial arts films and other film practices, recent revisionist readings have redirected the prejudice against left-wing films in favor of popular genres such as martial arts films, family melodramas, and costume dramas. By isolating left-wing films from other film practices in the 1920s, the rewriting of Chinese film history continues to

evolve around the binary opposition between left-wing and non-left-wing films, although with a reversed hierarchy. Through an extended tracing of the contours of fire, I highlight the perpetual process of mutual borrowing among these different media and genre practices and their shared interest in the plural dimensions of affect: its relation with perception, body, and media technology as well as its impact on crowds and mass publics.

This overview performs a methodological revision necessary for understanding the film history that follows—especially, resistance cinema in Chongqing, a subject even further marginalized today. The historical media configurations of fire informed both the making and the reception of resistance films. Significantly, Sun Yu's *Baptism by Fire* recycles these shared elements, albeit with a noteworthy augmentation.[34] The film similarly deploys the trope of firefighters saving the city after the great bombing, and the last scene exactly reproduces the climactic scene in *Hero in the Fire* and *Raging Flames,* in which the hero saves the heroine from the siege. Yet the recurrent scene with the river division involves a crucial transformation of spectatorship. When A Ying (He Ying) witnesses the devastating fire that devours half of the city across the Yangtze River, "her heart burns with the smoke and fire that shrouds the city." This scene leads directly to A Ying's conversion from a female spy associated with the aerial view above to a heroic fighter sharing the experiences of her compatriots on the ground. In this iteration fire is no longer a spectacular image; with all its heat and emotional intensity, it not only traverses the space of the spectator but also galvanizes the latter into feverish action.[35]

This self-reflective moment of the film no longer desires but actually depicts the ideal scene of spectatorship: media stimuli transform into the spectator's immediate action, annihilating the spatial demarcation between the screen and the audience. What brought about this optimal result if not the chivalric martial arts body in fiery films?

Artistic Action: The Making of a Resistance Subject

In *Baptism by Fire,* the female protagonist (Fang Yin) is the "sentimental" subject, and the contiguity of her gender with sentimentality is arrived at through a detour of love. Fang starts out as a modern

girl and a female knight-errant, though for the wrong cause. As a female spy in the employ of the Nanjing puppet regime, Fang first heads for the glamorous and "decadent" spaces in Chongqing—the dance halls, restaurants, and nightclubs—to gather information. In this sphere she remains a "social flower" (*jiaoji hua*) not unlike the sensational female stars from Shanghai in the 1920s and 1930s, whose historical symbiosis with dance hall socialites was widely known to the media public, avid consumers of film journals and tabloids.[36] Fang's social dances in this sphere limit her contacts, however, to corrupt officials, profiteers, and parasitical wives and mistresses who cannot provide useful information. In other words, she is confined to the old circle from the east coast who, transplanted to Chongqing, remain strangers in the city. Several days later, Fang Yin, disguised as a female worker, faints at the gate of a munitions factory in Chongqing and is revived by the workers. This time, through a symbolic death and wearing tattered clothes, she finds access to the military information she needs. In the process of appropriating the munitions factory, the main target for Japanese air bombing, she undergoes a performative self-transformation. In order to make her disguise believable, she works hard and mingles with the workers and their families, ends up identifying with her new role, and falls in love with it while also falling in love with a model worker, Lao Wei. With her new position at the munitions factory and her budding romantic relationship, she is now associated with a different social group and placed at the center of the industrial–military construction of the wartime capital. Lao Wei introduces her to the new faces and life in Chongqing: the construction sites, the mass rallies and parades, the adults and children in the parks, and the scenic spots of the city.

Only at this point does her departure from the east coast leap from a geographical to a paradigmatic shift. Her transformation goes through three steps, corresponding to the occurrences of fire in the film that define her as a resistance subject. First, she delivers herself to the munitions factory and annuls her previous appearance and identity by merging with the new masses. This is realized through the symbolic force of the industrial fire in the steel crucible, organized, as director Sun Yu openly acknowledges, like Soviet iconography and film aesthetics. Second, her union with the crowd is not simply a "melting" but, more important, a "molding" process that

requires her "emblematic" transformation of the material "mass" into a resistance subject. I used the word *emblematic* in the double sense of a symbolic transformation of both herself and the dialectic between the individual and the mass, as outlined in Jeffrey Schnapp's observation of the "emblematic crowd."[37] In Schnapp's breathtaking tracing of the political–historical perceptions of the crowd and their inscriptions in graphic and photographic arts, he detects the persistent interpenetration between the oceanic and the emblematic crowd in modern political art beginning with the Renaissance. The "oceanic" refers to the undifferentiated mass, whereas the "emblematic" captures the crowd as sharing a metonymic contiguity with the superindividual emerging from it. In other words, even though Fang Yin abnegates her individual self to immerse herself in the mass, her new individual gives a face and a name to the amorphous and anonymous crowd and demonstrates the very operative mechanism she undergoes in the making of a resistance subject. This operation involves the most extravagant fire scenes in the film. As discussed earlier, the documentary sequence demonstrating Japanese destruction of the city of Chongqing by incendiary bombs includes a spectatorial transformation that catalyzes the historical sedimentation of a long-standing aesthetics of fire. Sitting on the cliff and watching the devouring fire across the Yangtze River, Fang Yin does not enjoy the same emotional, experiential, and identity distance as the wealthy families on the balcony in the Tian Han play, or a "cushioned shock" that guarantees her indifferent gratification of the senses. Her personal tie with the munitions neighborhood (her romance, her camaraderie with the workers, and her maternal love for a five-year-old girl brought up by the workers) injects her spectatorial experience with a high affective dose. Her gender matters less to her as a woman than as an emblematic corporealization of sentimentality.

Third, the resistance subject not only is authorized as emblematic of the crowd and authenticated as a sentimental subject but also becomes authorized when she conducts the chemical transformation from sentiment to action. In this sense, she is barely a contemplative subject enjoying a safe distance from the object of aesthetics.[38] If the first fire scene melds her with the collective, this scene tests the mobility of the masses—the goal of mobilization. The new age of art, characterized by its propagandistic or mobilizing power, is

contemplated in a provocative essay by Gao Changhong entitled "Yishu xingdong" ("Artistic Action"):

> Art is usually considered a conceptual form or expression of ideas but rarely seen as action. . . . To understand art correctly, one must approach it from the perspective of the study of action [*xingdongxue*]. Art, like any other action, has its behavioral basis. It is based on behavior because art is the *biaochu* (bringing to surface and exterior, representation/ externalization/articulation) of reflex. The exterior form of reflex is muscular movement [*dongzuo*], which then develops into voice and language. . . . Song is the articulation [*biaochu*] of voice, and poetry the articulation [*biaochu*] of language; both developed earliest in art. When music develops from vocal music to instrumental music, the latter continues to be conditioned by movement. Painting and sculpture are both based on the movement of hands. Architecture demands not only hand but also full-body movement. Fiction was originally articulated [*biaochu*] by movement and language; later, it developed into a recording system and uses language solely to represent [*biaochu*] behavior and action. Drama performance is a comprehensive art. Its script, like fiction, is a record. Its performance, like dance, is full-body movement. Its dialogue, like poetry and primitive fiction, is represented [*biaochu*] by language. The stage set, like architecture and painting, is plastic art [*zaoxing yishu*]. Any drama performance successfully synthesizing the above arts is like a mobile, collective sculpture. . . . Is the newly flourishing art, film, an exception? No. Film is mechanized drama performance. They differ in that film is divided into two stages, that is, the movement of the machine represents [*biaochu*] the movement of the human body. This can be understood by a comparison with music similarly divided into the two stages of composition and performance.[39]

In this highly behaviorist genealogy, beginning with music and poetry and ending with film, Gao establishes the physiological basis of all art as reflexes manifested in exterior forms of "muscular

movement." Art is hence representation (*biaochu*) of such movements in a direct or mediated manner. A key term in this passage is *biaochu*, literally meaning "bringing to the surface and exterior." It expresses externalizing, articulating, manifesting, or as I have translated it to incorporate its various uses as a verb and a noun, "representing." Curiously, while fiction and play scripts are considered recording devices of physical movement, film is seen not as a recording system but as a "mechanized movement." Endowed with physiological connotations, its movement supersedes and fulfills the potential of the human body. Through a comparison with music, Gao designates a radical position for film not as a secondary recording device striving to capture a prior physical movement but as the agency of performance. This counterintuitive inversion between the performer and cinematic technology bypasses a teleology of decline despite Gao's emphasis on the physiological. This places film technology at the very continuum of various arts as manifestations of bodily reflexes and muscular movement.

After laying this behaviorist foundation, Gao is quick to point out that although "any art is grounded in behavior, manifested [*biaochu*] in muscular movement, and then again represented in movement and gesture," this groundwork establishes art only as behavior, not as action.[40] To qualify art as action, Gao lists three conditions. First, art is collective. Any individual movement remains as behavior; only collective acts become action. The majority of art (music, drama performance, dance, singing, film, architecture), except for a few cases (solo performance, poetry, fiction, painting), is collective. Even sculpture, painting, and fiction and playwriting are sometimes collectively carried out. Second, art *represents* everyday action. Individual everyday manifestations (*biaochu*)—crying, for instance—remain as behavior, yet once they are onstage, they become actions and therefore art. Third, art can evoke similar action. Every action is simultaneously a reaction and a stimulus: "Artistic action differs from other action because as reaction it resembles its stimulus, and as stimulus it can evoke the same reaction." Art as action can absorb any general action and reproduce it.

Having established art as action, Gao delineates the "movement principle" of artistic action in three stages: action-art-action (*xingdong-yishu-xingdong*). The first stage is from action to art. Here,

"action" refers to general action and provides the widest sense of experience for the artists to absorb and represent in their art. Second is from art to art. This describes the reaction of those who appreciate art and receive the stimuli of art. For Gao these reactions, ranging from art criticism to average audience responses, remain in the realm of art. Therefore, criticism itself is creation, whereas the audience shedding tears responding to the stage stimuli is "only *artistic* crying, not *actual* crying." The third stage is from art to action. The theater audience, for example, after being moved by a play and leaving the theater, inadvertently reproduces the action onstage in their everyday life: "The action here is not the same as the artistic action but the same as the actual action represented in artistic action."[41] Only after these three stages is the promise of art fulfilled. Gao calls the first stage creation, the second appreciation and criticism, and the third the impact and pragmatic use (*shiyong*) of art. Each stage, as Gao points out, involves action, yet these actions are not equal but a process in development. Through the three stages art is not only fulfilled but also developed. The history of art itself follows the same trajectory by fulfilling and developing itself in countless historical movements from action to art to action, up through modern art.

This trajectory closely connects artistic movement and artistic action; art and the world; and art, artist, and audience. More important, it makes one giant step beyond the ideal spectatorial experience as projected by the Huaju writer in "The Resonance of the Audience," discussed in chapters 1 and 2. Although maximum audience affect is aimed at by a variety of popular and modernist art—including illustrated lithographic journals, civilized plays, spoken drama, fiery films, and left-wing films—for Gao the audience's reaction in the theater, be it tears or motor responses (vocal, muscular, and so on, including collective singing, applauding, and gesturing), remains in the realm of art. What matters for Gao is that art will not be fulfilled until its impact is carried outside the theater into everyday action. His distinction between "artistic action" and "actual everyday action" is significant not only in terms of production but also, more important, in terms of reception. This model, exceeding the boundary of consumption where artistic affect is to be exhausted within the realm of entertainment, bears particularly urgent significance in the context of war and the demand for resistance aesthetics.

Gao's avant-garde gesture emphasizing art as action is closely related to his enduring interest in behaviorism and continues his earlier practices as the founding member of the Sturm und Drang Society (Kuangbiao she), established in 1924 with a group of authors from Shanxi, in the northwest of China. Gao and his comrades were particularly enthusiastic about advocating science and expressionism and active in literary practices of poetry, art, and spoken drama, drawing on a medley of Western sources of inspiration.[42] Calling himself a behaviorist and economist, Gao introduced some behaviorist works as early as 1926 and 1927. His stated interest in economics was rather an index of his avid investment in Marxism. Gao went to Japan in 1929. Staying in Germany for two years during the rise of fascism, Gao developed increasing concern about fascism, but his writings on the topic were rejected by various publishers. Gao's concern about fascism and his continued interest in behaviorism nevertheless made their way into his writings in the Chongqing period, published mainly as newspaper articles. For Gao the zeitgeist of resistance demanded that art express both the will of the writer and that of the people. Since the people's will was being articulated in the War of Resistance, art should represent their struggle. For Gao the war was a "political action," and because artistic action covered both the artwork and the people's actions beyond the realm of art, art and war became isomorphic.

Gao Changhong's argument was not an isolated case. The call for art as a weapon resonated in numerous wartime literary and dramatic works. The urgency of functionalizing art for immediate mass action radicalized the notion of art while it was incorporated into wartime mobilization. The *Mulan Joins the Army* incident with which I begin this book is an illustrative case of artistic action. When the dramatist Hong Shen and his fellow film and drama workers stopped the film screening and went onstage, they turned the stage into a live-action play and stimulated the audience to carry the protest onstage out to the street. Although Gao Changhong's theory of action moved beyond Hong Shen's behaviorist theory of acting in the 1920s by turning artistic action into a theory of active spectatorship, of *agitation*, interestingly, it was Hong Shen and his fellow film and drama workers who carried out this theory, turning an artistic action onstage into an actual action on the street. In film productions,

significantly, the redefinition of art as war stimulated an aesthetics of action that evoked and negotiated with earlier practices in appealing to the mass audience. Further, this aesthetics, continuing and transforming a standing tradition, was shared by film productions across geopolitical divisions within China.

Beyond Chongqing: A Tale of Three Cities

Paradise on Orphan Island

As discussed, the mass burning of the *Mulan Joins the Army* film print in Chongqing has been cited as hinterland "mob violence" against Shanghai entertainment cinema, yet the incident also illuminates the constant transregional traffic across the geopolitical division. Until the end of 1941, before the Japanese takeover of Hong Kong and Shanghai, Chongqing enjoyed particularly intense interactions with these two cities in human and material traffic, which made a visible impact on film production and exhibition. On the production side, directors, actors, screenplay writers, and film technicians traveled back and forth between the three metropolises to seek temporary dwelling, material support, and realization of their political ambition while situations in these regions shifted within the eight years of war. On the exhibition scene film productions made in the three cities shared screening venues across the distinct political regimes while being subject to local and multiple censorships. This fluid boundary and overlapping film culture in cross-border film production and exhibition makes us rethink the historiographical tendency to reifiy the geopolitical borders by salvaging an exclusively local culture at the expense of its heterogeneity and transregionality.[43] Limited space does not allow me to give a full treatment of such transregional dynamics during the wartime. Instead, I examine two cases of film production in Hong Kong and Shanghai between 1938 and 1941 that particularly challenge the easy geopolitical division that subscribes to an equally problematic distinction between entertainment and propaganda cinema. The labels of *propaganda, education,* and *entertainment cinema,* as I show in chapter 5, are historical categories with particular ideological trappings, yet they also share considerable overlap in conception and practice. This chapter

explores their overlaps, with a particular attention to their aesthetic operations. Across the categorical distinctions, I call these films *agitational cinema,* which despite their distinct ideological and social orientations, equally reflect upon the experience of a new paradigm of war with a shared investment in perception and action. These films not only engage the geospatial dynamic in wartime China but also effect a temporal retrospection and negotiation of the history of spectatorial affect in Chinese cinema.

The first film, *Gudao tiantang* (*Paradise on Orphan Island*), was made in Hong Kong in 1939 by the company Dadi (Grandland), the Hong Kong branch of the Chongqing film studio Zhongzhi (Figure 6.6).[44] As a production reflecting upon wartime experiences in Shanghai, made in Hong Kong for a Chongqing-based film studio, the film links the three cities in ways that require our attention to cross the geopolitical divisions and challenge their underlying assumptions.

While it remains the convention to label films according to their site of production, wartime cross-border film exhibitions and productions complicate notions such as Hong Kong, Chongqing, and Shanghai cinema. In May 1939 the Chongqing studio Zhongzhi established a small branch in Hong Kong to take advantage of the city's relative stability and material access to film equipment and stocks while tapping into a broader network of Southeast Asian film production and exhibition. Led by Zhongzhi's vice president and sound engineer, Luo Jingyu, and joined by several actors and technicians from Chongqing, the company took the separate name Dadi yingye gongsi (Grandland Motion Picture Corporation) to seek legitimate operation under the British colonial government, which maintained a neutral position toward Japan. Dadi was a small operation that lasted for only a year, and not unlike the forty or so small commercial studios in Hong Kong, it relied on local film studios and artists for shooting space and film crews and, hence, was never an exclusively Chongqing operation.[45] Despite its connection with Zhongzhi, Dadi was, more aptly, a "diasporic venture," one that involved migrant filmmakers and local resources targeting transregional networks of circulation.[46] In addition to its small Zhongzhi crew (about eight people sent from Chongqing), who were active in prewar Shanghai—including noted cinematographer Wu Weiyun,

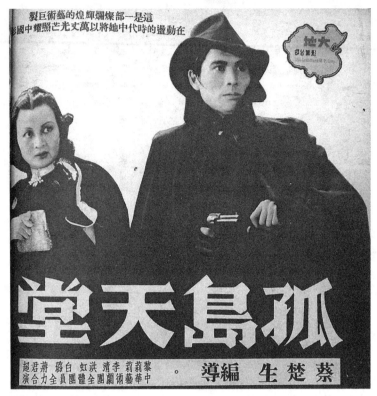

Figure 6.6. Publicity image for *Paradise on Orphan Island*. *Dadi huabao* 7 (July 1939).

film editor Qian Xiaozhang, actor Hong Hong, and Luo Jingyu's wife, Li Lili, the famous Shanghai film star—Dadi recruited a much larger number of local and migrant actors in Hong Kong, including the popular stars Lu Dun and Li Shuoshuo, the former Shanghai Lianhua Studio actors Li Qing, Bai Lu, and Jiang Junchao, and actors from the spoken drama society Zhonghua yishu jutuan.[47] Borrowing the studio space and facilities of Qiming, one of the big-four local studios, Dadi made only two films, *Paradise on Orphan Island* and *Baiyun guxiang* (*Fatherland Calls,* Situ Huming), yet both met with popular success in Hong Kong, Chongqing, and southwest China.[48] Once established in Hong Kong, Dadi had to struggle on its own, with minimal support from Chongqing. Despite its plans to make a

number of films by noted directors Fei Mu, Tan Youliu, and Ouyang Yuqian, Dadi had to fold its business due to financial difficulty and internal politics at the Chongqing front.[49]

Paradise on Orphan Island has luckily survived. The film took over three months to make and cost over HK$30,000, which almost broke the studio financially. Compared with the average time (seven to ten days) and cost of a film produced (HK$7,000 to HK$8,000) in Hong Kong at the time, *Paradise on Orphan Island* was a relatively lavish production, with better shooting and recording facilities and more care exercised in cinematography, lighting, acting, and film set (the film boasts a Bell & Howell sound film camera with five lenses, a sound recording device invented by Luo Jingyu, and a stage set created by the noted designer Ye Jian).[50] When it opened in Hong Kong and Chongqing, the film made an impressive box-office record of twelve consecutive days of initial screenings in Hong Kong, reaching an audience of fifty thousand, and of nineteen days in Chongqing, with a total of fifty-seven screenings that reached sixty thousand viewers. The film was screened subsequently in Southeast Asia and other parts of the hinterland.[51]

The film, set in Orphan Island Shanghai, depicts the oppression of everyday living under Japanese occupation. A group of mysterious youths form an assassination team to annihilate Japanese collaborators who subject the city to constant surveillance and terror. Assisted by a dance hall lady (Li Lili) exiled from Manchuria, they succeed in wiping out the collaborators and join the peasant guerrillas in the end.

Directed by veteran left-wing filmmaker Cai Chusheng, who grew up in Canton and made his name in Shanghai and had migrated to Hong Kong, *Paradise on Orphan Island* recycles several major themes from his earlier films and deploys popular genres that might have contributed to its appeal. The film is clearly set in Shanghai, but the location is referred to only obliquely in the opening caption as "a certain orphan island" right after Yuan Shikai's usurpation of the republic in 1915. According to the same caption, Yuan's warlord followers organized the Skeleton Gang (Kuloudang) on the island, and the film supposedly depicts the Skeleton Gang's oppression and the "ordinary masses' tendency to revolution."

This disclaimer, ostensibly intended to prevent censorship of

the film because of its anti-Japanese narrative, in effect allegorizes Shanghai's wartime situation and associates the film with the adventure thriller popular in the 1910s and early 1920s. The name Skeleton Gang evokes a cinematic memory of one of the earliest feature-length Chinese narrative films, *Hongfen kulou* (*Red Beauty Skeleton*, 1921), an adventure thriller partly modeled after the widely popular French serial adventure *Les vampires* (Louis Feuillade, 1915). The phrase may also refer to *Kuloudao* (*Skeleton Island*), a feature made in 1929 by the small Shanghai studio Huangpu during the high tide of martial arts and action-thriller films, when Cai Chusheng was apprenticing in martial arts filmmaking in various smaller studios.[52] The black cloak that the male protagonist (Li Qing) wears appears frequently in 1910s French and American adventure serials as well as in the early and mid-1920s Hollywood male adventure films, which make a visible presence in Chinese productions, and is worn by characters such as the Robin Hood figure played by Jin Yan in *Yijian mei* (*A Spray of Plum Blossoms*, 1931). The black cloak is also associated with horror, such as the 1927 *Phantom of the Opera* and its 1937 Chinese remake *Midnight Singing*, in which the male protagonist, Jin Shan, wears the same black cloak.

The allegorical allusion to Shanghai immediately changes to more direct references. The first scene shows the male (in the black cloak) and female protagonists standing against the background of an iconic photographic representation of Shanghai's bund. The two characters sing the theme song: "Orphan Island! Is this heaven or hell! This sprawling foreign market is surrounded by giant waves of evil and danger. The five million people on the island, are they sad or happy?" The clear references to Shanghai—including the city's staple "sprawling foreign market" (*shili yangchang*), its wartime nickname of Orphan Island, and its population of five million—make the opening disclaimer an empty gesture. Later in the film, the name Shanghai is employed several times. As the song continues, the background changes to a rectangular paperboard lined with barbed wire that frames passing images of Shanghai while male and female protagonists stand at the edge, watching the moving images (Figure 6.7). In a gesture reminiscent of the peep show opening in *Scenes of City Life* (1935) and the car window screen in Cai's own film *The New Woman* (1934), the paperboard turns the image into a movie screen

while the images change from still pictures to an assortment of mov-
ing images. Curiously, these images include both documentary shots
of Shanghai and wartime films made in Hong Kong, *Youji jinxingqu*
(*Guerrilla Marches*, 1938), and Chongqing, *Defending Our Hometown*
(1939), in addition to the film's self-citation of its own later scenes.
This choice is obviously a compromise due to the impossibility of
shooting on location in Shanghai and the limited access to avail-
able film prints.[53] Yet the result of this mini–compilation film is an
imaginary city that merges the three particular cities into the same
space of experience. This allegorical introduction makes *Paradise on
Orphan Island* a film about the three cities, compiling images from
prewar and wartime Shanghai, Hong Kong, and Chongqing.

While the film draws from earlier adventure genres' appeal to a
popular audience, it wrestles with the crisis of perception and the po-
litical stakes of action in a pivotal historical time. This is best shown
in the scene of an elaborate New Year's Eve party at the Paradise Ball-
room (Tiantang huayuan wuting), where Li Lili has tricked the head
collaborator into bringing his entire staff to the party. The ballroom
scene starts with a montage sequence of the New Year's Eve cele-
bration, with dancing couples in New Year's hats tangled in festive
paper streamers, diagonally positioned musicians playing trumpets
and violins, and foaming beer overflowing from glass mugs. In a flash
the oceanic immersion and surface intoxication in this scene are
superimposed with an enlarged, single female eye (judging from the
painted and plucked eyebrow), with a male violinist in the upper-left
corner (Figure 6.8). As the eye blinks, the image quickly dissolves
to another continuous montage sequence of dancing couples, hard
drinking, and heavy eating while the festive confusion of senses is
accentuated by a Hawaiian dance performance superimposed with
an applauding audience. The enlarged single eye figures as auteurist
self-reference, an extratextual address to the audience, and an im-
perative for clairvoyance to penetrate the shifting, intoxicating sur-
face. It places a stamp of perception upon the floating surface and the
confused senses and provides a counterpart to the surveilling gaze
of occupation. Within the diegesis, that eye is embodied by Li Lili,
as the single eye cuts to her dancing with guests and her appearance
is often superimposed with musicians: a violin playing, a piano with
hands. Li's single eye and its association with the musicians at work

Figure 6.7. Barbed wire frames the cinematic image of Shanghai. *Paradise on Orphan Island* (1939).

provide a narrative hint of her underground coordination with her partners.[54] At the same time, the emphatic gesture of the eye and its direct link to musical orchestration binds perception with action.

At the dinner table every guest receives a New Year's gift, and the men are surprised to find that they each receive a toy dog. The legibility of the sign is further articulated when one of the collaborators points at the guests and repeats the sentence that cheers up those who feel a bit offended by their gift: "I am a dog too! Aren't *you* a dog? Aren't *you* a dog? Aren't *you* a dog? We are all dogs!" One of the dancing partners shows her gift to others and asks naively why a theater prop, a puppet (*kuilei*) dressed in the traditional costume of an official, is the New Year's gift. The word "puppet" makes her partner unhappy; he throws it to the floor and yells, "I don't care whether it's a puppet or not!" The man's reaction is not surprising, as the term "puppet" appeared frequently in newspapers in reference to the collaborators and Wang Jingwei's "puppet government." His identity as a collaborator is once again confirmed when the head of the collaborators assures Li Lili that all his subordinates have arrived at the party, as he promised her they would.

Figure 6.8. New Year's Eve party superimposed with an enlarged, single female eye, with a male violinist in the upper-left corner. *Paradise on Orphan Island* (1939).

In a moment a group of handsome young men make a flamboyant entrance into the ball, wearing Zorro-like eye masks, flashy tuxedoes, and bow ties (Figure 6.9). One of them showers wine on the drunken musician and takes over his drums (Figure 6.10a). The party celebration alternates with close-ups of guns being hidden in flower bouquets, handkerchiefs, and paper streamers. As the eye-masked Li Qing breaks a balloon with his cigarette, the assassinations begin (6.10b). In this excessively rowdy party scene, percussion coordinates with gunshots, gunshots conflate with balloon explosions, laughs mingle with screams, and collaborators fall like drunkards. The dancers throw balloons and step onto the fallen balloons, until a woman takes her hand from her partner's back and, to her horror, sees blood. Her bloodstained hand, stretched in expressionist extremity, is foregrounded at the center of the frame, with the dancers screaming in the background (Figure 6.11a). Notably, this choreography of the hand is strikingly similar to the iconic representation in the 1917 *Shenbao* newspaper advertisement for *The Clutching Hand* (or *The Exploits of Elaine,* 1914), a Pearl White serial adventure shown in Shanghai in 1917 (Figure 6.11b). Amid continuous confusion between sensuous

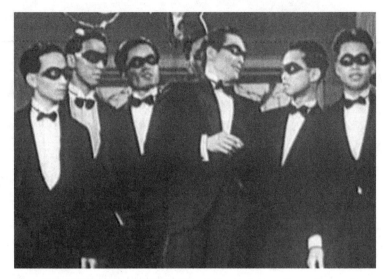

Figure 6.9. Grand entrance at the New Year's Eve party: guerrilla youths wearing Zorro-like eye masks. *Paradise on Orphan Island* (1939).

indulgence and assassination, the outstretched hand overwrites the scene, aligning horror aesthetics with the legibility of criminality, evoking memories of victimhood while making a gesture of accusation and an icon of revenge. The head of the puppet on the floor is smashed and stepped on. Other guests flee; the assassins confront the collaborators face-to-face; and the scene turns into an engaged fistfight, with forceful fists thrown toward the screen.

In this climactic scene Cai Chusheng turns his favorite set into an intensive negotiation of sensation, perception, and action. The dance hall, as the epitome of the phantasmagoric confusion of senses characterizing modern consumer culture, is infiltrated by an action-thriller mode of sensorial assault carrying highly legible imprints. The similarity between these two types of sensorial engagement—the phantasmagoric sensorial immersion/intoxication and the guerrilla-type avant-gardist attack on the senses—is highlighted and mimicked by cinematic fast cutting alternating between the two realms. Both operate on the involuntary response of the body, or bodily reflex, which is largely dictated by musical rhythm.

The musician as the mastermind of phantasmagoria dictating

Figure 6.10a. Male protagonist (Li Qing). *Paradise on Orphan Island* (1939).

Figure 6.10b. Surrogate musician orchestrating the assassination at the New Year's Eve party. *Paradise on Orphan Island* (1939).

Figure 6.11a. Bloodstained hand at the New Year's Eve party. *Paradise on Orphan Island* (1939).

Figure 6.11b. Newspaper ad for American serial queen thriller *The Clutching Hand* (1914). *Shenbao*, June 26, 1917.

automatic body reflexes is underscored by the montage sequences superimposed and punctuated by close-ups of the musicians playing their instruments. Later in the ball, the musician—significantly, the percussionist—is allegorically taken over by another mastermind of action. An eye-masked youth usurps the drummer; his presence in and absence from the band serve as bookends for the whole gunfire

sequence. Although it is Li Qing who provides the final signal for the actual shooting by exploding the balloon, the action (signaled by Li Lili's change of expression and the gun preparation) starts once the surrogate drummer is in place. His drumming orchestrates and overlays the shooting. As the action continues, the three-way crosscutting between the drummer, the armed assassins, and the falling collaborators accelerates into a two-way parallel cut between the drummer and the fallen enemy. After the woman's bloodstained hand attracts a large crowd, the surrogate drummer leaves the band, and the real percussionist sobers up and resumes his position. Simultaneously, the assassination team ends their masquerade and confronts their enemy with fists.

The similarities between the two types of sensorial engagement are what enable the assassination on the narrative level. The gunshots and the metallic percussion are equally stimulating and intoxicating in a spiral of aesthetics and anesthetics of shock and sensation that characterize the experience of commercial modernity.[55] Similarly, the fallen body is undifferentiated from the usual bodily coordination in rhythmic movement or the climactic kiss of danger—the tango, for instance—as part of the *fort-da* game of fall and rescue.[56] Nevertheless, their similarities are the beginning, not ending, points in a process of deconstruction and renegotiation. The allegorical usurpation of the musician portrays a desire to rewrite the operation of sensation from passive immersion to active participation. The latter becomes a critique of the former, albeit executed in violence. The modern consumer's radical renunciation of subjectivity in exchange for intersubjective sensorial intoxication is not shown as leading to the threshold of illumination or intervention in the experience of modernity. Rather, the consumers are depicted as collaborating with the oppressors, submitting to the orchestration by the mastermind musician. The film thus launches a charged critique equating consumptive and colonial modernity, made more poignant at the moment of war.

The film's critique of consumptive sensorial indulgence is accompanied by a desire for transparency, consequently resolving the crisis of perception through action. The enlarged eye overrides the multifarious images of the dance hall and coordinates with the assassination taking place—Li Lili is seen as distracting the collaborators

while watching the action with expressive eyes. She is both a witness to and culprit of the action. Her enlarged eye is echoed by the eye masks of the assassins, whose action is synchronized with their seeing. Their privileged access to political perception and action is further underlined by their love of identification: the identity gifts, the smashing of the puppet, and the bloodstained hand. Their obsession with legibility and identity spells out the very problematic of such identification, just as their vision could have been prescribed or imposed as the enlarged single eye—their only knowledge of their targets came from a collection of collaborator photographs.

Terror, as Sloterdijk observes, is not an "isolated, one-sided attack" but a "fighting method that immediately spreads to both sides of the conflict."[57] In a way, the resistance assassins are angry youths who have grown up in the commercial culture, executing a critique of the obfuscating surface culture in vengeful violence. The only crisis for this politicized action and perception is probably its proximity to violence, making it difficult to separate heroes from foes, joy from terror, frenzy from vengeance. The physical fight romanticizes close combat but registers its displacement by a different war when the enemy is far more removed and illusive in an expanded war zone like the intoxicating air at the party. Since the hero fights against a more anonymous yet pervasive enemy, as well as against himself, the hero's cause is harder to explicate. This is evident in an awkward love scene in which a depressed and uncharacteristically overacting Li Lili (she was pregnant during the film shooting) carries on a strained conversation with a restrained Li Qing. Their frustrated love ends with Li Lili's doubt about Li Qing's emotions while Li Qing struggles to reaffirm his "humanity" despite his image as an "iron man." In a different context, Gao Changhong, when asked to deliver a lecture to students at the Lu Xun Art Institute in Yan'an shortly after his arrival in 1941, ended his speech after two sentences: "Art is insurrection. Art is uprising." He was immediately mocked with the nickname "Gao Uprising" (Gao Qiyi).[58]

The film's interest in rewriting sensation and binding perception with action is not simply illustrated metadiegetically within the film text but also exercised in cinematic evocation of an intermedial spectatorship built on the interplay between media and extratextual knowledge. This is accentuated most clearly in the film's use of

photography. The photograph is another one of Cai Chusheng's fa-
vorite themes, as can be seen in earlier films such as *The New Woman*
and *Dawn over the Metropolis*. The most interesting use in *Paradise
on Orphan Island* occurs in an early scene of the dance hall when
a dance hostess, offended by the head collaborator, her suitor, who
abandons her for Li Lili, goes to the dressing room. After complain-
ing about her lost paramour, she shows off a photograph he gave her.
When her fellow workers laugh at the inscription, the hostess be-
comes embarrassed and angry. She tears the photograph into pieces
and flushes it down the toilet. This use of the photograph confuses its
materiality with its iconic representation. The scene recalls *The New
Woman*, in which Wei Ming's daughter tears up her parents' wedding
photograph, which contains an image of her unfaithful father. Yet in
Paradise on Orphan Island, both the photograph and the act of tear-
ing bear an extratextual reference: the power of the scene depends
not so much on the narrative within the film—in which the hostess
is not a sympathetic object—but on the shared knowledge, contem-
poraneity, and sentiment among the audience. Hence, the aggressive
act toward the photograph is a celebratory moment of spectatorial
collective bonding.[59]

Another instance of intermedial spectatorship creating shared
spectatorial perception and legibility involves the creative deploy-
ment of disability. The film presents a mute character, Huang Wuyan
(Li Jingbo), whose presence mobilizes the widest range of modes
of communication. By suppressing speech and "disabling" sound
cinema, the mute mobilizes every possible means of heightened ex-
pressivity: found objects, pantomime, scripts, silent cries, and noises
that point to the inadequacy of language in articulating the capital
injustice and atrocity he has experienced. Like the sound picture in
the 1930s, Li's acting initiates the full range of silent-film aesthetics
and accentuates the cross-medial interplay with expressive cam-
era work. As he takes out a piece of newspaper and finds characters
that address his need, making subjective choices of material from a
larger context—choosing the characters for *family* and *freedom* from
advertisements for commercial products and the ones for *revenge,* in
boldface, from a crime story—the camera cuts to a close-up of the
characters to accentuate his choice. A montage narrative of memory
and desire is created in this interaction between the camera, objects,

and acting. As a melodramatic device the mute has always been an embodiment of moral power and heightened legibility by delaying speech for other means of expressivity.[60] Michel Chion points out the significance of the mute in sound cinema. As the double of the *acousmêtre*—the disembodied voice carrying the horrific power of surveillance—the voiceless body is either angelic or diabolic in its ubiquity through seeing all.[61] In the film the mute does function as the witness of the events within the narrative as well as within the larger history. What remains distinct about *Paradise on Orphan Island* is its utilization of silent-film aesthetics at the historical juncture when the transition to sound was still in the very recent past, hence evoking wider accessibility across different linguistic regions.[62] Further, the mute's pantomime depends not merely on a self-sufficient clarity of significance but on shared historical memory and experience. His gesturing and sound mimicking of an airplane and its bombing triggers, for instance, the haunting trauma of the audience, who were the constant witnesses and victims of the war's capital atrocity.

Cai's films were not an isolated case in Hong Kong. Resistance films were made not only by the Chongqing-affiliated studios, and the symbiosis between commercial and political propaganda was particularly visible. The film publicity for *Paradise on Orphan Island* took full advantage of the culture of consumption, binding political propaganda with commercial publicity. *Paradise on Orphan Island* opened in Hong Kong on September 19, 1939, at the prestigious Queen's Theater. The event was hosted by the noted writer Xu Dishan and sponsored by Bell & Howell, Kodak, and the Shanghai herbal medicine company Xinya, which distributed souvenirs at the film screening, including a prized 8 mm Filmo movie camera.[63] Beyond Dadi Studio, starting in 1937, a considerable number of national defense films were made and exhibited in Hong Kong, and they achieved box-office success despite some theater managers' misgivings.[64] In 1938, the same year the docudrama *Eight Hundred Heroes* was made in Wuhan by the Chinese Film Studio, Hong Kong made its own version under the same title (directed by Lu Si). The Hong Kong version was shown four months before the Wuhan production was screened in Hong Kong. Although the film is no longer extant, newspaper publicity indicates that it was more narrative driven than its mainland counterpart, mixing romance, comedy, and even

Cantonese theme songs in order to appeal to the largest-possible audience. Film reviews criticized some of these elements, which ended up compromising the message to its target audience. Yet the publicity highlighted not the romance but the sensational thrills, heroism, and use of documentary footage. The ads used large type to underscore "real Shanghai scenery," that "the real eight hundred heroes appear on screen," and the "human flesh bomb" (*renrou zhadan*)—a soldier wrapping himself with explosives, jumping from a skyscraper, and killing more than thirty enemies.[65] Another resistance film released in April 1938, *Xuejian Baoshan cheng* (*Bloodstained Baoshan City*, Situ Huimin), was praised for its "rough sketches," "aroma of dynamite and blood," and the absence of "thighs, farce, and soft romance."[66] In the same year, Tang Xiaodan made *Shanghai huoxian hou* (*Shanghai at the Battlefront*). Similar to the Hong Kong publicity for Sun Yu's *Baptism by Fire*, the film was foregrounded for its Shanghai fire scene, although it was described as "interwoven with the fire of love." Veteran director Hou Yao made *Xuerou changcheng* (*The Great Wall of Blood and Flesh*), which was promoted as having captured Guangzhou under bombing and on fire, as well as the soldiers' struggles to dig the bodies of the dead out of the rubble. In 1941 a Hong Kong production of *Gudao qingxia* (*Romantic Heroes on the Orphan Island*, Mo Kuangshi, 1941) made by the film studio Huasheng starring the Cantonese male star Xue Juexian seemed to recapitulate plotlines similar to those of *Paradise on Orphan Island* (Figure 6.12).

These films, except for the newly discovered Hou Yao's films, are no longer extant, so it is difficult to judge how they might have approached the war differently from those of left-wing filmmakers such as Cai Chusheng.[67] Newspaper and journal publicity (these films occupied much larger and more prominent spaces than other films, including Hollywood productions) testify, however, to a shared interest in the aesthetics of astonishment, documentary realism, and an appeal to sensation that centered on affect at the height of war. Different agents and interest groups, including the filmmakers, exhibitors and distributors, and the advertising industry took advantage of the multiple and conflicting appeals of sensation while repacking and recycling attractions from familiar genres into wartime films. Not unlike *Baptism by Fire,* these films embraced rather than evaded the radical transformation of perception imposed by the war.

Figure 6.12. Publicity image for the Hong Kong national defense film *Romantic Heroes on the Orphan Island* (1941).

Princess Iron Fan

On the actual Orphan Island of Shanghai, film production was constrained doubly by the censorship of the Japanese and international settlement authorities yet demonstrated an engagement with the immediate experience of war equal to filmmaking in Chongqing and Hong Kong. This engagement was not lessened by the fact that most of the productions had chosen to address war through traditional costume dramas. Produced in enclosed sound studios and tuned in to dialogue, historical allusion, and narrative allegory, these films engaged the audience through a knowledge of historical events, dramatic conventions, and shared contemporary concerns. An animated feature made in 1941 addressed the war more directly, however. It shares so much of interest with the Chongqing and Hong Kong films discussed earlier that it merits a closer examination.

Princess Iron Fan was the first feature-length animation produced in China and achieved tremendous popularity in Shanghai and beyond (Figure 6.13). Inspired by the success of Disney's *Snow White and the Seven Dwarfs* (1937) and created by China's animation pioneers the Wan Brothers, the film took a year and a half to finish and involved more than two hundred animators and staff. The film was produced in the same year as *Baptism by Fire* and was equally invested with a central attraction to fire.

The Wan Brothers—Wan Laiming, Wan Guchan, Wan Chaochen, and Wan Dihuan—started experimenting with animation in the 1920s when they were hired as book illustrators and stage-set designers for the Commercial Press and its affiliated film studio, the National Light Studio (Guoguang).[68] After Guoguang was closed, they joined the Great Wall Studio (Changcheng), where they made their first animation in 1926, *Danao huashi* (*Uproar in the Studio*).[69] Between 1926 and 1935 they made more than twenty animation shorts (just under one thousand feet in length for each film) for Da Zhonghua, Lianhua, and Mingxing Studios, including two sound animations.[70] Most of these shorts had plots, and a series of productions combined live action with animation, delivering a consistent group of characters, including an artist and his cartoon friends (an ink monkey, a frog, a hippopotamus, a giraffe, a mouse, and so on), with actors interacting with animated characters.[71]

Figure 6.13. Publicity image for *Princess Iron Fan* (1941). Press kit. Private collection.

The Wan Brothers were closely connected to the wartime hinterland, as they migrated to Wuhan and Chongqing at the outbreak of war in 1937. They made animation shorts for the Chinese Film Studio, including the seven-volume *Kangzhan geji* (*Resistance Songs*) and the five-volume *Kangzhan biaoyu katong* (*Resistance Slogan Cartoons*). Some of these shorts have survived. One short from *Resistance Songs* is titled *Manjianghong* (*Blood-Tainted River*), after the song lyric (*ci*) written by the famous Southern Song general Yue Fei on defending against the invasion of the Jurchen. It features Yue Fei fighting with his enemy, who in this iteration is a Japanese samurai wearing wooden clogs. The *Resistance Slogan Cartoons* are slides of striking expressionist images of soldiers, battlefields, and skeletons, embossed with slogans and accompanied by folk songs rewritten with resistance lyrics. *Resistance Songs* and *Resistance Slogan Cartoons* were usually shown as extras before feature films and occurred frequently in advertised film programs in Chongqing newspapers, a testament to their popularity. They were also shown separately, taken by traveling exhibition groups to more remote

places in the hinterland, and were much better received than feature films.

In the fall of 1939, the Wan Brothers returned to Shanghai to be reunited with their family after facing technological and financial constraints in Chongqing. Upon the invitation of Zhang Shankun, the wartime film tycoon in Shanghai, the Wan Brothers joined Zhang's Xinhua Studio, now registered as an American company called United China Movies (Zhongguo lianhe yingye gongsi), to establish an animation branch. They soon started producing *Princess Iron Fan,* led by the elder twin brothers, Wan Laiming and Wan Guchan. The film took sixteen months to prepare and shoot, with the effort of over seventy animation apprentices, and gained great popularity when it was first released in 1941.[72] It played for forty-five consecutive days in three Shanghai theaters and was exported to Singapore, Indonesia, and Japan.[73]

The film is based on an episode from the famous traditional vernacular novel *Journey to the West,* about Sun Wukong, the Monkey King who escorts his master, Tripitaka Tang, and two other disciples on a pilgrimage to India, facing repeated traps by demons and spirits. In the episode the film reproduces, inclusive of chapters 59 to 61 from the novel, the Monkey King and his master are blocked by the Mountain of Flames, and Sun Wukong tries three times to borrow the magical palm-leaf fan from Princess Iron Fan so as to quench the fire. The film makes a rather faithful adaptation of the story, albeit with two revisions of the narrative, on which I comment later.

Similar to *Paradise on Orphan Island,* the film starts with a disclaimer:

> *The Journey to the West* was originally an unsurpassable
> fairy tale. Yet because of frequent misunderstandings, it was
> considered a god-spirit novel. Our film, based on this novel,
> is actually made to cultivate children's psychology. Hence the
> content does not deal with god-spirits. We only recount the
> story of Tripitaka Tang and his three disciples at the Mountain of Flames to demonstrate the ordeals in one's life journey.

This opening statement curiously reinterprets the novel as a fairy tale (*tonghua*) instead of its usual association as a god-spirit novel

(*shenguai xiaoshuo*). This conscious distancing from the god-spirit genre dissociates the film from a suspicious sibling: the martial arts god-spirit films.

As discussed in chapters 1 and 2, martial arts films were widely popular between 1927 and 1931, but this popularity died down after the rise of studio syndication, anti-Japanese sentiment, and GMD censorship. The god-spirit element endowed the martial arts genre not only with physical prowess but also with magic, executed by cinematic techniques that often involved the use of animation to create effects like flying arrows, swords fighting in the air, and bodily metamorphosis.[74] Owing to animation's affinity with martial arts god-spirit films, the Wan Brothers were no strangers to this genre. As set designers for Mingxing Studio between 1927 and 1931, they participated frequently in the making of martial arts films with magical effects, including the legendary *Burning of the Red Lotus Temple*. An extended animation sequence occurs in the seventh sequel of the film serial. *Princess Iron Fan* also had a martial arts predecessor under the same title, made by the Tianyi Film Studio in 1927 and starring Hu Die, later a movie queen.

Although the Wan Brothers distanced their fairy-tale interpretation of *Journey to the West* from the god-spirit renditions, the two genres were often mentioned together in the heyday of god-spirit films in the 1920s. Critics found examples of the god-spirit genre from the West in animated cartoons, adventure films (*The Thief of Bagdad, Peter Pan*), and fairy tales.[75] When new, that film genre was received with enthusiasm as promising a refreshing art form with "new things, new ideals, and new activities beyond our imagination."[76] Filmmakers were urged to revisit the rich reserve of Chinese folklore, though "modernizing" it with scientific technology and minimizing its superstitious elements. For instance, film critics suggested applying cinematic techniques to represent the Monkey King as the embodiment of individual psyche: "Sun Wukong's shape and movement should be nothing but the fleeting psychological changes concretized to the audience."[77] Although its origin may have been equally archaic and "superstitious," the fairy tale was associated with the West and incorporated as part of children's literature in constituting the child as a separate social being.[78] Since god-spirit films were seen as the epitome of uniquely cinematic techniques, their

rendition of folklore was expected to be distinct from traditional theatrical adaptations.

The Wan Brothers' realignment of *Journey to the West* from god-spirit novel to fairy tale was, therefore, a continuous gesture of "modernizing" a suspicious tradition. This became more necessary after the actual god-spirit film practices flourished in an assortment of "deviations" capitalizing on violence, racy imagery, and superstition, which were, paradoxically, the very product of modern imagination and scientific technology. GMD censorship cracked down on the genre in the early 1930s as part of the Nationalist modernization project of the New Life Movement. Conveniently, this occurred at the time when god-spirit films had already run their course and larger companies such as Lianhua and Mingxing were in the process of syndication. Wiping out the smaller studios that thrived on god-spirit films became a politically and economically profitable choice. As a result of the campaign, martial arts god-spirit films carried a lasting stigma. They were also repeatedly invoked in later film discourses, including left-wing and resistance film discussions, as a rhetorical antithesis. The Wan Brothers followed a trajectory similar to that of many left-wing filmmakers—such as Cai Chusheng, Sun Yu, Cheng Bugao, and Shi Dongshan—who apprenticed in martial arts filmmaking in the 1920s and disavowed that association after they joined left-wing filmmakers in the 1930s. They infused enthusiasm into films by combining animation with children's education, scientific enlightenment, and the nationalistic agenda, making films such as *Tongbao suxing* (*Citizens, Wake up!*), *Hangkong jiuguo* (*Saved by Aviation*), *Dikang* (*Resistance*), *Guohuo nian* (*The Year of National Goods*), and *Xin Shenghuo yundong* (*New Life Movement*). As mentioned in chapter 4, they also joined the left-wing Diansheng Studio and participated in the making of *Scenes of City Life*.

In practice, though, *Princess Iron Fan* shows much affinity with the martial arts god-spirit films. Magic, violence, and risqué scenes all appear in the film's "fairy-tale" interpretation of the novel. In addition, Princess Iron Fan and her maid strongly resemble the figures of *nüxia* with their armor, swords, and physical prowess, which is not surprising considering that animation and martial arts god-spirit films overlap historically and conceptually. Just as the magical effects of god-spirit films were seen in the 1920s as the apex of film

technology and the embodiment of the cinematic, often aided by the use of animation, animation itself has been seen as a prototype of cinema and the pure embodiment of film technology. The affinity of animation with the martial arts god-spirit genre and technology played out, however, in an unusual historical context.

The return of martial arts films to wartime Shanghai was a complex phenomenon. Within the first year after the outbreak of the war, Mingxing reprinted and redistributed its (in)famous *The Burning of the Red Lotus Temple,* followed by a number of martial arts god-spirit films that resurfaced in Shanghai movie theaters. This was made possible in part by the loosening of GMD censorship after the government's westward migration. The decline of film production within the first year after the war, due to the destruction of studios, the migration of film workers, and unstable economic conditions, made the reexhibition of past favorites a pragmatic choice. Moreover, these films seemed relatively harmless to the censorship authorities in the foreign concession zone. Finally, martial arts films provided a popularly acceptable conduit for the intense and immediate experience of the war, a situation similar to the genre's flourishing during the aftermath of the Northern Expedition in the late 1920s. Between 1939 and 1941, a handful of martial arts films were made in Shanghai, including a remake of *The Burning of the Red Lotus Temple* into a sound film by Dahua Studio. Along with popular stage adaptations of martial arts films, the old films stayed active in the movie theater repertoire, often in second- and third-run theaters, which were more accessible to lower-class and semiliterate audiences. Just as the Wan Brothers' career spanned Shanghai martial arts god-spirit, left-wing, and Chongqing resistance cinema, *Princess Iron Fan* showed similarly varied interests, highlighting continuities in these three film categories across a historical spectrum of engaging affect and perception, which was needed more urgently in an unusual historical time.

The film's interest in perception was partly akin to the specific technology of animation. *Princess Iron Fan* was advertised as a "three-dimensional sound animation" (*yousheng liti katong*), which the Wan brothers achieved through a cel-animation process deploying a multiplane camera. Cel animation produced the illusion of motion by photographing individual frames of composite images created by drawings on transparent celluloids (cels) layered on top of

each other. The animation process was tedious and labor intensive. The Wan Brothers organized the large number of labor force including women, ranging from one hundred to three hundred staff per day depending on different reports, into a precision-driven assembly line.[79] To create the drawings, the animators were assigned to ten sections devoted to different steps of the production. Starting with background design and drawing, the production moved on to character design, creating sketches for major characters in various poses using live actors, for which three-dimensional figurines were created separately by a sculpture section, sometimes involving rotoscoping by tracing images shot first with actors in live-action and built sets.[80] The motion design section then sketched major character movement and calculated the exact time and number of images needed for specific motion, including lip movement. The animation section accordingly filled out the intermediary images between major-movement sketches, with each image numbered, followed by a section in charge of cleaning the rough sketches. The pencil sketches were then transferred onto transparent celluloid sheets first by ink outlining, which were then filled out with colors, done by two separate sections. Each step was taken with great care, enforced by a supervision section for accuracy, with suggested revisions to ensure perfect coordination of individual elements. The images were then ready for photographing.

From contemporary descriptions, the Wan Brothers used a multiplane camera set that seemed a variation on the models built in the United States between 1933 and 1937, more famously known through the Walt Disney Studio's design for shooting *Snow White*.[81] Wan's set consisted of a vertical stand about twenty feet tall that held four layers of drawings on transparent celluloid. Each layer allowed individual lighting and could be moved vertically and horizontally. The camera was mounted facing down on the top of the stand on a circular shaft so that it could rotate around.[82] The multiplane camera set overcame the flatness of animation drawings by creating individual layers of foreground, middle ground, and background to achieve a sense of perspectival depth. The adjustable layers and the rotation of the camera created the effects of camera tracking, panning, and zooming without distorting the perspective. To address the complex coordination of the camera, the individual level of the drawings, and the lighting, the machine required four to five people to manipulate

it at one time.[83] The intensity of the work involved in the production of *Princess Iron Fan* resulted in labor strife, causing delay due to animators' strikes demanding unpaid salary.[84]

The cel-animation process with the multiplane camera is thus not a single technology or apparatus, as Thomas LaMarre astutely points out, but a "machine ensemble" that gathers diverse technical devices and schema otherwise incompatible. Prior to the multiplane camera set, LaMarre argues, there is a more abstract machine, which he calls the "multiplanar animetic machine," an open structure that addresses the composite image formation (embodied by but beyond the multiplane camera set) and the creation of movement (animatic) by the mechanical succession of frames. This machine is both technical/material and abstract/immaterial, comprising human, virtual, and actual machines, and "unfolds in divergent series as it folds other machines into it."[85] I would argue that in the context of *Princess Iron Fan,* this machine folds in the perceptual habits and codes developed in martial arts, left-wing, and Chongqing resistance cinema while it unfolds, in diverse directions, their historical and ideological trappings. The multiplanar animetic machine is a "thinking technology," as LaMarre would put it, that thinks through animation's technological constraints and possibilities.[86] In *Princess Iron Fan,* such thinking closely concerns the crisis of perception and identity in the context of war, enacted in the vacillation between depth and surface, form and formlessness, figure and ground.

Assisted by the multiplane camera, *Princess Iron Fan* prides itself on the creation of perspectival depth and versatile camera movement. The opening of the film starts, for example, with an iris shot of a mountain with houses on the top. The camera tracks in to the picture, and then a dissolve shows the interior of a palace with a colossal column in the foreground. The camera tracks in again and passes the column toward an entrance at the far end of the interior, behind raised drapes. As the glass layer bearing the image of the interior entrance moves toward the camera to give the impression of the camera moving through the entrance to the inner layer of the palace, the interior is superimposed with the opening statement cited earlier. The image then dissolves again to track in to a close-up of a book on the table entitled *Sanzang zhenjing* (*The Tripitaka Scripture*). This opening sequence deploys various editing techniques (dissolve, iris

mask, superimposition, cut) and camera tracking to create the impression of continuous tracking in depth. This effect, enhanced by the column, the drapes, and the painted frame of the inner entrance, lays bare the multiple flat planes of images through which a depth of space is constructed.

The scopophilic pleasure and voyeuristic mode of knowledge enabled by these effects of tracking in depth is soon balanced with a different mode of perception, that of immersion. At the first impressive fire scene, Sun Wukong flies out the window of a local residence and tumbles in the air until he reaches the Mountain of Flames. The camera tracks through hardboard layers in the shape of a mountain cave, and the Monkey King is immediately besieged by fire. The fire first shows his demonic face in close-up, and then, the Monkey King is thrown backward into a sea of fire. He sweats in the enclosing flames, flies out, and finds temporary rest on a cloud. Just as he looks around, the fire god appears, attacks him from above and behind, shrouds him, hangs him upside down in the air, pounds him from both sides, and swallows him. No sooner does the Monkey King escape to rest behind a rock than the fire arrives. The two first play hide-and-seek, which accelerates into a circular chase, several ambushes, and attacks from all directions until the monkey flies away with a burned bottom and returns to the palace through the window.

In this fire scene the Monkey King departs from a perspectival window, yet once he enters the realm of fire, he is deprived of the privilege of a contemplative observer. The greatest challenge for him within the Mountain of Flames is to stay still and look ahead so as to maintain a total perspective. But fire attacks him from every direction, and his famous vision, which could penetrate the cloud and see across long distances—"fiery-eye golden pupil" (*huoyan jingjin*)—gives way to the most violent tactile encounter. This perceptual situation recalls what Merleau-Ponty suggests is the radical intersubjectivity between one and the world in his critique of the Cartesian objectifying gaze: "I am immersed in it. After all, the world is all around me, not in front of me."[87] Fire assumes, interestingly, both an anthropomorphic face and a faceless anonymity, and its power relies not only on its omnipresence and omnipotence but also on its ceaseless metamorphosis, which constantly challenges efforts to identify and locate it. This power is what defines animation, its plasticity.

The radical promise of animation for perception, as epitomized by fire, was articulated enthusiastically by Eisenstein at about the same time *Princess Iron Fan* was made and released. In Eisenstein's notes on Disney, written between 1940 and 1941, before his move to Alma-Ata, where the Mosfilm studio had been relocated during the war, he associates animation with fire by identifying "the attractiveness of fire first and foremost through its omnipotence in the realm of the creation of plastic shapes and forms."[88] For Eisenstein the genius of Disney products lie in their "plasmaticness," the figures' ability to stretch and shrink, to dynamically assume any form, to mock any attempts at ossification in endless changeability, mobility, and diversity. This "plasmatic" behavior, like a "primal protoplasm," helps regain a radical childhood, a historical prememory, a "sensuous thought" free of the shackles of logic and rationality, and for the American audience, an instantaneous, albeit symptomatic triumph over the fetters of the capitalist "big gray wolf"—the Fordist regulation of time and the chessboard organization of social life. The power of such plasmatic freedom as demonstrated in Disney animation is seen as similar to the magical effects of fire, as Eisenstein traces a long history of the human fascination with fire from Nero to Gorky. Yet for Eisenstein, Disney animation resembles fire not only because of its perpetual mutable form but also due to its ability to evoke a powerful affective response. That affect is comparable to pyromania, the passion for fire that causes arson. Nineteenth-century European psychologists considered pyromania a pathological regression caused by the semi-intoxicating effect of the movement and rhythm of fire—comparable to alcohol, dancing, and swinging. Eisenstein locates this pathological state, however, in a celebratory stage in the "immersion in sensuous thought" in childhood. This, too, he observes, is achieved by Disney animation.

In the fire sequence of *Princess Iron Fan,* the pervasive, unpredictable, and endless movement of fire, together with its appearance, becomes reflexive of cinema as a plasmatic medium. This reflexivity operates on the level of both the medium and the spectators' body while negotiating with a voyeuristic mode of perception.[89] Motivated by the narrative desire for Sun Wukong to "take a look" at the Mountain of Flames, this scopophilic mode of knowledge is frustrated once Sun Wukong enters the realm of fire. Just as the

multiplanar creation of depth corresponding to the tracking camera gives way to the plasmatic flatland of animation, the Monkey King's desire to gain a clear perspective of the Mountain of Flames surrenders to total immersion in semi-intoxicating sensuous thought. That immersion certainly has an aftereffect outside the realm. Even after the Monkey King returns to the safety zone behind the perspectival window, his behind is still on fire.

This elaborate fire scene, repeated with variations three times in the film, is recapitulated with similar effects in a sequence of wind, highlighting plastic form as alternative perception. The Monkey King's first attempt to borrow the fire-quenching palm-leaf fan ends in miserable failure after he engages in banter and a sword fight with the princess. The princess waves her magical fan to blow away Sun Wukong and creates a tornado that overwhelms the whole region. The windstorm shakes the ground, destroying any possibility of stability and individual totality, tilting the earth, tumbling objects, and stripping off everything in view, including the leaves on trees, a woman's clothes (one of the most lewd scenes in the film), a house's roof, a cat's fur, and Monk Sha's lower body. While everyone, including the animated objects and buildings, struggles in vain to maintain their totality and anchorage, their elastic bodies bent in various forms become the shapes and movement of the wind, or "unmediated emergence of unconscious forms of response to external stimuli."[90] As in the fire sequence, the wind becomes the figure of heightened plasmaticity and motivates the most dynamic scene of formal transpositions, exchanges, and fragmentations. The plastic form as alternative perception is further articulated at the beginning of the next sequence. Sun Wukong is blown to a temple, where in the novel, the bodhisattva Ling-chi gives him a wind-arresting elixir to overcome the princess's power. In the film the elixir is changed, however, into a "wind-arresting bead" (*dingfengzhu*). To show its power, the bodhisattva holds up the transparent bead, through which we see a crystal-ball image of the whole mountain region, now restored to stability. The struggle with the wind becomes a competition of two distinct perceptual modes, that of transparency and immersion, one totalistic and contemplative, the other disorientating, tactile, and overwhelming.

These parallel modes of perception persist in the film as well as the history of Chinese cinema and are in fact an index of the two

impulses/stages in animation history circulated in the international realm. Just as Disney animation changed its emphasis from graphic anarchy in earlier works before the mid-1930s to narrative cohesion and graphic realism, *Princess Iron Fan* bears these double interests throughout the film. Its use of the multiplane camera—obviously influenced by the 1937 *Snow White and the Seven Dwarfs,* which was a huge success in wartime Shanghai—together with narrative realism is modeled after Hollywood live-action films. During the conversation among Tripitaka Tang, Wu-k'ung, and the local resident, for example, the camera pans back and forth among the three to create a three-way shot and countershot effect, quite close to Hollywood continuity editing. At the same time, the film shows multiple influences, resulting in an anachronistic and anarchic quality. The Monkey King does resemble Mickey Mouse to a degree, whereas the Fox Spirit looks like Fleischer's Betty Boop in Chinese costume. As the Wan Brothers recalled, the Fleischer Brothers were very popular in Shanghai in the 1920s, about five to six years earlier than Disney's first presence in China. *Out of the Ink Well* with its character Koko the Clown was most widely seen and had inspired the Wan Brothers' first film, *Chaos in the Artist's Studio,* together with its competitor in the same year, *The Ball Man.* Felix the Cat (Heimao) became a public persona in Shanghai, appearing as a trademark for various commodities, a dance hall gift, and a newspaper cartoon character.[91] The Wan Brothers also mentioned German as well as Russian animations, which they considered superior to American animations. This variety of influences made its way into the film, and despite its late date of production, the Wan Brothers showed a predilection toward plasmatic flexibility, justified by the story's fairy-tale/god-spirit quality. The characters take apart their bodies (for example, Zhu Bajie the pig takes off his ear and uses it as a fan), practice metamorphosis, and become flattened, squashed, or stretched repeatedly. The film's ease with violence and racy elements (albeit often at the expense of women) shows resistance to moral principles, a residue of martial arts god-spirit films as well as early Disney squash-and-stretch animation.

Yet this radicalized perception is simultaneously sadomasochistic: this psychosocial experience of spectatorship is the center of debate between Adorno and Benjamin. Whether the sadistic laughter

evoked by Disney violence is therapeutic or indicative of further submission to capitalistic power—through the audience's masochistic identification with the aggressor—remains the ambivalent promise of cinematic technological reflexivity.[92] Placed in the context of war, Eisenstein's discussion of pyromania and immersion in sensuous thought gains a different significance. In wartime Shanghai and beyond, this ambivalence was even more poignant, considering the pervasive effects of war that affected both aggressors and victims, diminishing the categorical difference between military aggression and resistance.[93] The fire and wind scenes in the film capture the exhilarating rebellion against normative forms and perceptions as well as the tyrannical assault on the senses in the war, assisted by industrial military technology. In terms of narrative, the fire and wind are associated with the antagonist, Princess Iron Fan. Her husband, the Bull Demon King, flies in the air with the soundtrack buzzing like an airplane, and his ride, a golden-eyed beast, walks with heavy thumping like a crushing tank. These associations with war and military technology, heightened by the soundtrack, create a reflexive horizon in which the audience can recognize the threshold experience of the war, turning the film into a collective bonding despite its ambivalent laughter. The plastic form of animation nevertheless defies the fixed border between the antagonist and the protagonist. As the film frequently exercises metamorphosis between god and human, animal and thing, and enemy and hero, it increasingly challenges the fixed identity of characters within a pervasive horizon of war.

Countering the fire and wind is not, however, a return to individual private perspective, in a way similar to the Monkey King's escape through the window or the restoration of visual stability by wind-arresting beads. The film modifies the original story so as to stage a new source of power. The original three attempts by Sun Wukong are changed to his two failed attempts, with Zhu Bajie the pig approaching the princess the third time. He successfully obtains the fan by disguising himself as the Bull Demon King, until the real king catches up, disguises himself as Sun Wukong, and retrieves the fan. Instead of having the Monkey King enjoy the final victory, the film reveals its new character, the masses. Similar to the left-wing treatment of the crowd as contiguous with and antagonistic to tropes of natural forces such as wind and fire, the masses become the apt

counterpart of the violent force of war. Portrayed anonymously in black silhouettes, diagonally framed and in simulated low-angle perspective, the masses assume an avant garde iconography quite similar to that used in the endings of national defense films produced between 1936 and 1937, as well as the wartime cartoons and propaganda posters, including the Wan Brothers' own works in the *Resistance Slogan Cartoons*.[94] It is Tripitaka Tang's disciples who engage in the most feverish martial arts fight with the Bull Demon King, but gods and spirits, martial arts heroes, and a revolutionary crowd accelerate the climax of the film. Just as Fang Yin dashes into the fire in *Baptism by Fire,* the presence of the masses in *Princess Iron Fan* prevents a return to an individual contemplative subject, instead vitalizing the screen with an ecstasy of collective action. Whether this action qualifies as "artistic action" in wartime Shanghai by Gao Changhong's standard remains unclear, but the audience was quick to point out the film's allegory of reality, and the film made its way to other places and was avidly received.[95] After all, Shanghai was never an "Orphan Island" during wartime but one of the nodal points in a tale of shared contemporaneity.

This chapter tentatively concludes my inquiry of propaganda as an affective medium by examining the distinct aesthetic participation and reflection of cinema in the atmospheric war. If terror bombing represented a new paradigm of war shifting from physical combat to an expanded war zone by filling the air with a pervasive and imponderable menace, propaganda, a modern institution of mass media, provided the counterpart of such bombing in reconstructing space and time through a radical reorientation of mass media. Whereas chapter 5 examines the repositioning of cinema as "a vibrating art in the air," a model of broadcast media as a mediating environment, this chapter looks at cinema as a "thinking technology" that through its technologically underdetermined aesthetic articulations reflects upon the stakes of affect in terms of a crisis of perception and those of the subject in a pervasive environment of the war.[96] Shifting the attention away from propaganda as the theory and practice of circulation that addresses mass media's core concerns of reproducibility and mobility, I turn to a different kind of circulation beyond a totalistic, one-way, top-down network. I find a concrete example in the phenomenon of agitational cinema, films that capture the menace of

the war with a shared interest in perception and action beyond the geopolitical divide between Chongqing, Hong Kong, and Shanghai. If agitation is the goal of propaganda as a highly directed, politicized spectatorship producing desirable perception and action, agitational cinema foregrounds agitation as an intense state of affective struggle caught between the challenge of perception and action. Although serving different audiences and agendas, these films overlap, through the traffic in human, material, and symbolic forces across geopolitical divides, in their interest in and negotiation with practices of affective spectatorship in earlier film history in China. Just as *Baptism by Fire* goes a long way in the history of fire configurations in Chinese mass media, *Paradise on Orphan Island* reconceives martial arts and action thrillers in an avant-garde reflection of consumptive and propagandistic culture, mimicking the terror of war via a modernist terror against consumptive immersion of the modern everyday surface and against the vanguard artists themselves as embodied by the vengeful youths in the film. *Princess Iron Fan* further refashions the mixed legacies of martial arts god-spirit, left-wing, and Chongqing resistance cinema in staging the inescapability of war and the plasticity of identity through the technological constraints and possibility of cel animation. Agitation captures the very ambiguity between the desire to maintain perceptual distance, clarity, and stability and the impossibility of such, often resulting in the tendency to displace the crisis of perception through action. The dialectic between immersion and transparency persists in these films: this is acted out in the ethics of perception and radical erasure of distance (*Baptism by Fire*); in the frenzy of action against surface intoxication in favor of transparent perception forged through an intermedial spectatorship (*Paradise on Orphan Island*); and in the contrast between perceptual depth and the flatness of the planes, character stability and plastic metamorphosis as well as in the dynamic interplay between figure and ground, active agent and prevalent environment (*Princess Iron Fan*). Fire returns in these films as the ubiquitous environment, the frenzy of action, and plastic movement. The unending battle between the perceiving subject and the overwhelming environment that undermines their boundary and the very stability and identity of the spectator is, perhaps, what constitutes the perpetual attraction of fire and that of cinema as the affective medium.

From prewar to wartime, between Shanghai, Chongqing, and Hong Kong, the trajectory of Chinese cinema was never singular, fixed, or predictable but involved many constellations and alternative routes, open to plural interpretations and narrations. By ending with wartime agitational cinema across the geopolitical divides and by teasing out their mutual imbrications and connections with prewar cinema, my particular tale of the three cities does not interweave a homogeneous story or space but questions the existing assumptions that naturalize binary oppositions between commercial and political modernity into geopolitical and temporal divides. In this sense, the *Mulan Joins the Army* incident, with which I open this book, both expresses the distrust of consumptive visual pleasure— translated as hostility toward film productions from a geopolitically suspect region—and suggests the constant traffic between these regions where a transregional film culture was fostered. That culture was by no means homogeneous or harmonious but full of tensions. After all, the radical artistic action would not have made sense without the context of a commercial theater—hence, their perpetual symbiosis, rather than the ideological isolations in which we would like to place them.

Acknowledgments

The completion of this book has taken travels and connections across three continents, two oceans, and several campuses. I owe thanks to the many people and institutions who have sustained me through this long journey.

I thank the Schoff Fund at the University Seminars at Columbia University for their help in publication. Material in this work was presented at the seminar "Cinema and Interdisciplinary Interpretation," and I benefited from the lively exchanges at three additional seminars: "Modern China," "Sites of Cinema," and "The History and Theory of Media."

My dissertation mentors at the University of Chicago, Miriam Hansen, Tom Gunning, Wu Hung, and Judith Zeitlin, inspired and nurtured this project from its very beginning. Their intellect, personality, and generosity enriched my project in every way and helped shape the core of this book. Miriam passed away while I was finishing the manuscript, and I hope this book constitutes a humble memorial to her. My other Chicago teachers—Bill Brown, Kyeong-Hee Choi, Prasenjit Duara, Lorean Kruger, James Lastra, Tang Xiaobing, Yuri Tsivian, and Michael Raine—opened my eyes to the fields of film and theater studies, literature, history, and philosophy and set fine examples for my scholarship. My Chicago pals, many of them now accomplished scholars—Kaveh Askari, Max Bohnenkamp, Chika Kinoshita, Jean Ma, Jason McGrath, Kevin Lawrence, Dan Morgan, Joshua Yumibe, Viren Murthy and Li Yuhang, Paize Keuleman and Eugenia Lean, Catherine Stuer, Xu Dongfeng, and Wang Yi—seasoned personal warmth with the spice of intellect and helped make the long, dark winter in Hyde Park a particularly suitable season for the life of the mind.

I thank the following institutions for granting me access to a wide range of material during my overseas research trips: Shanghai

Municipal Library, Suzhou Municipal Library, Shanghai Municipal Archive, East China Normal University, Fu Dan University, China National Library, Hong Kong Film Archive, Hong Kong University, China Film Archive, Chongqing Municipal Library, and Central Academy of Drama. Among their staff members and librarians, I thank Zhang Wei, Zhu Tianwei, Zhu Lianqun, and Shen Ning. Among the film scholars I met during these trips, I thank Cao Menglang, Gao Xiaojian, Law Kar, Li Shaobai, Li Suyuan, Lu Hongshi, Rao Shuguang, Shi Man, Yu Muyun, and Zhang Jianyong for their stimulating conversations. The filmmakers, dramatists, critics, and their family members generously granted me extended interviews and even fed me homemade food. I thank Li Lili Zhang Ruifang, Huang Suying, Ge Yihong, Zhu Shuhong, Lai Sek, Ying Xuan, Ouyang Shanzun, Ouyang Jingru, Hong Gang, Wang Jue, Wan Sheng, Chen Lansun, Yang Wei, and Su Dan. Among these scholars and artists, Li Lili, Ying Xuan, Yu Mowan, and Shi Man have passed away. Their deaths are irreplaceable losses for Chinese film history and made my project more personal and urgent.

The three institutions where I have served as faculty—The Ohio State University, Columbia University, and the University of California–Berkeley—provided me with lively and brilliant intellectual circles. At Ohio I am grateful for the warmth and support of Kirk Denton, Mark Bender, Chan Park, Ronald Green, John Davidson, Judith Mayne, Patrick Sieber, Goh Meow Hui, and David Filipi. At Columbia, for their mentorship, friendship, and conversations, I thank Paul Anderer, Kim Brandt, Jim Cheng, Jane Gaines, Hikari Hori, Ted Hughes, Bob Hymes, Dorothy Ko, Nancy Friedland, Eugenia Lean, Li Feng, Lydia Liu, David Lurie, Richard Peña, Wendy Schwartz, Shang Wei, Haruo Shirane, Tomi Suzuki, Chengzhi Wang, W. B. Worthen, and Matti Zelin. The University Seminars at Columbia University provided me with an intellectual home beyond my department and gave me opportunities to present my work and learn from an incredible range and depth of scholarship. I thank Stefan Andriopoulos, Brian Larken, Reinhold Martin, Jonathan Crary, Noam Elcott, Marilyn Ivy, Andreas Huyssen, Nico Baumbach, Ben Kafka, and Joan Cohen for their helpful advice and pleasant discussions.

Thanks go to my colleagues at Berkeley—Jinsoo An, Robert

Ashmore, Pheng Cheah, Mark Csikszentmihalyi, Michael Dear, Mary Ann Doane, Andrew Jones, Shannon Jackson, Anton Kaes, Anne Nesbet, Daniel O'Neill, Mark Sandberg, Myriam Sass, Jeffrey Skoller, Chenxi Tang, Alan Tansman, Paula Varsano, Sophie Volpp, Kristen Whissel, Linda Williams, and Wen-Hsin Yeh—who have created a congenial and productive atmosphere and kept me nurtured in my new intellectual home. From house-hunting consultations to meals to trips to the movies, they have helped me make a smooth transition to the West Coast and given me joy in their intellectual solidarity.

I give thanks to many colleagues in the field—Dudley Andrew, Chris Berry, Yomi Braester, Eileen Cheng, Xiaomei Cheng, Robert Chi, Francesco Casetti, Aaron Gerow, Angela Dalla Vacche, Kristine Harris, Victoria Harris, Alexa Huang, Haiyan Lee, Jiyan Mi, Markus Nornes, Guo-juin Hong, Jerome Silbergeld, Song Mingwei, Paul Pickowicz, David Wang, Eugene Wang, Zhen Zhang, and Yingjin Zhang—for sharing advice, sources, and tips, bringing inspiration and encouragement, and keeping a close eye on my development. As the spouse of a former Vanderbilt University faculty, I thank Paul Young, Allison Schachter and Ben Tran, Ruth Rogaski, Yoshikuni Iganashi, Tracy Miller, and Gerald Figal for their warm support.

Thanks go to the scholars who critiqued and read my manuscript at its different stages: Chris Berry, Eileen Cheng, Andrew Jones, Joan Judge, Lydia Liu, Dan Morgan, Haruo Shirane, Zhang Yingjin, Zhang Zhen, Angela Dalla Vacche, and David Wang. Their generous gifts of time, knowledge, and insight greatly aided my manuscript's development.

My work on the manuscript received generous fellowship support from Berkeley's Center for Chinese Studies, the Getty Research Institute, Harvard University's Fairbank Center, and Internationale Kolleg für Kulturtechnikforschung und Medienphilosophie (IKKM) in Germany. Course relief and faculty research funds at Ohio, Columbia, and Berkeley gave me the needed time and support to complete and revise the manuscript. The Leonard Hastings Schoff Publication Fund at Columbia University provided timely support for the production of this book.

From 2010 to 2011, I had a heavenly year at the Getty Research Institute, with the best weather, nourishment, and camaraderie. I

thank my fellow scholars at Getty for their good humor and inspiration; senior curators Marcia Reed, Frances Terpak, and Jeffrey Cody for their invaluable input; and John Taine for his wonderful friendship and for exploring Los Angeles's best galleries, architecture, and restaurants. The two heads of the scholar programs—Katja Zelljadt and Alexa Sekyra—and the incredible staff kept us feeling constantly spoiled. I owe special thanks to Olivier Lugon for his spirited fellowship and for sharing conversations, inspirations, and weekend rides to our offices for extended work hours. I thank Peter Bloom for graciously allowing me to visit his class at Getty and Erkki Huhtamo for showing me his incredible collection of optical media.

My biggest surprise came from a fortuitous meeting with William Krisel and James Pickard Jr., sons of Alexander Krisel and James Pickard, film entrepreneurs and sound engineers in Shanghai. Through pleasant conversations in person, at the dinner table, and through fax, phone, and e-mail, I discovered that William's and James's fathers worked on the same floor in the same building in Shanghai. I thank William for his superb detective skills and for faxing the book pages that led to this wonderful discovery. I am grateful to Judy Dan Woo, daughter of filmmaker Dan Duyu, who with the assistance of her husband, Tom Woo, and daughter, Becky Woo-Bechtel, generously allowed me to reproduce artwork by Dan Duyu.

IKKM at Bauhaus-Universität Weimar provided an intellectual boost and a great environment in which to tighten my manuscript's conceptual framework. I was humbled by the brilliant and lively minds of fellow scholars Francesco Casetti, Jimena Canales, Michel Chion, Thomas Elsaesser, Ben Kafka, Tom Levin, and Sigrid Weigel. I thank my hosts in Weimer, Lorens Engels, Bernhard Siegert, Laura Frahm, Volker Pantenburg, Michael Cuntz, Anne Ortner, Katerina Krtilova, and Wolfgang Beilenhoff. In Berlin Lutz Huening and Olivier Lugon provided a home away from home and accompanied me on wondrous architectural expeditions. Christine (Noll) Brinckmann and Britta Hartmann shared many movie nights at Arsenal and warmed my German winter with delicious home cooking and beer.

An invitation to the Quadrant program at the University of Minnesota gave me tremendous encouragement and incentive for the revision of my manuscript. I thank the lecture and workshop

organizers and participants for their invaluable input—particularly, Christophe M. Wall-Romana, Alice Lovejoy, and Jason McGrath.

With unfailing enthusiasm, faith, and patience, University of Minnesota Press editor Jason Weidemann helped hone my manuscript and guide its completion. I thank him for keeping me on track and for his sage advice. I thank associate editor Danielle Kasprzak and the whole production team at the press, who worked diligently alongside Jason and was a source of pleasant and timely support.

It is my good fortune to have an amazing family—my parents and parents-in-law, my sister and her family, my American family Pat, Joan, Fred, and the late Gladys, and all their cats and dogs—who embrace me with endless love and keep me strong in challenging times. My grandfather Bao Dingcheng did not live to see the completion of this book, but he remains a source of strength and inspiration. This book is a tribute to him. He migrated from Shanghai to Chongqing at a different moment in history and dealt with tremendous challenges with both courage and optimism. Thanks also go to Popolo and the late Gnuni, our two loving cats, who constantly remind me of the poverty of human intelligence and passion.

Finally, my deepest thanks go to Ling Hon. He has availed himself unconditionally as my traveling pal, technical support, entertainer, and most rigorous critic. For keeping the flame of youth alive, here is my token of love.

Notes

Introduction

1. The narrative, about a female hero who cross-dresses in order to participate in the war in the place of her father, was made popular by its Disney rendition, *Mulan,* in 1998.

2. The film was shown in the same afternoon in the city's two first-run theaters, Cathay and Weiyi, with Cathay starting the film one hour earlier (1:30 p.m.) so that the two theaters could share the same print. For details of the incident, see "Zai Yu beifen shijian teji" (Collected reports on the burning [of *Mulan Joins the Army*] in Chongqing), *Dianying shijie* 11 (April 1940): 16, 21–22, 25, 27, 30.

3. Chongqing newspapers and movie theaters, including Weiyi, denounced the film as "destroying law and order, contemptuous of the government, and infringing upon the rights of legal citizens." See "Zai Yu beifen shijian teji," 16. In a contemporary study, Poshek Fu cites this event as hinterland "mob violence" and Nationalist prejudice against wartime commercial Shanghai cinema. Poshek Fu, *Between Shanghai and Hong Kong: The Politics of Chinese Cinemas* (Stanford, Calif.: Stanford University Press, 2003), 38–48. However, the film was actually approved by the Nationalist government's Central Film Censorship Commission, which denounced the mass burning the day after the incident and allowed continuous screening of the film.

4. See summaries of the incident in "ZaiYu bei fen shijian teji." Fu did not mention that the names of both the director and the film studio were deliberately cut out of the credits used for the opening screening, which created some surprise among the audience. One Shanghai writer in this special issue acknowledged that Shanghai-produced films were routinely shown in the occupied cities and were subject to various textual and extratextual manipulations. The narrative and thematic emphasis could be distorted by practices such as reediting the film, adding subtitles and intertitles, and even furnishing an on-site lecturer (the equivalent of a Japanese *benshi*). See Puti, "Zaitan Mulan congjun," *Da wanbao,* March 25, 1940, reprinted in "ZaiYu bei fen shijian teji," 25. The political status of the

film print in this particular historical moment is further highlighted by the omission of the director's name in the film print for its Chongqing exhibition and by the fact that film prints could have multiple versions depending on the exhibition context.

5. A decade earlier, Hong Shen himself had performed a famed protest at Shanghai's Grand Theater against the screening of Paramount's *Welcome Danger* for its racist depictions of Chinese in the film, starring Harold Lloyd in his first talkie. The incident was widely covered by mass media. See *Xinwenbao* and *mingguo ribao,* February 22, 1930; and in a special issue devoted to the Harold Lloyd incident, *Xin yinxing yu tiyu* (Silverland and sportsworld), February 22, 1930, 12–18.

6. Interviews with actor Wang Jue (June 3 and 6, 2008, Taipei), who worked for the Chinese Motion Picture Corporation; set designer Wan Sheng, who worked for the film studio's Wansui Theatre (June 16, 2008, Chongqing); and *Sao dangbao* reporter Chen Lansun (June 18, 2008, Chongqing). Wang Jue revealed to me, with vivid detail, that he was one of the agitators who stormed the movie theater and burned the film.

7. Xiong Foxi, "Xiju de jiefang yu xinsheng" (The rebirth and liberation of drama), *Chenbao,* January 21, 1936.

8. For descriptions of film fires associated with early cinema exhibition, see Charles Musser, *The Emergence of Cinema: The American Screen to 1907* (Berkeley: University of California Press, 1990), especially 181–83, 511n34. In Russia Yuri Tsivian vividly documents the particularly precarious atmosphere associated with film viewing in these early years and the consequent mystery and power associated with the projection room and the projectionist. See Yuri Tsivian, *Early Cinema in Russia and Its Cultural Reception* (Chicago: University of Chicago Press, 1994), 51–52.

9. Bernhard Siegert, *Relays: Literature as an Epoch of the Postal System* (Stanford, Calif.: Stanford University Press, 1999).

10. See Claude Shannon and Warren Weaver, *The Mathematical Theory of Communication* (Urbana: University of Illinois Press), 1999.

11. Friedrich Kittler, *Gramophone, Film, Typewriter,* trans. Geoffrey Winthrop-Young and Michael Wutz (Stanford, Calif.: Stanford University Press, 1999); Friedrich Kittler, *The Optical Media,* trans. Anthony Enns (Cambridge, U.K.: Polity Press), 2010.

12. Given the mutual borrowing between structural linguistics and postwar information theory, one could say the latter asserts a strong impact on the epistolary model, even in Siegert's own history of the postal epoch, which is informed by such a linguistic model. On Shannon's influence on structuralism and poststructuralist thinking, see Lydia Liu, "iSpace:

Printed English after Joyce, Shannon, and Derrida," *Critical Inquiry* 32 (Spring 2006).

13. Stefan Hoffmann, *Geschichte des Medienbegriffs* (Hamburg: Felix Meiner, 2002), 34.

14. See Erhard Schüttpelz, "Trance Mediums and New Media: The Heritage of a European Term," in *Trance Mediums and New Media,* ed. Heike Behrend, Anja Dreschke, and Martin Zillinger (New York: Fordham University Press, 2014). I thank Professor Schüttpelz for generously sharing the paper before its publication. On spiritualism and mass media, see Jeffrey Sconce, *Haunted Media: Electronic Presence from Telegraphy to Television* (Durham, N.C.: Duke University Press, 2000); Tom Gunning, "To Scan a Ghost: The Ontology of Mediated Vision," *Grey Room* 26 (2007): 94–127; Stefan Andriopoulos, *Possessed: Hypnotic Crimes, Corporate Fiction, and the Invention of Cinema* (Chicago: University of Chicago Press, 2008); Stefan Andriopoulos, *Ghostly Apparitions: German Idealism, the Gothic Novel, and Optical Media* (New York: Zone Books, 2013).

15. Wendy Hui Kyong Chun, introduction to *New Media, Old Media,* 2–3.

16. Ibid., 3.

17. For a more detailed discussion on mediation, see John Guillory, "Genesis of the Media Concept," *Critical Inquiry* 36 (Winter 2010): 321–61. Guillory resists the direct association between media and mediation by tracing a much longer philosophical history in an effort to rethink the place of literary studies in the age of media studies. Mark Hansen and W. J. T. Mitchell have traced two intellectual lineages for these two mediation models: one belongs to the Marxist tradition of unidimensional mediation—from Lukács to Althusser's model of ideology to the Frankfurt school's analysis of the culture industry to Kittler's technological determinism, which ostensibly perverts yet reinforces the base–superstructure relationship, the other pointing to a revisionist notion of mediation as a dynamic process—originating from Antonio Gramsci's conception of hegemony and evolving in diverse schools, including British cultural studies (Raymond Williams and Stuart Hall), the post-Marxist Ernesto Laclau and Chantel Mouffee, and the Italian school (Maurizio Lazzarato to Michael Hardt and Antonio Negri). See "Introduction," *Critical Terms for Media Studies,* ed. W. J. T. Mitchell and Mark Hansen (Chicago: The University of Chicago Press, 2010), xx–xxi.

18. Guillory, "Genesis," 356.

19. Ibid., 357–62.

20. Oliver Grau, *Virtual Art: From Illusion to Immersion,* trans. Gloria Custance (Cambridge, Mass.: MIT Press, 2003).

21. Beatrice Colomina, *Publicity and Privacy* (Cambridge, Mass.: MIT Press, 1996); Jorge Otero-Pailos, *Architecture's Historical Turn: Phenomenology and the Rise of the Postmodern* (Minneapolis: University of Minnesota Press, 2010); Allison Griffiths, *Shivers down Your Spine* (New York: Columbia University Press, 2008).

22. Martin Jay, "Scopic Regimes of Modernity," in *Vision and Visuality,* ed. Hal Foster, 3–23 (New York: Bay Press, 1988); Laura Marks, *The Skin of the Film* (Durham, N.C.: Duke University Press, 2000); Vivian Sobchack, *The Address of the Eye* (Princeton, N.J.: Princeton University Press, 1992); Vivian Sobchack, *Carnal Thought* (Berkeley: University of California Press, 2004); Jennifer Barker, *The Tactile Eye* (Berkeley: University of California Press, 2009), Mark Hansen, *New Philosophy for New Media* (Cambridge, Mass.: MIT Press, 2004); Angela Dalla Vacche, ed., *The Visual Turn: Classical Film Theory and Art History* (New Brunswick, N.J.: Rutgers University Press, 2002).

23. Niklas Luhmann, *The Reality of Mass Media,* trans. Kathleen Cross (Stanford, Calif.: Stanford University Press, 2000); Marshall McLuhan, *Understanding Media: The Extensions of Man* (New York: McGraw-Hill, 1964). W. J. T. Mitchell, *What Do Pictures Want? The Lives and Loves of Images* (Chicago: University of Chicago Press, 2005).

24. Mitchell, *What Do Pictures Want?*, 204.

25. Henri Bergson, *Matter and Memory,* trans. Nancy Paul and W. Scott Palmer (New York: Macmillan, 1913).

26. Ruth Leys, "The Turn to Affect: A Critique," *Critical Inquiry* 37 (2011): 434–72.

27. Brian Massumi, *Parables for the Virtual: Movement, Affect, and Sensation* (Durham, N.C.: Duke University Press, 2002), 28. In his translator's note for Deleuze and Guattari's *A Thousand Plateaus,* Massumi does provide a positive definition of affect: "*L'affect* (Spinoza's *affectus*) is an ability to affect and be affected. It is a prepersonal intensity corresponding to the passage from one experiential state of the body to another and implying an augmentation or diminution in that body's capacity to act." Brian Massumi, "Notes on the Translation and Acknowledgements," in *A Thousand Plateau: Capitalism and Schizophrenia,* by Gilles Deleuze and Félix Guattari, trans. Brian Massumi (Minneapolis: University of Minnesota, 1987), xvi.

28. William Mazzarella, "Internet X-Ray: E-Governance, Transparency, and the Politics of Immediation in India," *Public Culture* 18, no. 3 (2006): 473–505, 476.

29. William Mazzarella, "Affect: What Is It Good For?," in *Enchantments of Modernity: Empire, Nation, Globalization,* ed. Saurabh Dube, 291–309 (London: Routledge, 2009), 299.

30. Ibid., 303.

31. For affect in relation to visuality, see Foster, *Vision and Visuality*; Jonathan Crary, *Technique of the Observer: On Vision and Modernity in the 19th Century* (Cambridge: MIT Press, 1992); Hal Foster, *Suspensions of Perception: Attention, Spectacle, and Modern Culture* (Cambridge: MIT Press, 1999). For body genres, see Carol Clover, *Men, Women, and Chain Saws: Gender in Modern Horror Film* (Princeton, N.J.: Princeton University Press, 1993); Linda Williams, ed., *Viewing Positions: Ways of Seeing Film* (New Brunswick, N.J.: Rutgers University Press, 1995); Linda Williams, "Film Bodies: Gender, Genre, and Excess," in *Feminist Film Theory: A Reader*, ed. Sue Thornham, 267–81 (New York: New York University Press, 1999). For cinema and urban modernity, see Juliana Bruno, *Streetwalking on a Ruined Map: Cultural Theory and the City Films of Elvira Notari* (Princeton, N.J.: Princeton University Press, 1993); Leo Charney and Vanessa Schwartz, eds., *Cinema and the Invention of Modern Life* (Berkeley: University of California Press, 1995); Lynne Kirby, *Parallel Tracks: The Railroad and Silent Cinema* (Exeter, U.K.: University of Exeter Press, 1997); Vanessa Schwartz, *Spectacular Realities: Early Mass Culture in Fin-de-Siècle Paris* (Berkeley: University of California Press, 1998); Ben Singer, *Melodrama and Modernity: Early Sensational Cinema and Its Contexts* (New York: Columbia University Press, 2001); Mark Sandberg, *Living Pictures, Missing Persons: Mannequins, Museums, and Modernity* (Princeton, N.J.: Princeton University Press, 2003). For new media studies, see Hansen, *New Philosophy for New Media*.

32. Haiyan Lee, *Revolution of the Heart: A Genealogy of Love in China, 1900–1950* (Stanford, Calif.: Stanford University Press, 2007); Eugenia Lean, *Public Passion: The Trial of Shi Jianqiao and the Rise of Public Sympathy in Modern China* (Berkeley, University of California Press, 2007).

33. The most exemplary account of such an approach remains Cheng Jihua, Xing Zuwen, and Li Shaobai, *Zhongguo dianying fazhan shi* (The history of development of Chinese cinema), 2 vols. (Beijing: Zhongguo dianying chubanshe, 1963). See also Chen Bo, *Zhongguo zuoyi dianying yundong* (The Chinese left-wing film movement) (Beijing: Zhongguo dianying chubanshe, 1993); Chen Bo and Yi Ming, eds., *Sanshi niandai Zhongguo dianying pinglun xuan* (Anthology of Chinese film criticism in the 1930s) (Shanghai: Shanghai renmin chubanshe, 1993).

34. For revisionist scholarship in Chinese, see, for example, Li Suyuan and Hu Jubing, *Zhongguo wusheng dianying shi* (Beijing: Zhongguo dianying, 1996); Lu Hongshi, ed., *Zhongguo dianying: Miaosu yu chanshi* (Chinese cinema: Description and interpretation) (Beijing: Zhongguo dianying, 2002). For pioneering new scholarship in English, see Kristine

Harris, "Silent Speech: Envisioning the Nation in Early Shanghai Cinema" (PhD diss., Columbia University, 1997); Yingjin Zhang, *Cinema and Urban Culture in China, 1922–1943* (Stanford, Calif.: Stanford University Press, 1999); Pang Laikwan, *Building a New China in Cinema: The Chinese Left-Wing Cinema Movement, 1932–1937* (Lanham: Rowman & Littlefield, 2002); Zhang Zhen, *An Amorous History of the Silver Screen: Shanghai Cinema, 1896–1937* (Chicago: University of Chicago Press, 2006).

35. See Miriam Hansen, "The Mass Production of the Senses: Classical Cinema as Vernacular Modernism," *Modernism/Modernity* 6, no. 2 (1999): 59–77; "Fallen Women, Rising Stars, New Horizons: Shanghai Silent Film as Vernacular Modernism," *Film Quarterly* 54, no. 1 (2000): 10–22; "Tracking Cinema on a Global Scale," *The Oxford Handbook on Global Modernisms*, ed., Mark Wollaeger and Matt Eatough, 2012.

36. Dan Morgan has astutely termed these two sets of interests the "vertical" versus the "horizontal" axes of vernacular modernism. See Dan Morgan, "Play with Danger: Vernacular Modernism and the Problem of Criticism," *New German Critique* 122 (2014): 70. See also my own essay in the same volume.

37. Singer, *Melodrama and Modernity*, 72. See Georg Simmel, "The Metropolis and Mental Life," in *The Sociology of Georg Simmel*, ed. Kurt H. Wolff, 409–24 (New York: Free Press, 1950); Siegfried Kracauer, *The Mass Ornament: Weimar Essays*, ed. and trans. Thomas Levin (Cambridge, Mass.: Harvard University Press, 1995); Walter Benjamin, "The Work of Art in the Age of Its Technological Reproducibility: Second Version," in *Selected Writings: Volume 3, 1935–1948*, ed. Howard Eilang and Michael Jennings, 101–33 (Cambridge, Mass.: Harvard University Press, 2002); Walter Benjamin, "On Some Motifs in Baudelaire," in *Illuminations*, ed. Hannah Arendt, 155–200 (New York: Harcourt Brace, 1968).

38. Silvia Harvey, "Whose Brecht? Memories for the Eighties," *Screen* 23, no. 1 (1982): 45–59, 48.

39. David Rodowick, *The Crisis of Political Modernism: Criticism and Ideology in Contemporary Film Theory* (Urbana: University of Illinois Press, 1988).

40. Harvey, "Whose Brecht," 50.

41. Ibid., 51–52.

42. Masha Slazkina has done admirable work in this direction by tracing the very tangible and tortuous passage of political modernism from the 1920s to the 1960s by way of institutional and human traffic between Russia, Italy, and South America. See "Moscow-Rome-Havana: A Film-Theory Road Map," *October*, no. 139, 97–116.

43. This taps into Jameson's understanding of Brecht's method as a

multilayered process of reflection, positing the reader/spectator in a triangulated relationship with the media/world. Frederick Jameson, *Brecht and Method* (London: Verso, 1998).

44. Harvey has pointed out Brecht's interest in the process of production, in entertainment, and in pleasure of the reader. See Harvey, "Whose Brecht?," 53–55.

45. Rey Chow, *The Age of the World Target: Self-Referentiality in War, Theory, and Comparative Work* (Durham, N.C.: Duke University Press, 2006), 83–84.

46. For scholarship on propaganda cinema, see Siegfried Kracauer, *From Caligari to Hitler: A Psychological History of the German Film* (Princeton, N.J.: Princeton University Press, 1947); Clayton R. Koppes and Gregory D. Black, *Hollywood Goes to War: How Politics, Profits, and Propaganda Shaped World War II Movies* (Berkeley: University of California Press, 1987); Eric Rentschler, *Minister of Illusion: Nazi Cinema and Its Afterlife* (Cambridge, Mass.: Harvard University Press, 1996); Richard Taylor, *Film Propaganda: Soviet Russia and Nazi Germany* (London: I. B. Tauris, 1998); David Welch, *Propaganda and the German Cinema, 1933–1945* (London: I. B. Tauris, 2001). While earlier scholarship on propaganda focused on ideological analysis, new scholarship on fascist cinema has focused more on its popular appeal and continuity with commercial film industry. See Linda Schulte-Sasse, *Entertaining the Third Reich: Illusions of Wholeness in Nazi Cinema* (Durham, N.C.: Duke University Press, 1996); Sabina Hake, *Popular Cinema of the Third Reich* (Austin: University of Texas Press, 2002).

47. Thomas Elsaesser, "Early Film History and Multi-Media: An Archaeology of Possible Futures?," in *New Media, Old Media: A History and Theory Reader,* ed. Wendy Hui Kyong Chun and Thomas Keenan, 13–26 (New York: Routledge, 2006), 20. For an examination of the diverse threads under the rubric of media archaeology in Anglophone and German scholars, see *Media Archaeology: Approaches, Applications, and Implications,* ed. Errki Huhtamo and Jussi Parrika (Berkeley: University of California Press, 2011).

48. Kittler, *Optical Media;* Siegfried Zielinski, *Deep Time of the Media: Toward an Archaeology of Hearing and Seeing by Technical Means,* trans. Gloria Custance (Cambridge, Mass.: MIT Press, 2008).

49. Elsaesser, "Early Film History."

50. Jussi Parikka has acknowledged this connection with the present and started to draw attention to Foucault's notion of genealogy and archeology in his recent book *What Is Media Archeology?* (London: Polity, 2012), 10–11, 22–23.

51. Jean-Louis Baudry, *L'effet cinéma* (Paris: Albatros, 1978). For an

English-language collection on the discussion of the topic, see Philip Rosen, ed., *Narrative, Apparatus, Ideology* (New York: Columbia University Press, 1986). For recent inquires on *dispositif,* see Giorgio Agamben, *Qu'est-ce qu'un dispositif?* (Paris: Payot & Rivages, 2007); Joachim Paech, "Berlegungen zum Dispositiv als Theorie medialer Topik," *Medienwissenschaft,* 4: 97, 400–420; Frank Kessler, "The Cinema of Attractions as Dispositif," in *The Cinema of Attractions Reloaded,* ed. Wanda Strauven, 57–69 (Amsterdam: Amsterdam University Press, 2007); Francois Alberta and Maria Tortajada, eds., *Cinema beyond Film: Media Epistemology in the Modern Era* (Amsterdam: Amsterdam University Press, 2010). For a thorough survey of various positions on *dispositif* and an in-depth analysis of its implication for film and media studies, see Frank Kessler, "Notes on *Dispositif,*" November 2007, http://www.frankkessler.nl/wp-content/uploads/2010/05/Dispositif-Notes.pdf. My discussion benefits greatly from Kessler's analysis. Since Kessler's is a work in progress, I cite by section number rather than by page number.

52. Michel Foucault, *Power/Knowledge: Selected Interviews and Other Writings, 1972–197,* ed. Colin Gordon (New York: Pantheon Books), 194–95.

53. John Pløger, "Foucault's Dispositif and the City," *Planning Theory* 51, no. 7 (2008): 51–70. Pløger has explored the potential openness of Foucault's framework for *dispositif* rather than reaffirming its tendency for totality and control.

54. Kessler, "Notes on *Dispositif,*" 2.5. For more open interpretations of *dispositif,* see Gilles Deleuze, "What Is a *Dispositif?,*" in *Michel Foucault Philosopher,* ed. Timothy J. Armstrong, 159–68 (New York: Routledge, 1992); Michel de Certeau, *The Practice of Everyday Life* (Berkeley: University of California Press, 1984).

55. Matti Peltonen, "From Discourse to Dispositif: Michel Foucault's Two Histories," *Historical Reflections/Reflexions Historiques* 30, no. 2 (2004): 205–19.

56. Pløger, "Foucault's Dispositif," 59.

57. In media history, the flexibility of the term *dispositif* can be seen in its reference to viewing positions, the character of a specific media technology, an organizational operation, and the technics of perception.

58. The standard demarcation of Chinese cinema from its inception to the end of the Republican period consists of 1896–1920 (emergence), 1921–31 (commercial development), 1932–37 (left-wing), 1937–1945 (wartime), 1946–49 (postwar). Such periodization is abided by Cheng Jihua, Xing Zuwen, and Li Shaobai, *Zhongguo dianying fazhan shi*; Li Suyuan and Hu Jubin, *Zhongguo wusheng dianying shi*; Pang Laikwan, *Building a New China in Cinema*; Shen, *The Origins of Left-Wing Cinema in China*; and

Hu Jubin, *Projecting a Nation: Chinese National Cinema before 1949* (Hong Kong: Hong Kong University Press, 2003).

59. Errki Huhtamo, "Dismantling the Fairy Engine: Media Archeology as Topos Study," *Media Archaeology*, 27–47.

1. Fiery Action

1. On the rise of martial arts films, see Li Suyuan and Hu Jubin, *Zhongguo wusheng dianying shi*.

2. According to *The General Catalogue of Chinese Film*, there were 241 martial arts and god-spirit films made between 1927 and 1932, among which thirty were made in 1928, eighty-five in 1929, sixty-nine in 1930, forty-three in 1931, and fourteen in 1932. Chinese Film Archive, ed., *The General Catalogue of Chinese Film*, 1960.

3. C. J. North, "The Chinese Motion Picture Market," *Trade Information Bulletin* 467 (May 4, 1927): 2. The bulletin was published by the Bureau of Foreign and Domestic Commerce, U.S. Department of Commerce. It is likely that the figures are exaggerated.

4. See film ads in *Shenbao* for *The Iron Claw*, June 6, 1917; and *The Clutching Hand*, June 26, 1917.

5. See film ads in *Shenbao*, May 25 and June 5–14, 1920.

6. See *Yingxi zazhi* 1 (1922): 20; *Shenbao*, May 25, 1916; *Shenbao*, June 14, 1920. Another film starring Roland yet to be further identified bears the Chinese title *Taiyang dang* (The solar gang).

7. *Shenbao*, May 2, 1921.

8. As North informs us about film exhibition in Amoy (Xiamen), Fuchien (Fujian) Province, the foreign film rental policy during this period generally asked for exhibition of two programs of no less than eight reels, with each program containing either a feature or two episodes of a serial plus a comedy to make up the eight reels. Each film was to be shown no more than three or four consecutive days. North, "The Chinese Motion Picture Market," 10. This description was substantiated when I browsed through the newspaper ads for this period. For example, the film exhibition for Pearl White's *The Black Secret* (1919) (or *Deguo da mimi* [The great secret of Germany]) shown in Shanghai in 1920 was documented to be wildly popular; and the Grand Shanghai Theater (Shanghai da xiyuan), which showed the film, decided to add three extra days of exhibition from Friday to Sunday but observed the rental policy in showing each new program (every two episodes) on Mondays and Thursdays. In conjunction with the serial, they also showed *Upstairs* starring Mabel Normand, which fits precisely with North's description of the film program consisting of two

episodes plus a comedy. *Shenbao*, June 11, 1920. The movie theaters showing the serial adventures included foreign-owned theaters such as the Apollo, Empire, Olympic, Isis, and Donghe (Japanese owned) and Chinese-owned theaters (previously established by foreigners) such as Gonghe, Shanghai, Haishenglou, and Ailun (Helen). The Chinese were often prohibited from attending the foreign theaters by much higher ticket prices. According to Guan Ji'an, Helen was the first Chinese theater to show serial adventures and gained great popularity, mainly because the theater was deliberately located in the Cantonese immigrant area along Haining Road to attract the Cantonese immigrants, who had difficulty understanding Shanghai and Suzhou dialect and appreciating local forms of entertainment. The success at Helen spurred other Chinese movie theaters to be built and helped spread the popularity of film. Guan Ji'an, "Yingxi shuru Zhongguo hou de bianqian" (Metamorphosis of the shadow play after its introduction to China), *Xi zazhi* 1 (1922). Although almost all of the theaters were built by foreigners, including Gonghe and Helen (by the British merchant A. Runjahn), Guan's narrative testifies to the popularity of serial adventures, which could have served as economic incentive for expanding the movie theaters. Except for Apollo (1910), these theaters were built between 1913 and 1915, prime time for serial adventures. The serial adventure's success in the Cantonese immigrant area is illustrative of its larger success in China later on. That the physical thrill was appreciated despite linguistic difference suggests the potential of these serial adventures as a global "vernacular" beyond local dialect.

9. Xu Banmei, *Huaju chuangshiqi huiyilu*, 120–21; Gong Jianong, *Gong Jianong congying huiyilu* (Memoir of Gong Jianong's film career), 3 vols. (Taipei: Wenxing shudian, 1967), 3:404. The two famous linked plays were *Lingbo xiazi* (Fairy on the water) and *Hong Meigui* (The red rose), coproduced by Xu Banmei's Kaixin Film Studio and the new drama stage Gong Wutai in 1924.

10. For pioneering research on Brodsky and his collaboration with Hong Kong filmmakers, see Law Kar and Frank Bren, with the collaboration of Sam Ho, *Hong Kong Cinema: A Cross-Cultural View* (Lanham, Md.: Scarecrow Press, 2004).

11. These films were shown mainly in the new drama theater as fillers and remained marginal in the entertainment scene.

12. Cheng Jihua, 20–23; Li Suyuan, 50–57.

13. Zheng Junli, "Xiandai Zhongguo dianying shilue" (A brief history of modern Chinese cinema), in *Zhongguo wusheng dianying* (Chinese silent film), ed. Zhongguo dianying ziliaoguan (Beijing: Zhongguo dianying chubanshe, 1996), 1391. This essay was first published in 1936.

14. In 1916, with the import of American film stock, a filmic version of *Heiji yuanhun* (Victims of opium) was made by Zhang Shichuan. The film is no longer extant but was made of four reels with a scene-to-scene adaptation of the new drama version. Still, the film held no comparison to the stage success of the play. Its significance was more retrospectively recounted, especially considering that the film made a bigger splash when it was reexhibited in 1923. In 1918 the Commercial Press established its film department and between 1918 and 1926 made over thirty landscape shorts, documentaries, and short feature films. But the films made before 1921 remained marginal in their impact. Not until the success of three feature-length films in 1921 did the domestic film industry come into view.

15. This standard narrative can be seen in the influential essay on new drama and Chinese cinema by Zhong Dafeng, "Lun 'yingxi'" (On 'shadow play'), *Beijing dianying xueyuan xuebao*, no. 2., 1985, collected in *Bainian Zhongguo dianying lilun wenxuan: 1897–2001* (Selected theoretical writings on one hundred years of Chinese cinema, 1897–2001), ed. Ding Yaping (Beijing: Wenhua yishu chubanshe, 2002), 1156–201. Zhong's narrative privileging family melodrama and the decline of new drama by the mid-1910s can be traced to as early as Zheng Junli's 1936 article "Xiandai Zhongguo dianying shilue." See *Zhongguo wusheng dianying*, 1389. See also Cheng Jihua, Xing Zuwen, and Li Shaobai, *Zhongguo dianying fazhan shi*, 22–23; Ge Yihong, *Zhongguo huaju tongshi* (Comprehensive history on Chinese spoken drama) (Beijing: Wenhua yishu chubanshe, 1990), 26–30. The latest reproduction of the same narrative can be seen in Xu Min, *Mingguo wenhua* (Republican culture), vol. 10 of *Shanghai tongshi* (Comprehensive history of Shanghai), ed. Xiong Yuezhi (Shanghai: Shanghai renmin chubanshe, 1999). Despite Xu Min's rich description summarizing the considerable range of secondary material, Xu still follows the same narrative line and regards post-1913 new drama as made of family melodrama and targeting a female audience. The interaction of serial adventure with new drama is missing from any of these histories.

16. See *Shenbao* and *Shibao*, 1911–21.

17. This interaction is further mediated by the stage borrowing of earlier and multiple sources, including Western detective fiction, the Chinese new novel, Chinese court case (*gong'an*) stories, and martial arts fiction.

18. These three films are *Yan Ruisheng* produced by Zhongguo yingxi yanjiushe (Chinese shadow play society), directed by Ren Pengnian and Xu Xinfu; *Red Beauty Skeleton* by Xinya Studio, directed by Guan Haifeng; and *The Sea Oath* by Shanghai Yingxi, directed by Dan Duyu. *Yan Ruisheng* (ten reels) was shown in Shanghai in July, 1921; *The Sea Oath* (six reels) was shown in January 1922; and *Red Beauty Skeleton* (ten reels) was shown in

May, 1922. See Li Suyuan and Hu Jubin, *Zhongguo wusheng dianying shi,* 67–78.

19. Li Suyuan and Hu Jubin, *Zhongguo wusheng dianying shi,* 68–69.

20. *Les vampires* was shown in Shanghai in 1917 with the distribution title *Yaodang* (The gang of evil spirits) and was highly popular. See the newspaper ad for *Yaodang* in *Shenbao,* June 6, 1917. The U.S. release of *Les vampires* also took place in 1917. It is possible that the film was imported to China through the United States given the large number of serial adventures it sent to China, whereas European exports to Asia were held back during the war.

21. Zheng Junli, "Xiandai Zhongguo dianying shilue."

22. Ben Singer, *Melodrama and Modernity: Early Sensational Cinema and Its Contexts* (New York: Columbia University Press, 2001), 176; Nicholas A. Vardac, *Stage to Screen: Theatrical Origins of Early Film—David Garrick to D. W. Griffith* (Cambridge: Harvard University Press, 1949).

23. Singer, *Melodrama and Modernity,* 178–82.

24. Singer, *Melodrama and Modernity,* 167–68.

25. See newspaper ads for film and theater programs between 1913 and 1921.

26. See play and film ads in *Shenbao,* 1911–17.

27. See note 14 on these films' popularity among Cantonese immigrants in Shanghai.

28. The reformed Beijing opera remained active, however, until the 1940s. They continued to stage spectacular realism with mechanized sets and adapted popular films back to the stage. The most famous example was *The Burning of the Red Lotus Temple,* made by Mingxing in 1928. A stage version was made in 1929 in the Great World, and a thirty-four-episode serialized play was shown from 1935 to 1939 on Gong wutai (Gong stage).

29. The story was translated from a Japanese translation of a French novel by the influential popular writer and journalist Chen Leng (pen name for Chen Jinghan [1878–1865]).

30. Ad for *It's Me* in *Dianying yuebao* 1 (April 1928).

31. *Shenbao,* July 30, 1916.

32. Yao Xufeng credits the play as the earliest new drama that staged mechanized sets. This is inaccurate judging from the fact that new drama plays around 1911 were already using mechanized sets, most famously for the new drama play *Twentieth-Century New Camellia.* See *Shen Bao,* October 3, 1911. Yao Xufeng, *Liyuan haishanghua* (Flowers of Shanghai in the pear garden) (Shanghai: Shanghai renmin chubanshe, 2003), 73.

33. Jennifer Bean, "Technologies of Early Stardom and the Extra-

ordinary Body," in *A Feminist Reader in Early Cinema*, ed. Jennifer Bean and Diane Negra (Durham, N.C.: Duke University Press, 2002), 412.

34. Ad for *It's Me* in *Dianying yuebao* 1 (April 1928).

35. Cheng Yan, "Tan yinpian zhong zhi wushu" (On martial arts in film), *Huaju tejuan* 2 (1927).

36. Gu Kenfu, "Fakan ci," *Yingxi zazhi* 1, no. 1 (1921): 8.

37. Andrew Morris, *Marrow of the Nation: A History of Sport and Physical Culture in Republican China* (Berkeley: University of California Press, 2004).

38. See Chen Tiesheng, ed., *Jinwu benji* (Record of Jinwu) (Shanghai: 1920).

39. Tennis, for example, was described as a mild sport most suitable for the summer and a benefit to *weisheng* (hygiene), as the sport helped cleanse the dirt from the blood circulation by sweating. See Chen Tiesheng, *Jingwu benji*, 122. On the construction of *weisheng* as a modern regime of power, see Ruth Rogaski, *Hygienic Modernity: Meanings of Health and Disease in Treaty Port China* (Berkeley: University of California Press, 2004).

40. See, for example, individual and group photographs in *Jingwu benji*, 47-58. Several male leading martial artists were wearing semi-nude costumes made from leopard skin.

41. Guo Weiyi, "Jingwu yingxiji" (Record of Jingwu film), in Chen Tiesheng, *Jingwu benji*, publicity page (page number not available).

42. Chen Gongzhe, *Jingwuhui wushinian* (Beijing: Chunfeng wenyi chubanshe, 2000), 50–52, 68. Chen mentions that his collaborator for the film, Cheng Zipei, was later known for his cinematography and made a film for Tianyi Studio entitled *Yiyun* (38).

43. Chen Gongzhe, *Jingwuhui wushinian*, 38–39.

44. Hong Shen, "Biaoyan shu" (The technology of acting), *Dianying yuebao* nos. 1-5, no. 1, 5 (1928).

45. Cheng Jihua et al., *Zhongguo dianying fazhan shi*.

46. Li Suyuan and Hu Jubin, *Zhongguo wusheng dianying shi*. In his most recent English history of Chinese cinema, Hu Junbin rearticulates the Northern Expedition as the predominant context for martial arts films. Hu Jubin, *Projecting a Nation: Chinese National Cinema before 1949* (Hong Kong: Hong Kong University Press, 2003).

47. Zhang Zhen, "Bodies in the Air: The Magic of Science and the Fate of the Early 'Martial Arts' Films in China," *Post Script* 20, no. 2 (2001): 43–60.

48. Zhang Zhen, "Bodies in the Air," 55–57. For the history of Shaw Brothers Studio, see Huang Ailing, ed., *The Shaw Screen* (Hong Kong: Hong Kong Film Archive, 2003).

49. Xi Chen, "Xiandai wenxue shang de xin langmanzhuyi," *Dongfang zazhi* 17, no. 12 (1920): 67–73. Du Shihuan, "Xin langman zhuyi de dianying" (Neoromanticist cinema), in *Dianying yu wenyi* (Film and literature), ed. Lu Mengshu (Shanghai: Liangyou chubanshe, 1928).

50. On the Chinese reception of neoromanticism in literature, see Shih Shumei, *The Lure of the Modern: Writing Modernism in Semicolonial China, 1917–1937* (Berkeley: University of California Press, 2001), 55–58, 239. As Shih Shumei forcefully argues, May Fourth writers' and critics' pragmatic use of Western modernism as a natural extension of a Western literary teleology in the service of their own discourse of progress has contributed to their interpretations of Western writers and thinkers in ways sometimes diametrically contrary to their use in Western modernism (58–68).

51. Chen Zhiqing, "Zailun xin yinxiong zhuyi de yingju" (A second discussion on the new heroist cinema), *Yinxing* 8 (May 1927): 11.

52. Ibid., 4.

53. Lu Mengshu, "Film and Revolution," in *Xinghuo* (Spark of fire) (Shanghai: Dianying shudian, 1927), 30.

54. For a detailed discussion on European national character discourse and its Chinese appropriation in the service of May Fourth literary modernity, see Lydia Liu, *Translingual Practice*, 45–76.

55. Traditionalism itself in mid-1920s China as a counterdiscourse against the May Fourth enlightenment was influenced significantly by Western critiques of modernity and often edged on a modernist self-Orientalism. For a cogent critical analysis of traditionalism, see Shih Shumei, *The Lure of the Modern*, chap. 6.

56. The frequent use of *life-force* in literary elitist discourse derives partly from Japanese literary critic Kuriyagawa Hakuson's *Kumon no shōchō* (The symbol of angst), which was translated by Lu Xun in 1924 and reprinted five times. Kuriyagawa used the notion of life-force as a combination of Bergsonian vitality and Freudian libido and attributed it as the source of literary and artistic creation. The new heroist critics added the Kuriyagawa understanding to Schopenhauer's notion of will and the Nietzschean notion of power, both of which were popular in China for over a decade.

57. Lu Mengshu, *Xinghuo*, 49.

58. See, for example, Du Shihuan, "Dong de minzuxing yu yangmeituqi" (The dynamic national character and self-assertion), *Yinxing* 7 (April 1927): 46–47; Zhang Weitao, "Yingxi zaji shiyi" (Random notes on film, no. 11), *Yinxing* 7 (April 1927): 32–33.

59. Zhang Weitao, "Yingxi zaji shiliu" (Random notes on film, no. 16), *Yinxing* 10 (July 1927): 30.

60. Chen Zhiqing, "Yipian jitu" (An infertile land), *Yinxing* 7 (April 1927): 16.

61. Tang Mengpu, "Guanyu *Canhua lei* de liangge wenti" (Two questions on *Broken Blossom*), *Yingxi chunqiu* 7 (April 1925): 16–17. The author complains about the offensive term *chink,* the stereotypical depiction of the Chinese as opium addicts, and Richard Barthelmess's ridiculously feminine and hunchbacked portrayal of the Chinese and his fetishistic attitude toward the white girl (Lillian Gish). The film was first shown in 1923 in Shanghai's Carlton Theater and was subsequently banned by the British for fear of "harming the China–Briton relationship." Reexhibited in 1925, the film did entail mass criticism from Chinese viewers. See also Chen Dingyuan, "Kanle *Canhua lei* yihou" (After seeing *Broken Blossom*), *Yingxi chunqiu* 7 (April 1925): 9. Both authors ask whether it would provoke the Western audience if the Chinese made similar derogatory films about the Western people and showed the films in the West.

62. K. K. K. "Ping *Qingnian jing* yingpian" (On *Warning for the Youth*), *Yingxi chunqiu* 12 (May 1925): 4–5. K. K. K. was the pen name for the later renowned Chinese director Cheng Bugao. See chapter 3 for more details on Cheng.

63. Wu Qingmin, "*Yuegong baohe* jiqi zai hu zhi piping" (*The Thief of Bagdad* and the criticism of the film in Shanghai) *Yingxi chunqiu* 7 (April 1925): 8–9.

64. Ibid.

65. The Chinese reaction toward the screen representation of an ethnic Mongolian as naturally Chinese registered a rather recent nationalist demarcation of Chinese nationality. The tension between ethnicity and nationality was touched upon by Lu Xun's critique of the Chinese audience's "overreaction" to *The Thief of Bagdad* in their willing confusion between the two ethnic groups. Lu Xun, "Lici cunzhao 3" (Evidence listed for your reference 3), originally published in *Zhongliu* (Midstream) 1, no. 3 (October 15, 1936), and collected in *Lu Xun quanji* (Complete works of Lu Xun), 10 vols. (Beijing: Renmin wenxue, 1956), 6:505. This confusion between ethnicity and nationality was facilitated by the eclectic stacking up of a racial stereotype: the Mongolian Khan (played by the Japanese actor Sojin), dressed in Qing-dynasty official costume with a scholar's fan and a long queue, was more recognizably Mandarin than Mongolian.

66. Wu Qingmin, "Yuegong baohe," 9.

67. This conflict was well registered by the modern Chinese literary icon Lu Xun, who wrote on Sternberg's visit to China in 1936. Recalling the "overreaction" of Chinese newspapers and journals to *The Thief of Bagdad*

years ago, Lu Xun was critical of Sternberg's negative portrayal of the Chinese in *Shanghai Express,* which evoked public outrage and resulted in its banning after only two days of screening in 1932. Sternberg's 1936 visit to China, much anticipated by Chinese intellectuals, disappointed most of them because of his defense of his Orientalist representation in *Shanghai Express* after his visit. While remaining critical of Sternberg, Lu Xun asked the Chinese to reflect, however, upon the negative portrayal of the Chinese by Sternberg and others and even suggested a complete translation of Arthur Smith's notorious *Chinese Characteristics* for "self-reflection, analysis, and reform." Lu Xun, "Lici cunzhao 3," 6:505.

68. Chen Zhiqing, "Zailun Xin yinxiong zhuyi," 12.

69. *Wenti ju* was a dominant May Fourth literary subgenre appearing in spoken drama and fiction. The name *problem drama* derived from the writers' shared desire to pose social concerns to the public through their portrayals of marriage freedom, women's rights, and so on. The most famous *wenti ju* were the Chinese adaptations of Ibsen's *A Doll's House* and Lu Xun's novella *Shangshi* (Regrets for things past), the former stirring widespread social debate over the question, "Where Should Nora Go after She Leaves Home?," the title of a famous essay by Lu Xun.

70. Ying, "Guanzhong de gongming" (The audience's resonance), *Huaju tejuan* 2 (1927): 17–18.

71. Ibid, 17.

72. *Hanyu wailaici cidian* (A dictionary of loan words in Chinese), ed. Liu Zhengtan et al. (Shanghai: Shanghai cishu chubanshe, 1984), 122. No major Chinese dictionary, including the authoritative *Zhonghua da cidian* (Great Chinese dictionary) and the Republican-period *Cihai* (Sea of words), indicates an archaic usage of the word. Other dictionaries indicate the absence of the term *gongming,* including *Gujin hanyu zidian* (The classical and modern Chinese dictionary), ed. Chu Yong'an et al. (Beijing: Commercial Press, 2003); *Zhonghua guhanyu zidian* (The ancient Chinese dictionary), ed. Jin Wenming et al. (Shanghai: Shanghai renmen chubanshe, 1997); and *Zhonghua diangu quanshu* (The complete dictionary of Chinese allusions), ed. Yu Changjiang et al. (Beijing: Zhongguo guoji guangbo chubanshe, 1994).

73. Shu Xincheng, *Cihai* (Shanghai: Zhonghua shuju, 1947), 161; and Shu Xincheng, *Cihai* (Shanghai: Zhonghua shuju, 1937), 349. "Resonance" is translated alternatively as *gongzheng,* which refers strictly to the scientific term without the additional metaphorical connotation that *gongming* carries. In classical Chinese, *gong,* whose ideograph depicts two hands holding a food or drinking utensil, is used as a verb meaning "to conduct together," "to share," or "to bear together"; as an adverb denoting "together"; and as a

preposition meaning "with." The character *ming,* a verb describing a bird's chirping, refers to other acoustic effects produced by musical instruments, human voices, and the clink of precious stones. *Hanzi xinyi fenxi zidian* (The Chinese character etymology dictionary), ed. Cao Xianzhuo et al. (Beijing: Beijing University, 1999), 171. A browse through *Siku quanshu* (Complete collection of the four treasuries), a comprehensive collection of classical Chinese writings compiled by the Qing imperial library, shows that there indeed have been instances of the characters *gong* and *ming* being used in conjunction, with *gong* serving as an adverb modifying the verb *ming,* referring to "sound produced together." These include the collective voicing of political opinions, birds flying and chirping together, leaves rustling in the wind, and ornamental stones on a horse colliding with each other (an allusion to riding horses together). Nevertheless, none of these conjoined appearances of the characters *gong* and *ming* indicate the existence of the word *gongming,* whereas in classical Chinese *ming* was often applied as a transitive verb followed by a noun, such as *gongming guoshi* (voicing together the right way for the country), *gong ming ke* (the clinking together of ornamental precious stones on a horse), and *gong ming qin* (playing the zither together).

74. Shu Xincheng, *Cihai;* see also Liu Zhengtan, *Hanyu wailaici cidian.*

75. Liu Zhengtan, *Hanyu wailaici cidian,* 21.

76. Writings in psychoanalysis and psychology were scattered throughout Chinese journals and newspapers in the 1910s (as early as 1907, Wang Guowei had translated Harold Höffding's *Outlines of Psychology*). John Dewey's (1919) and Bertrand Russell's (1920) visits to China spurred a wider interest in psychology and psychoanalysis. By 1931 over sixty-seven journals published articles on psychology; one major psychology journal, *Xinli zazhi* (The journal of psychology), lasted from 1922 to 1932. For some statistics on psychological publications in the early 1930s, see Zhang Yaoxiang, *Xinlixue lunwen suoyin* (Index of essays on psychology) (Shanghai: Nanxin, 1931).

77. On psychoanalysis and modern Chinese literature, see Zhang Jingyuan, *Psychoanalysis in China: Literary Transformations, 1919–1949* (Ithaca, N.Y.: East Asia Program, Cornell University, 1992).

78. These works include translations of J. B. Watson, William James, William McDougall, Le Bon, and more. Many of the works were translated from the English editions.

79. Ying, "Guanzhong de gongming," 17.

80. Ibid., 18.

81. Kuriyagawa Hakuson's *Kumon no shōchō* was translated into Chinese three times between 1921 and 1924, respectively by Ming Quan (pseudonym)

in 1921 for *Study Lamp,* by Feng Zikai for the Literary Association Series, and by Lu Xun in 1924 for the Beixin Bookstore. Lu Xun's rendition was reprinted five times. See Bonnie S. McDougall, *The Introduction of Western Literary Theories into Modern China, 1919–1925* (Tokyo: Center for East Asian Cultural Studies, 1971), 108.

82. A comparison between the *Huaju* essay and Lu Xun's and Feng Zikai's translations show that the *Huaju* author transposed the passages from the Lu Xun rendition, which is understandable given the popularity of the Lu Xun translation.

83. Lu Xun, preface to *Kumen de xiangzheng,* in *Lu Xun quanji,* 20 vol. (Shanghai: Lu Xun quanji chubanshe, 1938), vol. 13. Lu Xun recounts that Kuriyagawa traveled to the United States and Korea despite his amputated leg due to illness, although little is known about his activities in these two countries.

84. On the impact of *Kindai no ren-aikan* in May Fourth debates on love, see Lee Haiyan, *Revolution of the Heart,* 172–73. On the Chinese literary reception of *Kumon no shōchō,* see Jing Tsui, *Failure, Nationalism, and Literature: The Making of Modern Chinese Identity, 1895–1937* (Stanford, Calif.: Stanford University Press, 2005), 208–21.

85. Tian Han, "Xin lomanzhuyi ji qit," in *Tian Han quanji* (The complete works of Tian Han), 20 vols. (Shijiazhuang: Huashan wenyi chubanshe, 2000), 14:157–90.

86. Liu Ping, ed., *Tian Han zai Riben* (Tian Han in Japan) (Beijing: Renmin wenxue chubanshe, 1997), 437.

87. At the same time, Kuriyagawa recognizes the similarity between Freud's and Bergson's theories of dream and creativity. The latter locates *Energie Spirituel* as the source of varied forms of experience, not so remote from a Freudian account of dream content as a distortion of libido.

88. Kuriyagawa, *Kumen de xiangzheng,* 52.

89. Kuriyagawa, *Kumen de xiangzheng,* 64; Kuriyagawa, *Kumon no shōchō,* in *Kuriyagawa Hakuson zenshū* (Complete works of Kuriyagawa Hakuson), ed. Sakakura Tokutarō et al. (Tokyo: Kuriyagawa Hakuson shū kankōkai, 1924–25), 2:177.

90. The book was first translated in full by Luo Dixian in 1921–22, though his ninth lecture on neoromanticism was translated in 1920 for *Dongfang zazhi* (Eastern miscellany). Bonnie McDougall describes *Ten Lectures* as Kuriyagawa's most popular work in China. See McDougall, *Introduction of Western Literary Theories,* 108–9. By 1925 the book had been printed five times, and by 1929, seven times. See the catalog of the National Library of China.

91. Kuriyagawa Hakuson, *Xiyang jindai wenyi sichao* (Modern Western

literary and artistic movements), trans. Chen Xiaonan (Taipei: Zhiwen chubanshe, 1976), 40–71; originally published as *Kindai bungaku jukkō* (Ten lectures on modern literature) in 1910.

92. Kuriyagawa follows the Jung–Wiener school's idea that mood is the result of external stimuli reaching the central nerve and radiating to the full body.

93. Kuriyagawa, *Xiyang jindai wenyi sichao*, 343–49.

94. Ibid., 349.

95. Ibid., 351.

96. See Hans Ulrich Gumbrecht, *Atmosphere, Mood, Stimmung: On a Hidden Potential of Literature,* trans. H. Erik Butler (Stanford, Calif.: Stanford University Press, 2012). For an illuminating interpretation of *stimmung* in relation to German aesthetics, biology, and film theory, see Inga Pollmann, "Invisible Worlds, Visible: Uexkll's Umwelt, Film, and Film Theory," *Critical Inquiry* 39, no. 4 (2013): 777–816.

97. Kuriyagawa defines the content of this sharable human life as the realm of *Erlebnis (taiken)*. As Leslie Pincus describes, Bergson's writings were introduced to Japan as early as 1910, serving as a timely alternative to increasingly questioned German neo-Kantianism dominant in Japan since the 1890s. For Bergson's transitional role, Pincus highlights the emphasis on individual inwardness that persisted from *Lebensphilosophie* to Heideger's phenomenology and later constituted the Japanese thinkers' theorization of collectivity as made of subjects of inner experience identified with "culture." However, Kuriyagawa's interest in audience resonance inflected by German aesthetic theory and European social psychology seems to blur the internal and external experience. On Bergson and the discussion of experience in Japan, see Leslie Pincus, *Authenticating Culture in Imperial Japan: Kuki Shūzō and the Rise of National Aesthetics* (Berkeley: University of California Press, 1996).

98. Kuriyagawa, *Kumen de Xiangzheng,* 65.

99. Ibid.

100. A comparison between the Lu Xun and Feng Zikai translations of *Symbol of Angst* shows that the *Huaju* article is based on the Lu Xun version, judging from the correspondence of the exact wording that the article uses.

101. Ying, "Guanzhong de gongming," 18.

102. Kuriyagawa, *Kumen de xiangzhen,* 84–91.

103. Ibid., 89.

104. Henri Bergson, *Matter and Memory,* trans. N. M. Paul and W. S. Palmer (New York: Zone Books, 1988), 232–33.

105. Ibid., 207.

106. Bergson, *Matter and Memory,* 131.

107. Qian Zhixiu, "Xianjin liangda zhexuejiang xueshuo gailue" (Outlines of two major philosophers), *Dongfang zazhi* 10, no. 1 (1913).

108. These books include but are not limited to the following: Henri Bergson [Bogesen], *Chuanghua lun* (Creative evolution), trans. Zhang Dongsun (Shanghai: Commercial Press, 1919); *Xingershangxue xulun* (An introduction to metaphysics), trans. Yang Zhengyu (Shanghai: Commercial Press, 1921); *Wuzhi yu jiyi* (Matter and memory), trans. Zhang Dongsun (Shanghai: Commercial Press, 1922); *Xinli* (Mind energy), trans. Hu Guoyu (Shanghai: Commercial Press, 1924); *Shijian yu yizhi ziyou* (Time and free will), trans. Pan Zinian (Shanghai: Commercial Press, 1926); J. Solomon, *Bogesen* (Bergson), trans. Tang Che and Ye Fenke (Shanghai: Taidong tushuju, 1922); H. W. Carr [Ka'er], *Bogesen bian de zhexue* (The philosophy of change), trans. Liu Yanlin (Shanghai: Commercial Press, 1923). Most of the books were based on the English translation, some in reference to the Japanese translation (e.g., *Chuanghua lun*). These books were reprinted more than once in the 1920s, and by 1932 most of the Bergson books had been reprinted, notably after the Japanese invasion.

109. "Bogesen zhuanhao" (Special issue on Bergson), *Guotuo* 3, no. 1 (1921).

110. For two major collections of these debates, see *Renshengguan zhi lunzhan* (Debates on world view) (Shanghai: Taidong tushuju, 1923); *Kexue yu renshengguan* (Science and world view) (Shanghai: Yadong tushuguan, 1923). For a summary of this debate from the camp of Bergsonian metaphysics, see Zhang Dongsun, *Kexue yu zhexue* (Science and Philosophy) (Shanghai: Commercial Press, 1924).

111. Chen Zhiqing, "Yipian jitu," 15.

112. Ibid.

113. Chen Zhiqing, "Yipian jitu," 13.

114. Du Shihuan, "Xin langman zhuyi de dianying," 122.

115. Chen Zhiqing, "Zailun Xin yinxiong zhuyi," 12.

116. See *Huaju tejuan* 1–2 (1927).

117. He Ken, "Wo duiyu woguo dianying de guan'gan yu jiwang" (My viewing experience and hope for the films of our country), *Huaju tejuan* 2 (1927), 19.

118. He Ken, "Xianshi" (Poem of dedication), *Huaju tejuan* 1 (June 1927).

119. See the synopsis in *Dianying yuebao* 8 (1928).

120. On the phenomenological study of fire, see Gaston Bachelard, *The Psychoanalysis of Fire,* trans. Alan C. M. Ross (Boston: Beacon Press, 1964).

121. Ying, "Guanzhong de gongming," 17.

122. Ibid., 17–18.

123. Interestingly, *Volga Boatman* was shown in Japan with a similar audience response that deviated from the film narrative. The Japanese film critic Iwasaki Akira in his book *Film and Capitalism* (Eiga to shihon-shugi) points out the irony between the film's antirevolution sentiment and the Japanese authority's banning of the film for its mere association with Russia. The book was partly translated by Lu Xun into Chinese, retitled *Dianying yu youchan jieji* (Film and the propertied class). Iwasaki Akira, *Dianying yu youchan jieji*, vol. 4 of *Lu Xun quanji* (Beijing: Renmin wenxue, 1956). Originally published as *Eiga to shihon-shugi* (Film and capitalism).

124. Zhang Huimin, "Bianzhi *Baifurong* zhi dongji" (Our film design for *The White Lotus*), *Huaju tejuan* 1 (June 1927), 1.

125. Cheng Yan, "Tan yingpian zhong de wushu," 46.

126. Hua Hua, "Huaju gongsi xiao xiaoxi" (Brief news about Huaju company), *Dianying yuebao* 11–12 (September 1929): 8.

127. See Linda Williams, "Melodrama Revised," in *Refiguring American Film Genres: Theory and History*, ed. Nick Browne, 42–88 (Berkeley: University of California Press, 1998); Christian Gledhill, "Rethinking Genre," *Reinventing Film Studies*, 221–43.

128. Williams, "Melodrama Revised."

129. Lee, *Revolution of the Heart*, 52.

130. Ibid., 54.

131. Tom Gunning, "The Horror of Opacity: The Melodrama of Sensation in the Plays of André de Lorde," in *Melodrama: Stage, Picture, Screen*, ed. Jacky Bratton et al. (London: British Film Institute, 1994), 51.

132. Ibid., 53.

2. A Culture of Resonance

1. On notions of cultural interface in discussions of contemporary new media, see Lev Manovich, *The Language of New Media* (Cambridge, Mass.: MIT Press, 2001).

2. Wu Chongqing, "Shengming qingdiao de bianzou: Bogesen shengming zhexue zai xiandai zhongguo de liubian" (Variation of the melody of life: Permutations of Bergson's philosophy of life in modern China), *Fujian luntan*, no. 4, 1993, 14–20.

3. References to hypnotism can be found as early as 1898. See "Renli cuimianshu" (Hypnotism by human power), *Guangzhibao*, no. 17, June 5, 1898; "Renli cuimianshu" (Hypnotism by human power), *Zhixinbao*, no. 53, May 20, 1898. Lectures on hypnotism were serialized in newspapers, such as in *Dalu* in 1902, and hypnotism as a popular imagination appeared in late-Qing fiction.

4. "Cuimianshu de yuanyuan," special issue for the twentieth anniversary of *Xinling wenhua*, June 1931, 1–4.

5. English translations of these organizations were original. As Li Xin points out, hypnotism and psychical research were entwined at their introduction to China, which is shown in the conflation of spiritualism/mentalism/psychical research and hypnotism in their Chinese and English names.

6. English translation original. The title could be alternatively translated as the Chinese Society for Psychic Research, striking a resemblance to the English Society for Psychical Research.

7. Yu Pingke, *Shiri chenggong cuimian mishu* (Secret manual for successful hypnotism in ten days) (Shanghai: Shanghai zhongguo xinling yanjiuhui, 1929), 4.

8. J.,"Zhongguo xinling yanjiu hui xiaoxi" (News on the Chinese Institute of Mentalism), *Xinling wenhua* (Psychical culture), special twentieth-anniversary issue, 1931, 4–8.

9. Li Xin, "Zhongguo lingxue huodong zhong de cuimianshu" (Hypnotism in Chinese spiritualist movement), *Ziran kexueshi yanjiu* (Studies in the history of natural sciences) 28, no.1 (2009): 12–23, 14, 17.

10. In 1918 a "comparative performance of hypnotism and magic" was performed in a movie theatre in Tianjin. "Cuimianshu bing damoshu shiyan bijiao dahui" (Comparative performance between hypnotism and the great magic), *Dagongbao*, February 23, 1918; as quoted in Li Xin, "Zhongguo lingxue huodong zhong de cuimianshu," 11.

11. A *Dianjing* was a device that assisted hypnotism designed by Yu Pingke. It was a small metal disk that was moved slowly away and toward the subject so as to focus the subject's attention and induce trance. See Yu Pingke, *Dianjing cuimian fa* (Shanghai: xinling kexue shuju, 1921).

12. Yu Pingke, *Qianliyan* (Shanghai: Chinese Institute of Mentalism, 1929).

13. On an intricate affinity between photography and rubbing, see Wu Hung, "On Rubbings: Their Materiality and Historicity," in *Writing and Materiality in China* ed. Judith Zeitlin and Lydia Liu, 29–72 (Cambridge, Mass.: Harvard University East Asian Publications, 2003); on the rich history and methods of tracing and reproducing calligraphy in China, see Robert E. Harrist Jr., "A Letter from Wang Hsi-chih and the Culture of Chinese Calligraphy," in *The Embodied Image: Chinese Calligraphy from the John B. Elliot Collection,* ed. Robert E. Harrist Jr., Wen Fong, et al., 240–59 (Princeton, N.J.: The Art Museum, Princeton University).

14. Yu Pingke, *Qianliyan,* 57.

15. Ibid.

16. One of these sources is R. Osgood Mason's 1897 *Telepathy and the Subliminal Self,* in which Mason evokes *telepathy* as a metonymic term to subsume diverse psychic phenomena, including clairvoyance, thought transmission (telepathy), crystal gazing, hypnotism, and mesmerism. R. Osgood Mason, *Telepathy and the Subliminal Self* (New York: H. Holt and Company, 1897). Yu cites Mason's title in his book.

17. Hong Shen, "Biaoyan shu," *Dianying yuebao.* The serialized article was later collected in *Hong Shen xiju lunwen ji* (Collection of Hong Shen's Essays on Drama) (1934, Shanghai, Tianma shudian), in which he acknowledged his "reckless invention" to apply behavioral psychology to the technology of dramatic acting (*xiju biaoyan de jishu*).

18. Hong Shen, "Biaoyan shu," *Dianying yuebao* 2 (May 1928): 15.

19. Hong Shen, "Biaoyan shu," *Dianying yuebao* 3 (August 1, 1928): 22.

20. Ibid., 19.

21. On sympathy as a new moral discourse in relation to nationalism in China, see Haiyan, *Revolution of the Heart,* 221–55.

22. On the cultural politics of sympathy being contingent upon the epistemological gap between China and the West, see Eric Hayot, *The Hypothetical Mandarin: Sympathy, Modernity, and Chinese Pain* (New York: Oxford University Press, 2009).

23. Robert S. Cox, *Body and Soul: A Sympathetic History of American Spiritualism* (Charlottesville: University of Virginia Press, 2003), 26.

24. Hong Shen, "Biaoyan shu," *Dianying yuebao* 5 (August 10, 1928), 32.

25. Yu Pingke, *Dianjing cuimian fa,* 20.

26. Yu Pingke, *Dianjing cuimian fa,* 23.

27. Yu Pingke, *Qianliyan,* 52.

28. For photoplay fiction in the United States, see Anne Morey, "'So Real as to Seem Like Life Itself: The Photoplay Fiction of Adela Rogers," in *A Feminist Reader in Early Cinema,* ed. Jennifer Bean and Diane Negra (Durham, N.C.: Duke University Press, 2002), 333–46; for photoplay fiction in Japan, see Sarah Frederick, "Novels to See/Movies to Read: Photographic Fiction in Japanese Women's Magazines," *Positions* 18, no. 3 (2010): 727–69.

29. See, for example, Yu Tianfen, "Meigui nülang" (The lady of roses), *Hongmeigui* (Red roses) 1, no. 16 (October 1924).

30. Hu Chunbing, "Yinmushang de wenxue" (Literature on the screen), *Dianying yu wenyi* (1928): 27. Hu Chunbing was a noted writer and dramatist who helped found the semiofficial Vanguard (Qianfeng) Theater in Guangzhou. He joined the Chinese League of Left-Wing Writers in 1932. He wrote screenplays for a number of films in the 1940s and moved to Hong Kong after 1949. Hu was an advocate of Cantonese opera reform.

31. Ibid., 25–27.

32. Alexander R. Galloway, *Gaming: Essays on Algorithmic Culture* (Minneapolis: University of Minnesota Press, 2006), 41. See also Joel Snyder and Neil Walsh Allen, "Photography, Vision, and Representation," *Critical Inquiry* 2, no. 1 (1975): 143–69, for a discussion of the problem of the "camera-eye" analogy to human vision. For Snyder and Allen human vision is fundamentally unstable and should not be equated to an image: "Rather, the image is kept in constant involuntary motion: the eyeball moves, the image drifts away from the fovea and is 'flicked' back, while the drifting movement itself vibrates at up to 150 cycles per second" (152).

33. Galloway, *Gaming*, 41.

34. Peter Wollen, "On Gaze Theory," *New Left Review* 44 (March 2007): 91–106, 101.

35. Wollen, "On Gaze Theory," 104–6.

36. Maurice Merleau-Ponty, "The Film and the New Psychology," in *Sense and Non-Sense* (Evanston, Ill.: Northwestern University Press, 1964), 54; quoted in Wollen, "On Gaze Theory," 104–5.

37. Carl Du Prel, "Fernsehen als Funktion des transzendentalen Subjekts," *Sphinx* 15 (1893): 200–209, 305–16; quoted in Stefan Andriopoulos, "Psychic Television," *Critical Inquiry* 31 (Spring 2005): 618–37, 626.

38. Marilyn Fabe, *Closely Watched Films: An Introduction to the Art of Narrative Film Technique* (Berkeley: University of California Press, 2004), 6.

39. Yu Pingke, *Qianliyan*, 72. Yu used the English word *television* when discussing *dianshi*.

40. Ibid., 73; emphasis added.

41. Ju Zhongzhou, "Cuimianshu de gedi zhiliao" (Distant healing by hypnotism), *Xinling wenhua*, June 1931, 104–6, 104.

42. Shen Xiaose, "Dianyingjie de jizhong xin faming" (Several new inventions in the film world"), *Dianying yuebao* 9 (1929): 1–7.

43. The earliest reference to television I was able to locate occurred in 1924. See Fu Shengzhi, "Wuxian dianying zhi yanjiu" (The research on wireless cinema), *Liuri dongjing gaodeng gongye xuexiao tongchuanghui huizhi* (Journal for the alumni of Tokyo Advanced Institute of Technology) 4 (1924): 61–67. Increasing coverage of television appeared in 1928 and 1929. See "Kexue zhi zuixin faming: Wuxian dianying" (The most recent scientific invention: Wireless cinema), *Donglin xizhua* 7 (1928): 1–3; "Dianshi zhi yanjiu" (Research on television), *Lixin zazhi* 1 (1929): 45–46. More monographs on television were compiled and translated from English in the 1930s. See Zhang Zuoqi, ed., *Dianshi qianshuo* (Introduction to television) (Shanghai: Zhonghua shuju, 1933), based on Sheldon Harold Horton and Edgar Norman Grisewood, *Television: Present Methods of*

Picture Transmission (New York: D. Van Nostrand Company, 1929); *Dian-shixue qianshuo,* translated from R. W. Hutchinson, *Easy Lessons on Tele-vision,* trans. Chen Yuesheng (Shanghai: Commercial Press, 1935).

44. This understanding of new media technology as intersections of other technologies also existed in the U.S. term for television *radio movie.* See "Radio Movie," *Science and Invention* 16, no. 7 (November 1928): 622–23.

45. R. W. Burns, *Television: An International History of the Formative Years* (London: Institution of Electrical Engineers in Association with the Science Museum, 1998). For a report of the U.S. demonstration, see "Tele-vision Now Reality: Device Demonstrated," *Troy Record,* April 8, 1927; "Television for the Home," *Popular Mechanics* 49, no. 4 (April 1928).

46. See, for example, Shang Da, "Wuxian dianying jiangcheng shishi" (Wireless cinema will turn into reality), *Kexue* (Science) 10, no. 5 (1925): 670; Shuntin "Wuxian dianying" (Wireless cinema), *Mingxing tekan* (Mingxing special issues) 4 (1925): 1–3; Lu Bin "Wuxiandian chuanying" (Radio transmission of images), *Ertong shijie* (Children's world) 20, no. 8 (1927): 17; Kong Xiang'e, "Dianchuan xiang de chenggong yu dianchuan ying de jianglai" (The Success and future of electronic image transmis-sion), *Dongfang zazhi* (Eastern miscellany) 23, no. 22 (1926): 65–69; "Dianchuan xingxiang de shiyan," (Experiment on electric transmission of images), *Shizhao yuebao* (Signs of the times) 23, no. 3 (1928): 5; "Wuxi-andian chuansheng chuanying zhi xinfaming" (New invention on wireless transmission of sound and image), *Dongsheng jingji yuekan* (Manchu-rian economic monthly) 4, nos. 5–6 (1928): 24; Ni Mingda, "Dianchuan xinxiang" (Electric transmission of images), *Wuxiandian xinbao* (Radio bimonthly) 1, no. 1 (1929): 18–24; "Wuxiandian chuandi qise, dianshishu di sanbu jinzhan" (Wireless transmission of color, the third stage develop-ment of television technology), *Junshi zazhi* (Military journal) 16 (1929): 40; "Wuxiandian yousheng dianying zhi faming" (Invention of wireless sound film), *Qingnian you* (Youth friendship) 9, no. 6 (1929): 65.

47. The lecture was published as Édouard Belin, "Chuandi tuxiang de dianbao" (The telegraphed image), trans. Li Shuhua, *Zhonghua jiaoyujie yuekan,* 1926, 7–22, 12. See also two reports of the event, "Jishi: Bai Lanshi zai Beijing Zhongfa daxue ji Beijing daxue jiangyan shiyan qi suo faming zhe chuandi tuxiang de dianbao" (Mr. M. Édouard Belin gave a lecture and demonstration on the telegraphed image he invented at the Beijing Sino–French University and Beijing University), *Zhongfa jiaoyujia* (Chi-nese French educators) 2 (1926): 58–59. As early as 1922, Belin's invention of distant imaging was already introduced in China. See K Z, "Beilin shi wuxiandian de gailiang ji zhaoxiangfa" (Belin improves wireless technol-ogy and his methods for telephotographing," *Dongfang zazhi* 19, no. 11

(1922): 72–73. The earliest account of telephotography I could track down is "Chuanxing zhi delüfeng" (Telephone that transmits image), *Dongfang zazhi* 1, no. 8 (1904): 24. The brief description refers to the invention as originated in France and to the image formation based on the acoustic principle and the use of magnetics.

48. Kong Xiang'e, "Wuxiandian chuan shengyingji zhi yanjiu" (Research on an apparatus for the radio transmission of sound and image), *Kexue* (Science) 13, no. 3 (1928): 378–404.

49. A comparison shows that the *Dianying yuebao* illustration was taken directly from the illustration appearing in *Science and Invention* 16, no. 7 (November 1928). See Figure 2.8.

50. Shen's description of the tuning fork oscillators as synchronization device was conceived by Nipkow in the television system he envisioned in 1884. See Burns, *Television*, 85–86.

51. "Television for the Home," 529–30.

52. *Wuxiandian yu Zhongguo*, 530.

53. *Science and Invention* 16, no. 7 (November 1928): 618–36.

54. Lin Lübing, "Gao goumai wuxiandian shouyinji de pengyou" (For friends who plan to purchase a radio), part 1, *Funü zazhi* (Women's journal) 17, no. 5 (1921): 123–28; part 2, *Funü zazhi* 17, no. 5 (1921): 99–106; Zheng Fangyan, "Wuxiandian duandianbo zhi shoufa" (Broadcasting and receiving wireless shortwave), part 1, *Kexue* 10, no. 9 (1925): 1110–44; part 2, *Kexue* 10, no. 10 (1925): 1240–73; You Jiazhang, "Zizhi wuxiandian shoushouqi" (Self-made wireless receiver), *Xuesheng zazhi* (Students' magazine) 14, no. 5 (1927): 26–28. Such dissemination of self-help knowledge spread across a wide range of journals, whereas the magazines devoted to amateur wireless fans, such as *Yeyu wuxiandian* and *Zhonghua wuxiandian*, occurred almost a decade later. For early monographs on amateur-radio assembling and reception, see Lin Lübing *Shiyan wuxian dianhua shouyingji zhizaofa* (Methods of making experimental wireless radio) (1927); Hu Runtong and Su Zuguo, *Wuxiandian shouyin xuzhi* (Essential knowledge on wireless radio reception) (Shanghai: Sushi xiongdi gongsi, 1928).

55. Although I have yet to identify the document on the screening of *The Jazz Singer* in China, the sequel starring Al Jolson with a minstrel show at the end of the film, *The Singing Fool*, was shown in China in 1929. See "Shanghai dianyingyuan fangying yousheng dianying de lishi" (The history of sound film exhibition in Shanghai movie theaters), *Diansheng zhoukan* 5, no. 36 (1936): 932.

56. On the racial politics of blackface and Jewish assimilation into American society through entertainment, see Michael Rogin, *Blackface,*

White Noise: Jewish Immigrants in the Hollywood Melting Pot (Berkeley: University of California Press, 1996).

57. See Andrew Jones, *Yellow Music: Media Culture and Colonial Modernity in the Chinese Jazz Age* (Durham, N.C.: Duke University Press, 2001).

58. Bruce Clark, "Communication," in *Critical Terms for Media Studies,* ed. W. J. T. Mitchell and Mark Hansen (Chicago: University of Chicago Press, 2010), 135.

59. Paul Young, "Media on Display: A Telegraphic History of Early American Cinema," in *New Media, 1740–1915,* ed. Lisa Gitelman and Geoffrey B. Pingree, 229–64 (Cambridge, Mass.: MIT Press, 2003).

60. Belin, "Chuandi tuxiang de dianbao."

61. "Wuxian dianxin" (Wireless electronic communication), *Dalu bao* (The Continental) 9 (1904): 33–40.

62. Ibid., 35.

63. Ting Gong, "Weirao diqiu zhi wuxiandian" (Wireless electricity circles around the earth), *Xiehe* 4, no. 31 (1914): 8–11.

64. Ibid., 8.

65. Ni Shangda, "Dui rimei wuxiandian jiaoshe woguo zhengfu yingxing zhuyi zhidian" (Several issues on Japanese and American transactions on wireless technology with the government), *Dongfang zazhi* 21, no. 7 (1924): 41–44.

66. Li Fan, "Mingri zhi dianyingyuan" (Movie theater of tomorrow), *Dianying yuebao* 9 (1929): 1.

67. See "The Movie Theater of the Future," *Science and Invention* 16, no. 4 (August 1928): 317. The article itself quotes the *Los Angeles Times* and attributes the vision of stereoscopic movies to Douglas Fairbanks.

68. Li Fan, "Mingri zhi dianyingyuan," 1.

69. Zhong Yan, "Guangbo dianying xiyuan zhi jianglai" (The future of radio movie theater), *Dianying yuebao* 9 (1929): 1–3.

70. Except for the Chinese characters, these two pictures are identical to the illustrations accompanying "Television Drama of Tomorrow," *Science and Invention* 16, no. 8 (December 1928): 695. The Chinese article has taken information largely from this article.

71. Henri Bergson, *Matter and Memory,* trans. N. M. Paul and W. S. Palmer (New York: Zone Books, 1988), 208–9.

72. Several scholars have observed, however, that Bergson's view of reality as flux converges with Gustave Le Bon's popularization of radio activity. See Brian Petrie, "Boccioni and Bergson," *Burlington Magazine* 116 (1974): 140–47; Mark Antliff, *Inventing Bergson: Cultural Politics and the*

Parisian Avant-Garde (Princeton, N.J.: Princeton University Press, 1993); Linda Henderson, "Editor's Introduction," *Science in Context* 17, no. 4 (2004): 449.

73. Erhard Schüttpelz, "Trance Mediums and New Media: The Heritage of a European Term," in *Trance Mediums and New Media*, ed. Heike Behrend, Anja Dreschke, and Martin Zillinger (New York: Fordham University Press, 2012). I thank Professor Schüttpelz for generously sharing her paper and for the delightful exchanges concerning our shared interests across different cultural contexts.

74. Jaap van Ginneken, *Crowds, Psychology, and Politics, 1871–1899* (Cambridge: Cambridge University Press, 2002).

75. Andriopoulos, *Possessed.*

76. Sconce, *Haunted Media.*

77. Albert Kümmel and Petra Löffler, eds., *Medientheorie 1888–1933: Texte und Kommentare* (Frankfurt, 2002), 556; quoted in Schüttpelz, "Trance Mediums and New Media."

78. Zhang Zhen, "Bodies in the Air: The Magic of Science and the Fate of the Early 'Martial Arts' Films in China," in *Chinese Language Film: Historiography, Poetics, Politics,* ed. Sheldon Lu and Emile Yueh-yu Yeh, 52–75 (Honolulu: University of Hawaii Press, 2005), 54.

79. Ibid., 54, 70.

80. Zhang Zhen, "Bodies in the Air," 70.

81. Linda Henderson, "Editor's Introduction," 423–66, 452. I thank Linda for generously sharing the article and her other related writings on ether, modernist art, and "the fourth dimension."

82. See Linda Henderson, "Vibratory Modernism: Boccioni, Kupka, and the Ether of Space," in *From Energy to Information: Representation in Science and Technology, Art, and Literature,* ed. Linda Henderson and Bruce Clarke, 126–49 (Stanford, Calif.: Stanford University Press, 2002).

83. Henderson, "Editor's Introduction," 451–52.

84. Hu Danian, *China and Albert Einstein: The Reception of the Physicist and His Theory in China, 1917–1979* (Cambridge, Mass.: Harvard University Press, 2005), 89–94.

85. See Tan Sitong, "Yitai shuo" (On the ether) and "Renxue" (An exposition of benevolence), in *Tan Sitong quanji* (The collected works of Tan Sitong) (Beijing: Zhonghua shuju, 1981), 289–375, 432–34, respectively.

86. David Wright, "Tan Sitong and the Ether Reconsidered," *Bulletin of the School of Oriental and African Studies, University of London* 57, no. 3 (1994): 551–75.

87. Tan Sitong, "Yitai shuo," 293–94.

88. Wright, "Tan Sitong and the Ether Reconsidered," 570.

89. Ibid., 556.

90. Kang Youwei, *Datongshu*, ed. Zhang Xichen and Zhou Zhenfu (Beijing: Guji chubanshe, 1956), 2; English translation from Wright, "Tan Sitong and the Ether Reconsidered," 565.

91. Kang wrote the book during his exile in India in 1901 and 1902, although he is said to have conceived of the book in 1884. See Fung Yu-lan, *History of Chinese Philosophy*, trans. Derk Bodde (Princeton, N.J.: Princeton University Press), 685. David Wright has translated *yingxi* (shadow play), Kang's original word, as "picture" while acknowledging the term often referred to magic lantern shows.

92. Kang, *Dongtongshu*, 29.

93. Bruce Clarke, *Energy Forms: Allegory and Science in the Era of Classical Thermodynamics* (Ann Arbor: University of Michigan Press, 2001), 18.

94. Ibid., 20–21.

95. For a cogent analysis of Guo Moruo's Skydog as well as the influence of Bergson on Guo's literary poetics, see Mi Jiayan, *Self-fashioning and Reflexive Modernity in Modern Chinese Poetry, 1919–1949* (Lewiston, N.Y.: Edwin Mellen Press, 2004), 23–46.

96. Guo Moruo, "Shengming di wenxue" (Literature of life), *Shishi xinbao. Xuedeng*, February 23, 1920; English translation from Mi Jiayan, *Self-Fashioning*, 23.

97. Chinese scholar Yu Hui identifies *energy* as one of the most frequently used terms in Guo's early poetry and literary theoretical writings. See Yu Hui, "Xishou yu chonggou, Guo Moruo de shengming zhuyi shixue" (Absorption and reconstruction: Guo Moruo and his vitalist poetics) *Ankang shizhuan xuebao* 17, no. 4 (2005): 67–69, 68.

98. Bergson, *Matter and Memory*, 57.

99. Ibid.

100. Anne Friedberg, *The Virtual Window: From Alberti to Microsoft* (Cambridge, Mass.: MIT Press, 2006). See also Oliver Grau, *Virtual Art: From Illusion to Immersion*, trans. Gloria Custance (Cambridge, Mass.: MIT Press, 2003), 13.

101. Ibid., 11.

102. Friedberg, *The Virtual Window*, 11. By calling it "liminally immaterial," Friedberg seems to be emphasizing its immaterial aspect. In another discussion Friedberg describes the virtual as "a substitute . . . an immaterial proxy for the material . . . a key marker of a secondary order in the relationship between the real and its copy, the original and its reproduction, the image and its likeness." Friedberg, *The virtual window*, 8. I would call it "liminal materiality" to emphasize its peculiar materiality.

103. Ibid, 11.

104. Henderson, "Vibratory Modernism," 133.

105. W. J. T. Mitchell has eloquently discussed the problematic of the medium and opposing conceptual models to approach it. For Mitchell a medium poses a particular challenge when it comes to defining its boundary. The medium of painting, as he elucidates, should include the painter and the beholder as well as the collector and its space of exhibition. Hence, the in-betweenness of media should be considered as "ever-elastic middles that expand to include what look at first like their outer boundaries. The medium does not lie between sender and receiver; it includes and constitutes them." W. J. T. Mitchell, *What Do Pictures Want: The Lives and Loves of Images* (Chicago: University of Chicago Press, 2004), 204. Mitchell thus opposes the conception of the medium as a system with the medium as an environment, which he defines as "a medium through which messages are transmitted, and a medium in which forms and images appear" (208).

3. Dances of Fire

1. Cheng himself participated in the making of a newsreel on the bombing of Shanghai, *The Battle of Shanghai*.

2. "Jap Installation Work O.K.—Up to 1932," *Observer,* January 1944. Pickard is one of the forgotten technicians working for the movie exhibition venues in Shanghai. The article recounts James Pickard's experience working in Japan and Shanghai between 1925 and 1937, first as an advisor for telephone exchange installations in Japan after the earthquake in 1923 and then to install sound systems in movie theaters in Tokyo and China (Shanghai, Harbin, Hong Kong, and Hankou) starting in 1929. Between 1929 and 1937, Pickard traveled between the two countries frequently to install sound systems. I am much indebted to James Pickard Jr., the son of James Pickard, for generously sharing with me the article, other documents, and numerous photographs taken by his father.

3. I have yet to identify the film, although a published photograph of the Odeon Theater on fire (before it was destroyed as shown in Pickard's photo) gives some hints. In the photo, behind the same Chinese poster (unwrinkled) for the film, a large picture poster in the lobby can be seen advertising the sound film *The Cheat* (George Abbot, 1931) starring Tallulah Bankhead, a remake of Cecil B. DeMille's better-known silent version produced in 1915. The film is not a musical but features dance sequences and jazz music. See the photograph in Vladmir Zhiganov, *The Russian in Shanghai* (Shanghai: Slovo, 1936). I thank Steve Upton for showing me his private collection of the album.

4. I was able to find J. E. Pickard's name listed as a manager of Western

Electric of Asia (along with H. Bentley Mackenzie) in a list of foreign film engineering companies in Shanghai. See "Waiguo dianying zaihua zhuangkuang" (Foreign business in China), *Zhongguo dianying nianjian* (1934): 3 (pagination relevant only to individual sections). The Western Electric branch in Shanghai was advertised as Electric Research Products and prominently publicized in film journals for installing movie theater sound equipment. For example, see issues of *Yingxi zazhi* from 1931 to 1932.

5. The 1937 Hong book lists these companies as occupying the top (sixth floor) of the Capitol building, which is still standing in Shanghai today. I am grateful to William Krisel, son of Alexander Krisel, for the Hong book and other materials, as well as extended conversations in person and by fax, phone, and e-mail. A lawyer from New York, Alexander Krisel headed the General Film Exchange in Shanghai from 1929 to 1937. He also opened the law office of Krisel & Krisel with his brother. Through his liaison, Hollywood luminaries, including Mary Pickford, Douglas Fairbanks, and Charlie Chaplin, visited Shanghai. Interview with William Krisel, May 13, 2011. Alexander Krisel's 16 mm home films document the visits of these luminaries as well as their interactions with Chinese film stars and distributors, such as the movie queen Hu Die and Lo Kan, owner of the Grand Theater and the Cathay Theater.

6. See Pang Laikwan, *Building a New China in Cinema: The Chinese Left-Wing Cinema Movement, 1932–1937* (Lanham, Md.: Rowman & Littlefield, 2002), 3–5; Zhang Zhen, *An Amorous History*, 246–48. Both base their observations on Li Shaobai, "Jianlun Zhongguo sanshi niandai 'dianying wenhua yundong' de xingqi" (A brief account of the rise of the "film culture movement" in 1930s China), *Dangdai dianying* 60 (1994): 77–84.

7. Cheng Jihua, Li Shaobai, and Xin Zuwen, *Zhongguo dianying fazhan shi* (History of the development of Chinese cinema), 2 vols. (Beijing: Zhongguo dianying, 1963); Chen Bo, *Zhongguo zuoyi dianying yundong* (The Chinese left-wing movement), ed. Guangbo dianying dianshibu dianyingju dangshi ziliao zhengji gongzuo lingdao xiaozu (Beijing: Zhongguo dianying, 1993); Chen Bo and Yi Ming, *Sanshi niandai Zhongguo dianying pinglun xuan* (Selected essays of Chinese film criticism in the 1930s) (Beijing: Zhongguo dianying, 1993).

8. Li Shaobai has renamed the "left-wing cinema movement" *dianying wenhua yundong* (film culture movement) or *xinxing dianying wenhua yundong* (new film culture movement).

9. For a major collection by one of the most prominent soft-cinema advocates, see Liu Na'ou, *Liu Na'ou guoji yantaohui lunwenji* (Conference proceedings for the international symposium on Liu Na'ou), ed. Xu Qinzhen (Tainan: Guojia Taiwan wenxueguan, 2005); Xu Qinzhen,

Modeng, Shanghai, Xin Ganjue: Liu Na'ou, 1905–1940 (Taipei: Xiuwei zixun keji gufen youxian gongsi, 2008). For an anthology of Liu Na'ou's works, see Kang Laixin, ed., *Liu Na'ou quanji: Dianyingji* (Complete works of Liu Na'ou: Volume on cinema) (Xinying, Tainan: Tainan County Cultural Bureau, 2001).

10. Tian Han, *"Huo zhi tiaowu"* (*Dances of Fire*), *Modeng* (Modern) 2 (July 1929); collected in *Tian Han quanji* (Complete works of Tian Han) (Shijiazhuang: Huashan, 2000), 33–80.

11. Ibid., 52.

12. *Nero and the Burning of Rome* (E. S. Porter, 1908). For photographs and discussion of the film, see Charles Musser, *Before the Nickelodeon: Edwin S. Porter and the Edison Manufacturing Company* (Berkeley: University of California Press, 1991), 415, 431.

13. *Yingxi chunqiu* 1 (March 1925). The film, directed by J. Gordon Edwards, was publicized to be shown in Shanghai Theater for eight consecutive days starting on May 16, 1925. Another film featuring Nero burning Rome, *Quo Vadis* (Gabriellino D'Annunzio and Georg Jacoby, 1925) was also shown in Shanghai.

14. Other films with a great fire sequence, Fritz Lang's *Die Nibelungen* (1924), *The Last Days of Pompeii* (Carmine Gallone, 1925), and *Faust* (dir. F. W. Murnau, 1926), were also shown in Shanghai in 1927. See Lu Mengshu, *Dianying yu wenyi*, 18, 19, 21.

15. For an excellent discussion of Loie Fuller's *Fire Dance*, see Elizabeth Coffman, "Women in Motion: Loie Fuller and the 'Interpenetration' of Art and Science," *Camera Obscura* 17, no. 1 (2002): 73–104.

16. See Luo Liang, *The Avant-Garde and the Popular in Modern China: Tian Han and the Intersection of Performance, Politics, and Popularity* (Ann Arbor: University of Michigan Press, 2014), 96.

17. Tian Han, preface to *Tian Han xiqu ji* (Collected plays of Tian Han), vol. 5 (Shanghai: Xiandai shuju, 1930).

18. Marston Anderson, *The Limits of Realism: Chinese Fiction in the Revolutionary Period* (Berkeley: University of California Press, 1990), 182.

19. Ibid., 185.

20. Walter Benjamin, "The Paris of the Second Empire in Baudelaire," in *Charles Baudelaire: A Lyric Poet in the Era of High Capitalism*, trans. Harry Zohn (London: Verso, 1983).

21. Tom Gunning, "From the Kaleidoscope to the X-ray: Urban Spectatorship, Poe, Benjamin, and *Traffic in Souls* (1913)," *Wide Angle* 19, no. 4 (October 1997): 25–61.

22. Gunning, "From the Kaleidoscope," 32.

23. Ibid., 30.

24. Mao Dun, *Ziye* (Midnight) (Shanghai: Kaming, 1933), 256; cited in Anderson, *The Limits of Realism*, 184.

25. For a fascinating analysis of Tian Han's transformation in his dramatic and political career, see Chen Xiaomei, "Tian Han and the Southern Society Phenomenon," in *Literary Societies of Republican China*, ed. Kirk Denton and Michel Hockx, 241–78 (Lanham, Md.: Lexington Books, 2008); Luo Liang's *The Avant-Garde and the Popular in Modern China* provides a thorough study on Tian Han's career and posits a radical rethinking of the avant-garde.

26. Tian Han, "Women de ziji pipan: Women de yishu yundong zhi lilun yu shiji" (Our self-criticism: Our theory and practice of the artistic movement), *Nanguo* 2, nos. 2–3 (1930); collected in *Tian Han lun chuangzuo* (Tian Han on creative writing) (Shanghai: Shanghai wenyi, 1983), 78.

27. Ibid., 77.

28. Wu Cun, "Wu Cun zisu" (Wu Cun's own account), *Lianhua huabao* 3, no. 7 (1934).

29. Zhang Zhen, *Amorous History*, 249–51. This view is not so different from the official historiography's myth of left-wing cinema as inheriting the May Fourth tradition.

30. Ibid., 249. While the May Fourth Movement ended around 1921 and the literary scene significantly transformed around 1923, the tendency to overgeneralize May Fourth literature as a literary mainstream up to 1937 has persisted. Michel Hockx has challenged this tendency to oversimplify May Fourth literature and the changes afterward as well as the complexity of the broader scope of cultural field. See Michel Hockx, "Is there a May Fourth Literature? A Reply to Wang Xiaoming," *Modern Chinese Literature and Culture* 11, no. 2 (1999): 40–52; see also Michel Hocks, *Questions of Style: Literary Societies and Literary Journals in Modern China, 1911–1937* (Leiden: Brill, 2003).

31. Hong Shen, preface to Vsevolod Pudovkin, *Kino-rezhisser i kino-material* (Film director and film material), trans. Xia Yan and Zheng Boqi, in *Dianying daoyan lun dianying jiaoben lun* (Film directing and screenplay writing) (Shanghai: Chenbaoshe, 1933), 1–2, 1.

32. Xia Yan, *Torrent* film script, *Dianying daoyan lun dianying jiaoben lun*, appendix, 18–19.

33. Anne Friedberg, *Windowshopping: Cinema and the Postmodern* (Berkeley: University of California Press, 1993), 20–29.

34. Ibid., 2.

35. Anderson, *The Limits of Realism*, 184.

36. Anderson, *The Limits of Realism*, 184. Ding Ling's "Water" also shares a good deal of narrative with *Torrent*, the former being a story about

an uprising in the middle of a flood. Xia Yan wrote the screenplay for *Torrent* in 1932, shortly after "Water" was published and gained rave reviews.

37. Cheng Bugao, *Yingtan yijiu* (Remembrance of the film world) (Beijing: Zhongguo dianying chubanshe, 1983), 5–13.

38. Li Shaobai, "Jianlun Zhongguo sanshi niandai 'dianying wenhua yundong' de xingqi."

39. Ibid., 80.

40. See Xu Xingzhi, "Xinxing meishu yundong de renwu" (The task for newly emergent art), *Yishu* 1 (1930); Feng Zikai, *Xiyang jianzhu jianghua* (Lectures on Western architecture) (Shanghai: Kaiming shudian, 1935); Shi Shumei identifies *xinxing* as referring to "from post-October Revolution Soviet Union." Shi Shumei, *The Lure of the Modern*, 287. Li Shaobai seems to be straddling between a gesture to relate the film movement to the leadership of the left wing and the Communist Party and an effort to recount the film movement as a more encompassing "united front" congealing a diverse range of the film world. The reference to "xinxing dianying wenhua yundong" is not attributed to the Japanese use but is associated more directly with the May Fourth new culture movement, treating the left-wing film movement as its extension.

41. Reference to "emergent" art includes American proletarian art, notably the proletarian theater New Playwright Group, in which John Dos Passos participated. See "Riben yanchu meiguo xinxing xiju" (American new drama being performed in Japan), *Xiandai wenxue* 1, no. 6 (1930): 203–4; Shi Cong, "Meiguo de xinxing xiju" (New drama in America), *Shishi leibian* 5 (1935): 84–86.

42. Ye Cheng, "Guanyu dianying de jige yijian" (Several suggestions for film), *Shalun* 1 (1930): 45–50.

43. Although Chinese left-wing drama movement has been discussed in relation to Japanese avant-garde and proletarian drama practices, no study as of today has paid attention to the connection between Chinese left-wing cinema and Japanese proletarian film movement. Instead, the Chinese left-wing film movement was studied in isolation as a local movement. On left-wing drama's Japan connection, see See Liu Ping, "The Left-Wing Drama Movement in China and Its Relationship to Japan," trans. Krista Van Fleet Hang, *Positions* 14, no. 2 (2006): 449–66. See also the issue devoted to proletarian art guest edited by Heather Bowen-Struyk. On Japanese proletarian film movement, see Markus Nornes, *Japanese Documentary Film: The Meiji Era through Hiroshima* (Minneapolis: University of Minnesota Press), chap. 2.

44. Lu Xun translated Iwasaki's excerpt published in *Shinkô geijutsu* nos. 1 and 2 in 1930, before Iwasaki published the book in 1931. The original

title for the article was "Zuowei xuanchuan, shandong shouduan de diany-ing" (Film as the instrument for propaganda). Lu Xun, "Xiandai diany-ing yu youchan jieji" (Film and the propertied class) "Dianying" *Mengya yuekan* 3, no. 1 (1930).

45. "Shukan faxing," in *Shanghai chubanzhi* (Shanghai: Shanghai she-hui kexueyuan, 2000).

46. See Ge Fei, "Dushi xuanwo zhong de duochong wenhua shenfen yu luxiang" (Multiple cultural identities and orientations in the urban mael-strom), *Zhongguo xiandai wenxue yanjiu congkan* 1 (2006): 158–74.

47. Vladimir M. Friche, *Yishu shehuixue* (The sociology of art), trans. Liu Na'ou (Shanghai: Shuimo shudian, 1930). Liu's translation of *The Sociology of Art* as well as his essays on Soviet literature published in *Xinwenyi* are now anthologized in *Liu Na'ou quanji, Lilunji*. Other books on the Left front published by the bookstore include Marc Ickowicz, *Weiwu shiguan de wenxuelun* (Historical materialist literary theory), trans. Dai Wangshu (Shanghai: Shuimo shudian, 1930), and Nikolai Bukhari, *Youxian jieji de jingji lilun* (Imperialism and the world economy), trans. Zheng Kan (Shanghai: Shuimo shudian, 1930).

48. Liu Na'ou, "Ecranesque," *Xiandai dianying* (Modern screen) 1, no. 2 (1933): 1.

49. Shi, Shumei, *The Lure of the Modern*, 287.

50. Marie-Laure Ryan, "On the Theoretical Foundations of Trans-medial Narratology," *Narratology beyond Literary Criticism: Mediality, Disciplinarity*, ed. Jan Christopher Meister, Tom Kindt, and Wilhelm Schernus, 1–24 (Berlin: Walter de Gruyter GmbH, 2005), esp. 14–18.

51. Liu Na'ou, "Yingpian yishu lun," 105.

52. Liu Na'ou, "Yingpian yishu lun," 105. I have retained the ambiguity of sound recorder/radio in the translation of *shouyinji*, which refers to both due to the ongoing interest in connecting radio technology with sound re-cording technology.

53. The notion of an eighth art draws from a Japanese literary and art dictionary that includes literature, music, painting, drama, architecture, sculpture, and dance as the seven arts. See Zhang Ruogu, "The Eighth Art," *Yinxing* 8 (1927).

54. Huang Zibu (pen name for Xia Yan), Xi Naifang (pen name for Zheng Boqi), Ke ling (Yao) Su Feng, "Chengshi zhiye ping" (On *The Night of the City*), *Chenbao*, March 9, 1933.

55. Ibid.

56. Zheng Boqi, "Duiyu dianying piping de xiwang" (Anticipations to film criticism), January 1, 1934, collected in Zheng Boqi, *Liangqi ji* (Shang-hai: Liangyou, 1937), 135–38; Zheng Boqi (aka Naifang), "Piping yu yanjiu"

(Criticism and research), *Dianying huabao* (The screen pictorial) 10 (April 15, 1934): 3.

57. Zheng Boqi, "Baiwan jin" (Le million), *Liangqi ji*, July 4–5, 1933, 159–68, esp. 163–64.

58. Hong Shen et al., "Women de chenshu: Jinhoude pipan shi 'jian-shede'" (Our statement: Criticism from now will be "constructive"), *Chenbao*, "Meiri dianying" column, June 18, 1933.

59. Liu Na'ou, "Zhongguo dianying miaoxie de shendu wenti" (The question of in-depth description in Chinese film), *Xiandai dianying* (Modern Screen) 1, no. 5 (1933), 2–3. Liu's discussion of "close-up in time" explicitly refers to Pudovkin, whose essay "Close-ups in Motion" was translated into Chinese by the left-wing dramatist and screenplay writer Xia Yan. See Huang Zibu (aka Xia Yan), "Shijian de 'texie'" (Close-ups in time), *Mingxing yuebao* 1, no. 1 (1933): 1–7.

60. Liu Na'ou, "Ecranesque," 1.

61. Liu Na'ou, "Yingpian yishu lun," 106. Liu does not specify to what the "thin membrane" refers, although the syntax hints at the celluloid. There remains, however, an ambiguity whether the "thin membrane" refers to the human eye or the celluloid, just as in the next quote he uses "the eye's membrane" to describe a camera.

62. Ibid.

63. Malcolm Turvey, *Doubting Vision: Film and the Revelationist Tradition* (Oxford: Oxford University Press, 2008).

64. A quick search through *Cine-cinea*, the major French film journal in the 1920s, confirms the use of *écranesque* as a general term closest in meaning to "cinématographique." *Le grand Robert de la langue française* identifies the word as being used in 1923 to refer to cinema. *Le grand Robert de la langue française,* 2nd ed. (Paris: Dictionnaires le Robert, 2001), 1851.

65. Liu Na'ou, "Ecranesque," 1.

66. For a cogent socioeconomic analysis of film industry, see Shu Yan, "Zhongguo dianying de benzhi wenti" (Essential questions of Chinese cinema), *Mingxing yuebao* 2, nos. 5–6 (1935): 1–5; Zheng Boqi, "Dianying de fazhan guocheng" (On the development of film), *Dianying huabao* 37 (1937): 9–10. Both articles understand the "essence" of cinema in terms of its material–technological and cultural uses as the mechanical product of industrial society and the economic operation of capitalism.

67. Cai Chusheng, "Zhaoguang" (Light of the dawn), *Xiandai Dianying* (Modern screen) 1 (March 1933).

68. Ellipses are in the original.

69. Advertisement for *The Simpleton's Luck, Huaju tejuan* 1 (1927).

70. Cai's connection with Huaju as well as several other martial arts

studios is absent in Cheng Jihua's *The History of Development in Chinese Cinema,* which remains reticent about Cai's career between 1927 and 1929. The fact that Cai was still a high official in the Chinese Film Bureau by the time of the book's writing could be a prescient factor for the book's "sanitization" of Cai's career history. Cai's self-distancing from Huaju was already at work by 1936, when he accounted for his bitter conflicts with Huaju's owner and described his apprenticeship at Huaju as a last resort rather than a voluntary choice. Judging from the fact that he acted for the Huaju production in Shantou in 1927 and left for Shanghai and joined the Huaju studio in the same year, it is highly probable that he had followed the studio to Shanghai. This self-censorship of his connection with martial arts productions might have contributed to the jarring narrative in the left-wing film critic Ling He's brief biography of Cai Chusheng in 1936. See Ling He, "Lun Cai Chusheng" (On Cai Chusheng), *Zhonghua tuhua zazhi* (Chinese pictorial journal) 44 (July 1936). The other minor studios Cai worked for include Naimei Studio and Hanlun Studio, established respectively by the first-generation Chinese female film stars Yang Naimei and Wang Hanlun. Interestingly, the two films Cai participated in making for these two studios were both martial arts films and, specifically, *nüxia* films featuring female knights-errant. Cai was an assistant director for *Qi nüzi* (The incredible woman, Shi Dongshan, 1928, Naimei Studio) and an actor in for *Nüling fuchouji* (The revenge of the female actress, Bu Wancang, 1929, Hanlun Studio). All the other films Cai assisted in making during this period in Tian Yi and other studios were martial arts films, including *Shuangxiong doujian* (Duel swordplay of the two heroes, Shi Dongshan, 1929, Tianyi Studio), *Huangtang jiangjun* (Ridiculous general, Shi Dongshan, 1929, Tianyi Studio), *Wudi yingxiong* (Invincible hero, Shao Zuiweng, 1929, Tianyi Studio)—Cai was listed in the credits as the screenplay writer—and *Rexue nan'er* (Hot-blooded men, Wan Laitian, 1929, Minxin Studio). See Ling He, "Lun Cai Chusheng," and the film catalog in Cheng Jihua's *The History of Development in Chinese Cinema.*

71. Ling He documents only four films that Cai assisted Zheng in making. Cheng Jihua's *The History of Development in Chinese Cinema* book mentions six films but lists only four of the film titles. The absent two could be the two screenplays Cai wrote for Mingxing that were rejected, including *She de nüxing* (The serpentine woman) and *Xin yingxiong* (The new hero). See Ling He, "Lun Cai Chusheng."

72. For articles on *Pink Dream,* see *Chenbao,* "Meiri dianying" column, September 6, 1932; collected in Chen Bo and Yi Ming, *Sanshi niandai Zhongguo dianying pinglun xuan* (Shanghai: Shanghai renmin chubanshe, 1993).

73. Lu Si, "Heshi cong mengzhong xinlai?" (When do we wake up from

a dream?), in Chen Bo and Yi Ming, *Sanshi niandai*, 331–32. On the trope of awakening in Chinese films in the 1930s, see Zhang Zhen, *An Amorous History*, 254–67.

74. On the trope of awakening in Shanghai cinema after 1932, see Zhang Zhen, *Amorous History*, 254–61.

75. Xi Naifang (Zheng Boqi), "Ping *Fenhongse de meng*: Meiguopian de yingxiang" (On *Pink Dream*: The influence of American films), in Chen Bo and Yi Ming, *Sanshi niandai*, 324–27.

76. Ke Ling and Yi Wen, "*Duhui de zaochen* ping yi" (Some thoughts on *Dawn over the Metropolis*), *Chenbao*, "Meiri dianying" column, March 22, 1933.

77. Huang Jiamo, "Yingxing yingpian yu Ruanxing yingpian" (Hard film versus soft film) *Modern Screen* 1, no. 6 (December 1933): 3.

78. Cai Chusheng, "Bashisi tian zhihou: gei yuguangqu de guanzhong men" (After eighty-four days: To the audience of *Song of the Fisherman*), in *Zhongguo zuoyi dianying yundong* (Chinese Left-wing movement) ed. Chen Bo (Beijing: Zhongguo dianying, 1993), 364–65; originally published in *Yingmi zhoubao* (Movie fan weekly) 1, no. 1 (September 1934).

79. For an insightful reading of the notion of time and the use of photography in *The New Woman*, see Hong Guojuin, "Framing Time: New Woman and the Cinematic Representation of Colonial Modernity in 1930s Shanghai," *Positions, East Asian Cultural Critique* 15, no. 3 (2007): 553–80.

80. Vsevolod Pudovkin, *On Film Technique: Three Essays and an Address*, trans. and ed. Ivor Montagu (London: Victor Gollancz, 1929), 16–17.

81. Kristine Harris, "The New Woman Incident: Cinema, Scandal, and Spectacle in 1935 Shanghai" in *Transnational Chinese Cinemas: Identity, Nationhood, Gender* ed. Sheldon Hsiao-peng Lu (Honolulu: University of Hawaii Press, 1997), 277–302, 297.

82. On the politics of popular music in Republican China, see Andrew Jones, *Yellow Music: Media Culture and Colonial Modernity in the Chinese Jazz Age* (Durham, N.C.: Duke University Press, 2001).

83. For a cogent analysis of *Roar, China* in terms of both the Chinese woodcut movement and the stage play, see Tang Xiaobing, *Origins of the Chinese Avant-Garde* (Berkeley: University of California Press, 2007), 213–28.

84. Harris, "The New Woman Incident," 297.

4. Transparent Shanghai

1. Feng Zikai, "Boli jianzhu" (Glass Architecture) *Xiandai* 2, no. 5 (1933): 660–62. *Les contemporains* is the original French title for the journal.

2. Feng mentions that he read Scheerbart's *Glasarchitektur* (1914)

through an abridged Japanese translation."Boli jianzhu," 661. In his 1935 book on Western architecture, he cites the Japanese art critic Itagaki Takao's books on Western architecture as his sources.

3. Walter Benjamin, "Experience and Poverty," in *Walter Benjamin: Selected Writings*, vol. 2, trans. Rodney Livingstone and others, ed. Michael W. Jennings, Howard Eiland, and Gary Smith (Cambridge: Harvard University Press, 1999), 731–36.

4. Feng Zikai's essay is not his only work on architecture. In 1935 Feng published *Lectures on Western Architecture*, which is considered one of the first book-length treatments of Western architectural history. Feng Zikai, *Xiyang jianzhu jianghua* (Lectures on Western architecture) (Shanghai: Kaiming shudian, 1935).

5. Walter Benjamin, "The Work of Art in the Age of its Technological Reproducibility," Second Version, Section XVIII, 31.

6. Sergei M. Eisenstein, "Montage and Architecture," *Assemblage* 10 (1989): 116–31.

7. Jay Leyda and Zena Voynow, *Eisenstein at Work* (New York: Pantheon Books, 1982). For a detailed study of *The Glass House,* see Francois Albera, *Glass House de Sergei M Eisenstein* (Paris: Les presses du réel, 2009).

8. Luo Fu, "Boliwu zhong toushizhe" (Those who throw stones in a glass house), *Chenbao*, "Meiri dianying" column, June 19, 1934.

9. Ibid.

10. Huang Jiamo, "Yingxing yingpian yu ruanxing yingpian," 3.

11. Liu Na'ou, "Zhongguo dianying miaoxie de shendu wenti," 3.

12. Christianity was introduced to China as early as the seventh century. Architectural historian Yang Bingde traces the appearance of Western architectural style even earlier to the sixth century, where he has spotted features of Ionic columns in the Longmen Grottoes. See Yang Bingde and Cai Meng, *Zhongguo jindai jianzhu shihua* (History of Modern Chinese Architecture) (Beijing: Jixie gongye chubanshe, 2004), 64–65.

13. Yang Bingde, *Zhongguo jindai Zhongxi jianzhu wenhua jiaorongshi* (The history of Sino–Western architectural exchange in modern China) (Wuhan: Hubei jiaoyu chubanshe, 2003), 127–228.

14. Chen Congzhou and Zhang Ming, eds., *Shanghai jindai jianzhu shigao* (Modern Shanghai urban architecture) (Shanghai: Sanlian shudian, 1988), 50–55; Zheng Shiling, *Shanghai jindai jianzhu fengge* (Shanghai: Shanghai jiaoyu chubanshe, 1995), 210–16.

15. Chinese architecture historians often demarcate 1930 as the rough transition from art deco (1927–30) to modernist architecture (1930s). See Yang Bingde and Cai Meng, *Zhongguo jindai jianzhu shihua*, 123–38.

16. See, for example, the Shanghai Empire Building, a drawing and

photograph of which appears in *Zhongguo jianzhu* 3, no. 4 (September 1935). Other examples include the Heji Apartment, the Capital Hotel, and the Meigu Apartment; all were featured in *Zhongguo jianzhu* 3, no. 3 (1935) and designed by the Allied Architects (Huagai jianzhu shiwusuo). See also the Japanese Language School in Tianjin (1934), which highlights the borders of the rectangular horizontal windows with white painted borders. The building also features two cylindrical columns that resemble factory or steamship chimneys. Yang Bingde, *zhongguo jindai zhongxi jianzhu wenhua jiaorong shi*, 215.

17. See, for example, the Shanghai branch of Zhejiang Xingye Bank (1931) in contrast to its Hangzhou branch, built with grand baroque style in 1923; see also design and photographs of the Ministery of Foreign Affairs' office building in Nanjing and Guangdong Bank in Shanghai (1934). *Chinese Architect* 3, no. 3 (August 1935): 29–33, 4–5, respectively.

18. Yang zhaohui, "Yinhang jianzhu zhi neiwaiguan" (On the exterior and interior of bank buildings), *Chinese Architect* 1, no. 4 (October 1933): 1–3.

19. *Zhongguo jianzhu* 2, no. 5 (1934): 1–33.

20. Winfried Nerdinger, ed., *Bruno Taut, 1880–1938: Architekt zwischen Tradition und Avantgarde* (Stuttgart: Deutsche Verlags-Anstalt, 2001), 345–46.

21. Peter Boeger, *Architektur der Lichtspieltheater in Berlin: Bauten und Projekte 1919–1930* (Berlin: W. Arenhövel, 1993), 21. My thanks go to Olivier Lugon for pointing out this connection to Bruno Taut's project and for his generous help with the German texts.

22. A culmination of such an architectural discourse was showcased in the 1932 Berlin architectural exhibition Sonne, Luft und Haus für alle (Sun, air and house for everyone), May 14 to August 7, 1932. See *Sonne, Luft und Haus für alle: Ausstellung Für Anbauhaus Kleingarten U. Wochenende, 14 Mai-7, Auust. Amtlicher Katalog Und Führer*, exhibition catalog (Berlin: Bauwelt-Verlag, 1932). See also Sigfried Giedion, *Befreites Wohnen* (Liberated living) (Zürich: Orell Füssli Verlag, 1929). The book cover features the typography of "Licht, Luft, Öffnung" (light, air, and opening).

23. Emphasizing privacy by limiting the field of vision via architectural design is not seen in a group of photographs of the Waiblingen country hospital (1926–28), showcased in Giedion, *Befreites Wohnen*, 57–58. The building shares the receding vertical lines of the floors at the Hongqiao Sanatorium, yet the photographs in the Giedion book frame the building's exterior to accentuate an *openness* to sun and air as well as the community, by emphasizing the horizontal span rather than the receding vertical line,

as in the case of pictorial and photographic representations of Hongqiao Sanatorium. Sigfried Giedion, *Befreites Wohnen*, images 57 and 58.

24. Giedion, *Befreites Wohnen*, caption for image 5.

25. Beatrice Colomina has discussed at great length modernist architecture's relationship with mass media in the European contexts in the 1920s. See Beatrice Colomina, *Publicity and Privacy: Modern Architecture as Mass Media* (Cambridge, Mass.: MIT Press, 1996).

26. *Chinese Architect* 2, no. 3 (1934): 10.

27. Ibid., 12.

28. Yang Bingde, *Zhongguo jindai jianzhu wenhua jiaorong shi*, 230–59; *Shanghai jindai jianzhu shigao*.

29. *Shanghai jindai jianzhu shigao*, 163.

30. Frank Dikötter, *Exotic Commodities: Modern Objects and Everyday Life in China* (New York: Columbia University Press, 2006), 164–65. The earliest image I was able to locate, thanks to Frances Terpark at the Getty Research Institute, is a lithographic print of a daguerreotype documenting the Cantonese merchant Pan Shicheng's (Paw-ssé-tchen) garden, with an aviary by Jules Itier, a daguerreotypist himself who produced the earliest preserved photographs of China. Jules Itier, *Journal d'un voyage en Chine en 1843, 1844, 1845, 1846* (Paris: Dauvin et Fontaine, 1848–1853). In the picture the plane, gridded windows on the ground floor suggest the use of plate glass. Itier's account of the daguerreotype refers to the building as the residence for his concubines as well as his other exotic collections, including a magic lantern, an optical room (*chamber optique*), a steamboat model, and a steam machine in a glass cage. Itier, *Journal d'un voyage en Chine*, vol. 3, 39–44. Meanwhile, unofficial historical accounts describe how Pan housed his dozen or so concubines in a building (presumably the same building Itier photographed) whose windows and walls are made of glass so as to monitor their sexual behavior. *Qingchao yeshi daguan* (Unofficial history of Qing dynasty), vol. 6 (Shanghai: Shanghai shudian, 1981), 110–11.

31. Wang Tao, *Yingruan zazhi* (Miscellaneous notes from the seaside) (1875; repr., Shanghai: Guiji chubanshe, 1989), 115.

32. See, for example, *Dianshizahi huabao*, vol. *jia* (19) (1884): 80; *Dianshizahi huabao*, vol. *xin* (1) (1886): 5. A late nineteenth-century photographic postcard shows the use of glass windows at the famous Qingliange (Paradise fun storytelling hall). See Catherine Yeh, *Shanghai Love: Courtesans, Intellectuals, and Entertainment Culture, 1850–1910* (Seattle: University of Washington Press, 2006), 103.

33. See, for example, Ding Weiliang (W. A. P. Martin), "Lun boli" (On Glass) *Zhongxi wenjianlu* (The Peking Magazine) 2 (September 1872):

79–83; Zhang Chisan, "Moguang bolijin" (Polished glass lens), *Jiaohui xinbao* (Church news), August 17, 1872, 199; "Aoguo jinshi: Boli zhiyi" (Recent news on Austria: Clothes made of woven glass), *Zhongxi wenjianlu* 10 (May 1873): 62; "Renxing boli" (Resilient glass), *Gezhi huibian* (The Chinese scientific magazine) 1 (February 1876): 9–10; "Shanghai Gezhi shuyuan nishe tieqian bolifang wei bowuguan shuo (futu)" (Shanghai Polytechnic Institution plans to build an iron and glass house for the museum [with illustration]), *Gezhi huibian* 2 (1877): 6–7; "Helanguo: Boli huayuan" (The Netherlands: Greenhouse) *Wanguo gongbao* (Chinese globe magazine) 574 (January 24, 1880); Cengjing canghai, "You Lundun da bolifang ji" (An account of my visit to London's Crystal Palace), *Yiwen Lu* 78 (1880): 286; "Boli wei qiao" (Glass bridge), *Huatu xinbao* (Chinese Illustrated News) 4, no. 6 (1883): 89; "Yure boli" (Heat-resistant glass), *Yiwen lu* 1397 (1894): 382; "Boli zaochuan" (Building a boat from glass), *Yiwen lu* 545 (1886): 123; "Boli lu" (Glass pavement), *Cuibao* 18 (1897); "Boli zaoxiang" (Glass imaging), *Liji xuetang bao* (Liji medical school paper) 9 (May 21, 1897); "Chuangzao bolibi" (Manufacturing glass walls), *Jichengbao* 11 (1897): 39; "Zhuan boli fa" (Method to drill glass), *Zhixinbao* 22 (1897): 20; "Boli leibie" (The variety of glass), *Zhixinbao* 68 (October 15, 1898).

34. Liu Shanling mentions that the first glass factory in Shanghai was established in 1882, although it lasted for only two years. Liu Shanling, *Xiyangfeng: Xiyang faming zai Zhongguo* (Inventions from the West in China) (Shanghai: Shanghai guji chubanshe, 1999), 202; Ting Rui, "Zhongguo zhi boli gongye" (Glass industry in China), *Xiehebao* 5, no. 32 (1914): 13–14. The glass industry was identified as one of the earliest industries in Republican China that resisted foreign industrial dominance. See "Gongshangbu pi chunan boli gongsi faqiren Jiang Yuhuan deng choushe boli gongchang cheng" (Submitted spproval from the minister of industry and commerce of glass factory building plan by Chunan Glass Company initiator Jiang Yuhuan), *Zhengfu gongbao* (Governmental gazette) 199 (November 9, 1912): 18. From the document, one can see that there were already a number of Chinese-owned glass factories built before 1912, although they did not run very successfully.

35. "Zhongguo boli gongye gaikuang" (Survey of the Chinese glass industry), *Gongshang banyuekan* (Industry and commerce biweekly) 4, no. 7 (1932): 1–11.

36. "Zhongguo boli gongye gaikuang," 9.

37. On the first plate glass factories in China, see Yu Dexin, "Zhongguo pingban boli shihua" (Brief history of Chinese plate glass), *Zhongguo jiancai* (Chinese construction material) 4 (1991): 42; 10 (1991): 35–36; 1 (1993): 45–46; 4 (1994): 42–43. See also "Boshan zhi boli gongye" (Glass

industry in Boshan), *Xiehebao* 5, no. 44 (1914): 13–14. The article mentions that Boshan enjoyed several centuries of glass production due to its rich sources of silica, lime, and coal, although the production remained largely manual and via home business, with the products focused on decorative objects (the most famous being snuff bottles). From the report one learns that around 1907 a large glass factory was already producing plate glass for windows in an impressive quantity (5,000 boxes were produced in 1909, though it had the capacity for producing 50,000). By 1914 the factory had stopped producing plate glasses, owing to economic constraints.

38. According to one report, the import of color or transparent window glass from Austria, Belgium, and Germany in 1912 cost a total of 12,100 pounds. See the section on glass and glassware in "Zhongguo shiye fazhan zhi jihui" (Opportunity for Chinese industrial development), *Jinbu* (Progress), 8, no. 1 (1915). In 1930 the import of plate glass reached 29,000,000 square feet, which was worth 1,450,000 *guanpingliang* (a government-issued standardized measurement of silver for customs purposes). See "Shanghai boli gongye diaocha" (Survey on Shanghai glass industry), *Gongshangye yuekan* 2, no. 13 (1930): 1–17, 3. According to an online diagram of historical ratios of *guanpingliang* to U.S. dollars in Shandong, in 1930 an amount of 1,450,000 *guanpingliang* could be converted to roughly 667,000 U.S. dollars. See the Department of Commerce of Shandong Province website at http://www.shandongbusiness.gov.cn/index/content/sid/51010.html.

39. Yaohua was the first factory in Asia to apply the most-advanced Fourcault process for plate glass production, and by 1925 it estimated an annual production of 150,000 boxes (100 square feet) of plate glass. "Zhongguo zhi xinshi bolichang" (China's new style glass factory), *Nangong yuekan* (South industrial monthly) 2 (1925): 20.

40. By 1932 Yaohua, with one thousand workers, was considered the largest glass factory in East Asia. "Zhongguo boli gongye gaikuang," 9.

41. I thank Sophie Volpp for reminding me of the prehistory of glass making in China and for generously sharing her sources.

42. Da Yu, "Boli shidai" (The epoch of glass), *Eastern Miscellany* 29, no. 2 (1932): 88–91.

43. Lin Liqin, "Boli jianyu" (Glass prison), *Zi Luolan* (Violet) 4, no. 9 (1929): 1–5.

44. Ibid., 5.

45. Friedberg, *Windowshopping*, 65.

46. Hu Genxi, *Si malu* (Fourth Avenue) (Shanghai: Xuelin chubanshe, 2001), 130–36. Hu describes "glass cup" ladies as appearing at the turn of the twentieth century in theaters, bars, cafés, teahouses, and amusement parks. Their job was originally to serve tea in glass cups, a novelty product

at the time. Gradually, they became involved in shadier business with their customers. I have yet to find references to "glass cup" ladies before the mid-1930s, by which time the reference had become rather common. See Li Yue, "Bolibei"(Glass cup), *Diyixian* (Front line) 1, no. 2 (1935): 78–80; "Bolibei xi koujiao" (The glass cups love to quarrel), *Yule* (Entertainment) 1, no.22 (1935): 537. The real glass cup transformed from a luxury item in the 1910s to an everyday object in the 1930s, as attested by articles on caring and repairing cracked glass cups in the 1910s and regulations specifying the use of glass cups on the fourth-class train in the mid-1930s. A love poem in 1936 evokes the glass cup as a container of past love, which the narrator decides to break, showing glass cups as edging between the precious and the mundane, breakable but replaceable. Peng Huashi, "Nazhi bolibei, woyao bata dage fensui" (That glass cup, let me break it into pieces), *Panghuang* (Wavering) 1 (June 1936): 24. The gendered connotation of the replaceability of glass cups is also given a twist.

47. Dan Duyu, *Meide jiejing* (Crystal of beauty) (Shanghai: Shanghai meishe, 1930).

48. I quote the notion of glass as the material of "dematerialization" from Friedberg, *The Virtual Window*, 115.

49. On the history of *opéretta,* see Richard Traubner, *Operetta: A Theatrical History* (London: Routledge, 1983).

50. Zheng Boqi (aka Naifang), "*Bali zhiguang*" (On *Mirages de Paris*), June 11, 1934; anthologized in Zheng Boqi, *Liangqi ji* (Shanghai: Liangyou, 1937), 154–58, 156.

51. "Piping yu yanjiu" (Criticism and research), *Dianying huabao* (The screen pictorial) 10 (April 15, 1934): 3; Zheng Boqi, "*Bali zhiguang,*" 158.

52. Zheng Boqi, "*Bali zhiguang,*" 158. Ironically, this last sentence from Zheng mimics the Coca-Cola advertisement circulating in China at the time.

53. On positive appraisals and critiques of *City Light,* see Jiang Tian, "Chaplin and *Chengshi zhiguang*" (Chaplin and *City Lights*), *Shibao,* "Dianying shibao" column, August 23, 1932; Jun Le, "*Chengshi zhiguang*" (*City Lights*), *Chenbao,* "Meiri dianying" column, November 20, 1933.

54. A good number of popular Hollywood films, such as *The Grand Hotel* (Edmund Goulding, 1932), *Queen Christina* (Rouben Mamoulian, 1933), *Little Women* (George Cukor, 1933), and *The Barretts of Wimpole Street* (Sidney Franklin, 1934) were well received by left-wing film critics. The attitude toward Hollywood cinema edged on both a crude Marxist critique and interest in innovative film aesthetics. Zheng was among the strongest voices in the latter camp, which was particularly invested in learning about film style and aesthetics. Zheng stood at the more radical side of left-wing

film criticism, however, in his preference for European over Hollywood cinema. Zheng discussed *Mädchen in Uniform* (Girl in uniform) (Leontine Sagan, 1931), a provocative film about same-sex female attraction by the female director Leontine Sagan, as politically audacious and formally innovative when compared with American films. Similarly, Xia Yan, assuming the pen name of Cai Shusheng, claimed the film was more powerful than all films imported from Britain, Germany, and the United States that year. He lauded Sagan over Hollywood's Greta Garbo.

55. The earliest exhibition of sound films in China dates back to 1926 with the showing of De Forest sound shorts (Phonofilm produced by sound-on-film process) in the Baixin and Xin Zhongyang Theaters. For a list of the films shown, see *Shanghai yanjiu ziliao*, 557–58. The earliest sound film exhibition facilities were installed in Shanghai in 1929, first in the Odeon Theater on January 7 with Vitaphone equipment. On February 9, 1929, Odeon showed *Captain Swagger* (Edward Griffith, 1928), the first feature-length sound film in China. In the second half of 1929, a number of movie theaters installed sound film exhibition facilities, including the Grand Theater (September 3, 1929, showing *The Singing Fool* with Vitaphone recording as well as a Fox Movietone newsreel lecture by Chiang Kai-shek), the Capitol, and the Carlton. In 1931 Shanghai Huawei Company produced its own sound projection equipment, called Sidatong, hence facilitating the equipping of sound systems in smaller movie theaters. See "Shanghai dianyingyuan fangying yousheng dianying de lishi" (The history of sound film exhibition in Shanghai movie theaters), *Diansheng zhoukan* 5, no. 36 (1936): 932. The special issue of *Film Monthly* was published on December 5, one month after the Robertson sound film demonstration. The issue was partly stimulated by the event, and most writers documented their attendance at the film showing, though their reactions differed from positive to pessimistic. See *Dianying yuebao* 8 (December 5, 1928).

56. Feng Naichao et al., "Yousheng dianying de qiantu" (The future of sound cinema), special issue of *Yishu yuekan* (Art monthly) 1 (March 16, 1930), 135–52.

57. Throughout the discussion, the English words "sound picture" are used in the original; the Chinese translation *shenghua* appears only once.

58. Feng Naichao et al., "Yousheng dianying de qiantu," 137.

59. *Show Boat* had a silent and a partial-sound version, and judging by the responses to the film, in reference to sound film and American musicals, the version shown in Shanghai was the partial-sound version. See *Yishu yuekan* 1 (1930), in which the film is referred to frequently in the discussion on film sound.

60. Chen Liting praises the use of various noises, including that of

the steamboat, as expressions of character emotion in the film *Bomben auf Monte Carlo* (*Chunbo yanying*). Other than the film's sound, critics praised its economic editing style, unique camera angles, and use of music and light. See Liting, "Chunbo yanying" and Chenwu, "Chunbo yanying," both published in *Chenbao*, "Meiru dianying" column, February 14, 1933.

61. The manifesto was first published in August 1928 and translated into English in the October 7, 1928, *New York Times*. Hong Shen based his Chinese translation on the English version. For the English translation of the manifesto, see Elisabeth Weis and John Belton, eds., *Film Sound: Theory and Practice* (New York: Columbia University Press, 1985), 83–85.

62. Hong Shen, trans., "Yousheng dianying zhi qiantu" (On the future of sound cinema), *Dianying yuebao* 8.

63. Zheng Boqi, "*Longxiang fengwu*" (Review of *Der Kongress Tanzt*), *Liangqi ji*, 169–72.

64. Liu Na'ou, "Ecranesque." Given Liu's interest in the machine aesthetic, his comments on the American talkie as a "typewriter" could be conceived more positively in terms of the analogy's implications of rhythm, speed, and the coordination of the body and the machine; in relation to sound cinema, however, he seems to be more interested in the sound and the image interplay than in synchronization, and how the art of cinema transcends its mere subjection to its material bases.

65. Zheng Boqi, "*Baiwanjin*" (*Le million*), *Liangqi ji*, 166.

66. Charles O'Brien, *Cinema's Conversion to Sound: Technology and Film Style in France and the U.S.* (Bloomington: Indiana University Press, 2005), 65–70.

67. See Xu Bibo, "Zhongguo yousheng dianying de zhanwang" (The future of Chinese sound cinema), *Shanhu*, nos. 1–4, no. 6 (1932); nos. 10–12, no. 2, no. 4 (1933).

68. Feng Zikai, *Xiyang jianzhu jianghua*, 3.

69. Liu Na'ou, "Yingpian yishulun" (On film art), *Dianying zhoubao*, nos. 2, 3, 7, 8, 9, 10, 15 (1932); anthologized in Ding Yaping, *Bainian Zhongguo dianying lilun wenxuan* (Beijing: wenhua yishu chubanshe, 2002), 104–18.

70. See Richard Abel. ed., *French Film Theory and Criticism*, vol. 1 (Princeton, N.J.: Princeton University Press, 1988), 195–320; Germane Dulac, "Aesthetics, Obstacles, Integral Cinegraphie," 389–97.

71. Liu Na'ou, "E Fa de yingxi lilun" (Russian and French film theory), *Dianying yuekan* 1 (1930): 74–78. In this essay, in addition to pure cinema, Liu devotes a whole section to "subjective film," including a diverse range of expressionist, surrealist, and poetic realist films and films containing such elements, including Murnau's *Der letzte Mann* (The last laugh, 1924), E.A. Dupont's Varieté (Variety, 1925), Paul Fejös's *Lonesome* (1928), and

Abel Gance's Napoléon (Napoleon, 1927), as well as films by G. W. Pabst, Jacques Feyder, Jean Epstein, and Dimitri Kirsanoff. Both Zheng Boqi and Liu mention their viewing of Pabst's film. Liu mentions L'atlantide (1932) and clarifies that the film is a new German film, not the French version (Jacques Feyder, 1921) shown in the Paris Theater in Shanghai several years before. Liu, "Lun qucai: Women xuyao chuncui de dianying zuozhe" (On film material: We need pure film author), Xiandai dianying 4 (July 1, 1933). In this essay Liu emphasizes the attention to medium specificity, although in a general sense different from "pure cinema."

72. The translation provided by Xia Yan and Zheng Boqi includes the equivalent of sections 3 and 4 of the first English edition of On Film Technique (1929), although in a different order. Rather, it complies with the order in Pudovkin's 1926 Russian version, Film Director and Film Material (section 4 in the first English edition of On Film Technique), which is translated as "Dianying daoyanlun" (On film directing), followed by what constitutes section 3 of the first English edition of On Film Technique, "The Film Scenario and Its Theory," which is translated as "Dianying jiaobenlun" (On film script). See Vsevolod Pudovkin, Kino-rezhisser i kino-material (Film director and film material) (Moscow: Kinopechat, 1926); Wsewolod Pudowkin, Filmregie und Filmmanuskript (Film direction and the film script), trans. Georg Friedland and Nadia Friedland (Berlin: Verlag der Lichtbildbühne, 1928); Vsevolod Pudovkin, On Film Technique: Three Essays and an Address, trans. and ed. Ivor Montagu (London: Victor Gollancz, 1929). This first English edition includes Pudovkin's introduction to the German edition and his "address to the Film Society," both of which are not translated in the Chinese edition. The German edition includes a whole section by S. Timoschenko on film art, as well as essays by Carl Mayer, Thea von Harbou, and L. Heilborn-Köbitz. Timoschenko's discussion of montage is translated by Shen Xiling as "Timoschenko de daoyanlun" (Timoschenko on film directing) in Dianying yishu 2–4 (1932); Xia Yan (under another pen name, Huang Zibu) translates another essay by Pudovkin, "Close-ups in Time," included in the 1933 English edition Film Technique and Film Acting and in the Chinese film journal Mingxing yeubao. See Huang Zibu, "Shijian de 'texie'" (Close-ups in time), Mingxing yuebao 1, no. 1 (1933): 1–7. The essay was originally published in Proletarskoe-Kino 1 (1932), as acknowledged by the Chinese translation. My thanks go to Ksenya Gurshtein and Olivier Lugon for their help with the Russian and German texts. A survey on international film journals, "Geguo dianying zazhi lueshu" (Brief account on international film magazines) was published in Mingxing yuebao 2, no. 1 (1933): 26–32. The essay introduces a number of major film journals on film technology, film production, and film theory in the United

States, Germany, France, Russia, and Italy, including journals devoted to film theory and avant-garde film, such as *Cinea, Close-up, Film für Alle,* and *Proletarskoe-kino.* The appendix lists film journals from twenty countries, most devoted to the United States, France, and Germany.

73. Liu Na'ou, "Yingpian yishulun," 107.

74. See Liu, "Yingpian yishulun," 106–8, in comparison with Pudovkin's "Introduction to the German Edition," xiii–xvi, in which Liu grafts almost sentence by sentence Pudovkin's discussion of editing, his contrast between "photographic" and "cinematographic," and the example he gave of the montage sequence from *The End of St. Petersburg.*

75. V. Pudovkin, *Eiga kantoku to eiga kyakuhon ron,* trans. Sasaki Norio (Tokyo: Ôrai Sha, 1930). I am indebted to members of the KineJapan discussion list for pointing me to the Japanese sources, especially Chika Kinoshita, Markus Nornes, Aaron Gerow, and Jonathan Abel. It remains to be determined whether Liu accessed this introduction through the English edition (1929) or the Japanese translation, both of which include Pudovkin's introduction to the German edition; this introduction was also published separately in *Film Weekly,* London, October 29, 1928. All three editions could be Liu's sources. It is worth noting that Liu substantially changed his translation/paraphrase of Pudovkin's description on montage between his 1930 essay and his 1932 essay.

76. Liu, "Ecranesque," 1; emphasis added.

77. Shi Chao was an actor for Diantong; Ye Luxi was an actress active on the stage.

78. *Paris in Spring* is a Paramount musical comedy directed by Lewis Milestone (1935).

79. Bai Ke, "*Dushi fengguang riji,*" *Diantong banyue huabao* 8 (1935).

80. Pang Laikwan, *Building a New China,* 145.

81. Pang, *Building a New China in Cinema,* 147. Pang makes this observation in disagreement with the late Chinese film scholar Lin Niantong, who argues that the progressive films of the 1930s apply conflict as a structural dialectical principle. Although Lin's observation is based on his very limited access to left-wing films and debate about the Chinese use of montage in combination with long takes—mainly based on post-1945 and post-1949 Chinese films—he remains careful in cautioning against a quick judgment concerning the impact of notions of montage between Pudovkin or Eisenstein in Chinese cinema. Lin Niantong, *Zhongguo dianying meixue* (Chinese film aesthetics) (Taipei: Yongchen, 1991), 37n9; see also Lin's observation of Chinese variations on montage in several aspects on pages 28–30.

82. See Xu Xingzhi, "Putefujin gei zhongguo daoyanjia de tishi" (What Pudovkin suggests to Chinese directors), *Dinaying huabao* 2 (July 1933).

Pudovkin's *Film Techniques and Film Acting* was partly translated by left-wing film critic Xia Yan and Zheng Boqi, in two books, *Dianying daoyan lun* and *Dianying jiaoben lun,* published in *Chenbao* in 1932 and collected in one volume in 1933, in which they also included Xia Yan's filmscript for *Torrent.*

83. Liu Na'ou, "Yingpian yishu lun" (On the art of cinema), originally published in *Dianying zhoubao,* July–October 1932, reprinted in Kang Laixin, ed., *Liu Na'ou quanji: dianyingji* (Complete works of Liu Na'ou: Volume on cinema) (Xinying, Tainan: Tainan County Cultural Bureau, 2001); see the section on montage and *cin'e-œil,* 259–69.

84. One could argue that the whole film is constructed on a conflict principle that contrasts the social spaces of the two sons, although it is loosely executed in the film's organization of time and space. *Dawn over the Metropolis* is distinct from *The Sisters,* directed by veteran director Zheng Zhengqiu, who was probably bent more on "a traditional aesthetics that valued the balance of oppositional forces into harmony." In *Dawn over the Metropolis,* though, the conflict is clearly not reconciled. The rich man's attempt to reconcile with his abandoned son is refused by the son, and the two sons remain antagonistic to each other.

85. Pang, *Building a New China in Cinema,* 147.

86. The perforated sole seems to be a favorite screen figure for portraying social poverty during this period. The image appears in Japanese director Mikio Naruse's films, such as *Flunky, Work Hard* (1931) and *Nightly Dreams* (1933).

87. Sergei Eisenstein, *The Film Sense,* trans. Jay Leyda (San Diego: Harcourt Brace Jovanovich, 1974), 74–83.

88. Gyorgy Kepes, *Language of Vision* (Chicago: Paul Theobald, 1944), 77.

89. Colin Rowe and Robert Slutzky, "Transparency: Phenomenal and Literal," *Perspecta* 8 (1963): 45–54.

90. Ibid., 46.

91. Ibid., 53.

92. A Ying, "Xianhua xihujing: Yangpian fazhan shilue" (Miscellaneous notes on West Lake scenes: A brief history of the peep show), in *A Ying quanji* (Complete works of A Ying), ed. Ke Ling, vol. 8 (Hefei: Anhui jiaoyu, 1999), 679–83.

93. A Ying, "Xianhua xihujing."

94. Joseph McDermott, "Chinese Lenses and Chinese Art," *Kaikodo Journal* 19 (Spring 2001): 9–29, esp. 21.

95. I thank Chris Horak for pointing out the conflation of radical film aesthetic with the old medium when I presented a section of this chapter at UCLA in spring 2011.

96. Written in a first-person narrative, the piece depicts Zhang Xiaoyun's scheming to obtain the fashion accessories from a female point of view. See Yuan Muzhi, "Yizhang wukuaiqian de hankoupiao" (A five-dollar Hankou bill), *Shidai manhua* (Times cartoon) 2 (February 20, 1934).

5. "A Vibrating Art in the Air"

1. Li Lishui, "Dianying wuxianda: du Xu Chi xiansheng 'Dianying de jixian' yiwenhou de shangque" (The cinema has no limit: A discussion of Mr. Xu Chi's article 'The Limit of Cinema'), *Dianying jishibao* (Movie chronicle) 1 (June 25, 1941): 4–5.

2. Ibid., 5.

3. Ibid.

4. For poetry recitation during the wartime, see John Crespi, *Voices in Revolution: Poetry and the Auditory Imagination in Modern China* (Honolulu: University of Hawaii Press, 2009); for street performance, see Hung Changtai, *War and Popular Culture: Resistance in Modern China, 1937–1945* (Berkeley: University of California Press, 1994); for reportage literature, see Charles Laughlin, *Chinese Reportage: The Aesthetics of Historical Experience* (Durham, N.C.: Duke University Press, 2002).

5. Mao Dun, "Guanyu bianji de jingguo" (The story of the editing process), in *Zhongguo de yiri* (One day in China) (Shanghai: Shenghuo shudian, 1936), 1–7. Mao Dun explains that the editors had to cut down the number of writings to 490 because of the publishing budget and their desire to cut down the price of the book to reach the widest readership.

6. The book opens with a woodcut panorama of a China saturated with political strife. The Sino–Japanese conflict figures prominently, evidenced by armed soldiers with Japanese and Chinese flags in battle. The year 1936 is also the beginning of both national defense literature and national defense film. With increased Japanese aggression toward China, the Chinese Left-Wing Writers Association and the Chinese Left-Wing Dramatists Association were disbanded in the beginning of 1936 so as to build a united national front including groups previously rejected by left-wing artists.

7. For a detailed and incisive reading of the picture, see Xiao Tie, "In the Name of the Masses: Conceptualizations and Representations of the Crowd in Early Twentieth Century China" (PhD diss., University of Chicago, 2011).

8. Mao Dun, "Guanyu bianji de jingguo," 2.

9. The Marco Polo Bridge incident was one more step in the prolonged Japanese aggression toward China beginning in 1931. In late 1931

China lost Manchuria in the northeast to the Japanese. In 1933 Japan seized Rehe, north of the Great Wall, and obtained a demilitarized zone along the railway line between Beiping, Tianjin, and Tanggu. In 1935 Japan took over the province of Chahar, west of Rehe, and gained the authority to appoint officials in the region. In 1936 Japan occupied Fengtian and sat astride the railway between Tianjin and Beijing. See Parks M. Coble, *Facing Japan: Chinese Politics and Japanese Imperialism, 1931–1937* (Cambridge: Harvard University Press, 1991).

10. Wang Yongfang, *Mingxin, zhanshi, renmin de yishujia: Chen Bo'er zhuanlue* (Star, soldier, people's artist: Brief biography of Chen Bo'er) (Beijing, Zhongguo huaqiao, 1994), 124.

11. On mass-media mobilizations during the Shanghai battle in 1937, see Hung Chang-tai, *War and Popular Culture*.

12. On Chiang's "space for time" policy, see Chiang Kai-shek, "Guofu qianyi yu kangzhan qiantu" (On the relocation of the national government and the future of the anti-Japanese war), in *Zongtong Jiang gong sixiang yanlun zongji*, ed. Zhongguo Guomindang dangshi weiyuanhui, vol. 13 (Taipei: Guomindang zhongyang dangshi weiyuanhui, 1974), 657; see also John Fairbank and Albert Feuerwerker, eds., *The Cambridge History of China*, vol. 13 (Cambridge: Cambridge University Press, 1986), 552–57.

13. See Hong Shen's document of the thirteen troupes and their traveling routes in Hong Shen, *Kangzhan shinianlai Zhongguo de xiju yundong yu jiaoyu* (The Chinese drama movement and education in the decade since the War of Resistance) (Shanghai: Zhonghua shuju, 1948), 5–6.

14. According to one estimate, 130,000 people participated in the local drama performances. See Wang Yao, *Zhongguo xin wenxue shigao* (Drafted history of new Chinese literature), vol. 2 (Shanghai: Shanghai wenyi, 1982), 488. Tian Han estimates that around 2,500 drama clubs with a total of about 75,000 people participated in the drama performances. See Tian Han et al., eds., *Zhongguo huaju yundong wushinian shiliaoji* (Historical material on the Chinese drama movement of the last fifty years), vol. 1 (Beijing: Zhongguo xiju, 1985), 231.

15. Jiang Shang'ou, "Zhongdian shi zengyang chengzhang de: guoying zhipian jiguan shikuang baogao zhi er" (How Zhongdian grew up: Second truthful report of the state-run film unit), *Zhongguo Dianying* (Chinese film, Chongqing) 1 (1941): 70–76. The achievements of Zhongdian are heavily denounced by Cheng Jihua, Xing Zuwen, and Li Shaobai in *Zhongguo dianying fazhan shi*.

16. The docudramas are *Minzhong yu junren* (The people and the soldiers, 1933) and *Taoyuan haojie ji* (The holocaust of the peach spring, 1933). The two feature films are *Zhanshi* (Soldiers, 1935) and *Mi dianma* (The

secret radio code, 1936), which was written by Zhang Daofan, who later became the minister of propaganda in wartime Chongqing.

17. Zheng Yongzhi, "Sannian laide Zhongguo dianying zhipianchang" (The China Motion Picture Corporation in the past three years), *Zhongguo dianying* (Chongqing) 1 (January 1941): 51–55.

18. Tang Na, "Fakan ci" (Editor's note for the first issue), *Kangzhan dinaying* 1 (March 1938, Wuhan).

19. Notably, Tang Na does not address the post-1932 films as left-wing films, the usual label in later historiography.

20. Tang refers to soft-film advocate Liu Na'ou's cooperation with Japanese film producer Matsuzaki Keiji in early 1938; in 1939 Liu joined the Japanese-founded Zhonghua Film Company and was soon assassinated supposedly by GMD patriots. See Fu, *Between Shanghai and Hong Kong*, 24–25. Notably, Liu also worked briefly for Zhongdian. The ambivalence of Liu's political alliance and his interest in working with the state or the colonial regime of power remain to be studied.

21. The Western presence in Chongqing occurred much earlier. The Jesuit missionary started a church in Chongqing in 1642, and the Catholic churches and community continued to grow throughout the next two centuries. Protestants entered Chongqing in the early nineteenth century and rapidly developed after the Taiping Rebellion. The presence of Western merchants in Chongqing was documented before the city opened its port. See Daniel Bays, ed., *Christianity in China: From Eighteenth Century to the Present* (Stanford, Calif.: Stanford University Press, 1996); Judith Wyman, "The Ambiguities of Chinese Anti-foreignism: Chongqing, 1870–1990," *Late Imperial China* 18, no. 2 (1998): 86–122.

22. Zhou Yong, ed., *Chongqing tongshi* (Comprehensive history of Chongqing), vols. 1–3 (Chongqing: Chongqing chubanshe, 2002).

23. On the mass-scale migration, including industrial and educational relocations, see Fairbank and Feuerwerker, eds., *The Cambridge History of China*, 557–65; Zhang Gong and Mu Zhixian, *Guomin zhengfu peidu shi* (The history of the Nationalist wartime capital in Chongqing) (Chongqing: Xinan shifang daxue chubanshe, 1993); Zhou Yong, ed., *Chongqing tongshi*, vol. 3; Liu Lu, "A Whole Nation Walking: The 'Great Retreat' in the War of Resistance, 1937–1945" (PhD diss., University of California–San Diego, 2002). The scale of the migration population remains a point in dispute, ranging from 10 to 100 million. Most agree on 30 to 40 million.

24. The Nationalist government, led by the then national president Lin Sen, relocated some of its civil administration sections to Chongqing in November 1937, while the military and diplomatic administration moved

to Wuhan. The relocation of the whole government was not complete until December 1938, when Wuhan was already lost.

25. "Demographical Survey by Chongqing Police Station, January, 1945," Chongqing Municipal Archive.

26. *Chongqing tongshi*, 874–75; Zhengxie xinan diqu wenshi ziliao xiezuo huiyi, ed., *Kangzhan shiqi neiqian xinan de gaodeng xuexiao* (Advanced institutions that moved to southwest China during the War of Resistance) (Guiyang: Guizhou mingzu, 1988). Among the 108 universities and colleges in China, more than 90 were damaged in varying degrees. As a result, more than 60 universities moved to the hinterland, with half of the universities relocating to Chongqing.

27. Yang Hansheng et al., "Guanyu guofang dianying zhi jianli" (On the establishment of a national defense cinema), *Kangzhan dianying* (Wuhan) 1 (March, 1938).

28. Luo Jingyu, "Lun dianying de guoce—bing huhuan yingjie dianying jishu de da geming" (On the national policy of film—and a call to welcome the great revolution of film technology), *Zhongguo dianying* (Chongqing) 1 (1941): 59–62; 2 (1941): 77–78.

29. Ibid.

30. Such characterization of educational versus commercial cinema along national boundaries is, of course, highly ideological. Not only had educational cinema flourished in the United States, but it played an important role in the exchange with Chinese filmmakers and educators, both before and during World War II. For a groundbreaking volume on nontheatrical films in the United States, see Charles Acland and Haidee Wasson, eds., *Useful Cinema* (Durham, N.C.: Duke University Press, 2011). Luo himself later came to the United States and participated in its nontheatrical film scene. See Weihong Bao and Nathaniel Brennan, "Cinema, Propaganda, and Networks of Experience: Exhibiting Chongqing Cinema in New York," in *American and Chinese Language Cinemas: Examining Cultural Flows,* ed. Lisa Funnell and Man Fung Yip (New York: Routledge, 2014), 119–35.

31. For debates on film as education versus entertainment in the 1920s, see Zhang Zhen, *Amorous History,* chap. 4. On the rise of educational film in China, see Peng Jiaoxue, *Minguo shiqi jiaoyu dianying fazhan jianshi* (Brief history on educational film in Republican China) (Beijing: Zhongguo chuanmei daxue chubanshe, 2009); see also Matthew Johnson's excellent study "International and Wartime Origins of the Propaganda State: The Motion Picture in China 1897–1955" (PhD diss., University of California–San Diego, 2008).

32. On state cinema, see Yang Yan and Xu Chengbing, *Minguo shiqi guanying dianying fazhan shi* (History of Republican-period state film) (Beijing: Zhongguo chuanmei daxue chubanshe, 2008). See also Johnson, "International and Wartime Origins of the Propaganda State's." On categories of educational film, see Zhongguo jiaoyu dianying xiehui zongwuzu, *Zhongguo jiaoyu dianying xiehui huiwu baogao* (Proceedings on Chinese educational cinematographic society) (Nanjing: Zhongguo jiaoyu dianying xiehui, 1935), 2–3, 19–20.

33. Luo Jingyu, "Lun Dianying de guoce," *Zhongguo dianying* 2 (1941): 78.

34. Ibid., 62.

35. See Ye Chen, "Guanyu dianying de jige yijian" (Several suggestions on film), *Shalun* (Siren) (1932); Mark Abé Nornes, *Japanese Documentary Film: The Meiji Era through Hiroshima* (Minneapolis: University of Minnesota Press, 2003).

36. Luo Jingyu, "Dianying gongye chuyi" (Preliminary thoughts on the film industry), *Zhongguo dianying* (Chongqing) 2 (1941): 11–18.

37. Luo Jingyu, "Dianying gongye chuyi," 17.

38. Ibid., 18.

39. Zheng Yongzhi, *Ruhe zhuazhu dianying zhe wuqi* (How to grasp film as a weapon) (Nanchang: Junshi weiyuanhui weiyuanzhang nanchang xingying zhenzhi xunlianchu dianyinggu, 1935).

40. Ibid., 35–51. Zheng was fully aware of the fascist tendency of Italian, German, and Japanese state cinema; in the last case, he cited the Japanese interest in film production in Manchuria as an instance of cultural imperialism.

41. Stephen Graham and Simon Marvin, *Splintering Urbanism: Networked Infrastructures, Technological Mobilities, and the Urban Condition* (London: Routledge, 2001).

42. Brian Larkin, *Signal and Noise: Media, Infrastructure, and Urban Culture in Nigeria* (Durham, N.C.: Duke University Press, 2008).

43. Sun Shiyi et al., "Zhongguo dianying de luxian wenti" (On the direction of Chinese cinema), *Zhongguo dianying* (1941): 1, 7–18. These are the minutes of a meeting held in Chongqing in October 5, 1940.

44. For instances of conflict between film workers and the state, see Cheng Jihua, Xing Zuwen, and Li Shaobai, *Zhongguo dianying fazhanshi*, 45–57.

45. Yang Cunren, "Nongcun yingpian de zhizuo wenti" (On the production of rural cinema), *Zhongguo dianying* (Chongqing) 1 (1941): 21–22.

46. Wu Lianggao, "Nongcun dianying yu wenyi dianying" (Rural film and art film), *Zhongguo dianying* 1, no. 2, 27–28.

47. Jiang Xianqi, "Guanyu nongcun dianying neirong de shangque" (A discussion on the content of rural films) *Zhongguo dianying* 1, no. 3 (1941): 30–32, 30. Other supporters of rural cinema turned the question into a different film category—namely, science and educational films aimed at the rural population. See Jiang Zenghuang, "Dianying dao nongcun qu" (Cinema going to the countryside), *Dianying yu boyin* (Film and radio) 1, nos. 7–8 (1942): 34–35.

48. Song Zhidi, "Luelun dianying tongsuhua wenti" (Preliminary thoughts on the vernacularization of film), *Saodang bao* (Chongqing), April 10, 1939.

49. Pan Jienong, "Shilun 'meiguo zuofeng,' ziben zhuyi guojia de shangye dianying de suowei 'shoufa' yu 'jiqiao'" (On American style, the so-called "method" and "technique" of capitalist commercial cinema), *Guomin gongbao* (Chongqing), September 3, 1941.

50. I was able to see the extant fragment of the film, available at the Hong Kong Film Archive. The film, a 16 mm silent version printed by the Hong Kong Yinguang company, shows excessive use of intertitles to capture the dialogue and rather elliptical montage. Several constructive montage sequences narrating the atrocity of the Japanese also demand a rather high level of visual comprehension.

51. Xiang Jinjiang, "Lun dianying de minzu xinshi" (On the national form of cinema), *Guomin gongbao* (Chongqing), June 8, June 15, and June 22.

52. Xiang Jinjiang, "Lun dianying de minzu xinshi," *Guomin gongbao,* June 15.

53. On discussions of Chinese practices of active "translation" of Western influence in modern literary and cultural articulations, see Lydia Liu, *Translingual Practice: Literature, National Culture, and Translated Modernity,China, 1900–1937* (Stanford, Calif.: Stanford University Press, 1995); Chen Xiaomei, *Occidentalism: A Theory of Counter-discourse in Post-Mao China* (New York: Oxford University Press, 1995).

54. For a collection of this debate, see Xu qiuxiang, ed., *Wenxue de 'minzu xinshi' taolun ziliao* (Collections on the "national form" of literature debate) (Nanning: Guangxi renmin chubanshe, 1986).

55. Wang Hui, "Difang xingshi, fangyan tuyu yu kangri zhanzheng shiqi 'minzu xingshi de lunzheng" (The debate on local form, dialect, and "national form" during the Sino–Japanese War), in *Wang Hui zixuan ji* (A self-compiled anthology of Wang Hui) (Nanning: Guangxi shifan daxue, 1997).

56. The Soviet- versus American-style discussion appeared less in the context of intelligibility than that of the affective impacts on the audience.

See the discussions in *Zhong-Su wenhua* (Chinese and Soviet culture) 7, no. 4 (October 10, 1940).

57. Another example is the use of a reporter to connect four individual stories in Shen Xiling's *Sons and Daughters of China* (1939). Unfortunately, the film is no longer extant. Xiao Lin, "*Zhonghua Ernü*" (*Sons and Daughters of China*), *Xin Shubao*, September 21, 1939.

58. Shi Dongshan started directing in 1925 with the film *Yanghua heng* (Regrets for the willow flower). His interest in modernist decor, melodramatic sentimentality, and fast-cutting montage have been recognized in works such as the highly acclaimed classical costume drama *Meiren ji* (The beauty trap, 1926), the first Chinese martial arts film *Wangshi sixia* (Four knights-errant named Wang, 1927), *Tongju zhiai* (Love in cohabitation, 1926), *Yinghan shuangxin* (Two stars in the Milky Way, 1931), and *Kuanghuan zhiye* (The night of the carnival, 1936).

59. Shi Dongshan, "Guanyu *Baowei women de tudi*" (On *Defending Our Land*), *Kangzhan dianying* (Wuhan) 1 (1938): 3.

60. Unfortunately, both *The Good Husband* (silent film) and *Marches of Victory* are no longer extant. The shot description is from Ge Yihong, "Cong *Huabei shi women de* yu *Hao zhangfu* shuodao women kangzhan dianying zhizuo de luxiang" (From *North China Is Ours* and *The Good Husband* to the direction of our resistance filmmaking), *Xinhua ribao*, February 22, 1940.

61. Ibid.

62. Shi Dongshan, "Guanyu baowei women de tudi," 14.

63. "Zhongguo dianying de luxian wenti" (On the direction of Chinese cinema), *Zhongguo dianying* (Chongqing) 1 (1941).

64. These diverse audience groups are summarized in the widely circulated triple slogan "Cinema going to the countryside; cinema joining the army; cinema traveling abroad" (*Dianying xiaxiang, dianying ruwu, dianying chuguo*). Shi Yan, "Sanze jianyi: gei Zhongguo dianyingjie" (Three suggestions: For the Chinese film world), *Saodang bao* (Chongqing), December 4, 1938.

65. This split also seems to reside in the difference between silent and sound film. In his first article Xu stresses the natural comprehensibility of image and movement. He asks filmmakers to minimize the use of dialogue wherever possible. Only in the second article does he mention the problem of dialect when explicitly discussing the practices of sound films.

66. Xu Chi, "Dinanying de jixian" (The limit of cinema), *Zhongguo dianying* (Chongqing) 2 (1941): 32–34. Although Xu quotes Lessing's essay "Laokoon" (1766), his position is very close to Wagner's as regards theater. Wagner sees the theater as the highest artwork, requiring each individual artwork to reach the common purpose. See Richard Wagner, *The Artwork*

of the Future and Other Works, trans. William Ashton Ellis (Lincoln: University of Nebraska Press, 1993), esp. 183–93.

67. Xu Chi, "Dianying de jixian," 34.

68. The images of America and Hollywood in Chongqing film discourses were usually considered "nondemocratic" within the leftist/socialist critique of capitalism, especially in the contrast between Soviet and American cinema. For some of the discussions regarding American versus Soviet cinema, see *Zhong-Su wenhua* 7, no. 4.

69. I am drawing on W. J. T. Mitchell's cogent analysis of Lessing's politics of dividing spatial and temporal art. See W. J. T. Mitchell, "The Politics of Genre: Space and Time in Lessing's Laocoön," *Representations* 6 (Spring 1984), 98–115.

70. Xu Chi, "Dianying zhong de yuyan wenti: Dianying de jixian zhi er" (On the question of language in cinema: The second part of the limit of cinema) *Zhongguo dianying* (Chongqing) 2 (1941): 33–37.

71. Esperanto was part of the May Fourth debate on modernizing everyday language. It was a popular subject to study among the educated youth in the late 1910s and 1920s.

72. On script reform in modern China, see Zhong Yurong's groundbreaking dissertation "Scripts of Modernity: The Transnational Making of Modern Chinese Language and Social Reform, 1916–1958" (Columbia University, 2013); on Esperanto in China, see Hou Zhiping, *Shijieyu yundong zai Zhongguo* (Esperanto movement in China) (Beijing: Zhongguo shijieyu chubanshe, 1985).

73. Xu Chi, "Shiren weiqi lindesai" (The Poet Vachel Lindsay), *Xiandai* 4, no. 2 (1933): 319–36.

74. Vachel Lindsay, *The Art of the Moving Picture* (New York: Modern Library, 2000); originally published in 1915.

75. Ibid., 122.

76. Miriam Hansen, "Mass Culture as Hieroglyphic Writing: Adorno, Derrida, Kracauer," *New German Critique* 56 (1992): 43–73; Lindsay, *The Art of the Moving Picture,* 124.

77. Wang Hui, "Difang xingshi," 354–60.

78. Ibid., 372–75.

79. Miriam Hansen, *Babel and Babylon: Spectatorship in American Silent Film* (Cambridge, Mass.: Harvard University Press, 1991), 78–84.

80. Ibid., 84; emphasis added.

81. Stuart Hall, "Old and New Identities, Old and New Ethnicities" in *Culture, Globalization, and the World System: Contemporary Conditions for the Representation of Identity* ed. Anthony King, 41–68 (Minneapolis: University of Minnesota Press, 1997), 67.

82. Li Lishui, "Dianying wuxianda"; Li Lishui, "Yishu de shengcun xiandui: Zailun dianying wuxianda" (The limit of art's existence: A second discussion on the infinite cinema), *Dianying jishibao* 2 (August 10, 1941), 8.

83. Li Lishui, "Dianying wuxianda," 5.

84. Ibid., 5.

85. Ibid.

86. Ibid.

87. Li Lishui, "Yishu de shengcun xiandu," 8.

88. Ibid.

89. Ibid.

90. Fan Houqin, "Wuxiandian zishu" (Autobiography of wireless technology), *Dianying yu boyin* 1, nos. 7–8 (1942): 2.

91. See Sun Mingjing, "Dianshi de lingyu" (The field of television), *Dianying yu boyin* 2, no. 2 (1943): 7–10. Translated by Sun Mingjing from M. G. Scroggie, *Television* (n.p.: Blackie and Son , 1935). Sun Mingjing was a pioneer in science educational film in China and one of the founders of *Dianying yu boyin* and the Audiovisual Education Department at Jinling. Sun allegedly succeeded in creating the first television set in China in 1934 in collaboration with the wireless engineer Yang Jianchu. See Sun Jiansan, "Zai zhongguo Television weishenme jiao 'dianshi'" (Why was television called 'dianshi' in China), *Zhongguo guangbo dianshi xuekan* 3 (2004): 68–70.

92. For news and explication of television in China in the 1920s, see chapter 3. *Dianying yu boyin* regularly reported international progress in and applications of television technology. For a report on the television exposition organized by the Federal Communications Commission, see Beverley Dudley, "The Challenge of Television's," *Phototechnique* 33 (1941): 38–42; translated by Luo Wunian in *Dianying yu boyin* 1, nos. 7–8 (1942): 5–6.

93. Ren Yining, "Kangzhan shiqi Chongqing dianying gaishu," in *Di qi jie Zhongguo jinji baihua dianying jie zhiweihui xueshu yantao bu*, ed. Chongqing yu Kangzhan dianying yishu lunwen ji (di qi jie Zhongguo jinji baihua dianying jie) (Chongqing: Chongqing chubanshe, 1998), 9.

94. Peng Jiaoxue, *Minguo shiqi jiaoyu dianying fazhan jianshi*, 76.

95. Sun Mingjing, "Zhongguo wenhua dageming zhong de yige xiaoshiyan" (A small experiment in the great cultural revolution in China), *Dianying yu boyin* 6, nos. 7–8 (1947).

96. According to Sun, the average attendances per night amounted to ten thousand. Sun Mingjing, "Zhongguo wenhua dageming zhong de yige xiaoshiyan." See also "Jinda dianjiao" (Jinling University's audiovisual education) *Dianying yu boyin* 1, nos. 7–8 (1941): 36–37.

97. Hou Qin and Chang Chi, "Lutian dianying fangying mu" (Screen

for open-air film screening), *Dianying yu boyin* 2, no. 2 (1943), 14; "Yidong bibaoche" (Mobile poster cart), *Dianying yu boyin* 2, no. 4 (1943): 18.

98. Sun Daying, "Xianwei fangying" (Microprojection); "Yingpian tushu" (Film book) *Dianying yu boyin* 2, no. 5 (1943): 28.

99. "Jinling daxue wushiwu zhounian jinian zhanlan: Dianhua jiaoyu bumen neirong shuyao" (Exhibition celebrating Jinling University's fifty-fifth anniversary: Brief report on the audiovisual education section), *Dianying yu boyin* 2, no. 4 (1943): 9–10.

100. Cao Shougong, "Dianjiao zhanlan" (Exhibition on audiovisual education), *Dianying yu boyin* 4, no. 6 (1945): 143–47.

101. See *Dianying yu boyin* 2, no. 5 (1943). The entire issue is devoted to the exhibition.

102. "Jinda wushiwu zhounian jinian zhanlan," 4.

103. Cao Futian, "Shilun xuanchuanxue" (On the study of propaganda), *Sichuan shifan daxue xuebao* 4 (1987): 44–47, 44.

104. Chen Yousong, "Dianying jiaoyu de diwei yu qushi zhi tantao" (On the role and tendency of film education), *Zhongguo jiaoyu dianying xiehui huiwu baogao*, 24–39.

105. Upton Sinclair, *Mammonart* (Pasadena, Calif.: self-published, 1925), 9.

106. Li Chuli, "Zengyang de jianshe geming wenxue" (How to build revolutionary literature), *Wenhua pipan* 2 (1928): 3–20, 5; Lu Xun, "Wenyi yu geming" (Literature, art, and revolution), *Yusi* 4, no. 16 (1928): 41–43. Li quotes Sinclair in English and then applies it in Chinese to literature. Li's article marks an important departure from the May Fourth cultural movement by declaring art and science, two staples of the May Fourth movement, ideologies of capitalism (10–11).

107. Lu Xun translated Iwasaki's excerpt published in *Shinkô geijutsu* nos. 1–2 in 1930 before Iwasaki published the book in 1931. The original Japanese title for the article was "Film as the instrument for publicity and agitation." Lu Xun, trans., "Xiandai dianying yu youchan jieji" (Film and the propertied class), *Mengya yuekan* 3, no. 1 (1930).

108. Pan Jienong, "Lun 'xuanchuan dianying'" (On propaganda cinema), *Dianying huabao* 34 (1935): 14–15.

109. Feng Zikai provocatively observes that "commercial art is the artistic propaganda of capitalism whereas proletarian art is the artistic propaganda of socialism." Feng Zikai, *Lectures on Western Architecture*, 1.

110. Zhu Yingpeng, *Kangzhan yu meishu* (Art and the war of resistance) (Changsha: Commercial Press, 1937).

111. Zhu Yingpeng, *Kangzhan yu meishu*, 14. Zhu's reference to "a subtle smile" might hint at Leonardo da Vinci's celebrated painting *Mona Lisa*,

which was well known in China by the late 1930s. The "maddening roar" could be referring to Li Hua's seminal woodcut work *Roar, China,* capitalizing on the full-scale politicization of sound and voice in the 1930s. See Tang Xiaobing, *Origins of the Chinese Avant-Garde*; Jones, *Yellow Music*; and my discussions in chapter 4.

112. Zhu Yingpeng, *Kangzhan yu meishu,* 14.

113. Zhu Yingpeng coauthored the second volume of a three-volume work devoted to art criticism. See Fu Yanchang, Zhu Yingpeng, and Zhang Ruogu, *Yishu sanjiayan* (Writings by three art critics) (Shanghai: Liangyou, 1927).

114. See Peng Fei, "Zhu Yingpeng de zanyang yu piping" (Praises and criticism by Zhu Yingpeng), *Rongbaozhai* 6 (2007): 268–73. On nationalist literature, see Zhang Daming, *Guomindang wenyi sichao: Sanmin zhuyi wenyi yu minzu zhuyi wenyi* (The nationalist literary and artistic thoughts: Literature and art for three principles of the people and nationalist literature and art) (Taibei: Xiuwei zixun, 2009).

115. On a reevaluation of nationalist literature and its relationship with left-wing literature, see Zhu Xuejian, "Zuoyi wenxue yu minzu zhuyi wenxue de jiehe yu congtu" (The alliance and conflict between left-wing and nationalist literature), *Shenyang shifan daxue xuebao* 35, no. 1 (2011): 88–91. Zhu discusses at length the tensions and overlapping interests between the two literary camps and their shared forums, although I find Zhu's celebration of nationalism and uncritical view toward nationalist literature rather problematic. That nationalist literature had served as an ideological tool for the ruling class by eclipsing class conflict with a cultural essentialist nationalism, an astute critique from the left-wing writers, seems to have entirely escaped the author's critical attention.

116. Zhang Zhizhong, "Xinwen zhanzhen yu Propaganda" (News war and propaganda), *Liudong xuebao* 2, no. 2 (1936): 95–100. The English word *propaganda* appears in the original title. Zhang studied electronic engineering at Shanghai Jiaotong University in the 1920s and served various roles in the Communist Party, including secretary at the Jiangsu Propaganda Department.

117. Ibid., 95.

118. Ibid., 100.

119. Ibid.

120. Zhu Yingpeng, *Kangzhan yu meishu,* 2.

121. William E. Daugherty, "Origin of PSYOP Terminology," in *The Art and Science of Psychological Operations: Case Studies of Military Application,* vol. 1 (Washington, D.C.: American Institute of Research, 1976),

18–19. Although references to psychological warfare often extended to an-cient wars, the retrospective application of such was a twentieth-century phenomenon.

122. Terrence H. Qualter, *Propaganda and Psychological Warfare* (New York: Random House, 1962); Lyneyve Finch, "Psychological Propaganda: The War of Ideas on Ideas during the First Half of the Twentieth Century," *Armed Forces & Society* 26, no. 3 (2000): 367–86.

123. See Zhang Yinhan, "Dazhan yu shenjin zhan" (The great war and the war of nerves), *Zhongguo gonglun* 9, no. 6 (1943): 5–7. "Psychological war" was also translated as *xinli zhan,* but the term was less frequently used. Qian Nengxin, "Xinli zhan yu shanji zhan" (Psychological warfare and blitz attack), *Xin Zhonghua* 1, no. 6 (1943): 61–66.

124. Peng Leshan, *Guangbo zhan* (Radio war) (Chongqing: Zhongguo bianyi chubanshe, 1943), 1. By evoking the term "Fourth Front" in English, Peng could be drawing from Charles Rolo's *Radio Goes to War: The Fourth Front* (New York: G. P. Putnam's Sons, 1942). The book contains a section on the broadcasting war between China and Japan and the international reach of XGOY (209–14).

125. *Dadi huabao* (Tati) 5 (April 1939): 34–35.

126. Ibid.; emphasis added.

127. *Kangzhan shiqi Chongqing de xinwenjie,* 122–24.

128. "Wuxiandian chuanzhen de shoufa" (Transmission and reception of radiophotography), *Lianhe huabao* 46 (September 24, 1943): 3; Jiang Chisheng, Shu Zongqiao, and Gu Li, *Zhongguo sheyingshi: 1937–1949* (History of Chinese photography: 1937–1949) (Beijing: Zhongguo shying chubanshe, 1998), 118–21.

129. "Yukun chuanzhen dianbao shiyan chengji yuanman" (Success-ful operation of radiophotography between Chongqing and Kunming), *Dianying yu boyin* 2, no. 4 (1943): 8.

130. Radiophotography became an important media technology during World War II, used in photojournalism as another boost to realism. Its authenticity, like photography, was more a technological aura than an ac-tual practice. Printed radiophotographs were frequently "doctored," as in printed photographs. See Jason Hill, "On the Efficacy of Artifice: *PM,* Radiophoto, and the Journalistic Discourse of Photographic Objectivity," *Études Photographiques* 26 (2010): 71–85.

131. Jacques Ellul, *Propaganda: The Formation of Men's Attitudes,* trans. Konrad Kellen and Jean Lerner (New York: Knopf, 1966), 62.

132. Ellul, *Propaganda,* 63.

133. While all of these publicity strategies were deployed in China, the

Chinese film magazines looked at more successful examples in other countries. See "Riben dianying shiye de xuanchuan fangfa" (Japanese publicity strategies for film), *Mingxing banyuekan* 5, no. 6 (1936).

134. Chongqing kangzhan congshu bianji weiyuan hui, ed., *Kangzhan shiqi Chongqing de xinwenjie* (The news media in Chongqing during the Sino–Japanese War), (Chongqing: Chongqing chubanshe, 1994), 4.

135. OWI obviously had its own agenda in promoting the U.S. public image in international exchange and maintaining Chinese morale during the war. For OWI propaganda efforts in China, see Matthew Johnson, "Propaganda and Sovereignty in Wartime China: Moral Operations and Psychological Warfare under the OWI," *Modern Asian Studies* 45, no. 2 (2011): 303–44.

136. *Kangzhan shiqi Chongqing de xinwenjie,* 101.

137. For foreign reporters' accounts of Chongqing and criticism of the GMD government, see Graham Peck, *Two Kinds of Time*; Theodore White and Annalee Jacoby, *Thunder Out of China* (New York: William Sloane Associates, 1946). Peck worked for AIS in Guilin in 1943.

138. Oskar Negt and Alexander Kluge, *Public Sphere and Experience* (Minneapolis: University of Minnesota Press, 1993).

139. Miriam Hansen, "Early Cinema, Late Cinema: Permutations of the Public Sphere," *Screen* 34, no. 3 (1993): 197–210, 203–4.

140. Ibid., 205.

141. Negt and Kluge, *Public Sphere and Experience,* 17–18.

142. Hansen, "Early Cinema," 205.

143. In a groundbreaking study on propaganda and modernism, Mark Wollaeger has pointed out the dialectical character of Ellul's analysis as an alternative to Adorno and Horkheimer's media determinism in their culture industry thesis. See *Modernism, Media, and Propaganda: British Narrative from 1900 to 1945* (Princeton, N.J.: Princeton University Press, 2006), 10.

6. Baptism by Fire

1. Graham Peck, *Two Kinds of Time* (Boston: Houghton Mifflin, 1950), 53.

2. Ibid., 55.

3. Zhang Gong and Mu Zhixian, *Guomin zhengfu peidu shi* (The history of the Nationalist wartime capital in Chongqing) (Chongqing: Xinan shifan daxue chubanshe, 1993), 145–71.

4. For a semiautobiographical account of the air bombing experienced

at close range, see Han Suyin, *Destination Chungking* (Boston: Little, Brown and Company, 1942), 262–318.

5. Peter Sloterdijk, *Terror from the Air*, trans. Amy Patton and Steve Corcoran (Los Angeles: Semiotext(e), 2009).

6. Walter Lippmann, *Public Opinion* (New York: Harcourt, Brace and Company, 1922).

7. *Saodang bao* (Chongqing), May 11, 1941. Judging from the newspapers in Chongqing, including *Guomin gongbao*, *Saodang bao*, and *Xin shubao*, the usual screening time for a single film lasted between three and seven days.

8. Hong Yi, "*Huo de xili* gei wo de qifa" (My inspiration from *Baptism by Fire*), *Guomin gonbao* (Chongqing), May 4, 1941.

9. *Huashang bao* (Chinese business news, Hong Kong), July 2, 1941.

10. Between 1938 and 1941, Zhongdian made seventy-seven films. Except for three feature films, the rest were newsreels, documentaries, cartoons, and song books. Zhongzhi made sixty-two films, among which eleven were feature films, with three made in Wuhan (with one finished in Chongqing), two made in the Hong Kong branch of the Chinese Film Studio, Dadi Studio (with one of them, *Baiyun guxiang* finished in Chongqing). See Zheng Yongzhi, "Kangzhan sinian lai de dianying" (Cinema in the past four years since the war of resistance), *Wenyi yuekan* (Literature and art monthly), August 1941. I have adjusted the numbers according to "Kangzhan yilai guoying zhipian jiguan chupin diaocha" (Survey of state film studio production since the war of resistance), *Zhongguo dianying* (Chongqing), 3 (March 1941).

11. Sun Yu, "Tan yingpian *Huode xili*" (On the film *Baptism by Fire*), *Guomin gonbao* (Chongqing), May 4, 1941. The film was shot mostly between October and December 1940 and finished in early 1941. Sun Yu's own memoir is not accurate regarding the time of shooting (Spring 1941) and exhibition (June 1941). See Sun Yu, *Dalu zhige* (Song of the big road) (Taipei: Yuanliu, 1990), 155.

12. Zhang Ruifang, who played the female lead role of Fang Yin, told me that the film was destroyed in a boat that caught fire as a result of the Japanese bombing, together with some other films Luo Jingyu planned to carry on his trip to the United States. Interview with Zhang Ruifang, August 22, 2003. A *New York Times* report about Luo Jingyu's U.S. visit mentions three films he brought (*The Light of East Asia, Fight to the Last,* and *Fatherland*), which does not include *Baptism by Fire*. Ezra Goodman, "Keeping Alight the Lamp of China," *New York Times,* June 14, 1942.

13. Synopsis.

14. Quoted in Ling He, "Tan *Shengli jinxingqu* yu *Huode xili*," *Xinshubao,* May 13, 1941.

15. The number of airplanes ranged between ninety and two hundred for each bombing, with one to five hundred bombs dropped each time. *The Cambridge History of China*, 13:567; Zhang Gong and Mu Zhixian, *Guomin zhengfu Chongqing peidu shi*, 145–61.

16. Zhang Gong and Mu Zhixian, *Guomin zhengfu Chongqing peidu shi*, 145–61.

17. Air raids were often conceived and referred to as "war of nerves." See, for example, the Chinese–English bilingual title, "Shenjingzhan gonglue xia yushi minxin zhending" (Chungking carries on despite air-raids), *Liangyou* 156 (1946): 4.

18. Sun Yu, "Tan yingpian *Huode xili*."

19. Sun Yu, *Dalu zhige*, 156.

20. Tong Yu, "Yiqie weile kangzhan" (All for the war of resistance), *Guomin gongbao* (Chongqing), May 4, 1941.

21. See, for example, "Nippon news" no. 2 (1940), no. 16 (1940), no. 63 (1941), no. 64 (1941), no. 65 (1941).

22. *Marine Air-raid Troupe* (Kaigun kūshū butai). Date to be determined, judging from its similarity with Japanese news no. 16, it was quite possibly made in 1940. I watched the documentary at the China Film Archive; the documentary's serial number is Jp-00318. This contrast between "aerial" and "earthly" perspective does not mean that Chinese films did not aspire to an aerial perspective. A number of documentaries were made on the Chinese and allied air force, of which Sun Yu's own *Iron Birds Fly High* is another example.

23. The notion of "air conquest" is monumentalized in one documentary starting with a sculpture of a pilot martyr with the two characters for *seikū* (air conquest).

24. See, for example, *Zhongguo xinwen tehao: Diji shouci zhayu* (Chinese special news: First Japanese bombing in Chongqing) (1939), *Diji erci hongzha Chongqing* (Second Japanese bombing of Chongqing) (1939), *Zhongguo xinwen liushi jiuhao* (Chinese news no. 69) (1940), *Zhongguo jinji xinwen haowai* (Chinese emergency news extra) (1940).

25. See the documentary *China's Stand* (1940). The documentary is narrated in English with a Chinese male voice.

26. *Zhongguo shizhong buqu* (China will fight to the last) (1940). The documentary is narrated in Chinese by Li Lili, the prominent female star from Shanghai in the 1930s. Intertitles were given bilingually in both Chinese and English.

27. A number of these images were recycled in the *Time*'s *March of Time* newsreel *China Fights Back* (1940).

28. "Xue yu huo de xili: Xin Chongqing zai gengsheng zhong" (Baptized by blood and fire: The Rebirth of Chongqing), *Liangyou* 143 (June 1939).

29. "Jingshen zong dongyuan" (National spiritual mobilization), *Liangyou* 143 (June 1939).

30. On the rise of martial arts films, see Li Suyuan and Hu Jubin, *Zhongguo wusheng dianying shi*.

31. On the notion of "sensory reflexive horizon," see Miriam Hansen's discussion in "The Mass Production of the Senses: Classical Cinema as Vernacular Modernism," in *Reinventing Film Studies*, ed. Christine Gledhill, (London: Oxford University Press, 2000), 332–50.

32. Unfortunately, the film is no longer extant for us to analyze its cinematic techniques.

33. Established in October 1932, immediately after the January 28 Japanese bombing of Shanghai, Yihua is the direct result of war at the decline of martial arts films. To cater to the changed audience interest, Zha and Peng invited Tian Han to write the screenplay. With funding from the Shanghai underground magnate Yan Chuntang, Yihua made some of the first left-wing films that included a strong social critique. The films featured Zha and Peng as fantastic embodiments of action, including *Minzu shengcun* (National existence, Tian Han, 1933), *Roubo* (Fistfight, Hu Tu, 1933), and *Angry Tide of the Chinese Sea* (discussed in chapter 4). In November 1933, Yihua was mysteriously vandalized by some GMD-related fascist blueshirts, creating one of the most notorious incidents of terror against left-wing cinema in Chinese film history. See Tian Han, *Yingshi zhuihuai lu*, 21–25.

34. The spectator's scene is also an inflection of another lost film, *Baiyun guxiang* (White cloud village), partly made in Hong Kong and finished in Chongqing in 1940, in which the female spy who seduces the male protagonist shows him the arsenal burning, making him realize that he has betrayed his country unaware. The scene becomes a turning point for the protagonist from corruption to heroic self-sacrifice, and similar to Fang Yin in *Baptism by Fire*, he dies in the battle with the enemy.

35. At the same time, the emotion that is aroused is rather different from what we define as interiority. The leftist writer Ling He complains of the obscurity of A Ying's inner activities: "What is her family lineage, her political attitude? How does the conflict between her interest as a collaborator and her righteousness happen? With all of the above omitted by the director, we are rather lost." Ling He, "Tan *Shengli jinxingqu* yu *Huode xili*."

36. Many of the Shanghai female stars in the 1920s and 1930s had a nightclub or dance hall entertainer background. Liang Saizhen and her two sisters, for example, were dance hall hostesses. After the Sino–Japanese war, film stars sought jobs at the dance halls, which paid better than the film industry, which was undergoing economic and political pressure with the change of regime. See Andrew Field, "Selling Souls in Sin City: Shanghai Singing and Dancing Hostesses in Print, Film, and Politics, 1920–1949," in *Cinema and Urban Culture in Shanghai*, ed. Zhang Yingjin, 99–127.

37. Jeffrey T. Schnapp, "The Mass Panorama," *Modernism/Modernity* 9, no. 2 (2002): 243–81.

38. Schnapp argues the affinity between the aesthetics of the sublime and the panoramic entertainment.

39. Gao Changhong, "Yishu xingdong," *Xinshubao,* August 22, 1939.

40. Ibid.

41. Ibid.; emphasis added.

42. As the founder of one of the most important literary societies in 1920s China, Gao Changhong (1898–1956?) led a rather eventful and tragic life, which was stigmatized by a conflict with Lu Xun, which many believed to have led to his downfall. Subsequent literary histories have spared very little space for the Sturm und Drang Society, despite its indisputable visibility and impact within literary circles at its time. Gao established *Kuangbiao yuekan* (The Sturm und Drang monthly) early in 1924 in Shanxi and started *Kuanbiao zhoukan* (The Sturm und Drang weekly) in the winter of 1924 in Beijing. He later moved the society to Shanghai and participated actively in the cultural scene in Shanghai. Gao went to Japan in 1929 to learn more about behavioral science and economics and went to Germany at the end of 1931. He left for Paris in 1936 when fascism was already rampant. In 1938 Gao came back to China and became an active writer in wartime Chongqing. In 1941 Gao went to Yan'an and was first welcome and then rejected, mainly because of his scandalous past conflict with the recently canonized Lu Xun in Yan'an. His arrogance and idealism further contributed to his loss of favor in Yan'an. In 1946, after the end of the Sino–Japanese War, Gao left Yan'an for Manchuria. His life went into oblivion afterward. He was last seen in 1956. Recent scholarship has started to pay attention to Gao, although it remains focused on his relationship with Lu Xun. Gao's wartime writings, highly complex theories of art and literature, war, and fascism, have not been addressed. For a biography of Gao, see Yan Xing, *Yisheng luomo, yisheng huihuang: Gao Changhong pinzhuan* (A life of solitude, a life of glory: Biography of Gao Changhong) (Tianjin: Baihua, 1996).

43. For an astute critique of such historiographical tendency, see Zhang Yingjin, "Beyond the Binary Imagination in Chinese Film Historiography:

Rethinking the Hong Kong–Shanghai Connection of Wartime Cinema," *Chinese Historical Review* 15, no. 1 (Spring 2008): 65–87.

44. The original English title for the film was *The Devils' Paradise*. I have chosen a more literal translation of the film title.

45. On the hectic film production and sharing of studio spaces and facilities from the four major studios in Hong Kong, see Poshek Fu, *Between Shanghai and Hong Kong*, 61–63; "Xianggang yingtan xinzhuanji, jianzi Heian zhong tuochu" (New opportunity for change: Hong Kong's film world gradually moving out of darkness), *Zhongguo yitan huabao*, Sept 19 (1939).

46. The notion of "diasporic venture" comes from Zhang Yingjin, who proposes a "diasporic" perspective in rethinking the history of Chinese cinema, to account for the massive movements of filmmakers across regions, embodied in the personal careers of people such as Lai Man-wai, Run Run Shaw, Cai Chusheng, and Situ Huimin. See Zhang Yingjin, "Beyond the Binary Imagination," 84–86.

47. Cai Chusheng, "Zeban yin," *Dadi yingxun* (1939): 4–5, 9–11.

48. *Baiyun guxiang*, which is no longer extant, had an eighteen-day run in Hong Kong and ranked number one at the box office. See Zhang Yingjin, "Beyond Binary opposition," 74. After the lease with Qiming ended in November 1939, *Baiyun guxiang* was later shot in Xiaguang Studio and completed in Chongqing. See "Dadi gongsi youyi xinzuo" (Another new film by Dadi Studio), *Qingqing dianying* 5, no. 4 (1940): 11.

49. See Dadi Yingxun 4–5 (1939); "Quwei yisu" (News for fun), *Qingqing dianying* 4, no. 27 (1939): 15; "Dadi yingpian gongsi geqian hou, Luo Jingyu litu huifu, xie 'Gudao tiantang' zhiyu qingqiu" (After Dadi folded, Luo Jingyu tries to recover the studio and carries *Paradise on Orphan Island* to appeal), *Dianying* 58 (1939): 3.

50. "Dadi yingye gongsi diyibu yingpian Gudao Tiantang," *Qingqing dianying zhoukan* 4, no. 12 (1939): 18–19.

51. After Chongqing and Hong Kong, the film was shown in the Philippines and Singapore. In December the film was shown again in Hong Kong at its first-run theaters with a new print produced in Chongqing. "Luo Jingyu jiang xie Li Lili fu xingzhou jieqia gudao tiantang yingquan," *Qingqing dianying* 4, no. 40 (1940): 16.

52. See my discussion of Cai Chusheng's career between 1927 and 1929 in chapter 4.

53. *Defending Our Hometown* was printed in Hong Kong and exhibited both in Hong Kong and Chongqing. The extant fragment for the film was discovered and is now preserved in Hong Kong.

54. This single eye also provides a revision of the male auteurist single eye in the film *Scenes of City Life,* as I discuss in chapter 5.

55. See Susan Buck-Morss, "Aesthetic and anaesthetics."

56. For an illuminating discussion on the Tango and its relationship with the experience of modernity grounded in the Russian context, see Yuri Tsivian, "The Tango in Russia," *Experiment: A Journal of Russian Culture* 2 (1996): 307–34.

57. Sloterdijk, *Terror from the Air,* 26–27.

58. Hou Weidong, preface to Yan Xing, *Yisheng luomo,* 9.

59. Another more elite, intermedial as well as extratextual reference is the use of painting in the film. In the scene preceding the photograph tearing, Li Lili sits at a dinner table looking at the collaborators across the table. When the camera cuts back to the two collaborators, the painting behind them comes into focus, framed between the two men: it is an art nouveau painting of Salomé holding John's head in her hand. The man, soon to be assassinated, even points his head against the picture background, explaining that he has to go to bed at ten because of his neurasthenia. As the man leaves, the lead collaborator comes back to his seat and meets the flirtatious gaze of Li Lili. This sequence, starting and ending with a close-up of Li Lili, makes the Salomé painting in the background a highly motivated element of the mise-en-scène. After the man flirts with Li across the table, the man makes the woman leave early. The background laughing in the restaurant becomes a loud comment on the scene—an effect quite similar to contemporary American sitcom "canned laughter." As the man stands up, he is again clearly framed in the Salomé painting. The legibility of the sign here, of course, would not be possible without the audience's shared knowledge of the painting and the Salomé narrative, made known among the elite circle by the Hollywood film (Charles Bryant, 1923) shown in China and Tian Han's translation and spoken drama adaptation of Oscar Wilde's *Salomé* in 1929. A women's magazine, titled *Salomé,* was also published in Shanghai from 1935, devoting significant space to film news and stardom. Li Lili herself appears on the cover for one of the issues. See *Salomé* 6 (1936).

60. On the aesthetics of muteness in melodrama, see Peter Brooks, *The Melodramatic Imagination: Balzac, Henry James, Melodrama, and the Mode of Excess* (New Haven, Conn.: Yale University Press, 1976), 56–80.

61. Michel Chion, *The Voice in Cinema,* trans. Claudia Gorbman (New York: Columbia University Press, 1999), 95–106.

62. The transition to sound was not completed until 1937 within the studio and exhibition network. Yet silent films continued to be shown in theaters in wartime Shanghai, Hong Kong, and Chongqing. Further, as I discuss earlier in this chapter, silent films were still produced in wartime Chongqing.

63. "'Gudao tiantang' xianying gongwen" (Public announcement for

the first screening of *Gudao tiantang*), *Zhongguo yitan huabao,* September 20, 1939.

64. See Dongfang Huifang, "Liangpian guangrong shiye zai lishi shang" (Two pages of glory in history), *Libao,* April 14–16, 1938. See also Zhang Yingjin, "Beyond the Binary Imagination."

65. Publicity for *Eight Hundred Heroes* in *Dagongbao* (Dagong news, Hong Kong), April 11, 1938.

66. Dongfang Huifang, "Liangpian guangrong shiye zai lishi shang."

67. Hou Yao's *Xuerou changcheng* and another resistance film, *Taipingyang shang de fengyun* (Storm over the Pacific, 1938), were recently discovered thanks to Jack Fong Lee's donation from San Francisco. Time does not allow me to watch the film and incorporate the findings, but I hope to explore them in the future.

68. For biographies of the Wan Brothers and Chinese animation history, see Marie-Claire Quiquemelle, "The Wan Brothers and Sixty Years of Animated Film in China," in *Perspectives on Chinese Cinema,* ed. Chris Berry (London: BFI, 1991), 175–86; John Lent and Ying Xu, "Chinese Animation Film: From Experimentation to Digitization," in *Art, Politics, and Commerce in Chinese Cinema,* ed. Zhu Ying and Stanley Rosen (Hong Kong: Hong Kong University Press, 2010), 112–26.

69. *Chaos in the Artist Studio* was considered the first animation in China, although the Wan Brothers already made an animated commercial entitled *Su Zhendong huawen daziji* (The Su Zhendong Chinese typewriter) in 1922, followed by two more animated commercials. Lent and Xu identified a number of animation shorts made by lesser-known artists before 1926. See Lent and Xu, "Chinese Animation Film," 112. I noticed that in 1926 another animation short was produced by Qin Lifan for Da Zhonghua Studio entitled *Qiuren* (The ball man). According to a Diansheng report, *The Ball Man* was not successful in its trial period and, hence, was never exhibited publicly. See "Guochan katongpian de zuo jin ming" (The past, present, and future of domestically produced animations), *Diansheng Zhoukan* (Cinema voice weekly) 38 (September 25, 1936). According to Da Zhonghua's publicity for *The Ball Man,* which advertised the film as the first animation made in China, the film was described as similar to *Out of the Ink Well* in featuring the Ball Man with the artist in the same animation. See the press kit for *Transparent Shanghai.*

70. Wan Laiming and Wan Guchan, "Xianhua katong" (Miscellaneous thoughts on animated cartoons), *Mingxing banyuekan* (Mingxing half-monthly) 1, no. 6 (July 1, 1935).

71. These narrative animation shorts were directed by Tang Jie, the director and actor for the famous comedy series *Mr. Wang* (Wang

Xiansheng). See "Zhongguo katong dahui" (Collections of Chinese animations), *Mingxing banyuekan* 5, no. 6 (July 1, 1936).

72. "Zhongguo katong yingpian zhimu Wanshi xiongdi congshi katong gongzuo de zishu." *Sanliujing huabao* 15, no. 7 (1941): 25.

73. Wan Laiming, *Wo yu Sun Wukong* (Taiyuan: Baiyue wenyi, 1986). On the film's reception and Japanese connection, see Daisy Yan Du, "On the Move: The Trans/national Animated Film in 1940s–1970s China" (PhD diss., University of Wisconsin–Madison, 2012).

74. See Li Suyuan and Hu Jubing, *Zhongguo wusheng dianying shi*, 229; Zhang Zhen, *Amorous History*. The use of animation in martial arts films continued in the 1950s Hong Kong martial arts films, before the Shaw Brothers' generation.

75. Cheng Xiaoqing, "Wo zhi shenguai yingpian guan" (My outlook on god-spirit films), in the press kit for *Pansi dong* (Cave of the spider women), Shanghai Film Studio, 1927.

76. Ying Dou, "Shenguai ju zhi wo jian" (My thoughts on god-spirit films), *Yinxing* 8 (1927); reprinted in *Zhongguo wusheng dianying* (Chinese silent films), ed. Zhongguo dianying ziliaoguan (Beijing: Zhongguo dianying chubanshe, 1996), 662–65, esp. 662.

77. Yingdou, "Shenguai ju zhi wo jian," 665.

78. For an in-depth discussion of fairy tale and the invention of the child in China's modern discourse embedded with developmental psychology, evolutionary theory, national character complex, and a burgeoning commodity culture, see Andrew F. Jones, *Developmental Fairy Tales: Evolutionary Thinking and Modern Chinese Culture* (Cambridge, Mass.: Harvard University Press, 2011).

79. Wan Laiming and Wan Guchan, "Women huizhi 'tieshan gongzhu' de jingguo" (How we created *Princess Iron Fan*), *Guolian yingxun* 1, no. 3 (1941): 1–2.

80. On the use of rotoscoping for the film, see "Katongpian yeyao da bujing" (Even animation needs set design), *Damei zhoubao*, December 1, 1940.

81. Newton Lee and Krystina Madel, *The Disney Stories: Getting to Digital* (New York: Springer, 2012), 60–61.

82. While some of the news reports attributed the machine to the one that the brothers improved on from a set they purchased in 1927 from an American merchant who failed to establish an animation business in China, the multiple-camera set was probably purchased from the United States around 1935, which the Wan Brothers used for making two sound animations. See Zhang Jingde, "Wanshi katong shezhi de chengxu" (The production process of Wan Brothers' animation), *Xianxiang* 8 (1935). The photo essay shows a "sound animation shooting machine" (*yousheng*

katong shezhi jiqi) the Wan Brothers recently purchased from the United States that fits the description of the one used for *Princess Iron Fan*. A 1940 report of the film confirms that the camera set was bought five or six years before. See "Wanshi xiongdi chuangzuo xiade Tieshan Gongzhu zuoqian kaipai" (*Princess Iron Fan* created by the Wan Brothers started shooting yesterday), *Qingqing dianying* 5, no. 29 (1940): 5.

83. Ibid.

84. "Zhang Shankun yu tieshan gongzhu," *Haiyan* 7 (1946), 4.

85. Thomas LaMarre, *The Anime Machine: A Media Theory of Animation* (Minneapolis: University of Minnesota Press, 2009), xxvi.

86. Ibid., xxx–xxxiii.

87. Maurice Merleau-Ponty, "Eye and Mind," in *The Primacy of Perception*, (Evanston, Ill.: Northwestern University Press, 1964), 159–90, 169; see also Miriam Hansen's reading of the fiery pool that denotes a noncontemplative reflexivity in "Benjamin and Cinema," 334–36.

88. Sergei Eisenstein, *Eisenstein on Disney*, ed. Jay Leyda (Calcutta: Seagull Books, 1986), 25.

89. The self-reflexive relation between fire and animation is seen in the affinity between fire and the Monkey King. The Monkey King himself is a product of fire and closely related to the Mountain of Flames. As described in chapter 60 of *Journey to the West*, the Mountain of Flames was nothing but the side product of the monkey when five hundred years before he escaped the Taoist brazier of eight trigrams. As he kicked over the elixir oven, several hot bricks still on fire dropped to the earth and became the Mountain of Flames. In the Taoist interpretation of the monkey among the five elements, Sun Wukong belongs to fire and metal, which makes him simultaneously isomorphic and vulnerable to fire. See Zhang Jing'er, *Xiyouji renwu yanjiu* (Character study of *Journey to the West*) (Taibei: Taiwan xuesheng shuju, 1984); Nakano Miyoko, *Saiyuki no himitsu: Tao to rentanjutsu no shinborizumu* (The Secret of *Journey to the West*: Dao and the symbolism of alchemy) (Tokyo: Fukutake Shoten, 1984).

90. Paul Wells, *Understanding Animation* (London: Routlege, 1998), 29.

91. Wan Laiming, Wan Guchan, Wan Chaocheng, "Xianhua katong" (Miscellaneous thoughts on animation), *Mingxing banyuekan* 5, no. 1 (April 16, 1936).

92. Miriam Hansen, "Of Mice and Ducks: Benjamin and Adorno on Disney," *The South Atlantic Quarterly* 92, no. 1 (Winter 1993): 27–61.

93. The fact the film was exported to Japan and subtitled in Japanese during the Sino–Japanese war further complicates the reception of the film and the sadomasochistic pleasure involved. See Daisy Yan Du, "On the Move."

94. There might also be some Soviet influence as well, as the Wan Brothers had mentioned the effect of woodcuts in Soviet animations, which appears in the black silhouette images of the masses. But the woodcut effect and iconography of the masses could have come from the Chinese woodcuts at the time, which were largely expressionistic with German, Polish, and Soviet influence. See Wan Laiming et al., "Xianhua katong," *Mingxing banyuekan* 5, no. 1.

95. See, "Jiyou yishi de tieshan gongzhu," *Qingqing dianying* 5, no. 37 (1940): 9.

96. I take the notion of "technological underdetermination" from LaMarre in considering technology as the necessary but insufficient condition for cultural articulations, but I also take another spin at "underdetermination" by considering the instability and indetermination of what counts as cinematic technology, as this book tries to demonstrate. See Lamarre, *The Anime Machine*, xxxi.

Filmography

The Adventures of Ruth. Dir. George Marshall. Ruth Roland Serials. 1919.

Aleksandr Nevskiy (Alexander Nevsky). Dir. Sergei Eisenstein. Mosfilm. 1938.

All Quiet on the Western Front. Dir. Lewis Milestone. Universal Pictures. 1930.

Asphalt. Dir. Joe May. Universum Film. 1929.

L'atlantide. Dir. G. W. Pabst. Nero Film AG. 1932.

L'atlantide. Dir. Jacques Feyder. Thalman & Cie. 1921.

Babai zhuangshi (Eight hundred heroes). Dir. Ying Yunwei. Central Film Studio. 1938.

Bai furong (The white lotus). Dir. Chen Tian. Huaju Studio. 1927.

Baiyun guxiang (Fatherland calls). Dir. Situ Huimin. Grandland Motion Picture Corporation (Hong Kong). 1940.

Bao jiaxiang (Defending our hometown). Dir. He Feiguang. Chinese Motion Picture Corporation. 1939.

Baowei women de tudi (Protecting the homeland). Dir. Shi Dongshan. Central Film Studio. 1938.

The Barretts of Wimpole Street. Dir. Sidney Franklin. Metro-Goldwyn-Mayer. 1934.

Berlin: Die Sinfonie der Grosstadt (Berlin: Symphony of a great city). Dir. Walter Ruttmann. Deutsche Vereins-Film. 1927.

The Birth of a Nation. Dir. D. W. Griffith. David W. Griffith Corp. 1915.

The Black Secret. Dir. George B. Seltz. George B. Seltz Productions. 1919.

Bomben auf Monte Carlo (Monte Carlo madness). Dir. Hanns Schwarz. Universum Film. 1931.

Broken Blossoms. Dir. D. W. Griffith. D. W. Griffith Productions. 1919.

Broken Lullaby. Dir. Ernst Lubitsch. Paramount Pictures. 1932.

Bronenosets Potemkin (Battleship Potemkin). Dir. Sergei Eisenstein. Goskino. 1925.

Captain Swagger. Dir. Edward Griffith. Pathé Exchange. 1928.

Changkong wanli (Iron birds fly high). Dir. Sun Yu. Central Film Studio. 1941.

Chapaev (Chapayev). Dir. Georgi Vasilyev and Sergei Vasilyev. Lenfilm Studio. 1934.

Chelovek s kino-apparatom (*Man with a Movie Camera*). Dir. Dziga Vertov. VUFKU. 1929.

Chengshi zhiye (The night of the city). Dir. Fei Mu. Lianhua Studio. 1933.

Chunchao (The tides of spring). Dir. Zheng Yingshi. Hengsheng Studio. 1933.

Chunfeng yangliu (Willow in the spring). Dir. Wang Fuqing. Dadong Jinshi Studio. 1932.

City Lights. Dir. Charles Chaplin. Charles Chaplin Productions. 1931.

The Clutching Hand (or *The Exploits of Elaine*). Dir. Louis J. Gasnier, George B. Seitz. Wharton Studio. 1914.

The Crowd. Dir. King Vidor. Metro-Goldwyn-Mayer. 1928.

Daiyun (The simpleton's luck). Dir. Chen Tian. Huaju Studio. 1927.

Dalu (The big road). Dir. Sun Yu. Lianhua Studio. 1934.

Danao huashi (Uproar in the studio). Dir. Mei Xuetao and Wan Guchan. The Great Wall Studio. 1926.

Dao ziran qu (Back to nature). Dir. Sun Yu. Lianhua Studio. 1936.

Dikang (Resistance). Mingxing Studio. 1935.

Dongya zhiguang (Light in east Asia). Dir. He Feiguang. Chinese Motion Picture Corporation. 1940.

Dong zhanchang (Battlefield in the east). Dir. Xu Suling. Central Film Studio. 1938.

Duhui de zaochen (Dawn over the metropolis). Dir. Cai Chusheng. Lianhua Studio. 1933.

Duo guobao (Fighting for the national treasure). Dir. Zhang Huichong. Lianhe Studio. 1929.

Dushi fengguang (Scenes of city life). Dir. Yuan Muzhi. Diantong Film Studio. 1935.

Entuziazm (Enthusiasm). Dir. Dziga Vertov. Ukrainfilm. 1930.

Fashions of 1934. Dir. William Dieterle. First National Pictures. 1934.

Feng (Wind). Dir. Wu Cun. Lianhua Studio. 1933.

Fengyun ernü (Sons and daughters of the storm). Dir. Xu Xingzhi. Diantong Film Studio. 1935.

Fenhongse de meng (Pink dream). Dir. Cai Chusheng. Lianhua Studio. 1932.

Flying down to Rio. Dir. Thornton Freeland. Radio Pictures. 1933.

42nd Street. Dir. Lloyd Bacon. Warner Brothers. 1933.

Genü Hongmudan (Songstress Red Peony). Dir. Zhang Shichuan. Mingxing Studio. 1931.

The Girl Detective. Dir. James W. Horne. Kalem Company. 1915.

Gongfu guonan (Together for national salvation). Dir. Cai Chusheng. Lianhua Studio. 1932.

The Grand Hotel. Dir. Edmund Goulding. Metro-Goldwyn-Mayer. 1932.

Gudao qingxiao (Romantic heroes on the Orphan Island). Dir. Mo Kuang-shi. Huasheng. 1941.

Gudao tiantang (Paradise on Orphan Island). Dir. Cai Chusheng. Grand-land Motion Picture Corporation (Hong Kong). 1939.

Gu'er jiuzu ji (The orphan rescues grandfather). Dir. Zheng Zhengqiu. Mingxing Studio. 1923.

Guohuo nian (The year of national goods). Dir. Tang Jie. Mingxing Studio. 1933.

Hangkong jiuguo (Saved by aviation). Dir. Tang Jie. Mingxing Studio. 1933.

Hao zhangfu (The good husband). Dir. Shi Dongshan. Central Film Studio. 1939.

Heiji yuanhun (Victims of opium). Dir. Guan Haifeng. Huanxian Film Company. 1916.

Hongfen kulou (Red beauty skeleton). Dir. Guan Haifeng. New Asia Film Company. 1921.

Hongxia (The red heroine). Dir: Wen Yimin. Youlian Studio. 1929.

Huangtang jiangjun (Ridiculous general). Dir. Shi Dongshan. Tianyi Studio. 1929.

Huo de xili (Baptism by fire). Dir. Sun Yu. Chinese Motion Picture Corporation. 1941.

Huoli yingxiong (Hero in the fire). Dir. Zhang Huimin. Huaju Studio. 1928.

Huoli zuiren (The Sinner in the Flames). Dir. Huang Mengjue. Taipingyang Studio. 1925.

Huoshao Hongliansi (The burning of the Red Lotus Temple). 18 episodes. Dir. Zhang Shichuan. Mingxing Studio. 1928–31.

Huoshao Jianfengzhai (The burning of the Sword-Blade Village). Dir. Ren Xipan and Fei Boqing. Xipan Studio. 1929.

Huoshao Jiulonghsan (The burning of the Nine-Dragon Mountain). Dir. Zhu Shouju. Da Zhonghua Baihe Studio. 1929.

Huoshao Pingyangcheng (The burning of Pingyang City). Dir. Yang Xiaozhong. Changming Studio. 1929.

Huoshao Qinglongsi (The burning of the Green Dragon Temple). Dir. Ren Yutian. Jinan Studio. 1929.

Huoshao Qixinglou (The burning of the Seven-Star Mansion). Dir. Yu Boyan. Fudan Studio. 1930.

Huoyue de xixian (The active western front). Dir. Pan Jienong. Central Film Studio. 1938.

I Am a Fugitive from a Chain Gang. Dir. Mervyn LeRoy. Warner Brothers. 1932.

The Iron Claw. Dir. George B. Seitz and Edward José. Edward José Productions. 1916.

The Jazz Singer. Dir. Alan Crosland. Warner Brothers. 1927.

Jiushiwo (It's me). Dir. Zhu Shouju. Da Zhonghua Baihe Studio. 1928.

Kangzhan biaoyu katong (Resistance slogan cartoons). 5 vols. Dir. Wan Guchan et al. Chinese Motion Picture Corporation. 1938–1939.

Kangzhan geji (Resistance songs). 7 vols. Dir. Wan Guchan et al. Chinese Motion Picture Corporation. 1938–1939.

Konets Sankt-Peterburga (The end of St. Petersburg). Dir. Vsevolod Pudovkin. Mezhrabpom-Rus. 1927.

Der Kongress Tanzt (Congress Dances). Dir. Erik Charell. Universum Film. 1931.

Kuanghuan zhiye (The night of the carnival). Dir. Shi Dongshan. Xinhua Studio. 1936.

Kuangliu (Torrent). Dir. Cheng Bugao. Mingxing Studio. 1933.

Langtaosha (Sand washing the waves). Dir. Wu Yonggang. Lianhua Studio. 1936.

Der letzte Mann (The last laugh). Dir. F. W. Murnau. Universum Film. 1924.

Liangxin fuhuo (Resurrected conscience). Dir. Bu Wancang. Mingxing Studio. 1926.

Das Lied der Sonne (Song of the sun). Dir. Max Neufeld. Itala Film. 1933.

Lieyan (Raging flame). Dir. Hu Rui. Yihua Studio. 1933.

Little Women. Dir. George Cukor. RKO Radio Pictures. 1933.

Lonesome. Dir. Paul Fejös. Universal Pictures. 1928.

Mädchen in Uniform. Dir. Leontine Sagan and Carl Froelich. Deutsche Film-Gemeinschaft. 1931.

Malu Tianshi (Street angel). Dir. Yuan Muzhi. Mingxing Studio. 1937.

Mat (Mother). Dir. Vsevolod Pudovkin. Mezhrabpom-Rus. 1926.

Meiren ji (The beauty trap). Dir. Shi Dongshan et al. Da Zhonghua Baihe Studio. 1926.

Mi dianma (The secret radio code). Dir. Zhang Daofan and Huang Tianzuo. Central Film Studio. 1936.

Le million. Dir. René Clair. Films Sonores Tobis. 1931.

Minzu shengcun (National existence). Dir. Tian Han. Yihua Studio. 1933.

Minzu wansui (Long live the people). Dir. Zheng Junli. Chinese Motion Picture Corporation. 1941.

Mirages de Paris. Dir. Fyodor Otsep. Path Natan. 1933.

Mulan. Dir. Tony Bancroft. Walt Disney Pictures. 1998.

Mulan congjun (Mulan joins the army). Dir. Bu Wancang. Xinhua Studio. 1939.

Muxing zhiguang (Maternal radiance). Dir. Bu Wancang. Lianhua Studio. 1933.

My iz Kronshtadta (We are from Kronstadt). Dir. Efim Dzigan. Mosfilm. 1936.

Nanguo zhichun (Spring in the south). Dir. Cai Chusheng. Lianhua Studio. 1932.

Napoléon (Napoleon). Dir. Abel Gance. Ciné France Films. 1927.

Nero. Dir. J. Gordon Edwards. Fox Film Corporation. 1922.

Nero and the Burning of Rome. Dir. Edwin S. Porter. Edison Manufacturing Company. 1908.

Nülingfuchouji (The revenge of the actress). Dir. Bu Wancang. Hanlun Studio. 1929.

Orphan of the Storm. Dir. D. W. Griffith. D. W. Griffith Productions. 1921.

Pansi dong (Cave of the spider women). Dir. Dan Duyu. Shanghai Film Studio. 1927.

Paris in Spring. Dir. Lewis Milestone. Paramount Pictures. 1935.

Pearl of the Army. Dir. Edward José. Astra Film. 1916.

The Perils of Pauline. Dir. Louis J. Gasnier and Donald MacKenzie. Pathé Frères. 1914.

Potomok Chingis-Khana (Storm over Asia). Dir. Vsevolod Pudovkin. Mezhrabpomfilm. 1928.

Putyovka v zhizn (The road to life). Dir. Nikolai Ekk. Mezhrabpomfilm. 1931.

Qiancheng wanli (Ten thousand miles ahead). Dir. Cai Chusheng. Xinsheng Studio. 1941.

Qi nüzi (The incredible woman). Dir. Shi Dongshan. 1928. Naimei Studio.

Qiuren (The ball man). Dir. Qin Lifan. Da Zhonghua Baihe Studio. 1926.

Queen Christina. Dir. Rouben Mamoulian. Metro-Goldwyn-Mayer. 1933.

The Red Circle. Dir. Sherwood MacDonald. Balboa Amusement Producing Company. 1915.

Rexue nan'er (Hot-blooded men). Dir. Wan Laitian. Minxin Studio. 1929.

Roubo (Fistfight). Dir. Hu Tu. Yihua Studio. 1933.

Ruth of the Rockies. Dir. George Marshall. Ruth Roland Serials. 1920.

Sange modeng nüxing (Three modern women). Dir. Bu Wancang. Lianhua Studio. 1933.

Shanghai ershisi xiaoshi (Twenty-four hours in Shanghai). Dir. Shen Xiling. Mingxing Studio. 1934.

Shanghai Express. Dir. Josef von Sternberg. Paramount Pictures. 1932.

Shanghai huoxian hou (Shanghai at the battlefront). Dir. Tang Xiaodan. Daguan Film Studio. 1938.

Shanhkayskiy dokument (Shanghai Document). Dir. Yakov Bliokh. Soyuzkino. 1928.

Shengli jinxing qu (Marches of victory). Dir. Shi Dongshan. Chinese Motion Picture Corporation. 1940.

Shengsi tongxing (Unchanged heart in life and death). Dir. Ying Yunwei. Mingxing Studio. 1936.

Shennü (The goddess). Dir. Wu Yonggang. Lianhua Studio. 1934.

Shizi jietou (Crossroads). Dir. Shen Xiling. Mingxing Studio. 1937.

Showboat. Dir. Harry Pollard. Universal Pictures. 1929.

Shuangxiong doujian (Sword duel of the two heroes). Dir. Shi Dongshan. Tianyi Studio. 1929.

The Singing Fool. Dir. Lloyd Bacon. Warner Brothers. 1928.

Sous les toits de Paris (Under the roofs of Paris). Dir. René Clair. Films Sonores Tobis. 1930.

Taipingyang shang de fengyun (Storm over the Pacific). Dir. Hou Yao. Tianyi Studio. 1938

Taoli jie (Plunder of peach and plum). Dir. Ying Yunwei. Diantong Film Studio. 1934.

The Thief of Bagdad. Dir. Raoul Walsh. Douglas Fairbanks Pictures. 1924.

Tianming (Daybreak). Dir. Sun Yu. Lianhua Studio. 1933.

Tieshan gongzhu (Princess Iron Fan). Dir. Wan Laiming and Wan Guchan. Zhongguo Lianhe Studio. 1941.

Tongbao suxing (Citizens, wake up!). Screenplay. Zhu Shilin. Lianhua Studio. 1932.

Tongju zhiai (Love in cohabitation). Dir. Shi Donghsan. Da Zhonghua Baihe Studio. 1926.

Touming de Shanghai (Transparent Shanghai). Dir. Lu Jie. Da Zhonghua Baihe Studio. 1926.

Touxing moying (Stealing the shadow and imitating the form). Dir. Zhang Huimin. Huaju Studio. 1929.

Touying moxing. Dir. Zhang Huimin. Huaju Studio. 1929.

Upstairs. Dir. Victor Schertzinger. Goldwyn Pictures Corporation. 1919.

Les vampires. Dir. Louis Feuillade. Gaumont. 1915.

Varieté (Variety). Dir. E. A. Dupont. Universum Film. 1925.

The Volga Boatman. Dir. Cecil B. DeMille. DeMille Pictures Corporation. 1926.

Wangshi sixia (Four knights-errant named Wang). Dir. Shi Dongshan. Da Zhonghua Baihe Studio. 1927.

Way Down East. Dir. D. W. Griffith. D. W. Griffith Productions. 1920.

Welcome Danger. Dir. Clyde Bruckman. Harold Lloyd Corporation. 1929.

Wonder Bar. Dir. Lloyd Bacon. First National Pictures. 1934.

Wudi yingxiong (Invincible hero). Dir. Shao Zuiwen. Tianyi Studio. 1929.

Xiao tianshi (Little angels). Dir. Wu Yongang. Lianhua Studio. 1934.

Xiao wanyi (Little toys). Dir. Sun Yu. Lianhua Studio. 1933.

Xinjiu Shanghai (Shanghai old and new). Dir. Cheng Bugao. Mingxing Studio. 1936.

Xin nüxing (The new woman). Dir. Cai Chusheng. Lianhua Studio. 1934.

Xin Shenghuo yundong (New life movement). Mingxing Studio. 1936.

Xuejian Baoshan cheng (Bloodstained Baoshan City). Dir. Situ Huimin. Xinshidai Studio. 1938.

Xuerou changcheng (The great wall of blood and flesh). Dir. Hou Yao. Wenhua Studio. 1938.

Xuezhong guchu (Orphan of the storm). Dir. Zhang Huimin. Huaju Studio. 1929.

Yanchao (Salt tide). Dir. Xu Shenfu. Mingxing Studio. 1933.

Yan Ruisheng. Dir. Ren Pengyan. Chinese Film Research Society. 1921.

Yeban gesheng (Midnight singing). Dir. Ma-Xu Weibang. Xinhua Studio. 1937.

Ye Meigui (Wild Rose). Dir. Sun Yu. Lianhua Studio. 1932.

Ye mingzhu (Lustrous pearls). Dir. Chen Tian. Huaju Studio. 1927.

Yichuan zhenzhu (A string of pearls). Dir. Li Zeyuan. Changcheng Studio. 1925.

Yijian mei (A Spray of plum blossoms). Dir. Bu Wancang. Lianhua Studio. 1931.

Yinghan shuangxin (Two stars in the Milky Way). Dir. Shi Dongshan. Lianhua Studio. 1931.

Youji jinxingqu (Marches of the guerillas). Dir. Situ Huimin. Qinming Studio. 1938.

Yuguangqu (Song of the fishermen). Dir. Cai Chusheng. Lianhua Studio. 1934.

Yuli hun (The soul of jade pear). Dir. Zhang Shichuan. Mingxing Studio. 1924.

Zhanshi (Soldiers). Dir. Yu Zhongying. Central Film Studio. 1935.

Zhongguo hai de nuchao (Angry tide of the Chinese sea). Dir. Yue Feng. Yihua Studio. 1933.

Zhonghua ernü (Sons and daughters of China). Dir. Shen Xiling. Central Film Studio. 1939.

Zimei hua (The sisters). Dir. Zheng Zhengqiu. Mingxing Studio. 1933.

Ziyou shen (Goddess of freedom). Dir. Situ Huimin. Diantong Film Studio. 1935.

Zlatye gory (Golden mountains). Dir. Sergei Yutkevich. Soyuzkino. 1931.

Index